The Object Reader

This unique and groundbreaking collection frames the classic debates on objects and aims to generate new ones by reshaping the ways in which the object can be taught and studied, from a wide variety of disciplines and fields.

 The Object Reader elucidates objects in many of their diverse roles, dynamics and capacities. Precisely because the dedicated study of objects does not reside neatly within a single discipline, this collection is comprised of numerous academic fields. The selected writings are drawn from anthropology, art history, classical studies, critical theory, cultural studies, digital media, design history, disability studies, feminism, film and television studies, history, philosophy, psychoanalysis, social studies of science and technology, religious studies and visual culture.

 The collection, composed of 20th and 21st century writing also seeks to make its own contribution through original work, in the form of 25 short 'object lessons' commissioned specifically for this project. These new and innovative studies from key writers across a range of disciplines will enable students to look upon their surroundings with trained eyes to search out their own 'object studies'.

Fiona Candlin is Lecturer in Museum Studies, School of Arts, Birkbeck, University of London.

Raiford Guins is a Founding Principal Editor for the *Journal of Visual Culture* and an Assistant Professor of Digital Cultural Studies in the Department of Comparative Literary and Cultural Studies and Consortium for Digital Arts, Culture and Technology (cDACT), State University of New York, Stony Brook.

IN-SIGHT

Series editor: Nicholas Mirzoeff

This series intends to promote the consolidation, development and thinking-through of the exciting interdisciplinary field of visual culture in specific areas of study. The titles in the series will range from thematic questions of ethnicity, gender and sexuality to examinations of particular geographical locations and historical periods. As visual media converge on digital technology, a key theme will be to what extent culture should be seen as specifically visual and what that implies for the critical engagement with global capital. The books are intended as resources for students, researchers and general readers.

The Feminism and Visual Culture Reader
Edited by Amelia Jones

The Nineteenth-century Visual Culture Reader
Edited by Jeannene M. Przyblyski and Vanessa R. Schwartz

Multicultural Art in America
Nicholas Mirzoeff

The Object Reader
Edited by Fiona Candlin and Raiford Guins

The Object Reader

Edited by

**Fiona Candlin
and Raiford Guins**

Routledge
Taylor & Francis Group

LONDON AND NEW YORK

First published 2009
by Routledge
2 Park Square, Milton Park, Abingdon, Oxon, OX14 4RN

Simultaneously published in the USA and Canada
by Routledge
711 Third Ave, New York, NY 10017

Routledge is an imprint of the Taylor & Francis Group, an informa business

Editorial selection and material © 2009 Fiona Candlin and Raiford Guins
Chapters © The contributors

Typeset in Perpetua and Bell Gothic by
The Running Head Limited, Cambridge, www.therunninghead.com
Printed and bound in Great Britain by
CPI Antony Rowe, Chippenham, Wiltshire

British Library Cataloguing in Publication Data
A catalogue record for this book is available from the British Library

Library of Congress Cataloging in Publication Data
A catalog record for this book has been requested

ISBN 10: 0–415–45229–5 (hbk)
ISBN 10: 0–415–45230–9 (pbk)

ISBN 13: 978–0–415–45229–8 (hbk)
ISBN 13: 978–0–415–45230–4 (pbk)

Contents

Sources

Part I Object

Part II Thing

Part III Objects and Agency

Part IV Object Experience

Part V The Objecthood of Images

Maurice M. Manring, 'Aunt Jemima Explained: The Old South, the Absent Mistress, and the Slave in a Box', in *Southern Cultures*, vol. 2, no. 1, Fall 1996, pp. 19–44.

Part VI Leftovers

Barbara Penner, 'A World of Unmentionable Suffering: Women's Public Conveniences in Victorian London', in *Journal of Design History*, vol. 14, no. 1, 2001, pp. 35–51.

Celeste Olalquiaga, 'Holy Kitschen: Collecting Religious Junk from the Street', in *Megalopolis: Contemporary Culture Sensibilities*, Minneapolis: University of Minnesota Press, 1992, pp. 36–55.

Julian Stallabrass, 'Trash', in *Gargantua: Manufactured Mass Culture*, London: Verso, 1996, pp. 171–88.

Christina Lindsay, 'From the Shadows: Users as Designers, Producers, Marketers, Distributors and Technical Support', in Nelly Oudshoern and Trevor Pinch (eds), *How Users Matter: The Co-Construction of Users and Technologies*, Cambridge, MA: MIT Press, 2003, pp. 29–50.

Permissions

EXTRACTS

Part I Object

Part II Thing

Part III Objects and Agency

Part IV Object Experience

Part V The Objecthood of Images

Part VI Leftovers

PICTURE CREDITS

The following were reproduced with kind permission. While every effort has been made to trace copyright holders and obtain permission, this has not been possible in all cases. Any omissions brought to our attention will be remedied in future editions.

Part I Object

Winnicott

Table p. 8 and Figures 1, 2, p. 12, from 'Transitional Objects and Transitional Phenomena', *Playing and Reality* by D. W. Winnicott, London: Routledge, 1971, pp. 1–25. Copyright © 1971 Routledge. Reproduced by permission of Taylor & Francis Books UK/Extract from *Playing and Reality* by D. W. Winnicott by permission of Paterson Marsh Ltd on behalf of The Winnicott Trust.

Ingold

Patterns of wrapping in coil basketry (1–5): from H. Hodges, *Artifacts: An introduction to Early Materials and Technology*, Duckworth, 1964, p. 131. Reproduced by permission of Gerald Duckworth & Co. Ltd.

Artefactual and natural spirals: A. from F. Boas, *Primitive Art*, published by Dover Publications, 1955 [1927], p. 20. Reproduced by kind permission of the Estate of Franz Boas; B. from D. W. Thompson, *On Growth and Form*, published by Cambridge University Press, 1961 [1917], p. 192. Reprinted by permission of the publisher.

DuBois

Myson, painting of naked woman with *olisboi*. Vase, terra cotta, fifth century BCE. Museo Archeologico Regionale, Syracuse. Photograph copyright the Trustees of the British Museum. Reproduced by permission of The British Museum Company Limited.

Detail of a vase by the Hasselmann Painter, *c.* 430–420 BCE. Photograph copyright the Trustees of the British Museum. Reproduced by permission of The British Museum Company Limited.

Krater by the Pan Painter, woman carrying a giant phallus. Second quarter of the fifth century BCE. Staatliche Museen zu Berlin – Preussischer Kulturebesitz, Antikensammlung/bpk. bpk/Antikensammlung, SMB/Ingrid Geske. Reprinted with permission.

'Baubo' figurine from Priene. Terra cotta, ca. 200 BCE. Staatliche Museen zu Berlin– Preussischer Kulturbesitz, Antikensammlung/bpk. bpk/Antikensammlung, SMB/ Ingrid Geske. Reprinted with permission.

Part II Thing

Latour

Effects of Good Government in the Countryside, 1338–40 (fresco) by Lorenzetti, Ambrogio (1285–c. 1348), Palazzo Pubblico, Siena, Italy/F. Lensini, Siena/The Bridgeman Art Library. Nationality / copyright status: Italian / out of copyright.

The UN Security Council meets at UN headquarters to hear the evidence of Iraq's weapons program presented by US Secretary of State Colin Powell, Wednesday, February 5, 2003, © AP/PA Photos/Richard Drew.

Althing in Thingvellir (Þingvellir), Iceland, photo: Sabine Himmelsbach. Reprinted with kind permission.

Columbia space shuttle debris. Photo courtesy of Getty Images News/Getty Images.

NASA crash investigator, Kennedy Space center in Cape Canaveral, Florida, March 11, 2003 © photo AP/PA Photos/NASA, Kim Shiflett.

Bleecker

Coal miner with canary.

Video surveillance, no dumping sign. Photo: Julian Bleecker. Reproduced with permission.

Screen shot from Flightaware.com. Courtesy of FlightAware. flightaware.com

Photo from the Institute for Applied Autonomy — www.appliedautonomy.com. Reproduced with permission.

Screen shot from blog – http://sparkytheaibo.vnunetblogs.com/the_palace_of_gl

The PigeonBlog Project. Reproduced by permission of Beatriz da Costa.

Part III Objects and Agency

Gell

Trobriand canoe-prow, Kitava Island, Milne Bay Province, PNG, photo Shirley F. Campbell, May 1977, from Shirley Campbell, 'The Art of the Kula', 1984, PhD thesis, Australian National University, Canberra. Reproduced by permission of the author.

John Frederick Peto (1854–1907), *Old Time Letter Rack*, 1894, oil on canvas, 76.2 × 63.5 cm (30⅛ × 25'') Museum of Fine Arts, Boston. Bequest of Maxim Karolik, 64.411. Photograph © 2008 Museum of Fine Arts, Boston.

Pablo Picasso (1881–1973), *Baboon and Young* (Vallauris, 1951). New York, Museum of Modern Art (MoMA). Bronze (cast 1955), after found objects, 21 × 13¼ × 20¾'' (53.3 × 33.3 × 52.7 cm). Mrs Simon Guggenheim Fund. 196.1956. © Succession Picasso/DACS 2008. Digital image © 2008, The Museum of Modern Art, New York/ Scala, Florence.

Taussig

Baron Erland Nordenskiold from Nordenskiold and Pérez, *An Historical and Ethnological Survey of the Cuna Indians*, 1938, Comparative Ethnographical Studies 10, Gothenburg: Ethnografiska Museum.

Rubén Pérez from Nordenskiold and Pérez, 1938.

Cuna curing figurines, drawn by Guillermo Hayans (circa 1948).

Turtle figurines used for hunting magic from Nordenskiold and Pérez, 1938.

Decoy turtle from Nordenskiold and Pérez, 1938.

Latour

Figures 8.1, 8.2, 8.3, 8.4. 8.5, 8.6, 8.7, 8.8 from Bruno Latour. 'Where Are the Missing Masses? The Sociology of a Few Mundane Artifacts' from Wiebe E. Bijker and John Law, *Shaping Technology/Building Society: Studies in Sociotechnical Change*,

pp. 225–58, © 1992 Massachusetts Institute of Technology, by permission of The MIT Press.

Part IV Object Experience

Bijker
Royal Enfield Advertisement. Reproduced by kind permission of Watsonian-Squire.
Line drawing of cyclists: 'the first rider has thrown his legs over the handlebars . . .'.
Lady and gentleman riding 'ordinary' bicycles with Starley wheels, 1874. Photo courtesy of the Science Museum/Science & Society Picture Library.
'King of the Road: The Social Construction of the Safety Bicycle' from Wiebe E. Bijker, *Of Bicycles, Bakelites, and Bulbs: Towards a Theory of Sociotechnical Change*, pp. 30–54, © 1995 Massachusetts Institute of Technology, by permission of The MIT Press.

Part V The Objecthood of Images

Edwards
Advertisement for 'My school year: your very own book of memories', 1997, Gillman and Soame, Oxford. Reproduced with permission.
Embroidered photographic shrine to George Young, killed during WWI, Trustees of Wisbech and Fenland Museum. Reproduced with permission.

Part VI Leftovers

Penner
Ordnance survey map of Camden town, 1894–6. Reproduced with permission of Camden Local Studies and Archives Centre.
Ladies' bloomers and 'combination' outfits 1897. Courtesy Barbara Penner.
Photo of intersection between Camden High Street and Park Street, 1900. Reproduced with permission of Camden Local Studies and Archives Centre.
Photo of urinettes in an installed and unnamed London Vestry, *c.* 1898. Courtesy Barbara Penner.
Plan of gentlemen's and ladies' convenience. Courtesy Barbara Penner.
Plan of gentlemen's and ladies' convenience. Courtesy Barbara Penner.
Longitudinal section of an underground gentlemen's and ladies' convenience. Courtesy Barbara Penner.
Proposed waiting rooms and convenience at Bristol by R. Stephen Ayling, Architect, *c.* 1898. Courtesy Barbara Penner.
Photo of Camden Town public convenience. Courtesy Barbara Penner.

Olalquiaga
Macarena Esperanza by Audrey Flack, 1971. Courtesy of Louis K. Meisel Gallery.

Stallabrass
27.1 Berlin, 1992.
27.2 Battersea, London, 1991.
27.3 Islington, London, 1989.
27.4 Sibiu, Romania, 1993.
27.5 Haringey, London, 1989.
27.6 Bloomsbury, London, 1994.
27.7 Henley-on-Thames, 1988.
27.8 The archaeological site of Empurias, Spain, 1994.
27.9 Gara de Nord, Bucharest, Romania, 1993.

By kind permission of Julian Stallabrass.

Part VII Object Lessons

Julier
Photograph courtesy of Joe Julier.

Rand
Photograph courtesy of Jackie Parker-Holmes.

Henning
Photograph courtesy of Keith Berry.

Pollock
Chantal Akerman, *Walking Next to One's Shoelace in an Empty Fridge* (*Marcher à côté de ses lacets dans un frigidaire vide*), 2004. Second room, second part of the installation. Courtesy Marian Goodman Gallery, Paris/New York. Photograph © Philippe Bouychou.

Friedberg
Gertrude Stein with her pet poodle. Photograph by Carl Mydans/Time & Life Pictures/ Getty Images.

Guins
Photograph by Dean Orbison. Reproduced by kind permission of Curtis Ebbesmayer and Dean Orbison. (Image from http://beachcombersalert.org/RubberDuckies.html)

Kleege
Photograph by George Doyle/Stockbyte/Getty Images.

Candlin
Picture credit: Terry Bolam.

Acknowledgements

The editors wish to express their gratitude and appreciation to the following people, without whom this project would not have been possible:

Nicholas Mirzoeff for encouraging *The Object Reader*'s conceptualization and development for this series. The idea for such a collection surfaced after participating in Penn State's 'Objects in/of Visual Culture' Conference, 19–20 March 2004.

Rebecca Barden for initially supporting this project in its earliest inception over a cup of coffee in Russell Square. Together we sketched ideas on a napkin.

Natalie Foster's constant enthusiasm and astute sensibilities have kept this project on track. Her continued support and professionalism has enabled (for us) a very productive and enjoyable working relation.

Julene Knox for her painstaking labour and utter patience when faced with our repeated queries and alterations.

Charlotte Wood for her assiduous editorial work.

The Faculty of Lifelong Learning, Birkbeck, for providing invaluable sabbatical leave and, when the two editors found themselves on opposite sides of the Atlantic, financial assistance for travel.

Steve La Voie of Art Center College of Design for his insightful conversations on the nature of objects in 'new' still-life photography.

'The Object Lesson' contributors for writing their erudite, surprising and provocative essays. One of the most pleasurable experiences in building this collection has been reading and learning from their object lessons.

Marquard Smith, Omayra Zaragoza Cruz and Aaron Williamson for giving their time, support, insight, intellect; for their willingness to listen, read, re-read, disagree and encourage. Thank you for covering our backs on so many occasions.

Fiona Candlin and Raiford Guins, 2009

Introducing objects

FIONA CANDLIN AND RAIFORD GUINS

What . . .

The essays contained in this book consider gifts, money, gadgets, toys, blankets, string, dildos, bird's nests, baskets, snail shells, jugs, sculpture, wreckage, blogjects, Christian relics, carved wooden figures of gringos, wooden turtle decoys, Trobriand Island canoe prows, a cathedral built of matchsticks, seatbelts, revolving doors, door keys, books, bicycles, tyres, prosthetic limbs, Weimar film sets, film footage, photographs, pancake mix packaging, public toilets, plastic religious icons, trash, Tandy's TRS-80 computer, Sony's robotic AIBO dog, flip-flops, a broken mug, a Soviet camera, an Eames chair, a flake of paint, a cardboard game-counter, a Paleolithic hand-axe, a Homies figure, an iPod, a chaise longue, a maternal object, synthetic polymers, an ouzo bottle, a Mao Zedong badge, a pixel, a rock, a saccharin container, a white cane, a child's tricycle, a snow-shaker, surfboards, digital thumbnails, a lube, and a haunted staircase. These items vary enormously yet they are all united in their familiar categorization as objects.

These objects are picked up, exhibited and displayed, given, exchanged, sold, networked, watched, worn, glimpsed, read, ridden on, played with, collected, inserted, pissed into, and thrown away. They are also found, loved, desired, worshipped, remembered, hated, feared, lost, scrutinized, studied, revered and much more. In all these forms objects surround us; they have practical uses, helping us to eat, sleep, wash, move and work, they keep us warm and cool us down, let us in and out, provide ease or speed, and, equally, badly designed, malfunctioning or worrying objects can stymie our abilities to act or rest. These same objects have symbolic functions, embodying and representing our gods and spirits, averting demons and encapsulating memory. They likewise have social meanings. They are used to assert status or power, circulate value, demarcate our habitats and habits, and enforce the law, as well as to connect us to and disconnect us from friends, colleagues or strangers. These objects can make us rich or ruin us; they can contribute to and utterly impoverish our environment. Indeed, our day-to-day, spiritual,

emotional, sexual, social, cultural and political lives are conducted in relation to objects and thoroughly mediated by them in whatever forms they take, qualities they possess and complex practices they help enable.

Measured by any standard, 'object' is a sprawling category. According to the *Oxford English Dictionary*, the origins of the word 'object' are found in the Latin word, *obicere*, that referred to the act of blocking, 'to throw at' or 'throw against' in the sense of disapproval or an objection (for example, 'I object'). Philosophical usage of the word 'object' has, within the Western tradition, been aligned with a 'thing which is perceived', a thing that is external 'from the apprehending mind, subject, or self'. 'Object' commonly refers to 'material thing(s)' that, like the various objects mentioned above, are 'presented to the eyes or other sense'. These things also fulfil another etymology of the word 'object', namely 'that to which action, or thought or feeling is directed, the thing (or person) to which something is done'.[1] In this sense objects can also be human, animal or vegetable, as well as mineral or synthetic. A person, poodle, turnip or a pink brocade sofa can all be potential objects, albeit in rather different ways. The category 'object' does not convincingly divide the natural from the artificial world, the material from the immaterial, the animate from the inanimate, or the human from the non-human.

The Object Reader elucidates objects in many of these diverse roles, dynamics and capacities. Precisely because the dedicated study of objects does not reside neatly within a single discipline, this volume draws from numerous academic fields. Selected writing originates from anthropology, art history, classical studies, critical theory, cultural studies, digital media, design history, disability studies, feminism, film and television studies, history, philosophy, psychoanalysis, social studies of science and technology, religious studies and visual culture. The collection composed of 20th- and 21st-century writing also seeks to make its own contribution through original work, in the form of 25 short 'object lessons' commissioned specifically for this project.

While *The Object Reader* does provide a starting point for the in-depth study of specific things, its main action is to offer readers epistemological vantages for the study of objects. That is, we envisage this collection as a guide to 'thinking about and thinking through objects'. The essays included here introduce a range of methods for studying objects: phenomenology, autobiography, cultural and anthropological theory, social and historical analysis, and philosophical inquiry. Simultaneously the featured writers question the constitution of the object, examining how something is understood to be waste, a commodity, technology, a specimen, an artefact, a gift or magical object and equally, how objects can have multiple classifications that are ambiguous and open to change. Pushing that question even further, some writers consider the borderlines between an object and a thing, asking how matter takes on form, becomes named, recognizable and comprehensible, indeed, how objects are understood as such.

...When and where...

Why then is *The Object Reader* warranted now? What has happened to the study of objects? Objects have long been and continue to be subjects of study within the disciplines of anthropology and philosophy. They also have long-standing currency in fields such as archaeology, design history, folklore, history of science, domestic and decorative arts, textiles, craft, and architecture, as well as within the multidisciplinary field of material culture studies. We would

suggest however that, as of late, the continued study of objects is intensifying across the arts, humanities and social sciences where fields of study not routinely aligned with objects have brought their research, archives, methods and pedagogy to bear.

This current interest in objects is not bound to a single discipline but is evident across many. Each discipline studies objects in accordance with its own archives, interests and discourses, which may or may not overlap. Thus, rather than portray recent research as a coherent area consensually acknowledged as 'object studies' or 'object culture', we prefer the loose designations, 'object study' and 'the study of objects'. We imagine the study of objects as scattered with patches of intensity wherein conceptual and material objects are construed in divergent ways.

First, the scattering –

At the moment, it seems that everywhere one looks in the academy, objects abound. In 2001, Reaktion Books launched its 'Objekt' series which, to date includes *Aircraft, Bridge, Dam* and *Motorcycle*. The final volume of MIT Press's Anyone Corporation architectural series was dedicated to 'things'.[2] In 2003 the Spanish art magazine *Exit* published a themed issue entitled 'Objetos Cotidianos' ('Ordinary Things').[3] At the Pennsylvania State University conference, 'Objects in/and of Visual Culture' (19–20 March 2004) artists and academics from art education, design, and visual studies presented papers and artwork on cadavers, souvenirs, flat-screen televisions, books, toys, educational objects and design. In the autumn of 2005 the University of California Humanities Research Institute hosted a research group entitled 'Object of Media Studies'. The group was comprised of scholars working in film, television, and media who examined the ephemeral form of the cinema ticket, celebrity tie-in products, mobile phone trees, the hard and software of *Ms Pac Man*, the storage case of the video-cassette, condoms, and the screen as a material object. 'Both in their materiality', writes Amelie Hastie (2006) who moderated the research group and edited the work for the University of Southern California's online journal *Vectors*, 'and in the affective chains of pleasure and desire that they do (or do not) activate, such objects point the way to new directions for media studies'. In the same year, Bruno Latour and Peter Weibel curated *Making Things Public* at the ZKM Center for Art and Media, Karlsruhe, Germany. The show has been published in the form of the monolithic book *Making Things Public: Atmospheres of Democracy* (2005).

Various schools of thought have all been active in questioning, reframing and rethinking the object and questions of materiality. Such publications include Justin Clemens and Dominic Pettman's *Avoiding the Subject: Media, Culture, and the Object* (2004), Stephen Melville's *The Lure of the Object* (2005), W. J. T. Mitchell's *What Do Pictures Want?: The Lives and Loves of Images* (2005), Matthew Fuller's *Media Ecologies: Materialist Energies in Art and Technoculture* (2005) and Philip van Allen et al.'s *The New Ecology of Things (NET)* (2007). More recently, the journal *Performance Research* produced a themed issue entitled 'On Objects' (2007) edited by Laurie Beth Clark, Richard Gough and Daniel Watt. The Design Research Group, in conjunction with the National College of Art and Design, hosted the conference 'Love Objects: Engaging Material Culture' in Dublin (13–14 February 2008). And as we compile this brief account of recent object-focused projects Sherry Turkle's edited collection *Evocative Objects: Things We Think With* (2007), that draws its content from MIT's Technology and Self-evocative Objects seminars, is being followed by two other volumes: *Falling for Science: Objects in Mind* and *The Inner History of Devices* (both 2008). Lastly, an international conference, 'Visuality/Materiality: Reviewing Theory, Method and Practice', is scheduled for 15–17 July 2009 in London.

Second, the patches of intensity –

From the 1990s and well into the 21st century, four areas of intense object study have been anthropology and material culture studies, science and technology studies, technoculture and digital media, and critical theory and philosophy. We will consider them briefly in turn.

In his editor's 'Introduction' to the collection *Material Cultures: Why Some Things Matter* (1998), Daniel Miller reviews the proliferation of thought on objects at the end of the 20th century. He argues that scholarship during the 1970s and 1980s established material culture as integral to subject formation and social world building; in particular Pierre Bourdieu (1977) emphasized the role of everyday things in socialization processes and Arjun Appadurai (1986) established that things have social lives, namely, different trajectories which allow them to 'move in and out of the commodity state' (1986: 13).[4] Bourdieu and Appadurai's highly influential writing shows how 'things matter' and, as Miller remarks, initiated 'a variety of approaches to the issue of materiality, varying from material culture as analogous with text to applications of social psychological models' (1998: 3). This position produced rich and fruitful work but, as scholars within the field subsequently recognized, it did have its limitations.

In 'The Technology of Enchantment and the Enchantment of Technology' (1992), which critiques the anthropology of art, Alfred Gell distances himself from sociological approaches to material culture studies as exemplified by Bourdieu. These, Gell argues, 'never actually look at the art object itself, as a concrete product of human ingenuity, but only at its power to mark distinctions' (p. 42). Moreover, he breaks with a semiotic analysis that he claims treats objects, specifically artworks, as 'species of writing' and attends to 'the represented symbolic meanings' rather than 'the presented object'. Gell proceeds to engage with art objects in terms of technical skill and effect, an approach further developed in *Art and Agency* where he argues that things somehow 'appear as, or "do duty as", persons' (1998: 9).

While rejecting Gell's concept of the 'personhood of things', Christopher Pinney, also refutes the sociological and communicative models that Gell opposes. Writing in Daniel Miller's edited collection *Materiality* (2005), Pinney suggests that the preoccupation with the social life of things (Appadurai 1986) is ostensibly concerned with objects and their materiality but actually entails the colonization of the object by the subject and the social. In this model and in sociology more generally, objects 'can only ricochet between the essentializing autonomous object and the dematerialized space of things whose only graspable qualities are their "biographies" and "social lives"' (p. 259). For Pinney 'the task of making objects once again material still seems impossible' for, as he details, it necessitates thinking outside notions of 'context' and considering that an image or object 'contains its own prior context' (p. 269). Tim Ingold negotiates similar questions in 'On Weaving a Basket' (2000) where he insists that anthropological and archaeological discussions of material culture have paid little attention to actual materials and properties, instead placing the emphasis on 'issues of meaning and form – that is on culture *as opposed to* materiality' (p. 340). In this model of 'so-called material culture', Ingold avers that 'culture is conceived to hover over the material world, but not to permeate it [. . .] in short, culture and materials do not mix; rather culture wraps itself around the universe of things, shaping and transforming their outward surfaces without ever penetrating their interiority' (p. 341). Ingold's own scholarship challenges that position, demonstrating the inseparability of culture and materiality when it is understood as substance.

Questions of interiority and exteriority have also been important to science and technology studies. In 1979 M. J. Mulkay pointed out that one can easily 'show that the social meaning of television varies with and depends upon the social context in which it is employed' but that 'it is much more difficult to show what is to count as a "working television set" is

similarly context-dependent in any significant respect' (p. 80). Trevor J. Pinch and Wiebe E. Bijker comment on the verity of this claim. They trace the development of research on science and technology and note that the early sociology of science ignored scientific knowledge and technological content in favour of economic and social accounts of scientific work; 'for the purpose of such studies, scientists might as well have produced meat pies' (Bijker, Hughes and Pinch 1987: 21). History of technology *did* consider the intricate workings of particular technologies but rarely went beyond description. It also tended to concentrate on successful innovations, thereby contributing to the implicit adoption of a linear structure of technology. Pinch and Bijker take on Mulkay's challenge to demonstrate the social construction of the *content* of artefacts. They argue in favour of a multidirectional model that interrogates the reasons why some design variations of an artefact are selected while others are rejected. Pinch and Bijker explain this process by investigating 'the problems and solutions posed by each artefact at particular moments', these problems being 'defined as such only when there is a social group for which it constitutes a problem' (pp. 29–30).

Bijker and Pinch 'preserve a notion of the social environment' (Bijker, Hughes and Pinch 1987: 12) whereas other approaches to technological artefacts conceive of objects and their users as having a more egalitarian relationship. Actor Network Theory (ANT), which is most closely associated with the writings of Michael Callon (1986, 1987), Bruno Latour (1993a, 1993b) and John Law (1991, 1999), integrates humans and non-humans into social networks, wherein the animate and non-animate both have an active role in the formulation, mediation and stabilization of social, cultural and political relations. Far from social and cultural practices attributing meaning to mute and lumpen stuff, this model suggests that social networks cannot function or cohere without the delegated intentionality and agency of things.

Current work in technoculture and digital media constructs the debates about networks of things differently again. The design critic Akiko Busch positions digital processes in opposition to ordinary things. 'With our cell phones,' she writes,

> e-mail, and assorted forms of wireless communication, the elusive corridors of cyberspace have whetted our appetite for what we can touch, hold, taste, see. In the virtual age, the sorcery of the physical has intensified. We become attached to objects out of sentiment, perhaps, or for their symbolic value – a wedding ring, a grandmother's quilt, an old fountain pen, all of which may commemorate personal history.
>
> (2004: 15–16)[5]

This nostalgia for 'the real', or fetishization of the tangible in Busch's imagined 'virtual age', is only possible when digital technologies are understood as being less material or less significantly material than other objects. This position ignores the barrage of devices and gadgets we use to navigate our daily digital life, their materiality becoming the focus of individual and social symbolic value. Cell-phones, Blackberries, game consoles or a 'pimped out' iPod all offer opportunities for personal attachment and physical intimacy (see Levy 2006 and Ito, Okabe and Matsuda 2006).

At the same time, though, we ought to realize that our understanding of technological objects is not confined to hardware or storage media. In the early 1990s Palo Alto Research Center (PARC) and other research centres and consortiums developed theories and applications of 'ubiquitous computing', 'pervasive computing', 'ambient intelligence' and 'wearable technology'. These all aim to augment and extend the connectivity of computing throughout

lived environments and within everyday objects. Once networked, objects have the ability to communicate with other objects. Adam Greenfield succinctly explains the implications when he writes:

> When everyday things are endowed with the ability to sense their environment, store metadata reflecting their own provenance, location, status and use history, and share that information with other such objects, this cannot help but redefine our relationship with such things.
>
> (2006: 23)

These changes to the capacities of objects and our social understanding of them have prompted new genres and classifications, such as 'spimes' (Sterling 2005) and 'blogjects' (Julian Bleecker in this collection). The 'spimes' of Sterling's speculation are 'material instantiations of an immaterial system' (Sterling 2005: 11), but as yet do not exist. Rendered on screens and via digital means, blogjects are and spimes are potentially networkable objects imbued with informatic and communicative abilities that comprise 'the internet of things'.

Our last area of intensity is critical theory and philosophy's return to and rethinking of 'the thing'. The emphasis here is less on modern philosophy's preference for the 'thing we perceive' as an object or phenomenon constituted by subjective forms, than for the noumenal, 'the thing in itself'. Bill Brown, in a themed issue of *Critical Inquiry* simply entitled 'Things' (2001), offers a prominent case in point.[6] Brown's essay 'Thing Theory' strikes a fresh chord in the subject–object debate by instigating an epistemic shift to account for 'things' as they rest 'outside the order of objects' (p. 5) in a state of liminality and amorphousness. Things are uncertain, ambiguous, excessive, unspecified. Brown captures this instability well when he writes that thingness is revealed and confronted when objects break, or no longer work in recognizable ways. To be 'thinged' within the dialectic of object/thing is to be adrift from order, caught in the complex crosscurrents of ontological instability. 'The story of objects asserting themselves as things', as Brown insists, 'is the story of a changed relation to the human subject and thus the story of how the thing really names less an object than a particular subject–object relation' (p. 4).

Working on the history of scientific artefacts Lorraine Daston continues with 'things'. Commenting that contextual and anthropological studies tend to speak to the social valuation and interpretation of objects and do not address the 'thingness of things', her edited collection *Things that Talk* grapples with things as 'nodes at which matter and meaning intersect' (2004: 16). Starting from the position that things are at once material and meaningful, Daston's own essay articulates how 'botanical models made of wax may be visually indistinguishable from those made of glass, but the modeling procedures are entirely different, and that difference in turn makes curiosities out of one but marvels out of the other' (p. 17). Her work considers the way 'matter constrains meaning and vice-versa', negotiating the cultural and material rather than impossibly separating and privileging one of those terms (ibid.).

The study of objects is contested ground. Quite clearly, these different modes of engagement are not necessarily compatible as there are diverse research methods, archives, learning strategies and politics that therein converge and conflict. Yet it is precisely the contestation of objects that generates such sophisticated and nuanced debate. In this volume, we have chosen *not* to adjudicate harshly, not to privilege one vantage point over another. Instead we have placed social histories of objects alongside philosophies of things, thereby preserving their productive frictions and the problems and pleasures each may pose.

How

The Object Reader is comprised of eight discrete sections. The first six sections present previously published writing framed by themes that are employed in explicit and implicit response to the debates outlined above. They are: 'Object', 'Thing', 'Objects and Agency', 'Object Experience', 'The Objecthood of Images' and 'Leftovers'. Thematic frames are designed to help the reader navigate ideas and to discourage disciplinary hierarchies. As is clear from their titles, the sections 'Object', 'Thing', 'Objects and Agency' and 'Object Experience' all resonate with the issues we addressed above. 'The Objecthood of Images' section is a slightly different case in that objects have not generally been the focus of scrutiny in recent art history or visual culture studies. Whereas Dick Pels, Kevin Hetherington and Frédéric Vandenberghe comment that 'Objects are back in strength in contemporary social theory' (2002: 2), Michael Ann Holly observes their absence from the study of visual culture: 'Contemporary visual studies doesn't give "objects" their due', she writes, and 'the fundamental phenomenological conviction that objects are active agents in their interpretation often seems missing from visual/cultural studies' (2003: 240). Art historian Malcolm Baker reiterates the point, 'many of the more theoretically informed discussions of images and art objects skirt around issues of material and technique. We have as it were "objecthood" without the material object' (2005: 120). This disciplinary lacuna can be attributed to a post-structuralist approach of 'reading' artworks and the social-historical stress on the context of the artwork.[7] In addition, the legacy of connoisseurship and formalism, which placed art objects at the centre of purportedly ahistorical and apolitical analyses, propagates an understandable scepticism of object-focused enquiry. Nevertheless, as the texts included in this and in other sections of the volume demonstrate (see Gell in particular), the materiality of images and art objects has been a recurring theme in art history, visual culture studies and other disciplines.[8]

The final section of previously published writing considers 'Leftovers'. The values, functions and social meanings contained in, or attributed to, objects over the duration of their lifespan are not fixed. They change over time. To write a biography of a thing, as Igor Kopytoff (1986) insists, we have to account for the various stages in its career. That is, we have to ask, 'how does a thing's use change with its age, and what happens to it when it reaches the end of its usefulness?' (p. 67).[9] The life cycle often ceases when the object is so far out of contention in terms of its potential usage and value that it becomes dilapidated fragments of its former form, and a thing far outside of its long-serving and often changing intelligibility. While the 'worthless' can gain a certain notoriety as kitsch, mass culture or even the nebulous category of 'junk-tique'; 'trash', 'rubbish', the 'used-up', 'antiquated', 'detritus' and 'waste' function as a sub-stratum to the lowest of the low. As many writers note, such 'qualities' also warrant a phase in the life history of a thing. For the biography to be as complete as possible requires that we consider the worthwhile/valued and worthless/valueless (see Thompson 1979, Gross 2002 and Moser 2002).

Each section combines writing on objects from different disciplines, and places writing considered seminal to the study of objects alongside newer work that renegotiates understandings of objects, conditions of experience, and practices. For example, the first section, 'Object', includes an excerpt from French sociologist Marcel Mauss's highly influential anthropological study, *The Gift: Forms and Functions of Exchange in Archaic Society*, in the same section as a chapter from classicist Page DuBois's *Slaves and Other Objects* dedicated to the study of slavery's material culture and female autosexual representations. The next section houses both Martin Heidegger's philosophical treatise 'The Thing', and Julian

Bleecker's 'Why Things Matter: A Manifesto for Networked Objects', within which the author, as mentioned previously, develops his neologism, 'blogject' – objects that blog. To reiterate, readers will also see different types of objects discussed within each section. 'Objecthood of Images' combines art objects, film props, photographs and the ephemeral packaging of Aunt Jemima pancake mix. Likewise, the objects in 'Leftovers' are early 20th-century women's public toilets, religious kitsch, trash, and antiquated computers. Content of the first six sections will be detailed shortly.

The seventh and penultimate section, 'Object Lessons', is comprised of invited work from an eclectic group of scholars who work across the arts, humanities and social sciences. We selected writers who work directly on objects (curators, art and design historians, for example) *as well as* those whose research has not previously attended to objects. This was an experiment to make good on our claim of the multidisciplinarity of object study. Contributors were asked to choose a particular object or type of object and to compose a short essay. We requested (or imposed!) brevity because it allowed us to include a broad spectrum of scholarship on multifarious objects. The resultant lessons take unexpected, experimental, performative, autobiographical, rigorous, historically acute, and creative forms. As innovative models of writing, we hope that they will enable readers to consider objects, in all their evidence and obscurity, with knowledgeable eyes and hands.

The final section, 'An Object Bibliography', consists of a bibliography organized into subjects pertinent to research on objects. References to pertinent journals, individual journal articles, edited collections and books coalesce within this resource. The bibliography is an active component in the collection, conceived to complement our content while providing references for authors' work not fully accounted for. Lastly, such a resource demonstrates the rich and extensive range of object study.

Part I Object

This first section provides ways of understanding objects. It is not an attempt to define objects per se; rather this section presents a range of epistemologies, from political theory, sociology, anthropology, semiotics, psychoanalysis and classics. The essays collectively raise questions about the classification of objects, their meanings, psychic and social functions. Marcel Mauss's influential essay, 'Gifts and the Obligation to Return Gifts' (1974 [1950]), shows that in giving, the donor gives part of himself. As gifts give rise to reciprocal exchange, and because each gift is inextricably bound to the identity of the giver, Mauss is able to analyse gift-giving both in relation to magical objects and to social cohesion. In a gift economy, objects create mutual interdependence between givers and receivers; objects are 'loaned rather than sold and ceded'. Mauss's gift economy operates in stark contrast to the commodification of objects and social relations within capitalism, as described by Georg Lukács in 'The Phenomenon of Reification' (1968 [1921]). Lukács posits that the nature of the commodity and the alienation that it imposes across the social spectrum is the central problem of capitalist society. The question he asks is: how has commodity exchange influenced 'the total outer and inner life of society'? Building upon Karl Marx's theory of commodity fetishism, Lukács works through the objective and subjective site of commodification – how objects circulate and consume our labour – to understand the process of reified consciousness, the objectification of our social relations. Roland Barthes's preface to the 1972 edition of *Mythologies* (1957) opens with the author's readdress of his project: 'an ideological

critique bearing on the language of so-called mass-culture [and] a first attempt to analyse semiologically the mechanics of this language' (p. 9). Barthes's cultural critique is aimed at the objects and practices constitutive of French daily life in the post-war period. His reading of French toys in the modestly titled 'Toys' essay asserts that toys prepare children for (gendered) social roles and teach them to become users as opposed to creators. Barthes mourns the transition from wood based toys to the 'coldness' of metal and plastic as his essay emphasizes the importance of materials in the child's conditioning process.

Drawing from the structuralism of Marx, Freud, Saussure and early Barthes, Jean Baudrillard's 'Subjective Discourse or The Non-functional System of Objects' (1968) is a cultural and social critique of the new system of objects forming consumer society in the Cold War period. His complete study analyses multiple systems of objects: functional objects (consumer goods), non-functional objects (antiques, collections) and what he purports as being metafunctional objects (gadgets, gizmos and robots). He rigorously works through these socio-ideological structures to obtain an understanding of how consumer culture produces needs, behaviour and fantasy. Approaching the topic from a very different direction, D. W. Winnicott also considers objects and fantasy. 'Transitional Objects and Transitional Phenomena' (1971) explores the intermediate phase between a baby's inability and his or her growing ability to distinguish 'me' from 'not-me'. This development is conducted in relation to a material or an immaterial transitional object, for instance part of a blanket, a toy or a repeated noise, over which the baby assumes rights. For the baby this original not-me possession acts as a defence against anxiety until the transitional period has been negotiated and he or she has successfully established both the separation between and the interrelation of external and inner realities. In his essay 'On Weaving a Basket' (2000) Tim Ingold softens the distinction between things that are made and things that grow. A standard characterization of artefacts assumes that their design is imposed from without, by a maker working with raw materials, whereas the blueprint of living things is carried within, by its genetic material. Taking woven baskets and gastropods as prime examples, Ingold argues that environmental factors and material properties are directly implicated in the 'form-generating process' of both things. Closing this section, Page DuBois's essay, 'Dildos' (2003), is part of her larger polemical study on the centrality of slaves and slavery within Greek antiquity, which is often rendered invisible by the canonical study and curatorial representation of ancient cultural artefacts. Ancient discourses on dildos, she argues, do not correlate with modern interpretations of 'perversity' or 'liberation'. The dildo as archaeological evidence (represented on vases, for example) is construed by DuBois within an overlapping heterogeneous system of meanings unfamiliar to our contemporary understandings of sexuality and the history of sex. 'What we find', she concludes, 'is not the postpsychoanalytic, queer domain of postmodern sexuality, nor a pathologized fetish phallocracy, but rather an object at the crossing of many different networks of meaning and performance' (p. 100). Her essay brilliantly demonstrates the need for close historical analysis for the interpretation of artefacts.

Part II Thing

The 'thingness of things' compels us to return, for the purposes of rethinking, to modern philosophy's treatment of the object–thing division. Immanuel Kant, in his *Critique of Pure Reason*, prescribes a distinction between the thing perceived, or 'the thing for us' (*das Ding für uns*), and 'the thing in itself' (*das Ding an sich*). That which is perceived is understood as

a phenomenon, while noumenon is independent, or well beyond the conditionality of subjective categories and forms. Although unknowable for Kant, things exist despite our subjectivity. Things are, as Elizabeth Grosz (2001) insists, 'matter already configured' (p. 169) and as such require a different philosophical genealogy from the canon that purports to, as Akira Asada and Arata Isozaki highlight, 'reject the thing-in-itself, considering it a metaphysical fiction, and deals instead only with the thing as object' (2001: 150). This section begins with Martin Heidegger's 'The Thing' (1971 [1951]) which declares that the thing is not an object. Heidegger invokes the etymology of the word 'object' to help argue for the difference between 'object' and 'thing'. He notes that early usages of the word 'object' imply an opposition: to stand against or before, to throw against, or dissent. 'When understood in oppositional terms', Mark C. Taylor explains in his dialogue with Heidegger's essay, 'the object is inseparable from the subject' (2001: 74). The thing eludes the oppositional and hierarchical structure between subject and object perpetuated by modern philosophy. Heidegger asks that we consider a jug in the service of questioning 'what in the thing is thingly?' (1971: 167). 'The jug's thingness', he queries, 'resides in its being *qua* vessel' (p. 169). The quality of the vessel is in its holding. 'When we fill the jug with wine', he continues, 'do we pour the wine into the sides and bottom? At most, we pour the wine between the sides and over the bottom. Sides and bottom are, to be sure, what is impermeable in the vessel' (p. 169). The thingness of the jug resides in its being *qua* vessel, yet the vessel is an empty space. This empty space, or 'nothing of the jug', defines it as a holding vessel. It also enables Heidegger to conclude that 'the vessel's thingness does not lie at all in the material of which it consists, but in the void that holds' (p. 169). Thingness is found in the nothingness of the void. Yet, this void actually marks a presence: as Taylor insists, 'though subjects might posit objects, both are radically, indeed primordially, conditioned by some thing that is incalculable and out of control' (2001: 75).

The incalculability posed by the thing's reconfiguration of the object and the subject–object binary is viewed through various critical lenses within this section. Each, in its own way and through its variegated interests, turns to 'the thing', 'things' and 'thingness'. Elizabeth Grosz's 'The Thing' (2001) turns to thinkers whom she groups as pragmatist. They include: Darwin, Nietzsche, Charles Sanders Peirce, William James, Henri Bergson, Richard Rorty and Gilles Deleuze. She prefers this genealogy to one that stems from Descartes and Kant, as it places 'action, practice, and movement at the center of ontology' (p. 169). This counter-lineage promises a shift from the thing's noumenal unknowability to provocation and promise. Grosz inaugurates a genealogy for the thing, while Bill Brown's 'Thing Theory' adds a great deal to such a formation. The work that 'things' perform, in their rearticulation of the subject–object relation, shows the exhaustion of objects when they are assigned the responsibility of being our social and psychic receptacles. Brown eloquently writes, 'If these objects [Claes Oldenburg's pop-art sculptures of everyday things] are tired, they are tired of our perpetual reconstitution of them as objects of our desire and of our affection. They are tired of our longing. They are tired of us' (p. 15). All of our looking 'through objects' for facts, meaning, objectivity, has caught up with them it seems.

Both Bruno Latour's 'From Realpolitik to *Ding*politik or How to Make Things Public' (2005) and Julian Bleecker's 'Why Things Matter: A Manifesto for Networked Objects – Cohabiting with Pigeons, Arphids and AIBOs in the Internet of Things' (2006) share a steadfast investment in the work things can perform, be it political, philosophical or engineering in practice. Latour reconceptualizes the very nature of politics, government and governance to ask what an 'object-oriented democracy' would consist of. Again the archaic etymology of a word, in this instance, *Ding* (thing), meaning 'assembly', is revived. 'If the *Ding*', Latour advises,

'designates both those who assemble because they are concerned as well as what causes their concerns and divisions, it should become the center of our attention: *Back to Things!*' (2005: 23). Bleecker shares this sentiment. He sees things not as inconsequential to the communication process but as actors in the social exchange and discourses of the internet of things. New thing-types, such as spimes and blogjects previously mentioned, are active agents in the circulation of conversation. The 'pigeon that blogs', outfitted with GPS devices, tracers and able to communicate information, 'now attains first-class citizen status. Their importance shifts from common nuisance and disgusting menace, to a participant in life and death discussions about the state of the micro-local environment. Pigeons that tell us about the quality of the air we breathe are the Web 2.0 progeny of the Canary in the Coal Mine' (2006: 5).

Part III *Objects and Agency*

Within Western rationalism, objects are generally considered to be inanimate; they are perceived instead of perceiving and acted upon rather than being active themselves. In contrast, this section considers objects that have powers to avert ill-will and evil spirits, to frighten enemies, bring blessings and to comfort. They also enable mundane but necessary aspects of day-to-day life as well as intricate social relations. The Christian relics described by Peter Brown in 'Praesentia' (1981) were thought to work miracles, but their more reliable effects lay in securing social relations across the entirety of the late Roman world. Giving and trading relics brought distant holy events close to hand, therefore symbolically uniting geographically disparate communities. Within the European tradition the form of the relic is unimportant; a fingernail or a splinter can equally embody the power of a saint, whereas Michael Taussig's text, 'In Some Way or Another One Can Protect Oneself from the Spirits by Portraying Them' (1993), shows how form is essential to magical thinking amongst the Cuna Indians. In an essay which weaves a meditation on writing about objects and Enlightenment reason with a consideration of magic, Taussig suggests that the power of Cuna Indian figurines to capture the spirit of the white Europeans is premised upon resemblances between them.

The form of objects is also vital to Alfred Gell's often-cited analysis in 'The Technology of Enchantment and the Enchantment of Technology' (1992) which centres on the striking designs of Trobriand Island canoe prows. For Gell the agency and magical effect of the prows is created by the incomprehensible and virtuoso skill of the designs; a form of enchantment which is potentially immanent in all kinds of technical activity. Finally, the belief in animate objects is often thought alien to a modern Western world, but Bruno Latour's essay 'Where Are the Missing Masses? The Sociology of a Few Mundane Artifacts' (1992) argues that humans delegate moral and practical responsibilities to objects which act on their behalf. In consequence, Latour understands social networks to be comprised of human and non-human actors.

Part IV *Object Experience*

'I am unpacking my library. Yes, I am. The books are not yet on the shelves, not yet touched by the mild boredom of order' (p. 61). So begins Walter Benjamin's famous essay, 'Unpacking My Library: A Talk about Book Collecting' (1931 [1968]) and our section on the subject's experience with objects. Benjamin's unpacking came at a time when his life was marked by

divorce and economic hardship. The pleasurable experience of unpacking volumes upon volumes of books is also an experience of 'unpacking' Benjamin's own life history: his self, his work and the projection of these entities onto material objects and the memories they invoke. Opening the crates is a reunion for Benjamin, the collector's collection returned. These precious objects are not valued for their utilitarian qualities (i.e. as reading material) or their status as luxury commodities, but their enchanted capacity to renew the past in modernity. Inside the collector, Benjamin insists, 'are spirits or at least little genii, which have seen to it that for a collector – and I mean a real collector, a collector as he ought to be – ownership is the most intimate relationship that one can have to objects' (p. 69).

The emphasis is on users and producers in Wiebe E. Bijker's 'King of the Road: The Social Construction of the Safety Bicycle' (1995). Our excerpt is part of a much longer essay that uses the history of the bicycle to theorize the development of technical artefacts. Bijker traces the transition from the 'running machine' of 1817 with its two equally weighted wheels, a horizontal cross bar and saddle, to the Ariel of 1870, that had its rider 'hurtling through space on one high wheel with another tiny wheel wobbling helplessly behind' (p. 30). For linear accounts of technical change, the high-wheeled bicycle is an anomaly but, by identifying the social processes involved, Bijker's historically rich and theoretically innovative analysis shows how an artefact's form is inextricable from the needs of relevant social groups.

The bicycle's design, like others, only stabilizes when one group's preferences dominate all others. Vivian Sobchack's 'A Leg to Stand on: Prosthetics, Metaphor, and Materiality' (2004) also addresses technological artefacts, in a wry take on recent debates about prosthetics. Sobchack examines the disparities between celebratory post-human theories of the body and her own lived experience of disability, writing that 'I am both startled and amused by the extraordinary moves made of and by "the prosthetic" of late – particularly since my prosthetic leg can barely stand on its own and certainly will never go out dancing without me' (p. 205). In counterpoint, Sobchack examines the metaphorical use of the term prosthetic in recent theory and discusses her own prosthetic in technological, experiential and political detail. In 'Objects Inspire' (2008), Sherry Turkle draws upon psychoanalysis and on scientists' autobiographies to illustrate how objects provide children and adults with ways of generating new ideas, understanding scientific principles and negotiating their inner and outer worlds. In a chapter which combines the introduction and conclusion of *Falling for Science: Objects in Mind*, Turkle argues that objects are essential to thought.

Part V The Objecthood of Images

Within canonical art history an embodied response has been considered antithetical to aesthetic experience, and the materiality of an object can mitigate against it being defined as an artwork. This hierarchical relationship between image and object is exemplified in Michael Fried's classic essay 'Art and Objecthood' (1986 [1967]) where he criticizes minimalist art for its anthropomorphism and connection to the human body. For Fried, 'great art' escapes the brute materiality of objecthood to attain autonomy from the surrounding world. In distinction, all the other essays included in this section consider the unavoidable physicality of image production, circulation, storage and handling and its intersection with the images' representative and symbolic capacities. In 'Calico-World: The UFA City in Neubabelsberg' (1995 [1926]), Siegfried Kracauer describes how the smallest flickering moment of film footage requires huge papier-mâché sets, make-up, lighting, casts of thousands and the labour

of directors, producers, camera operator, assistants and assistants to assistants. Kracauer writes lyrically about these film sets but is also deeply wary of them and what they connote as culture industry ideology: an 'empty nothingness. A bad dream about objects that has been forced into the corporeal realm' (p. 281).

Elizabeth Edwards also links images to their materiality, in this case suggesting that the materiality of a photograph is inextricable from its function as a surrogate memory. As she argues in 'Photographs as Objects of Memory' (1999), photographs are used as a means of making the instant concrete and preserving it in drawers, scrapbooks, albums, lockets and wallets. Handling and glancing at them reconnects us to a past. The final essay in this section is M. M. Manring's 'Aunt Jemima Explained: The Old South, the Absent Mistress, and the Slave in a Box' (1996). For readers outside of North America, Aunt Jemima is the name and face of a famous pancake mix, a fictional black character of the antebellum South, who was later portrayed by a series of actresses. Here Manring traces her changing image and embodiment in relation to the invention, promotion and use of instant foods, and demonstrates the impossibility of separating that image from racist stereotypes, or from the material conditions of black and white women's labour.

Part VI Leftovers

Despite non-functionality, outlived use or discarded status, leftover objects can still become highly collectable and socially valued. Found objects are important in art practice, trash is recycled, a forgotten memento is rediscovered and cherished, and an obsolete technology is resuscitated. Some objects may be functional, yet their function – and the specific bodies associated with that function – may provoke conflict and controversy; Barbara Penner's 'A World of Unmentionable Suffering: Women's Public Conveniences in Victorian London' (2001) is a case in point. Working at the interstices of design and architectural history, she interrogates the patriarchal power-relations involved in planning women's public lavatories in London. The everyday object of the toilet became a catalyst for social anxiety, for it connoted the presence of female bodies and female sexuality in city streets shaped and policed by Victorian morality. Penner explains how the built environment affects a moral policing of female corporality: 'Often located underground without windows, protected from the "public" gaze and, by means of internal partitions, from the eyes and ears of others women, the conveniences were meant to seal off and contain the "unmentionable" secrets of the female body' (p. 46).

The next two writers in this section, Celeste Olalquiaga and Julian Stallabrass, also examine objects found in and on city streets. Olalquiaga's 'Holy Kitschen: Collecting Religious Junk from the Street' (1992) investigates Latin American religious ephemera, their place on domestic altars and their recontextualization in the form of religious kitsch. Religious souvenirs and other assorted paraphernalia of Catholic iconography transcend stark boundaries of holy object, taste, art, tack and popular culture as religious imagery and kitsch congregate. 'The connection', as Olalquiaga urges, 'proves particularly relevant because kitsch permits the articulation of the polemics of high and low culture in contexts broader than that of religious imagery, smoothing the way for a better understanding of its attraction and importance for vicarious experience' (p. 41). Whether gaudy or folklore, high or low, Olalquiaga's objects are not, like Julian Stallabrass's interest, trash. His essay, simply entitled 'Trash' (1996), explores the afterlife of commodities, asking what objects gain or lose when they are relegated to the

status of rubbish. Drawing upon writers associated with the Frankfurt School (particularly Walter Benjamin), Stallabrass argues that the commodity-turned-trash loses its covetable, slick allure but 'stripped of this mystification, gains a doleful truthfulness, as though confessing: it becomes a reminder that commodities, despite all their tricks, are just stuff; little combinations of plastic or metal or paper. The stripping away of branding and its attendant emotive attachments reveals the matter of the object behind the veneer imposed by manufactured desire' (p. 175). What if a commodity or artefact isn't afforded an afterlife? What if it is kept 'alive' long after its expected expiration and rescued from the landfill? Christina Lindsay's 'From the Shadows: Users as Designers, Producers, Marketers, Distributors and Technical Support' (2003) studies a community of hobbyists whose value system privileges activity over passivity, DIY over consumerism, autodidactic skills over expediency, reliability over wastefulness, and the pleasures of curiosity and involvement in technological co-design over the standardization of the mass market. The TRS-80's life history is dependent upon an ethos of co-construction: users adopt multiple roles as designers, producers, retailers and technicians to sustain the computer well beyond its expected obsolescence. For them, the apparently obsolete Tandy personal-computer, the TRS-80, is an embodiment of their moral values.

Let's begin this object study . . .

Notes

1 Additional definitions of 'object' include a purpose or aim (objective), and the rules of grammar define the 'object' as a noun or noun phrase 'which forms the complement of an active nontransitive verb'. In the contemporary period, 'object' has gained additional meanings within the lexicon of computer programming (object-oriented programming) where it refers to data, packages of information and graphic images (Microsoft's Office 2008 offers its users an 'object palette' to assist in producing graphically robust documents in Word).

2 Entitled *Anything*, the essays in the tenth volume, edited by Cynthia C. Davidson, examine things as 'abstraction', 'object', 'material', 'feeling', 'obsession' and as 'idea'.

3 Artwork dedicated to the examination of objects by William Eggleston, Claus Goedicke, Takashi Yasumura, Silvia Gruner, Chema Madoz, Olivier Richon, Cinthya Soto, and Peter Fischli and David Weiss is included in *Exit*'s 'Ordinary Things' issue.

4 And we ought to stress Igor Kopytoff's 'The Cultural Biography of Things: Commoditization as Process', in Appadurai's collection (1986), which argues that the usage of a thing dictates its many meanings in its social biography.

5 One wonders if there was ever a time when we *did not* become sentimentally attached to such objects.

6 Fourteen contributors, from English, history, comparative literature, art history and visual arts, consider an assortment of things such as the flapper dress, coffeemakers, gloves of Renaissance Europe, and cigarettes in film. The 'Things' issue of *Critical Inquiry* has since been published as a book by the University of Chicago in 2004.

7 In consequence to the heavy emphasis upon linguistic models, as W. J. T. Mitchell notes in *Picture Theory: Essays on Verbal and Visual Representation*, 'semiotics, rhetoric, and various models of textuality have become the lingua franca for critical reflection on the arts. Society is a text. Nature and its scientific representations are "discourses". Even the unconscious is structured like a text' (1994: 11). This intellectual inheritance works in (at least) two different ways for visual culture studies. On the one hand, linguistic models inform the discussion of images across media, but even when language and text are conceptualized in their broadest terms, this mode of thinking does not lend itself to the careful consideration of objects and materiality.

8 Mieke Bal's essay 'Visual Essentialism and the Object of Visual Culture' (2003) argues against defining visual culture studies in relation to objects, as this potentially pre-defines which objects are deemed 'visual'. Instead she recommends adopting visuality as the object of study as, for Bal, 'it is the practices of looking invested in any object [. . .] the possibility of performing acts of seeing, not the materiality of the object seen that decides whether an artifact can be considered from the perspective of visual culture studies' (p. 11). While we realize that Bal is purposefully avoiding an essentialist or naively realist view of objects, she still risks a model of visual culture where cultural meaning and practice are draped over the object; its stuff and substance exerting no constraint or direction over its interpretation or use (see Daston [2004] and Ingold [2000] on these points). It is entirely possible to be critical of positivist attitudes towards objects and the rhetoric of the real while studying objects in all of their complex materiality.

9 Igor Kopytoff, 'The Cultural Biography of Things: Commoditization as Process', in Arjun Appadurai (ed.), *The Social Life of Things: Commodities in Cultural Perspective*. Cambridge: Cambridge University Press, 1986, pp. 64–94. To demonstrate the different phases constitutive of an object's value, Kopytoff offers his well-known and often cited model of the hut in Zaire's Suku culture. Its biography begins as a structure to house a couple. As it ages the hut is occupied in ways that contrast with its initial usage. New and changing means and motives of occupation produce different phases in the hut's life history. In Kopytoff's account usage dictates the hut's many phases of meaning: function and value change over time. During one phase the hut may be a social gathering place for younger people, while in a later phase (perhaps when it starts to become too worn for human occupancy) it may be used as a structure to shelter animals until its final demise, or as Kopytoff puts it so well, 'until at last the termites win and the structure collapses' (p. 67).

References

Appadurai, A. (ed.) (1986) *The Social Life of Things: Commodities in Cultural Perspective*, Cambridge: Cambridge University Press.

Asada, A. and Isozaki, A. (2001) 'A Concise Genealogy of the Thing', in C. C. Davidson (ed.), *Anything*, Cambridge, MA: MIT Press, pp. 148–55.

Attfield, J. (2000) *Wild Things: The Material Culture of Everyday Life*, Oxford: Berg Publishers.

Baker, M. (2005) 'Some Object Histories and the Materiality of the Sculptural Object', in S. Melville (ed.), *The Lure of the Object*, New Haven: Yale University Press.

Bal, M. (2003) 'Visual Essentialism and the Object of Visual Culture: Now and Then', *Journal of Visual Culture*, vol. 2, no. 1 (April), pp. 5–32.

Barthes, R. (1972) 'Toys', in *Mythologies*, New York: Hill and Wang, pp. 53–5.

Baudrillard, J. (1968) 'Subjective Discourse or The Non-Functional System of Objects', in *The System of Objects*, trans. James Benedict, London: Verso.

Benjamin, W. (1992) 'Unpacking My Library: A Talk about Book Collecting', in *Illuminations*, ed. Hannah Arendt, trans. Harry Zohn, London: Fontana Press, pp. 61–9.

Bijker, W. E. (1995) *Of Bicycles, Bakelites, and Bulbs: Towards a Theory of Sociotechnical Change*, Cambridge, MA: MIT Press.

Bijker, W. E. and Law, J. (eds) (1987) *Shaping Technology/Building Society*, Cambridge, MA: The MIT Press.

Bijker, W. E., Hughes, T. P. and Pinch, T. (1987) *The Social Construction of Technological Systems*, Cambridge, MA: The MIT Press.

Bleecker, J. (2006) 'Why Things Matter: A Manifesto for Networked Objects – Cohabiting with Pigeons, Arphids, and AIBOs in the Internet of Things', http://www.nearfuturelaboratory.com/files/WhyThingsMatter.pdf.

Bourdieu, P. (1977) *Outline of a Theory of Practice*, Cambridge: Cambridge University Press.

Brown, B. (2001) 'Thing Theory', *Critical Inquiry*, vol. 28, no. 1 (Autumn), 1–22.

Brown, B. (2001) 'Things', *Critical Inquiry*, vol. 28, no. 1 (Autumn).

Brown, P. (1981) 'Praesentia' in *The Cult of the Saints: Its Rise and Function in Latin Christianity*, Chicago: University of Chicago Press, pp. 86–105

Buchli, V. (ed.) (2002) *The Material Culture Reader*, Oxford: Berg.

Busch, A. (2004) *The Uncommon Life of Common Objects: Essays on Design and the Everyday*, New York: Metropolis Books.

Callon, M. (1986) 'Some Elements of a Sociology of Translation: Domestication of the Scallops and the Fishermen of St Brieuc Bay', in J. Law (ed.), *Power, Action and Belief: A New Sociology of Knowledge*, London: Routledge & Kegan Paul, pp. 196–233.

—— (1987) 'Society in the Making: The Study of Technology as a Tool for Sociological Analysis', in W. E. Bijker et al. (eds), *The Social Construction of Technical Systems: New Directions in the Sociology and History of Technology*, London: MIT Press, pp. 83–103.

Clark, L. B., Gough, R. and Watt, D. (eds) (2007) 'On Objects', *Performance Research*, 12, p. 4.

Clemens, J. and Pettman, D. (2004) *Avoiding the Subject: Media, Culture, and the Object*, Amsterdam: Amsterdam University Press.

Daston, L. (2004) *Things that Talk: Object Lessons from Art and Science*, New York: Zone Books.

Davidson, C. C. (ed.) (2001) *Anything*, Cambridge, MA: MIT Press.

DuBois, P. (2003) 'Dildos', in *Slaves and Other Objects*, Chicago: University of Chicago Press, pp. 82–100.

Edwards, E. (1999) 'Photographs as Objects of Memory', in Marius Kwint, Christopher Breward and Jeremy Aynsley (eds), *Material Memories: Design and Evocation*, Oxford: Berg, pp. 221–36.

Exit (2003) 'Ordinary Things', p. 11.

Fried, M. (1986 [1967]) 'Art and Objecthood', in *Art and Objecthood: Essays and Reviews*, Chicago: Chicago University Press, pp. 148–71.

Fuller, M. (2005) *Media Ecologies: Materialist Energies in Art and Technoculture*, Cambridge, MA: MIT Press.

Gell, A. (1992) 'The Technology of Enchantment and the Enchantment of Technology', in Jeremy Coote and Anthony Shelton (eds), *Anthropology, Art and Aesthetics*, Oxford: Clarendon Press, pp. 40–63.

—— (1998) *Art and Agency: An Anthropological Theory*, Oxford: Clarendon.

Greenfield, A. (2006) *Everyware: The Dawning Age of Ubiquitous Computing*, Berkeley: New Riders.

Gross, D. (2002) 'Objects from the Past', in B. Nevill and J. Villeneuve (eds), *Waste-Site Stories: The Recycling of Memory*, Albany: State University of New York Press, pp. 29–38.

Grosz, E. (2001) 'The Thing', in *Architecture from the Outside: Essays on Virtual and Real Space*, Cambridge, MA: MIT Press, pp. 167–84.

Hastie, A. (2006) 'Objects of Media Studies', Ephemera. *Vectors: Journal of Culture and Technology in a Dynamic Vernacular*, no. 2, p. 1. http://vectors.usc.edu/index.php?page=7&projectId=65

Heidegger, M. (1971 [1951]) 'The Thing', in *Poetry, Language, Thought*, trans. Albert Hofstadter, New York: Harper and Row, pp. 163–86.

Holly, M. A. (2003) 'Responses to Mieke Bal's Visual Essentialism and the Object of Visual Culture: Now and Then', *Journal of Visual Culture*, vol. 2, no. 2 (August), pp. 238–242.

Ingold, T. (2000) 'On Weaving a Basket', in *Perception and Environment*, London and New York: Routledge, pp. 339–48.

Ito, M., Okabe, D. and Matsuda, M. (2006) *Personal, Portable, Pedestrian: Mobile Phones in Japanese Life*, Cambridge, MA: MIT Press.

Kopytoff, I. (1986) 'The Cultural Biography of Things: Commoditization as Process', in A. Appadurai (ed.), *The Social Life of Things: Commodities in Cultural Perspective*, Cambridge: Cambridge University Press, pp. 64–94.

Kracauer, S. (1995 [1926]) 'Calico-World: The UFA City in Neubabelsberg', in *The Mass Ornament: Weimar Essays*, Cambridge, MA: Harvard University Press, pp. 281–8.

Küchler, S. and Miller, D. (2005) *Clothing as Material Culture*, Oxford: Berg.

Lane-Fox Pitt-Rivers, A. (1906) 'On the Evolution of Culture', in J. L. Myers (ed.), *The Evolution of Culture and Other Essays*, Oxford: Clarendon Press.

Latour, B. (1992) 'Where Are the Missing Masses? The Sociology of a Few Mundane Artifacts', in Wiebe E. Bijker and John Law (eds), *Shaping Technology/Building Society: Studies in Socio-technical Change*, Cambridge, MA: MIT Press, pp. 225–58.

—— (1993a) *We Have Never Been Modern*, Cambridge, MA: Harvard University Press.

—— (1993b) 'The Enlightenment without the Critique: A Word on Michel Serres's Philosophy', in A. Phillips Griffiths (ed.), *Contemporary French Philosophy*, Cambridge: Cambridge University Press, pp. 83–97.

—— (2005) 'From Realpolitik to *Ding*politik or How to Make Things Public', in Bruno Latour and Peter Weibel (eds), *Making Things Public: Atmospheres of Democracy*, Cambridge, MA: MIT Press, pp. 14–43.

Law, J. (1991) 'Introduction: Monsters, Machines, and Sociotechnical Relations', in J. Law (ed.) *A Sociology of Monsters: Essays on Power, Technology, and Domination*, London: Routledge.

—— (1999) 'After ANT: Complexity, Naming and Topology', in J. Law and J. Hassard (eds), *Actor Network Theory and After*, Oxford: Blackwell, pp. 1–14.

Levy, S. (2006) *The Perfect Thing: How the iPod Shuffles Commerce, Culture, and Coolness*, New York: Simon & Schuster.

Lindsay, C. (2003) 'From the Shadows: Users as Designers, Producers, Marketers, Distributors and Technical Support', in Nelly Oudshoorn and Trevor Pinch (eds), *How Users Matter: The Co-Construction of Users and Technologies*, Cambridge, MA: MIT Press, pp. 29–50.

Lukács, G. (1968 [1921]) 'The Phenomenon of Reification', in *History and Class Consciousness*, trans. Rodney Livingston, Cambridge, MA: MIT Press, pp. 83–92.

Manring, M. M. (1996) 'Aunt Jemima Explained: The Old South, the Absent Mistress, and the Slave in a Box', in *Southern Cultures*, vol. 2, no. 1, pp. 19–44.

Mauss, M. (1974 [1950]) 'Gifts and the Obligation to Return Gifts', in *The Gift: Forms and Functions of Exchange in Archaic Society*, London: Routledge & Kegan Paul, pp. 6–16.

Melville, S. (ed.) (2002) *The Lure of the Object*, Williamstown, MA: Sterling and Francine Clark Art Institute.

Miller, D. (1987) *Material Culture and Mass Consumption*, Oxford: Blackwell.

—— (1998) *Material Cultures: Why Some Things Matter*, Chicago: University of Chicago Press.

—— (2005) *Materiality*, Durham, NC: Duke University Press.

Mitchell, W. J. T. (1994) *Picture Theory: Essays on Verbal and Visual Representation*, Chicago: University of Chicago Press.

—— (2005) *What Do Pictures Want?: The Lives and Loves of Images*, Chicago: University of Chicago Press.

Moser, W. (2002) 'The Acculturation of Waste', in B. Nevill and J. Villeneuve (eds), *Waste-Site Stories: The Recycling of Memory*, Albany: State University of New York Press, pp. 85–106.

Mulkay, M. J. (1979) 'Knowledge and Utility: Implications for the Sociology of Knowledge', *Social Studies of Science*, no. 9, pp. 63–80.

Olalquiaga, C. (1992) 'Holy Kitschen: Collecting Religious Junk from the Street', in *Megalopolis: Contemporary Culture Sensibilities*, Minneapolis: University of Minnesota Press, pp. 36–55.

Pels, D., Hetherington, K. and Vandenberghe, F. (2002) 'The Status of the Object: Performance, Mediations, and Technique', special issue on Objects, *Theory, Culture and Society*, vol. 19 (5/6).

Penner, B. (2001) 'A World of Unmentionable Suffering: Women's Public Conveniences in Victorian London', in *Journal of Design History*, vol. 14, no. 1, pp. 35–51.

Pinney, C. (2005) 'Things Happen: Or, From Which Moment Does That Object Come?', in D. Miller (ed.), *Materiality*, Durham, NC: Duke University Press.

Sobchack, V. (2004) 'A Leg to Stand on: Prosthetics, Metaphor, and Materiality', in *Carnal Thoughts: Embodiment and Moving Image Culture*, Berkeley: University of California Press, pp. 205–25.

Stallabrass, J. (1996) 'Trash', in *Gargantua: Manufactured Mass Culture*, London: Verso, pp. 171–88.

Sterling, B. (2005) *Shaping Things*, Cambridge, MA: MIT Press.

Taussig, M. (1993) 'In Some Way or Another One Can Protect Oneself from the Spirits by Portraying Them', in *Mimesis and Alterity: A Particular History of the Senses*, New York: Routledge, pp. 1–18.

Taylor, M. C. (2001) 'Remote Control', in C. C. Davidson (ed.), *Anything*, Cambridge, MA: MIT Press, pp. 73–6.

Thompson, M. (1979) *Rubbish Theory: The Creation and Destruction of Value*, Oxford: Oxford University Press.

Turkle, S. (ed.) (2007) *Evocative Objects: Things We Think With*, Cambridge, MA: MIT Press.

—— (ed.) (2008) *Falling for Science: Objects in Mind*, Cambridge, MA: MIT Press.

—— (ed.) (2008) *The Inner History of Devices*, Cambridge, MA: MIT Press.

van Allen, P. (ed.) (2007) *The New Ecology of Things (NET)*, Pasadena: Media Design Program, Art Center College of Design.

Winnicott, D. W. (1971) 'Transitional Objects and Transitional Phenomena', in *Playing and Reality*, London: Routledge, pp. 1–25.

PART I

Object

Marcel Mauss

GIFTS AND THE OBLIGATION TO RETURN GIFTS

1 Total prestation masculine and feminine property (Samoa)

In our earlier researches on the distribution of the system of contractual gifts, we had found no real potlatch in Polynesia. The Polynesian societies whose institutions came nearest to it appeared to have nothing beyond a system of total prestations, that is to say of permanent contracts between clans in which their men, women and children, their ritual, etc., were put on a communal basis. The facts that we had studied, including the remarkable Samoan custom of the exchange of decorated mats between chiefs on their marriages, did not indicate more complex institutions.[1] The elements of rivalry, destruction and fighting seemed to be absent, although we found they were present in Melanesia. We now reconsider the matter in the light of new material.

The system of contractual gifts in Samoa is not confined to marriage; it is present also in respect of childbirth,[2] circumcision,[3] sickness,[4] girls' puberty,[5] funeral ceremonies[6] and trade.[7] Moreover, two elements of the potlatch have in fact been attested to: the honour, prestige or *mana* which wealth confers;[8] and the absolute obligation to make return gifts under the penalty of losing the *mana*, authority and wealth.[9]

Turner tells us that on birth ceremonies, after receiving the *oloa* and the *tonga*, the 'masculine' and 'feminine' property, 'the husband and wife were left no richer than they were. Still, they had the satisfaction of seeing what they considered to be a great honour, namely, the heaps of property collected on the occasion of the birth of their child.'[10] These gifts are probably of an obligatory and permanent nature, and returns are made only through the system of rights which compels them. In this society, where cross-cousin marriage is the rule, a man gives his child to his sister and brother-in-law to bring up; and the brother-in-law, who is the child's maternal uncle, calls the child a *tonga*, a piece of feminine property.[11] It is then a 'channel through which native property[12] or *tonga*, continues to flow to that family from the parents of the child. On the

other hand, the child is to its parents a source of foreign property or *oloa*, coming from the parties who adopt it, as long as the child lives.' 'This sacrifice of natural ties creates a systematic facility in native and foreign property.' In short, the child (feminine property) is the means whereby the maternal family's property is exchanged for that of the paternal family. Since the child in fact lives with his maternal uncle he clearly has a right to live there and thus has a general right over his uncle's property. This system of fosterage is much akin to the generally recognized right of the sister's son over his uncle's property in Melanesia.[13] We need only the elements of rivalry, fighting and destruction for the complete potlatch.

Now let us consider the terms *oloa* and more particularly *tonga*. The latter means indestructible property, especially the marriage mats[14] inherited by the daughters of a marriage, and the trinkets and talismans which, on condition of repayment, come through the wife into the newly founded family; these constitute real property.[15] The *oloa* designates all the things which are particularly the husband's personal property.[16] This term is also applied today to things obtained from Europeans, clearly a recent extension.[17] We may disregard as inexact and insufficient the translation suggested by Turner of *oloa* as foreign and *tonga* as native; yet it is not without significance, since it suggests that certain property called *tonga* is more closely bound up with the land, the clan and the family than certain other property called *oloa*.[18]

But if we extend our field of observation we immediately find a wider meaning of the notion *tonga*. In the Maori, Tahitian, Tongan and Mangarevan languages it denotes everything which may be rightly considered property, which makes a man rich, powerful or influential, and which can be exchanged or used as compensation: that is to say, such objects of value as emblems, charms, mats and sacred idols, and perhaps even traditions, magic and ritual.[19] Here we meet that notion of magical property which we believe to be widely spread in the Malayo-Polynesian world and right over the Pacific.[20]

2 The spirit of the thing given (Maori)

This last remark leads to a contention of some importance. The *taonga* are, at any rate with the Maori, closely attached to the individual, the clan and the land; they are the vehicle of their *mana*—magical, religious and spiritual power. In a proverb collected by Sir G. Grey[21] and C. O. Davis,[22] *taonga* are asked to destroy the person who receives them; and they have the power to do this if the law, or rather the obligation, about making a return gift is not observed.

Our late friend Hertz saw the significance of this; disinterestedly he had written 'for Davy and Mauss' on the card containing the following note by Colenso: 'They had a kind of system of exchange, or rather of giving presents which had later to be exchanged or repaid.'[23] For example, they exchange dried fish for pickled birds and mats.[24] The exchange is carried out between tribes or acquainted families without any kind of stipulation.

But Hertz had also found—I discovered it amongst his papers—a text whose significance we had both missed, for I had been aware of it myself. Speaking of the *hau*, the spirit of things and particularly of the forest and forest game, Tamati Ranaipiri, one of Mr. Elsdon Best's most useful informants, gives quite by chance the key to the whole problem.[25] 'I shall tell you about *hau*. *Hau* is not the wind. Not at all. Suppose you have some particular object, *taonga*, and you give it to me; you give it to me without a price.[26]

We do not bargain over it. Now I give this thing to a third person who after a time decides to give me something in repayment for it (*utu*),[27] and he makes me a present of something (*taonga*). Now this *taonga* I received from him is the spirit (*hau*) of the *taonga* I received from you and which I passed on to him. The *taonga* which I receive on account of the *taonga* that came from you, I must return to you. It would not be right on my part to keep these *taonga* whether they were desirable or not. I must give them to you since they are the *hau*[28] of the *taonga* which you gave me. If I were to keep this second *taonga* for myself I might become ill or even die. Such is *hau*, the *hau* of personal property, the *hau* of the *taonga*, the *hau* of the forest. Enough on that subject.'

This capital text deserves comment. It is characteristic of the indefinite legal and religious atmosphere of the Maori and their doctrine of the 'house of secrets'; it is surprisingly clear in places and offers only one obscurity: the intervention of a third person. But to be able to understand this Maori lawyer we need only say: 'The *taonga* and all strictly personal possessions have a *hau*, a spiritual power. You give me *taonga*, I give it to another, the latter gives me *taonga* back, since he is forced to do so by the *hau* of my gift; and I am obliged to give this one to you since I must return to you what is in fact the product of the *hau* of your *taonga*.'

Interpreted thus not only does the meaning become clear, but it is found to emerge as one of the *leitmotifs* of Maori custom. The obligation attached to a gift itself is not inert. Even when abandoned by the giver, it still forms a part of him. Through it he has a hold over the recipient, just as he had, while its owner, a hold over anyone who stole it.[29] For the *taonga* is animated with the *hau* of its forest, its soil, its homeland, and the *hau* pursues him who holds it.[30]

It pursues not only the first recipient of it or the second or the third, but every individual to whom the *taonga* is transmitted.[31] The *hau* wants to return to the place of its birth, to its sanctuary of forest and clan and to its owner. The *taonga* or its *hau*—itself a kind of individual[32]—constrains a series of users to return some kind of *taonga* of their own, some property or merchandise or labour, by means of feasts, entertainments or gifts of equivalent or superior value. Such a return will give its donor authority and power over the original donor, who now becomes the latest recipient. That seems to be the motivating force behind the obligatory circulation of wealth, tribute and gifts in Samoa and New Zealand.

This or something parallel helps to explain two sets of important social phenomena in Polynesia and elsewhere. We can see the nature of the bond created by the transfer of a possession. We shall return shortly to this point and show how our facts contribute to a general theory of obligation. But for the moment it is clear that in Maori custom this bond created by things is in fact a bond between persons, since the thing itself is a person or pertains to a person. Hence it follows that to give something is to give a part of oneself. Secondly, we are led to a better understanding of gift exchange and total prestation, including the potlatch. It follows clearly from what we have seen that in this system of ideas one gives away what is in reality a part of one's nature and substance, while to receive something is to receive a part of someone's spiritual essence. To keep this thing is dangerous, not only because it is illicit to do so, but also because it comes morally, physically and spiritually from a person. Whatever it is, food,[33] possessions, women, children or ritual, it retains a magical and religious hold over the recipient. The thing given is not inert. It is alive and often personified, and strives to bring to its original clan and homeland some equivalent to take its place.

3 The obligation to give and the obligation to receive

To appreciate fully the institutions of total prestation and the potlatch we must seek to explain two complementary factors. Total prestation not only carries with it the obligation to repay gifts received, but it implies two others equally important: the obligation to give presents and the obligation to receive them. A complete theory of the three obligations would include a satisfactory fundamental explanation of this form of contract among Polynesian clans. For the moment we simply indicate the manner in which the subject might be treated.

It is easy to find a large number of facts on the obligation to receive. A clan, household, association or guest are constrained to demand hospitality,[34] to receive presents, to barter[35] or to make blood and marriage alliances. The Dayaks have even developed a whole set of customs based on the obligation to partake of any meal at which one is present or which one has seen in preparation.[36]

The obligation to give is no less important. If we understood this, we should also know how men came to exchange things with each other. We merely point out a few facts. To refuse to give, or to fail to invite, is—like refusing to accept—the equivalent of a declaration of war; it is a refusal of friendship and intercourse.[37] Again, one gives because one is forced to do so, because the recipient has a sort of proprietary right over everything which belongs to the donor.[38] This right is expressed and conceived as a sort of spiritual bond. Thus in Australia the man who owes all the game he kills to his father- and mother-in-law may eat nothing in their presence for fear that their very breath should poison his food.[39] We have seen above that the *taonga* sister's son has customs of this kind in Samoa, which are comparable with those of the sister's son (*vasu*) in Fiji.[40]

In all these instances there is a series of rights and duties about consuming and repaying existing side by side with rights and duties about giving and receiving. The pattern of symmetrical and reciprocal rights is not difficult to understand if we realize that it is first and foremost a pattern of spiritual bonds between things which are to some extent parts of persons, and persons and groups that behave in some measure as if they were things.

All these institutions reveal the same kind of social and psychological pattern. Food, women, children, possessions, charms, land, labour, services, religious offices, rank—everything is stuff to be given away and repaid. In perpetual interchange of what we may call spiritual matter, comprising men and things, these elements pass and repass between clans and individuals, ranks, sexes and generations.

4 Gifts to men and gifts to gods

Another theme plays its part in the economy and morality of the gift: that of the gift made to men in the sight of gods or nature. We have not undertaken the wider study necessary to reveal its real import; for the facts at our disposal do not all come from the areas to which we have limited ourselves; and a strongly marked mythological element which we do not yet fully understand prevents us from advancing a theory. We simply give some indications of the theme.

In the societies of North-East Siberia[41] and amongst the Eskimo of West Alaska[42] and the Asiatic coast of the Behring Straits, the potlatch concerns not only men who

rival each other in generosity, and the objects they transmit or destroy, and the spirits of the dead which take part in the transactions and whose names the men bear; it concerns nature as well. Exchanges between namesakes—people named after the same spirits—incite the spirits of the dead, of gods, animals and natural objects to be generous towards them.[43] Men say that gift-exchange brings abundance of wealth. Nelson and Porter have given us good descriptions of these ceremonies and the effect they have on the dead, on the game, the fish and shell-fish of the Eskimo. They are expressively called, in the language of British trappers, the 'Asking Festival' or the 'Inviting-in Festival'.[44] Ordinarily they are not confined within the limits of winter settlements. The effect upon nature has been well shown in a recent work on the Eskimo.[45]

The Yuit have a mechanism, a wheel decorated with all manner of provisions, carried on a greasy pole surmounted with the head of a walrus. The top of the pole protrudes above the tent of which it forms the centre. Inside the tent it is manoeuvred by means of another wheel and is made to turn clockwise like the sun. It would be hard to find a better expression of this mode of thought.[46]

The theme is also to be found with the Koryak and Chukchee of the extreme north-west of Siberia.[47] Both have the potlatch. But it is the maritime Chukchee who, like their Yuit neighbours, practise most the obligatory-voluntary gift-exchanges in the course of protracted thanksgiving ceremonies which follow one after the other in every house throughout the winter. The remains of the festival sacrifice are thrown into the sea or cast to the winds; they return to their original home, taking with them all the game killed that year, ready to return again in the next. Jochelsen mentions festivals of the same kind among the Koryak, although he was present only at the whale festival. The system of sacrifice seems there to be very highly developed.[48]

Bogoras rightly compares these with the Russian *koliada* customs in which masked children go from house to house begging eggs and flour and none dare refuse them. This is a European custom.[49]

The connection of exchange contracts among men with those between men and gods explains a whole aspect of the theory of sacrifice. It is best seen in those societies where contractual and economic ritual is practised between men. Where the men are masked incarnations, often shamanistic, being possessed by the spirit whose name they bear, they act as representatives of the spirits.[50] In that case the exchanges and contracts concern not only men and things but also the sacred beings that are associated with them.[51] This is very evident in Eskimo, Tlingit, and one of the two kinds of Haida potlatch.

There has been a natural evolution. Among the first groups of beings with whom men must have made contracts were the spirits of the dead and the gods. They in fact are the real owners of the world's wealth.[52] With them it was particularly necessary to exchange and particularly dangerous not to; but, on the other hand, with them exchange was easiest and safest. Sacrificial destruction implies giving something that is to be repaid. All forms of North-West American and North-East Asian potlatch contain this element of destruction.[53] It is not simply to show power and wealth and unselfishness that a man puts his slaves to death, burns his precious oil, throws coppers into the sea, and sets his house on fire. In doing this he is also sacrificing to the gods and spirits, who appear incarnate in the men who are at once their namesakes and ritual allies.

But another theme appears which does not require this human support, and which may be as old as the potlatch itself: the belief that one has to buy from the gods and that

the gods know how to repay the price. This is expressed typically by the Toradja of the Celebes. Kruyt tells us that the 'owner' can 'buy' from the spirits the right to do certain things with his or rather 'their' property. Before he cuts his wood or digs his garden or stakes out his house he must make a payment to the gods. Thus although the notion of purchase seems to be little developed in the personal economic life of the Toradja, nevertheless, the idea of purchase from gods and spirits is universally understood.[54]

With regard to certain forms of exchange which we describe later Malinowski remarks on facts of the same order from the Trobriands. A malignant spirit is evoked— a *tauvau* whose body has been found in a snake or a land crab—by means of giving it *vaygu'a* (a precious object used in *kula* exchanges, at once ornament, charm and valuable). This gift has a direct effect on the spirit of the *tauvau*.[55] Again at the *mila-mila* festival,[56] a potlatch in honour of the dead, the two kinds of *vaygu'a*—the *kula* ones and those which Malinowski now describes for the first time as 'permanent' *vaygu'a*[57]—are exposed and offered up to the spirits, who take the shades of them away to the country of the dead;[58] there the spirits rival each other in wealth as men do on their return from a solemn *kula*.[59]

Van Ossenbruggen, who is both a theorist and a distinguished observer, and who lives on the spot, has noted another point about these institutions.[60] Gifts to men and to gods have the further aim of buying peace. In this way evil influences are kept at bay, even when not personified; for a human curse will allow these jealous spirits to enter and kill you and permit evil influences to act, and if you commit a fault towards another man you become powerless against them. Van Ossenbruggen interprets in this way not only the throwing of money over the wedding procession in China, but even bridewealth itself. This is an interesting suggestion which raises a series of points.[61]

We see how it might be possible to embark upon a theory and history of contractual sacrifice. Now this sacrifice presupposes institutions of the type we are describing, and conversely it realizes them to the full, for the gods who give and repay are there to give something great in exchange for something small. Perhaps then it is not the result of pure chance that the two solemn formulas of contract, the Latin *do ut des* and the Sanskrit *dadami se, dehi me* have come down to us through religious texts.[62]

Notes

1 Davy, in *Foi Jurée*, p. 140, studies these exchanges with reference to the marriage contract. Here we point out further implications.
2 Turner, *19 Years*, p. 178; *Samoa*, pp. 82ff.; Stair, *Old Samoa*, p. 75.
3 Krämer, *Samoa-Inseln*, vol. II, pp. 52–63.
4 Stair, *Old Samoa*, p. 180; Turner, *19 Years*, p. 225; *Samoa*, p. 91.
5 Turner, *19 Years*, p. 184; *Samoa*, p. 91.
6 Krämer, *Samoa-Inseln*, vol. II, p. 105; Turner, *Samoa*, p. 146.
7 Krämer, ibid., pp. 96, 313. The *malaga* trading expedition (cf. the *walaga* of New Guinea) is very like the potlatch and characteristic of the neighbouring Melanesian archipelago. Krämer uses the word *Gegenschenk* for the exchange of *oloa* and *tonga* which we shall discuss. We do not intend to follow the exaggerations of the English school of Rivers and Elliot Smith or those of the Americans who, after Boas, see the whole American potlatch as a series of borrowings, but still we grant that an important part is played by the diffusion of institutions. It is specially important in this area where trading expeditions go great

distances between islands and have done from early times; there must have been transmitted not only the articles of merchandise but also methods of exchange. Malinowski, whom we quote later, recognizes this. See Lenoir, 'Expéditions maritimes en Mélanésie' in *Anthropologie*, 1924.

8 Rivalry among Maori clans is often mentioned, particularly with regard to festivals, e.g. by S. P. Smith, *J.P.S.*, XV, 87.

9 This is not properly potlatch because the counter-prestation lacks the element of usury. But as we shall see with the Maori the fact that no return is made implies the loss of *mana*, or of 'face' as the Chinese say; the same is true for Samoa.

10 Turner, *19 Years*, p. 178; *Samoa*, p. 52. The theme of honour through ruin is fundamental to North-West American potlatch.

11 Turner, *19 Years*, p. 178; *Samoa*, p. 83, says the young man is 'adopted'. This is wrong; it is fosterage. Education is outside his own family certainly, but in fact it marks a return to his uterine family (the father's sister is the spouse of the mother's brother). In Polynesia both maternal and paternal relatives are classificatory. See our review of E. Best, *Maori Nomenclature* in *L'Année Sociologique*, VII, 420 and Durkheim's remarks in V, 37.

12 *19 Years*, p. 179; *Samoa*, p. 83.

13 See our remarks on the Fiji *vasu* in 'Procès verbal de l'I.F.A.', *Anthropologie*, 1921.

14 Krämer, *Samoa-Inseln*, vol. I, p. 482; vol. II, p. 90.

15 Ibid., vol. II, p. 296. Cf. p. 90 (*toga* equals *Mitgift*); p. 94 exchanges of *oloa* and *toga*.

16 Ibid., vol. I, p. 477. Violette, *Dictionnaire Samoan-Français*, defines *toga* as 'native valuables consisting of fine mats, and *oloa* valuables such as houses, cloth, boats, guns'; and he refers back to *oa*, valuables in general.

17 *19 Years*, p. 179; cf. p. 186; Tregar, *Maori Comparative Dictionary*, p. 468 under *taonga* confuses this with *oloa*. The Rev. Ella, 'Polynesian Native Clothing', in *J.P.S.*, VIII, 165, describes the *ie tonga* (mats); they were 'the chief wealth of the natives; indeed at one time were used as a medium of currency in payment for work, etc., also for barter, interchange of property, at marriage and other special occasions of courtesy. They are often retained in families as heirlooms, and many old *ie* are well known and more highly valued as having belonged to some celebrated family'. Cf. Turner, *Samoa*, p. 120. We shall see that these expressions have their equivalents in Melanesia, in North America and in our own folklore.

18 Krämer, *Samoa-Inseln*, vol. II, pp. 90, 93.

19 See Tregar, *Maori Comparative Dictionary*, under *taonga*: (Tahitian) *tataoa*, to give property, *faataoa*, to compensate; (Marquesan) Lesson, *Polynésiens*, vol. II, p. 232, *taetae; tiau tae-tae*, presents given, 'local produce given in exchange for foreign goods'. Radiguet, *Derniers Sauvages*, p. 157. The root of the word is *tahu*, etc.

20 See Mauss, 'Origines de la Notion de la Monnaie,' in *Anthropologie*, 1914, where most of the facts quoted, except for Negrito and American material, belong to this domain.

21 *Proverbs*, p. 103.

22 *Maori Momentoes*, p. 21.

23 In *Transactions of the New Zealand Institute*, I, 354.

24 New Zealand tribes are divided in theory by the Maori themselves into fishermen, agriculturalists and hunters, who are supposed to exchange their produce. Cf. Best, 'Forest-Lore', in *Transactions of the New Zealand Institute*, XLII, 435.

25 Ibid., p. 431; translation, p. 439.

26 The word *hau*, like the Latin *spiritus*, means both wind and soul. More precisely *hau* is the spirit and power of inanimate and vegetable things. The word *mana* is reserved for men and spirits and is not applied to things as much as in Melanesian languages.

27 *Utu* means satisfaction in blood vengeance.

28 *He hau*. These sentences were all abridged by Best.

29 Many facts illustrating this point were collected by R. Hertz in his *Péché et l'Expiation*. They show that the sanction against theft is the mystical effect of the *mana* of the object stolen; moreover, the object is surrounded by taboos and marked by its owner, and has *hau*, spiritual power, as a result. This *hau* avenges theft, controls the thief, bewitches him and leads him to death or constrains him to restore the object.

30 In Hertz will be found material on the *mauri* to which we allude here. *Mauri* are talismans, safeguards and sanctuaries where the clan soul (*hapu*) dwells with its *mana* and the *hau* of its land.

Best's documents require more comment than we can give here, especially those concerned with *hau whitia* and *kai hau*. See especially 'Spiritual Concepts', in *J.P.S.*, X, 10 (Maori text), and IX, 198. Best translates *hau whitia* well as 'averted *hau*'. The sins of theft, of non-repayment, of non-counter-prestation are a 'turning aside' of the spirit (*hau*) as in the case of a refusal to make an exchange or give a present. *Kai hau* is badly translated as the equivalent of *hau whitia*. It implies the act of eating the soul, and may well be synonymous with *whangai hau* (cf. Tregear, Tregar, *Maori Comparative Dictionary*, under *kai* and *whangai*). But *kai* refers to food and the word alludes to the sharing of food and the fault of remaining in debt over it. Further, the word *hau* itself also belongs to the realm of ideas. Williams, *Maori Dictionary*, p. 47, says '*hau*, return present by way of acknowledgement for a present received'.

31 We draw attention to the expression *kai-hau-kai*, Tregar, *Maori Comparative Dictionary*, p. 116: 'The return present of food, etc., made by one tribe to another. A feast (in the South).' This signifies that the return gift is really the 'spirit' of the original prestation returning to its point of departure: 'food that is the *hau* of other food.' European vocabularies have not the ability to describe the complexity of these ideas.

32 The *taonga* seem to have an individuality beyond that of the *hau*, which derives from their relationship with their owner. They bear names. According to the best authorities (Tregar, *Maori Comparative Dictionary*) under *pounamu*, from the manuscript of Colenso) they comprise: the *pounamu*, jades that are the sacred property of the clan chiefs; the rare sculptured *tiki*; various kinds of mats of which one is called *koruwai* (the only Maori word recalling the Samoan *oloa*, although we have sought for an equivalent). A Maori document gives the name *taonga* to the *karakia*, individual heritable magic spells, *J.P.S.*, IX, 126, 133.

33 E. Best, 'Forest Lore', in *Transactions of the New Zealand Institute*, XLII, 449.

34 We should really discuss here the ideas implied in the interesting Maori expression 'to despise *tahu*'. The main document is Best, 'Maori Mythology', in *J.P.S.*, IX, 113. *Tahu* is a symbolic name for food in general, its personification. 'Do not despise *tahu*' is the injunction to a person who refuses a gift of food. It would take much space to study Maori food beliefs so we simply point out that this personification of food is identical with Rongo, the god of plants and of peace. The association of ideas becomes clearer: hospitality, food, communion, peace, exchange, law.

35 See Best, 'Spiritual Concepts', in *J.P.S.*, IX, 198.

36 See Hardeland, *Dayak Wörterbuch* under *indjok, irek, pahuni*. The comparative study of these institutions could be extended to cover the whole of Malayan, Indonesian and Polynesian civilization. The only difficulty is in recognizing the institution. For instance, it is under the name of 'compulsory trade' that Spencer St. John describes the way in which (in Brunei) the aristocrats seek tribute from the Bisayas by first giving them a present of cloth to be repaid with high interest over a number of years (*Life in the Forests of the Far East*, vol. II). The error arises from the custom of civilized Malayans of borrowing cultural traits from their less civilized brothers without understanding them. We do not enumerate all the Indonesian data on this point.

37 Not to invite one to a war dance is a sin, a fault which, in the South Island, is called *puha*. H. T. de Croisilles, 'Short Traditions of the South Island', in *J.P.S.*, X, 76. (Note *tahua* means a gift of food.)

Maori ritual of hospitality comprises: an obligatory invitation that should not be refused or solicited; the guest must approach the reception house looking straight ahead; his host should have a meal ready for him straight away and himself partake of it humbly; on leaving, the guest receives a parting gift (Tregear, *The Maori Race*, p. 29). See later, identical rites in Hindu hospitality.

In fact the two rules are closely connected like the gifts they prescribe. Taylor, *Te ika a mani*, p. 132, no. 60, translates a proverb expressing this: 'When raw it is seen, when cooked it is taken' (it is better to eat half-cooked food and to wait until strangers arrive than to have it cooked and be obliged to share it with them).

Chief Hekemaru, according to legend, refused food unless he had been seen and received by the village he was visiting. If his procession passed through unnoticed and then messengers arrived begging him to return and take food, he replied that 'food would not follow his back'. He meant that food offered to the 'sacred back of his head' would endanger those who gave it. Hence the proverb: 'Food will not follow at the back of Hekemaru' (Tregear, *The Maori Race*, p. 79).

38 Among the tribe of Tuhoe Best ('Maori Mythology', in *J.P.S.*, VIII, 113) saw these principles: When a famous chief is to visit a district, his *mana* precedes him. The people hunt and fish for good food. They get nothing. 'That is because our *mana* has preceded us and driven all the food (fish and birds) afar off that they may not be visible to the people. Our *mana* has banished them.' (There follows an explanation of snow in terms of *whai riri*—a sin against water—which keeps food away from men.) This rather difficult passage describes the condition of the land as the result of a *hapu* of hunters who had failed to make preparations to receive the chief of another clan. They would have committed *kaipapa*, a 'sin against food', and thus destroyed their cultivations, hunting grounds and fisheries—their entire sources of food.

39 E.g. Arunta, Unmatjera, Kaitish; Spencer and Gillen, *Northern Tribes of Central Australia*, p. 610.

40 On *vasu* see especially Williams, *Fiji and the Fijians*, 1858, vol. I, p. 34, and cf. Steinmetz, *Entwickelung für die Strafe*, vol. II, pp. 241ff. The right of the sister's son is only analogous to family communism. There are other rights present, the right of in-laws and what may be called 'permitted theft'.

41 See *Chukchee*. Obligation to give, receive and return gifts and hospitality is more marked with the Maritime than the Reindeer Chukchee. See 'Social Organization', *Jesup North Pacific Expedition*, VII, 634, 637. Cf. rules for sacrificing and slaughtering reindeer. 'Religion', ibid., II, 375; the duty of inviting, the right of the guest to demand what he wants and his obligation to give a present.

42 The obligation to give is a marked Eskimo characteristic. See our 'Variations saisonnières des Sociétés Eskimos', in *L'Année Sociologique*, IX, 121. A recent work on the Eskimo gives other tales which impart generosity: Hawkes, 'The Labrador Eskimo' in *Canadian Geological Survey*, Anthropological Series, p. 159.

In 'Variations saisonnières' we considered Alaskan Eskimo feasts as a combination of Eskimo elements and potlatch borrowings. But since writing that we have found the true potlatch as well as gift customs described for the Chukchee and Koryak in Siberia, so the Eskimo might have borrowed from them. Also the plausible theory of Sauvageot (*Journal des Americanistes*, 1924) on the Asiatic origin of Eskimo languages should be taken into account. This theory confirms the archaelological and anthropological theories on the origin of the Eskimo and their civilization. Everything points to the fact that the western Eskimo are nearer the origin linguistically and ethnologically than the eastern and central. This seems proved by Thalbitzer.

One must then say that the eastern Eskimo have a potlatch of very ancient origin. The special totems and masks of the western festivals are clearly of Indian derivation. The

disappearance in east and central Arctic America of the Eskimo potlatch is ill explained except by the gradual degeneration of the eastern Eskimo societies.

43 Hall, *Life with the Esquimaux*, vol. II, p. 320. It is remarkable that this is found not with reference to the Alaskan potlatch, but to the central Eskimo, who have only communal winter festivals and gift exchange. This shows that the notion extends beyond the limits of the potlatch proper.

44 Nelson, 'Eskimos about Behring Straits', in *Annual Report of the Bureau of American Ethnology*, XVIII, 303, and Porter, *11th Census*, pp. 138, 141, and especially Wrangold, *Statistische Ergebnisse*, etc., p. 132. For the 'asking stick', cf. Hawkes, 'The Inviting-in Feast of the Alaskan Eskimos', in *Canadian Geological Survey*, Memo. 45, Anthropological Series, II, 7.

45 Hawkes, ibid., pp. 3, 7. Cf. p. 9 description of one such festival, Unalaklit v. Malemiut. One of the most characteristic traits is the series of comical prestations on the first day and the gifts concerned. One tribe tries to make the other laugh and can demand anything it wants. The best dancers receive valuable presents (pp. 12–14). This is a clear and rare example (I know of others in Australia and America) of representation in ritual of a theme which is frequent enough in mythology: the spirit of jealousy which, when it laughs, leaves hold of its object.

The Inviting-in Festival ends with a visit of the *angekok* (shaman) to the spirit-men, *inua*, whose mask he wears and who tell him they have enjoyed the dance and will send game. Cf. the gift made to seals, Jennes, 'Life of the Copper Eskimos' in *Report of the Canadian Arctic Expedition*, vol. XII, 1922, p. 178.

Other themes of gift-giving customs are strongly marked; e.g. the chief *naskuk* has no right to refuse a gift or food however scarce it may be for fear of being evermore disgraced. Hawkes, ibid., p. 9.

Hawkes rightly considers (p. 19) the festival of the Dene described by Chapman (*Congrès des Américanistes de Québec*, 1907, vol. II) as an Eskimo borrowing from Indians.

46 See illustration in *Chukchee*, p. 403.

47 Ibid., pp. 399–401.

48 *Koryak*, pp. 64, 90, 98.

49 *Chukchee*, p. 400. On customs of this type see Frazer, *The Golden Bough* (3rd edn), vol. III, pp. 78–85, 91 ff.; vol. X, pp. 169 ff., also pp. 1, 161.

50 This is a basic trait of all North-West American potlatch. It is not very noticeable, however, since the ritual is so totemistic that its effect upon nature is less evident than its influence over spirits. It is more obvious in the Behring Straits, especially with the Chukchee and the Eskimo potlatch of Saint-Lawrence Isle.

51 See potlatch myth in Bogoras, *Chukchee Mythology*, p. 14. One shaman asks another: 'with what will you answer?' (i.e. make return gift). A struggle ensues but finally they come to an agreement; they exchange their magic knives and necklaces, then their (assistant) spirits and lastly their bodies (p. 15). Thereafter they are not entirely successful for they forget to exchange their bracelets and tassels ('my guide in motion'), p. 16. These objects have the same spiritual value as the spirits themselves.

52 Jochelsen, 'Koryak Religion', *Jesup North Pacific Expedition*, VI, 30. A Kwakiutl spirit song (from winter ceremony shamanism) comments: 'You send us all things from the other world, O spirits / You heard that we were hungry / We shall receive many things from you.' *Sec. Soc.*, p. 487.

53 *Foi Jurée*, pp. 224 ff., refers.

54 *Koopen*, pp. 163–8, 158–9, 3 and 5 of the summary.

55 *Argonauts*, p. 511.

56 Ibid., pp. 72, 184.

57 Ibid., p. 512. Cf. 'Baloma, Spirits of the Dead', in *Journal of the Royal Anthropoligical Institute*, 1917.

58 The Maori myth of Te Kanava (Grey, *Polynesian Mythology*, Routledge edn, p. 213) relates how spirits took the shadows of the *pounamu* (jasper, etc.—in other words *taonga*) displayed in their honour. An identical myth from Mangaia (Wyatt Gill, *Myths and Songs from the South Pacific*, p. 257) tells the same tale about red shell necklaces and how they gain the favours of the beautiful Manapu.

59 *Argonauts*, p. 513. Malinowski (p. 510, etc.) lays too much claim to the novelty of his data which are identical with aspects of Tlingit and Haida potlatch.

60 'Het Primitieve Denken, voorn. in Pokkengebruiken', in *Bijdr. tot de Taal-, Land-, en Volkenk. v. Nederl. Indie*, LXXI, 245–6.

61 Crawley, *The Mystic Rose*, p. 386, has already put forward a hypothesis on these lines, and Westermarck examined it and adduced some proof. See especially *History of Human Marriage*, 2nd edn, vol. I, pp. 394ff. His approach is vitiated since he identifies the system of total prestations and the more highly developed potlatch in which the exchanges (including exchange of women in marriage) form only a part.

62 Vajasaneyisamhita. See Hubert and Mauss, 'Essai sur le Sacrifice' in *L'Année Sociologique*, II. 105.

Georg Lukács

THE PHENOMENON OF REIFICATION

THE ESSENCE OF COMMODITY-STRUCTURE has often been pointed out. Its basis is that a relation between people takes on the character of a thing and thus acquires a 'phantom objectivity', an autonomy that seems so strictly rational and all-embracing as to conceal every trace of its fundamental nature: the relation between people. It is beyond the scope of this essay to discuss the central importance of this problem for economics itself. Nor shall we consider its implications for the economic doctrines of the vulgar Marxists which follow from their abandonment of this starting-point.

Our intention here is to *base* ourselves on Marx's economic analyses and to proceed from there to a discussion of the problems growing out of the fetish character of commodities, both as an objective form and also as a subjective stance corresponding to it. Only by understanding this can we obtain a clear insight into the ideological problems of capitalism and its downfall.

Before tackling the problem itself we must be quite clear in our minds that commodity fetishism is a *specific* problem of our age, the age of modern capitalism. Commodity exchange and the corresponding subjective and objective commodity relations existed, as we know, when society was still very primitive. What is at issue *here*, however, is the question: how far is commodity exchange together with its structural consequences able to influence the *total* outer and inner life of society? Thus the extent to which such exchange is the dominant form of metabolic change in a society cannot simply be treated in quantitative terms—as would harmonise with the modern modes of thought already eroded by the reifying effects of the dominant commodity form. The distinction between a society where this form is dominant, permeating every expression of life, and a society where it only makes an episodic appearance is essentially one of quality. For depending on which is the case, all the subjective and objective phenomena in the societies concerned are objectified in qualitatively different ways.

Marx lays great stress on the essentially episodic appearance of the commodity form in primitive societies: "Direct barter, the original natural form of exchange, represents rather the beginning of the transformation of use-values into commodities, than that of commodities into money. Exchange value has as yet no form of its own, but is still directly bound up with use-value. This is manifested in two ways. Production, in its entire organisation, aims at the creation of use-values and not of exchange values, and it is only when their supply exceeds the measure of consumption that use-values cease to be use-values, and become means of exchange, i.e. commodities. At the same time, they become commodities only within the limits of being direct use-values distributed at opposite poles, so that the commodities to be exchanged by their possessors must be use-values to both—each commodity to its non-possessor. As a matter of fact, the exchange of commodities originates not within the primitive communities, but where they end, on their borders at the few points where they come in contact with other communities. That is where barter begins, and from here it strikes back into the interior of the community, decomposing it."[1] We note that the observation about the disintegrating effect of a commodity exchange directed in upon itself clearly shows the qualitative change engendered by the dominance of commodities.

However, even when commodities have this impact on the internal structure of a society, this does not suffice to make them constitutive of that society. To achieve that it would be necessary —as we emphasized above—for the commodity structure to penetrate society in all its aspects and to remould it in its own image. It is not enough merely to establish an external link with independent processes concerned with the production of exchange values. The qualitative difference between the commodity as one form among many regulating the metabolism of human society and the commodity as the universal structuring principle has effects over and above the fact that the commodity relation as an isolated phenomenon exerts a negative influence at best on the structure and organisation of society. The distinction also has repercussions upon the nature and validity of the category itself. Where the commodity is universal it manifests itself differently from the commodity as a particular, isolated, non-dominant phenomenon.

The fact that the boundaries lack sharp definition must not be allowed to blur the qualitative nature of the decisive distinction. The situation where commodity exchange is not dominant has been defined by Marx as follows: "The quantitative ratio in which products are exchanged is at first quite arbitrary. They assume the form of commodities inasmuch as they are exchangeables, i.e. expressions of one and the same third. Continued exchange and more regular reproduction for exchange reduces this arbitrariness more and more. But at first not for the producer and consumer, but for their go-between, the merchant, who compares money-prices and pockets the difference. It is through his own movements that he establishes equivalence. Merchant's capital is originally merely the intervening movement between extremes which it does not control and between premises which it does not create."[2]

And *this* development of the commodity to the point where it becomes the dominant form in society did not take place until the advent of modern capitalism. Hence it is not to be wondered at that the personal nature of economic relations was still understood clearly on occasion at the start of capitalist development, but that as the process advanced and forms became more complex and less direct, it became increasingly difficult and rare to find anyone penetrating the veil of reification. Marx sees the matter in this way: "In preceding forms of society this economic mystification arose

principally with respect to money and interest-bearing capital. In the nature of things it is excluded, in the first place, where production for the use-value, for immediate personal requirements, predominates; and secondly, where slavery or serfdom form the broad foundation of social production, as in antiquity and during the Middle Ages. Here, the domination of the producers by the conditions of production is concealed by the relations of dominion and servitude which appear and are evident as the direct motive power of the process of production."[3]

The commodity can only be understood in its undistorted essence when it becomes the universal category of society as a whole. Only in this context does the reification produced by commodity relations assume decisive importance both for the objective evolution of society and for the stance adopted by men towards it. Only then does the commodity become crucial for the subjugation of men's consciousness to the forms in which this reification finds expression and for their attempts to comprehend the process or to rebel against its disastrous effects and liberate themselves from servitude to the 'second nature' so created.

Marx describes the basic phenomenon of reification as follows: "A commodity is therefore a mysterious thing, simply because in it the social character of men's labour appears to them as an objective character stamped upon the product of that labour; because the relation of the producers to the sum total of their own labour is presented to them as a social relation, existing not between themselves, but between the products of their labour. This is the reason why the products of labour become commodities, social things whose qualities are at the same time perceptible and imperceptible by the senses. . . . It is only a definite social relation between men that assumes, in their eyes, the fantastic form of a relation between things."[4]

What is of central importance here is that because of this situation a man's own activity, his own labour becomes something objective and independent of him, something that controls him by virtue of an autonomy alien to man. There is both an objective and a subjective side to this phenomenon. *Objectively* a world of objects and relations between things springs into being (the world of commodities and their movements on the market). The laws governing these objects are indeed gradually discovered by man, but even so they confront him as invisible forces that generate their own power. The individual can use his knowledge of these laws to his own advantage, but he is not able to modify the process by his own activity. *Subjectively*—where the market economy has been fully developed—a man's activity becomes estranged from himself, it turns into a commodity which, subject to the non-human objectivity of the natural laws of society, must go its own way independently of man just like any consumer article. "What is characteristic of the capitalist age," says Marx, "is that in the eyes of the labourer himself labour-power assumes the form of a commodity belonging to him. On the other hand it is only at this moment that the commodity form of the products of labour becomes general."[5]

Thus the universality of the commodity form is responsible both objectively and subjectively for the abstraction of the human labour incorporated in commodities. (On the other hand, this universality becomes historically possible because this process of abstraction has been completed.) *Objectively*, in so far as the commodity form facilitates the equal exchange of qualitatively different objects, it can only exist if that formal equality is in fact recognised—at any rate in *this* relation, which indeed confers upon them their commodity nature. *Subjectively*, this formal equality of human labour in the

abstract is not only the common factor to which the various commodities are reduced; it also becomes the real principle governing the actual production of commodities.

Clearly, it cannot be our aim here to describe even in outline the growth of the modern process of labour, of the isolated, 'free' labourer and of the division of labour. Here we need only establish that labour, abstract, equal, comparable labour, measurable with increasing precision according to the time socially necessary for its accomplishment, the labour of the capitalist division of labour existing both as the presupposition and the product of capitalist production, is born only in the course of the development of the capitalist system. Only then does it become a category of society influencing decisively the objective form of things and people in the society thus emerging, their relation to nature and the possible relations of men to each other.[6]

If we follow the path taken by labour in its development from the handicraft via co-operation and manufacture to machine industry we can see a continuous trend towards greater rationalisation, the progressive elimination of the qualitative, human and individual attributes of the worker. On the one hand, the process of labour is progressively broken down into abstract, rational, specialised operations so that the worker loses contact with the finished product and his work is reduced to the mechanical repetition of a specialised set of actions. On the other hand, the period of time necessary for work to be accomplished (which forms the basis of rational calculation) is converted, as mechanisation and rationalisation are intensified, from a merely empirical average figure to an objectively calculable work-stint that confronts the worker as a fixed and established reality. With the modern 'psychological' analysis of the work-process (in Taylorism) this rational mechanisation extends right into the worker's 'soul': even his psychological attributes are separated from his total personality and placed in opposition to it so as to facilitate their integration into specialised rational systems and their reduction to statistically viable concepts.[7]

We are concerned above all with the *principle* at work here: the principle of rationalisation based on what is and *can be calculated*. The chief changes undergone by the subject and object of the economic process are as follows: (1) in the first place, the mathematical analysis of work-processes denotes a break with the organic, irrational and qualitatively determined unity of the product. Rationalisation in the sense of being able to predict with ever greater precision all the results to be achieved is only to be acquired by the exact breakdown of every complex into its elements and by the study of the special laws governing production. Accordingly it must declare war on the organic manufacture of whole products based on the *traditional amalgam of empirical experiences of work*: rationalisation is unthinkable without specialisation.[8]

The finished article ceases to be the object of the work-process. The latter turns into the objective synthesis of rationalised special systems whose unity is determined by pure calculation and which must therefore seem to be arbitrarily connected with each other. This destroys the organic necessity with which inter-related special operations are unified in the end-product. The unity of a product as a *commodity* no longer coincides with its unity as a use-value: as society becomes more radically capitalistic the increasing technical autonomy of the special operations involved in production is expressed also, as an economic autonomy, as the growing relativisation of the commodity character of a product at the various stages of production.[9] It is thus possible to separate forcibly the production of a use-value in time and space. This goes hand in hand with the union in time and space of special operations that are related to a set of heterogeneous use-values.

(2) In the second place, this fragmentation of the object of production necessarily entails the fragmentation of its subject. In consequence of the rationalisation of the work-process the human qualities and idiosyncrasies of the worker appear increasingly as *mere sources of error* when contrasted with these abstract special laws functioning according to rational predictions. Neither objectively nor in his relation to his work does man appear as the authentic master of the process; on the contrary, he is a mechanical part incorporated into a mechanical system. He finds it already pre-existing and self-sufficient, it functions independently of him and he has to conform to its laws whether he likes it or not.[10] As labour is progressively rationalised and mechanised his lack of will is reinforced by the way in which his activity becomes less and less active and more and more *contemplative*.[11] The contemplative stance adopted towards a process mechanically conforming to fixed laws and enacted independently of man's consciousness and impervious to human intervention, i.e. a perfectly closed system, must likewise transform the basic categories of man's immediate attitude to the world: it reduces space and time to a common denominator and degrades time to the dimension of space.

Marx puts it thus: "Through the subordination of man to the machine the situation arises in which men are effaced by their labour; in which the pendulum of the clock has become as accurate a measure of the relative activity of two workers as it is of the speed of two locomotives. Therefore, we should not say that one man's hour is worth another man's hour, but rather that one man during an hour is worth just as much as another man during an hour. Time is everything, man is nothing; he is at the most the incarnation of time. Quality no longer matters. Quantity alone decides everything: hour for hour, day for day. . . ."[12]

Thus time sheds its qualitative, variable, flowing nature; it freezes into an exactly delimited, quantifiable continuum filled with quantifiable 'things' (the reified, mechanically objectified 'performance' of the worker, wholly separated from his total human personality): in short, it becomes space.[13] In this environment where time is transformed into abstract, exactly measurable, physical space, an environment at once the cause and effect of the scientifically and mechanically fragmented and specialised production of the object of labour, the subjects of labour must likewise be rationally fragmented. On the one hand, the objectification of their labour-power into something opposed to their total personality (a process already accomplished with the sale of that labour-power as a commodity) is now made into the permanent ineluctable reality of their daily life. Here, too, the personality can do no more than look on helplessly while its own existence is reduced to an isolated particle and fed into an alien system. On the other hand, the mechanical disintegration of the process of production into its components also destroys those bonds that had bound individuals to a community in the days when production was still 'organic'. In this respect, too, mechanisation makes of them isolated abstract atoms whose work no longer brings them together directly and organically; it becomes mediated to an increasing extent exclusively by the abstract laws of the mechanism which imprisons them.

The internal organisation of a factory could not possibly have such an effect—even within the factory itself—were it not for the fact that it contained in concentrated form the whole structure of capitalist society. Oppression and an exploitation that knows no bounds and scorns every human dignity were known even to pre-capitalist ages. So too was mass production with mechanical, standardised labour, as we can see, for instance, with canal construction in Egypt and Asia Minor and the mines in Rome.[14] But mass

projects of this type could never be *rationally mechanised*; they remained isolated phenomena within a community that organised its production on a different ('natural')
basis and which therefore lived a different life. The slaves subjected to this exploitation,
therefore, stood outside what was thought of as 'human' society and even the greatest and noblest thinkers of the time were unable to consider their fate as that of human
beings.

As the commodity becomes universally dominant, this situation changes radically
and qualitatively. The fate of the worker becomes the fate of society as a whole; indeed,
this fate must become universal as otherwise industrialisation could not develop in this
direction. For it depends on the emergence of the 'free' worker who is freely able to
take his labour-power to market and offer it for sale as a commodity 'belonging' to him,
a thing that he 'possesses'.

While this process is still incomplete the methods used to extract surplus labour
are, it is true, more obviously brutal than in the later, more highly developed phase,
but the process of reification of work and hence also of the consciousness of the worker
is much less advanced. Reification requires that a society should learn to satisfy all its
needs in terms of commodity exchange. The separation of the producer from his means
of production, the dissolution and destruction of all 'natural' production units, etc.,
and all the social and economic conditions necessary for the emergence of modern capitalism tend to replace 'natural' relations which exhibit human relations more plainly by
rationally reified relations. "The social relations between individuals in the performance
of their labour," Marx observes with reference to pre-capitalist societies, "appear at all
events as their own personal relations, and are not disguised under the shape of social
relations between the products of labour."[15]

But this implies that the principle of rational mechanisation and calculability must
embrace every aspect of life. Consumer articles no longer appear as the products of an
organic process within a community (as for example in a village community). They
now appear, on the one hand, as abstract members of a species identical by definition
with its other members and, on the other hand, as isolated objects the possession or
non-possession of which depends on rational calculations. Only when the whole life of
society is thus fragmented into the isolated acts of commodity exchange can the 'free'
worker come into being; at the same time his fate becomes the typical fate of the whole
society.

Of course, this isolation and fragmentation is only apparent. The movement of
commodities on the market, the birth of their value, in a word, the real framework of
every rational calculation is not merely subject to strict laws but also presupposes the
strict ordering of all that happens. The atomisation of the individual is, then, only the
reflex in consciousness of the fact that the 'natural laws' of capitalist production have
been extended to cover every manifestation of life in society; that—for the first time
in history—the whole of society is subjected, or tends to be subjected, to a unified economic process, and that the fate of every member of society is determined by unified
laws. (By contrast, the organic unities of pre-capitalist societies organised their metabolism largely in independence of each other.)

However, if this atomisation is only an illusion it is a necessary one. That is to say,
the immediate, practical as well as intellectual confrontation of the individual with society, the immediate production and reproduction of life—in which for the individual
the commodity structure of all 'things' and their obedience to 'natural laws' is found

to exist already in a finished form, as something immutably given—could only take place in the form of rational and isolated acts of exchange between isolated commodity owners. As emphasised above, the worker, too, must present himself as the 'owner' of his labour-power, as if it were a commodity. His specific situation is defined by the fact that his labour-power is his only possession. His fate is typical of society as a whole in that this self-objectification, this transformation of a human function into a commodity reveals in all its starkness the dehumanised and dehumanising function of the commodity relation.

Notes

1 *A Contribution to the Critique of Political Economy*, p. 53.
2 *Capital* III, p. 324.
3 *Capital* III, p. 810.
4 *Capital* I, p. 72. On this antagonism cf. the purely economic distinction between the exchange of goods in terms of their value and the exchange in terms of their cost of production. *Capital* III, p. 174.
5 *Capital* I, p. 170.
6 Cf. *Capital* I, pp. 322, 345.
7 This whole process is described systematically and historically in *Capital* I. The facts themselves can also be found in the writings of bourgeois economists like Bücher, Sombart, A. Weber and Gottl among others—although for the most part they are not seen in connection with the problem of reification.
8 *Capital* I, p. 384.
9 *Capital* I, p. 355 (note).
10 That this should appear so is fully justified from the point of view of the *individual* consciousness. As far as class is concerned we would point out that this subjugation is the product of a lengthy struggle which enters upon a new stage with the organisation of the proletariat into a class—but on a higher plane and with different weapons.
11 *Capital* I, pp. 374–6, 423–4, 460, etc. It goes without saying that this 'contemplation' can be more demanding and demoralizing than 'active' labour. But we cannot discuss this further here.
12 *The Poverty of Philosophy*, pp. 58–9.
13 *Capital* I, p. 344.
14 Cf. Gottl: *Wirtschaft und Technik*, Grundriss der Sozialökonomik II, 234 et seq.
15 *Capital* I, p. 77.

Roland Barthes

TOYS

FRENCH TOYS: one could not find a better illustration of the fact that the adult Frenchman sees the child as another self. All the toys one commonly sees are essentially a microcosm of the adult world; they are all reduced copies of human objects, as if in the eyes of the public the child was, all told, nothing but a smaller man, a homunculus to whom must be supplied objects of his own size.

Invented forms are very rare: a few sets of blocks, which appeal to the spirit of do-it-yourself, are the only ones which offer dynamic forms. As for the others, French toys *always mean something*, and this something is always entirely socialized, constituted by the myths or the techniques of modern adult life: the Army, Broadcasting, the Post Office, Medicine (miniature instrument-cases, operating theatres for dolls), School, Hair-Styling (driers for permanent-waving), the Air Force (Parachutists), Transport (trains, Citröens, Vedettes, Vespas, petrol-stations), Science (Martian toys).

The fact that French toys *literally* prefigure the world of adult functions obviously cannot but prepare the child to accept them all, by constituting for him, even before he can think about it, the alibi of a Nature which has at all times created soldiers, postmen and Vespas. Toys here reveal the list of all the things the adult does not find unusual: war, bureaucracy, ugliness, Martians, etc. It is not so much, in fact, the imitation which is the sign of an abdication, as its literalness: French toys are like a Jivaro head, in which one recognizes, shrunken to the size of an apple, the wrinkles and hair of an adult. There exist, for instance, dolls which urinate; they have an oesophagus, one gives them a bottle, they wet their nappies; soon, no doubt, milk will turn to water in their stomachs. This is meant to prepare the little girl for the causality of house-keeping, to 'condition' her to her future role as mother. However, faced with this world of faithful and complicated objects, the child can only identify himself as owner, as user, never as creator; he does not invent the world, he uses it: there are, prepared for him, actions without adventure, without wonder, without joy. He is turned into a little stay-at-home

householder who does not even have to invent the mainsprings of adult causality; they are supplied to him ready-made: he has only to help himself, he is never allowed to discover anything from start to finish. The merest set of blocks, provided it is not too refined, implies a very different learning of the world: then, the child does not in any way create meaningful objects, it matters little to him whether they have an adult name; the actions he performs are not those of a user but those of a demiurge. He creates forms which walk, which roll; he creates life, not property: objects now act by themselves, they are no longer an inert and complicated material in the palm of his hand. But such toys are rather rare: French toys are usually based on imitation, they are meant to produce children who are users, not creators.

The bourgeois status of toys can be recognized not only in their forms, which are all functional, but also in their substances. Current toys are made of a graceless material, the product of chemistry, not of nature. Many are now moulded from complicated mixtures; the plastic material of which they are made has an appearance at once gross and hygienic, it destroys all the pleasure, the sweetness, the humanity of touch. A sign which fills one with consternation is the gradual disappearance of wood, in spite of its being an ideal material because of its firmness and its softness, and the natural warmth of its touch. Wood removes, from all the forms which it supports, the wounding quality of angles which are too sharp, the chemical coldness of metal. When the child handles it and knocks it, it neither vibrates nor grates, it has a sound at once muffled and sharp. It is a familiar and poetic substance, which does not sever the child from close contact with the tree, the table, the floor. Wood does not wound or break down; it does not shatter, it wears out, it can last a long time, live with the child, alter little by little the relations between the object and the hand. If it dies, it is in dwindling, not in swelling out like those mechanical toys which disappear behind the hernia of a broken spring. Wood makes essential objects, objects for all time. Yet there hardly remain any of these wooden toys from the Vosges, these fretwork farms with their animals, which were only possible, it is true, in the days of the craftsman. Henceforth, toys are chemical in substance and colour; their very material introduces one to a coenaesthesis of use, not pleasure. These toys die in fact very quickly, and once dead, they have no posthumous life for the child.

Jean Baudrillard

SUBJECTIVE DISCOURSE OR THE NON-FUNCTIONAL SYSTEM OF OBJECTS

I Marginal objects: antiques

There is a whole range of objects – including unique, baroque, folkloric, exotic and antique objects – that seem to fall outside the system we have been examining. They appear to run counter to the requirements of functional calculation, and answer to other kinds of demands such as witness, memory, nostalgia or escapism. It is tempting to treat them as survivals from the traditional, symbolic order. Yet for all their distinctiveness, these objects do play a part in modernity, and that is what gives them a double meaning.

Atmospheric value: historicalness

The fact is that the marginal object is not an anomaly relative to the system, for *the functionality of modern objects becomes historicalness in the case of the antique object* (or marginality in the baroque object, or exoticism in the primitive object) *without this implying that the object ceases to function as a sign within the system*. What we have here is the connotation of nature, of 'naturalness' – indeed, fundamentally we have the ultimate instantiation of that connotation, which is to be found in signs of previous cultural systems. The cigarette lighter described above had a mythological dimension in its reference to the sea, but it still served a purpose; the way in which antiques refer to the past gives them an *exclusively* mythological character. The antique object no longer has any practical application, its role being merely to *signify*. It is astructural, it refuses structure, it is the extreme case of disavowal of the primary functions. Yet it is not afunctional, nor purely 'decorative', for it has a very specific function within the system, namely the signifying of time.[1]

The system of atmosphere is defined in terms of extension, yet inasmuch as it aspires to be total it must conquer all of existence, including, therefore, the essential dimension of time. Clearly it is not real time but the signs or indices of time that antiques embody.[2] This allegorical presence in no way contradicts the general scheme: nature, time – nothing can escape, and everything is worked out on the level of signs. Time, however, is far less amenable than nature to abstraction and systematization. The living contradiction it enshrines resists integration into the logic of a system. This 'chronic' difficulty is what we see reflected in the spectacular connotation of the antique object. The connotation of naturalness can be subtle, but the connotation of historicalness is always glaring. The immobility of antiques has something self-conscious about it. No matter how fine it is, an antique is always eccentric; no matter how authentic it is, there is always something false about it. And indeed, it *is* false in so far as *it puts itself forward as authentic within a system whose basic principle is by no means authenticity but, rather, the calculation of relationships and the abstractness of signs.*

Symbolic value: the myth of the origin

The antique thus has a particular status. To the extent that it is there to conjure up time as part of the atmosphere, and to the extent that it is experienced as a sign, it is simply one element among others, and relative to all others.[3] On the other hand, to the extent that it is not on a par with other objects and manifests itself as total, as an authentic presence, it enjoys a special psychological standing. It is in this respect that the antique may be said, though it serves no obvious purpose, to serve a purpose nevertheless at a deeper level. What lies behind the persistent search for old things – for antique furniture, authenticity, period style, rusticity, craftsmanship, hand-made products, native pottery, folklore, and so on? What is the reason for the strange acculturation phenomenon whereby advanced peoples seek out signs extrinsic to their own time or space, and increasingly remote relative to their own cultural system (a phenomenon which is the converse of 'underdeveloped' peoples' attraction to the technological products and signs of the industrialized world)?

The demand to which antiques respond is the demand for definitive or fully realized being.[4] The tense of the mythological object is the perfect: it is that which occurs in the present as having occurred in a former time, hence that which is founded upon itself, that which is 'authentic'. The antique is always, in the strongest sense of the term, a 'family portrait': the immemorialization, in the concrete form of an object, of a former being – a procedure equivalent, in the register of the imaginary, to a suppression of time. This characteristic of antiques is, of course, precisely what is lacking in functional objects, which exist only in the present, in the indicative or in the practical imperative, which exhaust their possibilities in use, never having occurred in a former time, and which, though they can in varying degrees support the spatial environment, cannot support the temporal one. The functional object is efficient; the mythological object is fully realized. The fully realized event that the mythological object signifies is birth. I am not the one who *is*, in the present, full of *angst* – rather, I am the one who *has been*, as indicated by the course of the reverse birth of which the antique object is the sign, a course which leads from the present far back into time: a regression, therefore.[5] The antique object thus presents itself as a myth of origins.

'Authenticity'

It is impossible not to draw a comparison between the taste for antiques and the passion for collecting (which we shall be discussing below). There are profound affinities between the two, and in both we find the same narcissistic regression, the same way of suppressing time, the same imaginary mastery of birth and death. All the same, there are two distinctive features of the mythology of the antique object that need to be pointed out: the nostalgia for origins and the obsession with authenticity. It seems to me that both arise from the mythical evocation of birth which the antique object constitutes in its temporal closure – being born implying, after all, that one has had a father and a mother. Obviously, beating a path back to the origins means regression to the mother; the older the object, the closer it brings us to an earlier age, to 'divinity', to nature, to primitive knowledge, and so forth. According to Maurice Rheims, this kind of mystique already existed in the High Middle Ages, when a Greek bronze or intaglio covered with pagan markings could acquire magical virtues in the eyes of a ninth-century Christian. The demand for authenticity is, strictly speaking, a very different matter. It is reflected in an obsession with certainty – specifically, certainty as to the origin, date, author and signature of a work. The mere fact that a particular object has belonged to a famous or powerful individual may confer value on it. The fascination of handicraft derives from an object's having passed through the hands of someone the marks of whose labour are still inscribed thereupon: we are fascinated by what has been *created*, and is therefore unique, because the *moment* of creation cannot be reproduced. Now, the search for the *traces of creation*, from the actual impression of the hand to the signature, is also a search for a line of descent and for paternal transcendence. Authenticity always stems from the Father: the Father is the source of value here. And it is this sublime link that antiques evoke in the imagination, along with the return journey to the mother's breast.

The neo-cultural syndrome: restoration

The quest for *authenticity* (being-founded-on-itself) is thus very precisely a quest for an *alibi* (being-elsewhere). Let me try to shed some light on these two notions by considering a well-known example of nostalgic restoration, as described in an article entitled 'How to Fix Up Your Ruin'.[6] This is what an architect does with an old farm in 'Ile-de-France'[7] that he has taken over and decided to restore:

> The walls, crumbling because of the lack of foundations, were demolished. Part of the original barn at the south gable was removed to make way for a terrace. . . . Of course the three major walls were reconstructed. For the purposes of waterproofing we left a 0.7-metre space beneath tarred flagstones at ground level. . . . Neither the staircase nor the chimney was part of the original structure. . . . We brought in Marseilles tile, Clamart flags, Burgundian *tuiles* for the roof; we built a garage in the garden and installed large French windows. . . . The kitchen is a hundred per cent modern, as is the bathroom. . . .

However: 'The half-timbering, which was in good condition, has been retained in the new construction'; *and*: 'The stone framework of the main entrance was carefully preserved during demolition, and its stones and tiles were reused.' The article is accompanied by photographs which indeed clearly show just what is left from the old farm in the wake of 'the architect's soundings and categorical choices': three beams and two stone blocks. But on this rock would our architect build his country house – and indeed, the couple of original stones left in that entrance-way now constitute the most fitting of symbolic foundations, reinvesting the whole edifice with value. It is they which exculpate the whole enterprise from all the compromises struck by modernity with nature in order to make the place more comfortable (an innocent enough intention in itself). The architect, now transformed into a gentleman farmer, has in actuality built himself the modern house that he wanted all along, but modernity of itself could not invest the place with value, could not make the house into a 'dwelling-place': true *being* was still lacking. Rather as a church does not become a genuinely sacred place until a few bones or relics have been enshrined in it, so this architect cannot feel at home (in the strongest sense: he cannot thoroughly rid himself of a particular kind of anxiety) until he can sense the infinitesimal yet sublime presence within his brand-new walls of an old stone that bears witness to past generations. Were it not for such witnesses, the oil heating and the garage (surmounted by its Alpine garden!) would be nothing more, sad to say, than what they are – the sad necessities of comfort. Nor is it only the functional arrangements that are exonerated by the authenticity of those old stones, but in some measure also the cultural exoticism of less important decorative elements (which are, naturally, 'in the best of taste and not in the least rustic'): opalescent lamps, straw-bottomed designer armchairs, a Dalmatian chair 'once strapped to the back of a donkey', a Romantic mirror, and so forth. The cunning of the cultural guilty conscience even leads to a curious paradox, for while the garage is concealed by a fake Alpine garden, a warming-pan introduced as a rustic accessory is described as 'there not as part of the décor but as a serviceable utensil'. 'It is used', we are assured, 'in wintertime'! So the garage's practical materiality is masked, but the warming-pan's practical essence is retrieved by means of mental acrobatics. In an oil-heated house a warming-pan is obviously quite superfluous. Yet if it is not used it will no longer be authentic, will become a mere cultural sign: the cultural, purposeless warming-pan will emerge as an all-too-faithful image of the vanity of the attempt to retrieve a natural state of affairs by rebuilding this house – and, indeed, an all-too-faithful image of the architect himself, who, fundamentally, has no part to play here, for his entire social existence lies elsewhere; his very *being* is elsewhere, and for him nature is nothing but a cultural luxury. Which is fair enough, so long as one can afford it. The architect, however, does not see things in that light: if the warming-pan serves no purpose, it is merely a sign of wealth, and is thus of the order of *having*, of status, and not of the order of *being*. It must therefore be declared to have some purpose, in contrast to such truly useful objects as the oil heater and the garage, which are studiously camouflaged, as though they were ineradicable blots on nature. The warming-pan is therefore genuinely mythological; so, for that matter, is the whole house (although in another sense it is totally real and functional, responding as it does to a perfectly clear desire for comfort and fresh air). By choosing not to raze the old farm and build on the site in accordance simply with his own need for comfort, by his insistence on saving old stones and beams, our architect betrays the fact that he experiences the refinement and flawless functionality of his house as inauthentic, that these characteristics do not satisfy his deepest wishes.

Man is not 'at home' amid pure functionality – he requires something like that lustre of the wood of the True Cross which could make a church truly holy, some kind of talisman – a shard of absolute reality ensconced, enshrined at the heart of ordinary reality in order to justify it. Such is the role of the antique object, which always takes on the meaning, in the context of the human environment, of an embryo or mother-cell. By means of such objects a dispersed being identifies with the original and ideal situation of the embryo, retrogressing to the microcosmic yet essential state of prenatal life. These fetishized objects are therefore by no means mere accessories, nor are they merely cultural signs among others: they symbolize an inward transcendence, that phantasy of a centre-point in reality which nourishes all mythological consciousness, all individual consciousness – that phantasy whereby a projected detail comes to stand for the ego, and the rest of the world is then organized around it. The phantasy of authenticity is sublime, and it is always located somewhere short of reality (*sub limina*). Like the holy relic,[8] whose function it secularizes, the antique object reorganizes the world in a dispersive fashion which is quite antithetical to the extensive nature of functional organization – such organization being the very thing, in fact, from which it seeks to protect the profound and no doubt vital lack of realism of the inner self.

As symbol of the inscription of value in a closed circle and in a perfect time, mythological objects constitute a discourse no longer addressed to others but solely to oneself. Islands of legend, such objects carry human beings back beyond time to their childhood – or perhaps even farther still, back to a pre-birth reality where pure subjectivity was free to conflate itself metaphorically with its surroundings, so that those surroundings became simply the perfect discourse directed by human beings to themselves.

Synchronism, diachronism, anachronism

Within the private environment, mythological objects constitute a realm of even greater privacy: they serve less as possessions than as symbolic intercessors – as ancestors, so to speak, than which nothing is more 'private'. They are a way of escaping from everyday life, and no escape is more radical than escape in time, none so thoroughgoing as escape into one's own childhood.[9] Perhaps there is something of this metaphorical escape in all aesthetic feeling, but the work of art as such calls for a rational reading, whereas the antique does not: antiques partake of 'legend', because they are defined first and foremost by their mythical quality, by their coefficient of authenticity. The antique as directly experienced is quite unaffected by period or style, whether the object is a model or whether it is serial in character, whether or not it is precious, or whether it is genuine or fake: it remains in all cases 'perfect'; it is neither internal nor external, but 'elsewhere'; neither synchronic nor diachronic, but *anachronistic*; relative to its possessor, it is neither the complement of a verb 'to be' nor the object of a verb 'to have', but falls, rather, into the grammatical category of an internal object that gives expression to the essence of the verb in an almost tautological manner.

The functional object is devoid of being. Reality prevents its regression to that 'perfect' dimension the fact of proceeding from which suffices to ensure being. This is why such objects seem so reduced, for whatever their price, merit or prestige, they configure, and must perforce continue to configure, the loss of the Father and the Mother. Rich in functionality but impoverished in meaning, their frame of reference is the

present moment, and their possibilities do not extend beyond everyday life. The mythological object, on the other hand, has minimal function and maximal meaning, while its frame of reference is the ancestral realm – perhaps even the realm of the absolute anteriority of nature. On the plane of direct experience, however, the antithetical traits of the mythological and the functional coexist in complementary fashion within the one system. Our architect, for example, has both oil heating and a peasant-style warming-pan. Similarly, a literary work may be available at the same time in paperback and in a limited edition or fine binding, an electric washing machine may cohabit with an old battledore, or a functional built-in cupboard may be found cheek by jowl with a prominently displayed Spanish cabinet.[10] This complementarity may even be discerned in the now common practice of dual residence, of combining a flat in the city and a house in the country.[11]

This duel between objects is fundamentally a duel of consciousness; it indicates a failure – and the attempt to redress that failure in a regressive fashion. In a civilization where synchronism and diachronism strive to establish systematic and exclusive control over reality, a third dimension, that of anachronism, nevertheless emerges (and this as much at the level of objects as at the level of behaviours and social structures). This regressive dimension, though it attests to a relative setback for the system, nevertheless finds a place within that system and even, paradoxically, enables the system to function.

Reverse projection: the technical object and primitive man

Naturally, this ambiguous coexistence of modern functionality and traditional 'décor' arises only after a certain level of economic development, industrial production and practical environmental saturation has been attained. Less privileged social strata (peasants, workers) and 'primitive' peoples have no interest in what is old: they aspire to the functional. All the same, there is a similarity here between 'primitive' and 'civilized' attitudes. When a 'savage' grabs a watch or a fountain pen merely because it is a 'Western' object, we find this behaviour comical or absurd, for the object is not being given its true meaning but appropriated hungrily in accordance with an infantile type of relationship involving a power phantasy. Instead of having a function, the object has a virtue: it has become a sign. Yet is this not the very same procedure of impulsive acculturation and magical appropriation that drives 'civilized' people towards sixteenth-century woodcuts or icons? In both cases what is being acquired under the form of the object is a 'virtue': the 'savage' acquires modern technology, the 'civilized' person acquires ancestral significance. The 'virtue' is not of the same order in the two instances, however. What 'under-developed' people want from the object is an image of the Father as *Power* – in the event, *colonial* power;[12] what nostalgic 'civilized' people want is an image of the Father signifying *birth* and value. In the first case, a projective myth; in the second, a retrogressive one. A myth of power – and a myth of origins: whatever it is that man lacks is invested in the object. The 'underdeveloped' fetishize power by means of the technical object; technically advanced, 'civilized' people, for their part, fetishize birth and authenticity by means of the mythological object.

This being said, the fetishism itself is identical. In the last reckoning every antique is beautiful *merely because it has survived, and thus become the sign of an earlier life*. It is our fraught curiosity about our origins that prompts us to place such mythological objects,

the signs of a previous order of things, alongside the functional objects which, for their part, are the signs of our current mastery. For we want at one and the same time to be entirely self-made and yet be descended from someone: to succeed the Father yet simultaneously to proceed from the Father. Perhaps mankind will never manage to choose between embarking on the Promethean project of reorganizing the world, thus taking the place of the Father, and being directly descended from an original being. Our objects bear silent witness to this unresolved ambivalence. Some serve as mediation with the present, others as mediation with the past, the value of the latter being that they address a lack. Antiques are preceded by a particle, so to speak, and their inherited nobility compensates for the premature aging of modern objects. There was a time when old people were beautiful because they were 'closer to God' and richer in experience; our technological civilization has rejected the wisdom of the old, but it bows down before the solidity of old things, whose unique value is sealed and certain.

The market in antiques

More is involved here than a snobbish and status-seeking itch of the kind evoked by Vance Packard, for example, when he describes how fashionable Bostonians install old panes of a purplish tinge in their windows: 'The defectiveness of those panes is highly cherished even when their functional value is dubious. The panes were part of a shipment of inferior glass foisted off on Americans by English glassmakers more than three centuries ago.'[13] Or again: 'It was found that, if a suburbanite aspires to move up into the "lower-upper class, he will buy antiques – symbols of old social position bought with new money".'[14] Yet social standing may be signalled in a thousand ways (by a car, a modern detached house, etc.), so why is the reference to the *past* so often chosen as a vector of status?[15] All acquired value tends to metamorphose into inherited value, into a received grace. But since blood, birth and titles of nobility have lost their ideological force, the task of signifying transcendence has fallen to material signs – to pieces of furniture, objects, jewellery and works of art of every time and every place. The door has thus been opened to a mass of 'authoritative' signs and idols (whose authenticity, in the end, is neither here nor there); the market has been invaded by a whole magical flora of real or fake furniture, manuscripts and icons. The past in its entirety has been pressed into the service of consumption. This has even created a kind of black market. The New Hebrides, Romanesque Spain and flea markets everywhere have already been stripped clean by the voracious appetite for nostalgia and primitivism of the Western world's bourgeois interiors. Statues of the Virgin and saints are stolen from churches, paintings are stolen from museums, then this booty is sold secretly to rich people whose residences are too new to give them the kind of satisfaction they want. It is a cultural irony – but an economic fact – that this thirst for 'authenticity' can now be slaked only by forgeries.

Cultural neo-imperialism

Fundamentally, the imperialism that subjugates nature with technical objects and the one that domesticates cultures with antiques are one and the same. This same private

imperialism is the organizing principle of a functionally domesticated environment made up of domesticated signs of the past – of ancestral objects, sacred in essence but desacralized, which are called upon to exude their sacredness (or historicalness) into a history-less domesticity.

In this way the entire past, as a repertory of forms of consumption, is incorporated into the repertory of present-day forms in order to constitute a kind of transcendent sphere of fashion.

II A marginal system: collecting

Littré's dictionary defines '*objet*' in one of its meanings as 'anything which is the cause or subject of a passion; figuratively – and *par excellence* – the loved object'.

Let us grant that our everyday objects are in fact objects of a passion – the passion for private property, emotional investment in which is every bit as intense as investment in the 'human' passions. Indeed, the everyday passion for private property is often stronger than all the others, and sometimes even reigns supreme, all other passions being absent. It is a measured, diffuse, regulating passion whose fundamental role in the vital equilibrium of the subject or the group – in the very decision to live – we tend not to gauge very well. Apart from the uses to which we put them at any particular moment, objects in this sense have another aspect which is intimately bound up with the subject: no longer simply material bodies offering a certain resistance, they become mental precincts over which I hold sway, (they become things of which I am the meaning,) they become my property and my passion.

The object abstracted from its function

If I use a refrigerator to refrigerate, it is a practical mediation: it is not an object but a refrigerator. And in that sense I do not possess it. A *utensil* is never possessed, because a utensil refers one to the world; what is possessed is always an object *abstracted from its function and thus brought into relationship with the subject*. In this context all owned objects partake of the same *abstractness*, and refer to one another only inasmuch as they refer solely to the subject. Such objects together make up the system through which the subject strives to construct a world, a private totality.

Every object thus has two functions – to be put to use and to be possessed. The first involves the field of the world's practical totalization by the subject, the second an abstract totalization of the subject undertaken by the subject himself outside the world. These two functions stand in inverse ratio to each other. At one extreme, the strictly practical object acquires a social status: this is the case with the machine. At the opposite extreme, the pure object, devoid of any function or completely abstracted from its use, takes on a strictly subjective status: it becomes part of a collection. It ceases to be a carpet, a table, a compass or a knick-knack and becomes an object in the sense in which a collector will say 'a beautiful object' rather than specifying it, for example, as 'a beautiful statuette'. An object no longer specified by its function is defined by the subject, but in the passionate abstractness of possession all objects are equivalent. And just one object no longer suffices: the fulfilment of the project of possession always means a

succession or even a complete series of objects. This is why owning absolutely any object is always so satisfying and so disappointing at the same time: a whole series lies behind any single object, and makes it into a source of anxiety. Things are not so different on the sexual plane: whereas the love relationship has as its aim a unique being, the need to *possess* the love object can be satisfied only by a succession of objects, by repetition, or, alternatively, by making the assumption that all possible objects are somehow present. Only a more or less complex organization of objects, each of which refers to all the others, can endow each with an abstractness such that the subject will be able to grasp it in that lived abstractness which is the experience of possession.

Collecting is precisely that kind of organization. Our ordinary environment is always ambiguous: functionality is forever collapsing into subjectivity, and possession is continually getting entangled with utility, as part of the ever-disappointed effort to achieve a total integration. Collecting, however, offers a model here: through collecting, the passionate pursuit of possession finds fulfilment and the everyday prose of objects is transformed into poetry, into a triumphant unconscious discourse.

The object as passion

'The taste for collection', says Maurice Rheims, 'is a kind of passionate game.'[16] For children, collecting is a rudimentary way of mastering the outside world, of arranging, classifying and manipulating. The most active time for childhood collecting is apparently between the ages of seven and twelve, during the latency period between early childhood and puberty. The urge to collect tends to wane with the onset of puberty, only to re-emerge as soon as that stage has passed. In later life, it is men over forty who most frequently fall victim to this passion. In short, there is in all cases a manifest connection between collecting and sexuality, and this activity appears to provide a powerful compensation during critical stages of sexual development. This tendency clearly runs counter to active genital sexuality, although it is not simply a substitute for it. Rather, as compared with genitality, it constitutes a regression to the anal stage, which is characterized by accumulation, orderliness, aggressive retention, and so on. The activity of collecting is not in any sense equivalent to a sexual practice, for it is not designed to procure instinctual satisfaction (as in fetishism, for example); it may nevertheless produce intense satisfaction as a reaction. The object here takes on the full significance of a loved object: 'Passion for the object leads to its being looked upon as a thing made by God. A collector of porcelain eggs is liable to believe that God never created a form more beautiful or more singular, and indeed that He devised this form solely for the greater delight of collectors.'[17] Collectors are forever saying that they are 'crazy about' this or that object, and they all without exception – even where the perversion of fetishism plays no part – cloak their collection in an atmosphere of clandestineness and concealment, of secrecy and sequestration, which in every way suggests a feeling of guilt. It is this passionate involvement which lends a touch of the sublime to the regressive activity of collecting; it is also the basis of the view that anyone who does not collect something is 'nothing but a moron, a pathetic human wreck'.[18]

The collector's sublimity, then, derives not from the nature of the objects he collects (which will vary according to his age, profession and social milieu) but from his fanaticism. And this fanaticism is identical whether it characterizes a rich connoisseur of

Persian miniatures or a collector of matchboxes. The distinction that may legitimately be drawn here, to the effect that the collector loves his objects on the basis of their membership in a series, whereas the connoisseur loves his on account of their varied and unique charm, is not a decisive one. In both cases gratification flows from the fact that possession depends, on the one hand, on the absolute singularity of each item, a singularity which puts that item on a par with an animate being – indeed, fundamentally on a par with the subject himself – and, on the other hand, on the possibility of a series, and hence of an infinite play of substitutions. Collecting is thus qualitative in its essence and quantitative in its practice. If the feeling of possession is based on a confusion of the senses (of hand and eye) and an intimacy with the privileged object, it is also based just as much on searching, ordering, playing and assembling. In short, there is something of the harem about collecting, for the whole attraction may be summed up as that of an intimate series (one term of which is at any given time the favourite) combined with a serial intimacy.

Man never comes so close to being the master of a secret seraglio as when he is surrounded by his objects. Human relationships, home of uniqueness and conflict, never permit any such fusion of absolute singularity with infinite seriality – which is why they are such a continual source of anxiety. By contrast, the sphere of objects, consisting of successive and homologous terms, reassures. True, such reassurance is founded on an illusion, a trick, a process of abstraction and regression, but no matter. In the words of Maurice Rheims: 'For man, the object is a sort of insentient dog which accepts his blandishments and returns them after its own fashion, or rather which returns them like a mirror faithful not to real images but to images that are desired.'[19]

The finest of domestic animals

Rheims's dog image is the right one, for pets are indeed an intermediate category between human beings and objects. The pathos-laden presence of a dog, a cat, a tortoise or a canary is a testimonial to a failure of the interhuman relationship and an attendant recourse to a narcissistic domestic universe where subjectivity finds fulfilment in the most quietistic way. Note, by the way, that these animals are not sexed (indeed, they are often neutered for their role as household pets); they are every bit as devoid of sex, even though they are alive, as objects are. This is the price to be paid if they are to provide emotional security: only their actual or symbolic castration makes it possible for them to serve as mitigators of their owners' castration anxiety. This is a part that all the objects that surround us also play to perfection. The object is in fact the finest of domestic animals – the only 'being' whose qualities exalt rather than limit my person. In the plural, objects are the only entities in existence that can genuinely coexist, because the differences between them do not set them against one another, as happens in the case of living beings: instead they all converge submissively upon me and accumulate with the greatest of ease in my consciousness. Nothing can be both 'personalized' and quantified so easily as objects. Moreover, this subjective quantifiability is not restricted: everything can be possessed, cathected or (in the activity of collecting) organized, classified and assigned a place. The object is thus in the strict sense of the word a mirror, for the images it reflects can only follow upon one another without ever contradicting one another. And indeed, as a mirror the object is perfect, precisely because it sends back

not real images, but desired ones. In a word, it is a dog of which nothing remains but faithfulness. What is more, you can look at an object without it looking back at you. *That is why everything that cannot be invested in human relationships is invested in objects.* That is why regression of this kind is so easy, why people so readily practise this form of 'retreat'. But we must not allow ourselves to be taken in by this, nor by the vast literature that sentimentalizes inanimate objects. The 'retreat' involved here really is a regression, and the passion mobilized is a passion for flight. Objects undoubtedly serve in a regulatory capacity with regard to everyday life, dissipating many neuroses and providing an outlet for all kinds of tensions and for energies that are in mourning. This is what gives them their 'soul', what makes them 'ours' – but it is also what turns them into the décor of a tenacious mythology, the ideal décor for an equilibrium that is itself neurotic.

A serial game

Yet this mediation would seem to be a poor one. How can consciousness let itself be fooled in this way? Such is the cunning of subjectivity: an object that is possessed can never be a poor mediation. It is always absolutely singular. Not in reality, of course: the possession of a 'rare' or 'unique' object is obviously the ideal aim of its appropriation, but for one thing the proof that a given object is unique can never be supplied in a real world, and, for another, consciousness gets along just fine without proof. The particular value of the object, its exchange value, is a function of cultural and social determinants. Its absolute singularity, on the other hand, arises from the fact of being possessed by me – and this allows me, in turn, to recognize myself in the object as an absolutely singular being. This is a grandiose tautology, but one that gives the relationship to objects all its density – its absurd facility, and the illusory but intense gratification it supplies.[20] What is more, while this closed circuit may also govern human relationships (albeit less easily), the relationship with objects has one characteristic that can never be found in the intersubjective realm: no object ever opposes the extension of the process of narcissistic projection to an unlimited number of other objects; on the contrary, the object imposes that very tendency, thereby contributing to the creation of a total environment, to that totalization of images of the self that is the basis of the miracle of collecting. For what you really collect is always yourself.

This makes it easier to understand the structure of the system of possession: any collection comprises a succession of items, but the last in the set is the person of the collector. Reciprocally, the person of the collector is constituted as such only if it replaces each item in the collection in turn. An analogous structure on the sociological level is to be found in the system of model and series: both the series and the collection serve to institute possession of the object – that is, they facilitate the mutual integration of object and person.[21]

From quantity to quality: the unique object

It may well be objected here that any exclusive passion for a single object on the part of an art lover suffices to demolish our hypothesis. It is quite clear, however, that the unique object is in fact simply the final term, the one which sums up all the others, that

it is the supreme component of an entire paradigm (albeit a virtual, invisible or implicit one) – that it is, in short, the emblem of the series.

In the portraits in which he illustrates the passion of curiosity, La Bruyère puts the following words into the mouth of a collector of fine prints: 'I suffer from a grave affliction which will surely oblige me to abandon all thought of prints till the end of my days: I have all of Callot except for one – and one which, to be frank, is not among his best works. Indeed, it is one of his worst, yet it would round out Callot for me. I have searched high and low for this print for twenty years, and I now despair of ever finding it.' The equivalence experienced here between the whole series minus one and the final term missing from the series is conveyed with arithmetical certainty.[22] The absent final term is a symbolic distillation of that series without which it would not exist; consequently it acquires a strange quality, a quality which is the quintessence of the whole quantitative calibration of the series. This term is the unique object, defined by its final position and hence creating the illusion that it embodies a particular goal or end. This is all well and good, but it shows us how it is quantity that impels towards quality, and how the value thus concentrated on this simple signifier is in fact indistinguishable from the value that infuses the whole chain of intermediate signifiers of the paradigm. This is what might be called the symbolism of the object, in the etymological sense (cf. Greek *sumballein*, to put together), in accordance with which a chain of signifiers may be summed up in just one of its terms. The object is the symbol not of some external agency or value but first and foremost of the whole series of objects of which it is the (final) term. (This in addition to symbolizing the person whose object it is.)

La Bruyère's example illustrates another rule, too: that the object attains exceptional value only by virtue of its absence. This is not simply a matter of covetousness. *One cannot but wonder whether collections are in fact meant to be completed*, whether lack does not play an essential part here – a positive one, moreover, as the means whereby the subject reapprehends his own objectivity. If so, the *presence* of the final object of the collection would basically signify the death of the subject, whereas its absence would be what enables him merely to rehearse his death (and so exorcize it) by having an object represent it. This lack is experienced as suffering, but it is also the breach that makes it possible to avoid completing the collection and thus definitively erasing reality. Let us therefore applaud La Bruyère's collector for never finding his last Callot, for if he had done so he would thereby have ceased to be the living and passionate man that he still was, after all. It might be added that madness begins once a collection is deemed complete and thus ceases to centre around its absent term.

This account of things is buttressed by another story told by Maurice Rheims. A bibliophile specializing in unique copies learns one day that a New York book-seller is offering a book that is identical to one of his prize possessions. He rushes to New York, acquires the book, summons a lawyer, has the offending second copy burnt before him and elicits an affidavit substantiating this act of destruction. Once he is back home, he inserts this legal document in his copy, now once again unique, and goes to bed happy. Should we conclude that in this case the *series* has been abolished? Not at all. It only seems so, because the collector's original copy was in fact invested with the value of all virtual copies, and by destroying the rival copy the book collector was merely reinstituting the perfection of a compromised symbol. Whether denied, forgotten, destroyed, or merely virtual, the series is still present. The serial nature of the most mundane of everyday objects, as of the most transcendent of rarities, is what nourishes

the relationship of ownership and the possibility of passionate play: without seriality no such play would be conceivable, hence no possession – and hence, too, properly speaking, no object. A truly unique, absolute object, an object such that it has no antecedents and is in no way dispersed in some series or other – such an object is unthinkable. It has no more existence than a pure sound. Just as harmonic series bring sounds up to their perceived quality, so paradigmatic series, whatever their degree of complexity, bring objects up to their symbolic quality – carrying them, in the same movement, into the sphere of the human relationship of mastery and play.

Objects and habits: wrist-watches

Every object oscillates between a practical specificity, a function which is in a sense its manifest discourse, and absorption by a series or collection where it becomes one term in a latent, repetitive discourse – the most basic and tenacious of discourses. This discursive system of objects is analogous to the system of habits.[23]

Habits imply discontinuity and repetition – not continuity, as common usage suggests. By breaking up time, our 'habitual' patterns dispel the anxiety-provoking aspect of the temporal continuum and of the absolute singularity of events. Similarly, it is thanks to their discontinuous integration into series that we put objects at our sole disposition, that we own them. This is the discourse of subjectivity itself, and objects are a privileged register of that discourse. Between the world's irreversible evolution and ourselves, objects interpose a discontinuous, classifiable, reversible screen which can be reconstituted at will, a segment of the world which belongs to us, responding to our hands and minds and delivering us from anxiety. Objects do not merely help us to master the world by virtue of their integration into instrumental series, they also help us, *by virtue of their integration into mental series*, to master time, rendering it discontinuous and classifying it, after the fashion of habits, and subjecting it to the same associational constraints as those which govern the arrangement of things in space.

There is no better illustration of this discontinuous and 'habitual' function than the wrist-watch.[24] The watch epitomizes the duality of the way we experience objects. On the one hand, it tells us the actual time; and chronometric precision is *par excellence* the dimension of practical constraints, of society as external to us, and of death. As well as subjecting us to an irreducible temporality, however, the watch as an object helps us to appropriate time: just as the automobile 'eats up' miles, so the watch-object eats up time.[25] By making time into a substance that can be divided up, it turns it into an object to be consumed. A perilous dimension of praxis is thus transformed into a domesticated quantity. Beyond just knowing the time, 'possessing' the time in and through an object that is one's own, having the time continuously recorded before one's eyes, has become a crutch, a necessary reassurance, for civilized man. The time is no longer in the home, no longer the clock's beating heart, but its registration on the wrist continues to ensure the same organic satisfaction as the regular throbbing of an internal organ. Thanks to my watch, time presents itself simultaneously as the very dimension of my objectification and as a simple household necessity. As a matter of fact, any object might be used to demonstrate how even the dimension of objective constraint is incorporated by everyday experience; the watch, however, is the best example, by virtue of its explicit relationship to time.

Objects and time: a controlled cycle

The problem of time is a fundamental aspect of collecting. As Maurice Rheims says: 'A phenomenon that often goes hand in hand with the passion for collecting is the loss of any sense of the present time.'[26] But is this really just a matter of an escape into nostalgia? Certainly, someone who identifies with Louis XVI down to the feet of his armchairs, or develops a true passion for sixteenth-century snuffboxes, is marking himself off from the present by means of a historical reference, yet this reference takes second place to his direct experience of collecting's systematic aspect. The deep-rooted power of collected objects stems neither from their uniqueness nor from their historical distinctiveness. It is not because of such considerations that the temporality of collecting is not real time but, rather, *because the organization of the collection itself replaces time.* And no doubt this is the collection's fundamental function: the resolving of real time into a systematic dimension. Taste, particularity, status, the discourse of society – any of these may cause the collection to open onto a broader relationship (though this will never go beyond a group of insiders); in all cases, however, the collection must remain, literally, a 'pastime'. Indeed, it abolishes time. More precisely, by reducing time to a fixed set of terms navigable in either direction, the collection represents the continual recommencement of a controlled cycle whereby man, at any moment and with complete confidence, starting with any term and sure of returning to it, is able to set his game of life and death in motion.

It is in this sense that the environment of private objects and their possession (collection being the most extreme instance) is a dimension of our life which, though imaginary, is absolutely essential. Just as essential as dreams. It has been said that if dreams could be experimentally suppressed, serious mental disturbances would quickly ensue. It is certainly true that were it possible to deprive people of the regressive escape offered by the game of possession, if they were prevented from giving voice to their controlled, self-addressed discourse, from using objects to recite themselves, as it were, outside time, then mental disorder would surely follow immediately, just as in the case of dream deprivation. We cannot live in absolute singularity, in the irreversibility signalled by the moment of birth, and it is precisely this irreversible movement from birth towards death that objects help us to cope with.

Of course the balance thus achieved is a neurotic one; of course this bulwark against anxiety is regressive, for time is objectively irreversible, after all, and even the objects whose function it is to protect us from it are perforce themselves carried off by it; and of course the defence mechanism that imposes discontinuity by means of objects is forever being contested, for the world and human beings are in reality *continuous*. But can we really speak here in terms of normality or anomaly? Taking refuge in a closed synchronicity may certainly be deemed denial of reality and flight if one considers that the object is the recipient of a cathexis that 'ought' to have been invested in human relationships. But this is the price we pay for the vast regulating power of these mechanisms, which today, with the disappearance of the old religious and ideological authorities, are becoming the consolation of consolations, the everyday mythology absorbing all the *angst* that attends time, that attends death.

It should be clear that we are not here promoting any spontaneous mythology according to which man somehow extends his life or survives his death by means of the objects he possesses. The refuge-seeking procedure I have been describing depends not

on an immortality, an eternity or a survival founded on the object *qua* reflection (something which man has basically never believed in) but, rather, on a more complex action which 'recycles' birth and death into *a system of objects*. What man gets from objects is not a guarantee of life after death but *the possibility, from the present moment onwards, of continually experiencing the unfolding of his existence in a controlled, cyclical mode, symbolically transcending a real existence the irreversibility of whose progression he is powerless to affect.*

We are not far from the ball which the child (in Freud's account) causes to disappear and reappear in order to experience the absence and presence of its mother alternately (*Fort! Da! Fort! Da!*) – in order to counter her anxiety-provoking absence with this infinite cycle of disappearance and reappearance of the object. The symbolic implications of play within the series are not hard to discern here, and we may sum them up by saying that the object is *the thing with which we construct our mourning*: the object represents our own death, but that death is transcended (symbolically) by virtue of the fact that we *possess* the object; the fact that by introjecting it into a work of mourning – by integrating it into a series in which its absence and its re-emergence elsewhere 'work' at replaying themselves continually, recurrently – we succeed in dispelling the anxiety associated with absence and with the reality of death. Objects allow us to apply the work of mourning to ourselves right now, in everyday life, and this in turn allows us to live – to live regressively, no doubt, but at least to live. A person who collects is dead, but he literally survives himself through his collection, which (even while he lives) duplicates him infinitely, beyond death, *by integrating death itself into the series, into the cycle.* Once again the parallel with dreams applies here. If any object's function – practical, cultural or social – means that it is the mediation of a *wish*, it is also, as one term among others in the systematic game that we have been describing, the voice of *desire*. Desire is, in fact, the motor of the repetition or substitution of oneself, along the infinite chain of signifiers, through or beyond death. And if the function of dreams is to ensure the continuity of sleep, that of objects, thanks to very much the same sort of compromise, is to ensure the continuity of life.[27]

The sequestered object: jealousy

At the terminal point of its regressive movement, the passion for objects ends up as pure jealousy. The joy of possession in its most profound form now derives from the value that objects can have for others and from the fact of depriving them thereof. This jealous complex, though it is characteristic of the collector at his most fanatical, presides also, proportionately speaking, over the simplest proprietary reflex. A powerful anal-sadistic impulse, it produces the urge to sequester beauty so as to be the only one to enjoy it: a kind of sexually perverse behaviour widely present in a diffuse form in the relationship to objects.

What does the sequestered object represent? (Its objective value is secondary, of course – its attraction lies in the very fact of its confinement.) If you do not lend your car, your fountain pen or your wife to anyone, that is because these objects, according to the logic of jealousy, are narcissistic equivalents of the ego: to lose them, or for them to be damaged, means castration. The phallus, to put it in a nutshell, is not something one loans out. What the jealous owner sequesters and cleaves to is his own libido, in the shape of an object, which he is striving to exorcize by means of a system of confinement

– the same system, in fact, by virtue of which collecting dispels anxiety about death. He castrates himself out of anguish about his own sexuality; or, more exactly, he uses a symbolic castration – sequestration – pre-emptively, as a way of countering anxiety about *real* castration.[28] This desperate strategy is the basis of the horrible gratification that jealousy affords. For one is always jealous of oneself. It is oneself that one locks up and guards so closely. And it is from oneself that one obtains gratification.

Obviously, this jealous pleasure occurs in a context of absolute disillusionment, because systematic regression can never completely eradicate consciousness of the real world or of the futility of such behaviour. The same goes for collecting, whose sway is fragile at best, for the sway of the real world lies ever just behind it, and is continually threatening it. Yet this disillusionment is itself part of the system – indeed, is as responsible as satisfaction for setting the system in motion: disillusionment never refers to the world but, rather, to an ulterior term; disillusionment and satisfaction occupy sequential positions in the cycle. The neurotic activation of the system is thus attributable to this constitutive disillusionment. In such cases the series tends to run its course at a faster and faster pace, chasing its tail as differences wear out and the substitution mechanism speeds up. The system may even enter a destructive phase, implying the self-destruction of the subject. Maurice Rheims evokes the ritualized 'execution' of collections – a kind of suicide based on the impossibility of ever circumscribing death. It is not rare in the context of the system of jealousy for the subject eventually to destroy the sequestered object or being out of a feeling that he can never completely rid himself of the adversity of the world, and of his own sexuality. This is the logical and illogical end of his passion.[29]

The object destructured: perversion

The effectiveness of the system of possession is directly linked to its regressive character. And this regression in turn is linked to the very *modus operandi* of perversion. If perversion as it concerns objects is most clearly discernible in the crystallized form of fetishism, we are perfectly justified in noting how throughout the system, organized according to the same aims and functioning in the same ways, the possession of objects and the passion for them is, shall we say, *a tempered mode of sexual perversion*. Indeed, just as possession depends on the discontinuity of the series (real or virtual) and on the choice of a privileged term within it, so sexual perversion is founded on the inability to apprehend the other *qua* object of desire in his or her unique totality as a person, to grasp the other in any but a discontinuous way: the other is transformed into the paradigm of various eroticized parts of the body, a single one of which becomes the focus of objectification. A particular woman is no longer a woman but merely a sex, breasts, belly, thighs, voice and face – and preferably just one of them.[30] She thus becomes a constituent 'object' in a series whose different terms are gazetted by desire, and whose real referent is by no means the loved person but, rather, the subject himself, collecting and eroticizing himself and turning the relationship of love into a discourse directed towards him alone.

The opening sequence in Jean-Luc Godard's film *Contempt* clearly illustrates this. The dialogue in this 'nude' scene goes as follows.

'Do you love my feet?' the woman asks. (Note that throughout the scene she is

inventorying herself in a mirror – this is not irrelevant, because in this way she attributes value to herself *as she is seen*, via her image, and thus, already, as spatially discontinuous.)

> 'Yes, I love them.'
> 'Do you love my legs?'
> 'Yes.'
> 'And my thighs?'
> 'Yes,' he replies once more. 'I love them.'
> (And so on, from foot to head, ending up with her hair.)
> 'So, you love me totally?'
> 'Yes, I love you totally.'
> 'Me too, Paul,' she says, summing up the situation.

It may be that the film's makers saw all this as the clarifying algebra of a demystified love. Be that as it may, such a grotesque reconstruction of desire is the height of inhumanity. Once broken down by body parts into a series, the woman as pure object is then reintegrated into the greater series of all woman-objects, where she is merely one term among others. The only activity possible within the logic of this system is the play of substitutions. This was what we recognized earlier as the motor of satisfaction in the collector.

In the love relationship the tendency to break the object down into discrete details in accordance with a perverse autoerotic system is slowed by the living unity of the other person.[31] When it comes to material objects, however, and especially to manufactured objects complex enough to lend themselves to mental dismantling, this tendency has free rein. With the automobile, for instance, it is possible to speak of '*my* brakes', '*my* tail fins', '*my* steering wheel'; or to say '*I* am braking', '*I* am turning' or '*I* am starting'. In short, all the car's 'organs' and functions may be brought separately into relation with the person of the owner in the possessive mode. We are dealing here not with a process of personalization at the social level but with a process of a projective kind. We are concerned not with *having* but with *being*. With the horse, despite the fact that this animal was a remarkable instrument of power and transcendence for man, this kind of confusion was never possible. The fact is that the horse is not made of pieces – and above all, that it is *sexed*. We can say 'my horse' or 'my wife', but that is as far as this kind of possessive denomination can go. That which has a sex resists fragmenting projection and hence also the mode of appropriation that we have identified as a perversion.[32] Faced by a living being, we may say 'my' but we cannot say 'I' as we do when we symbolically appropriate the functions and 'organs' of a car. That type of regression is not available to us. The horse may be the recipient of powerful symbolic cathexes: we associate it with the wild sexuality of the rutting season, as with the wisdom of the centaur; its head is a terrifying phantasy linked to the image of the father, yet its calm embodies the protective strength of Cheiron the teacher. It is never cathected, however, in the simplistic, narcissistic, far more impoverished and infantile manner in which the ego is projected onto structural details of cars (in accordance with an almost delusional analogy with disassociated parts and functions of the human body). The existence of a dynamic symbolism of the horse may be attributed precisely to the fact that isolated identifications with distinct functions or organs of the horse are an impossibility; nor is there any

prospect, therefore, of collapsing this relationship into an autoerotic 'discourse' concerned with disconnected elements.

Fragmentation and regression of that kind presuppose a technique, but one which has become autonomous at the level of the part-object. A woman broken down into a syntagma of erogenous zones is classified exclusively by the functionality of pleasure, to which the response is an objectivizing and ritualizing erotic technique that masks the anxiety associated with the interpersonal relationship while at the same time serving as a genuine (gestural and effective) dose of reality at the very heart of perversion as a phantasy system. The fact is that every mental system needs a credibility factor of this sort – a foothold in the real, a technical rationale or justification. Thus the accelerator referred to in the words 'I am accelerating', or the whole car implied when we say 'my car', serves as the real, technical justification for a whole realm of narcissistic annexation *short* of reality. The same goes for erotic technique, when it is accepted for what it is; for at this level we are no longer in the genital sphere, which opens onto reality, onto pleasure, but, rather, in a regressive, anal sphere of sexual systematizing for which erotic gestures are merely the justification.

Clearly, then, 'technical' is a very long way indeed from implying 'objective'. Technique does have this quality when it is socialized, when it is adopted by technology, and when it informs new structures. In the everyday realm, however, it constitutes a field that is always hospitable to regressive phantasies, because the possibility of a destructuring is ever imminent. Once assembled and mounted, the components of a technical object imply a certain coherence. But such a structure is always vulnerable to the human mind: held together from without by its function, it is purely formal for the psyche. The hierarchy of its elements can be dismantled at any time, and those elements made interchangeable within a paradigmatic system which the subject uses for his self-recitation. The object is discontinuous already – and certainly easy for thought to disassemble. Moreover, the task is all the easier now that the object – especially the technical object – is no longer lent unity by a set of human gestures and by human energy. Another reason why the car, in contrast to the horse, is such a perfect object for the purposes of narcissistic manipulation is that mastery over the horse is muscular and active, and calls for a gestural system designed to maintain balance, whereas mastery over a car is simplified, functional and abstract.

From serial motivation to real motivation

Hitherto our discussion has paid no heed whatsoever to the actual nature of the objects that are collected: we have concentrated on the systematic aspects of collecting and ignored the thematic. It is obvious, however, that collecting masterpieces is not exactly the same thing as collecting cigar bands. First of all, a distinction must be drawn between the concept of collection (Latin *colligere*, to choose and gather together) and the concept of accumulation. At the simplest level, matter of one kind or another is accumulated: old papers are piled up, or quantities of food are stored. This activity falls somewhere between oral introjection and anal retention. At a somewhat higher level lies the serial accumulation of identical objects. As for collecting proper, it has a door open onto culture, being concerned with differentiated objects which often have exchange value, which may also be 'objects' of preservation, trade, social ritual, exhibition – perhaps

even generators of profit. Such objects are accompanied by projects. And though they remain interrelated, their interplay involves the social world outside, and embraces human relationships.

However powerful external motivations may be, collections can never escape from their internal systematization; at best they may represent a compromise between internal and external factors, and even when a collection transforms itself into a discourse addressed to others, it continues to be first and foremost a discourse addressed to oneself. Serial motivation is discernible everywhere. Research shows that buyers of books published in series (such as *10/18* or *Que sais-je?*[33]), once they are caught up in collecting, will even acquire titles of no interest to them: the distinctiveness of the book relative to the series itself thus suffices to create a purely formal interest which replaces any real one. The motive of purchase is nothing but this contingent association. A comparable kind of behaviour is that of people who cannot read comfortably unless they are surrounded by all their books; in such cases the specificity of what is being read tends to evaporate. Even farther down the same path, the book itself may count less than the moment when it is put back in its proper place on the shelf. Conversely, once a collector's enthusiasm for a series wanes it is very difficult to revive, and now he may not even buy volumes of genuine interest to him. This is as much evidence as we need to draw a clear distinction between serial motivation and real motivation. The two are mutually exclusive and can coexist only on the basis of compromise, with a notable tendency, founded on inertia, for serial motivation to carry the day over the dialectical motivation of interest.[34]

Mere collecting, however, may sometimes create real interest. The person who sets out to buy every title in the *Que sais-je?* series may end up confining his collection to a single subject, such as music or sociology. Once a certain quantitative threshold is reached, sheer accumulation may occasionally give way to a measure of discrimination. There is no hard-and-fast rule here. Artistic masterpieces *may* be collected with the same regressive fanaticism as cheese labels; on the other hand, children who collect stamps are continually swapping them with their friends. No iron-clad connection exists, therefore, between a collection's thematic complexity and its real openness to the outside world. At best such complexity may give us a clue, may be grounds for a presumption of openness.

A collection can emancipate itself from unalloyed accumulation not only by virtue of its cultural complexity but also by virtue of what is missing from it, by virtue of its incompleteness. A lack here is always a specific demand, an appeal for such and such an absent object. And this demand, in the shape of research, passion, or messages to other people,[35] suffices to shatter that fatal enchantment of the collector which plunges him into a state of pure fascination. A recent television programme on collecting made the point well: every collector who presented his collection to the viewing audience would mention the very special 'object' that he did not have, and invite everyone to find it for him. So, even though objects may on occasion lead into the realm of social discourse, it must be acknowledged that *it is usually not an object's presence but far more often its absence that clears the way for social intercourse.*

A discourse addressed to oneself

It remains characteristic of the collection that sooner or later a radical change will occur capable of wrenching it out of its regressive system and orientating it towards a project

or task (whether status-related, cultural or commercial is of no consequence, just so long as an object eventually brings one human being face to face with another – at which point the object has become a message). All the same, no matter how open a collection is, it will always harbour an irreducible element of non-relationship to the world. Because he feels alienated and abolished by a social discourse whose rules escape him, the collector strives to reconstitute a discourse that is transparent to him, a discourse whose signifiers he controls and whose referent *par excellence* is himself. In this he is doomed to failure: he cannot see that he is simply transforming an open-ended objective discontinuity into a closed subjective one, where even the language he uses has lost any general validity. This kind of totalization by means of objects always bears the stamp of solitude. It fails to communicate with the outside, and communication is missing within it. In point of fact, moreover, we cannot avoid the question whether objects can indeed ever come to constitute any other language than this: can man ever use objects to set up a language that is more than a discourse addressed to himself?

The collector is never an utterly hopeless fanatic, precisely because he collects objects that in some way always prevent him from regressing into the ultimate abstraction of a delusional state, but at the same time the discourse he thus creates can never – for the very same reason – get beyond a certain poverty and infantilism. Collecting is always a limited, repetitive process, and the very material objects with which it is concerned are too concrete and too discontinuous ever to be articulated as a true dialectical structure.[36] So if non-collectors are indeed 'nothing but morons', collectors, for their part, invariably have something impoverished and inhuman about them.

Notes

1 I am restricting my account to antiques because they are the clearest example of 'non-systematic' objects. Obviously this account might be applied equally well, using the same premises, to other varieties of marginal objects.

2 Just as naturalness is basically a disavowal of nature, so historicalness is a refusal of history masked by an exaltation of the signs of history: history simultaneously invoked and denied.

3 In point of fact the antique may be perfectly integrated into structures of atmosphere, for its presence is apprehended *en bloc* as 'warm', in contrast to the modern environment as a whole, which is 'cold'.

4 And once again my remarks should be taken as equally applicable, by extension, to exotic objects; for modern man, in any case, changing country or latitude is essentially equivalent to plunging into the past (as tourism well demonstrates). The fascination for hand-made or native products, for bazaar items from all over the globe, arises less from their picturesque variety than from the anteriority of their forms or their manufacture, and from the allusion they contain to an earlier world – invariably a throwback to the world of our childhood and its playthings.

5 Two opposed tendencies are involved here. Inasmuch as the antique is integrated into the *current* cultural system, it comes from the depths of time *as signifier in the present of the empty dimension of time*. By contrast, the individual regression that the antique object makes possible is *a movement of the present into the past, into which it projects the empty dimension of being*.

6 'Comment bricoler votre ruine', *La maison française*, May 1963.

7 [*Translator's note*: The author's inverted commas suggest the quaintness of the name 'Ile-

de-France' at the time of writing, for this was then an archaic regional denomination with no modern administrative meaning. This changed in 1976, when the entity known as the Région Parisienne was rebaptized Ile-de-France.]

8 The significance of the relic is that it makes it possible to enshrine the identity of God or that of the soul of a dead person within an object. And there is no relic without a reliquary: the value 'slides' from the one to the other, and the reliquary, often made of gold, becomes the unmistakable signifier of authenticity, and hence more effective as a symbol.

9 Travelling as a tourist always involves going in search of lost time.

10 We should not seek one-to-one correspondences here, however, because the functional field of modern objects is configured in quite a different way from that of antiques. Moreover, the function of antique objects in this context exists only in the sense of a function that is extinct.

11 This splitting of the traditional single home into principal and secondary – or functional and 'naturalized' – residences offers the clearest possible illustration of the systematizing process: the system splits into two in order to strike a balance between terms that are formally antithetical yet fundamentally complementary. This split affects the whole of everyday life, as witness an organization of work and leisure wherein leisure by no means transcends or even provides an outlet from productive activity: instead, a selfsame everyday reality splits into two as a means of overriding the contradictions and imposing itself as a coherent and definitive system. It is true that this process is less marked in the case of isolated objects; the fact remains that every functional object is potentially capable of splitting in this way, of *becoming formally opposed to itself so as to fit more effectively into the overall system.*

12 In the case of the child, too, objects in the environment come in the first place from the Father (and in early infancy from a phallic mother). To appropriate these objects is to appropriate the power of the Father (as Roland Barthes shows, apropos of motorcars, in 'La voiture, projection de l'ego', *Réalités*, no. 213, October 1963). The exercise of this power parallels the process of identification with the Father, and embraces all the conflicts this entails; consequently it is always ambiguous and partly aggressive in character.

13 *The Status Seekers* (New York: David McKay, 1959), p. 68.

14 Ibid.

15 Certainly this tendency increases in a general way as people climb the social ladder, but it really takes off only once a certain status and a minimal level of 'urban acculturation' have been reached.

16 *La vie étrange des objets* (Paris: Plon, 1959), p. 28. [*Translator's note:* There is an English translation by David Pryce-Jones: *Art on the Market* (London: Weidenfeld & Nicolson, 1961). I have not used it here.]

17 Ibid., p. 33.

18 M. Fauron, president of the cigar-band collectors' association, in *Liens* (review of the Club français du Livre), May 1964.

19 Rheims, *La vie étrange des objets*, p. 50.

20 It also creates disillusion, of course, itself bound up with the tautological character of the system.

21 The *series* is practically always a kind of game that makes it possible to select any one term and invest it with the privileged status of a *model*. A child is throwing bottle-tops: which one will go the farthest? It is no coincidence if the same one always comes out ahead: this is his favourite. The model he thus constructs, the hierarchy he sets up, is in fact himself – for he does not identify himself with one bottle-top but, rather, with the fact that one bottle-top always wins. And he is just as present in each of the other tops, unmarked terms in the antagonism between winner and losers: throwing the bottle-tops one by one is playing at constituting oneself as a series in order then to constitute oneself as a model. Here, in a

nutshell, is the psychology of the collector; and a collector who collects only privileged or 'unique' objects is simply making sure that he himself is the object that always wins.

22 Any term in the series may become the final term: any Callot can be the one to 'round out Callot'.

23 Moreover, any object immediately becomes the foundation of a network of habits, the focus of a set of behavioural routines. Conversely, there is probably no habit that does not centre on an object. In everyday existence the two are inextricably bound up with each other.

24 The watch is also indicative (as is the disappearance of clocks) of the irresistible tendency of modern objects towards miniaturization and individualization. It is also the oldest, the smallest, the closest to us, and the most valuable of personal machines – an intimate and highly cathected mechanical talisman which becomes the object of everyday complicity, fascination (especially for children), and jealousy.

25 Exactness about time parallels speed in space: time has to be gobbled up as completely as possible.

26 *La vie étrange des objects*, p. 42.

27 A story told by Tristan Bernard provides an amusing illustration of the fact that collecting is a way of playing with death (that is, a passion), and in consequence stronger, symbolically, than death itself. There was once a man who collected children: legitimate, illegitimate, children of a first or a second marriage, foundlings, by-blows, and so on. One day he gave a house party at which his entire 'collection' were present: a cynical friend of his remarked, however, 'There is one kind of child you do not have.' 'What type?' the host wanted to know. 'A posthumous child,' came the answer. Whereupon this passionate collector first got his wife pregnant and promptly thereafter committed suicide.

The same system is to be found, minus the narrative trappings, in games of chance. This is the reason for their fascination, which is even more intense than that of collecting. Such games imply a pure transcendence of death: subjectivity cathects the pure series with an imaginary mastery, quite certain that whatever the ups and downs of the play, no one has the power to reintroduce into it the *real* conditions of life and death.

28 Of course this also goes for pets, and by extension for the 'object' in the sexual relationship, whose manipulation in jealousy is of a similar kind.

29 We must not confuse disillusionment, an internal motor of the regressive system of the series, with the lack we spoke of above, which on the contrary tends to foster emergence from the system. Disillusionment causes the subject to tighten his retrogressive embrace of the series; lack causes him to evolve (relatively speaking) in the direction of the outside world.

30 The regressive tendency, ever more specialized and impersonal, may converge on the hair or the feet, or, ultimately, crystallize – at the opposite pole to any living being – on a garter or a brassiere; we thus come back to the material object, whose possession may be described as the perfect way of eliminating the presence of the other.

31 This explains why the passionate feelings are transferred to the fetish, whose function is a radical simplification of the living sexual object which makes this object equivalent to the penis and cathects it accordingly.

32 By the same token possessive identification operates in the case of living beings only to the extent that such beings may be perceived as asexual: 'Does our head hurt?', we may say to a baby. When we are confronted by a sexed being, however, this kind of confusional identification is halted by castration anxiety.

33 [*Translator's note:* These are well-known series of pocket books in uniform format. *Que sais-je?* is a series of short monographs on a vast array of topics.]

34 This distinction between serial satisfaction and pleasure proper is an essential one. True pleasure is a sort of pleasure-in-pleasure whereby mere satisfaction is transcended as such, and grounds itself in a relationship. In serial satisfaction, by contrast, this second-level

pleasure, this qualitative dimension of pleasure, disappears, is missing or unfulfilled. Satisfaction must depend on linear succession alone: an unattainable totality is extended by means of projection and compensated for by means of repetition. People stop reading the books they buy, then proceed to buy more and more. Similarly the repetition of the sexual act, or a multiplicity of sexual partners, may serve indefinitely as an ersatz form of love as exploration. Pleasure in pleasure is gone, only satisfaction remains – and the two are mutually exclusive.

35 Even in this case, however, the collector tends to call upon other people solely as observers of his collection, integrating them as third parties only in an already constituted subject – object relationship.

36 As distinct from science or memory, for example – which also involve collecting, but the collecting of facts or knowledge.

D. W. Winnicott

TRANSITIONAL OBJECTS AND
TRANSITIONAL PHENOMENA

I N T H I S C H A P T E R I give the original hypothesis as formulated in 1951, and I then follow this up with two clinical examples.

I Original hypothesis[1]

It is well known that infants as soon as they are born tend to use fist, fingers, thumbs in stimulation of the oral erotogenic zone, in satisfaction of the instincts at that zone, and also in quiet union. It is also well known that after a few months infants of either sex become fond of playing with dolls, and that most mothers allow their infants some special object and expect them to become, as it were, addicted to such objects.

There is a relationship between these two sets of phenomena that are separated by a time interval, and a study of the development from the earlier into the later can be profitable, and can make use of important clinical material that has been somewhat neglected.

The first possession

Those who happen to be in close touch with mothers' interests and problems will be already aware of the very rich patterns ordinarily displayed by babies in their use of the first 'not-me' possession. These patterns, being displayed, can be subjected to direct observation.

There is a wide variation to be found in a sequence of events that starts with the newborn infant's fist-in-mouth activities, and leads eventually on to an attachment to a teddy, a doll or soft toy, or to a hard toy.

It is clear that something is important here other than oral excitement and satisfaction, although this may be the basis of everything else. Many other important things can be studied, and they include:

1 The nature of the object.
2 The infant's capacity to recognize the object as 'not-me'.
3 The place of the object – outside, inside, at the border.
4 The infant's capacity to create, think up, devise, originate, produce an object.
5 The initiation of an affectionate type of object-relationship.

I have introduced the terms 'transitional objects' and 'transitional phenomena' for designation of the intermediate area of experience, between the thumb and the teddy bear, between the oral erotism and the true object-relationship, between primary creative activity and projection of what has already been introjected, between primary unawareness of indebtedness and the acknowledgement of indebtedness ('Say: "ta"').

By this definition an infant's babbling and the way in which an older child goes over a repertory of songs and tunes while preparing for sleep come within the intermediate area as transitional phenomena, along with the use made of objects that are not part of the infant's body yet are not fully recognized as belonging to external reality.

Inadequacy of usual statement of human nature

It is generally acknowledged that a statement of human nature in terms of interpersonal relationships is not good enough even when the imaginative elaboration of function and the whole of fantasy both conscious and unconscious, including the repressed unconscious, are allowed for. There is another way of describing persons that comes out of the researches of the past two decades. Of every individual who has reached to the stage of being a unit with a limiting membrane and an outside and an inside, it can be said that there is an *inner reality* to that individual, an inner world that can be rich or poor and can be at peace or in a state of war. This helps, but is it enough?

My claim is that if there is a need for this double statement, there is also need for a triple one: the third part of the life of a human being, a part that we cannot ignore, is an intermediate area of *experiencing*, to which inner reality and external life both contribute. It is an area that is not challenged, because no claim is made on its behalf except that it shall exist as a resting-place for the individual engaged in the perpetual human task of keeping inner and outer reality separate yet interrelated.

It is usual to refer to 'reality-testing', and to make a clear distinction between apperception and perception. I am here staking a claim for an intermediate state between a baby's inability and his growing ability to recognize and accept reality. I am therefore studying the substance of *illusion*, that which is allowed to the infant, and which in adult life is inherent in art and religion, and yet becomes the hallmark of madness when an adult puts too powerful a claim on the credulity of others, forcing them to acknowledge a sharing of illusion that is not their own. We can share a respect for *illusory experience*, and if we wish we may collect together and form a group on the basis of the similarity of our illusory experiences. This is a natural root of grouping among human beings.

I hope it will be understood that I am not referring exactly to the little child's teddy

bear or to the infant's first use of the fist (thumb, fingers). I am not specifically study-
ing the first object of object-relationships. I am concerned with the first possession,
and with the intermediate area between the subjective and that which is objectively
perceived.

Development of a personal pattern

There is plenty of reference in psychoanalytic literature to the progress from 'hand to
mouth' to 'hand to genital', but perhaps less to further progress to the handling of truly
'not-me' objects. Sooner or later in an infant's development there comes a tendency on
the part of the infant to weave other-than-me objects into the personal pattern. To some
extent these objects stand for the breast, but it is not especially this point that is under
discussion.

In the case of some infants the thumb is placed in the mouth while fingers are made
to caress the face by pronation and supination movements of the forearm. The mouth is
then active in relation to the thumb, but not in relation to the fingers. The fingers caress-
ing the upper lip, or some other part, may be or may become more important than the
thumb engaging the mouth. Moreover, this caressing activity may be found alone, with-
out the more direct thumb-mouth union.

In common experience one of the following occurs, complicating an auto-erotic
experience such as thumb-sucking:

(i) with the other hand the baby takes an external object, say a part of a sheet or blan-
 ket, into the mouth along with the fingers; or
(ii) somehow or other the bit of cloth is held and sucked, or not actually sucked; the
 objects used naturally include napkins and (later) handkerchiefs, and this depends
 on what is readily and reliably available; or
(iii) the baby starts from early months to pluck wool and to collect it and to use it for
 the caressing part of the activity; less commonly, the wool is swallowed, even
 causing trouble; or
(iv) mouthing occurs, accompanied by sounds of 'mum-mum', babbling, anal noises,
 the first musical notes, and so on.

One may suppose that thinking, or fantasying, gets linked up with these functional
experiences.

All these things I am calling *transitional phenomena*. Also, out of all this (if we study
any one infant) there may emerge some thing or some phenomenon – perhaps a bundle
of wool or the corner of a blanket or eiderdown, or a word or tune, or a mannerism –
that becomes vitally important to the infant for use at the time of going to sleep, and is a
defence against anxiety, especially anxiety of depressive type. Perhaps some soft object
or other type of object has been found and used by the infant, and this then becomes
what I am calling a *transitional object*. This object goes on being important. The parents
get to know its value and carry it round when travelling. The mother lets it get dirty
and even smelly, knowing that by washing it she introduces a break in continuity in the
infant's experience, a break that may destroy the meaning and value of the object to the
infant.

I suggest that the pattern of transitional phenomena begins to show at about four to six to eight to twelve months. Purposely I leave room for wide variations.

Patterns set in infancy may persist into childhood, so that the original soft object continues to be absolutely necessary at bed-time or at time of loneliness or when a depressed mood threatens. In health, however, there is a gradual extension of range of interest, and eventually the extended range is maintained, even when depressive anxiety is near. A need for a specific object or a behaviour pattern that started at a very early date may reappear at a later age when deprivation threatens.

This first possession is used in conjuction with special techniques derived from very early infancy, which can include or exist apart from the more direct auto-erotic activities. Gradually in the life of an infant teddies and dolls and hard toys are acquired. Boys to some extent tend to go over to use hard objects, whereas girls tend to proceed right ahead to the acquisition of a family. It is important to note, however, that *there is no noticeable difference between boy and girl in their use of the original 'not-me' possession*, which I am calling the transitional object.

As the infant starts to use organized sounds ('mum', 'ta', 'da') there may appear a 'word' for the transitional object. The name given by the infant to these earliest objects is often significant, and it usually has a word used by the adults partly incorporated in it. For instance, 'baa' may be the name, and the 'b' may have come from the adult's use of the word 'baby' or 'bear'.

I should mention that sometimes there is no transitional object except the mother herself. Or an infant may be so disturbed in emotional development that the transition state cannot be enjoyed, or the sequence of objects used is broken. The sequence may nevertheless be maintained in a hidden way.

Summary of special qualities in the relationship

1 The infant assumes rights over the object, and we agree to this assumption. Nevertheless, some abrogation of omnipotence is a feature from the start.
2 The object is affectionately cuddled as well as excitedly loved and mutilated.
3 It must never change, unless changed by the infant.
4 It must survive instinctual loving, and also hating and, if it be a feature, pure aggression.
5 Yet it must seem to the infant to give warmth, or to move, or to have texture, or to do something that seems to show it has vitality or reality of its own.
6 It comes from without from our point of view, but not so from the point of view of the baby. Neither does it come from within; it is not a hallucination.
7 Its fate is to be gradually allowed to be decathected, so that in the course of years it becomes not so much forgotten as relegated to limbo. By this I mean that in health the transitional object does not 'go inside' nor does the feeling about it necessarily undergo repression. It is not forgotten and it is not mourned. It loses meaning, and this is because the transitional phenomena have become diffused, have become spread out over the whole intermediate territory between 'inner psychic reality' and 'the external world as perceived by two persons in common', that is to say, over the whole cultural field.

At this point my subject widens out into that of play, and of artistic creativity and appreciation, and of religious feeling, and of dreaming, and also of fetishism, lying and stealing, the origin and loss of affectionate feeling, drug addiction, the talisman of obsessional rituals, etc.

Relationship of the transitional object to symbolism

It is true that the piece of blanket (or whatever it is) is symbolical of some part-object, such as the breast. Nevertheless, the point of it is not its symbolic value so much as its actuality. Its not being the breast (or the mother), although real, is as important as the fact that it stands for the breast (or mother).

When symbolism is employed the infant is already clearly distinguishing between fantasy and fact, between inner objects and external objects, between primary creativity and perception. But the term transitional object, according to my suggestion, gives room for the process of becoming able to accept difference and similarity. I think there is use for a term for the root of symbolism in time, a term that describes the infant's journey from the purely subjective to objectivity; and it seems to me that the transitional object (piece of blanket, etc.) is what we see of this journey of progress towards experiencing.

It would be possible to understand the transitional object while not fully understanding the nature of symbolism. It seems that symbolism can be properly studied only in the process of the growth of an individual and that it has at the very best a variable meaning. For instance, if we consider the wafer of the Blessed Sacrament, which is symbolic of the body of Christ, I think I am right in saying that for the Roman Catholic community it *is* the body, and for the Protestant community it is a *substitute*, a reminder, and is essentially not, in fact, actually the body itself. Yet in both cases it is a symbol.

Clinical description of a transitional object

For anyone in touch with parents and children, there is an infinite quantity and variety of illustrative clinical material. The following illustrations are given merely to remind readers of similar material in their own experiences.

Two brothers: contrast in early use of possessions

Distortion in use of transitional object. X, now a healthy man, has had to fight his way towards maturity. The mother 'learned how to be a mother' in her management of X when he was an infant and she was able to avoid certain mistakes with the other children because of what she learned with him. There were also external reasons why she was anxious at the time of her rather lonely management of X when he was born. She took her job as a mother very seriously and she breast-fed X for seven months. She feels that in his case this was too long and he was very difficult to wean. He never sucked his thumb or his fingers and when she weaned him 'he had nothing to fall back on'. He had never had the bottle or a dummy or any other form of feeding. He had a very strong and early *attachment to her herself*, as a person, and it was her actual person that he needed.

From twelve months he adopted a rabbit which he would cuddle, and his affectionate regard for the rabbit eventually transferred to real rabbits. This particular rabbit lasted till he was five or six years old. It could be described as a *comforter*, but it never had the true quality of a transitional object. It was never, as a true transitional object would have been, more important than the mother, an almost inseparable part of the infant. In the case of this particular boy the kinds of anxiety that were brought to a head by the weaning at seven months later produced asthma, and only gradually did he conquer this. It was important for him that he found employment far away from the home town. His attachment to his mother is still very powerful, although he comes within the wide definition of the term normal, or healthy. This man has not married.

Typical use of transitional object. X's younger brother, Y, has developed in quite a straightforward way throughout. He now has three healthy children of his own. He was fed at the breast for four months and then weaned without difficulty. Y sucked his thumb in the early weeks and this again 'made weaning easier for him than for his older brother'. Soon after weaning at five to six months he adopted the end of the blanket where the stitching finished. He was pleased if a little bit of the wool stuck out at the corner and with this he would tickle his nose. This very early became his 'Baa'; he invented this word for it himself as soon as he could use organized sounds. From the time when he was about a year old he was able to substitute for the end of the blanket a soft green jersey with a red tie. This was not a 'comforter' as in the case of the depressive older brother, but a 'soother'. It was a sedative which always worked. This is a typical example of what I am calling a *transitional object*. When Y was a little boy it was always certain that if anyone gave him his 'Baa' he would immediately suck it and lose anxiety, and in fact he would go to sleep within a few minutes if the time for sleep were at all near. The thumb-sucking continued at the same time, lasting until he was three or four years old, and he remembers thumb-sucking and a hard place on one thumb which resulted from it. He is now interested (as a father) in the thumb-sucking of his children and their use of 'Baas'.

The story of seven ordinary children in this family brings out the following points, arranged for comparison in the table below:

		Thumb	Transitional object		Type of child
X	Boy	0	Mother	Rabbit (comforter)	Mother-fixated
Y	Boy	+	'Baa'	Jersey (soother)	Free
Twins	Girl	0	Dummy	Donkey (friend)	Late maturity
	Boy	0	'Ee'	Ee (protective)	Latent psychopathic
Children of Y	Girl	0	'Baa'	Blanket (reassurance)	Developing well
	Girl	+	Thumb	Thumb (satisfaction)	Developing well
	Boy	+	'Mimis'	Objects (sorting)[1]	Developing well

1 Added note: This was not clear, but I have left it as it was. D.W.W., 1971.

Value in history-taking

In consultation with a parent it is often valuable to get information about the early tech-niques and possessions of all the children of the family. This starts the mother off on a comparison of her children one with another, and enables her to remember and com-pare their characteristics at an early age.

The child's contribution

Information can often be obtained from a child in regard to transitional objects. For instance:

Angus (eleven years nine months) told me that his brother 'has tons of teddies and things' and 'before that he had little bears', and he followed this up with a talk about his own history. He said he never had teddies. There was a bell rope that hung down, a tag end of which he would go on hitting, and so go off to sleep. Probably in the end it fell, and that was the end of it. There was, however, something else. He was very shy about this. It was a purple rabbit with red eyes. 'I wasn't fond of it. I used to throw it around. Jeremy has it now, I gave it to him. I gave it to Jeremy because it was naughty. It *would* fall off the chest of drawers. *It still visits me. I like it to visit me.*' He surprised himself when he drew the purple rabbit.

It will be noted that this eleven-year-old boy with the ordinary good reality-sense of his age spoke as if lacking in reality-sense when describing the transitional object's qualities and activities. When I saw the mother later she expressed surprise that Angus remembered the purple rabbit. She easily recognized it from the coloured drawing.

Ready availability of examples

I deliberately refrain from giving more case-material here, particularly as I wish to avoid giving the impression that what I am reporting is rare. In practically every case-history there is something to be found that is interesting in the transitional phenomena, or in their absence.

Theoretical study

There are certain comments that can be made on the basis of accepted psychoanalytic theory:

1 The transitional object stands for the breast, or the object of the first relationship.
2 The transitional object antedates established reality-testing.
3 In relation to the transitional object the infant passes from (magical) omnipotent control to control by manipulation (involving muscle erotism and coordination pleasure).
4 The transitional object may eventually develop into a fetish object and so persist

as a characteristic of the adult sexual life. (See Wulff's (1946) development of the theme.)

5 The transitional object may, because of anal erotic organization, stand for faeces (but it is not for this reason that it may become smelly and remain unwashed).

Relationship to internal object (Klein)

It is interesting to compare the transitional object concept with Melanie Klein's (1934) concept of the internal object. The transitional object is *not an internal object* (which is a mental concept) – it is a possession. Yet it is not (for the infant) an external object either.

The following complex statement has to be made. The infant can employ a transitional object when the internal object is alive and real and good enough (not too persecutory). But this internal object depends for its qualities on the existence and aliveness and behaviour of the external object. Failure of the latter in some essential function indirectly leads to deadness or to a persecutory quality of the internal object.[2] After a persistence of inadequacy of the external object the internal object fails to have meaning to the infant, and then, and then only, does the transitional object become meaningless too. The transitional object may therefore stand for the 'external' breast, but *indirectly*, through standing for an 'internal' breast.

The transitional object is never under magical control like the internal object, nor is it outside control as the real mother is.

Illusion-disillusionment

In order to prepare the ground for my own positive contribution to this subject I must put into words some of the things that I think are taken too easily for granted in many psychoanalytic writings on infantile emotional development, although they may be understood in practice.

There is no possibility whatever for an infant to proceed from the pleasure principle to the reality principle or towards and beyond primary identification (see Freud, 1923), unless there is a good-enough mother. The good-enough 'mother' (not necessarily the infant's own mother) is one who makes active adaptation to the infant's needs, an active adaptation that gradually lessens, according to the infant's growing ability to account for failure of adaptation and to tolerate the results of frustration. Naturally, the infant's own mother is more likely to be good enough than some other person, since this active adaptation demands an easy and unresented preoccupation with the one infant; in fact, success in infant care depends on the fact of devotion, not on cleverness or intellectual enlightenment.

The good-enough mother, as I have stated, starts off with an almost complete adaptation to her infant's needs, and as time proceeds she adapts less and less completely, gradually, according to the infant's growing ability to deal with her failure.

The infant's means of dealing with this maternal failure include the following:

1 The infant's experience, often repeated, that there is a time-limit to frustration. At first, naturally, this time-limit must be short.
2 Growing sense of process.
3 The beginnings of mental activity.
4 Employment of auto-erotic satisfactions.
5 Remembering, reliving, fantasying, dreaming; the integrating of past, present, and future.

If all goes well the infant can actually come to gain from the experience of frustration, since incomplete adaptation to need makes objects real, that is to say hated as well as loved. The consequence of this is that *if all goes well* the infant can be disturbed by a close adaptation to need that is continued too long, not allowed its natural decrease, since exact adaptation resembles magic and the object that behaves perfectly becomes no better than a hallucination. Nevertheless, *at the start* adaptation needs to be almost exact, and unless this is so it is not possible for the infant to begin to develop a capacity to experience a relationship to external reality, or even to form a conception of external reality.

Illusion and the value of illusion

The mother, at the beginning, by an almost 100 per cent adaptation affords the infant the opportunity for the *illusion* that her breast is part of the infant. It is, as it were, under the baby's magical control. The same can be said in terms of infant care in general, in the quiet times between excitements. Omnipotence is nearly a fact of experience. The mother's eventual task is gradually to disillusion the infant, but she has no hope of success unless at first she has been able to give sufficient opportunity for illusion.

In another language, the breast is created by the infant over and over again out of the infant's capacity to love or (one can say) out of need. A subjective phenomenon develops in the baby, which we call the mother's breast.[3] The mother places the actual breast just there where the infant is ready to create, and at the right moment.

From birth, therefore, the human being is concerned with the problem of the relationship between what is objectively perceived and what is subjectively conceived of, and in the solution of this problem there is no health for the human being who has not been started off well enough by the mother. *The intermediate area to which I am referring is the area that is allowed to the infant between primary creativity and objective perception based on reality-testing.* The transitional phenomena represent the early stages of the use of illusion, without which there is no meaning for the human being in the idea of a relationship with an object that is perceived by others as external to that being.

The idea illustrated in Figure 1 is this: that at some theoretical point early in the development of every human individual an infant in a certain setting provided by the mother is capable of conceiving of the idea of something that would meet the growing need that arises out of instinctual tension. The infant cannot be said to know at first what is to be created. At this point in time the mother presents herself. In the ordinary way she gives her breast and her potential feeding urge. The mother's adaptation to the infant's needs, when good enough, gives the infant the *illusion* that there is an external reality that corresponds to the infant's own capacity to create. In other words, there is

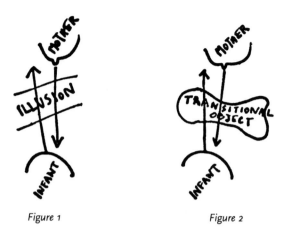

Figure 1 Figure 2

an overlap between what the mother supplies and what the child might conceive of. To the observer, the child perceives what the mother actually presents, but this is not the whole truth. The infant perceives the breast only in so far as a breast could be created just there and then. There is no interchange between the mother and the infant. Psychologically the infant takes from a breast that is part of the infant, and the mother gives milk to an infant that is part of herself. In psychology, the idea of interchange is based on an illusion in the psychologist.

In Figure 2 a shape is given to the area of illusion, to illustrate what I consider to be the main function of the transitional object and of transitional phenomena. The transitional object and the transitional phenomena start each human being off with what will always be important for them, i.e. a neutral area of experience which will not be challenged. *Of the transitional object it can be said that it is a matter of agreement between us and the baby that we will never ask the question: 'Did you conceive of this or was it presented to you from without?' The important point is that no decision on this point is expected. The question is not to be formulated.*

This problem, which undoubtedly concerns the human infant in an hidden way at the beginning, gradually becomes an obvious problem on account of the fact that the mother's main task (next to providing opportunity for illusion) is disillusionment. This is preliminary to the task of weaning, and it also continues as one of the tasks of parents and educators. In other words, this matter of *illusion* is one that belongs inherently to human beings and that no individual finally solves for himself or herself, although a *theoretical* understanding of it may provide a *theoretical* solution. If things go well, in this gradual disillusionment process, the stage is set for the frustrations that we gather together under the word weaning; but it should be remembered that when we talk about the phenomena (which Klein (1940) has specifically illuminated in her concept of the depressive position) that cluster round weaning we are assuming the underlying process, the process by which opportunity for illusion and gradual disillusionment is provided. If illusion-disillusionment has gone astray the infant cannot get to so normal a thing as weaning, nor to a reaction to weaning, and it is then absurd to refer to weaning at all. The mere termination of breast-feeding is not a weaning.

We can see the tremendous significance of weaning in the case of the normal child. When we witness the complex reaction that is set going in a certain child by

the weaning process, we know that this is able to take place in that child because the illusion-disillusionment process is being carried through so well that we can ignore it while discussing actual weaning.

Development of the theory of illusion-disillusionment

It is assumed here that the task of reality-acceptance is never completed, that no human being is free from the strain of relating inner and outer reality, and that relief from this strain is provided by an intermediate area of experience (cf. Riviere, 1936) which is not challenged (arts, religion, etc.). This intermediate area is in direct continuity with the play area of the small child who is 'lost' in play.

In infancy this intermediate area is necessary for the initiation of a relationship between the child and the world, and is made possible by good-enough mothering at the early critical phase. Essential to all this is continuity (in time) of the external emotional environment and of particular elements in the physical environment such as the transitional object or objects.

The transitional phenomena are allowable to the infant because of the parents' intuitive recognition of the strain inherent in objective perception, and we do not challenge the infant in regard to subjectivity or objectivity just here where there is the transitional object.

Should an adult make claims on us for our acceptance of the objectivity of his subjective phenomena we discern or diagnose madness. If, however, the adult can manage to enjoy the personal intermediate area without making claims, then we can acknowledge our own corresponding intermediate areas, and are pleased to find a degree of overlapping, that is to say common experience between members of a group in art or religion or philosophy.

Summary

Attention is drawn to the rich field for observation provided by the earliest experiences of the healthy infant as expressed principally in the relationship to the first possession.

This first possession is related backwards in time to auto-erotic phenomena and fist- and thumb-sucking, and also forwards to the first soft animal or doll and to hard toys. It is related both to the external object (mother's breast) and to internal objects (magically introjected breast), but is distinct from each.

Transitional objects and transitional phenomena belong to the realm of illusion which is at the basis of initiation of experience. This early stage in development is made possible by the mother's special capacity for making adaptation to the needs of her infant, thus allowing the infant the illusion that what the infant creates really exists.

This intermediate area of experience, unchallenged in respect of its belonging to inner or external (shared) reality, constitutes the greater part of the infant's experience, and throughout life is retained in the intense experiencing that belongs to the arts and to religion and to imaginative living, and to creative scientific work.

An infant's transitional object ordinarily becomes gradually decathected, especially as cultural interests develop.

What emerges from these considerations is the further idea that paradox accepted can have positive value. The resolution of paradox leads to a defence organization which in the adult one can encounter as true and false self organization (Winnicott, 1960a).

II An application of the theory

It is not the object, of course, that is transitional. The object represents the infant's transition from a state of being merged with the mother to a state of being in relation to the mother as something outside and separate. This is often referred to as the point at which the child grows up out of a narcissistic type of object-relating, but I have refrained from using this language because I am not sure that it is what I mean; also, it leaves out the idea of dependence, which is so essential at the earliest stages before the child has become sure that anything can exist that is not part of the child.

Psychopathology manifested in the area of transitional phenomena

I have laid great stress on the normality of transitional phenomena. Nevertheless, there is a psychopathology to be discerned in the course of the clinical examination of cases. As an example of the child's management of separation and loss I draw attention to the way in which separation can affect transitional phenomena.

As is well known, when the mother or some other person on whom the infant depends is absent, there is no immediate change owing to the fact that the infant has a memory or mental image of the mother, or what we call an internal representation of her, which remains alive for a certain length of time. If the mother is away over a period of time which is beyond a certain limit measured in minutes, hours, or days, then the memory or the internal representation fades. As this takes effect, the transitional phenomena become gradually meaningless and the infant is unable to experience them. We may watch the object becoming decathected. Just before loss we can sometimes see the exaggeration of the use of a transitional object as part of *denial* that there is a threat of its becoming meaningless. To illustrate this aspect of denial I shall give a short clinical example of a boy's use of string.

String[4]

A boy aged seven years was brought to the Psychology Department of the Paddington Green Children's Hospital by his mother and father in March 1955. The other two members of the family also came: a girl aged ten, attending an ESN school, and a rather normal small girl aged four. The case was referred by the family doctor because of a series of symptoms indicating a character disorder in the boy. An intelligence test gave the boy an IQ of 108. (For the purposes of this description all details that are not immediately relevant to the main theme of this chapter are omitted.)

I first saw the parents in a long interview in which they gave a clear picture of the boy's development and of the distortions in his development. They left out one important detail, however, which emerged in an interview with the boy.

It was not difficult to see that the mother was a depressive person, and she reported that she had been hospitalized on account of depression. From the parents' account I was able to note that the mother cared for the boy until the sister was born when he was three years three months. This was the first separation of importance, the next being at three years eleven months, when the mother had an operation. When the boy was four years nine months the mother went into a mental hospital for two months, and during this time he was well cared for by the mother's sister. By this time everyone looking after this boy agreed that he was difficult, although showing very good features. He was liable to change suddenly and to frighten people by saying, for instance, that he would cut his mother's sister into little pieces. He developed many curious symptoms, such as a compulsion to lick things and people; he made compulsive throat noises; often he refused to pass a motion and then made a mess. He was obviously anxious about his elder sister's mental defect, but the distortion of his development appears to have started before this factor became significant.

After this interview with the parents I saw the boy in a personal interview. There were present two psychiatric social workers and two visitors. The boy did not immediately give an abnormal impression and he quickly entered into a squiggle game with me. (In this squiggle game I make some kind of an impulsive line-drawing and invite the child whom I am interviewing to turn it into something, and then he makes a squiggle for me to turn into something in my turn.)

The squiggle game in this particular case led to a curious result. The boy's laziness immediately became evident, and also nearly everything I did was translated by him into something associated with string. Among his ten drawings there appeared the following:

lasso
whip
crop
a yo-yo string
a string in a knot
another crop
another whip.

After this interview with the boy I had a second one with the parents, and asked them about the boy's preoccupation with string. They said that they were glad that I had brought up this subject, but they had not mentioned it because they were not sure of its significance. They said that the boy had become obsessed with everything to do with string, and in fact whenever they went into a room they were liable to find that he had joined together chairs and tables; and they might find a cushion, for instance, with a string joining it to the fireplace. They said that the boy's preoccupation with string was gradually developing a new feature, one that had worried them instead of causing them ordinary concern. He had recently tied a string round his sister's neck (the sister whose birth provided the first separation of this boy from his mother).

In this particular kind of interview I knew I had limited opportunity for action: it would not be possible to see these parents or the boy more frequently than once in six months, since the family lived in the country. I therefore took action in the following way. I explained to the mother that this boy was dealing with a fear of separation,

attempting to deny separation by his use of string, as one would deny separation from a friend by using the telephone. She was sceptical, but I told her that should she come round to finding some sense in what I was saying I should like her to open up the matter with the boy at some convenient time, letting him know what I had said, and then developing the theme of separation according to the boy's response.

I heard no more from these people until they came to see me about six months later. The mother did not report to me what she had done, but I asked her and she was able to tell me what had taken place soon after the visit to me. She had felt that what I had said was silly, but one evening she had opened the subject with the boy and found him to be eager to talk about his relation to her and his fear of a lack of contact with her. She went over all the separations she could think of with him with his help, and she soon became convinced that what I had said was right, because of his responses. Moreover, from the moment that she had this conversation with him the string play ceased. There was no more joining of objects in the old way. She had had many other conversations with the boy about his feeling of separateness from her, and she made the very significant comment that she felt the most important separation to have been his loss of her when she was seriously depressed; it was not just her going away, she said, but her lack of contact with him because of her complete preoccupation with other matters.

At a later interview the mother told me that a year after she had had her first talk with the boy there was a return to playing with string and to joining together objects in the house. She was in fact due to go into hospital for an operation, and she said to him: 'I can see from your playing with string that you are worried about my going away, but this time I shall only be away a few days, and I am having an operation which is not serious.' After this conversation the new phase of playing with string ceased.

I have kept in touch with this family and have helped with various details in the boy's schooling and other matters. Recently, four years after the original interview, the father reported a new phase of string preoccupation, associated with a fresh depression in the mother. This phase lasted two months; it cleared up when the whole family went on holiday, and when at the same time there was an improvement in the home situation (the father having found work after a period of unemployment). Associated with this was an improvement in the mother's state. The father gave one further interesting detail relevant to the subject under discussion. During this recent phase the boy had acted out something with rope which the father felt to be significant, because it showed how intimately all these things were connected with the mother's morbid anxiety. He came home one day and found the boy hanging upside down on a rope. He was quite limp and acting very well as if dead. The father realized that he must take no notice, and he hung around the garden doing odd jobs for half an hour, after which the boy got bored and stopped the game. This was a big test of the father's lack of anxiety. On the following day, however, the boy did the same thing from a tree which could easily be seen from the kitchen window. The mother rushed out severely shocked and certain that he had hanged himself.

The following additional detail might be of value in the understanding of the case. Although this boy, who is now eleven, is developing along 'tough-guy' lines, he is very self-conscious and easily goes red in the neck. He has a number of teddy bears which to him are children. No one dares to say that they are toys. He is loyal to them, expends a great deal of affection over them, and makes trousers for them, which involves careful sewing. His father says that he seems to get a sense of security from his family, which

he mothers in this way. If visitors come he quickly puts them all into his sister's bed, because no one outside the family must know that he has this family. Along with this is a reluctance to defaecate, or a tendency to save up his faeces. It is not difficult to guess, therefore, that he has a maternal identification based on his own insecurity in relation to his mother, and that this could develop into homosexuality. In the same way the preoccupation with string could develop into a perversion.

Comment

The following comment seems to be appropriate.
1. String can be looked upon as an extension of all other techniques of communication. String joins, just as it also helps in the wrapping up of objects and in the holding of unintegrated material. In this respect string has a symbolic meaning for everyone; an exaggeration of the use of string can easily belong to the beginnings of a sense of insecurity or the idea of a lack of communication. In this particular case it is possible to detect abnormality creeping into the boy's use of string, and it is important to find a way of stating the change which might lead to its use becoming perverted.

It would seem possible to arrive at such a statement if one takes into consideration the fact that the function of the string is changing from communication into a *denial of separation*. As a denial of separation string becomes a thing in itself, something that has dangerous properties and must needs be mastered. In this case the mother seems to have been able to deal with the boy's use of string just before it was too late, when the use of it still contained hope. When hope is absent and string represents a denial of separation, then a much more complex state of affairs has arisen – one that becomes difficult to cure, because of the secondary gains that arise out of the skill that develops whenever an object has to be handled in order to be mastered.

This case therefore is of special interest if it makes possible the observation of the development of a perversion.
2. It is also possible to see from this material the use that can be made of parents. When parents can be used they can work with great economy, especially if the fact is kept in mind that there will never be enough psychotherapists to treat all those who are in need of treatment. Here was a good family that had been through a difficult time because of the father's unemployment; that had been able to take full responsibility for a backward girl in spite of the tremendous drawbacks, socially and within the family, that this entails; and that had survived the bad phases in the mother's depressive illness, including one phase of hospitalization. There must be a great deal of strength in such a family, and it was on the basis of this assumption that the decision was made to invite these parents to undertake the therapy of their own child. In doing this they learned a great deal themselves, but they did need to be informed about what they were doing. They also needed their success to be appreciated and the whole process to be verbalized. The fact that they have seen their boy through an illness has given the parents confidence with regard to their ability to manage other difficulties that arise from time to time.

Notes

1 Published in the *International Journal of Psycho-Analysis*, vol. 34, part 2 (1953); and in D. W. Winnicott, *Collected Papers: Through Paediatrics to Psycho-Analysis* (1958), London: Tavistock Publications.
2 Text modified here, though based on the original statement.
3 I include the whole technique of mothering. When it is said that the first object is the breast, the word 'breast' is used, I believe, to stand for the technique of mothering as well as for the actual flesh. It is not impossible for a mother to be a good-enough mother (in my way of putting it) with a bottle for the actual feeding.
4 Published in *Child Psychology and Psychiatry*, vol. 1 (1960); and in Winnicott, *The Maturational Processes and the Facilitating Environment* (1965), London: Hogarth Press and the Institute of Psycho-Analysis.

References

Freud, Sigmund (1923) *The Ego and the Id*, standard edition, vol. 19.

Klein, Melanie (1934) 'A Contribution to the Psychogenesis of Manic-Depressive States', in *Contributions to Psychoanalysis 1921–1945*, London: Hogarth Press and the Institute of Psychoanalysis, 1948.

Klein, Melanie (1940) 'Mourning and Its Relation to Manic-Depressive States', in *Contributions to Psycho-Analysis 1921–1945*, London: Hogarth Press and the Institute of Psycho-Analysis.

Riviere, Joan (1936) 'On the Genesis of Psychical Conflict in Earliest Infancy', *International Journal of Psycho-Analysis*, 17.

Winnicott, D. W. (1960) 'Ego Distortion in Terms of True and False Self', in *The Maturational Processes and the Facilitating Environment*, London: Hogarth Press and the Institute of Psycho-Analysis, 1965.

Tim Ingold

ON WEAVING A BASKET

ARTEFACTS ARE MADE, organisms grow: at first glance the distinction seems obvious enough. But behind the distinction lie a series of highly problematic assumptions concerning mind and nature, interiority and exteriority, and the genesis of form. We have only to consider the artefactual status of such an everyday object as a basket to realise that the difference between making and growing is by no means as obvious as we might have thought. I shall begin by showing that the reasons why the basket confounds our expectations of the nature of the artefact stem from the fact that it is woven. If the basket is an artefact, and if artefacts are made, then weaving must be a modality of making. I want to suggest, to the contrary, that we should understand making as a modality of weaving. This switch of emphasis, I believe, could open up a new perspective not just on basketry in particular, but on all kinds of skilled, form-generating practices. But it would also have the effect of softening the distinction between artefacts and living things which, as it turns out, are not so very different after all.

Making and growing

What is implied about artefacts by their characterisation as things that are made rather than things that grow? First of all, a division is assumed between form and substance, that is between the design specifications of the object and the raw materials of which it is composed. In the case of living things, it is supposed that the information specifying the design of an organism is carried in the materials of heredity, the genes, and thus that every new life-cycle is inaugurated with the injection of this specification into a physical medium. But with artefacts, this relation between form and substance is inverted. Form is said to be applied from without, rather than unveiled from within. The very distinction between a within and a without of things, however, implies the existence

of a *surface*, where solid substance meets the space of action of those forces that impinge upon it. Thus the world of substance – of brute matter – must present itself to the maker of artefacts as a surface to be transformed.

In commonsense, practical terms, this is not hard to imagine. Many of our most familiar artefacts are (or were, before the days of synthetic materials) made of more or less solid stuff such as stone, metal, wood or clay. The very usefulness of these objects depends on their being relatively resistant to deformation. We ourselves, however, inhabit a gaseous medium – air – which, offering no such resistance, not only allows complete freedom of movement, but also transmits both light and sound. Quite apart from the obvious fact that we need air to breathe, and thus simply to stay alive, the possibilities of movement and perception (visual and aural) that air affords are crucial for any artefact-producing activity. There is, then, a pretty clear distinction between the gaseous medium that surrounds us and the solid objects that clutter our environment; moreover the patterns of reflected light off the surfaces of these objects enable us to see them for what they are (Gibson 1979: 16–22).

These practical considerations, however, all too easily become confused in our thinking with speculations of a more metaphysical kind. To show why this is so, consider the case of the beehive. Is this an artefact or not? Surely, hives don't grow. Insofar as it results from the application of exterior force to raw material, the hive would appear to be as much 'bee-made' as the human house is 'man-made'. Or is it? Musing on this question, Karl Marx famously came to the conclusion that 'what from the very first distinguishes the most incompetent architect from the best of bees, is that the architect has built a cell in his head before he constructs it in wax'. In other words, the criterion by which the house is truly artificial – and by comparison the beehive only figuratively so – is that it issues from a representation or 'mental model' which has been fashioned in the imagination of the practitioner prior to its execution in the material. We may assume that bees, by contrast, lack the powers of imagination, and have no more conception of their hives than they do of their own bodies, both of which are formed under genetic control (Ingold 1983, cf. Marx 1930: 169–70).

Here, the exteriority of the forces that shape artefacts is understood in quite another sense, in terms not of the physical separation of gaseous medium and solid substance but of the *meta*physical separation of mind and nature. Unlike the forms of animals and plants, established through the evolutionary mechanism of natural selection and installed genetically at the heart of the organisms themselves (in the nucleus of every cell), the forms of artefacts are supposed to have their source within the human mind, as preconceived, intellectual solutions to particular design problems. And whereas organic growth is envisaged as a process that goes on *within* nature, and that serves to reveal its inbuilt architecture, in the making of artefacts the mind is understood to place its ideal forms *upon* nature. If making thus means the imposition of conceptual form on inert matter, then the surface of the artefact comes to represent much more than an interface between solid substance and gaseous medium; rather it becomes the very surface of the material world of nature as it confronts the creative human mind.

This is precisely the kind of view that lies at the back of the minds of anthropologists and archaeologists when they speak of artefacts as items of so-called 'material culture'. The last thing they mean to suggest, in resorting to this phrase, is that in the manufactured object the domains of culture and materiality somehow overlap or intermingle. For nothing about their substantive composition *per se* qualifies artefacts for

inclusion within culture. The materials from which they are made – wood, stone, clay or whatever – are in any case generally available in nature. Even with objects manu-factured from synthetic materials for which no naturally occurring counterparts exist, their status as items of material culture is in no way conditional upon their 'unnatural' composition. A child's toy made of plastic is no more cultural, on that account, than its wooden equivalent. It is the form of the artefact, not its substance, that is attributed to culture. This is why, in the extensive archaeological and anthropological literature on material culture, so little attention is paid to actual materials and their properties. The emphasis is almost entirely on issues of meaning and form – that is, on culture *as opposed* to materiality. Understood as a realm of discourse, meaning and value inhabiting the collective consciousness, culture is conceived to hover over the material world but not to permeate it. In this view, in short, culture and materials do not mix; rather, culture wraps itself around the universe of material things, shaping and transforming their out-ward surfaces without ever penetrating their interiority. Thus the particular surface of every artefact participates in the impenetrable surface of materiality itself as it is envel-oped by the cultural imagination.

Surface, force and the generation of form

Let us consider the most ordinary of everyday objects, one that crops up in a surpris-ing range and variety of cultural settings around the world: a coiled basket. Has the basket been created through working on the surface of some raw material? Have the forces impacting on this surface been applied from without? Did they serve to impress onto the material a pre-existent, conceptual design? In every case, as I show below, the answer is 'Not exactly'. Thus the basket is not 'made' in the sense in which we normally understand the term. Nor, evidently, has it grown of its own accord. Thus neither of the available alternatives seem to work for the basket. It does not fit our stereotype of the artefact, and it is not a life-form. Let us start instead from the simple observation that constructing a basket is a process of weaving. In what follows, I shall consider what weaving entails, respectively, with regard to the topology of *surface*, the application of *force* and the generation of *form*.

 We have seen that making, in what for convenience I shall henceforth call the 'standard view', implies the prior presence of a surface to be transformed. Thus the flint knapper chips away at the surface of stone, the carpenter carves and chisels the sur-face of wood, the blacksmith hammers on the surface of molten metal, and the potter applies manual pressure to the surface of clay. But once it has been cut and prepared for weaving, the basket-maker does nothing to the surface of her fibrous material. In the process of weaving, the surface of the basket is not so much transformed as built up. Moreover, there is no simple or straightforward correspondence between the surface of the basket and the surfaces of its constituent fibres. For example, the two outer surfaces of the transverse wrapping fibres that stitch successive loops of the coil are alternately 'outside' and 'inside' so far as the surface of the basket is concerned (see [Figure 6.1]). Indeed it is in the nature of weaving, as a technique, that it produces a peculiar kind of surface that does not, strictly speaking, have an inside and an outside at all.

 In the special case of coiled basketry, there is a limited parallel with the technique of coil-building in pottery. Here the clay is first rolled out into long, thin, worm-like

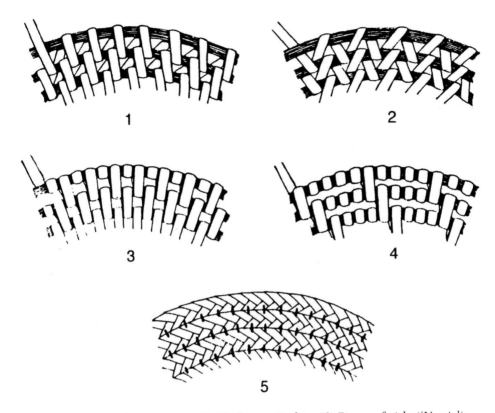

Figure 6.1 Patterns of wrapping in coiled basketry: (1) plain; (2) Figure-of-eight ('Navajo');
(3) long and short ('lazy squaw'); (4) Peruvian coil; (5) sewn coil. From H. Hodges, *Artifacts:
an introduction to early materials and technology*, published by Duckworth, 1964, p. 131.

strips, rather analogous to the lengths of bundled fibres making up the basketry coil.
These strips are then wound around and around to form the base and sides of the vessel.
In this case too, a surface is built up. In the process, however, the original surfaces of the
coiled strips congeal into a single mass, and the final smoothing leaves no trace of the
original mode of construction. But there is another difference, equally critical, which
brings me to the issue of force. The potter may have to contend with the force of grav-
ity (his material, being both heavy and pliable, is inclined to sag). But the clay does not
exert any independent force. This is not the case with basketry, however, which involves
the bending and interweaving of fibres that may exert a considerable resistance of their
own. Indeed the basket holds together, and assumes a rigid form, precisely because of
its tensile structure.[1] In short, the form of the basket is the result of a play of forces,
both internal and external to the material that makes it up. One could say that the form
unfolds within a kind of force field, in which the weaver is caught up in a reciprocal and
quite muscular dialogue with the material.

This point leads me to the final question concerning the generation of form.
According to the standard view, the form pre-exists in the maker's mind, and is simply
impressed upon the material. Now I do not deny that the basket-maker may begin work
with a pretty clear idea of the form she wishes to create. The actual, concrete form of

the basket, however, does not issue from the idea. It rather comes into being through the gradual unfolding of that field of forces set up through the active and sensuous engagement of practitioner and material. This field is neither internal to the material nor internal to the practitioner (hence external to the material); rather, it cuts across the emergent interface between them. Effectively, the form of the basket emerges through a pattern of *skilled movement*, and it is the rhythmic repetition of that movement that gives rise to the regularity of form. This point was made long ago by Franz Boas, in his classic work on *Primitive Art*.

> The basketmaker who manufactures a coiled basket, handles the fibres composing the coil in such a way that the greatest evenness of coil diameter results . . . In making her stitches the automatic control of the left hand that lays down the coil, and of the right that pulls the binding stitches over the coil brings it about that the distances between the stitches and the strength of the pull are absolutely even so that the surface will be smooth and evenly rounded and that the stitches show a perfectly regular pattern.
>
> (Boas 1955 [1927]: 20)

Spirals in nature and art

Boas illustrates the point with a drawing, which I reproduce here [Figure 6.2A]. Opposite, I have placed another drawing, this time taken from the work of the great biologist D'Arcy Wentworth Thompson, *On Growth and Form* [Figure 6.2B]. It depicts the shell of a certain kind of gastropod. Although both the coiled basket and the shell have a characteristic spiral form, they are spirals of different kinds: the first is an equable spiral, the second logarithmic (that is, the radius of each successive whorl increases arithmetically in the one instance, and geometrically in the other). The equable spiral, as Thompson explains, is characteristic of artificial forms that have been produced by mechanically bending, coiling or rolling up a given length of material, whereas the logarithmic spiral is commonly produced in nature as a result of growth by deposition, where the material is cumulatively laid down at one end whilst maintaining an overall constancy of proportion (Thompson 1961 [1917]: 178–9). Either way, however, the form appears to emerge with a certain logical inevitability from the process itself, of rolling up in the former case and laying down in the latter.

Now it is very often assumed, in the study of both organisms and artefacts, that to ask about the form of things is, in itself, to pose a question about *design*, as though the design contained a complete specification that has only to be 'written out' in the material. This assumption is central to the standard view which, as we have already seen, distinguishes between living and artificial things on the criterion of the interiority or exteriority of the design specification governing their production without questioning the premise that the resultant forms are indeed specified independently and in advance of the processes of growth or manufacture wherein they are realised. Thus it is supposed that the basic architecture of the organism is already established, as a genetic 'blueprint', from the very moment of conception; likewise the artefact is supposed to pre-exist, fully represented as a 'virtual object' in the mind, even before a finger has been lifted in its construction. In both cases the actualisation of the form is reduced to a

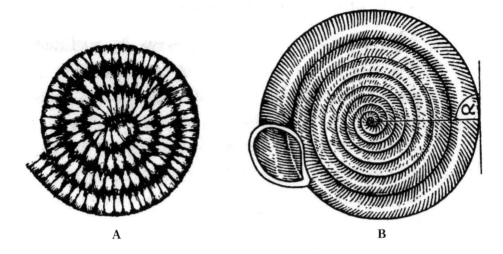

A B

Figure 6.2 Artefactual and natural spirals: (A) Coiled basketry. From F. Boas, *Primitive art*, published by Dover Publications, 1955 [1927], p. 20. (B) Gastropod shell. The angle α is known as the 'spiral angle', which in this case is large. From D. W. Thompson, *On growth and form*, published by Cambridge University Press, 1961 [1917], p. 192.

simple matter of mechanical transcription: all the *creative* work has already been done in advance, whether by natural selection or human reason.[2]

How then, starting from this premise, might we set about accounting for the formation of spirals in nature and in art, in the shell of the gastropod and the coil of the basket? The account would likely run along the following lines: the form of the shell is internally specified in the gastropod's genetic inheritance, and revealed in its growth; the form of the basket is externally specified in the mind of the weaver, as part of a received cultural heritage, and revealed in its manufacture. Now natural selection, according to Darwinian orthodoxy, designs organisms to be adapted to their particular conditions of life, and as many scholars have suggested, a somewhat analogous process of blind variation and selective retention, operating in the arena of cultural ideas, could do likewise in designing artefacts that are well suited to their purpose. The fact that we come across spirals in the growth of living things (as in gastropods) as well as in the making of artefacts (as in basketry) may be purely fortuitous, or it may be the outcome of some kind of adaptive convergence – of natural selection and the human intellect, operating quite independently, arriving at parallel solutions to what might be, in essence, a rather similar problem of engineering design. If, to be more precise, the solution calls for a spiral of the equable type, or alternatively of the logarithmic type, then this is what we will find in the resultant forms, regardless of whether the design itself is encoded genetically or culturally. Hence by this account, the distinction between equable and logarithmic spirals would not, in itself, be relevant as an index of the organic or artefactual status of the objects concerned.

The limits of design

According to the standard view, as outlined above, form is fully explicable in terms of the design that gives rise to it. Once you have accounted for the genesis of the design you have, to all intents and purposes, explained the form. Or have you? Would it be possible, even in theory, for any design to specify the form of an organism or artefact *completely*? In his fascinating study of the design principles embodied in the construction of living organisms and manufactured artefacts, originally written as a textbook for students of engineering, Michael French (1988: 266–7) speculates on the question of just how much information would be needed to specify every aspect of the form of an organism. His conclusion is that the amount would be unimaginably large, far beyond what could be coded in the DNA of any known life-form. Nor is the situation any different with artefacts. True, even the greatest achievements of human engineering are no match for the most commonplace of organisms: thus the steam locomotive, as French wryly observes, 'is simplicity itself compared with the intricacies of the buttercup' (1988: 1). But then, no human design could approach the DNA of the genome in its informational content. Once again, a complete specification would apparently lie beyond the realms of possibility. In short, the forms of both organisms and artefacts seem to be significantly underdetermined by their underlying blueprints. That being the case, French suggests, we may have to recognise that a great many features of organisms and artefacts are merely accidental, due to chance, revealing not the designs themselves but their limitations.

Though intended to shore up the argument from design against the objection that no specification can be exhaustive, this appeal to chance is a *reductio ad absurdum* that does more to highlight the poverty of the argument itself. To show why, let me turn to another example of spiral formation: the vortex of bathwater as it runs out of the plughole. Is the form of the vortex a matter of chance? It is certainly not dictated by the specifications of any design. You can determine whether the spiral runs clockwise or anticlockwise by setting up a current through the water with your hand; beyond that, however, the spiral appears to form of its own accord. But its formation is anything but an accident. It can, in fact, be explained in terms of well-established principles of fluid dynamics.

The example of the vortex is not my own; it is taken from the work of the biologist Brian Goodwin (1982), who uses it to say something very important about the generation of spiral forms in living organisms. In a certain species of snail, the majority of individuals have shells with a right-handed, logarithmic spiral, but in some the spiral is left-handed. It has been shown that the direction of the spiral is controlled by the products of a particular gene, just as the direction of the spiral vortex in bathwater is controlled by the intentional movement of your hand. But – and this is the crucial point – the *form* of the shell is no more the product of a genetic programme than is the form of the vortex the product of a design in your mind. There is, in short, no design for the spiral of the gastropod shell. Rather, the form arises through a process of growth within what is known technically as the 'morphogenetic field' – that is, the total system of relations set up by virtue of the presence of the developing organism in its environment. And the role of genes in the morphogenetic process is not to specify the form, even incompletely, but to set the parameters – such as handedness and spiral angle (see [Figure 6.2B]) – within which it unfolds (Goodwin 1982: 111).

On the growth of artefacts

Returning from the growth of organisms to the manufacture of artefacts, a parallel argument applies. Just as organic form is generated in the unfolding of the morphogenetic field, so the form of the artefact evolves within what I have called a field of forces. Both kinds of field cut across the developing interface between the object (organism or artefact) and an environment which, in the case of the artefact, critically includes its 'maker'. Where the organism engages its environment in the process of ontogenetic development, the artefact engages its maker in a pattern of skilled activity. These are truly creative engagements, in the sense that they actually *give rise* to the real-world artefactual and organic forms that we encounter, rather than serving – as the standard view would claim – to transcribe pre-existent form onto raw material. Moreover as a moment's reflection on the example of the vortex in bathwater will show, the properties of materials are directly implicated in the form-generating process. It is therefore no longer possible to sustain the distinction between form and substance that, as we have seen, is so central to the standard view of making things. Finally, the templates, measures and rules of thumb of the artisan or craftsman no more add up to a design for the artefacts he produces than do genes constitute a blueprint for the organism. Like genes, they set the parameters of the process but do not prefigure the form.[3]

All these points apply to the making of a coiled basket. Thus the equable form of the spiral base of the basket does not follow the dictates of any design; it is not imposed upon the material but arises through the work itself. Indeed the developing form acts as its own template, since each turn of the spiral is made by laying the longitudinal fibres along the edge formed by the preceding one. Now D'Arcy Thompson was of course right to point out that there is a difference between *bending* material into shape, as in basketry, and an organism's *growing* into it, as with the shell of the gastropod, and that this can lead to forms with contrasting mathematical properties. Nevertheless, if the unfolding of the morphogenetic field is described as a process of growth, would it not be fair to suggest that there is a sense in which artefacts, whose forms likewise evolve within a field of forces, 'grow' too – albeit according to different principles?

We could describe that growth as a process of *autopoiesis*, that is, the self-transformation over time of the system of relations within which an organism or artefact comes into being. Since the artisan is involved in the same system as the material with which he works, so his activity does not transform that system but is – like the growth of plants and animals – part and parcel of the system's transformation of itself. Through this autopoietic process, the temporal rhythms of life are gradually built into the structural properties of things – or as Boas put it, with regard to artefacts:

> The rhythm of time appears here translated into space. In the flaking, adzing, hammering, in the regular turning and pressing required in the making of coiled pottery, in weaving, regularity of form and rhythmic repetition of the same movement are necessarily connected.
>
> (Boas 1955 [1927]: 40)

The artefact, in short, is the crystallisation of activity within a relational field, its regularities of form embodying the regularities of movement that gave rise to it.

I would like to conclude this comparison of the coiled basket and the gastropod

shell by commenting on the reasons for the remarkable durability of their respective forms. According to the standard view, since form emanates from design, the persistence of form can only be explained in terms of the stability of the underlying design specifications. In the case of the organism these specifications are genetic, in the case of the artefact they are cultural. The constancy of form is thus a function of the fidelity with which genetic or cultural information is copied from one generation to the next, combined with the effects of natural selection – or its analogue in the realm of cultural ideas – in weeding out less well-adapted variants.

The argument I have proposed here, however, is just the opposite. If forms are the outcomes of dynamic, morphogenetic processes, then their stability can be understood in terms of the generative principles embedded in the material conditions of their production. For the shell the principle is one of invariant proportion; for the basket it is the principle that every increment of longitudinal extension is coupled to what has gone before by transverse attachment. Whereas the first principle, through simple iteration, will always and everywhere generate a logarithmic spiral, the second will just as reliably generate an equable one. It is these generative principles, and not the fidelity of genetic or cultural copying, that underwrite the constancy of the respective forms, and explain their persistence over immense spans of both historical and evolutionary time.

Making as a way of weaving

I now return to my earlier suggestion, that we reverse our normal order of priorities and regard making as a modality of weaving, rather than the other way around. One intriguing observation points us in this direction. Our word 'loom' comes from Middle English *lome*, which originally referred to a tool or utensil of any kind. Does this not suggest that to our predecessors, at least, the surface-building activity of weaving, rather than any of those activities involving the application of force to pre-existing surfaces, somehow epitomised technical processes in general?

The notion of making, of course, defines an activity purely in terms of its capacity to yield a certain object, whereas weaving focuses on the character of the process by which that object comes into existence. To emphasise making is to regard the object as the expression of an idea; to emphasise weaving is to regard it as the embodiment of a rhythmic movement. Therefore to invert making and weaving is also to invert idea and movement, to see the movement as truly generative of the object rather than merely revelatory of an object that is already present, in an ideal, conceptual or virtual form, in advance of the process that discloses it. The more that objects are removed from the contexts of life-activity in which they are produced and used – the more they appear as static objects of disinterested contemplation (as in museums and galleries) – the more, too, the process disappears or is hidden behind the product, the finished object. Thus we are inclined to look for the meaning of the object in the idea it expresses rather than in the current of activity to which it properly and originally belongs. It is precisely this contemplative attitude that leads to the redesignation of the ordinary objects of the quotidian environment as items of 'material culture' whose significance lies not so much in their incorporation into a habitual pattern of use as in their symbolic function. In suggesting that the relation between making and weaving be overturned, my purpose is to

bring these products of human activity back to life, to restore them to the processes in which they, along with their users, are absorbed.[4]

In what way, then, does weaving epitomise human technical activity? What sense does it make to say that the blacksmith in his forge, or the carpenter at his bench, in transforming the surfaces of metal and wood respectively, is actually weaving? Of course, to adopt this idiom is to interpret the notion of weaving more broadly than is customary. It does however help to draw attention to three points about skill which are exemplified in basketry but which are nevertheless common to the practice of any craft. First, the practitioner operates within a field of forces set up through his or her engagement with the material; secondly, the work does not merely involve the mechanical application of external force but calls for care, judgement and dexterity; and thirdly, the action has a narrative quality, in the sense that every movement, like every line in a story, grows rhythmically out of the one before and lays the groundwork for the next.

This broad interpretation of weaving, though it may sound strange to modern, Western ears, is fully in accord with the understandings of the Yekuana, a native people of southern Venezuela. In his study of Yekuana baskets and basketry, David Guss observes that the master craftsman in this society, a person accredited with exceptional wisdom, 'not only weaves the world when making a basket, but *in everything he does*' (1989: 170, my emphasis). Yet this creative process of world-weaving, Guss shows, is not limited to the experts. It rather engages all Yekuana people throughout their lives – albeit at a lower level of perfection – in their manufacture of the essential equipment of traditional livelihood. In every case, from building houses and canoes to fabricating manioc graters and baskets, making is regarded as a way of weaving.

Paradoxically, however, in translating the indigenous term by which such locally produced items are distinguished from imported, commercially manufactured 'stuff' (such as tin cans and plastic buckets), Guss renders them as things not woven but *made*. Moreover the essence of making, in his view, lies in loading the object with metaphorical significance or semiotic content, such that artefacts become a mirror in which people can see reflected the fundamentals of their own culture. The symbolic capacity of artefacts, Guss insists, 'far outweighs their functional value' (1989: 70). Weaving the world, then, turns out to be a matter of 'making culture', of submitting the disorder of nature to the guidelines of traditional design.

Now the epistemology by which Guss converts the manifold products of world-weaving back into 'things made', instances of the cultural transformation of nature (1989: 161), is one that I reject. It is, as I have shown, an epistemology that takes as given the separation of the cultural imagination from the material world, and thus presupposes the existence, at their interface, of a surface to be transformed. According to what I have called the standard view, the human mind is supposed to inscribe its designs upon this surface through the mechanical application of bodily force – augmented, as appropriate, by technology. I mean to suggest, to the contrary, that the forms of objects are not imposed from above but grow from the mutual involvement of people and materials in an environment. The surface of nature is thus an illusion: the blacksmith, carpenter or potter – just as much as the basket-maker – works from within the world, not upon it. There are surfaces of course, but these divide states of matter, not matter from mind. And they emerge within the form-generating process, rather than pre-existing as a condition for it.

The philosopher Martin Heidegger expressed the very same point through an exploration of the notions of building and dwelling. Opposing the modernist convention that

dwelling is an activity that goes on within, and is structured by, an environment that is already built, Heidegger argued that we cannot engage in any kind of building activity unless we already dwell within our surroundings. 'Only if we are capable of dwelling', he declared, 'only then can we build' (1971: 160). Now dwelling is to building, in Heidegger's terms, as weaving is to making in mine. Where making (like building) comes to an end with the completion of a work in its final form, weaving (like dwelling) continues for as long as life goes on – punctuated but not terminated by the appearance of the pieces that it successively brings into being.[5] Dwelling in the world, in short, is tantamount to the ongoing, temporal interweaving of our lives with one another and with the manifold constituents of our environment.

The world of our experience is, indeed, continually and endlessly coming into being around us as we weave. If it has a surface, it is like the surface of the basket: it has no 'inside' or 'outside'. Mind is not above, nor nature below; rather, if we ask where mind is, it is in the weave of the surface itself. And it is within this weave that our projects of making, whatever they may be, are formulated and come to fruition. Only if we are capable of weaving, only then can we make.

Notes

1 To adopt an architectural term, the coherence of the basket is based upon the principle of *tensegrity*, according to which a system can stabilise itself mechanically by distributing and balancing counteracting forces of compression and tension throughout the structure. Significantly, tensegrity structures are common to both artefacts and living organisms, and are encountered in the latter at every level from the cytoskeletal architecture of the cell to the bones, muscles, tendons and ligaments of the whole body (Ingber 1998).

2 This prioritisation of design over execution betrays a ranking of intellectual over physical labour that . . . is one of the hallmarks of Western modernity. It divides the scientist from the technician, the engineer from the operative, the architect from the builder, and the author from the secretary.

3 In a wonderful article on the building of the great cathedral of Chartres, in the thirteenth century, David Turnbull (1993) shows that this most magnificent of human artefacts was preceded by no plan whatsoever. The building took shape gradually, over a considerable period of time, through the labour of many groups of workers with diverse skills, whose activities were loosely co-ordinated by the use of templates, string and constructive geometry.

4 I do not intend by this to reinstate the time-worn opposition between practical utility and symbolic meaning. The notion of utility implied by this opposition is an impoverished one that sets up a radical division between the acting subject and the object used, and reduces skilled practice to purely mechanical relations of cause and effect. In speaking of the *absorption* of artefacts into the life-activity of their users my aim is to emphasise, to the contrary, the inseparability of persons and objects in real-life contexts of accustomed (that is, usual) practice. The usefulness of an object, then, lies not in its possession of utility but in its partaking of the *habituality* of everyday life (Gosden 1994: 11).

5 Among the Bunu, a Yoruba-speaking people of central Nigeria, this idea is expressed in their weaving of lengths of white cloth: 'Cloths are often removed [from the loom] without cutting, accentuating the endless quality of these pieces. When eventually the unwoven warp is cut in order to use the cloth, the fringes are left, again suggesting continuity rather than the finiteness of cut and hemmed edges' (Renne 1991: 715).

References

Boas, F. (1955) *Primitive Art*. New York: Dover Publications.

French, M. J. (1988) *Invention and Evolution: Design in Nature and Engineering*, Cambridge: Cambridge University Press.

Gibson, J. J. (1979) *The Ecological Approach to Visual Perception*, Boston: Houghton.

Goodwin, B. C. (1982) 'Biology without Darwinian Spectacles', *Biologist*, 29, pp. 108–12

Gosden, C. (1994) *Social Being and Time*, Oxford: Blackwell.

Guss, D. M. (1989) *To Weave and Sing: Art, Symbol and Narrative in the South American Rain Forest*, Berkeley, CA: University of Berkeley Press

Heidegger, M. (1971) *Poetry, Language, Thought*, New York: Harper and Row.

Ingber, D. E. (1998) 'The Architecture of Life', *Scientific American*, vol. 278, no. 1, pp. 30–9.

Ingold, T. (1983) 'The Architect and the Bee: Reflections on the Work of Animals and Man'. *Man* (N.S.), 18, pp. 1–20.

Marx, K. (1930) *Capital*, vol. 1. London: Dent.

Renne, E. P. (1991) Water, Spirits and Plain White Cloth. *Man* (N.S.) 26, pp. 705–22.

Thompson, D. W. (1961) *Growth and Form*, Cambridge: Cambridge University Press.

Turnbull, D. (1993b) The Ad Hoc Collective Work of Building Gothic Cathedrals with Templates, Strings and Geometry. *Science, Technology and Human Values*, 18, pp. 315–40.

Chapter 7

Page DuBois

DILDOS

Hermogenes: "Any name which you give, in my opinion, is the right one, and if you change that and give another, the new name is as correct as the old—we frequently change the names of our slaves, and the newly imposed name is as good as the old. For there is no name given to anything by nature; all is convention and habit of the users."

Plato, *Cratylus* 384d

IN THIS CHAPTER, I consider further ways in which slaves have been rendered invisible in modern practices of representing antiquity. The question of slavery here intersects with that of sexuality, another vexed issue for the presentation of ancient society to modern audiences. In most of the museums of the world, there is an occlusion of the presence of slaves in antiquity and, in addition, of the vital erotic life of ancient peoples: their myriad and various representations of sexual intercourse; of the *phallos*, a sacred object; and of the *phallos*'s double, the dildo. The suppression of slaves meets the suppression of sexuality in modernity's deployment of and phantasmic investment in a certain idea of antiquity as a lost golden age of freedom and philosophical detachment. Even in the relatively new subdiscipline of the history of sexuality, work in classics has focused on women and on homoeroticism; slaves, disturbingly ubiquitous as available sexual partners, have been effaced. How are we to understand the ubiquity of slaves in antiquity, and their consequent informing of ancient sexualities?

Can we even speak of "sexuality" when discussing antiquity? This question implicates the work of Michel Foucault, especially the second volume of his history of sexuality, *The Use of Pleasure*, which has met with much ambivalence from the discipline of classical studies.[1] A passionate debate has arisen concerning the value of his arguments concerning the Greeks. Misunderstandings have resulted from this work, which is multifaceted and part of a much longer and unrealized project. In keeping with the positivist orientation alluded to earlier, many classicists tend to focus on problematic details of Foucault's work on the Greeks, which stands at the very beginning of a projected long

narrative concerning what might be considered "world-historical" issues in the geneal-
ogy of Western ideas about pleasure.

Foucault's perspective on antiquity was influenced by Hegel's notions of the evolu-
tion of the subject, even though Foucault himself would have disavowed the progressive
aspects of such influence. Foucault looked to the philosophical and prescriptive strain of
discourses in Greek culture for traces of the beginnings of a philosophical subject. His
gaze was directed toward the influential Platonic project of asceticism and cultivation of
the self, which involves in its historical development a turn away from politics and the
polis, as Hegel argues. This strain produces post-Platonic Stoicism, for example, and has
its effects on new, Roman notions of the body and marriage and on Christian theological
developments, which Foucault began to describe in The Care of the Self.[2] Foucault's work,
although limited in certain respects, does shed light on this important strain of discourse
in ancient culture. Some scholarly readers' dismissal of this work, because of a reduced
body of evidence upon which his findings depend, leads them also to reject or ignore im-
portant insights about historicity and cultural difference that are compatible with the
most valuable insights on classical culture of our era, those of the Parisian school.[3]

For some, Foucault seems to deny that there is sexuality in antiquity, and they go so
far as to suggest that following his arguments might lead one to conclude there was no
sex at all in the ancient world. The point is that the sexual universe we inhabit—defined
as it is by the sexologists of the nineteenth century, by Freud and Lacan, by liberation-
ist movements of the later twentieth century, by transgressive bodies of the twenty-first
—cannot be mapped unproblematically onto antiquity and the activities and codes of
meaning we see in the ancient world in relation to the acts we call sexual. The debate
has sometimes centered on the question of the existence of "homosexuality" in antiquity,
but in fact is rooted in the question of the historicity of sexuality itself as a category. A
healthy dose of estrangement and of historicism might enable a perspective on how the
ancient world is not just commonsensically the same as our own, in the domain of sex as
in many others, and significantly includes the ubiquity of slaves, who figure prominently
in that domain, although they have until recently been remarkably absent from the nas-
cent field of the history of sexuality in antiquity, including the work of Foucault.[4]

In this chapter, I look at how taking slaves into account might affect the subdiscipline
of the history of sexuality in classical studies. At the beginning of Les Mots et les choses,
published in 1966, Foucault cites a text he claims was from Borges, an entry from "a
certain Chinese encyclopedia": "'animals are divided into: (a) belonging to the Emperor,
(b) embalmed, (c) tame, (d) suckling pigs, (e) sirens, (f) fabulous, (g) stray dogs, (h)
included in the present classification, (i) frenzied, (j) innumerable, (k) drawn with a very
fine camelhair brush, (l) et cetera, (m) having just broken the water pitcher, (n) that
from a long way off look like flies.'"[5] Foucault recalls "the laughter that shattered . . . all
the familiar landmarks of my thought—our thought, the thought that bears the stamp of
our age and our geography—breaking up all the ordered surfaces and all the planes with
which we are accustomed to tame the wild profusion of existing things." He remarks of
this list: "What is impossible is not the propinquity of the things listed, but the very site
on which their propinquity would be possible" (xvi). The laughter of Foucault, Borges's
orientalism, that attribution of the fantastic taxonomy to the Chinese, might serve once
and for all to erode confidence in and to estrange our own taxonomies, and to argue
most persuasively that not only in fiction but also in history it is possible to think that the
conceptual world we now inhabit has not always existed, that culture has been organized

otherwise elsewhere. The very categories of sexuality and pornography have to be put into question when we look at such a distant culture as that of ancient Greece. And here, as elsewhere, the overlooked presence of slaves contributes to a mapping of difference.

I would like to juxtapose that Foucauldian-Borgesian catalogue with one from Aristophanes. In a passage preserved in Pollux's *Onomasticon*, supposedly from the *Thesmophoriazusae* of Aristophanes, recording all kinds of women's ornaments and equipment, we find a male actor performing the role of a woman pronouncing a list:

> xuron, katoptron, psalida, keroten, litron,
> prokomion, ukhthoibous, mitras, anademata,
> egkhousan, olethron ton bathun, psimuthion,
> muron, kiserin, strophi', opisthosphendonen,
> kalumma, phukos, periderai', hupogrammata,
> truphokalasirin, elleboron, kekruphalon,
> dzom'ampekhonon, truphema, paruphes, xustida,
> khitona, barathron, egkuklon, kommotrion.

Like a Platonic interlocutor, her companion asks for more: *eita ti;*

> diopas, dialithon, plastra, molokhion, botrus,
> khlidona, peronas, amphideas, hormous, pedas,
> sphragidas, haluseis, daktulious, kataplasmata,
> pompholugas, apodesmous, olisbous, sardia,
> hupoderidas, helikteras . . .

Some of these items are still mysterious and as yet undeciphered. Here is nonetheless the translation of John Maxwell Edmonds:

> Here's razor, mirror, scissors, wax-salve, soda
> A false front, trimmings, hair-ribbons, bandeaux,
> Alkanet, "sudden death," some face-powder,
> Some scent, a pumice-stone, breastbands, a hair-bag,
> A veil, some rouge, two necklaces, some eye-paint,
> Peignoir, some hellebore, a hair-net, girdle,
> Shawl, woollie, bordered wrapper, velvet gown,
> Camisole, "death-pit," tippet, curling-tongs—

The series continues:

> Earrings, a pendant, more earrings—a lot,
> Pins, necklet, armlet, bangles, carcanets,
> Anklets, seals, chains, rings, plasters, bandelettes,
> "Bubbles," carnelians, baubons, more earrings . . .

> [This last line reads, literally, "'bubbles (whatever they are), breast-bands,
> dildos (*olisbous*),' carnelians, i.e., Sardian stones"]
> (Aristophanes frag. 321 = 320 K = 332 Austin)[6]

Clement of Alexandria also cites, most disapprovingly, some of this list, calling it *ton gynaikeion kosmon*, "women's ornament, or dress." This well-equipped Athenian woman was massively, comically fortified with apparatus, and the dildo figured in her panoply. The list also contains a *kekruphalon* (l.6), "hair-net" and punningly, "secret phallus," and *sphragides* (l.12), "seals or gem-rings," possibly dildos as well, according to Jeffrey Henderson.[7] Of course this is comedy, a comic catalogue, with these items seeded in among the jewels for comic effect; but they nonetheless figure prominently in this catalogue of women's appliances, in this site of promiscuous juxtaposition.

Greek vases often bore representations of the *olisbos*, or dildo, sometimes indistinguishable from the *phallos*, a mimetic representation of the detached and erect penis used in rituals. Vases show dildos hanging on the walls above prostitutes, *pornai* or *hetairai*, being deployed in scenes of group sex, and in scenes of solitary female masturbation. One vase shows a woman using two dildos simultaneously [Figure 7.1]. In another [Figure 7.2], a vase painter pictured a woman watering a bed of *phalloi/olisboi;* scholars disagree about whether this scene depicts a hopeful future user of the dildo crop, or a woman keeping the ceramic products of a potter from drying out. Another vase [Figure 7.3] shows a woman carrying off a giant *phallos/olisbos* as large as she is; is this a scene from ritual, as some scholars claim, or a figure for female sexual insatiability? The matter of the visual representation of the dildo has been usefully taken up by scholars, including Eva Keuls and François Lissarrague.[8]

The object in question is, in English, the *dildo*, a word always associated now with

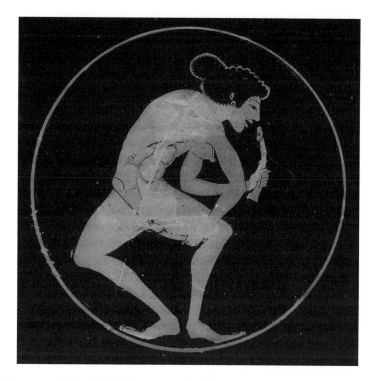

Figure 7.1 Myson, painting of naked woman with *olisboi*. Vase, terra cotta, fifth century BCE. Museo Archeologico Regionale, Syracuse. Photograph copyright the Trustees of the British Museum.

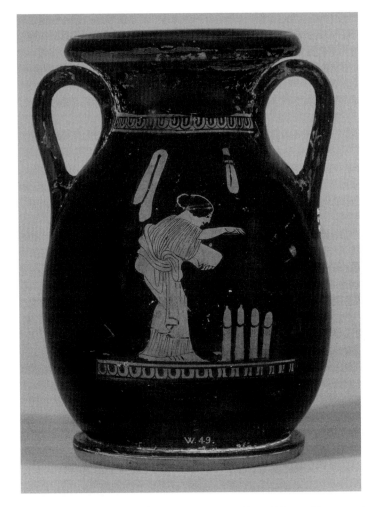

Figure 7.2 Detail of a vase by the Hasselmann Painter, ca. 430–420 BCE. Photograph copyright the Trustees of the British Museum.

what we call sexuality, sexual practices, sex. The *Oxford English Dictionary* classifies the word as "obsolete," describing it as a word of obscure origin, once used in the refrains of ballads. It is "also a name of the penis or phallus, or a figure thereof; the lingam of Hindoo worship." Ben Jonson used the word in 1610 in *The Alchemist*:

> Here I find . . .
> The seeling fill'd with poesies of the candle:
> And Madame, with a Dildo, writ o' the walls.
> (V.iii)

Also in the seventeenth century, in an account of East India, a certain Fryer describes an Oriental scene: "Under the Banyan Tree, an Altar with a Dildo in the middle being erected, they offer Rice." In the semantic network into which it falls in English, *dildo*

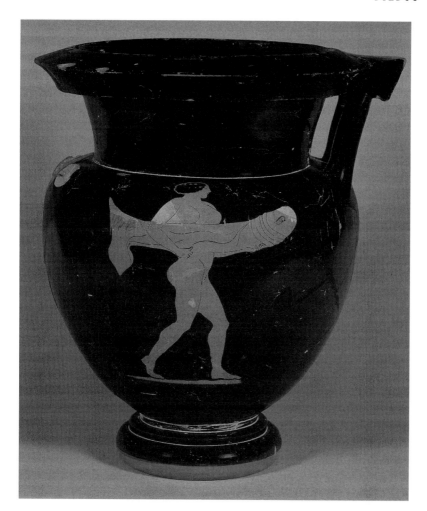

Figure 7.3 Krater by the Pan Painter, woman carrying a giant phallus. Second quarter of the fifth century BCE. Staatliche Museen zu Berlin—Preussischer Kulturbesitz, Antikensammlung/bpk.

was a disparaging nickname for men or boys, with a slightly obscene connotation; was once associated with nonsense rhymes, with questionable females, and with the sexual practices of exotic others. In Jonson's hand, the dildo seems to take on the connotations of suspect sexual acts, in a cultural situation in which sexuality as a category is just emerging—perhaps still the world in which the appropriate category is not in fact sexuality, that product of nineteenth-century scientism, but rather sodomy, or another word connected with the confessional, with illegal acts of various sorts, not yet scrutinized in the coherent pseudoscientific work of such sexologists as Kraft-Ebbing and Freud.[9]

If one is open to the possibility that sexuality as such does not yet exist in the seventeenth century in England, then what does it mean to match this word *dildo* with its Greek "equivalents," the word listed alongside it in that very arbitrary catalogue we call a dictionary? Or, better, if we make a concordance, what are all the usages of this word in classical texts; what does a reading of the collected examples of this word yield? The

standard Greek–English dictionary of Liddell, Scott, and Jones (hereinafter LSJ) gives a definition of *olisbos* only in Latin—*penis coriaceus*—characteristically deferring the dangerously obscene meaning, "leather penis," with a linguistic displacement into another "dead" language.[10]

Our own contemporary, postmodern sense of these particular objects figures in two discourses. We live in a world in which the dildo is a literalization of the Freudian fetish, a figuring of the phallus, that nonexistent thing that conceals or protects the viewer from the castration of the mother which Freud describes as "fact" in his 1927 essay "Fetishism."[11] We understand the dildo in light of discourses about pleasure or drives or needs, in a post-Freudian, post-Lacanian syntax in which the dildo serves as a pathological substitute, as a fetish, as a simulacrum of the penis. Or we understand the dildo as figuring in liberatory sexual practices, representing the refusal of rigid gender identities, signifying a celebration of multiple postmodern sexualities, within the context of gay and lesbian and sex-affirmative feminist discourse.

One can offer an interpretation, a reading of the dildo within ancient Greek society, that remains within a network of purely sexual or sexological meanings. If the meaning of ancient sexual practices depends on one's location in the act of penetration, as David Halperin has argued, then women cannot be imagined by men to have sex unless penetration occurs.[12] In keeping with the metaphors of plow and of stilus, so common in decorous literary representations of sexual intercourse, the Greek male imagination can only conceive of women's masturbation or sex play with a substitute phallus, the *olisbos*.[13] Sexual acts performed between women, or female masturbation, cannot take place in the absence of dildos; and there are multiple examples of dildos being used by men with women in art, and by women alone, on the vases used by the Greeks for drinking parties, *symposia*, and Dionysiac celebration. A line of reading consistent with a certain feminist perspective would imply a critique of the phallocentric politics of representation of this object in ancient art and text. One might even imagine an interpretation that argued for ancient women's seizure of the dildo as an appropriation of the penis, the *phallos*, the feminist hijacking or compensatory provision of this all-important instrument of penetration. A hermeneutic, historicist model here, one that recognizes our situation in a Freudian, sexualized universe, one in which our truth, our secret, has come to be understood as our sexual nature, might be more productive.

The encrypted dictionaries and writings on ancient sexuality have the effect of reproducing this hiddenness and latency in describing the sexual practices of antiquity, deftly concealing them from students, from scholars who must labor, must know Latin if they are to read the obscene in Greek, so that there is an artificially produced "sexuality," a forbidden, obscene zone of our knowledge of ancient Greece. Jeffrey Henderson's *Maculate Muse: Obscene Language in Attic Comedy*, for example, an elaborate exploration of Greek comic diction with obscene English equivalents, a lexicon for the obscene comedies of Aristophanes, supplements the more decorous or repressed entries of the dictionary.[14] Not until 1975 was such information compiled and made available in one text for the English-speaking Aristophanes readers, who had previously been confronted with the evasive tactics of Liddell, Scott, and Jones, and with euphemism and bowdlerization even in such texts as the Loeb editions, which commit themselves to the task of printing Greek (and Latin) texts and English translations on facing pages, but which sometimes offer a translation not in English but in the other of the ancient languages when confronted with ancient obscenity.

My argument is that when we look at the taxonomy connected with the *olisbos/dildo*, just one of the objects we associate exclusively with the restricted domain of sexuality, in ancient Greece we find not our familiar organization of sex, sexual practices, sexology, sexuality, but a very different set of things to think. What is the web, the cultural and semantic field, the syntax in which the dildo figures in ancient discourses? I will look at some other texts in which the dildo appears, neither to treat them exhaustively, nor to read them from the perspective of modernist feminism, but rather to try to sort out another taxonomy, a cultural field in which we might situate the *olisbos*, one that implicates the slave and slavery. This will be an unfamiliar taxonomy to those for whom the object figures only within the field of sexology and sexuality, within a limited social-scientific study of private life, within the post-Enlightenment creation of the private sphere described by Jürgen Habermas.[15]

Olisbos

Sappho's fragment 99a was discovered on a third-century CE papyrus, and is thought by some scholars to be the work of Alcaeus rather than Sappho. It reads, fragmentarily, in David Campbell's translation:

> ". . . after a short (time?) . . . descendants of Polyanax . . . strike the strings
> . . . receiving the '*olisbos*' . . . kindly . . . quivers . . ."[16]

The phrase I am interested in here is tentatively recorded as "*olisb' dokois*"; the participial adjective *olisb . dokoisi* seems to agree with *khordaisi*, strings. There is a vigorous debate concerning the meaning of *olisbos* here, one that reveals the difficulties of situation within the elite institution of classical scholarship, which has been both repelled and fascinated by ancient sexual practices, producing an unnerved and self-conscious discourse about them.

Denys Page remarks in his *Sappho and Alcaeus*, à propos of the scandal of Sappho's sexual desire for young women:

> To the . . . question—so often propounded, so seldom considered without
> prejudice—whether evidence for practice as well as inclination is to be found
> in the fragments of Sappho's poetry a negative answer must be returned.[17]

In a subsequent note, after the discovery of the Oxyrhynchus fragment xxi, attributed to Sappho and listed as fragment 99a in her corpus, Page adds that he "had written that there is no reliable evidence in the fragments of Sappho for any impropriety in the conduct of herself or her companions. This remains true as stated in that form" (144 n. 1). (Yet he has been made uneasy.) Such a remark resembles that of a translator of Sappho who once made a distinction between the "inversion" of the poet, in light of evident desire, and the absence of evidence for "perversion," activity driven by such desire. Such scholars evidently mean to compliment the poet and rescue her from those who might think her improper, a pervert, and show the degree to which modern ideas about sexuality, desire, and judgment colored and obscured classical scholarship about ancient sexual activity well into the twentieth century.[18] About fragment 99a, Page continues,

"Sappho used in her poetry a word of quite unusual coarseness, referring to practices about which silence is almost universally maintained." He goes on to detail his view about the reading of the manuscript, laboring to show that the word at the beginning of column I.5 need not be construed as *olisbos*, "dildo," but concluding finally: "The answer is that it is practically certain that *olisb*— is what was written" (145).

M. L. West resists not the textual reading of *olisbo*— but rather the translation of it as "dildo," arguing that the word must be a synonym for *plektron*, the instrument used for striking the lyre.[19] As Giuseppe Giangrande later writes about this strategy, "the only way to preserve a puritanical vision of Sappho was to dream up a new meaning for *olisbos*."[20] This metaphorical understanding of the *olisbos*, as *plektron*, "pick," or "bow," for the playing of a musical instrument, protects Sappho from the allegations of "unusual coarseness," either in invective or in some more benign view of the use of the *olisbos*.

Giangrande, on the other hand, insists that *olisbos* always means *aidoion dermatinon*, "leather private part." He maintains that if *olisbodokoisi* is the reading here, and if it agrees with *khordaisi*, this is an example of "adjectival enallage," that is, the substitution of one grammatical form for another. The rhetorical figure *enallage*, adduced by Giangrande to account for the transfer of the epithet from the person to the thing, is a kind of characterizing displacement, in which all that the *olisbos*-receiving person touches takes on the qualities of *olisbos*-reception. "[T]he *khordai* of the instrument used by the player . . . are called *olisbodokoisi* because the player herself was *olisbodokos*" (250). Giangrande retreats into a macaronic flurry, employing the German *Notbehelf* to amplify his sense, and also resorting to Latin; in disagreement with K. J. Dover, who believes the *olisbos* was used exclusively for solitary female masturbation, he writes that the device "was used whenever the replacement of a real *mentula* was needed." Giangrande concludes that the word "leaves us in no doubt as to what Sappho and her companions were up to, and confirms the ancient view that Sappho was a *tribas*" (250). That is to say, as LSJ define the term, "a woman who practises unnatural vice with herself or with other women," a "rubber," from *tribo*, "rub."[21] Giangrande, in the scholarly debate that ensues, insists that *olisbos* always and everywhere means "dildo." He also discovers dildos in Callimachus's 38th Epigram, in which Simon the prostitute, abandoning her trade, dedicates her apparel and her apparatuses to Aphrodite; he argues that the disputed wickerworks of her dedication are in fact *olisboi* as well.[22]

If Sappho sings of sexual acts, satisfaction of desire on soft beds, of desire for girls, the *olisbos* in her work can be located as well in another semantic field, that of objects with which one performs tasks, produces pleasure, musical or sexual, and adorns oneself. There may after all be some analogy posed or suggested between the playing of the lyre with the *plektron*, the plucking or striking of the strings, and the sexual activity of striking or rubbing with the dildo—the connection of the *olisbos* with the *plektron* implicit but present, even if it may have been exaggerated in order puritanically to deny the use of the word *olisbos* in a sexual context in Sappho's verse. This semantic nexus is intriguing, since we find a possible connection between two "instruments," tools, devices to produce a certain result, rather than a connection through discourses of sexuality per se. The dildo might then be understood as an instrument and even eventually as a commodity, a product of artisanal labor, just as much as an element of possible invective, or as a figure in erotic discourse.

This fragment follows Sappho 98, which describes a *poikilan mitran*, a decorated headband which the poet laments she cannot obtain for Kleis. Campbell notes that

"S. may be saying that luxuries (reminders of happy days in Mytilene) are not obtainable, now that she is in exile."[23] The yearning for absent luxuries is a theme that recurs in other passages I want to discuss, in which objects, especially luxury items, associated with beauty, erotic pleasure, and feminine finery cease to be available and become the objects of frustrated desire.

Elsewhere in the fifth-century comedies of Aristophanes, we again find the *olisbos*, here a commodity difficult to put one's hand on. In Aristophanes' *Lysistrata*, the character Kalonike complains about the absence of men—husbands or seducers—saying:

> Even lovers have vanished without a trace. Ever since the Milesians revolted from us, I haven't even seen a six-inch dildo, which might have been a consolation, however small.[24]

> [all'oude moikhou kataleleiptai phepsalux
> ex hou gar hemas proudosan Milesioi,
> ouk eidon oud'olisbon oktodaktulon,
> hos en an hemin skutine 'pikouria.]

(107–10)

The *skutine 'pikouria*, "leather helper," is a joke, a play on the proverbial *sukine epikouria*, "a support made of fig wood," that is, illusory help. She clearly thinks a dildo, at least a dildo of this size, an "eight-finger" model six inches or so, would be relatively useless. Here Sappho's theme of the scarcity of the luxury commodity from Asia Minor recurs; the dildo, fabricated in Miletus, is nowhere to be found now that the Athenians are at odds with the Milesians, and the women must act, setting in motion their sex strike. Later in the play we find another complaint about the inadequacy of the imitation penis; Lysistrata has explained her plan to deny the men of Greece their sexual satisfaction, and the women explore alternative possibilities for their own pleasure. Lysistrata orders the Greek women, if their husbands ignore them, to "skin the skinned dog," said by Henderson to refer to masturbation with a dildo, with possible reference to the depilated pubis of Greek women.[25] In the next line Kalonike complains:

> phluaria taut' esti ta memimemena.
> [Facsimiles are nothing but poppycock.]

(158–59)

The women of Aristophanes, while recognizing that the well-equipped woman possesses the dildo, prefer the real thing.[26]

There is a distinction to be drawn between the *phallos* of comedy and the *olisbos* or dildo. Henderson says that "the ordinary comic phallus was of course not erect, but . . . made of leather, pendant, red, uniformly thick."[27] Special *phalloi* were used in comedy performances when erections were called for. The use of the *phallos* as part of the comic costume has its affinities with ritual uses of the detached phallus, which was "sacrificed": for example, thrown in the form of cakes into troughs in the rite of the Thesmophoria, erected as apotropaic sign at Apollo's shrine at Delos, and carried in Dionysiac processions. The phallos synecdochically embodies potency, fertility, and masculinity. Athenaeus cites Semos on the *phallophoroi*, "phallus-bearers," who are known to carry

the simulacrum of the male member, erect, on poles and to perform songs in honor of Dionysos (xiv.621–22). Athenaeus also (xv.676f), intriguingly and fleetingly mentions *narkissous olisbous*, "narcissus-dildoes," whatever they might be. Ritual uses of the *phallos* approach the limit of the *phallos* worn in comedy, which may be the point of intersection between the sacred, Dionysiac *phallos* and the mimesis of a body part used for sexual pleasure, the *olisbos*/dildo.

Another comic passage, Cratinus's fragment 316, recorded by Photius in the *Lexicon*, glosses the word *misete*, meaning "lecherous," and connects the *olisbos* with a whole set of metaphors used in tragedy and elsewhere in comedy to connote sexual intercourse, representing the woman's body as a field to be plowed, a tablet to be inscribed, an oven to be heated and filled.[28] Photius cites Cratinus: "misetai de gynaikes olisboisin khresontai"; [And lecherous womankind will the *olisbos* use]. Nauck suggested that this was a parody of the oracle in Herodotus 8.96, "and devotees of Aphrodite Colias (i.e. courtesans) will cook with (the wood of) oars." Edmonds comments:

> [F]or, as Herodotus tells us, it was on the promontory where stood this Aphrodite's temple that wreckage of the battle of Salamis was washed up; this oracle would be on everybody's lips in 480–79 and perhaps remembered in the autumn of 433 after the battle of Sybota, which Athens and Corcyra considered they had won over courtesan-loving Corinth.[29]

Here the dildo, rather than taking over the function of plow or stilus, serves like oars, used as firewood to heat the ovens that are women's bodies.

The sixth mime of Herodas centers on a dildo, a finely crafted red model. In this text, in a genre frequently disdained by scholarship focused on high culture, Metro, visiting her friend Koritto, first complains about the laziness of slaves. She then asks Koritto: "lissomai se, me pseusei / phile Korittoi, tis kot'en o soi rapsas / ten kokkinon baubona" [Please tell me the truth, dear Koritto, who stitched you the scarlet *baubon*?] [Figure 7.1][30] Note the convention of omitting to translate the obscene word *baubon*, or dildo. Koritto is shocked that Metro has seen the *baubon;* she had loaned it to Eubule, who gave it to Nossis, who showed it to Metro, who wants to have one made for herself. Koritto finally reveals that a certain Kerdon made it. Metro recalls that there are two Kerdons, one of whom "couldn't stitch a plectrum for a lyre" (6.51). A third Kerdon made this *baubon*, and Koritto marvels at his craftsmanship: "in workmanship he is a true Koan, you would think you saw not Kerdon's handiwork, but Athena's" (6.65–68). In fact, the maker had made two:

> [A]t first glance my eyes swelled out of my head; I may tell you,—we are alone—,they [*ta balli'*] were firmer than the real article, and not only that, but as soft as sleep, and the laces are more like wool than leather; a kinder cobbler to a woman you could not possibly find.
>
> (6.69–73)

This mime, replete with the language of rubbing and grinding, ends with a sly warning against *ornithokleptai*, "bird-thieves" (6.102); the editor notes solemnly, "the most anxious care cannot protect poultry against depredation."

The word *ballia*, used of the pair of dildos, may be related to the word *phallos*. *Baubon*,

Figure 7.4 "Baubo" figurine from Priene. Terra cotta, ca. 200 BCE. Staatliche Museen zu Berlin–Preussischer Kulturbesitz, Antikensammlung/bpk.

on the other hand, used in the earlier passage here as well as in the catalogue of women's accessories in the first Aristophanes fragment cited, has not been satisfactorily accounted for. It may be derived from the verb *baubao*, "sleep," "lull to sleep"; this etymology would be supported by Koritto's admiring observation that the *ballia* are *he malakotes hupnos*, "the softest sleep," "the softness sleep." However, some scholars have connected this name for the *olisbos* with Baubo, who in the cult of Eleusis, the Eleusinian mysteries, causes the mourning Demeter to burst into laughter, pulling up her dress to expose her genitals; Baubo who is represented in a series of remarkable figurines from Priene [Figure 7.4]. Maurice Olender, in his important essay on Baubo, describes these statuettes:

> [T]he disproportionately large head sits directly on top of the legs, blending into and replacing the hips of the atrophied body. The huge face is broad and frontal, with a nose and with two large eyes in the position of the breasts.

Below the mouth, and corresponding to the dimple in the chin, is a representation of a woman's genitals.[31]

Olender explores the possibility that Baubo, the feminine, is the personification of the vulva, corresponding to the *baubon*, like Priapos, the incarnation of the *phallos*. Koritto's toy, the sought-after dildo, product of artisanal labor, may have mythological resonance, connections with the very early myth and cult of Demeter at Eleusis.

What, then, can we say about the *olisbos*, the dildo, in Greek antiquity? I would place it in a complex, various, heterogeneous set of overlapping cultural networks that resemble very little our sexological fixing of this same object as fetish or as toy. The dildo in ancient Greece is, although rarely visible in displays in museums,

1 part of women's apparatus of seduction.
2 like the plow or stylus—i.e., a tool for cultivation or inscription, or like the firewood that warms the womb, a woman's oven, an instrument for working on women's bodies.
3 an instrument of pleasure—for sounding the lyre, for causing women's bodies to resound in pleasure—to their praise or blame.
4 an artifact, one artisanal object among others, the product of skilled labor.
5 a commodity—often exotic, a luxury item from the East.
6 a *baubon*—a tranquilizer, or a figuration in the masculine of the mythological character Baubo.

Representations of the dildo/*olisbos* do not appear in the public spaces of most museums with collections of ancient objects, and, like slaves, seem invisible to the modern gaze. I want to conclude this chapter by arguing that the *olisbos* intersects with slavery in another way: that it is also necessary to locate the *olisbos* within the context of slavery, in a cultural series that begins with inanimate tools; passes to tools that are imitations of the animate; passes then to those bodies that are, in Aristotle's phrase (*Politics* 1253b), "animate tools," the bodies of slaves; and ends with fully human bodies, the bodies of the free. Aristotle says:

if every tool could perform its own work when ordered, or by seeing what to do in advance . . . if shuttles wove and plectrums played harps of themselves [*ta plektra ekitbarizen*] . . ., masters would have no need of slaves.
(1254a)

Here Sappho's *olisbos*, imagined as a plectrum, recurs in a new context. Such is a recurrent phantasy, in this slave culture, of a world where things might behave like slaves, where inanimate tools would work as do the animate.

The following passage, a fragment from a comic writer of the mid-fifth century BCE, Krates, preserved in the writings of Athenaeus, belongs in a utopian, postslavery imaginary. It comes from a comedy called *Animals*, or *Beasts*, in which the animals rise up and refuse to be eaten by men; there follows an exchange in what might be thought of as a low utopia, in which the object world, the lifeless, soulless world of things, is imagined as coming to life:

Then there shall be no one who may own a slave or a slave girl, but each
man, each old man, shall have to serve himself?

By no means: for I am going to make everything walk about on its own.

How is that going to help?

Each object will come to him when he calls for it. Put yourself down next to
me, table. . . . Get kneading, my sweet little kneading trough. Fill up, jug.
Where's the cup got to? Go and get yourself washed. Cake, come along over
here. The pot ought to empty out the cabbages. Get moving, fish:—"but I'm
not yet toasted on the other side!" Then why don't you turn yourself over—
and cover yourself with oil and salt.

<div align="right">(Athenaeus, Deiphnosophistai 267e–f)</div>

Athenaeus cites other passages from other comic writers, who similarly describe the
gratifyingly automatic arrival of food and drink.[32] In a world without slaves, the imag-
inable, utopian alternative to slave labor is not work by the free but labor performed by
inanimate objects themselves.

In an especially revealing fragment from the comic *adespota*, fragments not assigned
to particular authors but possibly also from the second *Thesmophoriazusai*, women again
complain of sexual frustration, and mention again the dildo, that leathern commodity
from Miletus:

[A. Are our respective husbands to go on]
 Treating us badly?
B. *I* think not, for one.
 If we've got sense we shall think out a plan
 To turn the tables on them.
A. If we can.
B. Listen [and learn.] What's the [kid] thing (*to skutinon*) they say
 The women play with at [Miletus], eh?
A. Why Trash by Nonsense [out of] Naughtiness;
 Reproach and Ridicule—that's all. With this
 It's just like wind-eggs—[there's no] chick [inside it.
 Your plan's a wish, no more, and if you tried it
 Like a fool, you'd only make things worse].
B. Still, though,
 I'm *told* it's like the genuine [thing. (*homoion posthio*) (i.e., "dick," "cock")]
A. I know,
 As moon to sun—looks like but gives no heat.
B. It *can't* do that.
A. Well things being thus, [I'm beat.]
 Let's—(*tois therapoisi koinos[aimetha / to pragma*)
 Whisper secretly the *pi*—(*to pi*) [for *peos*, cock][33]

The Greek *tois koinosaimetha to pragma* might better be understood to mean "if we, should
we communicate, share the plan, the plot, the 'thing,' in other words, "have sex with

the servants," which Edmonds, bowdlerizing as he does throughout, translates as "suppose the servants came to hear."[34] As they allegedly did in the history of Sparta, slaves were positioned to serve as substitute sexual partners when husbands or lovers were absent, when dildos did not satisfy, at least in the fevered, libidinous imagination of a comic female character. In Aristophanes' extant *Thesmophoriazusai*, Euripides' kinsman, disguised as a woman at a women's festival, gives voice to this very fear, in his list of Euripides' omissions concerning women's crimes: "Nor how we get banged by the slaves and mule grooms if we haven't got anyone else, he doesn't talk about that" (491–92).[35] In the comic fragment cited earlier, an imagined dildo figures in a graduated series of things and objects, in which slaves and their bodies find their place in the list of commodities at the disposal of the free.

The seventh mime of Herodas describes a trip to the workshop of Kerdon the shoemaker, who displays his fine handiwork to Metro and a friend, including a list of sixteen special types of shoes. The fifth centers on the unfaithful slave-lover of Bitinna, who jealously orders him flogged, then tattooed. The slave is an unruly commodity who might choose unacceptable sexual partners and enrage his mistress; the ideal world of static, inanimate objects like shoes remains more manageable. The *olisbos*/dildo, unlike the sacred or ritual *phallos*, can be understood to figure within this cultural domain, to occur in a series of objects, object-subjects, devices for satisfying women. In a world inhabited by slaves, such commodities figure differently.

We might think again about sexuality and slavery and their intersections, about those ancient human beings who were not human in the same way as citizens or the free, who dwelt on a borderline between humans and things. There are in the ancient world some human beings without status, without standing, some bodies that are things, that blend gradually into the landscape of animals and of inanimate objects, that have property value without consciousness, without subjectivity, or whose subjectivity and consciousness represent a threat to mastery. The rhetorical representation of slaves as dildo-like sex toys works to fix them in a hierarchy of objects, not persons. Such an unfamiliar categorization of human beings and objects is polemically inscribed into ancient Greek ways of thinking about politics, others, bodies and mastery, material existence, sexual acts, and the objects of the material world. The dildo, a representation, a simulacrum of a human body part, is for the Greeks not a fetish, a veil for the castration of the female, nor a toy. Rather, it is an inanimate imitation of a part of an animate human body, in a world in which there are various kinds of bodies, those human bodies that must be tools, those human bodies that are free and master others, in sex as in all forms of activity.

What we find in the ancient dildo—invisible like slaves in modern museums, with their displays of works of high art—is not the postpsychoanalytic, queer domain of postmodern sexuality, nor a pathologized fetish of phallocracy, but rather an object at the crossing of many different networks of meaning and performance. We cannot see the ancient *olisbos* if we are bound by our own restriction of such objects to the domain of perverse or liberatory sexuality. There certainly are representations of sexual practices in antiquity, not often available for viewing in museums. They must be mapped otherwise, not simply and unproblematically identified with the objects of our own contemporary landscape, not limited to our projections of our own sexual meanings, defined by categories of perversion or queerness, but rather taking on distinct meanings in a world informed by the opposition between slave and free.

Notes

1 Michel Foucault, *The History of Sexuality*, vol. 2, *The Use of Pleasure*, trans. R. Hurley (New York: Vintage Books, 1990). Negative reactions included A. Richlin, "Zeus and Metis: Foucault, Feminism, Classics," *Helios* 18 (1991): 160–80; B. Thornton, "Constructionism and Ancient Greek Sex," *Helios* 18 (1991): 181–93; and more recently, James Davidson, *Courtesans and Fishcakes: The Consuming Passions of Classical Athens* (New York: HarperCollins, 1997), xxi–xxv, 313–14. The most prominent advocate of a Foucauldian perspective on Greek antiquity has been David Halperin; see *One Hundred Years of Homosexuality and Other Essays on Greek Love* (New York: Routledge, 1990) and *Saint Foucault* (New York: Oxford University Press, 1995).

2 Michel Foucault, *The History of Sexuality*, vol. 3, *The Care of the Self*, trans. Robert Hurley (New York: Pantheon Books, 1986).

3 See the works in the bibliography by Jean-Pierre Vernant, Pierre Vidal-Naquet, Nicole Loraux, Marcel Detienne, and Francois Lissarrague. [Note 3 not applicable in this volume.]

4 See, for example, *Before Sexuality: The Construction of Erotic Experience in the Ancient Greek World*, ed. D. Halperin, J. J. Winkler, and F. I. Zeitlin (Princeton, NJ: Princeton University Press, 1990), in which slaves rarely figure.

5 Michel Foucault, *The Order of Things: An Archaeology of the Human Sciences* (New York: Pantheon Books, 1971), xv.

6 John Maxwell Edmonds, *The Fragments of Attic Comedy*, vol. 1 (Leiden: E. J. Brill, 1957).

7 Jeffrey Henderson, *The Maculate Muse: Obscene Language in Attic Comedy* (New Haven, Conn.: Yale University Press, 1975), 124.

8 Eva Keuls, *The Reign of the Phallus* (New York: Harper and Row, 1985).

9 See Alan Bray, *Homosexuality in Renaissance England* (London: Gay Men's Press, 1982); Jonathan Goldberg, ed., *Queering the Renaissance* (Durham, NC: Duke University Press, 1994), and *Sodometries: Renaissance Texts, Modern Sexualities* (Stanford, Calif.: Stanford University Press, 1992); Halperin, *One Hundred Years of Homosexuality*.

10 H. G. Liddell and Robert Scott, comps., *A Greek-English Lexicon*, 9th rev. ed., by H. S. Jones (Oxford: Oxford University Press, 1948) (1st ed. 1843).

11 Sigmund Freud, "Fetishism," in *The Standard Edition of the Complete Psychological Works* (London: Hogarth Press and the Institute of Psycho-Analysis, 1953–73). See also *Fetishism as Cultural Discourse?*, ed. B. Pietz and E. Apter (Ithaca, NY: Cornell University Press, 1993).

12 Davidson, in *Courtesans and Fishcakes*, is critical of such an emphasis on penetration and domination (169ff.): "This theory has been overstated and presents a model of Athenian society which is not only simplistic and overschematic but quite misleading" (169). He focuses on the complexity of relations, "a nexus of exchanged values involving love, gifts, desirability and favours" (ibid.).

13 On plow and stilus, see Page DuBois, *Sowing the Body: Psychoanalysis and Ancient Representations of Women* (Chicago: University of Chicago Press, 1988).

14 Henderson, *The Maculate Muse*.

15 Jürgen Habermas, "The Public Sphere," in *Jürgen Habermas on Society and Politics: A Reader*, ed. Steven Seidman (Boston: Beacon Press, 1989), 231.

16 David A. Campbell, ed. and trans., *Greek Lyric I, Sappho and Alcaeus*, Loeb Classical Library Series (Cambridge, Mass.: Harvard University Press, 1982).

17 Denys Page, *Sappho and Alcaeus* (Oxford: Oxford University Press, 1955), 144.

18 See Joan DeJean, *Fictions of Sappho, 1546–1937* (Chicago: University of Chicago Press, 1989); Page duBois, *Sappho Is Burning* (Chicago: University of Chicago Press, 1995).

19 *Plektidzomai*, "bandy blows," can mean "toy amorously," as at Aristophanes *Ekkleziadzousai* 964, Herodas *Mimiambi* 5.29 (LSJ).

20 M. L. West, "Burning Sappho," *Maia* 22 (1970): 307–33; Giuseppe Giangrande, "Sappho and the *Olisbos*," *Emerita* 48 (1980): 249–50.

21 See A. Guarino, "Professorenerotismus," *Labeo* 27 (1981): 439–40, and the response, Giuseppe Giangrande, "A che serviva l' 'olisbos' di Saffo?," *Labeo* 29 (1983): 154–55. K. J. Dover believes that if *olisbodokoisi* is the proper reading of the text, it is "tantalising but perhaps not important" to our understanding of Greek female homosexuality, because the olisbos "is associated essentially with solitary female masturbation." K. J. Dover, *Greek Homosexuality* (Oxford: Oxford University Press, 1978), 176, n. 9.

22 Giuseppe Giangrande, "Emendations to Callimachus," *Classical Quarterly*, n.s., 12 (1962): 212–22.

23 Campbell, *Greek Lyric I, Sappho and Alcaeus*, 125 n. 3.

24 *Aristophanes*, vol. 3, ed. and trans. Jeffrey Henderson, Loeb Classical Library Series (Cambridge, Mass.: Harvard University Press, 2000). Even in 1964, Douglass Parker, a refreshingly direct translator for his day, dodges the obscenity: "Lovers can't be had for love or money, / not even synthetics. Why, since those beastly Milesians / revolted and cut off the leather trade, that handy / do-it-yourself kit's vanished from the open market."

 Aristophanes, *Four Comedies*, trans. Douglass Parker (Ann Arbor: University of Michigan Press, 1969), 24 (Parker assigns this speech to "Kleonike.") See also Aristophanes, *Lysistrata*, ed. Jeffrey Henderson (Oxford: Oxford University Press, 1987).

25 Henderson, *The Maculate Muse*, 133.

26 Other mentions of dildos by ancient writers include the comic writer Sophron 24, *solenes*, for pipes and dildos; the *likhneuma* of widows, *gerra Naxia* (Epicharmus 174), for phallus, according to Henderson "a usage probably taken from the cult of Aphrodite at Naxos" (*The Maculate Muse*, 25), incidentally supporting Giangrande's argument ("Emendations to Callimachus") about the *gerra* in Callimachus. In an interesting passage from Eubulus (75.10), pastry is personified as the wife of Pluto, and the finger is compared to "the ramming beak of a trireme": "Demeter's girl, when kneaded, has a hollow cleft—like the swath of a trireme—made in her by the finger's poking: the excellent precursor to a meal!" Here the act of penetration is made equivalent both to the pastry cook's act of kneading, and the ramming action of a warship.

27 Henderson, *The Maculate Muse*, 111.

28 See duBois, *Sowing the Body*.

29 Edmonds, *The Fragments of Attic Comedy*, 1:132–33. The Herodotus passage reads as follows: "After the battle (of Salamis) the Greeks towed over to Salamis all the disabled vessels which were adrift in the neighbourhood, and then prepared for a renewal of the fight, fully expecting that Xerxes would use his remaining ships to make another attack. Many of the disabled vessels and other wreckage were carried by the westerly wind to a part of the Attic coast called Colias, and in this way it came about that not only the prophecies of Bacis and Musaeus about this battle were fulfilled, but also another prophecy which had been uttered many years previously by an Athenian soothsayer named Lysistratus: the words of this one were, "The Colian women shall cook their food with oars." Herodotus 8.96 (*The Histories*, rev. A. R. Burn and trans. A. de Selincourt [Harmondsworth, England: Penguin Books, 1972], 555).

30 Herodas, *Mimiambi*, ed. I. C. Cunningham (Oxford: Oxford University Press, 1971), 6.17–19; translation from Herodas, *The Mimes and Fragments*, with notes by W. Headlam, ed. A. D. Knox (Cambridge: Cambridge University Press, 1922).

31 Maurice Olender, "Aspects of Baubo: Ancient Texts and Contexts," in *Before Sexuality: The Construction of Erotic Experience in the Ancient Greek World*, ed. D. Halperin, J. J. Winkler, and F. I. Zeitlin (Princeton, N.J.: Princeton University Press, 1990), 83. On Gorgo-

Baubo, see also J.-P. Vernant, *La mort dans les yeux. Figures de l'autre en Grèce ancienne* (Paris: Hachette, 1985).

32 For a mining of this and other texts on pleasure, see Davidson, *Courtesans and Fishcakes.*

33 Edmonds, *The Fragments of Attic Comedy*, 1:948–51.

34 On sex with slaves, especially helots, a more permissible form of intercourse in the Greek imaginary, see Pierre Vidal-Naquet, "Slavery and the Rule . . . Myth and Utopia," in *Myth, Religion and Society: Structuralist Essays*, ed. R. L. Gordon (Cambridge: Cambridge University Press, 1981), 187–200.

35 Aristophanes, *Birds, Lysistrata, Women at the Thesmophoria*, trans. J. Henderson, Loeb Classical Library Series (Cambridge, Mass.: Harvard University Press, 2000).

PART II

Thing

Martin Heidegger

THE THING

ALL DISTANCES IN TIME AND SPACE ARE SHRINKING. Man now reaches overnight, by plane, places which formerly took weeks and months of travel. He now receives instant information, by radio, of events which he formerly learned about only years later, if at all. The germination and growth of plants, which remained hidden throughout the seasons, is now exhibited publicly in a minute, on film. Distant sites of the most ancient cultures are shown on film as if they stood this very moment amidst today's street traffic. Moreover, the film attests to what it shows by presenting also the camera and its operators at work. The peak of this abolition of every possibility of remoteness is reached by television, which will soon pervade and dominate the whole machinery of communication.

Man puts the longest distances behind him in the shortest time. He puts the greatest distances behind himself and thus puts everything before himself at the shortest range.

Yet the frantic abolition of all distances brings no nearness; for nearness does not consist in shortness of distance. What is least remote from us in point of distance, by virtue of its picture on film or its sound on the radio, can remain far from us. What is incalculably far from us in point of distance can be near to us. Short distance is not in itself nearness. Nor is great distance remoteness.

What is nearness if it fails to come about despite the reduction of the longest distances to the shortest intervals? What is nearness if it is even repelled by the restless abolition of distances? What is nearness if, along with its failure to appear, remoteness also remains absent?

What is happening here when, as a result of the abolition of great distances, everything is equally far and equally near? What is this uniformity in which everything is neither far nor near—is, as it were, without distance?

Everything gets lumped together into uniform distancelessness. How? Is not this

merging of everything into the distanceless more unearthly than everything bursting apart?

Man stares at what the explosion of the atom bomb could bring with it. He does not see that the atom bomb and its explosion are the mere final emission of what has long since taken place, has already happened. Not to mention the single hydrogen bomb, whose triggering, thought through to its utmost potential, might be enough to snuff out all life on earth. What is this helpless anxiety still waiting for, if the terrible has already happened?

The terrifying is unsettling; it places everything outside its own nature. What is it that unsettles and thus terrifies? It shows itself and hides itself in the *way* in which everything presences, namely, in the fact that despite all conquest of distances the nearness of things remains absent.

What about nearness? How can we come to know its nature? Nearness, it seems, cannot be encountered directly. We succeed in reaching it rather by attending to what is near. Near to us are what we usually call things. But what is a thing? Man has so far given no more thought to the thing as a thing than he has to nearness. The jug is a thing. What is the jug? We say: a vessel, something of the kind that holds something else within it. The jug's holding is done by its base and sides. This container itself can again be held by the handle. As a vessel the jug is something self-sustained, something that stands on its own. This standing on its own characterizes the jug as something that is self-supporting, or independent. As the self-supporting independence of something independent, the jug differs from an object. An independent, self-supporting thing may become an object if we place it before us, whether in immediate perception or by bringing it to mind in a recollective re-presentation. However, the thingly character of the thing does not consist in its being a represented object, nor can it be defined in any way in terms of the objectness, the over-againstness, of the object.

The jug remains a vessel whether we represent it in our minds or not. As a vessel the jug stands on its own as self-supporting. But what does it mean to say that the container stands on its own? Does the vessel's self-support alone define the jug as a thing? Clearly the jug stands as a vessel only because it has been brought to a stand. This happened during, and happens by means of, a process of setting, of setting forth, namely, by producing the jug. The potter makes the earthen jug out of earth that he has specially chosen and prepared for it. The jug consists of that earth. By virtue of what the jug consists of, it too can stand on the earth, either immediately or through the mediation of table and bench. What exists by such producing is what stands on its own, is self-supporting. When we take the jug as a made vessel, then surely we are apprehending it—so it seems—as a thing and never as a mere object.

Or do we even now still take the jug as an object? Indeed. It is, to be sure, no longer considered only an object of a mere act of representation, but in return it is an object which a process of making has set up before and against us. Its self-support seems to mark the jug as a thing. But in truth we are thinking of this self-support in terms of the making process. Self-support is what the making aims at. But even so, the self-support is still thought of in terms of objectness, even though the over-againstness of what has been put forth is no longer grounded in mere representation, in the mere putting it before our minds. But from the objectness of the object, and from the product's self-support, there is no way that leads to the thingness of the thing.

What in the thing is thingly? What is the thing in itself? We shall not reach the thing in itself until our thinking has first reached the thing as a thing.

The jug is a thing as a vessel—it can hold something. To be sure, this container has to be made. But its being made by the potter in no way constitutes what is peculiar and proper to the jug insofar as it is *qua* jug. The jug is not a vessel because it was made; rather, the jug had to be made because it is this holding vessel.

The making, it is true, lets the jug come into its own. But that which in the jug's nature is its own is never brought about by its making. Now released from the making process, the self-supporting jug has to gather itself for the task of containing. In the process of its making, of course, the jug must first show its outward appearance to the maker. But what shows itself here, the aspect (the *eidos*, the *idea*), characterizes the jug solely in the respect in which the vessel stands over against the maker as something to be made.

But what the vessel of this aspect *is* as this jug, what and how the jug *is* as this jug-thing, is something we can never learn—let alone think properly—by looking at the outward appearance, the *idea*. That is why Plato, who conceives of the presence of what is present in terms of the outward appearance, had no more understanding of the nature of the thing than did Aristotle and all subsequent thinkers. Rather, Plato experienced (decisively, indeed, for the sequel) everything present as an object of making. Instead of "object"—as that which stands before, over against, opposite us—we use the more precise expression "what stands forth." In the full nature of what stands forth, a two-fold standing prevails. First, standing forth has the sense of stemming from somewhere, whether this be a process of self-making or of being made by another. Secondly, standing forth has the sense of the made thing's standing forth into the unconcealedness of what is already present.

Nevertheless, no representation of what is present, in the sense of what stands forth and of what stands over against as an object, ever reaches to the thing *qua* thing. The jug's thingness resides in its being *qua* vessel. We become aware of the vessel's holding nature when we fill the jug. The jug's bottom and sides obviously take on the task of holding. But not so fast! When we fill the jug with wine, do we pour the wine into the sides and bottom? At most, we pour the wine between the sides and over the bottom. Sides and bottom are, to be sure, what is impermeable in the vessel. But what is impermeable is not yet what does the holding. When we fill the jug, the pouring that fills it flows into the empty jug. The emptiness, the void, is what does the vessel's holding. The empty space, this nothing of the jug, is what the jug is as the holding vessel.

But the jug does consist of sides and bottom. By that of which the jug consists, it stands. What would a jug be that did not stand? At least a jug *manqué* hence a jug still—namely, one that would indeed hold but that, constantly falling over, would empty itself of what it holds. Only a vessel, however, can empty itself.

Sides and bottom, of which the jug consists and by which it stands, are not really what does the holding. But if the holding is done by the jug's void, then the potter who forms sides and bottom on his wheel does not, strictly speaking, make the jug. He only shapes the clay. No—he shapes the void. For it, in it, and out of it, he forms the clay into the form. From start to finish the potter takes hold of the impalpable void and brings it forth as the container in the shape of a containing vessel. The jug's void determines all the handling in the process of making the vessel. The vessel's thingness does not lie at all in the material of which it consists, but in the void that holds.

And yet, is the jug really empty?

Physical science assures us that the jug is filled with air and with everything that

goes to make up the air's mixture. We allowed ourselves to be misled by a semipoetic way of looking at things when we pointed to the void of the jug in order to define its acting as a container.

But as soon as we agree to study the actual jug scientifically, in regard to its reality, the facts turn out differently. When we pour wine into the jug, the air that already fills the jug is simply displaced by a liquid. Considered scientifically, to fill a jug means to exchange one filling for another.

These statements of physics are correct. By means of them, science represents something real, by which it is objectively controlled. But—is this reality the jug? No. Science always encounters only what *its* kind of representation has admitted beforehand as an object possible for science.

It is said that scientific knowledge is compelling. Certainly. But what does its compulsion consist in? In our instance it consists in the compulsion to relinquish the wine-filled jug and to put in its place a hollow within which a liquid spreads. Science makes the jug-thing into a nonentity in not permitting things to be the standard for what is real.

Science's knowledge, which is compelling within its own sphere, the sphere of objects, already had annihilated things as things long before the atom bomb exploded. The bomb's explosion is only the grossest of all gross confirmations of the long-since-accomplished annihilation of the thing: the confirmation that the thing as a thing remains nil. The thingness of the thing remains concealed, forgotten. The nature of the thing never comes to light, that is, it never gets a hearing. This is the meaning of our talk about the annihilation of the thing. That annihilation is so weird because it carries before it a twofold delusion: first, the notion that science is superior to all other experience in reaching the real in its reality, and second, the illusion that, notwithstanding the scientific investigation of reality, things could still be things, which would presuppose that they had once been in full possession of their thinghood. But if things ever had already shown themselves *qua* things in their thingness, then the thing's thingness would have become manifest and would have laid claim to thought. In truth, however, the thing as thing remains proscribed, nil, and in that sense annihilated. This has happened and continues to happen so essentially that not only are things no longer admitted as things, but they have never yet at all been able to appear to thinking as things.

To what is the nonappearance of the thing as thing due? Is it simply that man has neglected to represent the thing as thing to himself? Man can neglect only what has already been assigned to him. Man can represent, no matter how, only what has previously come to light of its own accord and has shown itself to him in the light it brought with it.

What, then, is the thing as thing, that its essential nature has never yet been able to appear?

Has the thing never yet come near enough for man to learn how to attend sufficiently to the thing as thing? What is nearness? We have already asked this question before. To learn what nearness is, we examined the jug near by.

In what does the jug-character of the jug consist? We suddenly lost sight of it—at the moment, in fact, when the illusion intruded itself that science could reveal to us the reality of the jug. We represented the effective feature of the vessel, that which does its holding, the void, as a hollow filled with air. Conceived in terms of physical science, that is what the void really is; but it is not the jug's void. We did not let the jug's void be *its* own void. We paid no heed to that in the vessel which does the containing. We have

given no thought to how the containing itself goes on. Accordingly, even what the jug contains was bound to escape us. In the scientific view, the wine became a liquid, and liquidity in turn became one of the states of aggregation of matter, possible everywhere. We failed to give thought to what the jug holds and how it holds.

How does the jug's void hold? It holds by taking what is poured in. It holds by keeping and retaining what it took in. The void holds in a twofold manner: taking and keeping. The word "hold" is therefore ambiguous. Nevertheless, the taking of what is poured in and the keeping of what was poured belong together. But their unity is determined by the outpouring for which the jug is fitted as a jug. The twofold holding of the void rests on the outpouring. In the outpouring, the holding is authentically how it is. To pour from the jug is to give. The holding of the vessel occurs in the giving of the outpouring. Holding needs the void as that which holds. The nature of the holding void is gathered in the giving. But giving is richer than a mere pouring out. The giving, whereby the jug is a jug, gathers in the twofold holding—in the outpouring. We call the gathering of the twofold holding into the outpouring, which, as a being together, first constitutes the full presence of giving: the poured gift. The jug's jug-character consists in the poured gift of the pouring out. Even the empty jug retains its nature by virtue of the poured gift, even though the empty jug does not admit of a giving out. But this nonadmission belongs to the jug and to it alone. A scythe, by contrast, or a hammer is incapable of a nonadmission of this giving.

The giving of the outpouring can be a drink. The outpouring gives water, it gives wine to drink.

The spring stays on in the water of the gift. In the spring the rock dwells, and in the rock dwells the dark slumber of the earth, which receives the rain and dew of the sky. In the water of the spring dwells the marriage of sky and earth. It stays in the wine given by the fruit of the vine, the fruit in which the earth's nourishment and the sky's sun are betrothed to one another. In the gift of water, in the gift of wine, sky and earth dwell. In the gift of the outpouring is what makes the jug a jug. In the jugness of the jug, sky and earth dwell.

The gift of the pouring out is drink for mortals. It quenches their thirst. It refreshes their leisure. It enlivens their conviviality. But the jug's gift is at times also given for consecration. If the pouring is for consecration, then it does not still a thirst. It stills and elevates the celebration of the feast. The gift of the pouring now is neither given in an inn nor is the poured gift a drink for mortals. The outpouring is the libation poured out for the immortal gods. The gift of the outpouring as libation is the authentic gift. In giving the consecrated libation, the pouring jug occurs as the giving gift. The consecrated libation is what our word for a strong outpouring flow, "gush," really designates: gift and sacrifice. "Gush," Middle English *guschen*, *gosshen*—cf. German *Guss*, *giessen*— is the Greek *cheein*, the Indoeuropean *ghu*. It means to offer in sacrifice. To pour a gush, when it is achieved in its essence, thought through with sufficient generosity, and genuinely uttered, is to donate, to offer in sacrifice, and hence to give. It is only for this reason that the pouring of the gush, once its nature withers, can become a mere pouring in and pouring out, until it finally decays into the dispensing of liquor at the bar. Pouring the outpour is not a mere filling and decanting.

In the gift of the outpouring that is drink, mortals stay in their own way. In the gift of the outpouring that is a libation, the divinities stay in their own way, they who receive back the gift of giving as the gift of the donation. In the gift of the outpouring,

mortals and divinities each dwell in their different ways. Earth and sky dwell in the gift of the outpouring. In the gift of the outpouring earth and sky, divinities and mortals dwell *together all at once*. These four, at one because of what they themselves are, belong together. Preceding everything that is present, they are enfolded into a single fourfold.

In the gift of the outpouring dwells the simple singlefoldness of the four.[1]

The gift of the outpouring is a gift because it stays earth and sky, divinities and mortals. Yet staying is now no longer the mere persisting of something that is here. Staying appropriates. It brings the four into the light of their mutual belonging. From out of staying's simple onefoldness they are betrothed, entrusted to one another. At one in thus being entrusted to one another, they are unconcealed. The gift of the outpouring stays the onefold of the fourfold of the four. And in the poured gift the jug presences as jug. The gift gathers what belongs to giving: the twofold containing, the container, the void, and the outpouring as donation. What is gathered in the gift gathers itself in appropriatively staying the fourfold. This manifold-simple gathering is the jug's presencing. Our language denotes what a gathering *is* by an ancient word. That word is: thing. The jug's presencing is the pure, giving gathering of the onefold fourfold into a single time-space, a single stay. The jug presences as a thing. The jug is the jug as a thing. But how does the thing presence? The thing things. Thinging gathers. Appropriating the fourfold, it gathers the fourfold's stay, its while, into something that stays for a while: into this thing, that thing.

The jug's essential nature, its presencing, so experienced and thought of in these terms, is what we call *thing*. We are now thinking this word by way of the gathering-appropriating staying of the fourfold. At the same time we recall the Old High German word *thing*. This reference to the history of language could easily tempt us to misunderstand the way in which we are now thinking of the nature of the thing. It might look as though the nature of the thing as we are now thinking of it had been, so to speak, thoughtlessly poked out of the accidentally encountered meaning of the Old High German *thing*. The suspicion arises that the understanding of the nature of the thingness that we are here trying to reach may be based on the accidents of an etymological game. The notion becomes established and is already current that, instead of giving thought to essential matters, we are here merely using the dictionary.

The opposite is true. To be sure, the Old High German word *thing* means a gathering, and specifically a gathering to deliberate on a matter under discussion, a contested matter. In consequence, the Old German words *thing* and *dinc* become the names for an affair or matter of pertinence. They denote anything that in any way bears upon men, concerns them, and that accordingly is a matter for discourse. The Romans called a matter for discourse *res*. The Greek *eiro* (*rhetos, rhetra, rhema*) means to speak about something, to deliberate on it. *Res publica* means, not the state, but that which, known to everyone, concerns everybody and is therefore deliberated in public.

Only because *res* means what concerns men are the combinations *res adversae, res secundae* possible. The first is what affects or bears on man adversely, the second what attends man favorably. The dictionaries, to be sure, translate *res adversae* correctly as bad fortune, *res secundae* as good fortune; but dictionaries have little to report about what words, spoken thoughtfully, say. The truth, then, here and elsewhere, is not that our thinking feeds on etymology, but rather that etymology has the standing mandate first to give thought to the essential content involved in what dictionary words, as words, denote by implication.

The Roman word *res* designates that which concerns somebody, an affair, a contested matter, a case at law. The Romans also use for it the word *causa*. In its authentic and original sense, this word in no way signifies "cause"; *causa* means the case and hence also that which is the case, in the sense that something comes to pass and becomes due. Only because *causa*, almost synonymously with *res*, means the case, can the word *causa* later come to mean cause, in the sense of the causality of an effect. The Old German word *thing* or *dinc*, with its meaning of a gathering specifically for the purpose of dealing with a case or matter, is suited as no other word to translate properly the Roman word *res*, that which is pertinent, which has a bearing. From that word of the Roman language, which there corresponds to the word *res*—from the word *causa* in the sense of case, affair, matter of pertinence—there develop in turn the Romance *la cosa* and the French *la chose*; we say, "the thing." In English "thing" has still preserved the full semantic power of the Roman word: "He knows his things," he understands the matters that have a bearing on him; "He knows how to handle things," he knows how to go about dealing with affairs, that is, with what matters from case to case; "That's a great thing," that is something grand (fine, tremendous, splendid), something that comes of itself and bears upon man.

But the decisive point now is not at all the short semantic history here given of the words *res, Ding, causa, cosa, chose,* and *thing,* but something altogether different, to which no thought whatever has hitherto been given. The Roman word *res* denotes what pertains to man, concerns him and his interests in any way or manner. That which concerns man is what is real in *res*. The Roman experience of the *realitas* of *res* is that of a bearing-upon, a concern. But the Romans never properly thought through the nature of what they thus experienced. Rather, the Roman *realitas* of *res* is conceived in terms of the meaning of *on* which they took over from late Greek philosophy; *on*, Latin *ens*, means that which is present in the sense of standing forth here. *Res* becomes *ens*, that which is present in the sense of what is put here, put before us, presented. The peculiar *realitas* of *res* as originally experienced by the Romans, a bearing-upon or concern, i.e., the very nature of that which is present, remains buried. Conversely, in later times, especially in the Middle Ages, the term *res* serves to designate every *ens qua ens*, that is, everything present in any way whatever, even if it stands forth and presences only in mental representation as an *ens rationis*. The same happens with the corresponding term *thing* or *dinc;* for these words denote anything whatever that is in any way. Accordingly Meister Eckhart uses the word *thing* (*dinc*) for God as well as for the soul. God is for him the "highest and uppermost thing." The soul is a "great thing." This master of thinking in no way means to say that God and the soul are something like a rock: a material object. *Thing* is here the cautious and abstemious name for something that is at all. Thus Meister Eckhart says, adopting an expression of Dionysius the Areopagite: *diu minne ist der natur, daz si den menschen wandelt in die dinc, di er minnet*—love is of such a nature that it changes man into the things he loves.

Because the word *thing* as used in Western metaphysics denotes that which is at all and is something in some way or other, the meaning of the name "thing" varies with the interpretation of that which is—of entities. Kant talks about things in the same way as Meister Eckhart and means by this term something that is. But for Kant, that which is becomes the object of a representing that runs its course in the self-consciousness of the human ego. The thing-in-itself means for Kant: the object-in-itself. To Kant, the character of the "in-itself" signifies that the object is an object in itself without reference to the

human act of representing it, that is, without the opposing "ob-" by which it is first of all put before this representing act. "Thing-in-itself," thought in a rigorously Kantian way, means an object that is no object for us, because it is supposed to stand, stay put, without a possible before: for the human representational act that encounters it.

Neither the general, long outworn meaning of the term "thing," as used in philosophy, nor the Old High German meaning of the word *thing*, however, are of the least help to us in our pressing need to discover and give adequate thought to the essential source of what we are now saying about the nature of the jug. However, *one* semantic factor in the old usage of the word *thing*, namely "gathering," does speak to the nature of the jug as we earlier had it in mind.

The jug is a thing neither in the sense of the Roman *res*, nor in the sense of the medieval *ens*, let alone in the modern sense of object. The jug is a thing insofar as it things. The presence of something present such as the jug comes into its own, appropriatively manifests and determines itself, only from the thinging of the thing.

Today everything present is equally near and equally far. The distanceless prevails. But no abridging or abolishing of distances brings nearness. What is nearness? To discover the nature of nearness, we gave thought to the jug near by. We have sought the nature of nearness and found the nature of the jug as a thing. But in this discovery we also catch sight of the nature of nearness. The thing things. In thinging, it stays earth and sky, divinities and mortals. Staying, the thing brings the four, in their remoteness, near to one another. This bringing-near is nearing. Nearing is the presencing of nearness. Nearness brings near—draws nigh to one another—the far and, indeed, *as* the far. Nearness preserves farness. Preserving farness, nearness presences nearness in nearing that farness. Bringing near in this way, nearness conceals its own self and remains, in its own way, nearest of all.

The thing is not "in" nearness, "in" proximity, as if nearness were a container. Nearness is at work in bringing near, as the thinging of the thing.

Thinging, the thing stays the united four, earth and sky, divinities and mortals, in the simple onefold of their self-unified fourfold.

Earth is the building bearer, nourishing with its fruits, tending water and rock, plant and animal.

When we say earth, we are already thinking of the other three along with it by way of the simple oneness of the four.

The sky is the sun's path, the course of the moon, the glitter of the stars, the year's seasons, the light and dusk of day, the gloom and glow of night, the clemency and inclemency of the weather, the drifting clouds and blue depth of the ether.

When we say sky, we are already thinking of the other three along with it by way of the simple oneness of the four.

The divinities are the beckoning messengers of the godhead. Out of the hidden sway of the divinities the god emerges as what he is, which removes him from any comparison with beings that are present.

When we speak of the divinities, we are already thinking of the other three along with them by way of the simple oneness of the four.

The mortals are human beings. They are called mortals because they can die. To die means to be capable of death as death. Only man dies. The animal perishes. It has death neither ahead of itself nor behind it. Death is the shrine of Nothing, that is, of that which in every respect is never something that merely exists, but which nevertheless

presences, even as the mystery of Being itself. As the shrine of Nothing, death harbors within itself the presencing of Being. As the shrine of Nothing, death is the shelter of Being. We now call mortals mortals—not because their earthly life comes to an end, but because they are capable of death as death. Mortals are who they are, as mortals, present in the shelter of Being. They are the presencing relation to Being as Being.

Metaphysics, by contrast, thinks of man as *animal*, as a living being. Even when *ratio* pervades *animalitas*, man's being remains defined by life and life-experience. Rational living beings must first *become* mortals.

When we say mortals, we are then thinking of the other three along with them by way of the simple oneness of the four.

Earth and sky, divinities and mortals—being at one with one another of their own accord—belong together by way of the simpleness of the united fourfold. Each of the four mirrors in its own way the presence of the others. Each therewith reflects itself in its own way into its own, within the simpleness of the four. This mirroring does not portray a likeness. The mirroring, lightening each of the four, appropriates their own presencing into simple belonging to one another. Mirroring in this appropriating-lightening way, each of the four plays to each of the others. The appropriative mirroring sets each of the four free into its own, but it binds these free ones into the simplicity of their essential being toward one another.

The mirroring that binds into freedom is the play that betroths each of the four to each through the enfolding clasp of their mutual appropriation. None of the four insists on its own separate particularity. Rather, each is expropriated, within their mutual appropriation, into its own being. This expropriative appropriating is the mirror-play of the fourfold. Out of the fourfold, the simple onefold of the four is ventured.

This appropriating mirror-play of the simple onefold of earth and sky, divinities and mortals, we call the world. The world presences by worlding. That means: the world's worlding cannot be explained by anything else nor can it be fathomed through anything else. This impossibility does not lie in the inability of our human thinking to explain and fathom in this way. Rather, the inexplicable and unfathomable character of the world's worlding lies in this, that causes and grounds remain unsuitable for the world's world-ing. As soon as human cognition here calls for an explanation, it fails to transcend the world's nature, and falls short of it. The human will to explain just does not reach to the simpleness of the simple onefold of worlding. The united four are already strangled in their essential nature when we think of them only as separate realities, which are to be grounded in and explained by one another.

The unity of the fourfold is the fouring. But the fouring does not come about in such a way that it encompasses the four and only afterward is added to them as that compass. Nor does the fouring exhaust itself in this, that the four, once they are there, stand side by side singly.

The fouring, the unity of the four, presences as the appropriating mirror-play of the betrothed, each to the other in simple oneness. The fouring presences as the world-ing of world. The mirror-play of world is the round dance of appropriating. Therefore, the round dance does not encompass the four like a hoop. The round dance is the ring that joins while it plays as mirroring. Appropriating, it lightens the four into the radi-ance of their simple oneness. Radiantly, the ring joins the four, everywhere open to the riddle of their presence. The gathered presence of the mirror-play of the world, joining in this way, is the ringing. In the ringing of the mirror-playing ring, the four nestle into

their unifying presence, in which each one retains its own nature. So nestling, they join together, worlding, the world.

Nestling, malleable, pliant, compliant, nimble—in Old German these are called *ring* and *gering*. The mirror-play of the worlding world, as the ringing of the ring, wrests free the united four into their own compliancy, the circling compliancy of their presence. Out of the ringing mirror-play the thinging of the thing takes place.

The thing stays—gathers and unites—the fourfold. The thing things world. Each thing stays the fourfold into a happening of the simple onehood of world.

If we let the thing be present in its thinging from out of the worlding world, then we are thinking of the thing as thing. Taking thought in this way, we let ourselves be concerned by the thing's worlding being. Thinking in this way, we are called by the thing as the thing. In the strict sense of the German word *bedingt*, we are the be-thinged, the conditioned ones. We have left behind us the presumption of all unconditionedness.

If we think of the thing as thing, then we spare and protect the thing's presence in the region from which it presences. Thinging is the nearing of world. Nearing is the nature of nearness. As we preserve the thing *qua* thing we inhabit nearness. The nearing of nearness is the true and sole dimension of the mirror-play of the world.

The failure of nearness to materialize in consequence of the abolition of all distances has brought the distanceless to dominance. In the default of nearness the thing remains annihilated as a thing in our sense. But when and in what way do things exist as things? This is the question we raise in the midst of the dominance of the distanceless.

When and in what way do things appear as things? They do not appear *by means of human making*. But neither do they appear without the vigilance of mortals. The first step toward such vigilance is the step back from the thinking that merely represents— that is, explains—to the thinking that responds and recalls.

The step back from the one thinking to the other is no mere shift of attitude. It can never be any such thing for this reason alone: that all attitudes, including the ways in which they shift, remain committed to the precincts of representational thinking. The step back does, indeed, depart from the sphere of mere attitudes. The step back takes up its residence in a co-responding which, appealed to in the world's being by the world's being, answers within itself to that appeal. A mere shift of attitude is powerless to bring about the advent of the thing as thing, just as nothing that stands today as an object in the distanceless can ever be simply switched over into a thing. Nor do things as things ever come about if we merely avoid objects and recollect former objects which perhaps were once on the way to becoming things and even to actually presencing as things.

Whatever becomes a thing occurs out of the ringing of the world's mirror-play. Only when—all of a sudden, presumably—world worlds as a world, only then does the ring shine forth, the joining from which the ringing of earth and heaven, divinities and mortals, wrests itself free for that compliancy of simple oneness.

In accordance with this ring thinging itself is unpretentious, and each present thing, modestly compliant, fits into its own being. Inconspicuously compliant is the thing: the jug and the bench, the footbridge and the plow. But tree and pond, too, brook and hill, are things, each in its own way. Things, each thinging from time to time in its own way, are heron and roe, deer horse and bull. Things, each thinging and each staying in its own way, are mirror and clasp, book and picture, crown and cross.

But things are also compliant and modest in number, compared with the countless

objects everywhere of equal value, compared with the measureless mass of men as living beings.

Men alone, as mortals, by dwelling attain to the world as world. Only what conjoins itself out of world becomes a thing.

Note

1 The German *Einfalt* means simplicity, literally onefoldedness.—TR.

Elizabeth Grosz

THE THING

> Philosophy should be an effort to go beyond the human state.
> Henri Bergson, *The Creative Mind: An Introduction to Metaphysics*

Things

THE THING GOES BY MANY NAMES. Indeed the very label, "the thing," is only a recent incarnation of a series of terms which have an illustrious philosophical history: the object, matter, substance, the world, noumena, reality, appearance, and so on. In the period of the Enlightenment, from Descartes to Kant, the thing became that against which we measured ourselves and our limits, the mirror of what we are not. While rare, anomalous readings of the thing emerge in post-Kantian philosophy, it is primarily associated with inert materiality. Much more recently, since the cold war, it has been associated, through this alienation from the subject, with an animated and potentially malevolent materiality, a biological materiality that is or may be the result of our unknowing (usually atomic or nuclear) intervention into nature, the revenge of the blob, of protoplasm, of radiated existence, which imperils man. Nevertheless, through these various permutations, the thing remains identified with immanence, with what we are capable of overcoming, albeit with the input of a technological supersession of the body and its reemergence in virtual form.[1] But instead of outlining *this* history, paying homage to the great thinkers of the thing, and particularly to the scientists who devoted their intellectual labors to unraveling its properties and deciphering the laws regulating its relations (the thing has become the property of the intellect and of science), I am seeking an altogether different lineage, one in which the thing is not conceived as the other, or binary double, of the subject, the self, embodiment, or consciousness, but as its condition and the resource for the subject's being and enduring. Instead of turning to Descartes or his hero, Newton, to understand things and the

laws governing them, we must instead begin with Darwin and his understanding of the thing—the dynamism of the active world of natural selection—as that which provides the obstacle, the question, the means, by which life itself grows, develops, undergoes evolution and change, becomes other than what it once was. The thing is the provocation of the nonliving, the half-living, or that which has no life, to the living, to the potential of and for life.

The thing in itself is not, as Kant suggested, noumenal, that which lies behind appearances and which can never appear as such, that which we cannot know or perceive. Rather, if we follow Darwin, the thing is the real that we both find and make. The thing has a history: it is not simply a passive inertia against which we measure our own activity. It has a "life" of its own, characteristics of its own, which we must incorporate into our activities in order to be effective, rather than simply understand, regulate, and neutralize from the outside. We need to accommodate things more than they accommodate us. Life is the growing accommodation of matter, the adaptation of the needs of life to the exigencies of matter. It is matter, the thing, that produces life; it is matter, the thing, which sustains and provides life with its biological organization and orientation; and it is matter, the thing, that requires life to overcome itself, to evolve, to become more. We find the thing in the world as our resource for making things, and in the process, for leaving our trace on things. The thing is the resource for both subjects and technology.

This Darwinian inauguration of the active thing marks the beginning of a checkered, even mongrel, philosophical history, a history that culminates in a self-consciously evolutionary orientation: the inauguration of philosophical pragmatism that meanders from Darwin, through Nietzsche, to the work of Charles Sanders Peirce, William James, Henri Bergson, and eventually, through various lines of descent, into the diverging positions of Richard Rorty, on the one hand, and Gilles Deleuze on the other. These are all, in their disparate ways, pragmatist philosophers who put the questions of action, practice, and movement at the center of ontology. What these disparate thinkers share in common is little else but an understanding of the *thing as question*, as provocation, incitement, or enigma.[2] The thing, matter already configured, generates invention, the assessment of means and ends, and thus enables practice. The thing poses questions to us, questions about our needs and desires, questions above all of action: the thing is our provocation to action and is itself the result of our action. But more significantly, while the thing functions as fundamental provocation—as that which, in the virtuality of the past and the immediacy of the present cannot be ignored—it also functions as a *promise*, as that which, in the future, in retrospect, yields a destination or effect, another thing. The thing is the precondition of the living and the human, their means of survival, and the consequence or product of life and its practical needs. The thing is the point of intersection of space and time, the locus of the temporal narrowing and spatial localization that constitutes specificity or singularity.

Space and time

The thing is born in time as well as space. It inscribes a specific duration and concrete boundaries within the broad outlines of temporal succession or flow and spatial mapping. It emerges out of and as substance. It is the coming-into-existence of a prior substance or thing, in a new time, producing beneath its processes of production a new

space and a coherent entity. The thing and the space it inscribes and produces are inaugurated at the same moment, the moment that movement is arrested, frozen, or dissected to reveal its momentary aspects, the moment that the thing and the space that surrounds it are differentiated conceptually or perceptually. The moment that movement must be reflected upon or analyzed, it yields objects and their states, distinct, localized, mappable, repeatable in principle, objects and states that become the object of measurement and containment. The depositing of movement, its divisibility, and its capacity to be seen statically are the mutual conditions of the thing and of space. The thing is positioned or located in space only because time is implicated, only because the thing is the dramatic slowing down of the movements, the atomic and molecular vibrations, that frame, contextualize, and merge with and as the thing.

The thing is the transmutation, the conversion of two into one: the conversion of the previous thing, plus the energy invested in the process of its production as a different thing, a unity or a one. The making of the thing, the thing in the process of its production as a thing, is that immeasurable process that the thing must belie and disavow to be a thing. Both James and Bergson agree that, in a certain sense, although the world exists independent of us—although there is a real that remains even when the human disappears—things as such do not exist in the real. The thing is a certain carving out of the real, the (artificial or arbitrary) division of the real into entities, bounded and contained systems, that in fact only exist as open systems within the real. James provides one of the classical pragmatic descriptions of the thing:

> What shall we call a *thing* anyhow? It seems quite arbitrary, for we carve out everything, just as we carve out constellations, to suit our human purposes. . . . The permanently real things for you [James's live audience] are your individual persons. To an anatomist, again, those persons are but organisms, and the real things are the organs. Not the organs, so much as their constituent cells, say the histologists; not the cells, but their molecules, say in turn, the chemists. . . . We break the flux of sensible reality into things, then, at our will.[3]

The thing is what we make of the world rather than simply what we find in the world, the way we are able to manage and regulate it according to our needs and purposes (even if not, as James suggests above, at will or consciously. We cannot but perceive the world in terms of objects. We do not do so as a matter of will). The thing is an outlined imposition we make on specific regions of the world so that these regions become comprehensible and facilitate our purposes and projects, even while limiting and localizing them. Things are our way of dealing with a world in which we are enmeshed rather than over which we have dominion. The thing is the compromise between the world as it is in its teeming and interminable multiplicity—a flux as James calls it, a continuum in Lacan's terms, or waves of interpenetrating vibrations in Bergson's understanding—and the world as we need it to be or would like it to be: open, amenable to intention and purpose, flexible, pliable, manipulable, passive. It is a compromise between mind and matter, the point of their crossing one into the other. It is our way of dealing with the plethora of sensations, vibrations, movements, and intensities that constitute both our world and ourselves, a practical exigency, indeed perhaps only one mode, not a necessary condition, of our acting in the world. James claims

that we have the choice of seeing the world as objects: however, we do not. Just as Kant imposed space and time as a priori intuitions, which we have no choice but to invoke and utilize, so too we must regard objects, distinguished from other objects and from a background, as necessary, if limited, conditions under which we act in the world. Space, time, and things are conceptually connected: space and time are understood to frame and contextualize the thing; they serve as its background:

> Cosmic space and cosmic time, so far from being the intuitions that Kant said they were, are constructions as patently artificial as any that science can show. The great majority of the human race never use these notions, but live in the plural times and spaces, interpenetrant and *durcheinander*.
>
> Permanent "things" again: the "same" thing and its various "appearances" and "alterations"; the different "kinds" of things; with the "kind" used finally as a "predicate" of which the thing remains the "subject"—what a straightening of the tangle of our experience's immediate flux and sensible variety does this list of terms suggest![4]

Bergson elaborates on James's position: the world as it is in its swarming complexity cannot be an object of intelligence, for it is the function of intelligence to facilitate action and practice. The possibility of action requires that objects and their relations remain as simplified as possible, as coagulated, unified, and massive as they can be so that their contours or outlines, their surfaces, most readily promote indeterminate action. We cannot but reduce this multiplicity to the order of things and states if we are to act upon and with them, and if we are to live among things and use them for our purposes. Our intellectual and perceptual faculties function most ably when dealing with solids, with states, with things, though we find ourselves at home most readily, unconsciously or intuitively, with processes and movements:

> Reality is mobile. There do not exist *things* made, but only things in the making, not *states* that remain fixed, but only states in process of change. Rest is never anything but apparent, or rather, relative. . . . *All reality is, therefore, tendency, if we agree to call tendency a nascent change of direction.*
>
> Our mind, which seeks solid bases of operation, has as its principal function, in the ordinary course of life, to imagine *states* and *things*. Now and then it takes quasi-instantaneous views of the undivided mobility of the real. It thus obtains *sensations* and *ideas*. By that means it substitutes fixed points which mark a direction of change and tendency. This substitution is necessary to common sense, to language, to practical life, and even . . . to positive science. *Our intelligence, when it follows its natural inclination, proceeds by solid perceptions on the one hand, and by stable conceptions on the other.*[5]

We stabilize masses, particles large and small, out of vibrations, waves, intensities, so we can act upon and within them, rendering the mobile and the multiple provisionally unified and singular, framing the real through things as objects for us. We actively produce objects in the world, and in so doing, we make the world amenable to our actions but also render ourselves vulnerable to their reactions. This active making is part of our engagement in the world, the directive force of our perceptual and motor relations

within the world. Our perception carves up the world and divides it into things. These things themselves are divisible, amenable to calculation and further subdivision; they are the result of a sort of subtraction: perception, intellect, cognition, and action reduce and refine the object, highlighting and isolating that which is of interest or potential relevance to our future action. To Bergson, the object is that cutting of the world that enables me to see how it meets my needs and interests: "The objects which surround my body reflect its possible action upon them."[6]

> The separation between a thing and its environment cannot be absolutely definite and clear-cut; there is a passage by insensible gradations from the one to the other: the close solidarity which binds all the objects of the material universe, the perpetuality of their reciprocal actions and reactions, is sufficient to prove that they have not the precise limits which we attribute to them. Our perception outlines, so to speak, the form of their nucleus; it terminates them at the point where our possible action upon them ceases, where, consequently, they cease to interest our needs. Such is the primary and the most apparent operation of the perceiving mind: it marks out divisions in the continuity of the extended, simply following the suggestions of our requirements and the needs of practical life.[7]

This cutting of the world, this whittling down of the plethora of the world's interpenetrating qualities, those "pervading concrete extensity, *modifications, perturbations,* changes of *tension* or of *energy* and nothing else"[8] into objects amenable to our action is fundamentally a *constructive* process: we make the world of objects as an activity we undertake by living with and assimilating objects. We make objects in order to live in the world. Or, in another, Nietzschean sense, we must live in the world artistically, not as *homo sapiens* but as *homo faber:*

> Let us start, then, from action, and lay down that the intellect aims, first of all, at constructing. This fabrication is exercised exclusively on inert matter, in this sense, that even if it makes use of organized material, it treats it as inert, without troubling about the life which animated it. And of inert matter itself, fabrication deals only with the solid; the rest escapes by its very fluidity. If, therefore, the tendency of the intellect is to fabricate, we may expect to find that whatever is fluid in the real will escape it in part, and whatever is life in the living will escape it altogether. *Our intelligence, as it leaves the hands of nature, has for its chief object the unorganized solid.*[9]

We cannot help but view the world in terms of solids, as things. But we leave behind something untapped of the fluidity of the world, the movements, vibrations, transformations that occur below the threshold of perception and calculation and outside the relevance of our practical concerns. Bergson suggests that we have other access to this rich profusion of vibrations that underlie the solidity of things.[10] Bergson describes these nonintellectual or extra-intellectual impulses as instincts and intuitions, and while they are no more able to perceive the plethora of vibrations and processes that constitute the real, they are able to discern the interconnections, rather than the separations between things, to develop another perspective or interest in the division and

production of the real. Intuition is our nonpragmatic, noneffective, nonexpedient rela-
tion to the world, the capacity we have to live in the world in excess of our needs, and
in excess of the self-presentation or immanence of materiality, to collapse ourselves, as
things, back into the world. Our "artisticness," as Nietzsche puts it, our creativity, in
Bergsonian terms, consists in nothing else than the continuous experimentation with
the world of things to produce new things from the fluidity or flux that eludes everyday
need, or use value.

Technology and the experimental

Technology, as human invention, is clearly one of the realms of "things" produced by
and as the result of the provocation of things-as-the-world. While things produce and
are what is produced by the activities of life, things themselves are the object and project
not only of the living but also of the technological. Technology is also a metaproduction:
the production of things that produce things, a second-order production. Technology is
in a sense the inevitable result of the encounter between life and matter, life and things,
the consequence of the living's capacity to utilize the nonliving (and the living) *pros-
thetically*. Technology has existed as long as the human has; the primates' capacity for
the use of found objects prefigures both the human and the technological. From the
moment the human appears as such, it appears alongside of both artifacts and technolo-
gies, poesis and techne, which are the human's modes of evolutionary fitness, the com-
pensations for its relative bodily vulnerability. According to Bergson, it is the propensity
of instinct (in animals) and intelligence (in higher primates and man) to direct them-
selves to things, and thus to the making of things, and it is the status and nature of the
instruments to which life is directed that distinguish the instincts from intelligence, yet
connect them in a developmental continuum, with intelligence functioning as an elabo-
ration of and deviation from instinct.[11]

Animals invent. They have instruments, which include their own body parts, as
well as external objects. Humans produce technologies and especially, Bergson sug-
gests, instruments that are detached and different from their own bodies, instruments
that the body must learn to accommodate, instruments that transform both the thing-
ness of things, and the body itself:

> Invention becomes complete when it is materialized in a manufactured
> instrument. Towards that achievement the intelligence of animals tends as
> towards an ideal . . . As regards human intelligence, it has not been suffi-
> ciently noted that mechanical invention has been from the first its essential
> feature, that even to-day our social life gravitates around the manufacture
> and use of artificial instruments, that the inventions which strew the road of
> progress have also traced its direction. . . . In short, *intelligence, considered in
> what seems to be its original feature, is the faculty of manufacturing artificial objects,
> especially tools to make tools, and of indefinitely varying the manufacture.*[12]

Technologies involve the invention of things that make things, of second-order things.
It is not that technologies mediate between the human and the natural—for that is to
construe technology as somehow outside either the natural or the human (which today

is precisely its misrepresented place) instead of seeing it as the indefinite extension of both the human and the natural and as their point of overlap, the point of the conversion of the one into the other, the tendency of nature to culture, and the cleaving of culture to the stuff of nature. Rather, the technological is the cultural construction of the thing that controls and regulates other things: the correlate of the natural thing. Pragmatism entails a recognition that the technological is and always has been the condition of human action, as necessary for us as things themselves, the cultural correlate of the thing, which is itself the human or living correlate of the world.

As Bergson acknowledges, while it is clumsy and cumbersome relative to the instrumentality our bodies provide us, technological invention does not succumb to a preexistent function. Although technology is in a sense made by us and for our purposes, it also performs a transformation on us: it increasingly facilitates not so much better action but wider possibilities of acting, more action. Technology is the great aid to action, for it facilitates, requires, and generates intelligence, which in turn radically multiplies our possibilities of action, our instrumental and practical relation with the world: "The essential function of intelligence is . . . to see the way out of a difficulty in any circumstances whatever, to find what is most suitable, what answers best the question asked. Hence it bears essentially on the relations between a given situation and the means of utilizing it."[13] In an extraordinary passage, Bergson claims that the intellect transforms matter into things, which render them as prostheses, artificial organs, and, in a surprising reversal, simultaneously humanizes or *orders* nature, appends itself as a kind of prosthesis to inorganic matter itself, to function as its rational or conceptual supplement, its conscious rendering. Matter and life become reflections, through the ordering the intellect makes of the world. Things become the measure of life's action upon them, things become "standing reserve," life itself becomes extended through things:

> All the elementary forces of the intellect tend to transform matter into an instrument of action, that is, in the etymological sense of the word, into an *organ*. Life, not content with producing organisms, would fain give them as an appendage inorganic matter itself, converted into an immense organ by the industry of the living being. Such is the initial task it assigns to intelligence. That is why the intellect always behaves as if it were fascinated by the contemplation of inert matter. It is life looking outward, adopting the ways of unorganized nature in principle, in order to direct them in fact.[14]

Inorganic matter, transformed into an immense organ, a prosthesis, is perhaps the primordial or elementary definition of architecture itself, which is, in a sense, the first prosthesis, the first instrumental use of intelligence to meld the world into things, through a certain primitive technicity, to fit the needs of the living. The inorganic becomes the mirror for the possible action of the living, the armature and architecture necessary for the survival and evolution of the living. Making, acting, functioning in the world, making oneself as one makes things—all these processes rely on and produce things as the correlate of the intellect, and leave behind the real out of which they were drawn and simplified.

Architecture and making

What is left out in this process of making/reflecting is all that it is in matter, all that is outside the thing and outside technology: the flux of the real,[15] duration, vibration, contractions, and dilations, the multiplicity of the real, all that is not contained by the thing or by intellectual categories. The uncontained, the outside of matter, of things, of that which is not pragmatically available for use, is the object of different actions than that of intelligence and the technological. This outside, though, is not noumenal, outside all possible experience, but phenomenal, contained within it. It is simply that which is beyond the calculable, the framed or contained. It is the outside that architecture requires but cannot contain. Bergson understands this outside in a number of ways: as the real in its totality, as mobility, as movement, flux, duration, the virtual, the continuity which places the human within and as the material. What is now in question is the making of things, and that from which things are made, rather than the things made. This is what the rigorous process of intuition draws us toward, not things themselves so much as the teeming, suffuse network within which things are formed and outlined, the flux of the real.

This teeming flux of the real—"that continuity of becoming which is reality itself,"[16] the integration and unification of the most minute relations of matter so that they exist only by touching and interpenetrating, the flow and mutual investment of material relations into each other— must be symbolized, reduced to states, things, and numeration in order to facilitate practical action. This is not an error that we commit, a fault to be unlearned, but a condition of our continuing survival in the world. We could not function within this teeming multiplicity without some ability to skeletalize it, to diagram or simplify it. Yet this reduction and division occur only at a cost, which is the failure or inability of our scientific, representational, and linguistic systems to acknowledge the in-between of things, the plural interconnections that cannot be utilized or contained within and by things but that makes them possible. Things are solids, more and more minute in their constitution, as physics itself elaborates more and more minute fundamental particles:

> Our intelligence is the prolongation of our senses. Before we speculate we must live, and life demands that we make use of matter, either with our organs, which are natural tools, or with tools, properly so-called, which are artificial organs. Long before there was a philosophy and a science, the role of intelligence was already that of manufacturing instruments and guiding the actions of our body on surrounding bodies. Science has pushed this labor of intelligence much further, but has not changed its direction. It aims above all at making us masters of matter.[17]

While the intellect masters that in the world which we need for our purposes, it is fundamentally incapable of understanding what in the world, in objects, and in us, is fluid, innumerable, outside calculation.[18] The limit of the intellect is the limit of the technical and the technological. The intellect functions to dissect, divide, atomize: contemporary binarization and digitalization are simply the current versions of this tendency to the clear-cut, the unambiguous, the oppositional or binary impulses of the intellect, which are bound by the impetus to (eventual or possible) actions. The

technological, including and especially contemporary digital technologies, carries within it both the intellectual impulse to divide relations into solids and entities, objects or things, ones and zeros, and the living impulse to render the world practically amenable. Digitization translates, retranscribes, and circumscribes the fluidity and flux by decomposing the analog or the continuous—currents—into elements, packages, or units, represented by the binary code, and then recomposing them through addition: analysis then synthesis. But these processes of recomposition lose something in the process, although they reproduce themselves perfectly. The sweep and spontaneity of the curve, represented only through the aid of smaller and smaller grids, or the musical performance represented only through the discrete elements of the score, represent a diminution of the fullness of the real; the analog continuum is broken down and simplified in digitization.[19] What is lost in the process of digitization, in the scientific push to analysis or decomposition, is precisely the continuity, the force, that binds together the real as complexity and entwinement:

> Suppose our eyes [were] made [so] that they cannot help seeing in the work of the master [painter] a mosaic effect. Or suppose our intellect [were] so made that it cannot explain the appearance of the figure on the canvas except as a work of mosaic. We should then be able to speak simply of a collection of little squares. . . . In neither case should we have got at the real process, for there are no squares brought together. It is the picture, i.e., the simple act, projected on the canvas, which, by the mere fact of entering our perception, is *decomposed* before our eyes into thousands and thousands of little squares which present, as *recomposed*, a wonderful arrangement.[20]

This is a prescient image of digitization: the recomposition of the whole through its decomposition into pixel-like units, the one serving as the representation of the other. The curve, the continuous stroke, the single movement of an arm, is certainly able to be decomposed into as many stops or breaks as one chooses: "A very small element of a curve is very near being a straight line. And the smaller it is, the nearer. In the limit, it may be termed a part of the curve or a part of the straight line, as you please, for in each of its points a curve coincides with its tangent."[21] But something of the curve or movement is lost when it is recomposed of its linear elements or grids, when the parts are added together—the simplicity and unity, the nondecomposable quality, disappears, to be replaced by immense complexity, that is, the duration of the movement disappears into its reconfiguration as measurable and reconfigurable space, object, or movement.

The thing and the body are correlates: both are artificial or conventional, pragmatic conceptions, cuttings, disconnections, that create a unity, continuity, and cohesion out of the plethora of interconnections that constitute the world. They mirror each other: the stability of one, the thing, is the guarantee of the stability and on-going existence or viability of the other, the body. The thing is "made" for the body, made as manipulable for the body's needs. And the body is conceived on the model of the thing, equally knowable and manipulable by another body. This chain of connections is mutually confirming. The thing is the life of the body, and the body is that which unexpectedly occurs to things. Technology is that which ensures and continually refines the ongoing negotiations between bodies and things, the deepening investment of the one, the body, in the other, the thing.

Technology is not the supersession of the thing but its ever more entrenched functioning. The thing pervades technology, which is its extension, and also extends the human into the material. The task before us is not simply to make things or to resolve relations into things, more and more minutely framed and microscopically understood; rather, it may be to liberate matter from the constraint, the practicality, the utility of the thing, to orient technology not so much to knowing and mediating as to experience and the rich indeterminacy of duration. Instead of merely understanding the thing and the technologies it induces through intellect, perhaps we can also develop an acquaintance with things through intuition, that Bergsonian internal and intimate apprehension of the unique particularity of things, their constitutive interconnections, and the time within which things exist.[22]

The issue is not, of course, to abandon or even necessarily to criticize technologies, architecture, or the pragmatics of the thing, but rather, with Bergson, to understand both their limits and their residues. Perception, intellection, the thing, and the technologies they spawn proceed along the lines of practical action, and these require a certain primacy in day-to-day life. But they leave something out: the untapped, nonpractical, nonuseful, nonhuman, or extra-human continuity that is the object of intuition, of empirical attunement without means or ends.

One of the questions ahead of us now is this: What are the conditions of digitization and binarization? Can we produce technologies of other kinds? Is technology inherently simplification and reduction of the real? What in us is being extended and prosthetically rendered in technological development? Can other vectors be extended instead? What might a technology of processes, of intuition rather than things and practice, look like?

References

1 See, for example, Hanna Fenichel Pitkin's curiously titled *The Attack of the Blob: Hannah Arendt's Concept of the Social* (Chicago: University of Chicago Press, 1998).

2 As William James implies in his discussion of the thing, or object, the object is that which has effects, directly or indirectly, on our perceptual responses and motor behavior. The object is the ongoing possibility of perception and action, the virtual trigger for responsiveness: "To attain perfect clearness in our thoughts of an object, then, we need only consider what conceivable effects of a practical kind the object may involve—what sensations we are to expect from it, and what reactions we must prepare. Our conception of these effects, whether immediate or remote, is then for us the whole of our conception of the object, so far as that conception has positive significance at all." William James, "What Pragmatism Means," in *Pragmatism and Four Essays from The Meaning of Truth* (Cleveland: Meridian Books, 1970), 43.

3 William James, "Pragmatism and Humanism," in ibid., 165.

4 William James," Pragmatism and Common Sense," in ibid., 118–119.

5 Henri Bergson, *The Creative Mind: An Introduction to Metaphysics*, trans. Mabelle L. Andison (New York: Citadel Press, 1992), 223.

6 Henri Bergson, *Matter and Memory*, trans. N. M. Paul and W. S. Palmer (New York: Zone Books, 1988), 21.

7 Ibid., 209–210.

8 Ibid., 201.

9 Henri Bergson, *Creative Evolution*, trans. Arthur Mitchell (New York: Random House, 1944), 153.

10 Indeed, Bergson's discussion of William James's pragmatism in *The Creative Mind* (see "On the Pragmatism of William James") indicates that James's notion of truth is itself an acknowledgment of the limit of knowledge rather than its pervasiveness: "The definition that James gives to truth, therefore, is an integral part of his conception of reality. If reality is not that economic and systematic universe our logic likes to imagine, if it is not sustained by a framework of intellectuality, intellectual truth is a human invention whose effect is to utilize reality rather than to enable us to penetrate it. And if reality does not form a single whole, if it is multiple and mobile, made up of cross-currents, truth which arises from contact with one of these currents,—truth felt before being conceived,—-is more capable of seizing and storing up reality than truth merely thought. (259)

11 Bergson suggests that instinct finds a kind of technology ready at hand in the body and its organs, in found objects whose use is instinctively dictated, and in the differential dispersal of instinctual capacities in social animals that are highly stratified, as many insects are. Intelligence, on the other hand, invents and makes technology, but it also diverts natural objects into technological products through their unexpected and innovative use:

"Instinct perfected is a faculty of using and even of constructing organizing instruments; intelligence perfected is the faculty of making and using unorganized instruments.

The advantages and drawbacks of these two modes of activity are obvious. Instinct finds the appropriate instrument at hand: this instrument, which makes and repairs itself, which presents, like all the works of nature, an infinite complexity of detail combined with a marvelous simplicity of function, does at once, when required, what it is called upon to do, without difficulty and with a perfection that is often wonderful. In return, it retains an almost invariable structure, since a modification of it involves a modification of the species . . . The instrument constructed intelligently, on the contrary, is an imperfect instrument. It costs an effort. It is generally troublesome to handle. But, as it is made of unorganized matter, it can take any form whatsoever, serve any purpose, free the living being from every new difficulty that arises and bestow on it an unlimited number of powers. Whilst it is inferior to the natural instrument for the satisfaction of immediate wants, its advantage over it is greater, the less urgent the need. Above all, it reacts on the nature of the being that constructs it; for in calling on him to exercise a new function, it confers on him, so to speak, a richer organization, being an artificial organ by which the natural organism is extended. For every need that it satisfies, it creates a new need; and so, instead of closing, like instinct, the round of action within which the animal tends to move automatically, it lays open to activity an unlimited field into which it is driven further and further, and made more and more free." Bergson, *Creative Evolution*, 140–141.

12 Ibid., 138–139 (emphasis in original).

13 Ibid., 150–151.

14 Ibid., 161.

15 Ibid., 250.

16 Bergson, *Matter and Memory*, 139.

17 Bergson, *The Creative Mind*, 43.

18 Bergson writes: "We shall never explain by means of particles, whatever these may be, the simple properties of matter . . . This is precisely the object of chemistry. It studies *bodies* rather than *matter;* and so we understand why it stops at the atom, which is still endowed with the general properties of matter. But the materiality of the atom dissolves more and more under the eyes of the physicist. We have no reason, for instance, for representing the atom to ourselves as a solid, rather than as a liquid or gaseous, nor for picturing the reciprocal action of atoms as shocks rather than in any other way. Why do we think of a solid atom, and why do we think of shocks? Because solids, being the bodies on which we clearly

have the most hold, are those which interest us most in our relations with the external world, and because contact is the only means which appears to be at our disposal in order to make our body act upon other bodies. But very simple experiments show that there is never true contact between two neighboring bodies, and besides, solidity is far from being an absolutely defined state of matter. Solidity and shock borrow, then, their apparent clearness from the habits and necessities of practical life." Bergson, *Matter and Memory*, 199.

19 On the distinction between the analog and the digital, see an early piece by Anthony Wilden, "Analog and Digital Communication: On Negation, Signification, and Meaning," in his *System and Structure: Essays on Communication and Exchange* (London: Tavistock, 1972).

20 Bergson, *Creative Evolution*, 90.

21 Ibid., 32.

22 Although it is commonly assumed that intuition is some vague feeling or sensibility, for Bergson it is a quite precise mode that refuses or precedes symbolization and representation: "We call intuition here the sympathy by which one is transported into the interior of an object in order to coincide with what there is unique and consequently inexpressible in it" (*The Creative Mind*, 190). Instead of a mere sympathy or identification, which is nothing but a psychologization or subjectivization of knowledge, Bergson wants to link intuition to an understanding of the absolute. What the intellect provides is a relative knowledge, a knowledge of things from a distance and thus from a perspective mediated by symbols, representations, and measurements, while intuition is what can provide an absolute analysis, which means one that is both internal and simple. This absolute is not understood in terms of an eternal or unchanging essence, but is rather, from the outside, a complex interplay of multiple forces and factors that, from the inside, resolves itself into a simple unity: "Seen from within, an absolute is then a simple thing; but considered from without, that is to say relative to something else, it becomes, within relation to those signs which express it, the piece of gold for which one can never make up the change" (ibid.).

Bibliography

Aristotle. *Politics*. Trans. H. Rackham. Cambridge: Harvard University Press, 1972.

Bacon, Francis. *The New Atlantis*. Harmondsworth: Penguin, 1974.

Bataille, Georges. *The Accursed Share*. 3 vols. Trans. Robert Hurley. New York: Zone Books, 1991.

Bataille, Georges, ed. *Encyclopedia Acephalica: Comprising the Critical Dictionary and Related Texts Edited by Georges Bataille and the Encyclopaedia Da Costa*. Ed. Robert Lebel and Isabelle Waldberg. London: Atlas Press, 1995.

Bataille, Georges. *On Nietzsche*. Trans. Bruce Boone. New York: Paragon House, 1992.

Bataille, Georges. *Visions of Excess: Selected Writings 1927–1939*. Ed. and trans. Allan Stoekl. Manchester: Manchester University Press, 1985.

Batchen, Geoffrey. "Spectres of Cyberspace." *Afterimage* 23, no. 3 (November/December 1995), 4–17.

Benedikt, Michael, ed. *Cyberspace: First Steps*. Cambridge: MIT Press, 1991.

Bergson, Henri. *Creative Evolution*. Trans. Arthur Mitchell. New York: Random House, 1944.

Bergson, Henri. *The Creative Mind: An Introduction to Metaphysics*. Trans. Mabelle L. Andison. New York: Citadel Press, 1992.

Bingham, Stephen. "The Key to Cybercity: Stephen Bingham." Interview by Brian Boigon and David Clarkson. *M5V*. no. 2 (Winter 1991–1992), 6–12.

Boigon, Brian, ed. *Culture Lab*. New York: Princeton Architectural Press, 1993.

Boundas, Constantin V. "Bergson-Deleuze: An Ontology of the Virtual." In Paul Patton, ed., *Deleuze: A Critical Reader*. Oxford: Blackwell, 1996.

Boundas, Constantin V., ed. *The Deleuze Reader*. New York: Columbia University, 1993.

Boundas, Constantin V., and Dorothea Olkowski, eds. *Gilles Deleuze and the Theatre of Philosophy*. New York: Routledge, 1994.

Braidotti, Rosi. "Toward a New Nomadism: Feminist Deleuzian Tracks; or, Metaphysics and Metabolism." In Constantin V. Boundas and Dorothea Olkowski, eds., *Gilles Deleuze and the Theatre of Philosophy*. New York: Routledge, 1994.

Butler, Rex, and Paul Patton, eds. "Dossier on Gilles Deleuze." *Agenda: Contemporary Art Magazine*, no. 33 (September 1993), 16–36.

Caillois, Roger. "Mimicry and Legendary Psychasthenia." *October*, no. 31 (1984), 17–32.

Casey, Edward. *Getting Back into Place: Toward a Renewed Understanding of the Place-World*. Bloomington: Indiana University Press, 1993.

Colombat, André Pierre. "A Thousand Trails to Work with Deleuze." *Sub-Stance* 20, no. 3 (1991), 11–23.

Colomina, Beatriz, ed. *Sexuality and Space*. New York: Princeton Architectural Press, 1992.

Davidson, Cynthia C., ed. *Anywhere*. New York: Rizzoli International Publications, 1992.

Deleuze, Gilles. "Ariadne's Mystery." *ANY*, no. 5 (1994), 8–9.

Deleuze, Gilles. *Bergsonism*. Trans. Hugh Tomlinson and Barbara Habberjam. New York: Zone Books, 1988.

Deleuze, Gilles. *Cinema 2: The Time-Image*. Trans. Hugh Tomlinson and Robert Galeta. Minneapolis: University of Minnesota Press, 1989.

Deleuze, Gilles. *Difference and Repetition*. Trans. Paul Patton. New York: Columbia University Press, 1994.

Deleuze, Gilles. "The Exhausted." *Parallax*, no. 3 (September 1996), 116–135.

Deleuze, Gilles. *The Fold: Leibniz and the Baroque*. Trans. Tom Conley. Minneapolis: University of Minnesota Press, 1993.

Deleuze, Gilles. *Foucault*. Trans. Seán Hand. Minneapolis: University of Minnesota Press, 1988.

Deleuze, Gilles. "He Stuttered." In Constantin V. Boundas and Dorothea Olkowski, eds., *Gilles Deleuze and the Theatre of Philosophy*. New York: Routledge, 1994.

Deleuze, Gilles. *Nietzsche and Philosophy*. Trans. Hugh Tomlinson. New York: Columbia University Press, 1983.

Deleuze, Gilles. *A Thousand Plateaus: Capitalism and Schizophrenia*. Trans. Brian Massumi. Minneapolis: University of Minnesota Press, 1987.

Deleuze, Gilles, and Félix Guattari. *Anti-Oedipus: Capitalism and Schizophrenia*. Trans. Robert Hurley, Mark Seem, and Helen R. Lane. Minneapolis: University of Minnesota Press, 1983.

Deleuze, Gilles, and Claire Parnet. *Dialogues*. Trans. Hugh Tomlinson and Barbara Habberjam. New York: Columbia University Press, 1987.

Derrida, Jacques. "Différance." In *Margins of Philosophy*, trans. Alan Bass. Chicago: University of Chicago Press, 1982.

Derrida, Jacques. "Faxitexture." In Cynthia C. Davidson, ed., *Anywhere*. New York: Rizzoli International Publications, 1992.

Eisenman, Peter. "Folding in Time: The Singularity of Rebstock." *Columbia Documents of Architecture and Theory: D* 2 (1993), 99–112.

Foucault, Michel. *Discipline and Punish: The Birth of the Prison*. Trans. Alan Sheridan. London: Allen Lane, 1974.

Foucault, Michel. "The Discourse on Language." In *The Archaeology of Knowledge*. New York: Harper Colophon, 1972.

Foucault, Michel. *The History of Sexuality*. Vol. 1, *An Introduction*. Trans. Robert Hurley. London: Allen Lane, 1978.

Foucault, Michel. *The Order of Things.* Trans. Alan Sheridan. London: Tavistock, 1970.

Freud, Sigmund. "The Ego and the Id." In *The Standard Edition of the Complete Psychological Works of Sigmund Freud*, ed. James Strachey. Vol. 19. London: Hogarth Press, 1953.

Gilbert, Nigel, and Rosaria Conte, eds., *Artificial Societies: The Computer Simulation of Social Life.* London: University College London Press, 1995.

Girard, René. *The Scapegoat.* Trans. Yvonne Freccero. Baltimore: Johns Hopkins University Press, 1986.

Grisham, Therese. "Linguistics as an Indiscipline: Deleuze and Guattari's Pragmatics." *SubStance* 20, no. 3 (1991), 36–54.

Grosz, Elizabeth. "Cyberspace, Virtuality and the Real: Some Architectural Reflections." In Cynthia C. Davidson, ed., *Anybody.* Cambridge: MIT Press, 1997.

Grosz, Elizabeth. *Space, Time and Perversion: Essays on the Politics of Bodies.* New York: Routledge, 1995.

Grosz, Elizabeth. "A Thousand Tiny Sexes: Feminism and Rhizomatics." In Constantin V. Boundas and Dorothea Olkowski, eds., *Gilles Deleuze and the Theatre of Philosophy.* New York: Routledge, 1994.

Grosz, Elizabeth. *Volatile Bodies: Toward a Corporeal Feminism.* Bloomington: Indiana University Press, 1994.

Guattari, Félix. "Space and Corporeity." *Columbia Documents of Architecture and Theory: D2* (1993), 139–148.

Hardt, Michael. *An Apprenticeship in Philosophy: Gilles Deleuze.* Minneapolis: University of Minnesota Press, 1933.

Heim, Michael. "Re Metaphysics of Virtual Reality." In Sandra K. Helsel and Judith P. Roth, eds. *Virtual Reality: Theory, Practice and Promise.* London: Meckler, 1991.

Helsel, Sandra K., and Judith P. Roth, eds. *Virtual Reality: Theory, Practice and Promise.* London: Meckler, 1991.

Hollier, Denis. "Mimesis and Castration 1937." *October*, no. 31 (1984), 3–16.

Ingraham, Catherine. "Moving Targets." *Columbia Documents of Architecture and Theory: D2* (1993), 112–122.

Irigaray, Luce. *An Ethics of Sexual Difference.* Trans. Carolyn Burke and Gillian C. Gill. Ithaca: Cornell University Press, 1993.

Irigaray, Luce. "Où et comment habiter?" *Les Cahiers du Grif*, issue on *Jouir*, no. 26 (March 1983).

Irigaray, Luce. *Speculum of the Other Woman.* Trans. Gillian C. Gill. Ithaca: Cornell University Press, 1985.

Irigaray Luce. *This Sex Which Is Not One.* Trans. Catherine Porter with Carolyn Burke. Ithaca: Cornell University Press, 1985.

Irigaray, Luce. "Volume without Contours." In *The Irigaray Reader*, ed. Margaret Whitford. Oxford: Blackwell, 1991.

James, William. *A Pluralistic Universe: Hibbert Lectures at Manchester College on the Present Situation of Philosophy.* Lincoln: University of Nebraska Press, 1996.

James, William. *Pragmatism and Four Essays from The Meaning of Truth.* Cleveland: Meridian Books, 1970.

Lacan, Jacques. *Écrits: A Selection.* Trans. Alan Sheridan. London: Tavistock, 1977.

Lacan, Jacques. "Some Reflections on the Ego." *International Journal of Psychoanalysis*, no. 34 (1953).

Le Doeuff, Michèle. "Daydream in Utopia." In Le Doeuff, *The Philosophical Imaginary*, trans. Colin Gordon. Stanford: Stanford University Press, 1989.

Le Doeuff, Michèle. "The Polysemy of Atopian Discourse." In Le Doeuff, *The Philosophical Imaginary*, trans. Colin Gordon. Stanford: Stanford University Press, 1989.

Lingis, Alphonso. *The Community of Those Who Have Nothing in Common.* Bloomington: Indiana University Press, 1994.

Massumi, Brian. "Everywhere You Want to Be: Introduction to Fear." In Brian Massumi, ed., *The Politics of Everyday Fear*. Minneapolis: University of Minnesota Press, 1993.

Massumi, Brian. *A User's Guide to Capitalism and Schizophrenia: Deviations from Deleuze and Guattari* Cambridge: MIT Press, 1992.

Mitchell, William J. *City of Bits: Space, Place, and the Infobahn*. Cambridge: MIT Press, 1995.

Moore, Thomas. *Utopia*. Cambridge: Cambridge University Press, 1975.

Morris, Meaghan. "Great Moments in Social Climbing: King Kong and the Human Fly." In Beatriz Colomina, ed., *Sexuality and Space*. New York: Princeton Architectural Press, 1992.

Nixon, Mark. "De Recombinant Architectura." *21.C* (January 1996), 46–64.

Novak, Marcos. "Liquid Architectures in Cyberspace." In Michael Benedikt, ed., *Cyberspace: First Steps*. Cambridge: MIT Press, 1991.

Pitkin, Hanna Fenichel. *The Attack of the Blob: Hannah Arendt's Concept of the Social*. Chicago: University of Chicago Press, 1998.

Plato. *The Laws*. Trans. A. E. Taylor. In *The Collected Dialogues of Plato*. New York: Pantheon Books, 1966.

Plato. *The Republic*. Trans. G. M. Gude. Indianapolis: Hackett Publishing, 1974.

Plato. *Timaeus and Critias*. Trans. Desmond Lee. Harmondsworth: Penguin, 1983.

Rajchman, John. "Anywhere and Nowhere." In Cynthia C. Davidson, ed., *Anywhere*. New York: Rizzoli International Publications, 1992.

Rajchman, John. *Constructions*. Cambridge: MIT Press, 1998.

Rajchman, John. "The Earth Is Called Light." *ANY*, no. 5 (1994), 12–13.

Rajchman, John. "Lightness: A Concept in Architecture." *ANY*, no. 5 (1994), 5–6.

Rheingold, Howard. *Virtual Reality*. New York: Summit Books, 1991.

Rorty, Richard. *Consequences of Pragmatism*. Brighton, Eng.: Harvester Press, 1982.

Ross, Andrew. *Strange Weather: Culture, Science and Technology in the Age of Limits*. London: Verso, 1991.

Schilder, Paul. *The Image and Appearance of the Human Body*. New York: International Universities Press, 1978.

Simondon, Gilbert. "The Genesis of the Individual." Trans. Mark Cohen and Sanford Kwinter. In Jonathan Crary and Sanford Kwinter, eds., *Incorporations*. New York: Zone Books, 1992.

Stone, Allucquère Roseanne. "Virtual Systems." In Jonathan Crary and Sanford Kwinter, eds., *Incorporations*. New York: Zone Books, 1992.

Thomsen, Christian W. *Visionary Architecture: From Babylon to Virtual Reality*. Munich: Prestel-Verlag, 1994.

Virilio, Paul. "The Law of Proximity." *Columbia Documents of Architecture and Theory: D 2* (1993), 123–138.

Watson, Sophie, and Katherine Gibson, eds. *Postmodern Cities and Spaces*. Oxford: Blackwell, 1995.

Whitford, Margaret. *Luce Irigaray: Philosophy in the Feminine*. London: Routledge, 1991.

Wilden, Anthony. *System and Stucture: Essays on Communication and Exchange*. London: Tavistock, 1972.

Bill Brown

THING THEORY

Le sujet naît de l'objet.

<div style="text-align:right">Michel Serres</div>

IS THERE SOMETHING PERVERSE, if not archly insistent, about complicating things with theory? Do we really need anything like thing theory the way we need narrative theory or cultural theory, queer theory or discourse theory? Why not let things alone? Let them rest somewhere else—in the balmy elsewhere beyond theory. From there, they might offer us dry ground above those swirling accounts of the subject, some place of origin unmediated by the sign, some stable alternative to the instabilities and uncertainties, the ambiguities and anxieties, forever fetishized by theory. Something warm, then, that relieves us from the chill of dogged ideation, something concrete that relieves us from unnecessary abstraction.

The longing for just such relief is described by A. S. Byatt at the outset of *The Biographer's Tale* (2000). Fed up with Lacan as with deconstructions of the Wolf-Man, a doctoral student looks up at a filthy window and epiphanically thinks, "I must have *things*." He relinquishes theory to relish the world at hand: "A real, very dirty window, shutting out the sun. A *thing*."[1]

In the last century, this longing became an especially familiar refrain. "Ideas," Francis Ponge wrote, shortly after World War II, "give me a queasy feeling, nausea," whereas "objects in the external world, on the other hand, delight me."[2] If, more recently, some delight has been taken in historicism's "desire to make contact with the 'real,'" in the emergence of material culture studies and the vitality of material history, in accounts of everyday life and the material *habitus*, as in the "return of the real" in contemporary art, this is inseparable, surely, from the very pleasure taken in "objects of the external world," however problematic that external world may be—however phantasmatic the externality of that world may be theorized to be.[3] These days, you can read books on the pencil, the zipper, the toilet, the banana, the chair, the potato, the bowler hat.[4] These days, history can unabashedly begin with things and with the senses by which

we apprehend them; like a modernist poem, it begins in the street, with the smell "of frying oil, shag tobacco and unwashed beer glasses."[5] Can't we learn from this materialism instead of taking the trouble to trouble it? Can't we remain content with the "real, very dirty window"—a "thing"—as the answer to what ails us without turning it into an ailment of its own?

Fat chance. For even the most coarse and commonsensical things, mere things, perpetually pose a problem because of the specific unspecificity that "things" denotes. Mind you, for Ponge, objects may seem substitutable for things, and by "siding with things" *(le parti pris des choses)* he meant to take the part of specified objects—doorknobs, figs, crates, blackberries, stoves, water.[6] But the very semantic *reducibility* of *things* to *objects*, coupled with the semantic *irreducibility* of *things* to *objects*, would seem to mark one way of recognizing how, although objects typically arrest a poet's attention, and although the object was what was asked to join the dance in philosophy, things may still lurk in the shadows of the ballroom and continue to lurk there after the subject and object have done their thing, long after the party is over. When it comes to Ponge, in fact, the matter isn't so simple as it seems. Michael Riffaterre has argued that the poems, growing solely out of a "word-kernel" *(mot-noyau)*, defy referentiality;[7] Jacques Derrida has argued that, throughout the poet's effort "to make the thing sign," the "thing is not an object [and] cannot become one."[8] Taking the side of things hardly puts a stop to that thing called theory.

"Things are what we encounter, ideas are what we project." That's how Leo Stein schematically put it.[9] Although the experience of an encounter depends, of course, on the projection of an idea (the idea of encounter), Stein's scheme helps to explain the suddenness with which things seem to assert their presence and power: you cut your finger on a sheet of paper, you trip over some toy, you get bopped on the head by a falling nut. These are occasions outside the scene of phenomenological attention that nonetheless teach you that you're "caught up in things" and that the "body is a thing among things."[10] They are occasions of contingency—the chance interruption—that disclose a physicality of things. In Byatt's novel, the interruption of the habit of looking *through* windows as transparencies enables the protagonist to look *at* a window itself in its opacity. As they circulate through our lives, we look *through* objects (to see what they disclose about history, society, nature, or culture—above all, what they disclose about *us*), but we only catch a glimpse of things.[11] We look through objects because there are codes by which our interpretive attention makes them meaningful, because there is a discourse of objectivity that allows us to use them as facts. A *thing*, in contrast, can hardly function as a window. We begin to confront the thingness of objects when they stop working for us: when the drill breaks, when the car stalls, when the windows get filthy, when their flow within the circuits of production and distribution, consumption and exhibition, has been arrested, however momentarily. The story of objects asserting themselves as things, then, is the story of a changed relation to the human subject and thus the story of how the thing really names less an object than a particular subject-object relation.

And, yet, the word *things* holds within it a more audacious ambiguity. It denotes a massive generality as well as particularities, even your particularly prized possessions: "'Things' were of course the sum of the world; only, for Mrs. Gereth, the sum of the world was rare French furniture and oriental china."[12] The word designates the concrete yet ambiguous within the everyday: "Put it by that green thing in the hall." It functions to overcome the loss of other words or as a place holder for some future specifying

operation: "I need that thing you use to get at things between your teeth." It designates an amorphous characteristic or a frankly irresolvable enigma: "There's a thing about that poem that I'll never get." For Byatt's protagonist, the quest for things may be a quest for a kind of certainty, but *things* is a word that tends, especially at its most banal, to index a certain limit or liminality, to hover over the threshold between the nameable and unnameable, the figurable and unfigurable, the identifiable and unidentifiable: Dr. Seuss's Thing One and Thing Two.[13]

On the one hand, then, the thing baldly encountered. On the other, some thing not quite apprehended. Could you clarify this matter of things by starting again and imagining them, first, as the amorphousness out of which objects are materialized by the (ap)perceiving subject, the anterior physicality of the physical world emerging, perhaps, as an after-effect of the mutual constitution of subject and object, a retroprojection? You could imagine things, second, as what is excessive in objects, as what exceeds their mere materialization as objects or their mere utilization as objects—their force as a sensuous presence or as a metaphysical presence, the magic by which objects become values, fetishes, idols, and totems. Temporalized as the before and after of the object, thingness amounts to a latency (the not yet formed or the not yet formable) and to an excess (what remains physically or metaphysically irreducible to objects). But this temporality obscures the all-at-onceness, the simultaneity, of the object/thing dialectic and the fact that, all at once, *the thing seems to name the object just as it is even as it names some thing else.*

If thing theory sounds like an oxymoron, then, it may not be because things reside in some balmy elsewhere beyond theory but because they lie both at hand and somewhere outside the theoretical field, beyond a certain limit, as a recognizable yet illegible remainder or as the entifiable that is unspecifiable. Things lie beyond the grid of intelligibility the way mere things lie outside the grid of museal exhibition, outside the order of objects. If this is why things appear in the name of relief from ideas (what's encountered as opposed to what's thought), it is also why the Thing becomes the most compelling name for that enigma that can only be encircled and which the object (by its presence) necessarily negates.[14] In Lacan, the Thing is and it isn't. It exists, but in no phenomenal form.

The real, of course, is no more phenomenal in physics than it is in psychoanalysis —or, as in psychoanalysis, it is phenomenal only in its effects. Somewhere beyond or beneath the phenomena we see and touch there lurks some other life and law of things, the swarm of electrons. Nonetheless, even objects squarely within the field of phenomenality are often less clear (that is, less opaque) the closer you look. As Georg Simmel said of telescopic and microscopic technology, "coming closer to things often only shows us how far away they still are from us."[15] Sidney Nagel brings the form of the drop into optical consciousness (pp. 23–39) and thus demonstrates (like Ponge) how the most familiar forms, once we look, seem unpredictable and inexplicable, to poets and physicists both. If, as Daniel Tiffany argues (pp. 72–98), humanistic criticism should assert its explanatory power when it comes to the problem of matter, this is because the problem can't be sequestered from the tropes that make matter make sense.[16]

Only by turning away from the problem of matter, and away from the object/thing dialectic, have historians, sociologists, and anthropologists been able to turn their attention to things (to the "social life of things" or the "sex of things" or the "evolution of things"). As Arjun Appadurai has put it, such work depends on a certain

"methodological fetishism" that refuses to begin with a formal "truth" that cannot, despite its truth, "illuminate the concrete, historical circulation of things." In *The Social Life of Things*, he argues that "even though from a *theoretical* point of view human actors encode things with significance, from a *methodological* point of view it is the things-in-motion that illuminate their human and social context."[17] Such methodological fetishism—what Appadurai calls the effort to "follow the things themselves"—disavows, no less, the tropological work, the psychological work, and the phenomenological work entailed in the human production of materiality as such. It does so, however, in the name of *avowing* the force of questions that have been too readily foreclosed by more familiar fetishizations: the fetishization of the subject, the image, the word. These are questions that ask less about the material effects of ideas and ideology than about the ideological and ideational effects of the material world and of transformations of it. They are questions that ask not whether things are but what work they perform—questions, in fact, not about things themselves but about the subject-object relation in particular temporal and spatial contexts. These may be the first questions, if only the first, that precipitate a new materialism that takes objects for granted only in order to grant them their potency—to show how they organize our private and public affection.[18]

Methodological fetishism, then, is not an error so much as it is a condition for thought, new thoughts about how inanimate objects constitute human subjects, how they move them, how they threaten them, how they facilitate or threaten their relation to other subjects. What are the conditions, Jonathan Lamb asks (pp. 133–66), for sympathizing with animals and artifacts, and how does such sympathy threaten Locke's "thinking thing," the self? Why, Michael Taussig asks as he reads Sylvia Plath's last poems (pp. 305–16), does death have the capacity both to turn people into things and to bring inanimate objects to life? How is it, Rey Chow asks (pp. 286–304), that an individual's collecting passion threatens the state? (And what, we might ask these days, as the Taliban obsessively obliterates figures of Buddha, does the state think it destroys when it destroys such objects?) These are questions that hardly abandon the subject, even when they do not begin there. When it comes to the Subject as such—that Cartesian subject which becomes the abstract subject of democracy and psychoanalysis—Matthew Jones points to its emergence within the spiritual exercise of concrete work, work with rulers and compasses.[19] He shows how "a simple mathematical instrument [the proportional compass] became the model and exemplar of Descartes's new subject," the subject "supposedly so removed from the material" (pp. 40–71).

What habits have prevented readers of Descartes from recognizing this material complication? What habits have prevented us—prevented you—from thinking about objects, let alone things? Or, more precisely, perhaps: what habits have prevented you from sharing your thoughts? In one of his neglected, slightly mad manifestos, Jean Baudrillard sanely declares that "we have always lived off the splendor of the subject and the poverty of the object." "It is the subject," he goes on to write, "that makes history, it's the subject that totalizes the world," whereas the object "is shamed, obscene, passive." The object has been intelligible only as the "alienated, accursed part of the subject"—the "individual subject or collective subject, the subject of consciousness or the unconscious." "The fate of the object," to Baudrillard's knowledge, "has been claimed by no one."[20] And, yet, the very grandiosity of Baudrillard's claim about *the* object (and the "potency of the object") threatens the subject no more than it threatens (by absorbing) both objects and things.[21]

In a response both to perceptual phenomenology and to the ontological quest for being, Cornelius Castoriadis pronounced the need to abandon our image of representation as "a projection screen which, unfortunately, separates the 'subject' and the 'thing.'"[22] Representation does not provide "impoverished 'images' of things"; rather, "certain segments" of representation "take on the weight of an 'index of reality' and become 'stabilized', as well as they might, without this stabilization ever being assured once and for all, as 'perceptions of things'" (*I*, pp. 331, 332). The argument shares the more recent emphasis on understanding materiality as a materiality-effect,[23] but it most pointedly seeks to recast thingness and its apprehension within, and as, the domain of the social: the "'thing' and the 'individual', the individual as 'thing' and as the one for whom there are indubitably 'things' are [all], to begin with . . . dimensions of the institution of society" (*I*, p. 332). By means of a particular "socialization of the psyche," then, "each society" imposes itself on the subject's senses, on the "*corporeal imagination*" by which materiality as such is apprehended (*I*, p. 334).

Though he is willing to grant (grudgingly) that there is some "transcultural pole of the institution of the things," one that "leans on the natural stratum," Castoriadis maintains, quite rightly, that this "still says nothing about *what* a thing is and what things are for a given society" (*I*, p. 334). The "perception of things" for an individual from one society, for instance, will be the perception of things "inhabited" and "animated"; for an individual from another society things will instead be "inert instruments, objects of possession" (*I*, pp. 334–35). This discrepancy between percepts (and thus not just the meaning but the very being of objects) has been a central topic of anthropology at least since the work of Marcel Mauss: however materially stable objects may seem, they are, let us say, different things in different scenes.[24] But when you ask "what things are for a given society" (noticing, by the way, how societies have taken the place of things as the given), surely the inquiry should include attention to those artistic and philosophical texts that would become sources, then, for discovering not epistemological or phenomenological truth but the truth about what force things or the question of things might have in each society. Indeed, such attention would help to preclude the homogenization of each society in its insular eachness. For, on the one hand, differences *between* societies can be overdrawn; as Peter Stallybrass and Ann Rosalind Jones make clear (pp. 114–32), the Western Renaissance may have witnessed "fetishism" elsewhere, but it was saturated by a fetishism of its own. On the other, differences *within* each society can be overlooked: to call a woman in Soweto a "slave of things" " is to charge her with being "a white black woman."[25]

The question is less about "what things are for a given society than about what claims on your attention and on your action are made on behalf of things. If society seems to impose itself on the "corporeal imagination," when and how does that imagination struggle against the imposition, and what role do things, physically or conceptually, play in the struggle? How does the effort to rethink things become an effort to *reinstitute* society? To declare that the character of things as things has been extinguished, or that objects have been struck dumb, or that the idea of respecting things no longer makes sense because they are vanishing—this is to find in the fate of things a symptom of a pathological condition most familiarly known as modernity.[26] In "Everyday Life and the Culture of the Thing" (1925), for instance, Boris Arvatov recognized that the revolution had yet to effect a fundamental change in the most quotidian interactions with the physical object world, the step of overcoming the "rupture between Things

and people that characterized bourgeois society," the step of achieving a newly "active contact" with the things in Soviet society. If achieving that change meant both encouraging the "psyche" to become "more thinglike" and "dynamiz[ing]" the thing into something "connected like a co-worker with human practice," then Arvatov was imagining a novel reification of people and a new personification of things that did not result (as it does in the Marxian script) from society's saturation with the commodity form.[27] Constructivist materialism sought to recognize objects as participants in the reshaping of the world: "Our things in our hands," Aleksandr Rodchenko claimed, "must be equals, comrades."[28] The women of the Constructivist movement, designing and manufacturing postrevolutionary clothes, came as close as anyone, Christina Kiaer argues (pp. 185–243), to integrating "socialist objects" within the world of consumable goods. In the Italian "romance" that Jeffrey Schnapp reconstructs (pp. 244–69), this politicization of things is inverted into the materialization of politics, the effort to fuse national and physical form. The call to "organize aluminum" on behalf of the fascist state accompanies the declaration that aluminum is the "autarchic metal of choice," the "Italian metal" par excellence. Materialism, these days, may appear in the name of—or *as* the name of—politics, but these cases exhibit a more intense effort to deploy material goods on behalf of a political agenda.

Beyond the boundaries of Soviet Russia, the conscious effort to achieve greater intimacy with things, and to exert a different determination for them, took place, most famously and at times comically, within the surrealist avant-garde. Among the various experimental "novelties" that would unify "thought with the object" through some "*direct* contact with the object," Salvador Dali "dream[ed] of a mysterious manuscript written in white ink and completely covering the strange, firm surfaces of a brand-new Rolls-Royce."[29] Although words and things have long been considered deadly rivals, as Peter Schwenger details (pp. 99–113), Dali had faith that they could be fused and that "everyone" would "be able to read from things."[30] When André Breton first dreamed up surrealism, he did so by trying to make good on a dream. He dreamed of finding a book at a flea market, a book with a wooden statue of an Assyrian gnome as its spine, and with pages made of black wool. "I hastened to acquire it," he writes, "and when I woke up I regretted not finding it near me." Still, he hoped "to put a few objects like this in circulation."[31]

By transforming the bricolage of the dreamwork into the practice of everyday life, the surrealists registered their refusal to occupy the world as it was. Walter Benjamin claimed they were "less on the trail of the psyche than on the track of things," acting less as psychoanalysts than as anthropologists. In "Dream Kitsch," he fuses the surrealist invigoration of cultural debris with the movement's own invigoration from "tribal artifacts." He describes them seeking "the totemic tree of objects within the thicket of primal history. The very last, the topmost face on the totem pole, is that of kitsch." Though this image visualizes the animation projected on to or into the "outlived world of things," the essay concludes by describing the process in reverse, describing how "in kitsch, the world of things advances on the human being" and "ultimately fashions its figures in his interior."[32] Subjects may constitute objects, but within Benjamin's materialism things have already installed themselves in the human psyche.

"Formal truths" about how things are part and parcel of society's institution hardly help to explain the ways that things have been recast in the effort to achieve some confrontation with, and transformation of, society. Because Benjamin devoted himself to

such explanations he assumes particular authority in the following pages. Among the other writers invoked in this special issue, Bruno Latour exerts no less influence; he has forcefully and repeatedly insisted that "things do not exist without being full of people" and that considering humans necessarily involves the consideration of things. The subject/object dialectic itself (with which he simply has no truck) has obscured patterns of circulation, transference, translation, and displacement.[33] Latour has argued that modernity artificially made an ontological distinction between inanimate objects and human subjects, whereas in fact the world is full of "quasi-objects" and "quasi-subjects," terms he borrows from Michel Serres.[34] Benjamin makes it clear that the avant-garde worked to make that fact known; modernism's resistance to modernity is its effort to deny the distinction between subjects and objects, people and things. Yet modernism's own "discourse of things," as John Frow calls it (pp. 270–85), is far from consistent in what it reveals as the source of their animation.

If modernism, when struggling to integrate the animate and the inanimate, humans and things, always knew that we have never been modern, this hardly means that you should accept such knowledge as a *fait accompli*. Indeed, Theodor Adorno, arguing against epistemology's and phenomenology's subordination of the object and the somatic moment to a fact of consciousness, understood the alterity of things as an essentially ethical fact. Most simply put, his point is that accepting the otherness of things is the condition for accepting otherness as such.[35]

When, shortly after the millennium turned, I told an art historian that I was working on things and editing a special issue of *Critical Inquiry*, she responded by saying: "Ah, well: it's the topic of the 1990s the way it was of 1920s, isn't it?"[36] This first felt like an unwitting accusation of belatedness (in the year 2000), and it did so because the academic psyche has internalized the fashion system (a system meant to accelerate the obsolescence of *things*). Still, if Benjamin was able to outstep the avant-garde in the 1920s by conceptualizing the "revolutionary energies" of surrealism's materialist bricolage,[37] this was in part because of the sociological ground cleared by Simmel's earlier account of the gap between the "culture of things" and modernity's human subject, and because of his insistence that the subject's desire, and not productive labor, is the source of an object's value.[38] Benjamin recognized that the gap between the function of objects and the desires congealed there became clear only when those objects became outmoded. "Things" seems like a topic of the nineties as it was of the twenties because the outmoded insights of the twenties (insights of Benjamin, of Bataille, of O'Keefe, among others) were reinvigorated.[39] Among those insights, we learn that history is exactly the currency that things trade in and that obsolescence as an accusation, whenever it represses its own history, is utterly passé. "Things" seems like a topic of the 1990s no less because, as the twentieth century drew to a close, it became clear that certain objects—Duchamp's *Fountain*, Man Ray's *Object to Be Destroyed*, Joseph Beuys's *Fat Chair*—kept achieving new novelty and that some modes of artistic production that foreground object culture more than image culture (mixed-media collage, the readymade, the *objet trouvé*) would persevere, however updated.[40]

But what decade of the century didn't have its own thing about things? Given Heidegger's lecture on "Das Ding" in 1950 and Lacan's location of the Thing *at* and *as* the absent center of the real in 1959; given Frank O'Hara's declaration that "the eagerness of objects to / be what we are afraid to do / cannot help but move us" in 1951,[41] Robert Rauschenberg's interruption of abstract expressionism, and the *chosisme* of the

decade's *nouveau roman*, the postwar era looks like an era both overwhelmed by the proliferation of things and singularly attentive to them. Only belatedly, in the 1980s, did Baudrillard declare that just as modernity was the historical scene of the subject's emergence, so postmodernity is the scene of the object's preponderance. If a genealogy of things has yet to be written, there's still a patent conceptual geology where simple elements appear in multiple layers—the scandal of the surrealist veneration of detritus reasserted in Claes Oldenburg's claim that a "refuse lot in the city is worth all the art stores in the world," and the scandal of the readymade resurfacing as the very different scandal of pop art in work like Oldenburg's best-known oversized and understuffed everyday objects: the mixer, the cheeseburger, the light bulb, the ice cream cone, the telephone, the wall switch.[42]

Since his exhibition at the Green Gallery in New York, 1962, through which he transformed himself from a dramaturg of happenings to the most noteworthy pop sculptor (as the stage sets for the happenings were disassembled into distinct works), Oldenberg has re-created, with relentless consistency, the iconic objects of everyday life. Donald Judd called Oldenburg's objects "grossly anthropomorphized."[43] Indeed, they are invariably and teasingly mammary, ocular, phallic, facial, scrotal. But the very "blatancy," as Judd went on to argue, seems to ridicule anthropomorphism as such.[44] In the same way, the grossly mimetic character of the work draws attention to the discrepancy between objectivity and materiality, perception and sensation, objective presence (a fan, a Fudgsicle, a sink) and material presence (the canvas, the plaster of paris, the vinyl), as though to theatricalize the point that all objects (not things) are, first off, iconic signs. (A sink looks like a sink.)

Despite the enormousness and enormity of objective culture in Oldenburg's world, it has somehow lost its potency. In the presence of his monumentally flaccid objects, it is difficult not to suffer some vague feeling of loss, as though they were half-deflated balloons, lingering in the ballroom two days after the party, hovering at eye level, now, and rather worn out. Finally allowed to relax, to just be themselves, objects sink into themselves, weary of form; they consider sinking into an amorphous heap, submitting to the *idée fixe* of gravity. Oldenburg's work may be melodramatic and sentimental, as Michael Fried declared in 1962, but it is also *about* melodrama and sentiment, meant to pose some question about, by physically manifesting the affective investment Americans have in the hamburger, the ice cream cone, chocolate cake.[45] Why have we turned the cheeseburger into a totemic food, a veritable member of the family, a symbol of the national clan? Though art may seem to be, most fundamentally, "a projection of our mental images upon the world of things," this is art that instead shows how weary that world has become of all our projections.[46] If these objects are tired, they are tired of our perpetual reconstitution of them as objects of our desire and of our affection. They are tired of our longing. They are tired of us.

But a recent work of Oldenburg's, his *Typewriter Eraser*, gleams in the new sculpture garden outside the National Gallery in Washington DC. Unlike his myriad soft objects, the eraser is pert, it is rigid, it is full of life and stands at attention, if slightly askew, its chrome as bright as the typical typewriter eraser was always dirty and dull. The pleasure of looking at the people looking at the *Typewriter Eraser*, amused by its monumentality, is inseparable from the pleasure of listening to the child who, befuddled by an anachronistic object she never knew, pleads: "What is that thing supposed to be?" What is this disk with the brush sticking out of it? What was a typewriter? How did that form

ever function? The plea expresses the power of this particular work to dramatize a generational divide and to stage (to melodramatize, even) the question of obsolescence. While the "timeless" objects in the Oldenburg canon (fans and sinks) have gone limp, this abandoned object attains a new stature precisely because it has no life outside the boundary of art—no life, that is, within our everyday lives. Released from the bond of being equipment, sustained outside the irreversibility of technological history, the object becomes something else.[47]

If, to the student of Oldenburg, the eraser ironically comments on the artist's own obsession with typewriters, it more simply transforms a dead commodity into a living work and thus shows how inanimate objects organize the temporality of the animate world. W. J. T. Mitchell makes it clear (pp. 167–84) that the discovery of a new kind of object in the eighteenth century, the fossil, enabled romanticism to recognize and to refigure its relation to the mortal limits of the natural world. In the case of the Oldenburg eraser, the present, which is the future that turned this object into a thing of the past, is the discourse network 2000, where the typewriter eraser has disappeared, not just into the self-correcting Selectric, but into the delete function. How, Oldenburg's objects seem to ask, will the future of your present ever understand our rhetoric of inscription, erasure, and the trace?[48]

As a souvenir from the museum of twentieth-century history, the *Typewriter Eraser* reminds us that if the topic of things attained a new urgency in the closing decades of that century, this may have been a response to the digitization of our world—just as, perhaps, the urgency in the 1920s was a response to film. But in the twenties the cinema provided a projection screen that didn't separate people and things but brought them closer, granting props the status of individuals, enabling neglected objects to assume their rightful value.[49] As Lesley Stern puts it (pp. 317–54) things can grab our attention on film; and they do so because they have become not just objects but actions. New media—perspectival painting, printing, telegraphy—each in its way newly mediates the relation between people and objects, each precipitates distance *and* proximity.

You could say that today's children were born too late to understand this memorial to another mode of writing, or you could say that Oldenburg (cleverly) re-created the object too late for it to be generally understood. It is an object that helps to dramatize a basic disjunction, a human condition in which things inevitably seem too late—belated, in fact, because we want things to come before ideas, before theory, before the word, whereas they seem to persist in coming after: as the alternative to ideas, the limit to theory, victims of the word. If thinking the thing, to borrow Heidegger's phrase, feels like an exercise in belatedness, the feeling is provoked by our very capacity to imagine that thinking and thingness are distinct.

Editor's note

All in-text page numbers set off in parentheses refer to original pagination for articles appearing in the original collection.

Notes

1 A. S. Byatt, *The Biographer's Tale* (New York, 2001), p. 2.

2 Francis Ponge, "My Creative Method," *The Voice of Things*, trans. and ed. Beth Archer (New York, 1972), p. 93. In contrast, it was the confrontation with the materiality of matter—"below all explanation"—that occasioned a very different nausea, not Ponge's but Roquentin's (Jean-Paul Sartre, *Nausea*, trans. Lloyd Alexander [New York, 1964], p. 129). For the canonical expression of the thing/theory binary in American poetry, see Robert Haas, "Meditation at Lagunitas," *Praise* (Hopewell, N.J., 1979), pp. 4–5.

3 Catherine Gallagher and Stephen Greenblatt, *Practicing New Historicism* (Chicago, 2000), p. 54. For a brief account of the emergence of material culture studies (institutionally marked by the *Journal of Material Culture*), see *Material Cultures: Why Some Things Matter*, ed. Daniel Miller (Chicago, 1998); and for the U.S. tradition, see *Learning from Things: Method and Theory of Material Culture Studies*, ed. David Kingery (Washington, D.C., 1995). On contemporary art, see Hal Foster, *The Return of the Real: The Avant-Garde at the End of the Century* (Cambridge, Mass., 1996). On the concept of exteriority, see esp. Jacques Derrida, *Positions*, trans. Alan Bass (Chicago, 1978), p. 64, and Judith Butler, *Bodies That Matter: On the Discursive Limits of "Sex"* (New York, 1993), p. 30.

4 See Henry Petroski, *The Pencil: A History of Design and Circumstance* (New York, 1989); Robert Friedel, *Zipper: An Exploration in Novelty* (New York, 1994); Julie L. Horan, *The Porcelain God: A Social History of the Toilet* (New York, 1997); Virginia Scott Jenkins, *Bananas: An American History* (Washington, D.C., 2000); Galen Cranz, *The Chair: Rethinking Culture, Body, and Design* (New York, 2000); Larry Zuckerman, *The Potato: How the Humble Spud Rescued the Western World* (San Francisco, 1999); and Fred Miller Robinson, *The Man in the Bowler Hat: His History and Iconography* (Chapel Hill, N.C., 1993).

5 Simon Schama, *The Embarrassment of Riches: An Interpretation of Dutch Culture in the Golden Age* (New York, 1987), p. 15.

6 His "delight" in these objects was prompted not by any familiarity, but by the suddenly recognized peculiarity of the everyday, the fact that water "lies flat on its stomach" in a "hysterical urge to submit to gravity," for instance, sacrificing "all sense of decency to this *idée fixe*, this pathological scruple" ("ce scrupule maladif") (Ponge, "Of Water," trans. C. K. Williams, *Selected Poems*, trans. Williams, John Montague, and Margaret Guiton, ed. Guiton [Winston-Salem, N.C., 1994], pp. 57, 58; *Le Parti pris des choses* is the title of the volume of poetry in which "Of Water" first appeared).

7 Michael Riffaterre, "Ponge tautologique, ou le fonctionnement du texte," *Ponge inventeur et classique*, ed. Philippe Bonnefis and Pierre Oster (Paris, 1977), p. 66. See also Riffaterre, "The Primacy of Words: Francis Ponge's Reification," *Figuring Things: Char, Ponge, and Poetry in the Twentieth Century*, ed. Charles D. Minahen (Lexington, Ky., 1994), pp. 27–38.

8 Derrida, *Signéponge/Signsponge*, trans. Richard Rand (New York, 1984), pp. 126, 14.

9 Leo Stein, *The A-B-C of Aesthetics* (New York, 1927), p. 44.

10 Maurice Merleau-Ponty, "Eye and Mind," trans. Carleton Dallery, *The Primacy of Perception and Other Essays on Phenomenological Psychology, the Philosophy of Art, History, and Politics*, trans. James M. Edie et al., ed. Edie (Evanston, Ill., 1964), p. 163.

11 The window scene in Byatt's novel should be read in relation to Nabokov's point about how things become multiply transparent and read in the context of a dialectic of *looking through* and *looking at*: "When we concentrate on a material object, whatever its situation, the very act of attention may lead to our involuntarily sinking into the history of that object" (Vladimir Nabokov, *Transparent Things* [New York, 1972], p. 1). We don't apprehend things except partially or obliquely (as what's beyond our apprehension). In fact, by looking *at* things we render them objects.

12 Henry James, *The Spoils of Poynton* (1896; New York, 1987), p. 49. In his preface for the New York edition of the novel (reprinted in this Penguin edition, pp. 23–33), James plays with a full range of the word's denotations (for example: "The thing is to lodge somewhere, at the heart of one's complexity an irrepressible *appreciation*" [p. 31]).

13 By hastily tracking some of the ways we use *things* to both mark and manage uncertainty, I am specifically not deploying an etymological inquiry to delimit and vivify the meaning of things. But see, most famously, Marcel Mauss, who finds in the "best" etymology of *res* a means of claiming that *res* "need not have been the crude, merely tangible thing, the simple, passive object of transaction that it has become" (Marcel Mauss, *The Gift: The Form and Reason for Exchange in Archaic Societies*, trans. W. D. Halls [1950; New York, 1990], p. 50); and Martin Heidegger, who finds in the Old German *dinc* the denotation of a gathering of people that enables him to concentrate on how "thinging" gathers; see Martin Heidegger, "The Thing," in *Poetry, Language, Thought*, trans. Albert Hofstadter (New York, 1971), pp. 174–82. I should add that Heidegger believes that it is the English word *thing* that has preserved the "semantic power" of the original Roman word *res*, which is to say its capacity to designate a case, an affair, an event (p. 175). In turn, Michel Serres complains that such etymology—wherein objects exist "only according to assembly debates"—shows how "language wishes the whole world to derive from language" (Michel Serres, *Statues: Le Second Livre des fondations* [Paris, 1987], p. 111).

14 See Jacques Lacan, *The Ethics of Psychoanalysis 1959–1960*, volume 7 of *The Seminar of Jacques Lacan*, trans. Dennis Porter, ed. Jacques-Alain Miller (New York, 1992), p. 139. The Thing can only be "represented by emptiness, precisely because it cannot be represented by anything else" (p. 129). For a useful commentary, see Slavoj Žižek, "Much Ado about a Thing," *For They Know Not What They Do: Enjoyment as a Political Factor* (London, 1991), pp. 229–78. Doctrinaire Lacanians may tell you that the Thing names only one thing in Lacan, but in fact it has different meanings and different valences in different texts and within single texts.

15 Georg Simmel, *The Philosophy of Money*, trans. Tom Bottomore, David Frisby, and Kaethe Mengelberg, 2d ed. (1907; New York, 1990), p. 475.

16 For a further elaboration of this point, see Daniel Tiffany, *Toy Medium: Materialism and Modern Lyric* (Berkeley, 2000), and *Material Events: Paul de Man and the Afterlife of Theory*, ed. Tom Cohen et al. (Minneapolis, 2001).

17 Arjun Appadurai, "Introduction: Commodities and the Politics of Value," *The Social Life of Things: Commodities in Cultural Perspective*, ed. Appadurai (Cambridge, 1986), p. 5.

18 The most influential books to introduce such questions have undoubtedly been Gaston Bachelard, *The Poetics of Space*, trans. Maria Jolas (Boston, 1969), and Susan Stewart, *On Longing: Narratives of the Miniature, the Gigantic, the Souvenir, the Collection* (Baltimore, 1984). For the most thorough recent representation of how objects organize human life, see the costarring role of the volleyball, Wilson, in *Castaway*, dir. Robert Zemeckis, prod. DreamWorks/Image Movers/Playtone, 2000.

19 On the Cartesian subject within democracy and psychoanalysis, see Joan Copjec, *Read My Desire: Lacan against the Historicists* (Cambridge, Mass., 1994), pp. 141–62.

20 Jean Baudrillard, *Fatal Strategies*, trans. Philip Beitchman and W. G. J. Niesluchowski, ed. Jim Fleming (New York, 1990), p. 111. For a more sober account of this history, see Serres, *Statues*, pp. 208–12. For Baudrillard's own account of his manifesto in the context of his earlier thoughts about objects (under the spell, as it were, of Mauss and Bataille), see Baudrillard, "From the System to the Destiny of Objects," *The Ecstasy of Communication*, trans. Bernard and Caroline Schutze, ed. Sylvère Lotringer (New York, 1988), pp. 77–95 and "Revenge of the Crystal: An Interview by Guy Bellavance," *Revenge of the Crystal: Selected Writings on the Modern Object and Its Destiny, 1968–1983*, trans. and ed. Paul Foss and Julian Pefanis (London, 1990), pp. 15–34.

21 I've made this point at greater length in Bill Brown, "The Secret Life of Things: Virginia Woolf and the Matter of Modernism," *Modernism and Modernity* 6 (Apr. 1999): 1–28.

22 Cornelius Castoriadis, *The Imaginary Institution of Society*, trans. Kathleen Blamey (1975; Cambridge, Mass., 1987), p. 329; hereafter abbreviated *I*. Castoriadis is a theorist of plentitude and thus complains about desire being defined by the lack of a desired object, when in fact the object must be present to the psyche as desirable, which means that the psyche has in fact already fashioned it; see *I*, pp. 288–90. Still, there is what you might call a dialectic of insufficiency that proves more troubling; crudely put, deconstruction teaches that the word is never as good as the referent, but pychoanalysis teaches that the actual object is never as good as the sign.

23 Thus, for instance, Judith Butler writes, in a footnote emphasizing the "temporality of matter," and thinking through Marx's first thesis on Feuerbach, "if materialism were to take account of praxis as that which constitutes the very matter of objects, and praxis is understood as socially transformative activity, then such activity is understood as constitutive of materiality itself" (Butler, *Bodies That Matter*, p. 250).

24 Thus Nicholas Thomas writes: "As socially and culturally salient entities, objects change in defiance of their material stability. The category to which a thing belongs, the emotion and judgment it prompts, and narrative it recalls, are all historically refigured" (Nicholas Thomas, *Entangled Objects: Exchange, Material Culture, and Colonialism in the Pacific* [Cambridge, Mass., 1991], p. 125). See also, for instance, *The Social Life of Things*, and *Border Fetishisms: Material Objects in Unstable Places*, ed. Patricia Spyer (New York, 1998).

25 Njabulo S. Ndebele, "The Music of the Violin," in *"Fools" and Other Stories* (Johannesburg, 1983), p. 146.

26 See Georg Lukács, *History and Class Consciousness: Studies in Marxist Dialectics*, trans. Rodney Livingstone (Cambridge, Mass., 1971), p. 92; Siegfried Kracauer, "Farewell to the Linden Arcade," *The Mass Ornament: Weimar Essays*, trans. and ed. Thomas Y. Levin (Cambridge, Mass., 1995), p. 342; and Hans-Georg Gadamer, "The Nature of Things and the Language of Things," *Philosophical Hermeneutics*, trans. and ed. David E. Linge (Berkeley, 1976), p. 71.

27 Boris Arvatov, "Everyday Life and the Culture of the Thing (Toward the Formulation of the Question)," trans. Christina Kiaer, *October*, no. 81 (Summer 1997): 121, 124, 126. See Kiaer's important introduction to the piece, "Boris Arvatov's Socialist Objects," *October*, no. 81 (Summer 1997): 105–18.

28 Quoted in Kiaer, "Rodchenko in Paris," *October*, no. 75 (Winter 1996): 3. I want to thank Susan Buck-Morss for drawing my attention to this essay.

29 Salvador Dali, "The Object as Revealed in Surrealist Experiment" (1931), in *Theories of Modern Art*, ed. Herschel B. Chipp (Berkeley, 1968), p. 424.

30 Ibid.

31 André Breton, *Introduction au discours sur le peu de réalité* (1927), which he quotes (dating it 1924, the year of his originating surrealist manifesto), in "Surrealist Situation of the Object" (1935), *Manifestoes of Surrealism*, trans. Richard Seaver and Helen R. Lane (Ann Arbor, Mich., 1972), p. 277.

32 Walter Benjamin, "Dream Kitsch" (1927), trans. Howard Eiland, *Selected Writings*, trans. Rodney Livingstone et al., ed. Michael Jennings, Eiland, and Gary Smith, 2 vols. to date (Cambridge, Mass., 1999), 2:4. In "Several Points on Folk Art," he writes that "art teaches us to see into things. Folk art and kitsch allow us to look out through things." But this act of looking *through* things depends on the human application of them as though they were a mask fused to the sensorium (Benjamin, "Einiges zur Volkskunst," *Gesammelte Schriften*, ed. Rolf Tiedemann and Herman Schweppenhäuser, 7 in 14 vols. [Frankfurt am Main, 1972–89], 6:187; trans. Darren Ilett). See also Benjamin, "Surrealism: The Last Snapshot of the European Intelligentsia," trans. Edmund Jephcott, *Selected Writings*, 2:207–21. In all these

essays, Benjamin is developing an image of "innervation," a term he uses to describe the mimetic internalization of the physical world—eventually the internalization of technological apparatuses. See Miriam Bratu Hansen, "Benjamin and Cinema: Not a One-Way Street," *Critical Inquiry* 25 (Winter 1999): 306–43.

33 Bruno Latour, "The Berlin Key or How to Do Words with Things," trans. Lydia Davis, in *Matter, Materiality, and Modern Culture*, ed. P. M. Graves-Brown (London, 2000), pp. 10, 20.

34 See Latour, *We Have Never Been Modern*, trans. Catherine Porter (Cambridge, Mass., 1993), pp. 10–11. For a history outside the realm of sociology, see Miguel Tamen, *Friends of Interpretable Objects* (Cambridge, Mass., 2000), and Tiffany, *Toy Medium*.

35 See Theodor W. Adorno, *Negative Dialectics*, trans. E. B. Ashton (New York, 1997), pp. 189–94; see also p. 16. Unlikely as it seems, it would be possible to relate this claim to the way that, for Lacan, the Thing proves to be the center around which the drive achieves its ethical force.

36 Although things may seem to have achieved a new prominence, I want to point out that *Modern Starts: People, Places, Things*, ed. John Elderfield et al. (exhibition catalog, Museum of Modern Art, New York, 7 Oct. 1999–14 Mar. 2000) symptomatically diminished things in relation to place and to people. In the exhibition catalogue, things receive only 58 (of 360) pages of attention.

37 Benjamin, "Surrealism," 2:210.

38 Simmel, "The Future of Our Culture" (1909), *Simmel on Culture*, trans. Mark Ritter and David Patrick Frisby, ed. David Patrick Frisby and Mike Featherstone (London, 1997), p. 101. By complicating the ideas he formulated in the 1890s, Simmel's best students— Lukács, Bloch, Benjamin, and Kracauer—achieved insights about the "culture of things" that continue to inspire some of today's most ambitious cultural analysis.

39 See, for instance, Michael Taussig, *Mimesis and Alterity: A Particular History of the Senses* (New York, 1993), pp. 232–33; Yve-Alain Bois and Rosalind Krauss, *Formless: A User's Guide* (Cambridge, Mass., 1997); and Wanda M. Corn, *The Great American Thing: Modern Art and National Identity, 1915–1935* (Berkeley, 1999).

40 See, for instance, Benjamin H. D. Buchloh's account of Arman's work of the 1950s in relation to the paradigm of the readymade, *Neo-Avant-garde and Culture Industry: Essays on European and American Art from 1955 to 1975* (Cambridge, Mass., 2000), pp. 269–79.

41 Frank O'Hara, "Interior (With Jane)," *The Collected Poems of Frank O'Hara*, ed. Donald Allen (New York, 1971), ll. 1–3, p. 55. For the material context of such attention in postwar France—that is, the sudden proliferation of American objects—see Kristin Ross, *Fast Cars, Clean Bodies: Decolonization and the Reordering of French Culture* (Cambridge, Mass., 1996). Georges Perec's *Les Choses: Une Histoire des années soixante* (Paris, 1965) may have restored a Balzacian mise-en-scène to the novel, but décor became the scene of depletion, an arrangement of empty signs, which is why the arrangement was such an inspiration for Baudrillard's *System of Objects*, trans. James Benedict (1968; New York, 1996).

42 Quoted by Barbara Rose, *Claes Oldenburg* (New York, 1970), p. 46.

43 Donald Judd, "Specific Objects" (1965), *Complete Writings, 1959–1975* (New York, 1975), p. 189.

44 Ibid.

45 See Michael Fried, "New York Letter," in *Pop Art: A Critical History*, ed. Steven Henry Madoff (Berkeley, 1997), p. 216; Oldenburg's aggressive consciousness of his sentimentality is suggested by the "nougat" in the following statement from his manifesto: "I am for the art of rust and mold. I am for the art of hearts, funeral hearts or sweetheart hearts, full of nougat. I am for the art of worn meathooks, and singing barrels of red, white, blue and yellow meat" (Claes Oldenburg, "Statement" [1961], in *Pop Art*, p. 215).

46 Rudolf Arnheim, "Art among the Objects," *Critical Inquiry* 13 (Summer 1987): 679.

47 Heidegger taxonomizes things into mere things (such as pebbles), equipment, and work

(such as art). Much of pop art, of course, works to elide such distinctions. See Heidegger, "The Origin of the Work of Art," *Poetry, Language, Thought*, pp. 15–88.

48 On the new tropes provided by new media, see the closing chapter of Eric Jager, *The Book of the Heart* (Chicago, 2000).

49 See Benjamin, "The Work of Art in the Age of Mechanical Reproduction," *Illuminations*, trans. Harry Zohn, ed. Hannah Arendt (New York, 1969), pp. 217–51; Jean Epstein, "*Bonjour Cinéma* and Other Writings by Jean Epstein," trans. Tom Milne, *Afterimage* 10 (Autumn 1981): 19; and Fernand Léger, *Functions of Painting*, trans. Alexandra Anderson (New York, 1965), p. 50. For an account of how assessments of early cinema obsess about the new magical powers bestowed on objects, see Rachel O. Moore, *Savage Theory: Cinema as Modern Magic* (Durham, N.C., 2000).

Bruno Latour[*]

FROM REALPOLITIK TO *DINGPOLITIK* OR HOW TO MAKE THINGS PUBLIC

The aide said that guys like me were "in what we call the reality-based community," which he defined as people who "believe that solutions emerge from your judicious study of discernible reality." I nodded and murmured something about enlightenment principles and empiricism. He cut me off. "That's not the way the world really works anymore," He continued. "We're an empire now, and when we act, we create our own reality. And while you're studying that reality – judiciously, as you will – we'll act again, creating other new realities, which you can study too, and that's how things will sort out. We're history's actors [. . .] and you, all of you, will be left to just study what we do."

Ron Suskind[1]

SOME CONJUNCTIONS OF PLANETS are so ominous, astrologers used to say, that it seems safer to stay at home in bed and wait until Heaven sends a more auspicious message. It's probably the same with political conjunctions. They are presently so hopeless that it seems prudent to stay as far away as possible from anything political and to wait for the passing away of all the present leaders, terrorists, commentators and buffoons who strut about the public stage.

Astrology, however, is as precarious an art as political science; behind the nefarious conjunctions of hapless stars, other much dimmer alignments might be worth pondering. With the political period triggering such desperation, the time seems right to shift our attention to other ways of considering public matters. And "matters" are precisely what might be put center stage. Yes, public *matters*, but how?

While the German Reich has given us two world wars, the German language has provided us with the word *Realpolitik* to describe a positive, materialist, no-nonsense, interest only, matter-of-fact way of dealing with naked power relations. Although this

"reality," at the time of Bismarck, might have appeared as a welcome change after the cruel idealisms it aimed to replace, it strikes us now as deeply *unrealistic*. In general, to invoke "realism" when talking about politics is something one should not do without trembling and shaking. The beautiful word "reality" has been damned by the too many crimes committed in its name.

What is the *res* of *res publica*?

By the German neologism *Dingpolitik*, we wish to designate a risky and tentative set of experiments in probing just what it could mean for political thought to turn "things" around and to become slightly more *realistic* than has been attempted up to now. A few years ago, computer scientists invented the marvelous expression of "object-oriented" software to describe a new way to program their computers. We wish to use this metaphor to ask the question: "What would an *object-oriented* democracy look like?"

The general hypothesis is so simple that it might sound trivial – but being trivial might be part of what it is to become a "realist" in politics. We might be more connected to each other by our worries, our matters of concern, the issues we care for, than by any other set of values, opinions, attitudes or principles. The experiment is certainly easy to make. Just go in your head over any set of contemporary issues: the entry of Turkey into the European Union, the Islamic veil in France, the spread of genetically modified organisms in Brazil, the pollution of the river near your home, the breaking down of Greenland's glaciers, the diminishing return of your pension funds, the closing of your daughter's factory, the repairs to be made in your apartment, the rise and fall of stock options, the latest beheading by fanatics in Falluja, the last American election. For every one of these objects, you see spewing out of them a different set of passions, indignations, opinions, as well as a different set of interested parties and different ways of carrying out their partial resolution.

It's clear that each object – each issue – generates a different pattern of emotions and disruptions, of disagreements and agreements. There might be no continuity, no coherence in our opinions, but there is a hidden continuity and a hidden coherence in what we are attached to. Each object gathers around itself a different assembly of relevant parties. Each object triggers new occasions to passionately differ and dispute. Each object may also offer new ways of achieving closure without having to agree on much else. In other words, objects – taken as so many issues – bind all of us in ways that map out a public space profoundly different from what is usually recognized under the label of "the political". It is this space, this hidden geography that we wish to explore.

It's not unfair to say that political philosophy has often been the victim of a strong object-avoidance tendency. From Hobbes to Rawls, from Rousseau to Habermas, many procedures have been devised to assemble the relevant parties, to authorize them to contract, to check their degree of representativity, to discover the ideal speech conditions, to detect the legitimate closure, to write the good constitution. But when it comes down to *what* is at issue, namely the object of concern that brings them together, not a word is uttered. In a strange way, political science is mute just at the moment when the objects of concern should be brought in and made to speak up loudly. Contrary to what the powerful etymology of their most cherished word should imply, their *res publica* does not seem to be loaded with too many *things*. Procedures to authorize

and legitimize are important, but it's only half of what is needed to assemble. The other half lies in the issues themselves, in the *matters* that matter, in the *res* that creates a *public* around it. They need to be represented, authorized, legitimated and brought to bear inside the relevant assembly.

What we call an "object-oriented democracy" tries to redress this bias in much of political philosophy, that is, to bring together two different meanings of the word *representation* that have been kept separate in theory although they have remained always mixed in practice. The first one, so well known in schools of law and political science, designates the ways to gather the legitimate people around some issue. In this case, a representation is said to be faithful if the right procedures have been followed. The second one, well known in science and in technology, presents or rather *represents* what is the object of concern to the eyes and ears of those who have been assembled around it. In this case, a representation is said to be good if the matters at hand have been accurately portrayed. Realism implies that the same degree of attention be given to the two aspects of what it is to represent an issue. The first question draws a sort of place, sometimes a circle, which might be called an assembly, a gathering, a meeting, a council; the second question brings *into* this newly created locus a topic, a concern, an issue, a *topos*. But the two have to be taken together: *Who* is to be concerned; *What* is to be considered?

When Thomas Hobbes instructed his engraver on how to sketch the famous frontispiece for *Leviathan*, he had his mind full of optical metaphors and illusion machines he had seen in his travels through Europe.[2] A third meaning of this ambiguous and ubiquitous word "representation," the one with which artists are most familiar, had to be called for to solve, this time visually, the problem of the composition of the "Body Politik". Up to now it has remained a puzzle: How to represent, and through which medium, the sites where people meet to discuss their matters of concern? It's precisely what we are tackling here.[3] Shapin and Schaffer might have renewed Hobbes's problem even more tellingly when they redrew his monster for *their* frontispiece and equipped his left arm not with the Bishop's crosier but with Boyle's air-pump.[4] From now on, the powers of science are just as important to consider: How do they assemble, and around which matters of concern?

But in addition to the visual puzzle of assembling composite bodies, another puzzle should strike us in those engravings. A simple look at them clearly proves that the "Body Politik" is not only made of people! They are thick with things: clothes, a huge sword, immense castles, large cultivated fields, crowns, ships, cities and an immensely complex technology of gathering, meeting, cohabiting, enlarging, reducing and focusing. In addition to the throng of little people summed up in the crowned head of the Leviathan, there are objects everywhere.

To be crowded with objects that nonetheless are not really integrated into our definition of politics is even more tellingly visible in the famous fresco painted by Lorenzetti in Siena's city hall.[5] Many scholars have deciphered for us the complex meaning of the emblems representing the Good and the Bad Government, and have traced their complex genealogy. But what is most striking for a contemporary eye is the massive presence of cities, landscapes, animals, merchants, dancers, and the ubiquitous rendering of light and space. The Bad Government is not simply illustrated by the devilish figure of Discordia but also through the dark light, the destroyed city, the ravaged landscape and the suffocating people. The Good Government is not simply personified by the various

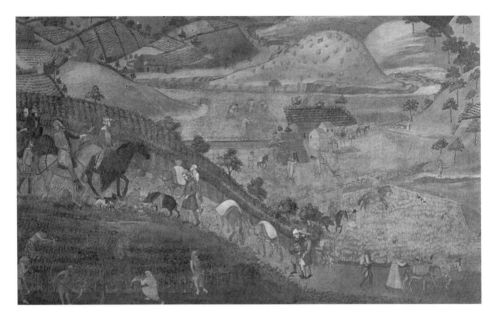

Figure 11.1 Ambrogio Lorenzetti, *The Effects of the Good Government*, 1338–1339, fresco (detail), Palazzo Pubblico, Siena, Sala dei Nove, © Comune di Siena, photo: Foto Lensini Siena.

emblems of Virtue and Concordia but also through the transparency of light, its well-kept architecture, its well-tended landscape, its diversity of animals, the ease of its commercial relations, its thriving arts. Far from being simply a *décor* for the emblems, the fresco requests us to become attentive to a subtle ecology of Good and Bad Government. And modern visitors, attuned to the new issues of bad air, hazy lights, destroyed ecosystems, ruined architecture, abandoned industry and delocalized trades are certainly ready to include in their definition of politics a whole new ecology loaded with things.[6] Where has political philosophy turned its distracted gaze while so many objects were drawn under its very nose?

A New Eloquence

In this show, we simply want to pack loads of stuff into the empty arenas where naked people were supposed to assemble simply to talk. Two vignettes will help us focus on those newly crowded sites.

The first one is a fable proposed by Peter Sloterdijk.[7] He imagined that the US Air Force should have added to its military paraphernalia a "pneumatic parliament" that could be parachuted at the rear of the front, just after the liberating forces of the Good had defeated the forces of Evil. On hitting the ground, this parliament would unfold and be inflated just like your rescue dingy is supposed to do when you fall in the water. Ready to enter and take your seat, your finger still red from the indelible ink that proves you have exercised your voting duty, instant democracy would thus be delivered! The lesson of this simile is easy to draw. To imagine a parliament without its material set

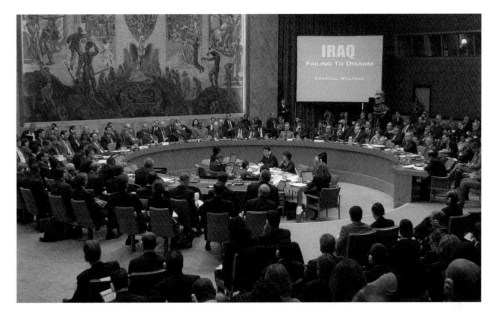

Figure 11.2 The United Nations Security Council meets at the UN headquarters to hear evidence of Iraq's weapons program presented by US Secretary of State Colin Powell Wednesday, February 5, 2003, © AP Photo/Richard Drew.

of complex instruments, "air-conditioning" pumps, local ecological requirements, material infrastructure, and long-held habits is as ludicrous as to try to parachute such an inflatable parliament into the middle of Iraq. By contrast, probing an object-oriented democracy is to research what are the material conditions that may render the air breatheable again.

The second vignette is the terrifying one offered by the now infamous talk former Secretary of State Colin Powell gave to the United Nations on February 5, 2003, about the unambiguous and undisputable fact of the presence of weapons of mass destructions in Iraq.[8] No doubt, the first half of the representation – namely the assembly of legitimate speakers and listeners – was well taken care of. All of those sitting around the UN Security Council horseshoe table had a right to be there. But the same can't be said of the second half, namely the representation of the facts of the matter presented by the Secretary of State. Every one of the slides was a blatant lie – and the more that time has passed, the more blatant it has become. And yet their showing was prefaced by these words: "My colleagues, every statement I make today is backed up by sources, solid sources. *These are not assertions.* What we are giving you are *facts* and conclusions based on solid intelligence" (my emphasis). Never has the difference between facts and assertions been more abused than on this day.

To assemble is one thing; to represent to the eyes and ears of those assembled what is at stake is another. An object-oriented democracy should be concerned as much by the procedure to detect the relevant parties as to the methods to bring into the center of the debate the proof of what it is to be debated. This second set of procedures to bring in the object of worry has several old names: *eloquence*, or more pejorative, *rhetoric*, or, even more derogatory, *sophistry*. And yet these are just the labels that we might need to

rescue from the dustbin of history.[9] Mr. Powell tried to distinguish the rhetoric of asser-
tions from the undisputable power of facts. He failed miserably. Having no truth, he had
no eloquence either. Can we do better? Can we trace again the frail conduits through
which truths and proofs are allowed to enter the sphere of politics?

Unwittingly, the secretary of state put us on a track where the abyss between asser-
tions and facts might be a nice "rhetorical" ploy, but it has lost its relevance. It would
imply, on the one hand, that there would be matters-of-fact which some enlightened
people would have unmediated access to. On the other hand, disputable assertions
would be practically worthless, useful only insofar as they could feed the subjective
passions of interested crowds. On one side would be the truth and no mediation, no
room for discussion; on the other side would be opinions, many obscure intermediar-
ies, perhaps some hecklings. Through the use of this indefatigable cliché, the *Pneumatic
Parliament* is now equipped with a huge screen on which thoroughly transparent facts
are displayed. Those who remain unconvinced prove by their resistance how irrational
they are; they have unfortunately fallen prey to subjective passions. And sure enough,
having aligned so many "indisputable" facts behind his position, since the "dispute" was
still going on, Powell had to close it arbitrarily by a show of unilateral force. Facts and
forces, in spite of so many vibrant declarations, always walk in tandem.

The problem is that transparent, unmediated, undisputable facts have recently
become rarer and rarer. To provide complete undisputable proof has become a rather
messy, pesky, risky business. And to offer a *public* proof, big enough and certain enough
to convince the whole world of the presence of a phenomenon or of a looming danger,
seems now almost beyond reach – and always was.[10] The same American administra-
tion that was content with a few blurry slides "proving" the presence of non-existing
weapons in Iraq is happy to put scare quotes around the proof of much vaster, better
validated, more imminent threats, such as global climate change, diminishing oil
reserves, increasing inequality. Is it not time to say: "Mr. Powell, given what you have
done with facts, we would much prefer you to leave them aside and let us instead com-
pare mere *assertions* with one another. Don't worry, even with such an inferior type of
proof we might nonetheless come to a conclusion, and this one will not be arbitrar-
ily cut short"?[11] Either we should despair of politics and abandon the hope of providing
public proofs altogether, or we should abandon the worn-out cliché of incontrovertible
matters of fact. Could we do better and manage to really conclude a dispute with "dis-
putable" assertions? After all, when Aristotle – surely not a cultural relativist! – intro-
duced the word "rhetoric" it was precisely to mean *proofs*, incomplete to be sure but
proofs nonetheless.[12]

This is what we wish to attempt: Where matters-of-fact have failed, let's try what I
have called matters-of-concern. What we are trying to register here [. . .] is a huge sea
change in our conceptions of science, our grasps of facts, our understanding of objectiv-
ity. For too long, objects have been wrongly portrayed as matters-of-fact. This is unfair
to them, unfair to science, unfair to objectivity, unfair to experience. They are much
more interesting, variegated, uncertain, complicated, far reaching, heterogeneous,
risky, historical, local, material and networky than the pathetic version offered for too
long by philosophers. Rocks are not simply there to be kicked at, desks to be thumped
at. "Facts are facts are facts"? Yes, but they are also a lot of other things *in addition*.[13]

For those like Mr. Powell, who have long been accustomed to getting rid of all
opposition by claiming the superior power of facts, such a sea change might be met with

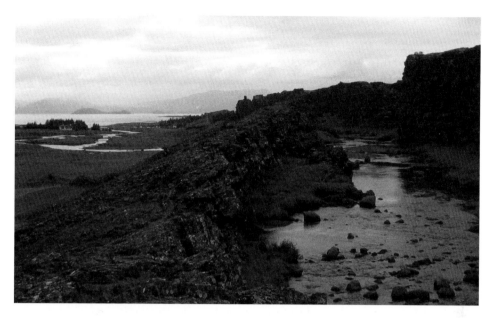

Figure 11.3 Althing in Thingvellir (Þingvellir), Iceland, photo. Sabine Himmelsbach. In 930 AD chieftains in Iceland gathered in a natural amphitheater and formed the world's first parliament, the *Althing*. The meeting place was called Thingvellir ("parliament plains"), and over the next 300 years representatives journeyed here once a year to elect leaders, argue cases, and settle disputes.

cries of derision: "relativism," "subjectivism," "irrationalism," "mere rhetoric," "sophistry"! They might see the new life of facts as so much subtraction. Quite right! It subtracts a lot of their power because it renders their lives more difficult. Think of that: They might have to enter into the new arenas for good and finally make their point to the bitter end. They might actually have to publicly prove their assertions *against other assertions* and come to a closure without thumping and kicking, without alternating wildly between indisputable facts and indisputable shows of terror. We wish to explore in this catalog many realist gestures other than just thumping and kicking. We want to imagine a *new eloquence*. Is it asking too much of our public conversation? It's great to be convinced, but it would be even better to be convinced *by some evidence*.[14]

Our notions of politics have been thwarted for too long by an absurdly unrealistic epistemology. Accurate facts are hard to come by, and the harder they are, the more they entail some costly equipment, a longer set of mediations, more delicate proofs. Transparency and immediacy are bad for science as well as for politics; they would make both suffocate.[15] What we need is to be able to bring inside the assemblies *divisive* issues with their long retinue of complicated *proof-giving* equipment. No unmediated access to agreement; no unmediated access to the facts of the matter. After all, we are used to rather arcane procedures for voting and electing. Why should we suddenly imagine an eloquence so devoid of means, tools, tropes, tricks and knacks that it would bring the facts into the arenas through some uniquely magical transparent idiom? If politics is earthly, so is science.

From objects to things

It's to underline this shift from a cheapened notion of objectivity to costly proofs that we want to resurrect the word "Ding" and use the neologism *Dingpolitik* as a substitute for *Realpolitik*. The latter lacks realism when it talks about power relations as well as when it talks about mere facts. It does not know how to deal with "indisputability". To discover one's own real naked interest requires probably the most convoluted and farfetched inquiry there is. To be brutal is not enough to turn you into a hard-headed realist.

As every reader of Heidegger knows, or as every glance at an English dictionary under the heading "Thing" will certify, the old word "Thing" or "Ding" designated originally a certain type of archaic assembly.[16] Many parliaments in Nordic and Saxon nations still activate the old root of this etymology: Norwegian congressmen assemble in the *Storting*; Icelandic deputies called the equivalent of "thingmen" gather in the *Althing*;[17] Isle of Man seniors used to gather around the *Ting*;[18] the German landscape is dotted with *Thingstätten* and you can see in many places the circles of stones where the Thing used to stand.[19] Thus, long before designating an object thrown out of the political sphere and standing there objectively and independently, the *Ding* or Thing has for many centuries meant the issue that brings people together *because* it divides them. The same etymology lies dormant in the Latin *res*, the Greek *aitia* and the French or Italian *cause*. Even the Russian *soviet* still dreams of bridges and churches.[20]

Of all the eroded meanings left by the slow crawling of political geology, none is stranger to consider than the Icelandic *Althing*, since the ancient "thingmen" – what we would call "congressmen" or MPs – had the amazing idea of meeting in a desolate and sublime site that happens to sit smack in the middle of the fault line that marks the meeting place of the Atlantic and European tectonic plates. Not only do Icelanders manage to remind us of the old sense of *Ding*, but they also dramatize to the utmost how much these political questions have also become questions of nature. Are not all parliaments now divided by the nature of things as well as by the din of the crowded *Ding*? Has the time not come to bring the *res* back to the res publica?[21] This is why we have tried to build the provisional and fragile assembly of our show on as many fault lines from as many tectonic plates as possible.

The point of reviving this old etymology is that we don't assemble because we agree, look alike, feel good, are socially compatible or wish to fuse together but because we are brought by divisive matters of concern into some neutral, isolated place in order to come to some sort of provisional makeshift (dis)agreement. If the *Ding* designates both those who assemble because they are concerned as well as what causes their concerns and divisions, it should become the center of our attention: *Back to Things!* Is this not a more engaging political slogan?

But how strange is the shape of the things we should go back to. They no longer have the clarity, transparency, obviousness of matters-of-fact; they are not made of clearly delineated, discrete objects that would be bathing in some translucent space like the beautiful anatomical drawings of Leonardo, or the marvelous wash drawings of Gaspard Monge, or the clear-cut "isotypes" devised by Otto Neurath.[22] Matters-of-fact now appear to our eyes as depending on a delicate aesthetic of painting, drawing, lighting, gazing, convening, something that has been elaborated over four centuries and that might be changing now before our very eyes.[23] There has been an aesthetic of matters-

of-fact, of objects, of *Gegenstände*. Can we devise an aesthetic of matters-of-concern, of Things? This is one of the (too many!) topics we wish to explore.[24]

Gatherings is the translation that Heidegger used, to talk about those Things, those sites able to assemble mortals and gods, humans and non-humans. There is more than a little irony in extending this meaning to what Heidegger and his followers loved to hate, namely science, technology, commerce, industry and popular culture.[25] And yet this is just what we intend to do in this book: the objects of science and technology, the aisles of supermarkets, financial institutions, medical establishments, computer networks – even the catwalks of fashion shows![26] – offer paramount examples of hybrid forums and agoras, of the gatherings that have been eating away at the older realm of pure objects bathing in the clear light of the modernist gaze. Who could dream of a better example of hybrid forums than the scale models used by architects all over the world to assemble those able to build them at scale I?[27] Or the thin felt pen used by draughtsmen to imagine new landscapes?[28] When we say "Public matters!" or "Back to Things!" we are not trying to go back to the old materialism of *Realpolitik*, because *matter itself* is up for grabs as well. To be materialist now implies that one enters a labyrinth more intricate than that built by Daedalus.

In the same fatal month of February 2003, another stunning example of this shift from object to things was demonstrated by the explosion of the shuttle Columbia.

Figure 11.4 NASA Crash Investigator, Kennedy Space Center in Cape Canaveral, Florida, March 11, 2003, © photo: AP Photo/NASA, Kim Shiflett. A member of the space shuttle reconstruction project team holds a piece of wreckage and tries to locate it on pictures of Columbia taken while the orbiter was in the vehicle assembly building.

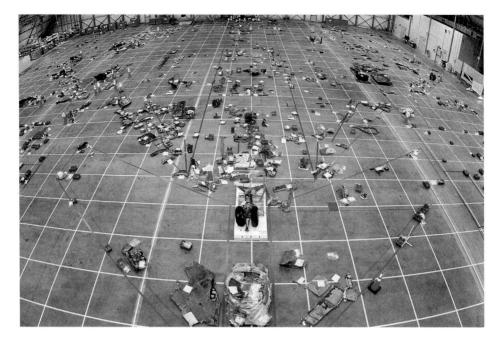

Figure 11.5 Columbia space shuttle debris (photo courtesy of Getty Images News / Getty Images).

"Assembly drawing" is how engineers call the invention of the blueprint.[29] But the word assembly sounds odd once the shuttle has exploded and its debris has been gathered in a huge hall where inquirers from a specially designed commission are trying to discover what happened to the shuttle. They are now provided with an "exploded view" of a highly complex technical object. But what has exploded is our capacity to understand what objects are when they have become *Ding*. How sad that we need catastrophes to remind us that when Columbia was shown on its launching pad in its complete, autonomous, objective form that such a view was even more of a lie than Mr. Powell's presentation of the "facts" of WMD. It's only *after* the explosion that everyone realized the shuttle's complex technology should have been drawn with the NASA bureaucracy *inside* of it in which they, too, would have to fly.[30]

The object, the *Gegenstand*, may remain outside of all assemblies but not the *Ding*. Hence the question we wish to raise: What are the various shapes of the *assemblies* that can make sense of all those *assemblages*? Questions we address are to the three types of representation brought together in this show: political, scientific and artistic.

Through some amazing quirk of etymology, it just happens that the same root has given birth to those twin brothers: the *Demon* and the *Demos* — and those two are more at war with each other than Eteocles and Polynices ever were.[31] The word "demos" that makes half of the much vaunted word "demo-cracy" is haunted by the demon, yes, the devil, because they share the same Indo-European root *da-* to divide.[32] If the demon is such a terrible threat, it's because it divides in two. If the demos is such a welcome solution, it's because it also divides in two. A paradox? No, it's because we ourselves are so divided by so many contradictory attachments that we have to assemble.

We might be familiar with Jesus' admonition against Satan's power,[33] but the same

power of division is also what provides the division/divide, namely the *sharing* of the same territory. Hence the *people*, the *demos*, are made up of those who share the same space and are divided by the same contradictory worries. How could an object-oriented democracy ignore such a vertiginous uncertainty? When the knife hovers around the cake of common wealth to be divided in shares, it may divide and let loose the *demon* of civil strife, or it may cut equal shares and let the *demos* be happily apportioned. Strangely enough, we are divided and yet might have to divide, that is to share, even more. The "demos" is haunted by the demon of division! No wonder that this show offers, I am afraid, such a *pandemonium*. Politics is a branch of teratology: from Leviathan to devils, from Discordia to Behemoth, and soon a whole array of ghosts and phantoms. Tricks *and* treats all the way down.

Notes

* Although I cannot thank all the people whose thoughts have contributed to this chapter without listing this entire catalog, I owe a very special thanks to Noortje Marres, whose work on Lippmann and Dewey has been central during the three years of preparation for this show.

1 Ron Suskind, "Without a Doubt", in: *New York Times*, October 17, 2004.
2 Horst Bredekamp, *Thomas Hobbes Visuelle Strategien. Der Leviathan: Urbild des modernen Staates. Werkillustrationen und Portraits*, Akademie Verlag, Berlin, 1999; Simon Schaffer, [. . .], chapter 3; about Nicéron's machine: Jean-François Nicéron, *La perspective curieuse à Paris chez Pierre Billaine Chez Jean Du Puis rue Saint Jacques à la Couronne d'Or avec l'Optique et la Catoptrique du RP Mersenne du mesme ordre Oeuvre très utile aux Peintres, Architectes, Sculpteurs, Graveures et à tous autres qui se meslent du Dessein*, 1663.
3 Dario Gamboni, [. . .]
4 Steven Shapin, Simon Schaffer, *Leviathan and the Air-Pump. Hobbes, Boyle and the Experimental Life*, Princeton University Press, Princeton, 1985.
5 Quentin Skinner, *Ambrogio Lorenzetti: the Artist as Political Philosopher*, Cambridge University Press, Cambridge, 1986; Anne-Marie Brenot, *Sienne au XIV siècle dans les fresques de Lorenzetti: la Cité parfaite*, L'Harmattan, Paris, 1999; Giovanni Pavanello, *Il Buono et il Cattivo Governo. Rappresentazioni nelle Arti dal Medioevo al Novecento*, exhib. cat., Fondazione Cini, Marsilio, Venice, 2004, [. . .] 2.
6 Peter Sloterdijk, *Sphären III – Schäume. Plurale Sphärologie*, Suhrkamp, Frankfurt/M., 2004.
7 Peter Sloterdijk, [. . .].
8 Full text is available at: http://www.state.gov/secretary/rm/2003/17300.htm
9 Barbara Cassin, *L'effet sophistique*, Gallimard, Paris, 1995, [. . .].
10 Simon Schaffer, [. . .].
11 See the complex set of assertions offered by Hans Blix, *Disarming Iraq*, Pantheon Books, New York, 2004.
12 "Enthymem" is the name given to this type of incomplete proof: Aristotle, *Treatise on Rhetorics*, Prometheus Books, New York, 1995.
13 Hans-Jörg Rheinberger, *Toward a History of Epistemic Thing. Synthesizing Proteins in the Test Tube*, Stanford University Press, Stanford, CA, 1997; Hans-Jörg Rheinberger, Henning Schmidgen, [. . .].
14 It's a striking feature of the 2004 American election to have witnessed the drift of the meaning of the word "convinced" from an objective to a subjective status: one now

designates by it the inner wholesomeness of an interior soul and no longer the effect on one's mind of some indirect and risky evidence: the "convinced" Bush won over the "flip-flopper" to-be-convinced Kerry.

15 Hanna Rose Shell about Marey's instrumentarium, [. . .]. Peter Galison about the Wall of Science, [. . .].

16 See the Oxford Dictionary: "ORIGIN: Old English, of Germanic origin: related to German *Ding*. Early senses included 'meeting' and 'matter', 'concern' as well as 'inanimate objects'." Martin Heidegger, *What is a thing?*, trans. W. B. Barton, Jr., Vera Deutsch, Regnery, Chicago, 1968; Graham Harman, [. . .].

17 Gísli Pálsson, [. . .].

18 Elizabeth Edwards and Peter James on Benjamin Stone's photographs, [. . .].

19 Barbara Dölemeyer, [. . .].

20 Oleg Kharkhordin, [. . .].

21 "When [the *res*] appears in this function, it is not as a seat where the unilateral mastery of a subject is exercised [. . .] If the *res* is an object, it has this function above all in a debate or an argument, a common object that *opposes* and *unites* two protagonists within a single relation." And, further on: "Its objectivity is ensured by the common agreement whose place of origin is controversy and judicial debate." Yan Thomas, "Res, chose et patrimoine (note sur le rapport sujet-objet en droit romain)", in: *Archives de philosophie du droit*, 25, 1980, pp. 413–426, here pp. 417f.

22 Frank Hartmann, [. . .].

23 Lorraine Daston, Peter Galison, "The Image of Objectivity", in: *Representation*, 40, 1992, pp. 81–128; Lorraine Daston, [. . .] Jessica Riskin, [. . .].

24 Peter Weibel, [. . .].

25 Richard Rorty, [. . .] Graham Harman, [. . .].

26 Pauline Terreehorst, Gerard de Vries, [. . .].

27 Albena Yaneva, [. . .].

28 Emilie Gomart, [. . .].

29 Wolfang Lefèvre, *Picturing Machines 1400–1700*, The MIT Press, Cambridge, MA, 2004.

30 Wiebe E. Bijker, [. . .].

31 Marcel Detienne (ed.), *Qui veut prendre la parole?*, Le Seuil, Paris, 2003.

32 Pierre Lévêque, "Répartition et démocratie à propos de la racine da-", in: *Esprit*, 12, 1993, pp. 34–39.

33 "Every kingdom divided against itself is laid waste, and no city or house divided against itself will stand; and if Satan casts out Satan, he is divided against himself; how then will his kingdom stand?" (Matthew 12: 25–26).

Julian Bleecker

WHY THINGS MATTER

A manifesto for networked objects – cohabiting with pigeons, arphids, and AIBOs in the internet of things

Abstract

The Internet of Things has evolved into a nascent conceptual framework for understanding how physical objects, once networked and imbued with informatic capabilities, will occupy space and occupy themselves in a world in which things were once quite passive. This paper describes the Internet of Things as more than a world of RFID tags and networked sensors. Once "Things" are connected to the Internet, they can only but become enrolled as active, worldly participants by knitting together, facilitating and contributing to networks of social exchange and discourse, and rearranging the rules of occupancy and patterns of mobility within the physical world. "Things" *in the pervasive* Internet, will become first-class citizens with which we will interact and communicate. Things will have to be taken into account as they assume the role of socially relevant actors and strong-willed agents that create social capital and reconfigure the ways in which we live within and move about physical space.

To distinguish the instrumental character of "things" connected to the Internet from "things" participating within the Internet of social networks, I use the neologism "Blogject"—"objects that blog."

What's a blogject? what about spimes?

"Blogject" is a neologism that's meant to focus attention on the participation of "objects" and "things" in the sphere of networked social discourse variously called the blogosphere, or social web. The Blogject is a kind of early ancestor to the Spime, Bruce Sterling's resonant, single-syllable noun for things that are searchable, track their location,

usage histories and discourse with the other things around them. Sterling is an articulate and thoughtful sci-fi design agent and he can come up with words like "Spime." I am an engineer and a researcher of near-future technocultures who also makes things and makes things up. I can grok "Spimey" things, and register Sterling's technology fiction. As an engineer, I can make Blogjects now because the semantics are immediately legible—objects, that blog. Tonight, I can go into my laboratory and begin to experiment with what a world might be like in which I co-occupy space with objects that blog. To make Spimey things—well, Sterling's technology fiction will have to explicate itself in the form of his forthcoming treatment, something I eagerly await. I read Sterling's Shaping Things as a field guide to the technology fiction I imagine he is presently writing about. Out of that reading came a tiny nugget of insight: if there's one thing Spimes will do, they will most certainly "blog."

Blogging? Objects?

The distinction between objects that blog, and human agents that blog is important to flesh out, starting with what bloggers are. "Bloggers" loosely defined, are participants in a network of exchange, disseminating thoughts, opinions, ideas—making culture—through this particular instrument of connections called the Internet. (Bloggers also do so when they meet face-to-face, but we'll avoid that important nuance for the time being.) Bloggers, as a type of social being, do more than literally blog. They report on what they see, know and think about. They may use "blog software"—a paleolithic mechanism for circulating culture—and lots of other things. Probably most importantly, they have something semantically weighty to talk about, whatever their particular idiom of social exchange may be—politics, geek news, gadgets, music, personality fetish, knitting, best practices for smoking salmon—what have you.

In the same way, Blogjects—objects that blog—don't just literally "blog" in the routine sense. Although there are good examples of some embryonic Blogjects that literally just blog (and don't even do a very good job—they're hardly two way, don't pay attention to comments—but I guess *some human bloggers don't pay attention to comments*, either), blogjects in the near-future will participate in the whole meaning-making apparatus that is now the social web, and that is becoming the "Internet of Things."[1] The most peculiar characteristic of Blogjects is that they participate in the exchange of ideas. Blogjects don't just publish, they circulate conversations. Not with some sort of artificial intelligence engine or other speculative high-tech wizardry. Blogjects become first-class a-list producers of conversations in the same way that human bloggers do—by starting, maintaining and being critical attractors in conversations around topics that have relevance and meaning to others who have a stake in that discussion. If the contribution to that discussion happens through some seemingly mundane bit of networked disseminated insight matters little in terms of their consequence. A Blogject can start a conversation with something as simple as an aggregation of levels of pollutants in groundwater. If this conversation is maintained and made consequential through hourly RSS feeds and visualizations of that same routine data, this Blogject is going to get some trackback.

Blogjects are slowly creeping out of the primordial soup of passive, low-impact thing-ness. Blogjects aspire to relevance, and assert themselves because of new perspectives or additional insights they can offer on a semantically meaningful topic.

Take the Pigeon that Blogs, for example—an early protozoa on the Blogject species evolutionary chain. The Pigeon that Blogs is a project by Beatriz da Costa. It's a pigeon, or more precisely, a flock of pigeons that are equipped with some telematics to communicate on the Internet wirelessly, a GPS device for tracing where its been flying, and an environmental sensor that records the levels of toxins and pollutants in the air through which they fly. These are the bits of data that the flocks "blog." They disseminate their flight paths, probably viewable on a Google Map, together with information about the current toxic state of the local atmosphere. The Pigeon that Blogs is a mash-up of GPS, GSM communications technology and pollution sensors representing a full-order species evolution. It's a pigeon pollution Google Maps mash-up.

What does this all mean? Like all good "mash-ups" it means more than the sum of its parts. Whereas once the pigeon was an urban varmint whose value as a participant in the larger social collective was practically nil or worse, the Pigeon that Blogs now attains first-class citizen status. Their importance quickly shifts from common nuisance and a disgusting menace, to a participant in life and death discussions about the state of the micro-local environment. Pigeons that tell us about the quality of the air we breathe are the Web 2.0 progeny of the Canary in the Coal Mine.

Blogjects: some characteristics

Blogjects have some rudimentary characteristics, very much part of the rules of behavior in a Spimey world. These are not definitive features, but rather elements, traits and idiosyncrasies that might be found amongst objects that participate in the social web. Here are three peculiarities of Blogjects:

- Blogjects track and trace where they are and where they've been;
- Blogjects have self-contained (embedded) histories of their encounters and experiences;
- Blogjects always have some form of agency—they can foment action and participate; they have an assertive voice within the social web.

Traces—blogjects know where they are

Traces are about knowing where you are and where you've been in a geospatial sense. Blogjects operate in the physical world and, therefore, would know where they are, where they have been. Blogjects would know what other Blogjects they have come in contact with, or been near. Blogjects have attachments associated with those traces. Where our Blogjects go, someone always knows. Human agents might make meaning of the traces of their luggage as a historical documentation of their travels. Security may turn luggage into field agents that record histories of encounters with the luggage of other people, perhaps people of concern, or luggage that is suspiciously "anonymous" or that has traveled to questionable territories with regularity.

Our luggage has already asserted itself during our intraplanetary travels. The most efficient traces of luggage keep it with us, wherever we go. I have not had luggage lose me for close to a decade, although I don't travel a great deal so I might not be the best litmus test for the Blogginess of luggage. But recently, a colleague recounted the story of a bit of nuisance luggage that lost its human. It seems the trace characteristics of the luggage Blogject left a trail toward Milan, Italy when the destination of the human was Barcelona, Spain. In fact, the luggage was on its way to Milan and so its human was duly re-routed as well, beyond its will. In the Internet of Things, Things, it is not human agency alone that shapes the way we occupy and move through space.

History—blogjects know from whence they have arrived

History is the remnants of experiences Blogjects acquire. It is a way to reveal and share those events, proximity-based interactions and encounters and disseminate them,

or leave them behind in particular locales as a way to "fill in" traces with semantic or even just instrumental remarks. Ideally the history is embedded, rather than indexical, so that Blogjects physically contain the full record of their experiences, where they occurred and with who and what. The barcode, for instance, is indexical in that it is a reference to information located elsewhere. Many Arphids are indexical in the same fashion, although newer units have storage built in which could be used to persist historical data within the actual device.

The web encyclopedia "*How Stuff Is Made*" anticipates the kind of embedded event histories that we would want our Things to contain, such as manufacturing processes, labor conditions, environmental consequences and so on.[2] This kind of history of Things has the consequential character of telling a story about their making, about their past. Blogjects, like Spimes know about their conditions of manufacture, including labor contexts, costs and profit margins; materials used and consumed in the manufacturing process; patent trackbacks; and, perhaps most significantly, rules, protocols and techniques for retiring and recycling Things. Things can no longer describe themselves with only a list of ingredients or country of manufacture or an RFID that merely makes the printed label digital and wireless—that just is not ontologically satisfying. This is like best practices for open source, object-oriented software design for Things that are physical, tangible and take up space. Objects, like their ephemeral, software kin, should be self-describing, they need to let us know what they are, what their API touch points are, how to construct them and how to destruct them. I want to know more than just what the Thing is. I want to know how to refactor and rejuvenate networked objects, and for that I need open source Things.

Agency—blogjects are assertive

Agency is perhaps the most provocative aspect of the Blogject feature set. Agency is about having an ability to foment action, to be decisive and articulate, to foment action. This isn't the Terminator fantasy of machines with guns that run amok, acting against humanity. The Blogject capacity for producing effects is far more powerful because it has always been pervasively, ubiquitously, everywhere tethered to the most far reaching, speedy, robust network of social exchange and discourse that humanity has ever constructed. In the Internet of Things, that kind of agency happens within the ecology of networked publics—streams, feeds, trackbacks, permalinks, Wiki inscriptions and blog posts.

Agency as I am using it here does not just mean a local "artificial intelligence" that makes a Blogject able to make autonomous, human-like decision or fashion croaky human-speech from text. Blogjects have no truck with the syntax of human thought. Things could not care any less about their Turing Test report card. Blogject intellect is their ability to effect change. Their agency attains through the consequence of their assertions, and through the significant perspective they deliver to meaningful conversations. Blogjects bring something heavy to the table. Or, they are brought to the table because they have semantic weight.

Agency is literally imbued in Blogjects. Things that matter completely sully the previously starched white relationship between subject and object, human and non-human. Things that matter inflect the course of social debate and discussion, and cannot help inflicting local and global change. Witness the Spotted Owl. Witness the Pacific

Northwest Salmon. Witness all the non-human, non-subject "things" that became fully imbued with the status of first-class citizens. Heck, most humans don't have the capacity to effect the kind of worldly change and receive the same order of protection, status and economic resources *as a fish*.

Why things matter?

For cohabitation—the question of space and place

The Internet of Things brings many vectors together—pervasive networks, the miniaturization of networked devices, mobile communication, the refashioning of physical space as we cohabit and co-occupy space with Things. When the network that has facilitated a profound, unprecedented knitting together of complex, multivalent social formations seeps into a space—the physical, geospatial world—which was previously void of such, what does it all mean? When it is not only "us" but also our "Things" that can upload, download, disseminate and stream meaningful and meaning-making *stuff*, how does the way in which we occupy the physical world become different? What sorts of implications and effects on existing social practices can we anticipate? How does our imaginary skew when we think about how we might move about and occupy future worlds alongside of objects that blog and other Spimey creatures?

When we think of the kind of social networks that the Internet facilitates, we think of human agents participating in an exchange of ideas, centered around meaningful topics, whatever they may be. Until now, "objects" and "things" have been conspicuously absent from this sphere of making culture. When considered in the context of a pervasive, ubiquitous, everywhere Internet—an Internet that spills out beyond the tethered connections and local WiFi hotspots to consume nearly every corner of the physical world—the idea of objects in that physical world, now able to network, communicate and participate in the social web becomes a tantalizing consideration for novel designed experiences.

Things with informatics and networking capabilities anticipate a transformation in the ways social practice "fills in" space by their mobility and their physicality. There is an important difference between an object that consumes and occupies space as an inert

i-SEE
"Now More Than Ever."

www.appliedautonomy.com/isee.html

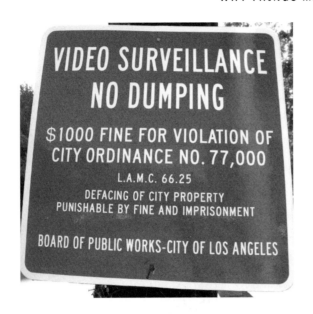

VIDEO SURVEILLANCE
NO DUMPING
$1000 FINE FOR VIOLATION OF
CITY ORDINANCE NO. 77,000
L.A.M.C. 66.25
DEFACING OF CITY PROPERTY
PUNISHABLE BY FINE AND IMPRISONMENT

BOARD OF PUBLIC WORKS-CITY OF LOS ANGELES

thing, and a Blogject that is able to capture information about the happenings in its sur-roundings, communicate with other informatic social beings and disseminate all of that anywhere in the world. We already know about security cameras and the concerns over privacy they pose, not to mention the ways they often make us think about our patterns of movement and practices for occupying physical space. The prescient emerging tech-nologists known collectively as the Institute for Applied Autonomy created a wonder-ful instrument called *iSee* that we might consider the Google Maps for the Internet of Things.[3] iSee contains a DIY database of surveillance cameras in the supremely pedes-trian New York City and some route finding software not unlike that used by Google Maps, and plots routes so as to avoid the maximum amount of exposure to cameras. iSee anticipates a world in which every flickr'ng camera is capturing real-time imagery from all over the networked world. How do you avoid being flickr'd? How do you insure that you get flickr'd? Will flickr'ng cameras self-aggregate their photographic cover-age, automatically discovering the flickr feeds of all the other cameras that were nearby them—at the fireworks show, or during the firehouse picnic—using NFC or Bluetooth proximity-based networking?

We might think about the way Blogjects will operate in a similar fashion to cap-ture and reorient physical space and thereby alter patterns of movement and occupancy within space. Michael Naimark and a team at Interval Research developed the Kundi project, a great example of a project that anticipates how the Internet of Things and Blogjects become a platform for reframing the meaning and the rules of occupancy of physical space.[4] The Kundi framework is deceptively simple, a testament to the foresight of the development team. With Kundi, connected Things (they were, in this case, web-cams capturing images of the real world) could have their content tagged as "hot" and draw in attention from anyone on the Internet. There are ludic scenarios, of course—it wouldn't be an Internet project if there weren't. But there is one usage scenario I've heard Naimark mention more than once—a Kundi Cam placed in a refugee camp where rape and murder are routine. Now imagine that the Blogject version of the Kundi Cam has a visible indicator showing how many tens of thousands of people around the world

are watching at any given moment. Behaviors change, threatening space edges towards safe space because Things are enrolled in the social web thicket.

Our occupancy in the world changes when we enroll Things amongst us *in* the social web. How will the rules of tenancy *within* the physical world change when our Things—physical objects—are informatic and networked? How will my behavior and my conception of physical space alter when the Internet pervades not only all the little nooks and crannies, but is accessible to all my little trinkets, my cereal box, my wallpaper, my ring?

Parenthetically, we'll have to begin choosing our prepositions with care—we are now in an era of pervasive networks and are thus more properly "in", not "on" the network. Careful choice of prepositions that help us orient matters deeply, and it helps think more clearly about not only the stakes of cohabiting with Things *within* the networked world, but also for thinking about how to design experiences for this very different mode of occupancy.

What about the other cohabitants that will now have the ability to get on the network within this pervasively networked future? Critter cams that disseminate a real-time video stream from a Kapok tree in the Amazonian rain forest or an RSS feed and podcast from a school of migrating whales showing all kinds of meaningful environmental data would definitely make it into my news aggregator. What difference would that make to how we cohabit physical space, how we understand the impacts our tenancy has? What difference do other blogging species have on how we understand how the world works, or how we work to change the world?

Space itself has been refashioned as a consequence of Spimey, blogging objects. Jeffrey Huang, an architect who has devoted considerable attention to the role of physical objects as digital interfaces, focuses his research on the ways in which the spaces we occupy are transformed by the introduction of architectural structures that are networked. Huang is noted for being both an architect and an Information Technology expert, so his eye is drawn to the ways in which structures, such as the massive, incredibly instrumented and networked distribution centers have arisen (even with their own airports!) to support the "bricks-and-clicks" online retailers, like Amazon. It is not only their physical dimensions that are massive, but the density of the network transactions

that occur within them, triggered via the simple click-click actions by underwear-clad insomniac shoppers at the edge of the network, sating their consumerism. Amazon distribution centers are one of the places where networked Things come to be. Clicks become boxes of books and electric shavers, all duly logged and traced through the equally massive networked operations of parcel carriers.

Huang's confluence of architect and IT expertise is prescient in an era in which structure, boundaries and paths are increasingly determined by where the network is, and where desirable networked actions and behaviors can be found. Who doesn't know where their own cellular operator's "dead zones" are? Or what cafe has good, cheap and thick WiFi bandwidth?

For co-participation

Occasionally objects, things, non-humans, non-subjects step out of their thingness to become more than lifeless props. Things can learn to walk upright, too, so as to distinguish themselves as valued companion species, with something to say, something to effect our disposition and attitude about our (we humans) role in managing and maintaining, or mismanaging and terrorizing the world in which we live. The Sony designers who created the firmware upgrade for Aib may have been unwitting participants in the Blogject evolution. The new version of the AIBO—a species whose future is uncertain—can take pictures of what it sees and establish a running blog of its whimsical musings. It's hard to resist the significance of the extrapolation of this idea, particularly when thought of in the context of our elaborate and bizarre kinship associations with domestic pets—arguably our closest companion species. Pets that blog are just the 21st century, networked world extension of the sometimes puzzling practice of giving pets "human" names like Bill, or referring to them with decidedly human kinship semantics like daughter or brother. As long as they have a network connection, why shouldn't they get their Web 2.0 upgrade and participate in the circulation of media and content? Things now have a voice in the collective of human social exchange.

The first-order consequence of the Internet of Things is a network in which socially meaningful exchanges takes place, were culture is made, experiences circulated through media sharing—only with objects and human agents. Whereas the Internet of Non-Things was limited to human agents, in the Internet of Things objects are also active participants in the creation, maintenance and knitting together of social formations through the dissemination of meaningful insights that, until now, were not easily circulated in human readable form. The important aspect of the Internet of Things is not that Arphids and data transponders are now connected onto the Internet. The significance of the Internet of Things is not at all about instrumented machine-to-machine communication, or sensors that spew reams of data credit card transactions, or quantities of water flows, or records of how many vehicles passed a particular checkpoint along a highway. Those sensor-based things are lifeless, asocial recording instruments when placed alongside of the Blogject.

Just like the motivation of the "alpha" blogger, the character of the motivated Blogject is to make, disseminate and enhance meaning, to draw attention and to be assertive. Like the alpha blogger, the Blogject enters into conversations that yield consequences. It's not at all interesting to have my car "blog" routine things such as the

routes I've driven, its time-average fuel consumption, or the street address of a restaurant I've just passed that has a menu that would appeal to my palate based on previous restaurant experiences. It is much more consequential, and much more assertive of a first-class participant in the network of social discourse for flocks of vehicles to provide macro-scale insights into how much fuel is consumed hourly on Interstate 405 in the Los Angeles basin, or how many tons of pollutants are exhausted into the atmosphere every hour.

The social and political import of the Internet of Things is that things can now participate in the conversations that were previously off-limits to Things. That's not as manifestly grand a statement as it may seem. It means, in simple terms, that Things, once plugged into the Internet, will become agents that circulate food for thought, that "speak on" matters from an altogether different point of view, that lend a Thing-y perspective on micro and macro social, cultural, political and personal matters.

The promising, exciting news around the Internet of Things cannot possibly be the "cool" factor of having my toothbrush connected to the network so that the Proctor & Gamble people knew when I was low on toothpaste. Design agents were always smarter than that. What if our RSS aggregators could tune into feeds from Amazonian forest and the daily clear-cut blog? Or critter cam video blogs that show us how really nasty seal bulls can be to their pups when they're not playing their circus act at Sea World. And video blogs from schools of dolphins and whales that will make it increasingly difficult to ignore the plumes of toxins in the oceans and the slaughter of their kin by whalers and felonious fishing fleets.

This manifesto isn't about predicting the future. This is a design imperative. I'm not saying this will happen—that birds and dogs and chairs and shoes will begin blogging and take over the world. I'm saying that design agents should think hard about the opportunities for creating more lively engagements with Things, enrolling them into the thick, contested and messy imbroglios of trans-species dialogue that lead to more habitable worlds. Let the Pigeons help us speak on the environment. Let Poultry get us to think seriously about a world where the H5N1 virus takes charge. Let Automobiles have a say about their fossil fuel consumption habits.

Forget about the Internet of Things as Web 2.0, refrigerators connected to grocery stores, and networked Barcaloungers. I want to know how to make the Internet of Things into a platform for World 2.0. How can the Internet of Things become a framework for creating more habitable worlds, rather than a technical framework for a television talking to an reading lamp? Now that we've shown that the Internet can become a place where social formations can accrete and where worldly change has at least a hint of possibility, what can we do to move that possibility out into the worlds in which we all have to live?

Notes

1 http://www.mobilejones.com/archives/2092/
2 http://www.howstuffismade.org
3 http://www.appliedautonomy.com/isee.html
4 http://www.naimark.net/projects/kundi.html

PART III

Objects and Agency

Peter Brown

PRAESENTIA

IN A CHARACTERISTIC MOMENT of penetrating disapproval, Hegel wrote of the piety of the middle ages:

> The Holy as a mere thing has the character of externality; thus it is capable of being taken possession of by another to my exclusion; it may come into an alien hand, since the process of appropriating it is not one that takes place in Spirit, but is conditioned by its quality as an external object. The highest of human blessings is in the hands of others.[1]

Hegel was speaking of the role of the clergy as the guardians of the Eucharist in the middle ages. But in the cult of relics also, late-antique and early-medieval piety lived down with gusto to his strictures. This cult gloried in particularity. *Hic locus est:* "Here is the place," or simply *hic*, is a refrain that runs through the inscriptions on the early martyrs' shrines of North Africa.[2] The holy was available in one place, and in each such place it was accessible to one group in a manner in which it could not be accessible to anyone situated elsewhere.

By localizing the holy in this manner, late-antique Christianity could feed on the facts of distance and on the joys of proximity. This distance might be physical distance. For this, pilgrimage was the remedy. As Alphonse Dupront has put it, so succinctly, pilgrimage was "une thérapie par l'espace."[3] The pilgrim committed himself or herself to the "therapy of distance" by recognizing that what he or she wished for was not to be had in the immediate environment.[4] Distance could symbolize needs unsatisfied, so that, as Dupront continues, "le pèlerinage demeure essentiellement départ": pilgrimage remains essentially the act of leaving.[5] But distance is there to be overcome; the experience of pilgrimage activates a yearning for intimate closeness. For the pilgrims who arrived after the obvious "therapy of distance" involved in long travel found

themselves subjected to the same therapy by the nature of the shrine itself. The effect of "inverted magnitudes" sharpened the sense of distance and yearning by playing out the long delays of pilgrimage in miniature. For the art of the shrine in late antiquity is an art of closed surfaces. Behind these surfaces, the holy lay, either totally hidden or glimpsed through narrow apertures. The opacity of the surfaces heightened an awareness of the ultimate unattainability in this life of the person they had traveled over such wide spaces to touch.[6]

In Tebessa, the approach to the shrine, as it wound past high walls, swung under arches, crossed courtyards, and finally descended into a small half-submerged chamber, was a microcosm of the long journey of pilgrimage itself.[7] At the shrine of Saint Lawrence at Rome, the first sign of patronage by a Christian emperor involved a heightening of the effect of distance; Constantine installed flights of stairs leading up and down from the grave, and "shut off" the grave itself with a grille of solid silver weighing a thousand pounds, thus keeping the tomb of Lawrence still at a short distance from the pilgrims.[8] At the shrine of Saint Peter, a whole ritual of access was played out:

> Whoever wishes to pray there [writes Gregory of Tours] must unlock the gates which encircle the spot, pass to where he is above the grave and, opening a little window, push his head through and there make the supplication that he needs.[9]

Golden keys to open these gates were treasured and potentially miraculous relics of the Roman pilgrimage,[10] as were the little cloths, the *brandea*, which the pilgrims lowered on to the tomb below, drawing them up heavy with the blessing of Saint Peter.[11] When the young prince Justinian wrote from Constantinople for a fragment of the priceless body of Saint Peter itself, he was flatly refused, and was sent instead one such cloth, inserted from a special window.[12] A yearning for proximity kept so carefully in suspense occasionally exploded. The Carthaginian noblewoman Megetia [. . .] had committed herself to the "therapy of distance" by traveling away from her family to the shrine of Saint Stephen in nearby Uzalis.[13] But she could not rest at that:

> While she prayed at the place of the holy relic shrine, she beat against it, not only with the longings of her heart, but with her whole body so that the little grille in front of the relic opened at the impact; and she, taking the Kingdom of Heaven by storm, pushed her head inside and laid it on the holy relics resting there, drenching them with her tears.[14]

The carefully maintained tension between distance and proximity ensured one thing: *praesentia*, the physical presence of the holy, whether in the midst of a particular community or in the possession of particular individuals, was the greatest blessing that a late-antique Christian could enjoy. For, the *praesentia* on which such heady enthusiasm focused was the presence of an invisible person. The devotees who flocked out of Rome to the shrine of Saint Lawrence, to ask for his favor or to place their dead near his grave, were not merely going to a place; they were going to a place to meet a person—*ad dominum Laurentium*.[15] The fullness of the invisible person could be present at a mere fragment of his physical remains and even at objects, such as the *brandea* of Saint Peter, that had merely made contact with these remains.[16] As a result, the Christian world came to

be covered with tiny fragments of original relics and with "contact relics" held, as in the case of Saint Peter, to be as full of his *praesentia* as any physical remains.[17] Translations—the movement of relics to people—and not pilgrimages—the movement of people to relics—hold the center of the stage in late-antique and early-medieval piety. A hectic trade in, accompanied by frequent thefts of, relics is among the most dramatic, not to say picaresque, aspects of western Christendom in the middle ages.[18] Only comparatively recently have medievalists succeeded in rendering this startling behavior intelligible.[19]

Let us consider for a moment the immediate profile and consequences of the beliefs that first encouraged the translation of relics in the late fourth century. If relics could travel, then the distance between the believer and the place where the holy could be found ceased to be a fixed, physical distance. It took on the shifting quality of late-Roman social relationships: distances between groups and persons were overcome by gestures of grace and favor,[20] and the dangerously long miles of the imperial communications system were overcome by a strenuously maintained ideology of unanimity and concord.[21] Those who possessed the holy, in the form of portable relics, could show *gratia* by sharing these good things with others, and by bringing them from the places where they had once been exclusively available to communities scattered throughout the Roman world. Behind every relic that was newly installed in its shrine throughout the Mediterranean, there had to lie some precise gesture of good will and solidarity. The inscription on an African shrine records merely the fact of distance overcome: "A piece of the wood of the Cross, from the Land of Promise, where Christ was born."[22] But Paulinus, writing inscriptions for his friend Sulpicius Severus, leaves us in no doubt of the reassuring touch of human friendship behind the "moment of high and terrible emotion"[23] of the arrival of such a fragment at Nola:

> Hoc Melani sanctae delatum munere Nolam
> Summum Hierosolymae venit ab urbe bonum.
> [Brought as a gift to Nola by the holy Melania, this, the highest of all goods,
> has come from the city of Jerusalem][24]

As a result, the transfer of relics, especially from the Holy Land to the Christian communities of the Western Mediterranean, can serve the historian as a faithful "trace element" that enables him to take an X-ray photograph of the intricate systems of patronage, alliance and gift-giving that linked the lay and the clerical elites of East and West in the late Roman Empire. In recent years, the theme of notable pilgrimages and translations of relics has passed from the sober domain of hagiographical antiquarianism into a series of elegant studies of patronage and politics among the Christian governing classes of the late fourth and early fifth centuries—I refer particularly to the work of David Hunt in England and of Ken Holum of the University of Maryland.[25]

I would like to point out some of the implications of this development. The yearning of pilgrimage and a "therapy of distance," associated with the neutral fact that a particular landscape lay at an unchangeable distance from other centers, came to be detached from a purely geographical setting: the holy could be brought ever closer through gestures of concord and gift giving which the men of late antiquity and the early middle ages treasured as the cement of their social world. A network of "interpersonal acts," that carried the full overtones of late-Roman relationships of generosity, dependence, and solidarity, came, in one generation, to link the Atlantic coast to the Holy Land; and,

in so doing, these "interpersonal acts" both facilitated and further heightened the drive to transmute distance from the holy into the deep joy of proximity.

Without an intense and wide-ranging network of late-Roman relationships of *amicitia* and *unanimitas* among the late-fourth-century *impresarios* of the cult of saints, relics would not have traveled as far, as fast, or with as much undisputed authority as they did. If this had not happened, if the translation of relics had not gained a major place in Christian piety, the spiritual landscape of the Christian Mediterranean might have been very different. It might have resembled that of the later Islamic world: the holy might have been permanently localized in a few privileged areas, such as the Holy Land, and in "cities of the saints," such as Rome. There might have been a Christian Mecca or a Christian Kerbela, but not the decisive spread of the cult of major saints, such as Peter and Paul, far beyond the ancient frontiers of the Roman world, as happened in Europe of the dark ages. Elsewhere, the holy might have been tied to the particularity of local graves that enjoyed little or no prestige outside their own region.[26] By the early fifth century, the strictly "geographical" map of the availability of the holy, which had tied the *praesentia* of the saints to the accidents of place and local history, had come to be irreversibly modified by a web of new cult sites, established by the translation of relics, which reflected the dependence of communities scattered all over Italy, Gaul, Spain, and Africa on the enterprise and generosity of a remarkable generation of distant friends.

Recent studies of the social and political contexts of translations of relics have revealed with such delightful, and even damaging, circumstantiality the relations and the motives of the principal human participants, that we should not forget the prime giver of good things, who was thought by late-antique men to stand behind the busy story of the discovery, the transfer, the accumulation—even, at times, the bare-faced robbery—of the holy. God gave the relic; in the first instance, by allowing it to be discovered, and then by allowing it to be transferred. As Augustine said in a sermon on Saint Stephen: "His body lay hidden for so long a time. It came forth when God wished it. It has brought light to all lands, it has performed such miracles."[27] Nowhere did the silver lining of God's amnesty shine more clearly from behind the black cloud of the late-antique sense of sin than accounts of the discovery and translation of relics. For these accounts are shot through with a sense of the miracle of God's mercy in allowing so precious a thing as the *praesentia* of the holy dead to become available to the Christian congregations in their own place and in their own times.

Behind the awkward Latin of the account by the priest Lucianus of the discovery of the body of Saint Stephen in a field outside the village of Caphargamala, in 415, we can sense the hopes and fears of the Aramaic speakers of the region.[28] Lucianus is warned to announce the good news to the bishop of Jerusalem:

> For it is especially fitting that we should be revealed in the time of your priesthood. . . . For the world is in danger, from the many sins into which it falls every day.[29]

When the coffin of Saint Stephen finally made its appearance, the touch of the divine mercy was overwhelming:

> At that instant the earth trembled and a smell of sweet perfume came from the place such as no man had ever known of, so much that we thought that

> we were standing in the sweet garden of Paradise. And at that very hour, from the smell of that perfume, seventy-three persons were healed.[30]

This mercy was further ratified by a downpour of rain which ended the cruel winter drought:

> And the earth drank its fill, and all here glorified the Lord, because of Stephen his holy one, and because our Lord Jesus Christ had deigned to open to this imperiled world the heavenly treasure of his mercy and lovingkindness.[31]

The discovery of a relic, therefore, was far more than an act of pious archaeology, and its transfer far more than a strange new form of Christian connoisseurship: both actions made plain, at a particular time and place, the immensity of God's mercy. They announced moments of amnesty. They brought a sense of deliverance and pardon into the present.

They could condense moods of public confidence. Thus, there is nothing strange in the decision of the church historian Sozomen to end his history with the story of the discovery and translation to Constantinople of the relics of the prophet Zechariah. Such an event made more plain even than did the cessation of barbarian invasion and civil wars the mood of public confidence on which the writer deemed it politic to end an account of the prosperity enjoyed by the Eastern Empire under Theodosius II. God had made manifest his approval of the reign of Theodosius by making accessible to the inhabitants of his empire the *praesentia* of the long-buried dead.[32]

A sense of the mercy of God lies at the root of the discovery, translation, and installation of relics. In such a mood, the relic itself may not have been as important as the invisible gesture of God's forgiveness that had made it available in the first place; and so its power in the community was very much the condensation of the determination of that community to believe that it had been judged by God to have deserved the *praesentia* of the saint. It is in this light that we can best see the steady drain of relics into the new capital, Constantinople.[33] The precise events of the discovery of the relic and the ceremonies surrounding its arrival and installation counted for more than the mere fact of its presence in the city. Many relics lapsed into obscurity after their arrival. What mattered was the arrival itself. This was an unambiguous token of God's enduring capacity to forgive the inhabitants of the rapidly growing, tension-ridden city.[34] As recognitions by God of the "manifest destiny" of the new capital and its right to survive, translations of relics were carefully remembered in art and liturgy on the same footing as those blessed moments when God had brought to a halt the awesome rumble of earth tremors.[35]

The discovery and the installation of a relic, therefore, was surrounded by a sense of amnesty and a heightening of morale. Precisely because of this, late-Roman men felt free to seek, in the ceremonies surrounding the cult of saints, a positive replication of social relations that preoccupied them so deeply. For the ravages of sin in late-antique social and personal relationships were suspended on those high moments when the invisible persons took up their place in the community: the *praesentia* of the saint could be associated with unambiguously good happenings in a world only too cluttered with bad happenings. As a result, the ceremonial and literature that surrounded the arrival, the installation, and the annual celebration of the cult of a patron saint in the western

Mediterranean, from the late fourth to the sixth centuries, built up a carefully artic-
ulated model of ideal relationships. This model helped the inhabitants of the towns to
make sense of the seedy and ambivalent facts of life in the western provinces during the
last century of the Western Empire and the first century of barbarian rule. If, as Ortega
y Gasset once wrote, "The virtues which count most for us are those we do not pos-
sess," then the cult of saints, from the fourth century onwards, made plain the virtues
which late-Roman men lacked and wished for most: concord and the unsullied exercise
of power. Let us examine the manner in which the cult of saints articulated these two
themes in the public life of the Christian communities. First, the theme of concord.

In the first place, the translation of relics symbolized the newly achieved solidarity of
an empire-wide class. The late fourth century saw the formation of a new Christian elite of
bishops and noble pilgrims. Much as the Sophists of the second century A.D. had found that
the patronage of the Roman emperors and alliance with Roman governing families had
raised them suddenly from positions of a purely local importance to a role in the empire as
a whole that was "conspicuous and stunning,"[36] so the bishops and the upper-class pilgrims
of the fourth century found themselves increasingly committed to the wide and dangerous
world of the new Christian empire. As Macrina used to remind her brother,

> Your father enjoyed a considerable reputation in his time for his culture; but
> his fame reached no further than the law courts of his own region. Later,
> he became known as a teacher of rhetoric throughout all Pontus. But all he
> wished for was fame within the bounds of his own home country. You, how-
> ever, are a name to conjure with in far cities, peoples and provinces.[37]

The new members of this Christian elite were in an exceptionally strong position to
encourage the discovery and translation of relics. Their wide journeys and their unan-
swerable social prestige made it easy for them to appropriate and to give the stamp
of authority to fragments of the holy. Yet there were also deeper reasons: the cult of
saints,[38] rendered eminently intelligible the social position of these restless figures. Like
those who were committed to permanent ascetic withdrawal, such as Paulinus at Nola,
highly placed strangers in foreign parts needed the constant presence of invisible com-
panions on their journeys, both for protection and as supernatural extensions of their
own immense prestige. Members of a class held together, ideally, by tenacious bonds of
friendship, they throve on the frequent interchange of visible tokens of their *unanimi-
tas*.[39] Relics offered a way of expressing both protection and solidarity. Their discovery
and transfer rendered tangible, as the mere sense of the overshadowing of a guard-
ian angel could not have done, the distinctly proprietary relationship which lonely and
enterprising men and women had always been expected to establish with their invisible
guardians.[40] Thus, the passing of relics from one community to another, or their discov-
ery, heightened the special status of the members of the Christian elite by making them
privileged agents, personally involved in administering the lovingkindness of God. As
Ambrose said of his own role in the discovery of the bodies of Gervasius and Protasius,

> Although this is a gift from God, yet I cannot deny the grace and favor which
> the Lord Jesus has bestowed on the time of my priesthood; for because I
> have not gained the status of a martyr, I have at least acquired these martyrs
> for you.[41]

Later, in the age of Sidonius Apollinaris and his colleagues[42] and of Gregory of Tours, we see the bishops of Gaul, in frequent discoveries and translations of relics, discreetly backing into the limelight of the newly found *praesentia* of the saints. It was their *merita*, their personal high standing with God, that had gained the mercy of new protectors for their community.[43]

Gaudentius of Brescia is one example of the new type of traveler. A wealthy man of ascetic leanings and strong antipathy to the Arian views then dominant in northern Italy, Gaudentius had decided to travel to the Holy Land. In Cappadocia he had received from the nuns of Caesarea relics of the forty martyrs of Sebaste, which they had received from none other than Saint Basil.[44] The community had "deigned to bestow" these on him as "faithful companions" of his journey:[45] the gift in distant Cappadocia had been a gesture of acceptance and solidarity.[46] Gaudentius echoed the gesture on his return. He called the church in which he placed these and other relics in Brescia "The Gathering of the Saints," *concilium sanctorum*.[47] Preaching in around 387 at a time when only a few of his colleagues had been able to travel to Brescia for fear of an impending barbarian invasion,[48] his "Church of the Gathering of the Saints" stood out, for Gaudentius, as a monument of happier days of ideal solidarity in a less dislocated world.

It was the same, a decade later, with Victricius of Rouen. We meet him first in a small circle of ascetics: Paulinus, Saint Martin, and he had once coincided at Vienne.[49] But Victricius's world soon became dangerously wide. As bishop of Rouen, he had come to live on the frayed edges of the Roman Empire, among the barbarians and pirates of the Seine estuary.[50] Along the English channel, the administrative unity on which the solidarity of Victricius's class had rested was rapidly vanishing.[51] Throughout northern Gaul, the Mediterranean had come to seem a long way away.[52] Yet, in these years, Victricius maintained his correspondence with Paulinus, now settled in Nola, visited Rome around 403,[53] wrote to Pope Innocent for examples of the custom of the Roman church to apply in his diocese,[54] and had even visited Britain around 394 to reestablish the concord of the churches.[55] Solidarities emphasized in the relatively safe environment in which Gaudentius had obtained and installed his relics in Brescia now needed yet more explicit tokens of ideal concord and of supernatural protection. Victricius had traveled to Britain with relics that came to him from northern Italy:[56] "habeo vestrarum praesentiam majestatum."[57] In a world less certain than the well-patroled pilgrimage routes of Asia Minor and the Near East, Victricius could "enjoy the company of these majestic presences." Secure in his own close relationship to his invisible companions, Victricius now placed the protection they had offered him at the disposal of the whole Christian congregation.[58] It was a reassuring gesture of distance shrinking to a community in danger of becoming an isolated sub-Roman region. For by the effect of "inverted magnitudes" which, as we have seen, so impressed his friend Paulinus, Victricius was able to bring to Rouen tiny fragments that condensed the solidarity of the whole Christian world: "So great a multitude of citizens of Heaven . . . so mysterious a unity of heavenly power."[59] In his sermon *De laude sanctorum* Victricius deliberately presented the installation of his relics as an event heavy with paradox: the splinters of bone and drops of blood were mysteriously joined to an immense invisible unity that embraced the cult sites of the entire Mediterranean. It was a moment for the distant congregation in Rouen to linger on the ideal of "a perfect and total concord."[60]

The late-Roman preoccupation with concord can be seen on every level of public life. The sermons of Gaudentius and Victricius allow us to sense its weight on an empire-wide

scale. For the massed fragments of relics gathered together in one place both condensed the ideal unity of the Christian church, as it had first been fused together by the Holy Ghost at Pentecost, and could be spoken of in a language also heavy with late-Roman secular ideals of concord and solidarity between distant friends and distant regions.[61] Yet the relics also emphasized the concord of the local community. The unity of the little fragments, some of them quite indistinguishable from each other,[62] summed up the ideal concord of the community in which they had come to rest. It is interesting to note how frequently late-Roman Christian communities emphasized the fact that they had more than one saint in their midst. While later centuries seem to have been more content to have one, single patron saint as protector, many late-Roman communities chose, instead, to opt for doublets: Peter and Paul in Rome, Felix and Fortunatus in Aquileia.[63] What we know about the associations of the cult of Peter and Paul in Rome makes us suspect that such an emphasis was deliberate: the feast of a pair of saints was a feast of concord in a potentially deeply divided city.[64] The festival of a pair of saints reenacted a highly pertinent "foundation myth" for the Christian community. It stressed the specifically late-Roman miracle by which two brothers—even two clergymen!—had managed to end their lives in perfect harmony. As Chromatius of Aquileia said, in his sermon on Saints Felix and Fortunatus: they "have adorned our own unity with a glorious martyrdom."[65] Such festivals gave an explicit, clerical interpretation to the spontaneous and largely unthinking outbursts of fellow-feeling associated with the shrines of the saints.[66]

If we look at the ceremonial of the saints in later centuries, we find the same pattern. The world of Gregory of Tours is full of serried ranks of saints. For the tombs of the individual saints are rarely allowed to stand alone in their neighborhood. Not every city had a single patron saint.[67] Rather, the bishops wove around each shrine a web of invisible colleagues that did justice to the enduring sense of the solidarity of the senatorial episcopate of Gaul. Centuries-old memories of senatorial and imperial concord stirred on the festivals of the saints. At the shrine of Saint Julian of Brioude, an area slightly set back from the towns, and precisely for that reason a joining point for the whole Auvergne, the possessed shout out: "Why do you bring in strangers to this place? You have gathered a whole council of the saints."[68] Adgregasti concilium: it is an image of united power, such as Gaudentius had appealed to over a century previously in his church foundation at Brescia. In a Gaul where the old yearnings for concordia among the great had lost none of their relevance,[69] the martyrs maintained some sense of awesome solidarity as they worked together "in the triumphal train of Christ."[70]

It is in the light of this double preoccupation with concord and the exercise of power that we should approach the ceremonial that welcomed the saint into the community in the first place and then reenacted each year at his festival the arrival of the saint's praesentia among his people. The De laude sanctorum of Victricius of Rouen, and later evidence, make plain that such ceremonies were consciously modeled on the ceremonial of the emperor's adventus, or "arrival in state" at a city.[71] In order to understand their full meaning, therefore, we must look for a moment at the associations and the function of that basic ceremony. For it is easy to be misled by late-Roman ceremonial. It has so often been presented exclusively as a device by which the majesty of the emperor was made plain to his subjects, and his person rendered inaccessible and awesome. Yet a more differentiated treatment of imperial ceremonial has made plain that such ceremonies were not played out merely to astonish and overawe the emperor's subjects: they were subtly orchestrated both so as to enlist and to register the participation of the

urban communities who attended the imperial *adventus*. Thus, far from being ceremonies limited to the court alone and devoted exclusively to the exaltation of the emperor's person, the ceremonies of the imperial *adventus* had always meant as much to the community which welcomed the emperor as they did to the emperor himself and his entourage. They registered a moment of ideal concord. For all groups in the community could unite in acclaiming the emperor's presence among them.[72] Each separate category within the city—young and old, men and women, tradesmen and nobility, foreigners and locals—had its rightful place in the ceremony of welcome.[73] The *praesentia* of the Emperor, therefore, was held to embrace the whole, undivided community.[74]

It is this aspect of the ceremony of *adventus* as a moment of ideal concord between the separate components of a small town that emerges most clearly from the sermon of Victricius and in the practice of the fifth- and sixth-century church in Gaul. Victricius used the solemn occasion of the arrival of his relics to place new social categories on the map of the Christian community of Rouen. For Victricius was not only a bishop. He was an admirer of Saint Martin and a patron of the new, frequently suspect, ascetic movement.[75] By treating the arrival of his relics as analogous to that of an emperor, he was not only emphasizing their invisible majesty; he was ensuring that their arrival would be an occasion for the Christians of Rouen to find room, in their view of their own community, for a further category. A solemn cortège of chanting monks and virgins now paraded alongside the traditional ranks of the clergy.[76]

Thus, the ceremonial of the saints came to be used in Gaul both to differentiate and to widen the Christian community. The saint's festivals were occasions when room had to be found for all categories of Catholic Christians, new and old alike. A few generations after Victricius preached in Rouen, the novel choirs of monks were joined by equally disturbing outsiders—the Frankish counts of the city, surrounded by their alien bodyguards.[77] Without the studiously all-inclusive ceremonial life that had been developed for the festivals of the saints, it would have been difficult to find a place for these outsiders in the life of the little towns of southern Gaul of the sixth century, whose capacity for deep rancor Gregory of Tours had described so well and so frequently. The Catholicism of the Franks meant, above all, their right to participate in great ceremonies of urban *consensus*.[78] It was by patronizing the basilicas of the saints and by appearing at their festivals, for instance, that Willithruta of Paris, a striking Frankish blonde from a warrior family of exemplary tribal ferocity, could gain acceptance in her community as "Roman in her devotion, if barbarian by birth."[79]

The ceremonials of *adventus*, therefore, as these were continued in the cult of the saints, could widen the bounds of the Christian urban community by giving a place to each one of the various groups within it. They might do more than that. For the festival of a saint was conceived of as a moment of ideal consensus on a deeper level. It made plain God's acceptance of the community as a whole: his mercy embraced all its disparate members, and could reintegrate all who had stood outside in the previous year. Hence the insistence that all Catholic Christians should be able to participate fully in the saint's festival. The terror of illness, of blindness, of possession, or of prison resided in the fear that, at that high moment of solidarity, the sinner would be seen to have been placed by his affliction outside the community:

> "Oh woe is me," a blind woman had cried to Saint Martin, "for blinded by my sins, I do not deserve to look upon this festival with the rest of the people."[80]

Hence the miracles which Gregory of Tours treasured at the festival of Saint Martin were miracles of reintegration into the community. The barriers that had held the individual back from the *consensus omnium* were removed. "With all the people looking on," the crippled walk up to receive the Eucharist.[81] The prisoners in the lockhouse roar in chorus to be allowed to take part in the procession, and the sudden breaking of their chains makes plain the amnesty of the saint.[82] The demons loose the bonds by which they had held the paralyzed and the possessed at a distance from their fellow men.[83] At that moment the amnesty of the saint's presence was proclaimed in the manner most astonishing to late-Roman men: the Christian community had, for a blessed moment, become one again.[84]

The translation of relics had made plain in clear and abiding ritual gestures the structures of patronage and the solidarities that bound together the Christian elites of the Western Roman Empire in its last century. The ceremonial of their installation and the annual celebration of their festival further emphasized the urgent need for concord on the local level. But the *praesentia* of the saint also spoke to the Christian congregation about yet another urgent concern; the nature of the exercise of power in their midst: and it did so in a manner shot through with the imaginative dialectic [. . .].

We must not forget that, while the relic might be discovered, transferred, installed, and the annual memory of the saint be celebrated in an atmosphere of high ceremony associated with unambiguously good happenings, the relic itself still carried with it the dark shadows of its origin: the invisible person, whose *praesentia* in the midst of the Christian community was now a token of the unalloyed mercy of God, had not only once died an evil death; but this evil death had been inflicted by an evil act of power.[85] The martyrs had been executed by the persecutors, or, in the case of Saint Martin, his life as a confessor had been punctuated by dramatic conflicts with unjust and proud authorities.[86] Their deaths, therefore, involved more than a triumph over physical pain; they were vibrant also with the memory of a dialogue with and a triumph over unjust power. If the *passio* of the saint played the same ceremonial role in registering the invisible *adventus* of the saint as had the panegyric on the occasion of the imperial "arrival in state," then we are dealing with a very strange panegyric indeed: for with the reading of the *passio*, the shadow of an act of unjust power, dramatically described, edges across the bright ceremony of the arrival of the saint in imperial majesty. Just as the fact of an evil death is suppressed by the imagery of the saint in Paradise, and its memory made all the more potent for being thus excluded, so, in the *De laude sanctorum* of Victricius, the memory of the ceremonial of the arrival of an emperor, with which the saint is now identified, is flanked by the memory of a scene of judgment and execution that is now all the more conspicuous for its absence:

> We see no executioner now on this spot, no bared sword. We approach the altars of the divine authorities; no blood thirsty enemy is present . . . no torturer hovers in the background.[87]

We should not underestimate the gusto with which the Christian communities of the western Mediterranean turned the celebration of the memory of the martyrs into a reassuring scenario by which unambiguously good power, associated with the amnesty of God and the *praesentia* of the martyr, overcame the ever-lurking presence of evil power.[88] The feasts of the martyrs, and the reading of their *passiones* on that occasion,

did more than allow individuals to live through a drama of the resolution of pain and illness; the local community as a whole could live through, at the martyr's feast, a tense moment when potent images of "clean" and "unclean" power came together.

The long drawn-out interrogations, the exchange of black jokes, and the gruesome descriptions of torture that are so obtrusive a feature of Prudentius's poems on the martyrs offer more than the spectacle of triumph over pain: they paint, in heavy tones taken from the known horrors of late-Roman judicial practice, the dark side of the ideal "clean" power now associated with the *praesentia* of the saints.[89]

The healing of the evils of power plainly preoccupied the crowds that gathered in the shrines almost as much as did the healing of the evils of the body. The priest who preached to the crowds of pilgrims assembled from Carthage and its neighborhood at the shrine of Saint Stephen at Uzalis warmed readily to such themes: for these registered the impact of the power of the saint in a full public setting.[90] Florentius was a man known to the community. As municipal accountant for Carthage, he had been accused of embezzlement. Dragged before the proconsul, "the angry authority rose up with a terrible voice." It was a bad moment: "At once, a deep chill went through the hearts of all present."[91] Florentius was hung up for interrogation on the rack. With that high good humor common among agents of the law in its more painful processes, the torturer nudged him in the ribs at that juncture and said: "Now is the time to pray to Saint Stephen." Lifting his eyes to the proconsul, he noticed the bench on which the assistants and friends of the proconsul were sitting, both as his legal advisers and as the *patroni* of the community grouped round the imperial representative. Instead of the unpleasant face of one of these, "ugly and scoured with wrinkled age," he saw a young man with a shining complexion: Stephen had become the *patronus* and *suffragator* of Florentius beside the proconsul, and was gesturing to him with the right hand not to worry. The proconsul cooled off, so that Florentius saw in him "no longer a judge but a father."[92]

It was a story which plainly lost nothing in the telling. What is revealing is the manner in which, through the intervention of Saint Stephen, the exercise of power in a situation where local opinion had been prepared to favor the culprit, had been "washed clean" to everyone's satisfaction: Florentius was very literally "let off the hook"; the patronage system of the late-Roman courts was made to work by the substitution of Saint Stephen for the ill-favored old man; and the proconsul could step back into his ideal role as father of the city.[93]

Carthage at that time was still a carefully governed city. The unpleasant experience of Florentius was only a small part of a series of brutal purges: Saint Stephen, it appears, had done little to protect Augustine's friend Marcellinus from summary execution in those years.[94] Stephen's intervention merely washed clean, in an ambiguous case, the undisrupted workings of imperial strong government. Other, more rudderless regions soon found themselves without a central government to "wash clean." Here the saint intervened in a situation created by competing patronage systems. In communities where *de facto* social power was frequently exercised by groups that were increasingly unacceptable to the Catholic congregations, either as non-Catholics or as barbarians, the saint could cover with his "clean" power the frequently abrasive process by which the power of the Catholic bishop, backed by his congregation, attempted to come up to level up with, or to hold in check, forms of "unclean" power created by the structure of secular government.[95]

Such was the situation precipitated by the arrival of the relics of Saint Stephen at

Mahon in Minorca in 417.[96] That part of the island had long been dominated by well-established Jewish families.[97] For the Christians this had created an ambivalent situation. In their opinion, under a Christian empire, "clean" power should have been exercised by the bishop, or at least by Catholic noblemen. In fact, the secular structures of the Empire had unambiguously designated a Jewish doctor of the law and father of the synagogue, Theodorus, as the unchallenged leader of the community: he had been exempted from municipal burdens, had acted as *defensor* of the city, and was now its *patronus*.[98] Theodore and his relatives stood at the head of a community where Jews and Christians had learned to coexist, sharing, for instance, in the same haunting beauty of their chanted Psalms.[99] Yet, at the time of the Vandal invasion of Spain, the secular structures of the empire which had given unchallenged power and privilege to Theodorus and his relatives seemed far away from the Balearic Isles. The arrival of the relics of Saint Stephen, coinciding as it did with a temporary absence of Theodorus in Mallorca, provided the opportunity to bring to an end his ambiguous position on the island. Stephen was the true, the "clean" *patronus*, who could replace the tainted and ambivalent power of a Jewish *patronus*.[100]

Much of what followed was violent and highly unpleasant; the reader must bear with me if, in describing a thoroughly dirty business, where violence and fear of yet greater violence played a decisive role, I limit myself to the perspective of bishop Severus, our only source, and speak of the *patrocinium* of Saint Stephen as "clean" power.[101] We sense, as in a few ancient texts, the horrid onset of communal religious violence, as Jews and Christians suddenly and ominously ceased to greet each other in the streets.[102] The synagogue was destroyed,[103] and the Jewish families driven for a time on to the bleak hillsides.[104] Yet it was something marginally more decent than a mere *pogrom*. Bishop Severus is careful to present these events, at least in retrospect, as part of the emergence of Stephen as the true *patronus* of the city, capable, as Theodorus had been, of embracing both Jews and Christians, in what was now the "clean," unambivalent exercise of power. This emphasis imposed subtle restraints, if not on what happened, at least on the manner the Christian community chose to remember an otherwise brutal takeover. For, because Stephen was the ideal *patronus*, his arrival on the island was not seen as an occasion to "purge" the island of Jews.[105] Rather it was seen as a bid to establish the consensus of a divided community on a new, "clean" basis. Within a few weeks, Theodorus and his relatives had made their peace with the bishop. Though becoming Christians, they maintained their full social status within their own community, though now subject to the higher *patrocinium* of Saint Stephen, and seated beside the Christian bishop as Christian *patroni*.[106] Thus, far from being eradicated, the "unclean" power of the established Jewish families has been "washed clean" by being integrated into the Christian community under Saint Stephen. And Saint Stephen was a *patronus* skilled in the arts of *consensus*. He played his part by offering good Jewish miracles. Jewish women see him as a globe of fire;[107] he scatters sweet manna on the hillside;[108] at his touch, sweet water springs from a cave.[109] As in Uzalis, so at Minorca, Stephen, by resolving the tensions between intertwined and potentially conflicting structures of power, had emerged as the *patronus communis*, "the patron of all."[110]

It is in this way that little communities for whom the structures of the Roman Empire either meant little, or had ceased to exist, grappled with the facts of local power in a changing world. The *praesentia* of the saints had been made available to them in gestures that condensed the poignant yearning for concord and solidarity among the elites

of the Western provinces in its last century; yet, once available, the imaginative dialectic that surrounded the person of the saint insured that the shrine would be more than a reminder of the ideal unity of a former age: the shrine became a fixed point where the solemn, necessary play of "clean power"—of *potentia* exercised as it should be—could be played out in acts of healing, exorcism and rough justice.

Notes

1 G. W. F. Hegel, *The Philosophy of History*, trans. J. Shibree (New York: Wiley Book Co., 1944): 377.

2 *ILCV* 1831; Y. M. Duval and Ch. Pietri, "*Membra Christi:* Culte des martyrs et théologie de l'Eucharistie," *Revue des études augustiniennes* 21 (1975): 289–301.

3 A. Dupront, "Pèlerinages et lieux sacrés," *Mélanges F. Braudel* (Toulouse: Privat, 1973), 2: 190.

4 Victor Turner and Edith Turner, *Image and Pilgrimage in Christian Culture* (New York: Columbia University Press, 1978): 15: "A pilgrim is one who divests himself of the mundane concomitants of religion—which become entangled with its practice in the local situation—to confront in a special 'far' milieu, the basic elements and structures of his faith in their unshielded, virgin radiance."

5 Dupront, "Pèlerinages," p. 191. Hence the constant toying with the theme in letters of edification: is it better to go to Jerusalem or to find true religion at home? In favor of going: *Epistola "Honorificentiae tuae"* 2, ed. C. P. Caspari, *Briefe, Abhandlungen und Predigten* (Christiania: Mallingsche Buchdruck, 1890): 8: "Et ego me, cum in patria consisterem, Dei aestimabam esse cultorem et placebam mihi." Against: Gregory of Nyssa, *Ep.* 2 *PG* 46. 1012C; Jerome *Ep.* 58. 3—yet written from the Holy Land. The debate continued: G. Constable, "Opposition to Pilgrimage in the Middle Ages," *Studia Gratiana* 19 (1976): 123–46.

6 Urs Peschow, "Fragmente eines Heiligensarkophags in Myra," *Istanbuler Mitteilungen* 24 (1974): 225–31: the plain marble side is pierced with peepholes or with holes to allow healing myrrh to flow out.

7 J. Christern, *Das frühchristliche Pilgerheiligtum von Tebessa* (Wiesbaden: F. Steiner, 1976): 245–46; Dupront, "Pèlerinages," p. 204: "Au terme du voyage, de marcher encore."

8 Charles Pietri, *Roma Christiana* (Paris: de Boccard, 1976): 39–40.

9 Greg. Tur. *GM* 27. 54.

10 Ibid. 27. 54.

11 Ibid. 27. 54.

12 *Collectio Avellana* 218, *Corpus Scriptorum Ecclesiasticorum Latinorum* (Vienna: Tempsky, 1895), 36: 678–79.

13 See chap. 2, above, p. 44. [original context].

14 *Miracula sancti Stephani* 2. 6, *PL* 41. 847.

15 *ILCV* 2129: a grave bought "ad domnu Laurentium."

16 See chap. 4, above, pp. 78–79 [original context]; J. M. McCulloh, "The Cult of Relics in the Letters and Dialogues of Pope Gregory the Great: A lexicographical study," *Traditio* 32 (1975): 158–61.

17 F. Prinz, "Stadtrömisch-italische Märtyrer und fränkische Reichsadel in Maas-Mosel-Raum," *Historische Jahrbuch* 87 (1967): 1–25 is a good example of how a previously peripheral region came to do justice to its growing political importance by the importation of Italian relics. The story is the same for Anglo-Saxon England and for central Europe.

18 F. Pfister, *Der Reliquienkult im Altertum* (Giessen: Töpelmann, 1912), 2: 614, makes plain that this is an aspect of the cult of relics largely absent in the ancient pagan world.

19 Patrick J. Geary, *Furta Sacra: Thefts of Relics in the Central Middle Ages* (Princeton: Princeton University Press, 1978).

20 W. Liebeschuetz, "Did the Pelagian Movement have Social Aims?" *Historia* 12 (1963): 228–38; J. F. Matthews, *Western Aristocracies and Imperial Court, A.D. 364–425* (Oxford: Clarendon Press, 1974): 7–31; Paulinus *Ep.* 31. 1: "Sed quia non habuimus huius muneris copiam et ille se spem eiusdem gratiae habere dixit a sancta Silvia," on the promise of a relic; Greg. Tur. *GM* 5. 41: "Unde ei tanta ibidem fuisset gratia, ut meruisset," the first question of a suspicious bishop to the bearer of a relic; the response was reassuring: "Quando, inquit, Hierosolymis abii, Futen abbatem repperi, qui magnam cum Sophia augusta gratiam habuit."

21 Santo Mazzarino, *Stilicone e la crisi imperiale dopo Teodosio* (Rome: Signorelli, 1942): 78–91; G. Dagron, *La naissance d'une capitale: Constantinople et ses institutions de 330 à 451* (Paris: Presses universitaires de France, 1974): 72; S. G. MacCormack, 'Roma, Constantinopolis, the Emperor and his Genius," *Classical Quarterly* 25 (1975): 148.

22 *ILCV* 2068.

23 Helen Waddell, *Wandering Scholars* (London: Constable, 1927): 28.

24 Paulinus *Ep.* 32. 3.

25 E. D. Hunt, "Saint Silvia of Aquitaine: The Role of a Theodosian Pilgrim in the Society of East and West," *Journal of Theological Studies* n.s. 23 (1972): 357–73; Kenneth G. Holum, "Pulcheria's Crusade A.D. 421–22 and the Ideology of Imperial Victory," *Greek, Roman and Byzantine Studies* 18 (1977): 153–72; Kenneth G. Holum and Gary Vikan, "The Trier Ivory, Adventus Ceremonial and the Relics of S. Stephen," *Dumbarton Oaks Papers* 33, in press.

26 Victor Turner and Edith Turner, *Image and Pilgrimage*, p. 233.

27 Augustine *Sermon* 319. 6. 6.

28 P. Peeters, *Le tréfonds oriental de l'hagiographie byzantine* (Brussels: Société des Bollandistes, 1950): 56, on Aramaic fragments of the letter of Lucianus.

29 *Epistula Luciani* 2, *PL* 41. 809.

30 Ibid. 8: 815.

31 Ibid. 9: 815.

32 Sozomen *Historia ecclesiastica* 9. 17; Glenn F. Chesnut, *The First Christian Historians* (Paris: Beauchesne, 1977): 167–200.

33 N. H. Baynes, "The Supernatural Defenders of Constantinople," *Byzantine Studies and Other Essays* (London: Athlone Press, 1960): 248–60; P. J. Alexander, "The Strength of the Empire and Capital as Seen through Byzantine Eyes," *Speculum* 37 349–57.

34 For the extraordinary mood revealed in an incident reported by Augustine *Sermo de urbis excidio* 9.

35 Dagron, *Formation d'une capitale*, p. 102 n.7; Holum and Vikan, "The Trier Ivory" (in press) on the commemorative quality of the ivory portraying the arrival of the relics of Saint Stephen. We must never forget the resilience of secular, subpagan rituals for the salvation of the city: citizens would gather at the base of the porphyry statue of Constantine, "with sacrifices, the burning of lights and incense and supplications to ward off catastrophe": Philostorgius *Historia ecclesiastica* 2. 7; Dagron, *Formation d'une capitale*, pp. 307–9, for further examples of a totally non-Christian myth of the city and its protection.

36 G. W. Bowersock, *Greek Sophists in the Roman Empire* (Oxford: Clarendon Press, 1969): 58.

37 Gregory of Nyssa *Vita Macrinae*, *PG* 46: 981B.

38 See chap. 3, above, p. 64 [original context].

39 Paulinus *Ep.* 31. 1. "Accipite ergo ab unanimis fratribus in omni bono vestrum sibi consortium cupientibus."

40 See the letter of the notables of Hermoupolis Magna to a philosopher representing their interests at the court of Gallienus; they pray that "Hermes, the god of our hometown, may ever be beside you": G. Méautis, *Hermoupolis la Grande* (Lausanne: Université de Neuchâtel,

1918), p. 175. Paulinus always experienced the protection of Felix on his journeys: *Carm.* 12. 25 and 13; he expected that Sulpicius Severus would keep a fragment of the Holy Cross to carry on his person, "ad cotidianam tutelam atque medecinam": *Ep.* 32. 7; when deported to the north as a hostage, Gregory of Tours's father took with him a golden locket of relics whose names were unknown to him: Greg. Tur. *GM* 83. 94; these relics offered him the same protection as other amulets: e.g., *Codex Bonnensis* 218 (66a) in J. Tambornino, *De Antiquorum Daemonismo* (Giessen: Töpelmann, 1909): 26; Gregory himself traveled with relics of Saint Martin round his neck, "licet temerario ordine": Greg. Tur. *VM* 3. 17. 187; J. Engemann, "Magische Übelabwehr in der Spätantike," *Jahrbuch für Antike und Christentum* 18 (1975): 22–48.

41 Ambrose *Ep.* 22. 12; Pope Damasus, also, was personally implicated as discoverer and validator of the tombs of the martyrs in the Roman catacombs, in a manner that stressed his personal relationship to them: *ILCV* 1981. 7; 1993. 9–10.

42 Sidonius Apollinaris *Ep.* 7. 1. 7.

43 P. Brown, *Relics and Social Status in the Age of Gregory of Tours*, Stenton Lecture (Reading: University of Reading Press, 1977): 15.

44 Gaudentius of Brescia *Sermon* 17, *PL* 20. 965A.

45 Ibid. 964A.

46 Ibid. 965A: "Idoneos veneratores tanti nos esse muneris approbantes."

47 Ibid. 971A.

48 Ibid. 960A.

49 Paulinus *Ep.* 18. 9.

50 Ibid. 18. 4.

51 E. Demougeot, "La Gaul nord-orientale à la veille de l'invasion germanique," *Revue historique* 236 (1966): 17–46.

52 The wife of a prefect of Gaul was taken back from Trier to Pavia to be buried: E. Gabba and G. Tibiletti, "Una signora di Treveri sepolta a Pavia," *Athenaeum* n.s. 38 (1960): 253–62.

53 Paulinus *Ep.* 18. 5.

54 Innocent *Ep. PL* 20. 469B.

55 Victricius of Rouen *De laude sanctorum* 1, *P/L* 20. 443B.

56 H. Delehaye, *Les origines du culte des martyrs* (Brussels: Société des Bollandistes, 1912): 65.

57 Victricius *De laude* 1. 444B.

58 Ibid. 2. 445A.

59 Ibid. 6. 448B; cf. Paulinus *Ep.* 32. 17: "Hic simul unum pium complectitur arca coetum et capit exiguo nomina tanta sinu."

60 Ibid. 7. 449E.

61 Ibid. 1. 444A; J. Gagé, "*Membra Christi* et la déposition des reliques sous l'autel," *Revue archéologique* 5 ser. 9 (1929): 137–53.

62 The relics of the Forty Martyrs of Sebaste, being ashes, were literally indistinguishable, and so the perfect image of a group indissolubly fused together: Gaudentius *Sermon* 17. 971A.

63 A. P. Billanovich, "Appunti di agiografia aquileiense," *Rivista di storia della chiesa in Italia* 30 (1976): 5–24.

64 Ch. Pietri, "*Concordia Apostolorum et Renovatio Urbis* (Culte des martyrs et propagande pontificale)," *Mélanges d'archéologie et d'histoire* 73 (1961): 275–322 and *Roma Christiana*, Bibliothèque de l'Ecole française d'Athènes et Rome, 224 (Paris: De Boccard, 1976), 1: 350–51: Peter as Moses, also, is a symbol of concord in a rebellious community. P. A. Février, "Natale Petri de cathedra," *Comptes rendus de l'Académie d'Inscriptions et Belles-Lettres*, 1977: 514–31.

65 *Chromace d'Aquilée; Sermons*, Sources chrétiennes 154, ed. J. Lemarié (Paris: Le Cerf, 1969): 182.

66 See chap. 2, above [original context].

67 I. N. Wood, "Early Merovingian Devotion in Town and Country," *The Church in Town and Countryside*, Studies in Church History 16, ed. D. Baker (Oxford: Blackwell, 1979): 72.

68 Greg. Tur. *VJ* 30. 126–27; on Brioude as a joining point of separate cities, Wood, "Early Merovingian Devotion," p. 74; cf. Victor Turner and Edith Turner, *Image and Pilgrimage*, pp. 200–201, for an analogous role in modern times for Le Puy: "set apart from major administrative centers."

69 Greg. Tur. *LH* 9. 20. 438: at the treaty of Andelot, A.D. 588, the kings promise each other "pura et simplex . . . in Dei nomine concordia." The concord of the Franks was a myth passed on to Byzantium, possibly by ambassadors: Agathias *Historiae* 1. 2. Need for concord may have influenced the attitudes of the Gallo-Roman episcopate and aristocracy, and ensured that the divisions of power among the Merovingian kings were territorially based: I. N. Wood, "Kings, Kingdoms and Consent," *Early Medieval Kingship*, ed. P. H. Sawyer and I. N. Wood (Leeds: The School of History, University of Leeds, 1977): 6–29—a new departure on a threadbare topic. For Gregory's own heartfelt wishes: Greg. Tur. *LH* 5 praef. On ecclesiastical solidarity shown in frequent councils: Council of Orléans (A.D. 541), canon 38, ed. C. de Clercq, *Concilia Galliae*, Corpus Christianorum 148A (Turnholt: Brepols, 1963): 142: "Ut per unitatem antestitum ecclesiastica fulgeat disciplina et inconvulsa maneat constitutio sacerdotum."

70 Greg. Tur. *VJ* 50. 133.

71 Sabine G. MacCormack, "Change and Continuity in Late Antiquity: The ceremony of *Adventus*," *Historia* 21 (1972): 721–52; N. Gussone, "Adventus-Zeremoniell und Translation von Reliquien: Victricius von Rouen *De laude sanctorum*," *Frühmittelalterliche Studien* 10 (1976): 125–33; for a sixth-century carving of a translation in Vienne: *Bulletin de la société des amis de Vienne* 67 (1971): 31, fig. 2; the ceremonial survived in its secular forms in Gaul: Greg. Tur. *LH* 6. 11. 281; 8. 1. 370.

72 Sabine G. MacCormack, *Art and Ceremonial in the Later Roman Empire* (Los Angeles and Berkeley: University of California Press, 1980), in press.

73 Victricius *De laude* 12: 454D–455A; Venantius Fortunatus *Carm.* 5. 3. 3; Greg. Tur. *LH* 8. 1. 370: The parade to greet the king included Jews and Syrians, chanting in Hebrew and Syriac. Compare Gregory Nazianzenus *Oratio* XXI, 29; *PG* 35. 1116B.

74 Victricius *De laude* 2. 446B: "Hinc denique totius populi circa maiestatem vestram unus affectus."

75 P. Andrieu-Guitrancourt, "La vie ascétique à Rouen au temps de saint Victrice," *Recherches de science religieuse* 40 (1952): 90–106.

76 Victricius *De laude* 3. 445C.

77 Count Becco came to the shrine of Saint Julian at Brioude in full dress with his retinue. No good came of that occasion; but it was intended to be an annual presence at the festival: Greg. Tur. *VJ* 16. 121.

78 I find it hard not to connect this with the puzzling forms of the ceremony of Clovis's reception of the insignia of a consul in Tours in AD 507. The ceremonial is connected at every point with the processional route associated with the cult of Saint Martin: Greg. Tur. *LH* 2. 38. 89.

79 Venantius Fortunatus *Carm.* 4. 26. 14–17; cf. *Carm.* 2. 8. 23–37, on Launebodis and his wife Bercthruda, who built the church of Saint Severinus, which no Roman had done, while Bercthruda distributed alms in person: on the integration of women through almsgiving, see chap. 2, above, pp. 46–47 [original context].

80 Greg. Tur. *VM* 2. 28. 169. This was at the approach of Easter, where leading members of the community were commanded not to stay in their villas, but to come to the ceremonies to receive the blessing of the bishop: Council of Orléans, canon 25, *Concilia Galliae*, p. 11; *Concilium Epaonense* 35: 33; Clermont 15: 109.

81 Greg. Tur. *VM* 2. 14. 163.

82 Greg. Tur. *VM* 1. 11. 145.

83 Greg. Tur. *VJ* 9. 118: "Visum est ei quasi multitudo catenarum ab eis membris solo decidere"; Greg. Tur. *GC* 86. 354; 93. 357.

84 Brown, *Relics and Social Status*, pp. 19–21 for the effect of this ceremony on the position of the bishop. His election was a result of a *consensus* of the community in his favor, so that the *consensus* of the saint's festival was a reenactment and revalidation of this election. See. V. Crapanzano, *The Hamadsha: A Study in Moroccan Ethnopsychiatry* (Los Angeles and Berkeley: University of California Press, 1973): 116–17, for an analogous demonstration of consensus at the "arrival" of the *mizwar* at the shrine of the saint. The ideal bishop was one who maintained a high level of concord: Venantius Fortunatus *Carm.* 3. 4. 25–26, on Leontius of Bordeaux: "Nam suos cives placida sic voce monebat, / confiteris ut hunc ad sua membra loqui." It remained a distant ideal: Brown, *Relics and Social Status*, pp. 17–20.

85 On the associations of the violently executed: A. D. Nock, *Sallustius: Concerning the Gods and the Universe* (Cambridge: Cambridge University Press, 1926): xcii n.219, and "Tertullian and the Ahori," *Vigiliae Christianae* 4 (1950): 129–41 in *Essays in Religion and the Ancient World*, ed. Z. Stewart (Oxford: Clarendon Press, 1972), 2: 712–19. Saint Martin had to determine whether a tomb in a shrine was that of a martyr or an executed brigand: Sulpicius Severus *Vita Martini* 11.

86 Sulpicius Severus *Vita Martini* 20; *Dialogi* 2. 3; 2. 5; 3. 4; 3. 8; 3. 11–13.

87 Victricius *De laude* 1. 443A.

88 This was a tendency far more widespread than we might think. The Christian communities were prepared to venerate as martyrs anyone they considered unjustly executed by the Roman secular authorities. See the extraordinary *Letter 1* of Jerome: *De muliere septies percussa* on a contemporary incident at Vercelli. The emperor Valentinian I was deterred from executing the town councils of three Pannonian cities for fear that they would be worshiped as martyrs, as were courtiers whom he had executed in Milan: Ammianus Marcellinus 27. 7. 5–6; H. I. Marrou, "Ammien Marcellin et les 'Innocents' de Milan," *Recherches de science religieuse* 40 (1952): 179–90.

89 See Prudentius *Peristephanon* 2. 313–488 on the lively and talkative martyrdom of Saint Lawrence. Yet at a time when the wealth of the Roman church was notorious, and when priests were only recently believed to have been subjected to judicial torture by a pagan prefect of the city, there is a topicality about the whole poem: Symmachus *Relatio* 21.

90 *Miracula sancti Stephani* 2. 5. 851.

91 Ibid. 2. 5. 852.

92 Ibid. 2. 5. 852.

93 The activities of the proconsuls of Carthage were subject to popular judgment, in the form of acclaim or hissing when their names were read out from a list: pseudo-Prosper of Aquitaine (Quodvultdeus) *Liber de promissionibus et praedictionibus Dei* 5. 14–15, *PL* 51. 855.

94 P. Brown, *Augustine of Hippo* (Los Angeles and Berkeley: University of California Press, 1967): 336–37.

95 As in the relations between the Frankish counts of the Auvergne and the shrine of Saint Julian at Brioude: Greg. Tur. *VJ* 16. 121, the case of count Becco; ibid. 43. 131, the power of a silk hanging from the shrine effects cures "et potestas iudicum, quotienscumque in eo loco superflue egit, confusa discessit."

96 *Epistula Severi ad omnem ecclesiam*, *PL* 41. 821–32.

97 Ibid. 2. 822.

98 Ibid. 4. 823.

99 Ibid. 10. 825. They even tell each other their dreams at this time of crisis: ibid. 8. 824.

100 Ibid. 4. 823: "Christiani autem ut corde, ita etiam et viribus humiles . . . patroni Stephani patrocinium deprecabantur."

101 Ibid. 5–6. 823, both sides are spoken of as "armies"; ibid. 9. 824: they are armed with sticks, stones, and slings, making a show of force which Roman law only permitted against brigands; some Jewish converts were brutally frank: ibid. 14. 829: "Ego igitur vitae meae periculo consulens ad ecclesiam iam pergam, ut necem quae mihi paratur effugiam."

102 Ibid. 3. 823.

103 Ibid. 10. 825.

104 Ibid. 11. 826; 13. 827–28.

105 Though Severus is pleased that there were no Jews settled in Jammona, there is no evidence that he or his supporters intended to drive the Jews from the island, or that they were in a position to do so: ibid. 2. 822.

106 Ibid. 12. 826; 14. 829; 17. 831; 18. 832: remarkable vignettes of the status and interrelations of the Jewish families. As a junior member of one family said to Theodore: "Quid times, domine Theodore? Si vis certe securus et honoratus et dives esse, in Christum crede, sicut et ego credidi. Modo tu stas, et ego cum episcopis sedeo." On the significance of lay patrons sitting beside the bishop as the joint heads of the community, see Julian *Ep.* 18, 450C.

107 Ibid. 15. 830. They first thought it was an angel.

108 Ibid. 15. 830.

109 Ibid. 17. 831.

110 *Miracula sancti Stephani* 2. 1. 843.

Michael Taussig

IN SOME WAY OR ANOTHER ONE CAN PROTECT ONESELF FROM THE SPIRITS BY PORTRAYING THEM

> He is driven not merely to awaken congealed life in petrified objects—as in allegory—but also to scrutinize living things so that they present themselves as being ancient, 'Ur-historical' and abruptly release their significance.
>
> T. W. Adorno, "Über Walter Benjamin"

He is driven . . . to awaken congealed life in petrified objects. Thus, Benjamin, in addressing the fetish character of objecthood under capitalism, demystifying and reenchanting, out-fetishizing the fetish. And if this necessarily involves a movement in the other direction, not awakening but petrifying life, reifying instead of fetishizing, doing what Adorno describes as the scrutiny of living things so that they present themselves as being Ur-historical and hence abruptly release their significance, then a strange parallel is set up with my reading of the Cuna shaman of the San Blas Islands off Panama, faced with a woman in obstructed labor and singing for the restoration of her soul. By her hammock in his singing he is seeing, scrutinizing, bringing into being an allegory of the cosmos as woman through whom is plotted the journey along the birth canal of the world—an action he undertakes by first awakening congealed life in his petrified fetish-objects, carved wooden figurines now standing by the laboring woman. With them he will journey. To them he sings:

> The medicine man gives you a living soul, the medicine man changes for you your soul, all like replicas, all like twin figures.[1]

Note the *replicas*. Note the magical, the soulful power that derives from replication. For this is where we must begin; with the magical power of replication, the image affecting

what it is an image of, wherein the representation shares in or takes power from the represented—testimony to the power of the mimetic faculty through whose awakening we might not so much understand that shadow of science known as magic (a forlorn task if ever there was one), but see anew the spell of the natural where the reproduction of life merges with the recapture of the soul.

The objectness of the object

Like Adorno and Benjamin, if not also this San Blas Cuna shaman, my concern is to reinstate in and against the myth of Enlightenment, with its universal, context-free reason, not merely the resistance of the concrete particular to abstraction, but what I deem crucial to thought that moves and moves us—namely, its sensuousness, its mimeticity. What is moving about moving thought in Benjamin's hands is precisely this. Adorno pictures Benjamin's writing as that in which "thought presses close to its object, as if through touching, smelling, tasting, it wanted to transform itself," and Susan Buck-Morss indicates how this very sensuousness is indebted to and necessary for what is unforgettable in that writing, its unremitting attempt to create "exact fantasies," translating objects into words, maintaining the objectness of the object in language such that here translation is equivalent to more than translation, to more than explanation—to a sizzling revelation exercising the peculiar powers of the mimetic faculty.[2]

The object

I want to begin with the problem to be found in Baron Erland Nordenskiold's compilation *An Historical and Ethnological Survey of the Cuna Indians*, published in Sweden by the Gothenburg Ethnological Museum in 1938, six years after the baron's death.[3] It was edited by Henry Wassén and, as its title page states, was "written in collaboration with the Cuna Indian, Rubén Pérez Kantule," a twenty-four-year-old secretary to the Cuna *Nele* de Kantule. (*Nele* is a title meaning High Chief and Seer which Nordenskiold and Pérez sometimes employ as a proper name.) You can see intimations of anthropological sympathy between the Swedish baron and the high chief's secretary from the frontispiece portrait photograph of Nordenskiold and that of Rubén Pérez, set above the title of the book's first chapter. Both well-groomed, in suit and tie, they share the same posture, these relaxed yet alert investigators of things Cuna.

Having been forced by illness to leave the land of the Cunas after a mere month of study there in 1927, two years after their successful revolt against the Panamanian government, the baron had invited Rubén Pérez to spend six months in Sweden to become his secretary and assist him in the interpretation of Cuna picture-drawings. When Pérez arrived in Sweden, he brought what Nordenskiold judged to be very valuable manuscript material—"songs, incantations, descriptions of illnesses, and prescriptions, all written in the Cuna language and mainly in our system of writing"—as well as a great many notes in English and Spanish concerning Cuna traditions and history dictated to him by the *Nele*, the Great Seer himself.

The problem I want to take up concerns the wooden figurines used in curing. Cuna call them *nuchukana* (pl.; *nuchu*, sing.), and in Nordenskiold and Pérez' text I find the

Figure 14.1 Baron Erland Nordenskiold (from Nordenskiold and Pérez, *An Historical and Ethnological Survey of the Cuna Indians*, 1938)

Figure 14.2 Rubén Pérez (from Nordenskiold and Pérez, 1938)

arresting claim that "all these wooden figures represent European types, and to judge by the kind of clothes, are from the eighteenth and possibly from the seventeenth century, or at least have been copied from old pictures from that time".

Pérez had never seen a wooden figure with a ring in the nose. Only the women wear such a ring. But Henry Wassén, asserting editorial prerogative, added a note saying that such figures do exist, however, and referred the reader to one, "certainly very old," which had been given him in 1935 in Balboa by Mrs. Dove L. Prather, to add to his collection. Not only the Indians collect *nuchus*.

Nordenskiold raised the question whether the figurines were a relatively modern invention among the Cuna, based on their observations of the Catholic saints. (426) There is indeed reason to suggest that the figurines are a creation of relatively modern times, possibly no later than nineteenth century. "Until very recently," wrote the U.S.

Figure 14.3 Cuna curing figurines. Drawn by Guillermo Hayans (circa 1948)

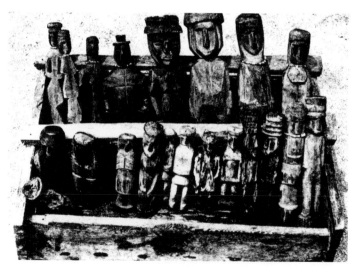

Figure 14.4 Cuna curing figurines

anthropologist David Stout in the 1940s, "none of the primary sources on Cuna history mention *nuchus*."[4] In an article he published in 1940, Wassén speculated on the influence African slaves may have had on Cuna and Chocó Indian "magic sticks." He wrote, "that the carved sticks which are used by the Kuna medicine singers are equipped with figures of Europeans in cloth from an older period and have been influenced by figures of the saints etc., strengthens my opinion that the Kunas have adopted these sticks relatively late." As an afterthought he added: "The figures of, for example, the Spaniards on the sticks could be explained as an emblem of power."[5] Certainly there is no mention whatsoever of the figurines in the detailed account left by the pirate's surgeon Lionel Wafer concerning his four months' stay among the Indians of the Darién Peninsula in 1681, and Wafer was extremely interested in Indian medicine and curing ritual. Indeed, his prestige and safety among them depended on such knowledge. He reports vividly on lively healing ritual involving the mimicry of what he takes to be the voices of spirits conversing with the healer. But there is no indication of figurines.[6]

In any event, whatever the temporal relation to European colonialism might be (and whatever could be learned from it), Nordenskiold was sure of one thing: "It is certain at any rate that the wooden figures which the Cunas carve and use as abiding places for their helping spirits, no longer look like either Indians or demons, but like white people." (426) And half a century later, in 1983, with the authority of having spent four years among the Cuna, the anthropologist and former U.S. Peace Corpsman Norman Chapin made basically the same point—the figurines "almost invariably are carved to look like non-Indians; if they are made to represent Indians, they are somewhat more exotic, wearing suits and hats with serrated tops, and are occasionally riding horses."[7]

The problem: mimesis unleashed

At this point the problem can be fairly stated (with some wonder, mind you) as to why these figures, so crucial to curing and thus to Cuna society, should be carved in the form of "European types." In short: why are they Other, and why are they the Colonial Other? This question leads to still more of a very particular and particularizing sort, because in asking it I am, as a "European type," brought to confront my cultured self in the form of an Indian figurine! What magic lies in this, my wooden self, sung to power in a language I cannot understand? Who is this self, objectified without my knowledge, that I am hell-bent on analyzing as object-over-there fanned by sea breezes and the smoke of burning cocoa nibs enchanting the shaman's singing?

Something trembles in the whole enterprise of analysis and knowledge-making here: the whole anthropological trip starts to eviscerate. And about time, too. For if I take the figurines seriously, it seems that I am honor-bound to respond to the mimicry of my-self in ways other than the defensive maneuver of the powerful by subjecting it to scrutiny as yet another primitive artifact, grist to the analytic machinery of Euroamerican anthropology. The very mimicry corrodes the alterity by which my science is nourished. For now I too am part of the object of study. The Indians have made me alter to my self. Time for a little chant of my own:

> And here where pirates arm in arm with Darién
> Indians roamed,

Of their bones is coral made.
What Enlightening spirits can I sing into Being
For rethinking the thinking Self,
Its European histories, its other futures?

Embodiment

These questions are entwined in the puzzling fact that there is a fundamental split between the outer carved form of the curing figurines and their inner substance. For the ethnography emphatically states, as a Cuna article of faith, that the spirit of the wood, not its outer form, determines the efficacy of the figurine. Thus we are forced to ponder why it is then necessary to carve an outer European, non-Indian form. Why bother carving forms at all if the magical power is invested in the spirit of the wood itself? And indeed, as our puzzling leads to more puzzling, why is embodiment itself necessary?

This question in turn turns on an equally obscure problem, the most basic of all: how are such figurines supposed to function in healing? I find it exceedingly strange that in the research on Cuna curing I have consulted, not only is there almost nothing written directly on the figurines, let alone on their healing function, but that this problem of why they exist and are used is not posed.

Certainly the anthropologist can record and speculate upon the famous curing chants such as the Muu-Igala (The Way of Muu) and the Nia-Igala (The Way of the Demon). Central to both is the odyssey undertaken by these figurines, or rather—and this is the point—by the spirits they "represent" in their search for the abducted soul of the sick person. And the anthropologist can mention other functions of the figurines as well. Nordenskiold (427) presents the case of a girl of the Narganá community who used to dream a lot about people who had died. Rubén Pérez took a figurine that she had held in her hands for but a few minutes to the shaman, who was then able to diagnose her visions as those of evil spirits, not of deceased persons, and to declare that unless she bathed in certain medicines she would lose her reason. In another instance, a man who fell ill in a settlement along the Gulf of Urabá took in his hands one of these wooden figurines, held it in the smoke of burning cocoa nibs, and then had a friend take it to the seer, who kept it in his house for some time, until in his dreams its soul told him from what kind of disease the Indian in far off Urabá, was suffering. (348) Bathing one's head in the water in which a figurine has been placed is a way of acquiring strength to learn a new skill, especially a foreign language. (365) Furthermore, figurines can counsel the healer. Rubén Pérez used to believe that the seer or *nele* received instruction from the figurines about what medicines to use for different illnesses. But the nele later told him that he learned these things from the illness demons themselves, although sometimes the figurines would give him advice. (348) The figurines have the power to make evil spirits appear before the seer, whose powers are quite miraculous, as itemized in the baron's and Rubén Pérez' text:

> There are a great many things that Nele of Ustúpu knows. He is able to see what illnesses are affecting any person who comes to consult him. When he examines a sick person he seats himself facing the patient and looks at him. He sees right through him as if he were made of glass. Nele sees all the

organs of the body. He is also able, with the assistance of the *nuchus* [i.e. fig-
urines] to give his verdict as to what illness a patient whom he has not even
seen is suffering from. Nele can foretell how long a person is going to live. It
is of the greatest importance that he is able to say when and how a person's
soul is carried away by spirits. (83)

And the text concludes at this point that the seers possess these occult powers, "thanks
to the *nuchus* [the figurines], the tutelary spirits." (83)

Then again, there is the astonishing carving and subsequent use of as many as fifty
or more figurines as large or larger than humans in the community-wide exorcism of
serious spiritual disturbance of an entire island or region. These exorcisms last many
days. The chief figurine in one such exorcism in the late 1940s was said by an Ameri-
can visitor to be a seven-foot-tall likeness of General Douglas MacArthur (and we will
have occasion to think again of this representation of the general when we consider the
meaning—to the Western eye—of Primitivist Parody and its mimetic relation to the
West):

> Because the Indians were not familiar with military regulations governing
> dress they made some grave errors. Instead of wearing khaki, the image is
> painted so as to be wearing a green cap with a pink band and one white star.
> His coat was painted a powder blue with two pink breast pockets. Below
> the left pocket was what appears to be a German Iron Cross. He also wore
> a black bow tie and black pants. Although the Indians have small flat noses,
> they admire long pointed ones. They therefore made the image with a nose
> that projected three inches from the face.[8]

The observer, of course, has the last word. Not content with describing the general, he
has to tell us that because the Indians suffer from nose envy, they have therefore elon-
gated and sharpened their image of MacArthur's nose—and here one senses the final
victory of Enlightenment, its nosiness, its consuming will to stick its beak in other peo-
ple's lives and "explain." But embodiment itself is never problematized. Why imagine a
nose? Why imagine at all? Why this urge to tangibilize? But, then, is it possible to con-
ceive of, let alone have, pure appearance?

Medicines should not be confused with decoys

Nordenskiold and Pérez' book has many things that make your head swim concerning
mimicry and how it implicates reality. Next to the curing figurines or nuchus, perhaps
none is more intriguing than what they say about imitations of turtles. Under the head-
ing "Various Cuna Medicines at the Göteborg Museum," they present a catalogued and
numbered list, including figures of turtles carved in wood. Pérez writes that they are
used as medicines by the Indians: "They bathe themselves with these figures which they
make themselves. A man can own as many as a hundred small figures made of different
kinds of wood which one finds along the coast, and the bathing is carried on in order to
acquire skill in turtle hunting." (492) You can see them in the accompanying drawing
the authors present, lifelike turtles doing their thing.

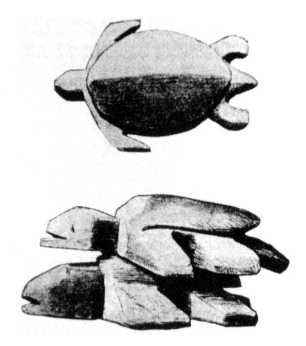

Figure 14.5 Turtle figurines used for hunting magic (from Nordenskiold and Pérez, 1938)

But then the editor, Henry Wassén, feels impelled to add a clarifying note. He wants us to be quite clear that these turtle-figures for "medicinal" use should not be confused with the balsawood turtles carved as decoys for hunting real live turtles. He quotes from a missionary describing the use of these decoys. They are *female* and the missionary refers to them as *tortuguillas*, cute-chicks of turtlishness, we might say, fixed to a net so as to attract male turtles, and even some females, so that they swim into the net and, in the vigor of pursuit, become entangled in the netted realness of this decoy's lure. (492–93)

Wassén provides a drawing of one of these decoys. It has a piece of rope around the stump where its head and neck "should" be. It strikes me as a "modernist" and unreal turtle with neither head nor neck nor flippers yet, to my way of seeing, which should never be confused with the turtle's, this is nevertheless quintessentially turtlish and irresistible. After all, it's a decoy. But then that's my point of view. My eye flicks back to the magically efficacious turtle, then back again to the decoy. In my mind's eye

Figure 14.6 Decoy turtle (from Nordenskiold and Pérez)

somewhere off screen, I see a "real" turtle happily splashing in the green-blue waters of the Caribbean. Is the decoy closer to the real turtle than the magically effective imitation? Or is the decoy closer to what the Indians think a real turtle thinks a real turtle looks like?—in which case why make the magical turtle-figures look so "real"?

"In some way or another one can protect oneself from evil spirits by portraying them"

The baron and the Indian, more than other authors I have read, provide revealing descriptions of the use of the curing figurines carved as "European types," but their text elides the problem of embodiment by taking it for granted. Making an object and thereby spiritualizing it, reification-and-fetishization, does not catch their eye. They simply say, for instance, that it was a certain mythical figure, Ibeorgun, who taught mankind how to use these wooden figures, and "from God originates the song that is chanted when one wishes the tutelary spirits to take up their abode in the wooden figures." (345)

But why does one so wish, and why does one need the object-figure to provide an abode for the tutelary spirits?

In a similar vein, in his 1961 essay "Anthropomorphic Figurines From Colombia, Their Magic and Art," the great Austrian-cum-Colombian anthropologist Gerardo Reichel-Dolmatoff states that "in certain curing ceremonies the sculptured or painted representation of these evil animal spirits is therefore of prime importance and therefore the shaman will make figurines of them and/or paint their forms on wooden slats." He refers the reader to an early essay by Nordenskiold, in which he wrote, "In some way or another one can protect oneself from evil spirits by portraying them."[9] The reference here is not to curing and curing figurines among the Cuna, but among their southern neighbors the Indians of the Chocó, with whom the Cuna have a fair amount of contact, including trade in magic and magical notions. Yet the important point about what I call the magic of mimesis is the same—namely that "in some way or another" the making and existence of the artifact that portrays something gives one power over that which is portrayed. But once again the issue is raised (in a footnote) only to be dropped, and the author goes on to present in the all-too-typical unproblematizing gloss the notion that among the Cuna "the figurines, which are always imagined as embodiments of benevolent human spirits (though derived from ancestral plant spirits) help the shaman in retrieving the souls," the embodiment itself being taken for granted.[10]

Other embodiments: spirit boats

Twenty-five years after this essay by Reichel-Dolmatoff, Stephanie Kane presented a vivid reminder (bearing in mind the Cuna story) of what we might tentatively call "the MacArthur effect" among these Chocó Indians. It is a tale of an Emberá shaman who was frightened speechless by the visitation of the spirits of white men, and who then decided, in a daring move, to capture them to add to his stable of spirit-helpers. She was being told this story by an Emberá man in a riverine settlement by the forest in the Darién peninsula of southern Panama in the 1980s. They were part of a crowd being lectured by a well-intentioned Catholic priest concerning the virtues of progress and

community. "Back when I was a little boy," the Chocó Valentin is telling her, in the midst of this homily:

> Easter time, I went with my grandfather [the shaman] on a journey to the Congo river to seek a buried chest of money. We had to cross the great bay, by the island they call Enchantment. The moon was clear. My cousin Bernabé was there. We saw a boat of many colors, luminous with pure gringos aboard. It sounded its horn and we, in the canoe, hauling, hauling, trying to catch up to the boat. We wanted to sleep alongside it but the boat moved out to sea, escaping us. Then we smelled gasoline. Our vision could no longer stand the fumes and grandfather said: "Let's go back. This is not a boat. This is a thing of the devil."

At this point Stephanie Kane—who is telling the story of the story—informs us that the attractive boat of the gringos is an illusion created by spirits. On another occasion this boat is described as being pretty, as if painted with red, with colored lights on every side.[11] Its smoke made your eyes burn. The shaman is talking with somebody or something in a strange tongue. Blurred with other foreign talk there were loud mechanical sounds like lifting a log with a winch. The anthropologist story-(re)teller describes this spirit boat "as the lure of an archetype; it represents spirit-motivated illusions of desire." It is more, she says, than an object of local mimicry.[12]

The Indians paddled like crazy yet got nowhere. The boat disappeared. They became violently sick, lost the power of speech, and were consumed by fever. When after great difficulty they managed to get home, the shaman oversaw their preparation of a healing ritual in which, through feasting and exchange of food and drink, he was able to get into the spirit world.

Valentin continues the story (and I want you to be alert at this point to the artwork he is now going to mention—to the three embodiments of body paint, balsa figurines, and dressing up the virginal young women in Indian gear). The shaman showed them:

> . . . how to paint the specific patterns necessary with the black dye called *jagua* [from the Genipa tree], how to work the balsa wood, and how to paint the young girls for the *chicha*. He put the girls in floor-length *parumas* [knee-length skirts worn by Emberá women].

The anthropologist breaks in to tell us that here the shaman has made an important choice. He could have decided to perform a defensive ritual, heal himself and his companions, and leave it at that. Instead he has boldly decided to take the initiative and acquire the gringo spirit-crew for himself, to capture them so as to add to his stable of spirit-powers. And how does he do this? He makes a copy of them:

> Grandfather could see all the crew members of the boat. And he made a [model of] the boat and put the crew in it. The captain with no head or neck, another crew member with no feet [and he] brought the boat from Yaviza. By means of his knowledge he made a tide, a current that came from below, like a motor, to get the boat up here. He tied it below the calabash tree, there next to Abibéba's house. The boat is still there.[13]

Other embodiments: ethnography as embodied retelling; on being concrete

I want to emphasize that unlike most ethnographic modes of representation, including some of the ethnography to which I have hitherto alluded (and will, perforce, continue to depend upon in my pursuit of the mimetic faculty), Stephanie Kane's mode relies not on abstract general locutions such as "among the Emberá it is believed that . . .," but instead concentrates on image-ful particularity in such a way that (anticipating my major theme), she creates like magical reproduction itself, a sensuous sense of the real, mimetically at one with what it attempts to represent. In other words, can't we say that *to give an example, to instantiate, to be concrete*, are all examples of the magic of mimesis wherein the replication, the copy, acquires the power of the represented? And does not the magical power of this embodying inhere in the fact that in reading such examples we are thereby lifted out of ourselves into those images? Just as the shaman captures and creates power by making a model of the gringo spirit-ship and its crew, so here the ethnographer is making her model. If I am correct in making this analogy with what I take to be the magician's art of reproduction, then the model, if it works, gains through its sensuous fidelity something of the power and personality of that of which it is a model. Whether we want to call this "magic" or not does not much matter. My point is not to assimilate this writerly practice to magic. Rather I want to estrange writing itself, writing of any sort, and puzzle over the capacity of the imagination to be lifted through representational media, such as marks on a page, into other worlds.

This becomes wondrously complex when we take into account, first, that the original for the shaman's model is an apparition, an illusion and deception (so we are told) from the spirit world, an apparition itself a model of a prior (let us say the "original") boat and gringo crew, and second that the ethnographer, like me and many if not most of her readers, is identifiable as being from the land of the gringos and is modeling in words an ethnography of a shaman's magical modeling of ourselves!—which we are now in this instant being led into, to set sail with our mirrored selves as we lift it from the page, coveting it forever so brief a moment in the crows' nest of our eyeball!

Neither head nor neck

I am well aware that mimesis, or at least the way I am using it, is starting to spin faster and faster between opposed yet interconnected meanings, and yet I want to push this instability a little farther by asking you to observe the frequent interruptions and asides, changes of voice and reference, by which this text on the Emberá, so manifestly a text about us too, breaks up intimations of seamless flow that would immunize mimetic representation against critique and invention. Didn't Valentin say—indeed make quite a point of it, when you consider his short and concise description—that the captain of the model-boat had neither head nor neck, and that one of the crewmen had no feet? With this replica of the boat and its gringo spirit crew we have mimesis based on quite imperfect but nevertheless (so we must presume) very effective copying that acquires the power of the original—a copy that is not a copy, but a "poorly executed ideogram," as Henri Hubert and Marcel Mauss, in the early twentieth century, put it in their often critical discussion of Frazer's theory of imitation.[14]

Sliding between photographic fidelity and fantasy, between iconicity and arbitrariness, wholeness and fragmentation, we thus begin to sense how weird and complex the notion of the copy becomes (and please remember how high the stakes are here, insinuated with the struggle for life and, as we saw in the shaman's lusting for more—a will to power in the face of attack by (illusory and fragmented) copies of reality. The task to which the mimetic faculty is here set is to capture that very same spirit power, and for the ethnographer graphing the ethnos, the stakes are no less important.

There are still other ways in which this curious affair of embodiment and fragmentation ("neither head nor neck") is practiced by this mode of ethnographic representation. For Kane embodies us readers not only by retelling tales, but also by embodying those very tales into a variety of distinct and conflicting contexts. She is being told the story of the gringo boat as she sits on the edge of a group being lectured to by a well-intentioned Catholic priest. That already fractured context is the embodiment of "modernity," in which paganism and paternalistic Catholic modernization jostle for discursive sovereignty. Another embodiment embodying this one is that this Emberá man's account of the history of these white men's spirits, and the destruction they eventually wreak after their release at the shaman's death, clearly conflicts with his cousin's story that blames gringo evangelical missionaries for the release of those spirits, because the missionaries, in a forthright ritual of the civilizing process, forced the shaman to burn his curing batons. "Bernabé [the cousin] was there," she writes, "when the gringos stood and poured gasoline on the batons. The other Emberá watching ran from the invisible spirits running wild out of the burning 'idol' that was their home and trap."[15]

Disembodiment

It is this disembodiment, this release and subsequent flight, that commands my attention. It is this moment that for me sums up Enlightenment, its reason, its signifying practice, as much as its relation to savagery, a relation that is not so much severed as preserved through colonial conquest and subsequent submersion in the bodily underground of mind. By their little bonfire on the edge of the forest, how ardently these gringos labor for the abstract universal! But what of the pestilent and uncontrollable spirit gringos thereby released, dancing wild through the flames? Where will their power, the power of magical mimesis reemerge?

Notes

* Where the same source is refered to often and continuously, the page reference is inserted in parentheses at the end of the relevant sentence.

1 Nils Homer and Henry Wassén, "The Complete Mu-Igala in Picture Writing: A Native Record of a Cuna Indian Medicine Song," *Etnologiska Studier* 21 (Göteborg, 1953). The text was first published, without pictures, in this same journal in 1948.
2 T. W. Adorno, "A Portrait of Walter Benjamin," *Prisms*, trans. Samuel and Sherry Weber (Cambridge: MIT Press, 1981), p. 233. Susan Buck-Morss, *The Origin of Negative Dialectics:*

Theodor W. Adorno, Walter Benjamin, and the Frankfurt Institute (New York: Free Press, 1961), p. 86.

3 Erland Nordenskiold, with Rubén Pérez, edited by Henry Wassén, *An Historical and Ethnological Survey of the Cuna Indians*, Comparative Ethnographical Studies 10 (Göteborg: Ethnografiska Musuem, 1938). Subsequent references to this work appear in the text in parentheses.

4 David Stout, *San Blas Acculturation: An Introduction* (New York: Viking Fund Publications in Anthropology 9, 1947), pp. 103–104.

5 Henry Wassén, "An Analogy Between a South American and Oceanic Myth Motif and Negro Influence in the Darién," *Etnologiska Studier* 10 (Göteborg, 1940), pp. 76, 79.

6 Could we tentatively suggest that what was once a lively mimicry of sound with frequent changes of voice and a dialogical interaction between healer and spirits became, sometime late in the nineteenth or early twentieth century, a mimicry of figurines in ritual healing in which, to all accounts, the voice of the chanter never shifts from its steady droning monotone? But note that carved figures are prominent in Christopher Columbus' and Oviedo's descriptions concerning indigenous divination and magic in other parts of the Caribbean at the opening stage of European conquest. Also note that in Lucien de Puydt's account of the scientific expedition that he led in 1865 in the Isthmus of Darién, financed by a French consortium interested in building a canal, he was impressed by the presence of what he called fetishes. (He wrote that the Cunas, "although idolators, believing in the supernatural potency of the grotesque festishes suspended in their houses, bowing reverentially to grossly formed figures and holding certain trees as sacred . . .")

7 Norman Mcpherson Chapin, "Curing among the San Blas Kuna of Panama," unpublished PhD dissertation (Tucson: University of Arizona, 1983), pp. 93–95. "Non-Indian" is inaccurate for the reason that, as far as I can ascertain, there are no *nuchukana* figurines representing African-American or black people. On the other hand, as Chapin himself points out (p. 93), when *ponikana*, or evil spirits, assume the form of human beings, they often do so as blacks, whom the Cuna, apparently, loathe. It should be pointed out here that blacks form a large part of the population of Panama and of the Caribbean and Darién peninsula surrounding the Cuna.

8 Leon S. De Smidt, *Among the San Blas Indians of Panama: Giving a Description of Their Manners, Customs, and Beliefs* (Troy, New York: 1948), cited in Chapin, 1983, pp. 356–57.

9 Gerardo Reichel-Dolmatoff, "Anthropomorphic Figurines from Colombia, Their Magic and Art," *Essays in Pre-Colombian Art and Archaeology*. Samuel K. Lothrop, ed. (Cambridge, Mass: Harvard University Press, 1961), pp. 240, 495.

10 Ibid., 240.

11 Stephanie Kane, "Emberá (Chocó) Village Formation: The Politics and Magic of Everyday Life in the Darién Forest." Unpublished Ph.D. dissertation (Austin: Department of Anthropology, University of Texas at Austin, 1986), p. 448.

12 Ibid., 449.

13 Stephanie Kane, "Surreal: Taboo and the Emberá-Gringa," paper delivered at the 87th Meeting of the American Anthropological Association (Phoenix, 1990), p. 11.

14 Marcel Mauss and Henri Hubert, *A General Theory of Magic*, trans. R. Brain (New York: W. W. Norton, 1972). This work is published in book form under the authorship of Mauss, yet the original *Année sociologique* essay is credited to the joint authorship of Henri Hubert and Marcel Mauss. I persist, therefore, in acknowledging this to be a jointly authored work.

15 Kane, 1990, p. 17.

Alfred Gell

THE TECHNOLOGY OF ENCHANTMENT AND THE ENCHANTMENT OF TECHNOLOGY

Introduction: methodological philistinism

The complaint is commonly heard that art is a neglected topic in present-day social anthropology, especially in Britain. The marginalization of studies of primitive art, by contrast to the immense volume of studies of politics, ritual, exchange, and so forth, is too obvious a phenomenon to miss, especially if one draws a contrast with the situation prevailing before the advent of Malinowski and Radcliffe-Brown. But why should this be so? I believe that it is more than a matter of changing fashions in the matter of selecting topics for study; as if, by some collective whim, anthropologists had decided to devote more time to cross-cousin marriage and less to mats, pots, and carvings. On the contrary, the neglect of art in modern social anthropology is necessary and intentional, arising from the fact that social anthropology is essentially, constitutionally, anti-art. This must seem a shocking assertion: how can anthropology, by universal consent a Good Thing, be opposed to art, also universally considered an equally Good Thing, even a Better Thing? But I am afraid that this is really so, because these two Good Things are Good according to fundamentally different and conflicting criteria.

When I say that social anthropology is anti-art, I do not mean, of course, that anthropological wisdom favours knocking down the National Gallery and turning the site into a car park. What I mean is only that the attitude of the art-loving public towards the contents of the National Gallery, the Museum of Mankind, and so on (aesthetic awe bordering on the religious) is an unredeemably ethnocentric attitude, however laudable in all other respects.

Our value-system dictates that, unless we are philistines, we should attribute value to a culturally recognized category of art objects. This attitude of aestheticism is culture-bound even though the objects in question derive from many different cultures, as when we pass effortlessly from the contemplation of a Tahitian sculpture to

one by Brancusi, and back again. But this willingness to place ourselves under the spell of all manner of works of art, though it contributes very much to the richness of our cultural experience, is paradoxically the major stumbling-block in the path of the anthropology of art, the ultimate aim of which must be the dissolution of art, in the same way that the dissolution of religion, politics, economics, kinship, and all other forms under which human experience is presented to the socialized mind, must be the ultimate aim of anthropology in general.

Perhaps I can clarify to some degree the consequences of the attitude of universal aestheticism for the study of primitive[1] art by drawing a series of analogies between the anthropological study of art and the anthropological study of religion. With the rise of structural functionalism, art largely disappeared from the anthropological bill of fare in this country, but the same thing did not happen to the study of ritual and religious belief. Why did things happen this way? The answer appears to me to lie in an essential difference between the attitudes towards religion characteristic of the intelligentsia of the period, and their attitudes towards art.

It seems to me incontrovertible that the anthropological theory of religion depends on what has been called by Peter Berger 'methodological atheism' (Berger, 1967: 107). This is the methodological principle that, whatever the analyst's own religious convictions, or lack of them, theistic and mystical beliefs are subjected to sociological scrutiny on the assumption that they are not literally true. Only once this assumption is made do the intellectual manœuvres characteristic of anthropological analyses of religious systems become possible, that is, the demonstration of linkages between religious ideas and the structure of corporate groups, social hierarchies, and so on. Religion becomes an emergent property of the relations between the various elements in the social system, derivable, not from the condition that genuine religious truths exist, but solely from the condition that societies exist.

The consequences of the possibility that there are genuine religious truths lie outside the frame of reference of the sociology of religion. These consequences—philosophical, moral, political, and so on—are the province of the much longer-established intellectual discipline of theology, whose relative decline in the modern era derives from exactly the same changes in the intellectual climate as have produced the current efflorescence of sociology generally and of the sociology of religion in particular.

It is widely agreed that ethics and aesthetics belong in the same category. I would suggest that the study of aesthetics is to the domain of art as the study of theology is to the domain of religion. That is to say, aesthetics is a branch of moral discourse which depends on the acceptance of the initial articles of faith: that in the aesthetically valued object there resides the principle of the True and the Good, and that the study of aesthetically valued objects constitutes a path toward transcendence. In so far as such modern souls possess a religion, that religion is the religion of art, the religion whose shrines consist of theatres, libraries, and art galleries, whose priests and bishops are painters and poets, whose theologians are critics, and whose dogma is the dogma of universal aestheticism.

Unless I am very much mistaken, I am writing for a readership which is composed in the main of devotees of the art cult, and, moreover, for one which shares an assumption (by no means an incorrect one) that I too belong to the faith, just as, if we were a religious congregation and I were delivering a sermon, you would assume that I was no atheist.

If I were about to discuss some exotic religious belief-system, from the standpoint

of methodological atheism, that would present no problem even to non-atheists, simply because nobody expects a sociologist of religion to adopt the premises of the religion he discusses; indeed, he is obliged not to do so. But the equivalent attitude to the one we take towards religious beliefs in sociological discourse is much harder to attain in the context of discussions of aesthetic values. The equivalent of methodological atheism in the religious domain would, in the domain of art, be *methodological philistinism*, and that is a bitter pill very few would be willing to swallow. Methodological philistinism consists of taking an attitude of resolute indifference towards the aesthetic value of works of art—the aesthetic value that they have, either indigenously, or from the standpoint of universal aestheticism. Because to admit this kind of value is equivalent to admitting, so to speak, that religion is true, and just as this admission makes the sociology of religion impossible, the introduction of aesthetics (the theology of art) into the sociology or anthropology of art immediately turns the enterprise into something else. But we are most unwilling to make a break with aestheticism—much more so than we are to make a break with theology—simply because, as I have been suggesting, we have sacralized art: art is really our religion.

We can not enter this domain, and make it fully our own, without experiencing a profound dissonance, which stems from the fact that our method, were it to be applied to art with the degree of rigour and objectivity which we are perfectly prepared to contemplate when it comes to religion and politics, obliges us to deal with the phenomena of art in a philistine spirit contrary to our most cherished sentiments. I continue to believe, none the less, that the first step which has to be taken in devising an anthropology of art is to make a complete break with aesthetics. Just as the anthropology of religion commences with the explicit or implicit denial of the claims religions make on believers, so the anthropology of art has to begin with a denial of the claims which objects of art make on the people who live under their spell, and also on ourselves, in so far as we are all self-confessed devotees of the Art Cult.

But because I favour a break with the aesthetic preoccupations of much of the existing anthropology of art, I do not think that methodological philistinism is adequately represented by the other possible approaches: for instance, the sociologism of Bourdieu (e.g. 1968), which never actually looks at the art object itself, as a concrete product of human ingenuity, but only at its power to mark social distinctions, or the iconographic approach (e.g. Panofsky, 1962) which treats art as a species of writing, and which fails, equally, to take into consideration the presented object, rather than the represented symbolic meanings. I do not deny for an instant the discoveries of which these alternative approaches are capable; what I deny is only that they constitute the sought-for alternative to the aesthetic approach to the art object. We have, somehow, to retain the capacity of the aesthetic approach to illuminate the specific objective characteristics of the art object as an object, rather than as a vehicle for extraneous social and symbolic messages, without succumbing to the fascination which all well-made art objects exert on the mind attuned to their aesthetic properties.

Art as a technical system

In this essay, I propose that the anthropology of art can do this by considering art as a component of technology. We recognize works of art, as a category, because they are

the outcome of technical process, the sorts of technical process in which artists are skilled. A major deficiency of the aesthetic approach is that art objects are not the only aesthetically valued objects around: there are beautiful horses, beautiful people, beautiful sunsets, and so on; but art objects are the only objects around which are *beautifully made*, or *made beautiful*. There seems every justification, therefore, for considering art objects initially as those objects which demonstrate a certain technically achieved level of excellence, 'excellence' being a function, not of their characteristics simply as objects, but of their characteristics as *made* objects, as products of techniques.

I consider the various arts—painting, sculpture, music, poetry, fiction, and so on—as components of a vast and often unrecognized technical system, essential to the reproduction of human societies, which I will be calling the technology of enchantment.

In speaking of 'enchantment' I am making use of a cover-term to express the general premiss that human societies depend on the acquiescence of duly socialized individuals in a network of intentionalities whereby, although each individual pursues (what each individual takes to be) his or her own self-interest, they all contrive in the final analysis to serve necessities which cannot be comprehended at the level of the individual human being, but only at the level of collectivities and their dynamics. As a first approximation, we can suppose that the art-system contributes to securing the acquiescence of individuals in the network of intentionalities in which they are enmeshed. This view of art, that it is propaganda on behalf of the status quo, is the one taken by Maurice Bloch in his 'Symbols, Song, Dance, and Features of Articulation' (1974). In calling art the technology of enchantment I am first of all singling out this point of view, which, however one refines it, remains an essential component of an anthropological theory of art from the standpoint of methodological philistinism. However, the theoretical insight that art provides one of the technical means whereby individuals are persuaded of the necessity and desirability of the social order which encompasses them brings us no closer to the art object as such. As a technical system, art is orientated towards the production of the social consequences which ensue from the production of these objects. The power of art objects stems from the technical processes they objectively embody: the *technology of enchantment* is founded on the *enchantment of technology*. The enchantment of technology is the power that technical processes have of casting a spell over us so that we see the real world in an enchanted form. Art, as a separate kind of technical activity, only carries further, through a kind of involution, the enchantment which is immanent in all kinds of technical activity. The aim of my essay is to elucidate this admittedly rather cryptic statement.

Psychological warfare and magical efficacy

Let me begin, however, by saying a little more about art as the technology of enchantment, rather than art as the enchantment of technology. There is an obvious prima-facie case for regarding a great deal of the art of the world as a means of thought-control. Sometimes art objects are explicitly intended to function as weapons in psychological warfare; as in the case of the canoe prow-board from the Trobriand Islands [Figure 15.1]—surely a prototypical example of primitive art from the prototypical anthropological stamping-ground. The intention behind the placing of these prow-boards on Kula[2] canoes is to cause the overseas Kula partners of the Trobrianders, watching the

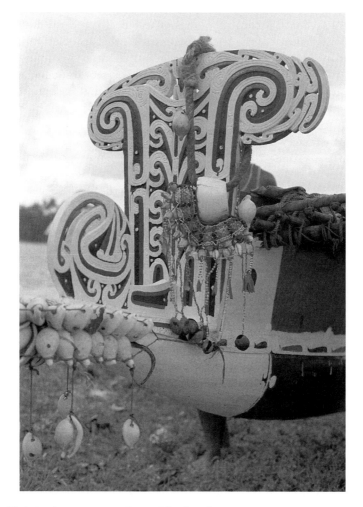

Figure 15.1 Trobriand canoe-prow; Kitava Island, Milne Bay Province, Papua New Guinea; photographer: Shirley F. Campbell, May 1977. The prow assembly is adorned with Kula shell valuables (see Campbell 1984).

arrival of the Kula flotilla from the shore, to take leave of their senses and offer more valuable shells or necklaces to the members of the expedition than they would other-wise be inclined to do. The boards are supposed to dazzle the beholder and weaken his grip on himself. And they really are very dazzling, especially if one considers them against the background of the visual surroundings to which the average Melanesian is accustomed, which are much more uniform and drab than our own. But if the demor-alization of an opponent in a contest of will-power is really the intention behind the canoe-board, one is entitled to ask how the trick is supposed to work. Why should the sight of certain colours and shapes exercise a demoralizing effect on anybody?

The first place one might seek an answer to such a question is in the domain of ethology, that is, in innate, species-wide dispositions to respond to particular percep-tual stimuli in predetermined ways. Moreover, were one to show such a board to an

ethnologist, they would, without a doubt, mutter 'eyespots!' and immediately start pulling out photographs of butterflies' wings, likewise marked with bold, symmetrical circles, and designed to have much the same effect on predatory birds as the boards are supposed to have on the Trobrianders' Kula partners, that is, to put them off their stroke at a critical moment. I think there is every reason to believe that human beings are innately sensitive to eye-spot patterns, as they are to bold tonal contrasts and bright colours, especially red, all of them features of the canoe-board design. These sensitivities can be demonstrated experimentally in the infant, and in the behavioural repertoire of apes and other mammals.

But one does not have to accept the idea of deep-rooted phylogenetic sensitivity to eye-spot patterns and the like to find merit in the idea that the Trobriand canoe-board is a technically appropriate pattern for its intended purpose of dazzling and upsetting the spectator. The same conclusion can follow from an analysis of the *Gestalt* properties of the canoe-board design. If one makes the experiment of attempting to fixate the pattern for a few moments by staring at it, one begins to experience peculiar optical sensations due to the intrinsic instability of the design with its opposed volutes, both of which tend to lead the eye off in opposite directions.

In the canons of primitive art there are innumerable instances of designs which can be interpreted as exploiting the characteristic biases of human visual perception so as to ensnare us into unwitting reactions, some of which might be behaviourally significant. Should we, therefore, take the view that the significance of art, as a component of the technology of enchantment, derives from the power of certain stimulus arrays to disturb normal cognitive functioning? I recall that Ripley's *Believe It Or Not* (at one time my favourite book) printed a design which was claimed to hypnotize sheep: should this be considered the archetypal work of art? Does art exercise its influence via a species of hypnosis? I think not. Not because these disturbances are not real psychological phenomena; they are, as I have said, easily demonstrable experimentally. But there is no empirical support for the idea that canoe-boards, or similar kinds of art objects, actually achieve their effects by producing visual or cognitive disturbances. The canoe-board does not interfere seriously, if at all, with the intended victim's perceptual processes, but achieves its purpose in a much more roundabout way.

The canoe-board is a potent psychological weapon, but not as a direct consequence of the visual effects it produces. Its efficacy is to be attributed to the fact that these disturbances, mild in themselves, are interpreted as evidence of the magical power emanating from the board. It is this magical power which may deprive the spectator of his reason. If, in fact, he behaves with unexpected generosity, it is interpreted as having done so. Without the associated magical ideas, the dazzlingness of the board is neither here nor there. It is the fact that an impressive canoe-board is a physical token of magical prowess on the part of the owner of the canoe which is important, as is the fact that he has access to the services of a carver whose artistic prowess is also the result of his access to superior carving magic.

The halo-effect of technical 'difficulty'

And this leads on to the main point that I want to make. It seems to me that the efficacy of art objects as components of the technology of enchantment—a role which is

particularly clearly displayed in the case of the Kula canoe—is itself the result of the enchantment of technology, the fact that technical processes, such as carving canoe-boards, are construed magically so that, by enchanting us, they make the products of these technical processes seem enchanted vessels of magical power. That is to say, the canoe-board is not dazzling as a physical object, but as a display of artistry explicable only in magical terms, something which has been produced by magical means. It is the way an art object is construed as having come into the world which is the source of the power such objects have over us—their becoming rather than their being.

Let me turn to another example of an art object which may make this point clearer. When I was about eleven, I was taken to visit Salisbury Cathedral. The building itself made no great impression on me, and I do not remember it at all. What I do remember, though, very vividly, is a display which the cathedral authorities had placed in some dingy side-chapel, which consisted of a remarkable model of Salisbury Cathedral, about two feet high and apparently complete in every detail, made entirely out of matchsticks glued together; certainly a virtuoso example of the matchstick modeller's art, if no great masterpiece according to the criteria of the salon, and calculated to strike a profound chord in the heart of any eleven-year-old. Matchsticks and glue are very important constituents of the world of every self-respecting boy of that age, and the idea of assembling these materials into such an impressive construction provoked feelings of the deepest awe. Most willingly I deposited my penny into the collecting-box which the authorities had, with a true appreciation of the real function of works of art, placed in front of the model, in aid of the Fabric Fund.

Wholly indifferent as I then was to the problems of cathedral upkeep, I could not but pay tribute to so much painstaking dexterity in objectified form. At one level, I had perfect insight into the technical problems faced by the genius who had made the model, having myself often handled matches and glue, separately and in various combinations, while remaining utterly at a loss to imagine the degree of manipulative skill and sheer patience needed to complete the final work. From a small boy's point of view this was the ultimate work of art, much more entrancing in fact than the cathedral itself, and so too, I suspect, for a significant proportion of the adult visitors as well.

Here the technology of enchantment and the enchantment of technology come together. The matchstick model, functioning essentially as an advertisement, is part of a technology of enchantment, but it achieves its effect via the enchantment cast by its technical means, the manner of its coming into being, or, rather, the idea which one forms of its coming into being, since making a matchstick model of Salisbury Cathedral may not be as difficult, or as easy, as one imagines.

Simmel, in his treatise on the *Philosophy of Money* (1979: 62 ff.), advances a concept of value which can help us to form a more general idea of the kind of hold which art objects have over us. Roughly, Simmel suggests that the value of an object is in proportion to the difficulty which we think we will encounter in obtaining that particular thing rather than something else. We do not want what we do not think we will ever get under any set of circumstances deemed realizable. Simmel (ibid. 66) goes on to say:

> We desire objects only if they are not immediately given to us for our use and enjoyment, that is, to the extent to which they resist our desire. The content of our desire becomes an object as soon as it is opposed to us, not only in the sense of being impervious to us, but also in terms of its distance

as something not yet enjoyed, the subject aspect of this condition being desire. As Kant has said: the possibility of experience is the possibility of objects of experience—because to have experiences means that our consciousness creates objects from sense-impressions. In the same way, the possibility of desire is the possibility of objects of desire. The object thus formed, which is characterised by its separation from the subject, who at the same time establishes it and seeks to overcome it by his desire, is for us a value.

He goes on to argue that exchange is the primary means employed in order to overcome the resistance offered by desired objects, which makes them desirable, and that money is the pure form of the means of engaging in exchange and realizing desire.

I am not here concerned with Simmel's ideas about exchange value and money; what I want to focus on is the idea that valued objects present themselves to us surrounded by a kind of halo-effect of resistance, and that it is this resistance to us which is the source of their value. Simmel's theory, as it stands, implies that it is difficulty of access to an object which makes it valuable, an argument which obviously applies, for example, to Kula valuables. But if we suppose that the value which we attribute to works of art, the bewitching effect they have on us, is a function, at least to some extent, of their characteristics as objects, not just of the difficulties we may expect to encounter in obtaining them, then the argument cannot be accepted in unmodified form. For instance, if we take up once again the instance of the matchstick model of Salisbury Cathedral, we may observe that the spell cast over me by this object was independent of any wish on my part to gain possession of it as personal property. In that sense, I did not value or desire it, since the possibility of possessing could not arise: no more am I conscious today of any wish to remove from the walls and carry away the pictures in the National Gallery. Of course, we do desire works of art, the ones in our price bracket, as personal property, and works of art have enormous significance as items of exchange. But I think that the peculiar power of works of art does not reside in the objects *as such*, and it is the objects as such which are bought and sold. Their power resides in the *symbolic* processes they provoke in the beholder, and these have *sui generis* characteristics which are independent of the objects themselves and the fact that they are owned and exchanged. The value of a work of art, as Simmel suggests, is a function of the way in which it resists us, but this 'resistance' occurs on two planes. If I am looking at an old master painting, which, I happen to know, has a saleroom value of two million pounds, then that certainly colours my reaction to it, and makes it more impressive than would be the case if I knew that it was an inauthentic reproduction or forgery of much lesser value. But the sheer incommensurability between my purchasing power and the purchase price of an authentic old master means that I cannot regard such works as significant exchange items: they belong to a sphere of exchange from which I am excluded. But none the less such paintings are objects of desire—the desire to possess them in a certain sense, but not actually to own them. The resistance which they offer, and which creates and sustains this desire, is to being possessed in an intellectual rather than a material sense, the difficulty I have in mentally encompassing their coming-into-being as objects in the world accessible to me by a technical process which, since it transcends my understanding, I am forced to construe as magical.

The artist as occult technician

Let us consider, as a step up from the matchstick model of Salisbury Cathedral, J. F. Peto's *Old Time Letter Rack* [Figure 15.2], sometimes known as *Old Scraps*, the notoriously popular *trompe-l'œil* painting, complete with artfully rendered drawing-pins and faded criss-cross ribbons, letters with still-legible, addressed envelopes to which lifelike postage stamps adhere, newspaper cuttings, books, a quill, a piece of string, and so on. This picture is usually discussed in the context of denunciations of the excesses of illusionism in nineteenth-century painting; but of course it is as beloved now as it ever was, and has actually gained prestige, not lost it, with the advent of photography, for it is now possible to see just how photographically real it is, and all the more remarkable for that. If it was, in fact, a colour photograph of a letter rack, nobody would give tuppence for it. But just because it is a painting, one which looks as real as a photograph, it is a famous work, which, if popular votes counted in assigning value to paintings, would be worth a warehouse full of Picassos and Matisses.

The popular esteem in which this painting is held derives, not from its aesthetic merit, if any, since nobody would give what it represents (that is, a letter rack) a second

Figure 15.2 John F. Peto, *Old Time Letter Rack*; 1894; oil on canvas; 30 × 25 in. (76.2 × 63.5 cm); Manoogian Collection. Museum of Fine Arts, Boston. Bequest of Maxim Karolik. Photograph © 2009 Museum of Fine Arts, Boston.

glance. The painting's power to fascinate stems entirely from the fact that people have great difficulty in working out how coloured pigments (substances with which everybody is broadly familiar) can be applied to a surface so as to become an apparently different set of substances, namely, the ones which enter into the composition of letters, ribbons, drawing-pins, stamps, bits of string, and so on. The magic exerted over the beholder by this picture is a reflection of the magic which is exerted inside the picture, the technical miracle which achieves the transubstantiation of oily pigments into cloth, metal, paper, and feather. This technical miracle must be distinguished from a merely mysterious process: it is miraculous because it is achieved both by human agency but at the same time by an agency which transcends the normal sense of self-possession of the spectator.

Thus, the letter rack picture would not have the prestige it does have if it were a photograph, visually identical in colour and texture, could that be managed. Its prestige depends on the fact that it is a painting; and, in general, photography never achieves the popular prestige that painting has in societies which have routinely adopted photography as a technique for producing images. This is because the technical processes involved in photography are articulated to our notion of human agency in a way which is quite distinct from that in which we conceptualize the technical processes of painting, carving, and so on. The alchemy involved in photography (in which packets of film are inserted into cameras, buttons are pressed, and pictures of Aunt Edna emerge in due course) are regarded as uncanny, but as uncanny processes of a natural rather than a human order, like the metamorphosis of caterpillars into butterflies. The photographer, a lowly button-presser, has no prestige, or not until the nature of his photographs is such as to make one start to have difficulties conceptualizing the processes which made them achievable with the familiar apparatus of photography.

In societies which are not over-familiar with the camera as a technical means, the situation is, of course, quite different. As many anthropologists who have worked under such conditions will have occasion to know, the ability to take photographs is often taken to be a special, occult faculty of the photographer, which extends to having power over the souls of the photographed, via the resulting pictures. We think this a naïve attitude, when it comes to photography, but the same attitude is persistent, and acceptable, when it is expressed in the context of painting or drawing. The ability to capture someone's likeness is an occult power of the portraitist in paint or bronze, and when we wish to install an icon which will stand for a person—for example, a retiring director of the London School of Economics—we insist on a painted portrait, because only in this form will the captured essence of the no-longer-present Professor Dahrendorf continue to exercise a benign influence over the collectivity which wishes to eternalize him and, in so doing, derive continuing benefit from his *mana*.

Let me summarize my point about Peto's *Old Scraps* and its paradoxical prestige. The population at large both admire this picture and think that it emanates a kind of moral virtue, in the sense that it epitomizes what painters 'ought' to be able to do (that is, produce exact representations, or rather, occult transubstantiations of artists' materials into other things). It is thus a symbol of general moral significance, connoting, among other things, the fulfilment of the painter's calling in the Protestant-ethic sense, and inspiring people at large to fulfil their callings equally well. It stands for true artistry as a power both in the world and beyond it, and it promotes the true artist in a symbolic role as occult technician. Joined to this popular stereotype of the true artist is the negative stereotype of the false ('modern') artist of cartoon humour, who is supposed not

to know how to draw, whose messy canvases are no better than the work of a child, and whose lax morality is proverbial.

Two objections can be made to the suggestion that the value and moral significance of works of art are functions of their technical excellence, or, more generally, to the importance of the fact that the spectator looks at them and thinks, 'For the life of me, I couldn't do that, not in a million years.' The first objection would be that *Old Scraps*, whatever its prestige among *hoi polloi*, cuts no ice with the critics, or with art-cultists generally. The second objection which might be raised is that, as an example of illusionism in art, the letter rack represents not only a particular artistic tradition (our own) but also only a brief interlude in that tradition, and hence can have little general significance. In particular, it cannot provide us with any insight into primitive art, since primitive art is strikingly devoid of illusionistic trickery.

The point I wish to establish is that the attitude of the spectator towards a work of art is fundamentally conditioned by his notion of the technical processes which gave rise to it, and the fact that it was created by the agency of another person, the artist. The moral significance of the work of art arises from the mismatch between the spectator's internal awareness of his own powers as an agent and the conception he forms of the powers possessed by the artist. In reconstructing the processes which brought the work of art into existence, he is obliged to posit a creative agency which transcends his own and, hovering in the background, the power of the collectivity on whose behalf the artist exercised his technical mastery.

The work of art is inherently social in a way in which the merely beautiful or mysterious object is not: it is a physical entity which mediates between two beings, and therefore creates a social relation between them, which in turn provides a channel for further social relations and influences. This is so when, for instance, the court sculptor, by means of his magical power over marble, provides a physical analogue for the less easily realized power wielded by the king, and thereby enhances the king's authority. What Bernini can do to marble (and one does not know quite what or how) Louis XIV can do to you (by means which are equally outside your mental grasp). The man who controls such a power as is embodied in the technical mastery of Bernini's bust of Louis XIV is powerful indeed. Sometimes the actual artist or craftsman is quite effaced in the process, and the moral authority which works of art generate accrues entirely to the individual or institution responsible for commissioning the work, as with the anonymous sculptors and stained-glass artists who contributed to the glorification of the medieval church. Sometimes the artists are actually regarded with particular disdain by the power élite, and have to live separate and secluded lives, in order to provide ideological camouflage for the fact that theirs is the technical mastery which mediates the relation between the rulers and the ruled.

I maintain, therefore, that technical virtuosity is intrinsic to the efficacy of works of art in their social context, and tends always towards the creation of asymmetries in the relations between people by placing them in an essentially asymmetrical relation to things. But this technical virtuosity needs to be more carefully specified; it is by no means identical with the simple power to represent real objects illusionistically: this is a form of virtuosity which belongs, almost exclusively, to our art tradition (though its role in securing the prestige of old masters, such as Rembrandt, should not be underestimated). An example of virtuosity in non-illusionistic modern Western art is afforded by Picasso's well-known *Baboon and Young* [Figure 15.3], in which an

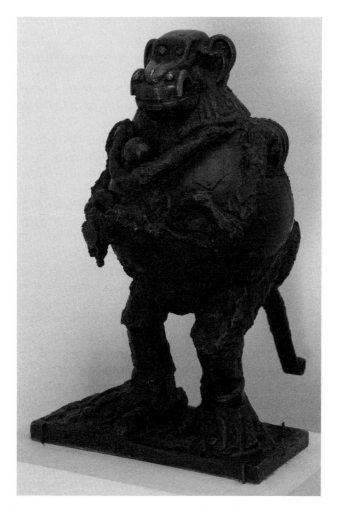

Figure 15.3 Pablo Picasso, *Baboon and Young*; 1950, Vallauris; bronze (cast 1955); 21⅛ × 14⅛ × 7⅜ in. (53.6 × 35.7 × 18.8 cm.); collection, The Museum of Modern Art, New York (Mrs Simon Guggenheim Fund).

ape's face is created by taking a direct cast from the body-shell of a child's toy car. One would not be much impressed by the toy car itself, nor by the verisimilitude of Picasso's ape just as a model of an ape, unless one were able to recognize the technical procedure Picasso used to make it, that is, commandeering one of his children's toys. But the witty transubstantiation of toy car into ape's face is not a fundamentally different operation from the transubstantiation of artists' materials into the components of a letter rack, which is considered quite boring because that is what artists' materials are for, generically. No matter what avant-garde school of art one considers, it is always the case that materials, and the ideas associated with those materials, are taken up and transformed into something else, even if it is only, as in the case of Duchamp's notorious urinal, by putting them in an art exhibition and providing them with a title (*Fountain*) and an author ('R. Mutt', alias M. Duchamp. 1917). Amikam Toren, one of the most ingenious

contemporary artists, takes objects like chairs and teapots, grinds them up, and uses the resulting substances to create images of chairs and teapots. This is a less radical procedure than Duchamp's, which can be used effectively only once, but it is an equally apt means of directing our attention to the essential alchemy of art, which is to make what is not out of what is, and to make what is out of what is not.

The fundamental scheme transfer between art production and social process

But let us focus our attention on art production in societies without traditions and institutions of 'fine art' of the kind which nurtured Picasso and Duchamp. In such societies art arises particularly in two domains. The first of these is ritual, especially political ritual. Art objects are produced in order to be displayed on those occasions when political power is being legitimized by association with various supernatural forces. Secondly, art objects are produced in the context of ceremonial or commercial exchange. Artistry is lavished on objects which are to be transacted in the most prestigious spheres of exchange, or which are intended to realize high prices at market. The kind of technical sophistication involved is not the technology of illusionism but the technology of the radical transformation of materials, in the sense that the value of works of art is conditioned by the fact that it is difficult to get from the materials of which they are composed to the finished product. If we take up the example of the Trobriand canoe-board once more, it is clear that it is very difficult to acquire the art of transforming the root-buttress of an ironwood tree, using the rather limited tools which the Trobrianders have at their disposal, into such a smooth and refined finished product. If these boards could be simply cast in some plastic material, they would not have the same potency, even though they might be visually identical. But it is also clear that in the definition of technical virtuosity must be included considerations which might be thought to belong to aesthetics.

Let us consider the position of a Trobriand carver, commissioned to add one more to the existing corpus of canoe-boards. The carver does not only have the problem of physically shaping rather recalcitrant material with inadequate tools: the problem is also one of visualizing the design which he mentally follows in carving, a design which must reflect the aesthetic criteria appropriate to this art genre. He must exercise a faculty of aesthetic judgement, one might suppose, but this is not actually how it appears to the artist in the Trobriands who carves within a cultural context in which originality is not valued for its own sake, and who is supposed by his audience, and himself, to follow an ideal template for a canoe-board, the most magically efficacious one, the one belonging to his school of carving and its associated magical spells and rites. The Trobriand carver does not set out to create a new type of canoe-board, but a new token of an existing type; so he is not seeking to be original, but, on the other hand, he does not approach the task of carving as merely a challenge to his skill with the materials, seeing it, instead, primarily as a challenge to his mental powers. Perhaps the closest analogy would be with a musician in our culture getting technically prepared to give a perfect performance of an already existing composition, such as the 'Moonlight' Sonata.

Carvers undergo magical procedures which open up the channels of their minds so that the forms to be inscribed on the canoe-board will flow freely both in and out. Campbell, in an unpublished study of Trobriand (Vakuta) carving (1984), records that

the final rite of carving initiation is the ingestion of the blood of a snake famed for its slipperiness. Throughout the initiation the emphasis is placed on ensuring free flow (of magical knowledge, forms, lines, and so on) by means of the metaphoric use of water and other liquids, especially blood and bespelled betel-juice. It is, of course, true that the Melanesian curvilinear carving style is dominated by an aesthetic of sinuous lines, well-represented in the canoe-board itself; but what for us is an aesthetic principle, one which we appreciate in the finished work, is from the carver's point of view a series of technical difficulties (or blockages of the flow) which he must overcome in order to carve well. In fact, one of the carver's initiatory rites represents just this: the master carver makes a little dam, behind which sea-water is trapped. After some magical to-do, the dam is broken and the water races back to the sea. After this, the initiate's mind will become quick and clear, and carving ideas will flow in similarly unimpeded fashion into his head, down his arms, out through his fingers, and into the wood.

We see here that the ability to internalize the carving style, to think up the appropriate forms, is regarded as a matter of the acquisition of a kind of technical facility, inseparable from the kind of technical facility which has to be mastered in order for these imagined forms to be realized in wood. Trobriand carving magic is technical-facility magic. The imaginative aspect of the art and the tool-wielding aspect of the art are one and the same. But there is a more important point to be made here about the magical significance of the art and the close relationship between this magical significance and its technical characteristics.

It will be recalled that these boards are placed on Kula canoes, their purpose being to induce the Kula partners of the Trobrianders to disgorge their best valuables, without holding any back, in the most expeditious fashion. Moreover, these and the other carved components of the Kula canoe (the prow-board, and the wash-board along the side) have the additional purpose of causing the canoe to travel swiftly through the water, as far as possible like the original flying canoe of Kula mythology.

Campbell, in her iconographic analysis of the motifs found on the carved components of canoes, is able to show convincingly that slipperiness, swift movement, and a quality glossed as 'wisdom' are the characteristics of the real and imaginary animals represented, often by a single feature, in the canoe art. A 'wise' animal, for instance, is the osprey, an omnipresent motif: the osprey is wise because it knows when to strike for fish, and captures them with unerring precision. It is the smooth, precise efficiency of the osprey's fishgetting technique which qualifies it to be considered wise, not the fact that it is knowledgeable. The same smooth and efficacious quality is desired for the Kula expedition. Other animals, such as butterflies and horseshoe bats, evoke swift movement, lightness, and similar ideas. Also represented are waves, water, and so on.

The success of the Kula, like the success of the carving, depends on unimpeded flow. A complex series of homologies, of what Bourdieu (1977) has called 'scheme transfers', exists between the process of overcoming the technical obstacles which stand in the way of the achievement of a perfect 'performance' of the canoe-board carving and the overcoming of the technical obstacles, as much psychic as physical, which stand in the way of the achievement of a successful Kula expedition. Just as carving ideas must be made to flow smoothly into the carver's mind and out through his fingers, so the Kula valuables have to be made to flow smoothly through the channels of exchange, without encountering obstructions. And the metaphoric imagery of flowing water, slippery snakes, and fluttering butterflies applies in both domains, as we have seen.

We saw earlier that it would be incorrect to interpret the canoe-board ethologically as an eye-spot design or, from the standpoint of the psychology of visual perception, as a visually unstable figure, not because it is not either of these things (it is both) but because to do so would be to lose sight of its most essential characteristic, namely, that it is an object which has been made in a particular way. That is, it is not the eye-spots or the visual instabilities which fascinate, but the fact that it lies within the artist's power to make things which produce these striking effects. We can now see that the technical activity which goes into the production of a canoe-board is not only the source of its prestige as an object, but also the source of its efficacy in the domain of social relations; that is to say, there is a fundamental scheme transfer, applicable, I suggest, in all domains of art production, between technical processes involved in the creation of a work of art and the production of social relations via art. In other words, there exists a homology between the technical processes involved in art, and technical processes generally, each being seen in the light of the other, as, in this instance, the technical process of creating a canoe-board is homologous to the technical processes involved in successful Kula operations. We are inclined to deny this only because we are inclined to play down the significance of the technical domain in our culture, despite being utterly dependent on technology in every department of life. Technique is supposed to be dull and mechanical, actually opposed to true creativity and authentic values of the kind art is supposed to represent. But this distorted vision is a by-product of the quasi-religious status of art in our culture, and the fact that the art cult, like all other cults, is under a stringent requirement to conceal its real origins, as far as possible.

The enchantment of technology: magic and technical efficacy

But just pointing to the homology between the technical aspect of art production and the production of social relations is insufficient in itself, unless we can arrive at a better understanding of the relation between art and magic, which in the case of Trobriand canoe art is explicit and fundamental. It is on the nature of magical thought, and its relation to technical activity, including the technical activity involved in the production of works of art, that I want to focus in the last part of this essay.

Art production and the production of social relations are linked by a fundamental homology: but what are social relations? Social relations are the relations which are generated by the technical processes of which society at large can be said to consist, that is, broadly, the technical processes of the production of subsistence and other goods, and the production (reproduction) of human beings by domesticating them and breeding them. Therefore, in identifying a homology between the technical processes of art production and the production of social relations, I am not trying to say that the technology of art is homologous to a domain which is not, itself, technological, for social relations are themselves emergent characteristics of the technical base on which society rests. But it would be misleading to suggest that, because societies rest on a technical base, technology is a cut-and-dried affair which everybody concerned understands perfectly.

Let us take the relatively uncontentious kind of technical activity involved in gardening—uncontentious in that everybody would admit this is technical activity, an admission they might not make if we were talking about the processes involved in setting up a marriage. Three things stand out when one considers the technical activity of

gardening: firstly, that it involves knowledge and skill, secondly, that it involves work, and thirdly, that it is attended by an uncertain outcome, and moreover depends on ill-understood processes of nature. Conventional wisdom would suggest that what makes gardening count as a technical activity is the aspect of gardening which is demanding of knowledge, skill, and work, and that the aspect of gardening which causes it to be attended with magical rites, in pre-scientific societies, is the third one, that is, its uncertain outcome and ill-understood scientific basis.

But I do not think things are as simple as that. The idea of magic as an accompaniment to uncertainty does not mean that it is opposed to knowledge, i.e. that where there is knowledge there is no uncertainty, and hence no magic. On the contrary, what is uncertain is not the world but the knowledge we have about it. One way or another, the garden is going to turn out as it turns out; our problem is that we don't yet know how that will be. All we have are certain more-or-less hedged beliefs about a spectrum of possible outcomes, the more desirable of which we will try to bring about by following procedures in which we have a certain degree of belief, but which could equally well be wrong, or inappropriate in the circumstances. The problem of uncertainty is, therefore, not opposed to the notion of knowledge and the pursuit of rational technical solutions to technical problems, but is inherently a part of it. If we consider that the magical attitude is a by-product of uncertainty, we are thereby committed also to the proposition that the magical attitude is a by-product of the rational pursuit of technical objectives using technical means.

Magic as the ideal technology

But the relationship between technical processes and magic does not only come about because the outcome of technical endeavours is doubtful and results from the action of forces in nature of which we are partially or wholly ignorant. Work itself, mere labour, calls into being a magical attitude, because labour is the subjective cost incurred by us in the process of putting techniques into action. If we return to Simmel's ideas that 'value' is a function of the resistance which has to be overcome in order to gain access to an object, then we can see that this 'resistance' or difficulty of access can take two forms: (i) the object in question can be difficult to obtain, because it has a high price at market or because it belongs to an exalted sphere of exchange; or (ii) the object can be difficult to obtain because it is hard to produce, requiring a complex and chancy technical process, and/or a technical procedure which has high subjective opportunity costs, i.e. the producer is obliged to spend a great deal of time and energy producing that particular product, at the expense of other things he might produce or the employment of his time and resources in more subjectively agreeable leisure activities. The notion of 'work' is the standard we use to measure the opportunity cost of activities such as gardening, which are engaged in, not for their own sake, but to secure something else, such as an eventual harvest. In one sense, gardening for a Trobriander has no opportunity cost, because there is little else that a Trobriander could conceivably be doing. But gardening is still subjectively burdensome, and the harvest is still valuable because it is difficult to obtain. Gardening has an opportunity cost in the sense that gardening might be less laborious and more certain in its outcome than it actually is. The standard for computing the value of a harvest is the opportunity cost of obtaining the resulting harvest, not

by the technical, work-demanding means that are actually employed, but effortlessly, by magic. All productive activities are measured against the magic-standard, the possibility that the same product might be produced effortlessly, and the relative efficacy of techniques is a function of the extent to which they converge towards the magic-standard of zero work for the same product, just as the value to us of objects in the market is a function of the relation between the desirability of obtaining those objects at zero opportunity cost (alternative purchases forgone) and the opportunity costs we will actually incur by purchasing at the market price.

If there is any truth in this idea, then we can see that the notion of magic, as a means of securing a product without the work-cost that it actually entails, using the prevailing technical means, is actually built into the standard evaluation which is applied to the efficacy of techniques, and to the computation of the value of the product. Magic is the baseline against which the concept of work as a cost takes shape. Actual Kula canoes (which have to be sailed, hazardously, laboriously, and slowly, between islands in the Kula ring) are evaluated against the standard set by the mythical flying canoe, which achieves the same results instantly, effortlessly, and without any of the normal hazards. In the same way, Trobriand gardening takes place against the background provided by the litanies of the garden magician, in which all the normal obstacles to successful gardening are made absent by the magical power of words. Magic haunts technical activity like a shadow; or, rather, magic is the negative contour of work, just as, in Saussurean linguistics, the value of a concept (say, 'dog') is a function of the negative contour of the surrounding concepts ('cat', 'wolf', 'master').

Just as money is the ideal means of exchange, magic is the ideal means of technical production. And just as money values pervade the world of commodities, so that it is impossible to think of an object without thinking at the same time of its market price, so magic, as the ideal technology, pervades the technical domain in pre-scientific societies.[3]

It may not be very apparent what all this has got to do with the subject of primitive art. What I want to suggest is that magical technology is the reverse side of productive technology, and that this magical technology consists of representing the technical domain in enchanted form. If we return to the idea, expressed earlier, that what really characterizes art objects is the way in which they tend to transcend the technical schemas of the spectator, his normal sense of self-possession, then we can see that there is a convergence between the characteristics of objects produced through the enchanted technology of art and objects produced via the enchanted technology of magic, and that, in fact, these categories tend to coincide. It is often the case that art objects are regarded as transcending the technical schemas of their creators, as well as those of mere spectators, as when the art object is considered to arise, not from the activities of the individual physically responsible for it, but from the divine inspiration or ancestral spirit with which he is filled. We can see signs of this in the fact that artists are not paid for 'working' for us, in the sense in which we pay plumbers for doing so. The artists' remuneration is not remuneration for his sweat, any more than the coins placed in the offertory plate at church are payments to the vicar for his praying on behalf of our souls. If artists are paid at all, which is infrequently, it is as a tribute to their moral ascendancy over the lay public, and such payments mostly come from public bodies or individuals acting out the public role of patrons of the arts, not from selfishly motivated individual consumers. The artist's ambiguous position, half-technician and half-mystagogue, places him at a disadvantage in societies such as ours, which are dominated by impersonal market values.

But these disadvantages do not arise in societies such as the Trobriands, where all activities are simultaneously technical procedures and bound up with magic, and there is an insensible transition between the mundane activity which is necessitated by the requirements of subsistence production and the most overtly magico-religious performances.

The Trobriand garden as a collective work of art

The interpenetration of technical productive activity, magic, and art, is wonderfully documented in Malinowski's *Coral Gardens and Their Magic* (1935). Malinowski describes the extraordinary precision with which Trobriand gardens, having been cleared of scrub, and not only scrub, but the least blade of grass, are meticulously laid out in squares, with special structures called 'magical prisms' at each corner, according to a symmetrical pattern which has nothing to do with technical efficiency, and everything to do with achieving the transcendence of technical production and a convergence towards magical production. Only if the garden looks right will it grow well, and the garden is, in fact, an enormous collective work of art. Indeed, if we thought of the quadrangular Trobriand garden as an artist's canvas on which forms mysteriously grow, through an occult process which lies partly beyond our intuition, that would not be a bad analogy, because that is what happens as the yams proliferate and grow, their vines and tendrils carefully trained up poles according to principles which are no less 'aesthetic' than those of the topiarist in the formal gardens of Europe.[4]

The Trobriand garden is, therefore, both the outcome of a certain system of technical knowledge and at the same time a collective work of art, which produces yams by magic. The mundane responsibility for this collective work of art is shared by all the gardeners, but on the garden magician and his associates more onerous duties are imposed. We would not normally think of the garden magician as an artist, but from the point of view of the categories operated by the Trobrianders, his position is exactly the same, with regard to the production of the harvest, as the carver's position is with regard to the canoe-board, i.e. he is the person magically responsible, via his ancestrally inherited *sopi* or magical essence.

The garden magician's means are not physical ones, like the carver's skill with wood and tools, except that it is he who lays out the garden originally and constructs (with a good deal of effort, we are told) the magic prisms at the corners. His art is exercised through his speech. He is master of the verbal poetic art, just as the carver is master of the use of visual metaphoric forms (ospreys, butterflies, waves, and so on). It would take too long, and introduce too many fresh difficulties, to deal adequately with the tripartite relationship between language (the most fundamental of all technologies), art, and magic. But I think it is necessary, even so, to point out the elementary fact that Trobriand spells are poems, using all the usual devices of prosody and metaphor, about ideal gardens and ideally efficacious gardening techniques. Malinowski (1935: i. 169) gives the following ('Formula 27'):

> I
> Dolphin here now, dolphin here ever!
> Dolphin here now, dolphin here ever!
> Dolphin of the south-east, dolphin of the north-west.

Play on the south-east, play on the north-west, the dolphin plays!
The dolphin plays!

II
The dolphin plays!
About my *kaysalu*, my branching support, the dolphin plays.
About my *kaybudi*, my training stick that leans, the dolphin plays.
About my *kamtuya*, my stem saved from the cutting, the dolphin plays.
About my *tala*, my partition stick, the dolphin plays.
About my *yeye'i*, my small slender support, the dolphin plays.
About my *tamkwaluma*, my light yam pole, the dolphin plays.
About my *kavatam*, my strong yam pole, the dolphin plays.
About my *kayvaliluwa*, my great yam pole, the dolphin plays.
About my *tukulumwala*, my boundary line, the dolphin plays.
About my *karivisi*, my boundary triangle, the dolphin plays.
About my *kamkokola*, my magical prism, the dolphin plays.
About my *kaynutatala*, my uncharmed prisms, the dolphin plays.

III
The belly of my garden leavens,
The belly of my garden rises,
The belly of my garden reclines,
The belly of my garden grows to the size of a bush hen's nest,
The belly of my garden grows like an ant-hill,
The belly of my garden rises and is bowed down,
The belly of my garden rises like the iron-wood palm,
The belly of my garden lies down,
The belly of my garden swells,
The belly of my garden swells as with a child.

and comments (1935: ii. 310–11):

> the invocation of the dolphin . . . transforms, by a daring simile, the Trobri-
> and garden, with its foliage swaying and waving in the wind, into a seascape
> . . . Bagido'u [the magician] explained to me . . . that as among the waves
> the dolphin goes in and out, up and down, so throughout the garden the rich
> garlands at harvest will wind over and under, in and out, of the supports.

It is clear that not only is this hymn to superabundant foliage animated
by the poetic devices of metaphor, antithesis, arcane words, and so on, all
meticulously analysed by Malinowski, but that it is also tightly integrated
with the catalogue of sticks and poles made use of in the garden, and the
ritually important constructions, the magic prisms and boundary tri-
angles which are also found there. The garden magician's technology of
enchantment is the reflex of the enchantment of technology. Technology
is enchanted because the ordinary technical means employed in the garden
point inexorably towards magic, and also towards art, in that art is the ideal-
ized form of production. Just as when, confronted with some masterpiece,
we are fascinated because we are essentially at a loss to explain how such

an object comes to exist in the world, the litanies of the garden magician express the fascination of the Trobrianders with the efficacy of their actual technology which, converging towards the magical ideal, adumbrates this ideal in the real world.

Notes

1 'Non-Western' has been suggested to me as a preferable alternative to 'primitive' in this context. But this substitution can hardly be made, if only because the fine-art traditions of Oriental civilizations have precisely the characteristics which 'primitive' is here intended to exclude, but cannot possibly be called 'Western'. I hope the reader will accept the use of 'primitive' in a neutral, non-derogatory sense in the context of this essay. It is worth point-ing out that the Trobriand carvers who produce the primitive art discussed in this essay are not themselves at all primitive; they are educated, literate in various languages, and famil-iar with much contemporary technology. They continue to fabricate primitive art because it is a feature of an ethnically exclusive prestige economy which they have rational motives for wishing to preserve.

2 The Kula is a system of ceremonial exchanges of valuables linking together the island com-munities of the Massim district, to the east of the mainland of Papua New Guinea (see Malinowski, 1922; Leach and Leach, 1983). Kula participants (all male) engage in Kula expeditions by canoe to neighbouring islands, for the purpose of exchanging two types of traditional valuable, necklaces and arm-shells, which may only be exchanged for one another. The Kula system assumes the form of a ring of linked island communities, around which necklaces circulate in a clockwise direction. Kula men compete with other men from their own community to secure profitable Kula partnerships with opposite numbers in overseas communities in either direction, the object being to maximize the volume of transactions passing through one's own hands. Kula valuables are not hoarded; it is suffi-cient that it should become public knowledge that a famous valuable has, at some stage, been in one's possession. A man who has succeeded in 'attracting' many coveted valuables becomes famous all around the Kula ring (see Munn, 1986).

3 In technologically advanced societies where different technical strategies exist, rather than societies like the Trobriands where only one kind of technology is known or practi-cable, the situation is different, because different technical strategies are opposed to one another, rather than being opposed to the magic-standard. But the technological dilemmas of modern societies can, in fact, be traced to the pursuit of a chimera which is actually the equivalent of the magic-standard: ideal 'costless' production. This is actually not costless at all, but the minimization of costs to the corporation by the maximization of social costs which do not appear on the balance sheet, leading to technically generated unemployment, depletion of unrenewable resources, degradation of the environment, etc.

4 In the Sepik, likewise, the growing of long yams is an art-form, and not just metaphorically, because the long yam can be induced to grow in particular directions by careful manipula-tion of the surrounding soil: it is actually a form of vegetable sculpture (see Forge, 1966).

References

Berger, Peter (1967). *The Social Reality of Religion*. Harmondsworth, Middx.: Penguin.
Bloch, Maurice (1974). 'Symbols, Song, Dance, and Features of Articulation: Is Religion an Extreme Form of Traditional Authority?', *Archives Européennes de Sociologie*, 15/1: 55–81.

Bourdieu, Pierre (1968). 'Outline of a Sociological Theory of Art Perception', *International Social Science Journal*, 20/4: 589–612.

—— (1977). *Outline of a Theory of Practice*. Cambridge: Cambridge Univ. Press.

Campbell, Shirley (1984). 'The Art of the Kula'. Ph.D. thesis, Australian National Univ., Canberra.

Forge, Anthony (1966). 'Art and Environment in the Sepik', *Proceedings of the Royal Anthropological Institute for 1965*. London: Royal Anthropological Institute, 23–31.

Leach, Jerry W., and Leach, Edmund (1983). *The Kula: New Perspectives on Massim Exchange*. Cambridge: Cambridge Univ. Press.

Malinowski, Bronislaw (1922). *Argonauts of the Western Pacific: An Account of Native Enterprise and Adventure in the Archipelagoes of Melanesian New Guinea*. London: Routledge.

—— (1935). *Coral Gardens and their Magic: A Study of the Methods of Tilling the Soil and of Agricultural Rites in the Trobriand Islands*. 2 vols. London: Allen & Unwin.

Munn, Nancy (1986). *The Fame of Gawa: A Symbolic Study of Value Transformation in a Massim (Papua New Guinea) Society*. Cambridge: Cambridge Univ. Press.

Panofsky, Erwin (1962). *Studies in Iconology: Humanistic Themes in the Art of the Renaissance*. New York: Harper & Row.

Simmel, Georg (1979). *The Philosophy of Money*. Boston: Routledge & Kegan Paul.

Bruno Latour

WHERE ARE THE MISSING MASSES? THE SOCIOLOGY OF A FEW MUNDANE ARTIFACTS

To Robert Fox

> Again, might not the glory of the machines consist in their being without this same boasted gift of language? "Silence," it has been said by one writer, "is a virtue which renders us agreeable to our fellow-creatures."
>
> Samuel Butler (*Erewhon*, chap. 23)

Early this morning, I was in a bad mood and decided to break a law and start my car without buckling my seat belt. My car usually does not want to start before I buckle the belt. It first flashes a red light "FASTEN YOUR SEAT BELT!", then an alarm sounds; it is so high pitched, so relentless, so repetitive, that I cannot stand it. After ten seconds I swear and put on the belt. This time, I stood the alarm for twenty seconds and then gave in. My mood had worsened quite a bit, but I was at peace with the law—at least with that law. I wished to break it, but I could not. Where is the morality? In me, a human driver, dominated by the mindless power of an artifact? Or in the artifact forcing me, a mindless human, to obey the law that I freely accepted when I get my driver's license? Of course, I could have put on my seat belt before the light flashed and the alarm sounded, incorporating in my own self the good behavior that everyone—the car, the law, the police—expected of me. Or else, some devious engineer could have linked the engine ignition to an electric sensor in the seat belt, so that I could not even have started the car before having put it on. Where would the morality be in those two extreme cases? In the electric currents flowing in the machine between the switch and the sensor? Or in the electric currents flowing down my spine in the automatism of my routinized behavior?

In both cases the result would be the same from an outside observer—say a watchful policeman: this assembly of a driver and a car obeys the law in such a way that it is impossible for a car to be at the same time moving *and* to have the driver without the belt on. A law of the excluded middle has been built, rendering logically inconceivable as well as morally unbearable a driver without a seat belt. Not quite. Because I feel so irritated to be forced to behave well that I instruct my garage mechanics to unlink the switch and the sensor. The excluded middle is back in! There is at least one car that is both on the move and without a seat belt on its driver—mine. This was without counting on the cleverness of engineers. They now invent a seat belt that politely makes way for me when I open the door and then straps me as politely but very tightly when I close the door. Now there is no escape. The only way not to have the seat belt on is to leave the door wide open, which is rather dangerous at high speed. Exit the excluded middle. The program of action[1] "IF a car is moving, THEN the driver has a seat belt" is enforced. It has become logically—no, it has become sociologically—impossible to drive without wearing the belt. I cannot be bad anymore. I, plus the car, plus the dozens of patented engineers, plus the police are making me be moral [Figure 16.1].

According to some physicists, there is not enough mass in the universe to balance the accounts that cosmologists make of it. They are looking everywhere for the "missing mass" that could add up to the nice expected total. It is the same with sociologists. They are constantly looking, somewhat desperately, for social links sturdy enough to tie all of us together or for moral laws that would be inflexible enough to make us behave properly. When adding up social ties, all does not balance. Soft humans and weak moralities are all sociologists can get. The society they try to recompose with bodies and norms constantly crumbles. Something is missing, something that should be strongly social

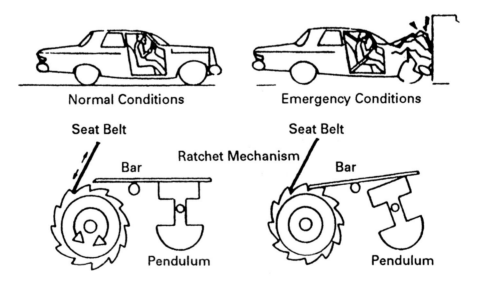

Figure 16.1 The designers of the seat belt take on themselves and then shift back to the belt contradictory programs: the belt should be lenient and firm, easy to put on and solidly fastened while ready to be unbuckled in a fraction of a second; it should be unobtrusive and strap in the whole body. The object does not reflect the social. It does more. It transcribes and displaces the contradictory interests of people and things.

and highly moral. Where can they find it? Everywhere, but they too often refuse to see it in spite of much new work in the sociology of artifacts.[2]

I expect sociologists to be much more fortunate than cosmologists, because they will soon discover their missing mass. To balance our accounts of society, we simply have to turn our exclusive attention away from humans and look also at nonhumans. Here they are, the hidden and despised social masses who make up our morality. They knock at the door of sociology, requesting a place in the accounts of society as stubbornly as the human masses did in the nineteenth century. What our ancestors, the founders of sociology, did a century ago to house the human masses in the fabric of social theory, we should do now to find a place in a new social theory for the nonhuman masses that beg us for understanding.

Description of a door

I will start my inquiry by following a little script written by anonymous hands.[3] On a freezing day in February, posted on the door of La Halle aux Cuirs at La Villette, in Paris, where Robert Fox's group was trying to convince the French to take up social history of science, could be seen a small handwritten notice: "The Groom Is On Strike, For God's Sake, Keep The Door Closed" ("groom" is Frenglish for an automated door-closer or butler). This fusion of labor relations, religion, advertisement, and technique in one insignificant fact is exactly the sort of thing I want to describe[4] in order to discover the missing masses of our society. As a technologist teaching in the School of Mines, an engineering institution, I want to challenge some of the assumptions sociologists often hold about the social context of machines.

Walls are a nice invention, but if there were no holes in them there would be no way to get in or out—they would be mausoleums or tombs. The problem is that if you make holes in the walls, anything and anyone can get in and out (cows, visitors, dust, rats, noise—La Halle aux Cuirs is ten meters from the Paris ring road—and, worst of all, cold—La Halle aux Cuirs is far to the north of Paris). So architects invented this hybrid: a wall hole, often called a *door*, which although common enough has always struck me as a miracle of technology. The cleverness of the invention hinges upon the hingepin: instead of driving a hole through walls with a sledgehammer or a pick, you simply gently push the door (I am supposing here that the lock has not been invented—this would overcomplicate the already highly complex story of La Villette's door); furthermore—and here is the real trick—once you have passed through the door, you do not have to find trowel and cement to rebuild the wall you have just destroyed: you simply push the door gently back (I ignore for now the added complication of the "pull" and "push" signs).

So, to size up the work done by hinges, you simply have to imagine that every time you want to get in or out of the building you have to do the same work as a prisoner trying to escape or as a gangster trying to rob a bank, plus the work of those who rebuild either the prison's or the bank's walls. If you do not want to imagine people destroying walls and rebuilding them every time they wish to leave or enter a building, then imagine the work that would have to be done to keep inside or outside all the things and people that, left to themselves, would go the wrong way.[5] As Maxwell never said, imagine his demon working *without* a door. Anything could escape from or penetrate into La Halle aux Cuirs, and soon there would be complete equilibrium between

the depressing and noisy surrounding area and the inside of the building. Some technologists, including the present writer in *Material Resistance, A Textbook* (1984), have written that techniques are always involved when asymmetry or irreversibility are the goal; it might appear that doors are a striking counter-example because they maintain the wall hole in a reversible state; the allusion to Maxwell's demon clearly shows, however, that such is not the case; the reversible door is the only way to trap irreversibly inside La Halle aux Cuirs a differential accumulation of warm historians, knowledge, and also, alas, a lot of paperwork; the hinged door allows a selection of what gets in and what gets out so as to locally increase order, or information. If you let the drafts get inside (these renowned "courants d'air" so dangerous to French health), the paper drafts may never get outside to the publishers.

Now, draw two columns (if I am not allowed to give orders to the reader, then I offer it as a piece of strongly worded advice): in the right-hand column, list the work people would have to do if they had no door; in the left-hand column write down the gentle pushing (or pulling) they have to do to fulfill the same tasks. Compare the two columns: the enormous effort on the right is balanced by the small one on the left, and this is all thanks to hinges. I will define this transformation of a major effort into a minor one by the words *displacement* or *translation* or *delegation* or *shifting*;[6] I will say that we have delegated (or translated or displaced or shifted down) to the hinge the work of reversibly solving the wall-hole dilemma. Calling on Robert Fox, I do not have to do this work nor even think about it; it was delegated by the carpenter to a character, the hinge, which I will call a *nonhuman*. I simply enter La Halle aux Cuirs. As a more general descriptive rule, every time you want to know what a nonhuman does, simply imagine what other humans or other nonhumans would have to do were this character not present. This imaginary substitution exactly sizes up the role, or function, of this little character.

Before going on, let me point out one of the side benefits of this table: in effect, we have drawn a scale where tiny efforts balance out mighty weights; the scale we drew reproduces the very leverage allowed by hinges. That the small be made stronger than the large is a very moral story indeed (think of David and Goliath); by the same token, it is also, since at least Archimedes' days, a very good definition of a lever and of power: what is the minimum you need to hold and deploy astutely to produce the maximum effect. Am I alluding to machines or to Syracuse's King? I don't know, and it does not matter, because the King and Archimedes fused the two "minimaxes" into a single story told by Plutarch: the defense of Syracuse through levers and war machines.[7] I contend that this reversal of forces is what sociologists should look at in order to understand the social construction of techniques, and not a hypothetical "social context" that they are not equipped to grasp. This little point having been made, let me go on with the story (we will understand later why I do not really need your permission to go on and why, nevertheless, you are free not to go on, although only *relatively* so).

Delegation to humans

There is a problem with doors. Visitors push them to get in or pull on them to get out (or vice versa), but then the door remains open. That is, instead of the door you have a gaping hole in the wall through which, for instance, cold rushes in and heat rushes out. Of course, you could imagine that people living in the building or visiting the Centre

d'Histoire des Sciences et des Techniques would be a well-disciplined lot (after all, historians are meticulous people). They will learn to close the door behind them and retransform the momentary hole into a well-sealed wall. The problem is that discipline is not the main characteristic of La Villette's people; also you might have mere sociologists visiting the building, or even pedagogues from the nearby Centre de Formation. Are they all going to be so well trained? Closing doors would appear to be a simple enough piece of know-how once hinges have been invented, but, considering the amount of work, innovations, sign-posts, and recriminations that go on endlessly everywhere to keep them closed (at least in northern regions), it seems to be rather poorly disseminated.

This is where the age-old Mumfordian choice is offered to you: either to discipline the people or to substitute for the unreliable people another delegated human character whose only function is to open and close the door. This is called a groom or a porter (from the French word for door), or a gatekeeper, or a janitor, or a concierge, or a turnkey, or a jailer. The advantage is that you now have to discipline only one human and may safely leave the others to their erratic behavior. No matter who it is and where it comes from, the groom will always take care of the door. A nonhuman (the hinges) plus a human (the groom) have solved the wall-hole dilemma.

Solved? Not quite. First of all, if La Halle aux Cuirs pays for a porter, they will have no money left to buy coffee or books, or to invite eminent foreigners to give lectures. If they give the poor little boy other duties besides that of porter, then he will not be present most of the time and the door will stay open. Even if they had money to keep him there, we are now faced with a problem that two hundred years of capitalism has not completely solved: how to discipline a youngster to reliably fulfill a boring and underpaid duty? Although there is now only one human to be disciplined instead of hundreds, the weak point of the tactic can be seen: if this *one* lad is unreliable, then the whole chain breaks down; if he falls asleep on the job or goes walkabout, there will be no appeal: the door will stay open (remember that locking it is no solution because this would turn it into a wall, and then providing everyone with the right key is a difficult task that would not ensure that key holders will lock it back). Of course, the porter may be punished. But disciplining a groom—Foucault notwithstanding—is an enormous and costly task that only large hotels can tackle, and then for other reasons that have nothing to do with keeping the door properly closed.

If we compare the work of disciplining the groom with the work he substitutes for, according to the list defined above, we see that this delegated character has the opposite effect to that of the hinge: a simple task—forcing people to close the door—is now performed at an incredible cost; the minimum effect is obtained with maximum spending and discipline. We also notice, when drawing the two lists, an interesting difference: in the first relationship (hinges vis-à-vis the work of many people), you not only had a reversal of forces (the lever allows gentle manipulations to displace heavy weights) but also a modification of *time schedule*: once the hinges are in place, nothing more has to be done apart from maintenance (oiling them from time to time). In the second set of relations (groom's work versus many people's work), not only do you fail to reverse the forces but you also fail to modify the time schedule: nothing can be done to prevent the groom who has been reliable for two months from failing on the sixty-second day; at this point it is not maintenance work that has to be done but the *same* work as on the first day—apart from the few habits that you might have been able to *incorporate* into his body. Although they appear to be two similar delegations, the first one is

concentrated at the time of installation, whereas the other is continuous; more exactly, the first one creates clear-cut distinctions between production, installation, and maintenance, whereas in the other the distinction between training and keeping in operation is either fuzzy or nil. The first one evokes the past perfect ("once hinges had been installed . . ."), the second the present tense ("when the groom is at his post . . ."). There is a built-in inertia in the first that is largely lacking in the second. The first one is Newtonian, the second Aristotelian (which is simply a way of repeating that the second is nonhuman and the other human). A profound temporal shift takes place when nonhumans are appealed to; time is *folded*.

Delegation to nonhumans

It is at this point that you have a relatively new choice: either to discipline the people or to *substitute* for the unreliable humans a *delegated nonhuman character* whose only function is to open and close the door. This is called a door-closer or a groom ("groom" is a French trademark that is now part of the common language). The advantage is that you now have to discipline only one nonhuman and may safely leave the others (bell-boys included) to their erratic behavior. No matter who they are and where they come from— polite or rude, quick or slow, friends or foes—the nonhuman groom will always take care of the door in any weather and at any time of the day. A nonhuman (hinges) plus another nonhuman (groom) have solved the wall-hole dilemma.

Solved? Well, not quite. Here comes the deskilling question so dear to social historians of technology: thousands of human grooms have been put on the dole by their nonhuman brethren. Have they been replaced? This depends on the kind of action that has been translated or delegated to them. In other words, when humans are displaced and deskilled, nonhumans have to be upgraded and reskilled. This is not an easy task, as we shall now see.

We have all experienced having a door with a powerful spring mechanism slam in our faces. For sure, springs do the job of replacing grooms, but they play the role of a very rude, uneducated, and dumb porter who obviously prefers the wall version of the door to its hole version. They simply slam the door shut. The interesting thing with such impolite doors is this: if they slam shut so violently, it means that you, the visitor, have to be very quick in passing through and that you should not be at someone else's heels, otherwise your nose will get shorter and bloody. An unskilled nonhuman groom thus presupposes a skilled human user. It is always a trade-off. I will call, after Madeleine Akrich . . . the behavior imposed back onto the human by nonhuman delegates *prescription*.[8] Prescription is the moral and ethical dimension of mechanisms. In spite of the constant weeping of moralists, no human is as relentlessly moral as a machine, especially if it is (she is, he is, they are) as "user friendly" as my Macintosh computer. We have been able to delegate to nonhumans not only force as we have known it for centuries but also values, duties, and ethics. It is because of this morality that we, humans, behave so ethically, no matter how weak and wicked we feel we are. The sum of morality does not only remain stable but increases enormously with the population of nonhumans. It is at this time, funnily enough, that moralists who focus on isolated socialized humans despair of us—us meaning of course humans and their retinue of nonhumans.

How can the prescriptions encoded in the mechanism be brought out in words? By

replacing them by strings of sentences (often in the imperative) that are uttered (silently and continuously) by the mechanisms for the benefit of those who are mechanized: do this, do that, behave this way, don't go that way, you may do so, be allowed to go there. Such sentences look very much like a programming language. This substitution of words for silence can be made in the analyst's thought experiments, but also by instruction booklets, or explicitly, in any training session, through the voice of a demonstrator or instructor or teacher. The military are especially good at shouting them out through the mouthpiece of human instructors who delegate back to themselves the task of explaining, in the rifle's name, the characteristics of the rifle's ideal user. Another way of hearing what the machines silently did and said are the accidents. When the space shuttle exploded, thousands of pages of transcripts suddenly covered every detail of the silent machine, and hundreds of inspectors, members of congress, and engineers retrieved from NASA dozens of thousands of pages of drafts and orders. This description of a machine—whatever the means—retraces the steps made by the engineers to transform texts, drafts, and projects into things. The impression given to those who are obsessed by human behavior that there is a missing mass of morality is due to the fact that they do not follow this path that leads from text to things and from things to texts. They draw a strong distinction between these two worlds, whereas the job of engineers, instructors, project managers, and analysts is to continually cross this divide. Parts of a program of action may be delegated to a human, or to a nonhuman.

The results of such *distribution of competences*[9] between humans and nonhumans is that competent members of La Halle aux Cuirs will safely pass through the slamming door at a good distance from one another while visitors, unaware of the local cultural condition, will crowd through the door and get bloody noses. The nonhumans take over the selective attitudes of those who engineered them. To avoid this discrimination, inventors get back to their drawing board and try to imagine a nonhuman character that will not *prescribe* the same rare local cultural skills to its human users. A weak spring might appear to be a good solution. Such is not the case, because it would substitute for another type of very unskilled and undecided groom who is never sure about the door's (or his own) status: is it a hole or a wall? Am I a closer or an opener? If it is both at once, you can forget about the heat. In computer parlance, a door is an exclusive OR, not an AND gate.

I am a great fan of hinges, but I must confess that I admire hydraulic door closers much more, especially the old heavy copper-plated one that slowly closed the main door of our house in Aloxe-Corton. I am enchanted by the addition to the spring of a hydraulic piston, which easily draws up the energy of whose who open the door, retains it, and then gives it back slowly with a subtle type of implacable firmness that one could expect from a well-trained butler. Especially clever is its way of extracting energy from each unwilling, unwitting passerby. My sociologist friends at the School of Mines call such a clever extraction an "obligatory passage point," which is a very fitting name for a door. No matter what you feel, think, or do, you have to leave a bit of your energy, literally, at the door. This is as clever as a toll booth.[10]

This does not quite solve all of the problems, though. To be sure, the hydraulic door closer does not bang the noses of those unaware of local conditions, so its prescriptions may be said to be less restrictive, but it still leaves aside segments of human populations: neither my little nephews nor my grandmother could get in unaided because our groom needed the force of an able-bodied person to accumulate enough energy to close the door later. To use Langdon Winner's classic motto (1980): Because of their prescriptions,

these doors *discriminate* against very little and very old persons. Also, if there is no way to keep them open for good, they discriminate against furniture removers and in general everyone with packages, which usually means, in our late capitalist society, working- or lower-middle-class employees. (Who, even among those from higher strata, has not been cornered by an automated butler when they had their hands full of packages?)

There are solutions, though: the groom's delegation may be written off (usually by blocking its arm) or, more prosaically, its delegated action may be opposed by a foot (salesmen are said to be expert at this). The foot may in turn be delegated to a carpet or anything that keeps the butler in check (although I am always amazed by the number of objects that *fail* this trial of force and I have very often seen the door I just wedged open politely closing when I turned my back to it).

Anthropomorphism

As a technologist, I could claim that provided you put aside the work of installing the groom and maintaining it, and agree to ignore the few sectors of the population that are discriminated against, the hydraulic groom does its job well, closing the door behind you, firmly and slowly. It shows in its humble way how three rows of delegated nonhuman actants[11] (hinges, springs, and hydraulic pistons) replace, 90 percent of the time, either an undisciplined bellboy who is never there when needed or, for the general public, the program instructions that have to do with remembering-to-close-the-door-when-it-is-cold.

The hinge plus the groom is the technologist's dream of efficient action, at least until the sad day when I saw the note posted on La Villette's door with which I started this meditation: "The groom is on strike." So not only have we been able to delegate the act of closing the door from the human to the nonhuman, we have also been able to delegate the human lack of discipline (and maybe the union that goes with it). On strike . . .[12] Fancy that! Nonhumans stopping work and claiming what? Pension payments? Time off? Landscaped offices? Yet it is no use being indignant, because it is very true that nonhumans are not so reliable that the irreversibility we would like to grant them is always complete. We did not want ever to have to think about this door again—apart from regularly scheduled routine maintenance (which is another way of saying that we did not have to bother about it)—and here we are, worrying again about how to keep the door closed and drafts outside.

What is interesting in this note is the humor of attributing a human characteristic to a failure that is usually considered "purely technical." This humor, however, is more profound than in the notice they could have posted: "The groom is not working." I constantly talk with my computer, who answers back; I am sure you swear at your old car; we are constantly granting mysterious faculties to gremlins inside every conceivable home appliance, not to mention cracks in the concrete belt of our nuclear plants. Yet, this behavior is considered by sociologists as a scandalous breach of natural barriers. When you write that a groom is "on strike," this is only seen as a "projection," as they say, of a human behavior onto a nonhuman, cold, technical object, one by nature impervious to any feeling. This is *anthropomorphism*, which for them is a sin akin to zoophily but much worse.

It is this sort of moralizing that is so irritating for technologists, because the automatic groom is already anthropomorphic through and through. It is well known that the

French like etymology; well, here is another one: *anthropos* and *morphos* together mean either that which *has* human shape or that which *gives shape* to humans. The groom is indeed anthropomorphic, in three senses: first, it has been made by humans; second, it substitutes for the actions of people and is a delegate that permanently occupies the position of a human; and third, it shapes human action by prescribing back what sort of people should pass through the door. And yet some would forbid us to ascribe feelings to this thoroughly anthropomorphic creature, to delegate labor relations, to "project"— that is, to translate—*other* human properties to the groom. What of those many other innovations that have endowed much more sophisticated doors with the ability to see you arrive in advance (electronic eyes), to ask for your identity (electronic passes), or to slam shut in case of danger? But anyway, who are sociologists to decide the real and final shape (*morphos*) of humans (*anthropos*)? To trace with confidence the boundary between what is a "real" delegation and what is a "mere" projection? To sort out forever and without due inquiry the three different kinds of anthropomorphism I listed above? Are we not shaped by nonhuman grooms, although I admit only a very little bit? Are they not our brethren? Do they not deserve consideration? With your self-serving and self-righteous social studies of technology, you always plead against machines and for deskilled workers—are you aware of *your* discriminatory biases? You discriminate between the human and the inhuman. I do not hold this bias (this one at least) and see only actors—some human, some nonhuman, some skilled, some unskilled— that exchange their properties. So the note posted on the door is accurate; it gives with humor an exact rendering of the groom's behavior: it is not working, it is on strike (notice, that the word "strike" is a rationalization carried from the nonhuman repertoire to the human one, which proves again that the divide is untenable).

Built-in users and authors

The debates around anthropomorphism arise because we believe that there exist "humans" and "nonhumans," without realizing that this attribution of roles and action is also a *choice*.[13] The best way to understand this choice is to compare machines with texts, since the inscription of builders and users in a mechanism is very much the same as that of authors and readers in a story. In order to exemplify this point I have now to confess that I am *not* a technologist. I built in my article a made-up author, and I also invented possible readers whose reactions and beliefs I anticipated. Since the beginning I have many times used the "you" and even "you sociologists". I even asked you to draw up a table, and I also asked your permission to go on with the story. In doing so, I built up an inscribed reader to whom I prescribed qualities and behavior, as surely as a traffic light or a painting prepare a position for those looking at them. Did you *underwrite* or *subscribe* this definition of yourself? Or worse, is there any one at all to read this text and occupy the position prepared for the reader? This question is a source of constant difficulties for those who are unaware of the basics of semiotics or of technology. *Nothing in a given scene* can prevent the inscribed user or reader from behaving differently from what was expected (nothing, that is, until the next paragraph). The reader in the flesh may totally ignore my definition of him or her. The user of the traffic light may well cross on the red. Even visitors to La Halle aux Cuirs may never show up because it is too complicated to find the place, *in spite* of the fact that their behavior and trajectory have been perfectly

anticipated by the groom. As for the computer user input, the cursor might flash forever without the user being there or knowing what to do. There might be an enormous gap between the prescribed user and the user-in-the-flesh, a difference as big as the one between the "I" of a novel and the novelist.[14] It is exactly this difference that upset the authors of the anonymous appeal on which I comment. On other occasions, however, the gap between the two may be nil: the prescribed user is so well anticipated, so carefully nested inside the scenes, so exactly dovetailed, that it does what is expected.[15]

The problem with scenes is that they are usually well prepared for anticipating users or readers who are at close quarters. For instance, the groom is quite good in its anticipation that people will push the door open and give it the energy to reclose it. It is very bad at doing anything to help people arrive there. After fifty centimeters, it is helpless and cannot act, for example, on the maps spread around La Villette to explain where La Halle aux Cuirs is [Figure 16.2]. Still, no scene is prepared without a preconceived idea of what sort of actors will come to occupy the prescribed positions.

This is why I said that although *you* were free not to go on with this paper, *you* were only "relatively" so. Why? Because I know that, because you bought this book, you are hard-working, serious, English-speaking technologists or readers committed to understanding new development in the social studies of machines. So my injunction to "read the paper, you sociologist" is not very risky (but I would have taken no chance with a French audience, especially with a paper written in English). This way of counting on earlier distribution of skills to help narrow the gap between built-in users or readers and users- or readers-in-the-flesh is like a *pre*-inscription.[16]

The fascinating thing in text as well as in artifact is that they have to thoroughly organize the relation between what is inscribed in them and what can/could/should be pre-inscribed in the users. Each setup is surrounded by various arenas interrupted by different types of walls. A text, for instance, is clearly *circumscribed*[17]—the dust cover, the title page, the hard back—but so is a computer—the plugs, the screen, the disk drive, the user's input. What is nicely called "interface" allows any setup to be connected to another through so many carefully designed entry points. Sophisticated mechanisms build up a whole gradient of concentric circles around themselves. For instance, in most modern photocopy machines there are troubles that even rather incompetent users may solve themselves like "ADD PAPER;" but then there are trickier ones that require a bit of explanation: "ADD TONER. SEE MANUAL, PAGE 30." This instruction might be backed up by homemade labels: "DON'T ADD THE TONER YOURSELF, CALL THE SECRETARY," which limit still further the number of people able to troubleshoot. But then other more serious crises are addressed by labels like "CALL THE TECHNICAL STAFF AT THIS NUMBER," while there are parts of the machine that are sealed off entirely with red labels such as "DO NOT OPEN—DANGER, HIGH VOLTAGE, HEAT" or "CALL THE POLICE." Each of these messages addresses a different audience, from the widest (everyone with the rather largely disseminated competence of using photocopying machines) to the narrowest (the rare bird able to troubleshoot and who, of course, is never there).[18] Circumscription only defines how a setup itself has built-in plugs and interfaces; as the name indicates, this tracing of circles, walls, and entry points inside the text or the machine does not prove that readers and users will obey. There is nothing sadder that an obsolete computer with all its nice interfaces, but no one on earth to plug them in.

Drawing a side conclusion in passing, we can call *sociologism* the claim that, given

Figure 16.2 This is the written instruction sent through the mail by people from the Centre d'Histoire des Sciences to endow their visitors with the competence of reading the signs leading to their office, La Halle aux Cuirs. Of course it implies the basic preinscribed competence: understanding French and knowing how to read a map, and it has no influence on the other programs of action that lead people to want to go to the Centre. It extends the mechanism of the door—its conscription—but it is still limited in scope. Like users' manuals, it is one of those many inscriptions that cover "the gap of execution" between people and settings.

the competence, pre-inscription, and circumscription of human users and authors, you can read out the scripts non-human actors have to play; and *technologism* the symmetric claim that, given the competence and pre-inscription of nonhuman actors, you can easily read out and deduce the behavior prescribed to authors and users. From now on, these two absurdities will, I hope, disappear from the scene, because the actors at any

point may be human or nonhuman, and the displacement (or translation, or transcription) makes impossible the easy reading out of one repertoire and into the next. The bizarre idea that society might be made up of human relations is a mirror image of the other no less bizarre idea that techniques might be made up of nonhuman relations. We deal with characters, delegates, representatives, lieutenants (from the French "lieu" plus "tenant," i.e., holding the place of, for, someone else)—some figurative, others nonfigurative; some human, others nonhuman; some competent, others incompetent. Do you want to cut through this rich diversity of delegates and artificially create two heaps of refuse, "society" on one side and "technology" on the other? That is your privilege, but I have a less bungled task in mind.

A scene, a text, an automatism can do a lot of things to their prescribed users at the range—close or far—that is defined by the circumscription, but most of the effect finally ascribed[19] to them depends on lines of other setups being aligned. For instance, the groom closes the door only if there are people reaching the Centre d'Histoire des Sciences; these people arrive in front of the door only if they have found maps (another delegate, with the built-in prescription I like most: "*you* are here" circled in red on the map) and only if there are roads leading under the Paris ring road to the Halle (which is a condition not always fullfilled); and of course people will start bothering about reading the maps, getting their feet muddy and pushing the door open only if they are convinced that the group is worth visiting (this is about the only condition in La Villette that is fulfilled). This gradient of aligned setups that endow actors with the pre-inscribed competences to find its users is very much like Waddington's "chreod":[20] people effortlessly flow through the door of La Halle aux Cuirs and the groom, hundreds of times a day, recloses the door—when it is not stuck. The result of such an alignment of setups[21] is to decrease the number of occasions in which words are used; most of the actions are silent, familiar, incorporated (in human or in nonhuman bodies)—making the analyst's job so much harder. Even the classic debates about freedom, determination, predetermination, brute force, or efficient will—debates that are the twelfth-century version of seventeenth-century discussions on grace—will be slowly eroded. (Because *you* have reached this point, it means I was right in saying that you were not at all free to stop reading the paper: positioning myself cleverly along a chreod, and adding a few other tricks of my own, I let you *here* . . . or did I? May be you skipped most of it, maybe you did not understand a word of it, o you, undisciplined readers.)

Figurative and nonfigurative characters

Most sociologists are violently upset by this crossing of the sacred barrier that separate human from nonhumans, because they confuse this divide with another one between *figurative* and *nonfigurative* actors. If I say that Hamlet is the figuration of "depression among the aristocratic class," I move from a personal figure to a less personal one—that is, class. If I say that Hamlet stands for doom and gloom, I use less figurative entities, and if I claim that he represents western civilization, I use nonfigurative abstractions. Still, they all are equally actors, that is, entities that *do* things, either in Shakespeare's artful plays or in the commentators' more tedious tomes. The choice of granting actors figurativity or not is left entirely to the authors. It is exactly the same for techniques. Engineers are the authors of these subtle plots and scenarios of dozens of delegated and

interlocking characters so few people know how to appreciate. The label "in-human" applied to techniques simply overlooks translation mechanisms and the many choices that exist for figuring or defiguring, personifying or abstracting, embodying or disembodying actors. When we say that they are "mere automatisms," we project as much as when we say that they are "loving creatures;" the only difference is that the latter is an anthropomorphism and the former a technomorphism or phusimorphism.

For instance, a meat roaster in the Hôtel-Dieu de Beaune, the little groom called "le Petit Bertrand," is the delegated author of the movement [Figure 16.3]. This little man is as famous in Beaune as is the Mannekenpis in Brussels. Of course, he is not the one who does the turning—a hidden heavy stone collects the force applied when the human

Figure 16.3 Le Petit Bertrand is a mechanical meat roaster from the sixteenth century that ornaments the kitchen of the Hôtel-Dieu de Beaune, the hospital where the author was born. The big handle (bottom right) is the one that allows the humans to wind up the mechanism; the small handle (top right) is made to allow a little nonhuman anthropomorphic character to move the whole spit. Although the movement is prescribed back by the mechanism, since the Petit Bertrand smiles and turns his head from left to right, it is believed that it is at the origin of the force. This secondary mechanism—to whom is ascribed the origin of the force—is unrelated to the primary mechanism, which gathers a large-scale human, a handle, a stone, a crank, and a brake to regulate the movement.

demonstrator or the cook turn a heavy handle that winds up a cord around a drum equipped with a ratchet. Obviously "le Petit Bertrand" believes he is the one doing the job because he not only smiles but also moves his head from side to side with obvious pride while turning his little handle. When we were kids, even though we had seen our father wind up the machine and put away the big handle, we liked to believe that the little guy was moving the spit. The irony of the "Petit Bertrand" is that, although the delegation to mechanisms aims at rendering any human turnspit useless, the mechanism is ornamented with a constantly exploited character "working" all day long.

Although this turnspit story offers the opposite case from that of the door closer in terms of figuration (the groom on the door does not look like a groom but really does the same job, whereas "le Petit Bertrand" does look like a groom but is entirely passive), they are similar in terms of delegation (you no longer need to close the door, and the cook no longer has to turn the skewer). The "enunciator" (a general word for the author of a text or for the mechanics who devised the spit) is free to place or not a representation of him or herself in the script (texts or machines). "Le Petit Bertrand" is a delegated version of whoever is responsible for the mechanism. This is exactly the same operation as the one in which I pretended that the author of this article was a hardcore technologist (when I really am a mere sociologist—which is a second localization of the text, as wrong as the first because really I am a mere philosopher . . .). If I say "we the technologists," I propose a picture of the author of the text as surely as if we place "le Petit Bertrand" as the originator of the scene. But it would have been perfectly possible for me and for the mechanics to position *no figurated character* at all as the author *in the scripts of* our scripts (in semiotic parlance there would be no *narrator*). I would just have had to say things like "recent developments in sociology of technology have shown that . . ." instead of "I," and the mechanics would simply have had to take out "le Petit Bertrand," leaving the beautiful cranks, teeth, ratchets, and wheels to work alone. The point is that removing the "Petit Bertrand" does not turn the mechanism into a "mere mechanism" where no actors are acting. It is just a different choice of style.

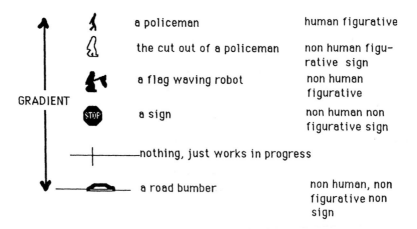

Figure 16.4 Students of technology are wary of anthropomorphism that they see as a projection of human characters to mere mechanisms, but mechanisms are another "morphism," a nonfigurative one that can also be applied to humans. The difference between "action" and "behavior" is not a primary, natural one.

	Figurative	Non-Figurative
Human	"I"	"Science shows that"...
Non-Human	"le Petit Bertrand"	a door-closer

Figure 16.5 The distinction between words and things is impossible to make for technology because it is the gradient allowing engineers to shift down—from words to things—or to shift up—from things to signs—that enables them to enforce their programs of actions.

The distinctions between humans and nonhumans, embodied or disembodied skills, impersonation or "machination," are less interesting that the complete chain along which competences and actions are distributed. For instance, on the freeway the other day I slowed down because a guy in a yellow suit and red helmet was waving a red flag. Well, the guy's moves were so regular and he was located so dangerously and had such a pale though smiling face that, when I passed by, I recognized it to be a machine (it failed the Turing test, a cognitivist would say). Not only was the red flag delegated; not only was the arm waving the flag also delegated; but the body appearance was also added to the machine. We road engineers (see? I can do it again and carve out another author) could move much further in the direction of figuration, although at a cost: we could have given him electronics eyes to wave only when a car approaches, or have regulated the movement so that it is faster when cars do not obey. We could also have added (why not?) a furious stare or a recognizable face like a mask of Mrs. Thatcher or President Mitterand—which would have certainly slowed drivers very efficiently.[22] But we could also have moved the other way, to a *less* figurative delegation: the flag by itself could have done the job. And why a flag? Why not simply a sign "work in progress?" And why a sign at all? Drivers, if they are circumspect, disciplined, and watchful will see for themselves that there is work in progress and will slow down. But there is another radical, nonfigurative solution: the road bumper, or a speed trap that we call in French "un gendarme couché," a laid policeman. It is impossible for us not to slow down, or else we break our suspension. Depending on where we stand along this chain of delegation, we get classic moral human beings endowed with self-respect and able to speak and obey laws, or we get stubborn and efficient machines and mechanisms; halfway through we get the usual power of signs and symbols. It is the complete chain that makes up the missing masses, not either of its extremities. The paradox of technology is that it is thought to be at one of the extremes, whereas it is the ability of the engineer to travel easily along the whole gradient and substitute one type of delegation for another that is inherent to the job.[23]

From nonhumans to superhumans

The most interesting (and saddest) lesson of the note posted on the door at La Villette is that people are not circumspect, disciplined, and watchful, especially not French

drivers doing 180 kilometers an hour on a freeway a rainy Sunday morning when the speed limit is 130 (I inscribe the legal limit in this article because this is about the only place where you could see it printed in black and white; no one else seems to bother, except the mourning families). Well, that is exactly the point of the note: "The groom is on strike, *for God's sake*, keep the door closed." In our societies there are two systems of appeal: nonhuman and superhuman—that is, machines and gods. This note indicates how desperate its anonymous frozen authors were (I have never been able to trace and honor them as they deserved). They first relied on the inner morality and common sense of humans; this failed, the door was always left open. Then they appealed to what we technologists consider the supreme court of appeal, that is, to a nonhuman who regularly and conveniently does the job in place of unfaithful humans; to our shame, we must confess that it also failed after a while, the door was again left open. How poignant their line of thought! They moved up and backward to the oldest and firmest court of appeal there is, there was, and ever will be. If humans and nonhuman have failed, certainly God will not deceive them. I am ashamed to say that when I crossed the hallway this February day, the door *was* open. Do not accuse God, though, because the note did not make a direct appeal; God is not accessible without mediators—the anonymous authors knew their catechisms well—so instead of asking for a direct miracle (God holding the door firmly closed or doing so through the mediation of an angel, as has happened on several occasions, for instance when Saint Peter was delivered from his prison) they appealed to the respect for God in human hearts. This was their mistake. In our secular times, this is no longer enough.

Nothing seems to do the job nowadays of disciplining men and women to close doors in cold weather. It is a similar despair that pushed the road engineer to add a golem to the red flag to force drivers to beware—although the only way to slow French drivers is still a good traffic jam. You seem to need more and more of these figurated delegates, aligned in rows. It is the same with delegates as with drugs; you start with soft ones and end up shooting up. There is an inflation for delegated characters, too. After a while they weaken. In the old days it might have been enough just to have a door for people to know how to close it. But then, the embodied skills somehow disappeared; people had to be reminded of their training. Still, the simple inscription "keep the door closed" might have been sufficient in the good old days. But you know people, they no longer pay attention to the notice and need to be reminded by stronger devices. It is then that you install automatic grooms, since electric shocks are not as acceptable for people as for cows. In the old times, when quality was still good, it might have been enough just to oil it from time to time, but nowadays even automatisms go on strike.

It is not, however, that the movement is always from softer to harder devices, that is, from an autonomous body of knowledge to force through the intermediary situation of worded injunctions, as the La Villette door would suggest. It goes also the other way. It is true that in Paris no driver will respect a sign (for instance, a white or yellow line forbidding parking), nor even a sidewalk (that is a yellow line plus a fifteen centimeter curb); so instead of embodying in the Parisian consciousness an *intrasomatic* skill, authorities prefer to align yet a third delegate (heavy blocks shaped like truncated pyramids and spaced in such a way that cars cannot sneak through); given the results, only a complete two-meter high continuous Great Wall could do the job, and even this might not make the sidewalk safe, given the very poor sealing efficiency of China's Great Wall. So the deskilling thesis appears to be the general case: always go from intrasomatic to

extrasomatic skills; never rely on undisciplined people, but always on safe, delegated non-humans. This is far from being the case, even for Parisian drivers. For instance, red lights are usually respected, at least when they are sophisticated enough to integrate traffic flows through sensors; the delegated policeman standing there day and night is respected even though it has no whistles, gloved hands, and body to *enforce* this respect. Imagined collisions with other cars or with the absent police are enough to keep them drivers in check. The thought experiment "what would happen if the delegated character was not there" is the same as the one I recommended above to size up its function. The same *incorporation* from written injunction to body skills is at work with car manuals. No one, I guess, casts more than a cursory glance at the manual before starting the engine of an unfamiliar car. There is a large *body* of skills that we have so well embodied or incorporated that the mediations of the written instructions are useless.[24] From extrasomatic, they have become intrasomatic. Incorporation in human or "excorporation" in non-human bodies is also one of the choices left to the designers.

The only way to follow engineers at work is not to look for extra- or intrasomatic delegation, but only at their work of *re-inscription*.[25] The beauty of artifacts is that they take on themselves the contradictory wishes or needs of humans and non-humans. My seat belt is supposed to strap me in firmly in case of accident and thus impose on me the respect of the advice DON'T CRASH THROUGH THE WINDSHIELD, which is itself the translation of the unreachable goal DON'T DRIVE TOO FAST into another less difficult (because it is a more selfish) goal: IF YOU DO DRIVE TOO FAST, AT LEAST DON'T KILL YOURSELF. But accidents are rare, and most of the time the seat belt should not tie me firmly. I need to be able to switch gears or tune my radio. The car seat belt is not like the airplane seat belt buckled only for landing and takeoff and carefully checked by the flight attendants. But if auto engineers invent a seat belt that is completely elastic, it will not be of any use in case of accident. This first contradiction (be firm and be lax) is made more difficult by a second contradiction (you should be able to buckle the belt very fast—if not, no one will wear it—but also unbuckle it very fast, to get out of your crashed car). Who is going to take on all of these contradictory specifications? The seat belt mechanism—if there is no other way to go, for instance, by directly limiting the speed of the engine, or having roads so bad that no one can drive fast on them. The safety engineers have to re-inscribe in the seat belt all of these contradictory usages. They pay a price, of course: the mechanism is *folded* again, rendering it more complicated. The airplane seat belt is childish by comparison with an automobile seat belt. If you study a complicated mechanism without seeing that it reinscribes contradictory specifications, you offer a dull description, but every piece of an artifact becomes fascinating when you see that every wheel and crank is the possible answer to an objection. The program of action is in practice the answer to an *antiprogram* against which the mechanism braces itself. Looking at the mechanism alone is like watching half the court during a tennis game; it appears as so many meaningless moves. What analysts of artifacts have to do is similar to what we all did when studying scientific texts: we added the other half of the court.[26] The scientific literature looked dull, but when the agonistic field to which it reacts was brought back in, it became as interesting as an opera. The same with seat belts, road bumpers, and grooms.

Texts and machines

Even if it is now obvious that the missing masses of our society are to be found among the nonhuman mechanisms, it is not clear how they get there and why they are missing from most accounts. This is where the comparison between texts and artifacts that I used so far becomes misleading. There is a crucial distinction between stories and machines, between narrative programs and programs of action, a distinction that explains why machines are so hard to retrieve in our common language. In storytelling, one calls *shifting out* any displacement of a character to another space time, or character. If I tell you "Pasteur entered the Sorbonne amphitheater," I translate the present setting—you and me—and shift it to another space (middle of Paris), another time (mid-nineteenth century), and to other characters (Pasteur and his audience). "I" the enunciator may decide to appear, disappear, or be represented by a narrator who tells the story ("that day, I was sitting on the upper row of the room"); "I" may also decide to position you and any reader inside the story ("had you been there, you would have been convinced by Pasteur's experiments"). There is no limit to the number of shiftings out with which a story may be built. For instance, "I" may well stage a dialogue inside the amphitheater between two characters who are telling a story about what happened at the Académie des Sciences between, say, Pouchet and Milnes-Edwards. In that case, the room becomes the place *from which* narrators shift out to tell a story about the Academy, and they may or not shift *back in* the amphitheater to resume the first story about Pasteur. "I" may also *shift in* the entire series of nested stories to close mine and come back to the situation I started from—you and me. All these displacements are well known in literature departments (Latour 1988b) and make up the craft of talented writers.

No matter how clever and crafted are our novelists, they are no match for engineers. Engineers constantly shift out characters in other spaces and other times, devise positions for human and non-human users, break down competences that they then redistribute to many different actors, and build complicated narrative programs and subprograms that are evaluated and judged by their ability to stave off antiprograms. Unfortunately, there are many more literary critics than technologists, and the subtle beauties of technosocial imbroglios escape the attention of the literate public. One of the reasons for this lack of concern may be the peculiar nature of the shifting-out that generates machines and devices. Instead of sending the listener of a story into another world, the technical shifting-out inscribes the words into *another matter*. Instead of allowing the reader of the story to be *at the same time* away (in the story's frame of reference) and here (in an armchair), the technical shifting-out forces the reader to chose *between* frames of reference. Instead of allowing enunciators and enunciatees a sort of simultaneous presence and communion to other actors, techniques allow both to *ignore* the delegated actors and walk away without even feeling their presence. This is the profound meaning of Butler's sentence I placed at the beginning of this chapter: machines are not talking actors, not because they are unable to do so, but because they might have chosen to remain silent to become agreeable to their fellow machines and fellow humans.

To understand this difference in the two directions of shifting out, let us venture once more onto a French freeway; for the umpteenth time I have screamed at my son Robinson, "Don't sit in the middle of the rear seat; if I brake too hard, you're dead." In an auto shop further along the freeway I come across a device *made for* tired-and-angry-

parents-driving-cars-with-kids-between-two-and-five (too old for a baby seat and not old enough for a seat belt) and-from-small-families (without other persons to hold them safely) with-cars-with-two-separated-front-seats-and-head-rests. It is a small market, but nicely analyzed by the German manufacturers and, given the price, it surely pays off handsomely. This description of myself and the small category into which I am happy to belong is transcribed in the device—a steel bar with strong attachments connecting the head rests—and in the advertisement on the outside of the box; it is also pre-inscribed in about the only place where I could have realized that I needed it, the freeway. (To be honest and give credit where credit is due, I must say that Antoine Hennion has a simi-lar device in his car, which I had seen the day before, so I really looked for it in the store instead of "coming across" it as I wrongly said; which means that a) there is some truth in studies of dissemination by imitation; b) if I describe this episode in as much detail as the door I will never be able to talk about the work done by the historians of technology at La Villette.) Making a short story already too long, I no longer scream at Robinson, and I no longer try to foolishly stop him with my extended right arm: he firmly holds the bar that protects him against my braking. I have delegated the continuous injunc-tion of my voice and extension of my right arm (with diminishing results, as we know from Feschner's law) to a reinforced, padded, steel bar. Of course, I had to make two detours: one to my wallet, the second to my tool box; 200 francs and five minutes later I had fixed the device (after making sense of the instructions encoded with Japanese ideograms).

We may be able to follow these detours that are characteristic of the technical form of delegation by adapting a linguistic tool. Linguists differentiate the *syntagmatic* dimen-sion of a sentence from the *paradigmatic* aspect. The syntagmatic dimension is the pos-sibility of *associating* more and more words in a grammatically correct sentence: for instance, going from "the barber" to "the barber goes fishing" to the "barber goes fish-ing with his friend the plumber" is what linguists call moving through the syntagmatic dimension. The number of elements tied together increases, and nevertheless the sen-tence is still meaningful. The paradigmatic dimension is the possibility, in a sentence of a given length, of *substituting* a word for another while still maintaining a grammatically correct sentence. Thus, going from "the barber goes fishing" to the "plumber goes fish-ing" to "the butcher goes fishing" is a tantamount to moving through the paradigmatic dimension.[27]

Linguists claim that these two dimensions allow them to describe the system of any language. Of course, for the analysis of artifacts we do not have a structure, and the definition of a grammatically correct expression is meaningless. But if, by substitu-tion, we mean the technical shifting to another *matter*, then the two dimensions become a powerful means of describing the dynamic of an artifact. The syntagmatic dimension becomes the AND dimension (how many elements are tied together), and the paradig-matic dimension becomes the OR dimension (how many translations are necessary in order to move through the AND dimension). I could not tie Robinson to the order, but through a detour and a translation I now hold together my will and my son.

The detour, plus the translation of words and extended arm into steel, is a shifting out to be sure, but not of the same type as that of a story. The steel bar has now taken over my competence as far as keeping my son at arm's length is concerned. From speech and words and flesh it has become steel and silence and extrasomatic. Whereas a narra-tive program, no matter how complicated, always remains a text, the program of action

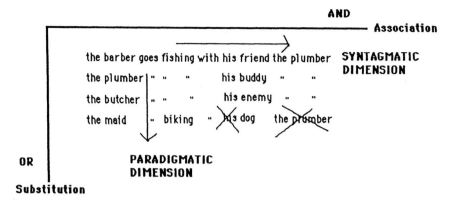

Figure 16.6 Linguists define meaning as the intersection of a horizontal line of association—the syntagm—and a vertical line of substitution—the paradigm. The touchstone in linguistics is the decision made by the competent speaker that a substitution (*or*) or an association (*and*) is grammatically correct in the language under consideration. For instance, the last sentence is incorrect.

substitutes part of its character to other nontextual elements. This divide between text and technology is at the heart of the myth of Frankenstein (Latour 1992). When Victor's monster escapes the laboratory in Shelley's novel, is it a metaphor of fictional characters that seem to take up a life of their own? Or is it the metaphor of technical characters that do take up a life of their own because they cease to be texts and become flesh, legs, arms, and movements? The first version is not very interesting because in spite of the novelist's cliché, a semiotic character in a text always needs the reader to offer it an "independent" life. The second version is not very interesting either, because the "autonomous" thrust of a technical artifact is a worn-out commonplace made up by

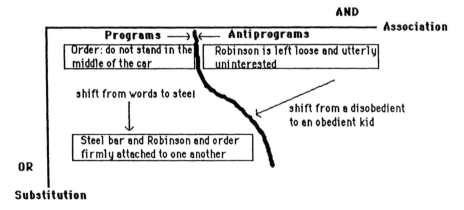

Figure 16.7 The translation diagram allows one to map out the story of a script by following the two dimensions: AND, the association (the latitude so to speak) and OR, the substitution (the longitude). The plot is defined by the line that separates the programs of action chosen for the analysis and the antiprograms. The point of the story is that it is impossible to move in the AND direction without paying the price of the OR dimension, that is, renegotiating the sociotechnical assemblage.

bleeding-heart moralists who have never noticed the throngs of humans necessary to keep a machine alive. No, the beauty of Shelley's myth is that we cannot chose between the two versions: parts of the narrative program are still texts, others are bits of flesh and steel—and this mixture is indeed a rather curious monster.

To bring this chapter to a close and differentiate once again between texts and artifacts, I will take as my final example not a flamboyant Romantic monster but a queer little surrealist one: the Berliner key:[28]

Yes, this is a key and not a surrealist joke (although this is *not* a key, because it is picture and a text about a key). The program of action in Berlin is almost as desperate a plea as in La Villette, but instead of begging "CLOSE THE DOOR BEHIND YOU PLEASE" it is slightly more ambitious and *orders*: "RELOCK THE DOOR BEHIND YOU." Of course the pre-inscription is much narrower: only people endowed with the competence of living in the house can use the door; visitors should ring the doorbell. But even with such a limited group the antiprogram in Berlin is the same as everywhere: undisciplined tenants forget to lock the door behind them. How can you force them to lock it? A normal key[29] endows you with the *competence* of opening the door— it proves you are *persona grata*—but nothing in it entails the *performance* of actually using the key again once you have opened the door and closed it behind you. Should you put up a sign? We know that signs are never forceful enough to catch people's attention for long. Assign a police officer to every doorstep? You could do this in East Berlin, but not

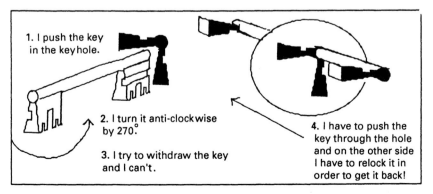

Figure 16.8 The key, its usage, and its holder.

in reunited Berlin. Instead, Berliner blacksmiths decided to re-inscribe the program of action in the very shape of the key and its lock—hence this surrealist form. They in effect sunk the contradiction and the lack of discipline of the Berliners in a more "realist" key. The program, once translated, appears innocuous enough: "UNLOCK THE DOOR." But here lies the first novelty: it is impossible to remove the key in the normal way; such a move is "proscribed" by the lock. Otherwise you have to break the door, which is hard as well as impolite; the only way to retrieve the key is to push the whole key through the door to the other side—hence its symmetry—but then it is still impossible to retrieve the key. You might give up and leave the key in the lock, but then you lose the competence of the tenant and will never again be able to get in or out. So what do you do? You rotate the key one more turn and, yes, you have in effect relocked the door and then, only then, are you able to retrieve the precious "sesame." This is a clever translation of a possible program relying on morality into a program relying on dire necessity: you might not want to relock the key, but you cannot do otherwise. The distance between morality and force is not as wide as moralists expect; or more exactly, clever engineers have made it smaller. There is a price to pay of course for such a shift away from morality and signs; you have to replace most of the locks in Berlin. The pre-inscription does not stop here however, because you now have the problem of keys that no decent key holder can stack into place because they have no hole. On the contrary, the new sharp key is going to poke holes in your pockets. So the blacksmiths go back to the drawing board and invent specific key holders adapted to the Berliner key!

The key in itself is not enough to fulfill the program of action. Its effects are very severely circumscribed, because it is only when you have a Berliner endowed with the double competence of being a tenant and knowing how to use the surrealist key that the relocking of the door may be enforced. Even such an outcome is not full proof, because a really bad guy may relock the door without closing it! In that case the worst possible antiprogram is in place because the lock stops the door from closing. Every passerby may see the open door and has simply to push it to enter the house. The setup that prescribed a very narrow segment of the human population of Berlin is now so lax that it does not even discriminate against nonhumans. Even a dog knowing nothing about keys, locks, and blacksmiths is now allowed to enter! No artifact is idiot-proof because any artifact is only a portion of a program of action and of the fight necessary to win against many antiprograms.

Students of technology are never faced with people on the one hand and things on the other, they are faced with programs of action, sections of which are endowed to *parts* of humans, while other sections are entrusted to parts of nonhumans. In practice they are faced with the front line of [. . .]. This is the only thing they can *observe*: how a negotiation to associate dissident elements requires more and more elements to be tied together and more and more shifts to other matters. We are now witnessing in technology studies the same displacement that has happened in science studies during the last ten years. It is not that society and social relations invade the certainty of science or the efficiency of machines. It is that society itself is to be rethought from top to bottom once we add to it the facts and the artifacts that make up large sections of our social ties. What appears in the place of the two ghosts—society and technology—is not simply a hybrid object, a little bit of efficiency and a little bit of sociologizing, but a *sui generis* object: the collective thing, the trajectory of the front line between programs and antiprograms. It is too full of humans to look like the technology of old, but

it is too full of nonhumans to look like the social theory of the past. The missing masses are in our traditional social theories, not in the supposedly cold, efficient, and inhuman technologies.

Notes

This paper owes to many discussions held at the Centre de Sociologie de l'Innovation, especially with John Law, the honorary member from Keele, and Madeleine Akrich. It is particularly indebted to Françoise Bastide, who was still working on these questions of semiotics of technology a few months before her death.

I had no room to incorporate a lengthy dispute with Harry Collins about this article (but see Collins and Yearley 1992, and Callon and Latour, 1992).

Trevor Pinch and John Law kindly corrected the English.

1 The program of action is the set of written instructions that can be substituted by the analyst to any artifact. Now that computers exist, we are able to conceive of a text (a programming language) that is at once words and actions. How to do things with words and then turn words into things is now clear to any programmer. A program of action is thus close to what Pinch et al. 1987 call "a social technology," except that all techniques may be made to be a program of action.

2 In spite of the crucial work of Diderot and Marx, careful description of techniques is absent from most classic sociologists—apart from the "impact of technology on society" type of study—and is simply black-boxed in too many economists' accounts. Modern writers like Leroi-Gourhan (1964) are not often used. Contemporary work is only beginning to offer us a more balanced account. For a reader, see MacKenzie and Wacjman 1985; for a good overview of recent developments, see Bijker et al. (1987). A remarkable essay on how to describe artifacts—an iron bridge compared to a Picasso portrait—is offered by Baxandall (1985). For a recent essay by a pioneer of the field, see Noble 1984. For a remarkable and hilarious description of a list of artifacts, see Baker 1988.

3 Following Madeleine Akrich's lead (1992), we will speak only in terms of *scripts* or scenes or scenarios, or setups as John Law (1992) says, played by human or nonhuman actants, which may be either figurative or nonfigurative.

4 After Akrich, I will call the retrieval of the script from the situation *de-scription*. They define actants, endow them with competences, make them do things, and evaluate the sanction of these actions like the *narrative program* of semioticians.

5 Although most of the scripts are in practice silent, either because they are intra- or extra-somatic, the written descriptions are not an artifact of the analyst (technologist, sociologist, or semiotician), because there exist many states of affairs in which they are *explicitly* uttered. The gradient going from intrasomatic to extrasomatic skills through discourse is never fully stabilized and allows many entries revealing the process of translation: user manuals, instruction, demonstration or drilling situations, practical thought experiments ("what would happen if, instead of the red light, a police officer were there"). To this should be added the innovator's workshop, where most of the objects to be devised are still at the stage of *projects* committed to paper ("if we had a device doing this and that, we could then do this and that"); market analysis in which consumers are confronted with the new device; and, naturally, the exotic situation studied by anthropologists in which people faced with a foreign device talk to themselves while trying out various combinations ("what will happen if I attach this lead here to the mains?"). The analyst has to empirically

capture these situations to write down the scripts. When none is available, the analyst may still make a thought experiment by comparing presence/absence tables and collating the list of all the actions taken by actors ("if I take this one away, this and that other action will be modified"). There are dangers in such a counterfactual method, as Collins has pointed out (Collins and Yearley 1992), but it is used here only to outline the semiotics of artifacts. In practice, as Akrich (1992) shows, the scripts are explicit and accountable.

6 We call the translation of any script from one repertoire to a *more durable* one transcription, inscription, or encoding. This definition does *not* imply that the direction always goes from soft bodies to hard machines, but simply that it goes from a provisional, less reliable one to a longer-lasting, more faithful one. For instance, the embodiment in cultural tradition of the user manual of a car is a transcription, but so is the replacement of a police officer by a traffic light; one goes from machines to bodies, whereas the other goes the opposite way. Specialists of robotics have abandoned the pipe dream of total automation; they learned the hard way that many skills are better delegated to humans than to nonhumans, whereas others may be taken away from incompetent humans.

7 See Authier 1989 on Plutarch's Archimedes.

8 We call prescription whatever a scene presupposes from its *transcribed* actors and authors (this is very much like "role expectation" in sociology, except that it may be inscribed or encoded in the machine). For instance, a Renaissance Italian painting is designed to be viewed from a specific angle of view prescribed by the vanishing lines, exactly like a traffic light expects that its users will watch it from the street and not sideways (French engineers often hide the lights directed toward the side street so as to hide the state of the signals, thus preventing the strong temptation to rush through the crossing at the first hint that the lights are about to be green; this prescription of who is allowed to watch the signal is very frustrating). "User input" in programming language, is another very telling example of this inscription in the automatism of a living character whose behavior is both free and predetermined.

9 In this type of analysis there is no effort to attribute forever certain competences to humans and others to nonhumans. The attention is focused on following how *any* set of competences is *distributed* through various entities.

10 Interestingly enough, the oldest Greek engineering myth, that of Daedalus, is about cleverness, deviousness. "Dedalion" means something that goes away from the main road, like the French word "bricole." In the mythology, science is represented by a straight line and technology by a detour, science by *epistémè* and technology by the *métis*. See the excellent essay of Frontisi-Ducroux (1975) on the semantic field of the name Daedalus.

11 We use *actant* to mean anything that acts and *actor* to mean what is made the source of an action. This is a semiotician's definition that is not limited to humans and has no relation whatsoever to the sociological definition of an actor by opposition to mere behavior. For a semiotician, the act of attributing "inert force" to a hinge or the act of attributing it "personality" are comparable in principle and should be studied symmetrically.

12 I have been able to document a case of a five-day student strike at a French school of management (ESSEC) to urge that a door closer be installed in the student cafeteria to keep the freezing cold outside.

13 It is of course another choice to decide who makes such a choice: a man? a spirit? no one? an automated machine? The *scripter* or designer of all these scripts is itself (himself, herself, themselves) negotiated.

14 This is what Norman (1988) calls the Gulf of Execution. His book is an excellent introduction to the study of the tense relations between inscribed and real users. However, Norman speaks only about dysfunction in the interfaces with the final user and never considers the shaping of the artifact by the engineers themselves.

15 To stay within the same etymological root, we call the way actants (human or nonhuman)

tend to extirpate themselves from the prescribed behavior *de-inscription* and the way they accept or happily acquiesce to their lot *subscription*.

16 We call *pre-inscription* all the work that has to be done upstream of the scene and all the things assimilated by an actor (human or nonhuman) before coming to the scene as a user or an author. For instance, how to drive a car is basically pre-inscribed in any (Western) youth years before it comes to passing the driving test; hydraulic pistons were also pre-inscribed for slowly giving back the energy gathered, years before innovators brought them to bear on automated grooms. Engineers can bet on this predetermination when they draw up their prescriptions. This is what is called "articulation work" (Fujimura 1987).

17 We call *circumscription* the organization in the setting of its own limits and of its own demarcation (doors, plugs, hall, introductions).

18 See Suchman for a description of such a setting (1987).

19 We call *ascription* the attribution of an effect to one aspect of the setup. This new decision about attributing efficiency—for instance, to a person's genius, to workers' efforts, to users, to the economy, to technology—is as important as the others, but it is derivative. It is like the opposition between the primary mechanism—who is allied to whom—and the secondary mechanism—whose leadership is recognized—in history of science (Latour 1987).

20 Waddington's term for "necessary paths"—from the Greek *chreos* and *odos*.

21 We call *conscription* this mobilization of well-drilled and well-aligned resources to render the behavior of a human or a nonhuman predictable.

22 Trevor Pinch sent me an article from the *Guardian* (2 September 1988) titled "Cardboard coppers cut speeding by third." A Danish police spokesman said an advantage of the effigies, apart from cutting manpower costs, was that they could stand for long periods undistracted by other calls of duty. Additional assets are understood to be that they cannot claim overtime, be accused of brutality, or get suspended by their chief constable without explanation. "For God's sake, don't tell the Home Office," Mr. Tony Judge, editor of the Police Review Magazine in Britain, said after hearing news of the [Danish] study last night. "We have enough trouble getting sufficient men already." The cut-outs have been placed beside notorious speeding blackspots near the Danish capital. Police said they had yielded "excellent" results. Now they are to be erected at crossings where drivers often jump lights. From time to time, a spokesman added, they would be replaced by real officers.

23 Why did the (automatic) groom go on strike? The answers to this are the same as for the question posed earlier of why no one showed up at La Halle aux Cuirs: it is not because a piece of behavior is prescribed by an inscription that the predetermined characters will show up on time and do the job expected of them. This is true of humans, but it is truer of nonhumans. In this case the hydraulic piston did its job, but not the spring that collaborated with it. Any of the words employed above may be used to describe a setup at any level and not only at the simple one I chose for the sake of clarity. It does not have to be limited to the case where a human deals with a series of nonhuman delegates; it can also be true of relations among nonhumans (yes, you sociologists, there are also relations among things, and *social* relations at that).

24 For the study of user's manual, see Norman 1988 and Boullier, Akrich, and Le Gaziou 1990.

25 Re-inscription is the same thing as inscription or translation or delegation, but seen in its movement. The aim of sociotechnical study is thus to follow the *dynamic* of re-inscription transforming a silent artifact into a *polemical* process. A lovely example of efforts at re-inscription of what was badly pre-inscribed outside of the setting is provided by Orson Welles in *Citizen Kane*, where the hero not only bought a theater for his singing wife to be applauded in, but also bought the journals that were to do the reviews, bought off the art critics themselves, and paid the audience to show up—all to no avail, because the wife

eventually quit. Humans and nonhumans are very undisciplined no matter what you do and how many predeterminations you are able to control inside the setting.

For a complete study of this dynamic on a large technical system, see Law (1992 and in preparation) and Latour (forthcoming).

26 The study of scientific text is now a whole industry: see Callon, Law, and Rip 1986 for a technical presentation and Latour 1987 for an introduction.

27 The linguistic meaning of a paradigm is unrelated to the Kuhnian usage of the word. For a complete description of these diagrams, see Latour, Mauguin, and Teil (1992).

28 I am grateful to Berward Joerges for letting me interview his key and his key holder. It alone was worth the trip to Berlin.

29 Keys, locks, and codes are of course a source of marvelous fieldwork for analysts. You may for instance replace the key (excorporation) by a memorized code (incorporation). You may lose both, however, since memory is not necessarily more durable than steel.

References

Madeleine Akrich. (1992) 'The Description of Technical Objects'. *Shaping Technology/Building Society: Studies in Sociotechnical Change*. Wiebe E. Bijker and Bruno Latour (ed.) Cambridge, MA: MIT Press.

John Law and Michael Callon. (1992) 'The Life and Death of an Aircraft. A Network Analysis of Technical Change'. *Shaping Technology/Building Society: Studies in Sociotechnical Change*. Wiebe E. Bijker and Bruno Latour (ed.) Cambridge, MA: MIT Press.

Pinch et al. (1992) 'Technology, Testing, Text. Clinical Budgeting in the UK National Health Service'. *Shaping Technology/Building Society: Studies in Sociotechnical Change*. Wiebe E. Bijker and Bruno Latour (ed.) Cambridge, MA: MIT Press.

PART IV

Object Experience

Walter Benjamin

UNPACKING MY LIBRARY
A talk about book collecting

I AM UNPACKING MY LIBRARY. Yes, I am. The books are not yet on the shelves, not yet touched by the mild boredom of order. I cannot march up and down their ranks to pass them in review before a friendly audience. You need not fear any of that. Instead, I must ask you to join me in the disorder of crates that have been wrenched open, the air saturated with the dust of wood, the floor covered with torn paper, to join me among piles of volumes that are seeing daylight again after two years of darkness, so that you may be ready to share with me a bit of the mood – it is certainly not an elegiac mood but, rather, one of anticipation – which these books arouse in a genuine collector. For such a man is speaking to you, and on closer scrutiny he proves to be speaking only about himself. Would it not be presumptuous of me if, in order to appear convincingly objective and down-to-earth, I enumerated for you the main sections or prize pieces of a library, if I presented you with their history or even their usefulness to a writer? I, for one, have in mind something less obscure, something more palpable than that; what I am really concerned with is giving you some insight into the relationship of a book collector to his possessions, into collecting rather than a collection. If I do this by elaborating on the various ways of acquiring books, this is something entirely arbitrary. This or any other procedure is merely a dam against the spring tide of memories which surges toward any collector as he contemplates his possessions. Every passion borders on the chaotic, but the collector's passion borders on the chaos of memories. More than that: the chance, the fate, that suffuse the past before my eyes are conspicuously present in the accustomed confusion of these books. For what else is this collection but a disorder to which habit has accommodated itself to such an extent that it can appear as order? You have all heard of people whom the loss of their books has turned into invalids, or of those who in order to acquire them became criminals. These are the very areas in which any order is a balancing act of extreme precariousness. 'The only exact knowledge there is,' said Anatole France, 'is the knowledge of the date of publication and the format of

books.' And indeed, if there is a counterpart to the confusion of a library, it is the order of its catalogue.

Thus there is in the life of a collector a dialectical tension between the poles of disorder and order. Naturally, his existence is tied to many other things as well: to a very mysterious relationship to ownership, something about which we shall have more to say later; also, to a relationship to objects which does not emphasize their functional, utilitarian value – that is, their usefulness – but studies and loves them as the scene, the stage, of their fate. The most profound enchantment for the collector is the locking of individual items within a magic circle in which they are fixed as the final thrill, the thrill of acquisition, passes over them. Everything remembered and thought, everything conscious, becomes the pedestal, the frame, the base, the lock of his property. The period, the region, the craftsmanship, the former ownership – for a true collector the whole background of an item adds up to a magic encyclopedia whose quintessence is the fate of his object. In this circumscribed area, then, it may be surmised how the great physiognomists – and collectors are the physiognomists of the world of objects – turn into interpreters of fate. One has only to watch a collector handle the objects in his glass case. As he holds them in his hands, he seems to be seeing through them into their distant past as though inspired. So much for the magical side of the collector – his old-age image, I might call it.

Habent sua fata libelli: these words may have been intended as a general statement about books. So books like *The Divine Comedy*, Spinoza's *Ethics*, and *The Origin of Species* have their fates. A collector, however, interprets this Latin saying differently. For him, not only books but also copies of books have their fates. And in this sense, the most important fate of a copy is its encounter with him, with his own collection. I am not exaggerating when I say that to a true collector the acquisition of an old book is its rebirth. This is the childlike element which in a collector mingles with the element of old age. For children can accomplish the renewal of existence in a hundred unfailing ways. Among children, collecting is only one process of renewal; other processes are the painting of objects, the cutting out of figures, the application of decals – the whole range of childlike modes of acquisition, from touching things to giving them names. To renew the old world – that is the collector's deepest desire when he is driven to acquire new things, and that is why a collector of older books is closer to the wellsprings of collecting than the acquirer of luxury editions. How do books cross the threshold of a collection and become the property of a collector? The history of their acquisition is the subject of the following remarks.

Of all the ways of acquiring books, writing them oneself is regarded as the most praiseworthy method. At this point many of you will remember with pleasure the large library which Jean Paul's poor little schoolmaster Wutz gradually acquired by writing, himself, all the works whose titles interested him in bookfair catalogues; after all, he could not afford to buy them. Writers are really people who write books not because they are poor, but because they are dissatisfied with the books which they could buy but do not like. You, ladies and gentlemen, may regard this as a whimsical definition of a writer. But everything said from the angle of a real collector is whimsical. Of the customary modes of acquisition, the one most appropriate to a collector would be the borrowing of a book with its attendant non-returning. The book borrower of real stature whom we envisage here proves himself to be an inveterate collector of books not so much by the fervour with which he guards his borrowed treasures and by the deaf ear

which he turns to all reminders from the everyday world of legality as by his failure to read these books. If my experience may serve as evidence, a man is more likely to return a borrowed book upon occasion than to read it. And the non-reading of books, you will object, should be characteristic of collectors? This is news to me, you may say. It is not news at all. Experts will bear me out when I say that it is the oldest thing in the world. Suffice it to quote the answer which Anatole France gave to a philistine who admired his library and then finished with the standard question, 'And you have read all these books, Monsieur France?' 'Not one-tenth of them. I don't suppose you use your Sèvres china every day?'

Incidentally, I have put the right to such an attitude to the test. For years, for at least the first third of its existence, my library consisted of no more than two or three shelves which increased only by inches each year. This was its militant age, when no book was allowed to enter it without the certification that I had not read it. Thus I might never have acquired a library extensive enough to be worthy of the name if there had not been an inflation. Suddenly the emphasis shifted; books acquired real value, or, at any rate, were difficult to obtain. At least this is how it seemed in Switzerland. At the eleventh hour I sent my first major book orders from there and in this way was able to secure such irreplaceable items as *Der blaue Reiter* and Bachofen's *Sage von Tanaquil*, which could still be obtained from the publishers at that time.

Well – so you may say – after exploring all these byways we should finally reach the wide highway of book acquisition, namely, the purchasing of books. This is indeed a wide highway, but not a comfortable one. The purchasing done by a book collector has very little in common with that done in a bookshop by a student getting a textbook, a man of the world buying a present for his lady, or a businessman intending to while away his next train journey. I have made my most memorable purchases on trips, as a transient. Property and possession belong to the tactical sphere. Collectors are people with a tactical instinct; their experience teaches them that when they capture a strange city, the smallest antique shop can be a fortress, the most remote stationery store a key position. How many cities have revealed themselves to me in the marches I undertook in the pursuit of books!

By no means all of the most important purchases are made on the premises of a dealer. Catalogues play a far greater part. And even though the purchaser may be thoroughly acquainted with the book ordered from a catalogue, the individual copy always remains a surprise and the order always a bit of a gamble. There are grievous disappointments, but also happy finds. I remember, for instance, that I once ordered a book with coloured illustrations for my old collection of children's books only because it contained fairy tales by Albert Ludwig Grimm and was published at Grimma, Thuringia. Grimma was also the place of publication of a book of fables edited by the same Albert Ludwig Grimm. With its sixteen illustrations my copy of this book of fables was the only extant example of the early work of the great German book illustrator Lyser, who lived in Hamburg around the middle of the last century. Well, my reaction to the consonance of the names had been correct. In this case too I discovered the work of Lyser, namely *Linas Märchenbuch*, a work which has remained unknown to his bibliographers and which deserves a more detailed reference than this first one I am introducing here.

The acquisition of books is by no means a matter of money or expert knowledge alone. Not even both factors together suffice for the establishment of a real library, which is always somewhat impenetrable and at the same time uniquely itself. Anyone

who buys from catalogues must have flair in addition to the qualities I have mentioned. Dates, place names, formats, previous owners, bindings, and the like: all these details must tell him something – not as dry, isolated facts, but as a harmonious whole; from the quality and intensity of this harmony he must be able to recognize whether a book is for him or not. An auction requires yet another set of qualities in a collector. To the reader of a catalogue the book itself must speak, or possibly its previous ownership if the provenance of the copy has been established. A man who wishes to participate at an auction must pay equal attention to the book and to his competitors, in addition to keeping a cool enough head to avoid being carried away in the competition. It is a frequent occurrence that someone gets stuck with a high purchase price because he kept raising his bid – more to assert himself than to acquire the book. On the other hand, one of the finest memories of a collector is the moment when he rescued a book to which he might never have given a thought, much less a wishful look, because he found it lonely and abandoned on the market place and bought it to give it its freedom – the way the prince bought a beautiful slave girl in *The Arabian Nights*. To a book collector, you see, the true freedom of all books is somewhere on his shelves.

To this day, Balzac's *Peau de chagrin* stands out from long rows of French volumes in my library as a memento of my most exciting experience at an auction. This happened in 1915 at the Rümann auction put up by Emil Hirsch, one of the greatest of book experts and most distinguished of dealers. The edition in question appeared in 1838 in Paris, Place de la Bourse. As I pick up my copy, I see not only its number in the Rümann collection, but even the label of the shop in which the first owner bought the book over ninety years ago for one-eightieth of today's price. 'Papeterie I. Flanneau,' it says. A fine age in which it was still possible to buy such a de luxe edition at a stationery dealer's! The steel engravings of this book were designed by the foremost French graphic artist and executed by the foremost engravers. But I was going to tell you how I acquired this book. I had gone to Emil Hirsch's for an advance inspection and had handled forty or fifty volumes; that particular volume had inspired in me the ardent desire to hold on to it forever. The day of the auction came. As chance would have it, in the sequence of the auction this copy of *La Peau de chagrin* was preceded by a complete set of its illustrations printed separately on India paper. The bidders sat at a long table; diagonally across from me sat the man who was the focus of all eyes at the first bid, the famous Munich collector Baron von Simolin. He was greatly interested in this set, but he had rival bidders; in short, there was a spirited contest which resulted in the highest bid of the entire auction – far in excess of three thousand marks. No one seemed to have expected such a high figure, and all those present were quite excited. Emil Hirsch remained unconcerned, and whether he wanted to save time or was guided by some other consideration, he proceeded to the next item, with no one really paying attention. He called out the price, and with my heart pounding and with the full realization that I was unable to compete with any of those big collectors I bid a somewhat higher amount. Without arousing the bidders' attention, the auctioneer went through the usual routine – 'Do I hear more?' and three bangs of his gavel, with an eternity seeming to separate each from the next – and proceeded to add the auctioneer's charge. For a student like me the sum was still considerable. The following morning at the pawnshop is no longer part of this story, and I prefer to speak about another incident which I should like to call the negative of an auction. It happened last year at a Berlin auction. The collection of books that was offered was a miscellany in quality and subject matter, and only a number of rare works on

occultism and natural philosophy were worthy of note. I bid for a number of them, but each time I noticed a gentleman in the front row who seemed only to have waited for my bid to counter with his own, evidently prepared to top any offer. After this had been repeated several times, I gave up all hope of acquiring the book which I was most interested in that day. It was the rare *Fragmente aus dem Nachlass eines jungen Physikers* [Posthumous Fragments of a Young Physicist] which Johann Wilhelm Ritter published in two volumes at Heidelberg in 1810. This work has never been reprinted, but I have always considered its preface, in which the author-editor tells the story of his life in the guise of an obituary for his supposedly deceased unnamed friend – with whom he is really identical – as the most important sample of personal prose of German Romanticism. Just as the item came up I had a brain wave. It was simple enough: since my bid was bound to give the item to the other man, I must not bid at all. I controlled myself and remained silent. What I had hoped for came about: no interest, no bid, and the book was put aside. I deemed it wise to let several days go by, and when I appeared on the premises after a week, I found the book in the secondhand department and benefited by the lack of interest when I acquired it.

Once you have approached the mountains of cases in order to mine the books from them and bring them to the light of day – or, rather, of night – what memories crowd in upon you! Nothing highlights the fascination of unpacking more clearly than the difficulty of stopping this activity. I had started at noon, and it was midnight before I had worked my way to the last cases. Now I put my hands on two volumes bound in faded boards which, strictly speaking, do not belong in a book case at all: two albums with stick-in pictures which my mother pasted in as a child and which I inherited. They are the seeds of a collection of children's books which is growing steadily even today, though no longer in my garden. There is no living library that does not harbour a number of booklike creations from fringe areas. They need not be stick-in albums or family albums, autograph books or portfolios containing pamphlets or religious tracts; some people become attached to leaflets and prospectuses, others to handwriting facsimiles or typewritten copies of unobtainable books; and certainly periodicals can form the prismatic fringes of a library. But to get back to those albums: Actually, inheritance is the soundest way of acquiring a collection. For a collector's attitude toward his possessions stems from an owner's feeling of responsibility toward his property. Thus it is, in the highest sense, the attitude of an heir, and the most distinguished trait of a collection will always be its transmissibility. You should know that in saying this I fully realize that my discussion of the mental climate of collecting will confirm many of you in your conviction that this passion is behind the times, in your distrust of the collector type. Nothing is further from my mind than to shake either your conviction or your distrust. But one thing should be noted: the phenomenon of collecting loses its meaning as it loses its personal owner. Even though public collections may be less objectionable socially and more useful academically than private collections, the objects get their due only in the latter. I do know that time is running out for the type that I am discussing here and have been representing before you a bit *ex officio*. But, as Hegel put it, only when it is dark does the owl of Minerva begin its flight. Only in extinction is the collector comprehended.

Now I am on the last half-emptied case and it is way past midnight. Other thoughts fill me than the ones I am talking about – not thoughts but images, memories. Memories of the cities in which I found so many things: Riga, Naples, Munich, Danzig,

Moscow, Florence, Basel, Paris; memories of Rosenthal's sumptuous rooms in Munich, of the Danzig Stockturm where the late Hans Rhaue was domiciled, of Süssengut's musty book cellar in North Berlin; memories of the rooms where these books had been housed, of my student's den in Munich, of my room in Bern, of the solitude of Iseltwald on the Lake of Brienz, and finally of my boyhood room, the former location of only four or five of the several thousand volumes that are piled up around me. O bliss of the collector, bliss of the man of leisure! Of no one has less been expected, and no one has had a greater sense of well-being than the man who has been able to carry on his disreputable existence in the mask of Spitzweg's 'Bookworm.' For inside him there are spirits, or at least little genii, which have seen to it that for a collector – and I mean a real collector, a collector as he ought to be – ownership is the most intimate relationship that one can have to objects. Not that they come alive in him; it is he who lives in them. So I have erected one of his dwellings, with books as the building stones, before you, and now he is going to disappear inside, as is only fitting.

Wiebe E. Bijker

KING OF THE ROAD
The social construction of the safety bicycle

2.3* Social groups and the development of the ordinary

The high-wheeled bicycle did not have one unambiguous meaning, but was evaluated in varied ways by different social groups. To describe its development, I will concentrate on the various social groups involved—in its production and use, as well as in criticizing and fighting it. These groups will be described in some detail, and at the same time I will further trace the development of the high-wheeled bicycle. Let us first return to the story of Rowley Turner and the Coventry Sewing Machine Cy. Ltd., and examine the social group of producers.

The bicycle producers

The Coventry Sewing Machine Cy. Ltd. changed its name to Coventry Machinists Co., Ltd. in 1869 when it embarked, as Rowley Turner had suggested, on the manufacturing of velocipedes. Such a change of production was quite common in those days, in part because the Franco-German War had a destabilizing effect on British industry. As export opportunities grew scarce, several machine manufacturers started looking for other trades. Weapon makers, sewing machine manufacturers, and agricultural machine producers were only too happy to shift their production to bicycles. It is significant that at this stage of velocipede development the machine industry enters the story. Until the late 1860s, the basic skills needed to make a velocipede were those of the carriage builder: working with cast iron, making long bow springs for saddles, bending steel rims, and constructing wooden wheels—this was all well within his trade. But tubular backbones, wire spokes, more sophisticated bearings, special stampings and castings—that was quite another business (Grew, 1921: 27).

Figure 18.1 Not only sewing machine manufacturers but even weapons makers turned to cycle production (part of advertisement reprinted in Grew (1921))

To understand this development better, I will briefly go back in history to sketch the founding of the Coventry Machinists Co. and the role of James Starley, often called in England the "Father of the Cycle Industry." Starley ran away from his Sussex home because he hated farming and wanted to be a mechanical inventor. He was subsequently employed as gardener in a large household. During this period he made several successful contraptions—for example, for use in the garden. One of his more colorful inventions, a "self-rocking basinette," was dropped when the prototype made a young child violently ill by rocking a bit too effectively (Williamson, 1966: 27). Starley repaired watches and clocks in the evening and thus educated himself about the basics of fine machine construction. Then one day he was asked to repair the sewing machine of the lady of the house. At that time a sewing machine was an expensive novelty that not many could afford, and it represented the most complicated mechanism that Starley had ever handled. He took the risk of stripping down the entire machine. He spotted the trouble (a tiny screw had worked loose), reconstructed the machine, and made it run better than ever. This impressed Starley's employer so that he persuaded his friend Josiah Turner, manager of the company that was the actual maker of this particular machine, to take on Starley as an employee of the London factory of Nelson, Wilson & Co. (Williamson, 1966: 33).

Turner quickly identified Starley as "a sort of mechanical genius." He helped him to take out a patent on a treadle arrangement that kept the sewing machine running while its operator's hands were free to guide the cloth. By this time Turner had such faith in Starley's technical capabilities that he proposed that they leave the London firm and start a new company together to exploit this invention. They did so, moved to Coventry, and founded the Coventry Sewing Machine Cy. in 1861 (Williamson, 1966: 36–37). Turner recruited other technicians from the London region as well: Thomas Bayliss, William Hillman, and George Singer, to name a few (Grew, 1921: 2; Williamson, 1966: 41). In Coventry they found a receptive atmosphere. To highlight the particular combination of unemployment in technically skilled and unskilled labor, I shall briefly review the economic circumstances of this county.

The Warwickshire city of Coventry was economically and socially in bad shape.

The weaving industry had been weakened by a decade of social conflicts between workers and employers. The long conflict, instigated partly by the tariff policies of the national government and partly by class struggle, almost ruined the ribbon weaving industry. Of the original eighty weaving masters existing before 1855, only twenty remained by 1865; there had been at least fifty bankruptcies. Unemployment was very high in Coventry. Poverty spread, and so many families were threatened by starvation that a national appeal was launched in the early 1860s (Williamson, 1966: 38–40). From the census reports of 1861 and 1871, a remarkable decrease of the population of Coventry can be traced, especially when these figures are seen in the perspective of the population growth in other towns in the Midlands.[1] The watchmaking industry, which had been expanding between 1830 and 1860, had declined as well, although for other reasons. Coventry watchmakers did not have factories, and the individual masters in their isolated workshops were not able to compete with the cheaper machine-produced products imported from America and Switzerland (Williamson, 1966: 40). Despite the displacement of people from Coventry, the new sewing machine company still found many skilled workers. For Coventry this meant the beginning of its development into an engineering city. The watch trade provided the nucleus of skilled labor, and the ribbon trade the pool of unskilled labor, with which Coventry would graduate from the sewing machine and the bicycle to the motor bicycle and the motorcar, climbing back toward prosperity as the nineteenth century drew to a close (Prest, 1960: x).

The Coventry Sewing Machine Cy. prospered to such an extent that larger premises were necessary after seven years. The company had continuously improved its sewing machines by adding innovations and turning out new models with names such as "The European," "Godiva," "Express," and "Swiftsure." When Rowley Turner convinced his uncle Josiah to start making velocipedes, the new product was approached in the same innovative spirit (Williamson, 1966: 41). Starley's immediate reaction when confronted with the new machine was to lift the velocipede and criticize it for being weighty and cumbersome (Williamson, 1966: 48). Starley learned to ride the machine, however, and he quickly thought of a series of small but important modifications. For example, he fitted a small step to the hub of the rear wheel to enable the rider to simply step on. The usual way of mounting a velocipede was to take a short run and leap into the saddle. Some of these modifications probably have been incorporated in the first velocipedes produced by the Coventry Machinists Co., but there are no records of these early products.

Starley and Hillman then concentrated on designing a new, light velocipede. As sewing machine constructors rather than carriage builders, they employed quite different techniques than had Michaux. For one thing, there were no wooden parts on their machine. They followed Reynolds and Mays by using wire spokes under tension to make the wheels without heavy struts (made of wood or, later, hollow steel tubes) loaded by pressure forces. But added to this was a mechanism to tighten these radially positioned spokes and thus stiffen the wheels, which in Reynolds's and Mays's case still lacked rigidity. This was done by fixing two levers to the middle of the hub; the levers were connected by wires to opposite positions on the rim. By tightening these wires, one could make the rim turn relative to the hub until the spokes had the required tension (Caunter, 1958: 6). Finally, they followed the trend of enlarging the front wheel. Thus Starley and Hillman patented the Ariel on 11 August 1870. They had such a confidence in their new product that they left the Coventry Machinists Co. and started a new business (Williamson, 1966: 49). Almost at the same time, W. H. J. Grout took

out a patent on his "Grout Tension Bicycle" (Grout, 1870). This patent added some further basic elements to the scheme of a high-wheeled bicycle, notably the hollow front fork that further reduced the frame's weight, massive rubber tires, and a new means of mounting the spokes. Grout's radial spokes were threaded into nipples loosely riveted into the rim, which could be used to adjust the tension of the spokes and thus to true the wheel by screwing them on and off the spokes. These two patents can be said to have laid the basic pattern of the high-wheeled bicycle in the early 1870s.

Of course Turner, Starley, and the other Coventry Machinists Co. men were not alone in identifying the velocipede as an attractive new line of manufacture. The city of Coventry soon saw a variety of former watchmakers, ships' engineers, cutlery shop workers, and gun makers starting small workshops in which to build velocipedes.[2] In other towns, such as Leicester and Liverpool, velocipede makers were commencing business as well. Coventry was not a manufacturing town, however, as was Birmingham; thus in search of suitable materials, the Coventry engineers had to turn elsewhere. For example, Sheffield provided bar steel for bearings and wire for spokes; Walsall supplied saddles; springs came from Redditch and Sheffield; Birmingham firms provided the drawn steel tubes crucial to making those light metal frames, and it supplied the steel balls for bearings (Grew, 1921: 27). The assistance of Birmingham was not without risk for Coventry. Although at first the firms in Birmingham produced only half-finished materials and velocipede parts, they started to look around for outlets for their production in slack times. For example, Perry & Co., pen makers, and the Birmingham Small Arms Co. (B.S.A.) began to supply sets of fittings and parts for small workshops, which were in this way able to build velocipedes without requiring the more expensive tools and machinery (Grew, 1921: 29–30). However, making good parts is not the same as making good bicycles, and Coventry remained the center of the British cycle industry for a long time. In the 1870s and 1880s the industry spread all over the Midlands, Yorkshire, and part of London.

Starley and Hillman did not immediately market their Ariel, but first produced and sold velocipedes in which they incorporated many of Starley's improvements. Hillman suggested that the launching of the high-wheeled bicycle had to be marked by a spectacular promotional feat. They decided to set up a kind of unusual test: completing the ride from London to Coventry in one day. And they did, probably in 1871.[3] Both gentlemen took their bicycles to Euston Station on the train, spent the night in the station hotel and got up before daylight. They had a light breakfast and started out along the cobbled roads of London. Once outside the city the roads became better, and at about 8 am they reached St. Albans, where they stopped to have an ample breakfast. The next stretch ran over the Chiltern Hills. On some of the steeper hills they had to walk, but compensation came on the long downhill portions where speeds of some twelve miles an hour were attained. "Disaster might have overtaken the gentlemen who wished to take full advantage of the hills, had it not been for Mr. Starley's ingenious brake." By one o'clock the riders had covered about half the distance, and they enjoyed dinner and an hour of rest near Bletchley. Mounted again, they were cheered on by the inhabitants of towns and villages, few of whom had seen a bicycle before. Only one mishap befell them. "Mr. Hillman was thrown from his machine when the rubber tyre of his front wheel came off but escaped with nothing worse than a grazed hand. He was able to bind the tyre on again and proceed without further trouble." The last miles from Daventry to Coventry were hard. The men were tired and the darkness made it difficult to avoid stones and holes in the road. But just when the clock of St. Michael's struck midnight, it is said,

they reached Starley's residence in Coventry. The ninety-six miles had been completed within one day and with the bicycles still in almost perfect condition. The contemporary account finishes by stating that "the bicycle that has been developed by Messrs. Starley and Hillman from the velocipede is a most efficient form of human transport. It may be recorded that the two intrepid gentlemen, though tired, and stiff after their long ride, were no worse for their adventure." However, an intimate footnote was added in the margin of this account that for both riders the experience was painful enough to oblige them to remain in their beds "for two or three days." When, subsequently, the Ariel was marketed in September 1871, it was priced at £8 (Williamson, 1966: 54).

So they were quite active, these bicycle producers. But for whom were they producing? For whom was the Ariel's spectacular promotion intended? The demand increased. By the end of the 1870s clubs and associations for cyclists had been established in most countries. To continue the story of the high-wheeled Ordinary bicycle, we will now shift our focus to its users.

The ordinary users

The memorable ride of Starley and Hillman enhanced the image of the new high-wheeled bicycle as a sport machine, and records were set and contested on all classic roads of England. For example, the Brighton Road is associated with the earliest bicycle performances, as is Watling Street, on which Starley and Hillman crossed the Chiltern Hills. Especially on the Brighton Road, relay rides were often held against the four-horse coach (Grew, 1921: 78). Track racing started soon as well. Probably the first was in 1869 in Crystal Palace, London (Woodforde, 1970: 161), but other tracks sprang up in Birmingham, Wolverhampton, and Leicester (Grew, 1921: 67–68). After the Franco-German War, racing on Ordinaries began on the continent as well.[4] Because the German local ordinances were rather limiting—for example, restricting racing on public roads to the early morning and late evening hours—in Germany the bicycle clubs started to build separate racing courses.[5]

Whereas skiing began as a way of getting about and evolved into a sport, bicycling began as a sport activity and evolved into a means of transport. Even when the rider of a high-wheeled bicycle was not actually racing, he viewed his activity primarily as an athletic pastime. It was not easy to mount the high-wheeled bicycle, even with the provision of a step directly above the trail wheel. Uwe Timm (1984: 17–22) gives a convincing and colorful description of his uncle Franz Schröder's efforts to learn how to ride a high-wheeled bicycle: "Schröder experienced this afternoon the large and fundamental difference between theory and practice. He mounted and fell down. The crowd of spectators was standing there and kept silent. He stood up again and fell off again."[6] He repeated this motion several times, to increasingly enthusiastic clapping and cheering: "Hopf, hopf, hopf, immer aufem Kopf!"[7] By the end of the afternoon he had learned how to mount and ride in a straight line; making a curve and dismounting were not yet in his repertoire, so each little ride ended in a fall. However, after another week of trying (in which he lost two finger tips between the spokes of the front wheel), he had mastered the art of riding a high-wheeled bicycle. No wonder bicyclists wore an anxious air. "Bicyclist's face," this expression was called, and newspapers predicted a generation with hunchbacks and tortured faces as a result of the bicycle craze (Thompson, 1941: 18). Going head-over-

heels was quite common, as we will see shortly. Partly for that reason, and because there was no freewheel mechanism—which implied that the cranks were permanently turning around when riding—a special mode of riding was practiced when moving downhill. This "coasting" again required some athletic ability: when the bicycle was moving fast, the legs were thrown over the handlebar to the front (see [Figure 18.2]).

Learning to ride a bicycle became a serious business in the 1870s. In some European cities, bicyclists had to pass an examination to prove their proficiency (Woodforde, 1970: 120). Bicycle schools existed in most towns of some importance. Partly this was made necessary by the maturity of the riders, none of whom had learned cycling as a child, which is now the usual way, at least in bicycling countries.[8] On the other hand, the bicycles of those days were definitely more difficult to ride than are modern versions. Even walking a bicycle could result in a bruised leg when the novice had not yet learned how to keep free of the revolving pedals.

Charles Spencer, owner of the London gymnasium bicycling school, described in his instruction book how to mount a high-wheeled Ordinary:

> Hold the handle with the left hand and place the other on the seat. Now take a few running steps, and when the right foot is on the ground give a hop with that foot, and at the same time place the left foot on the step, throwing your right leg over on to the seat. Nothing but a good running hop will give

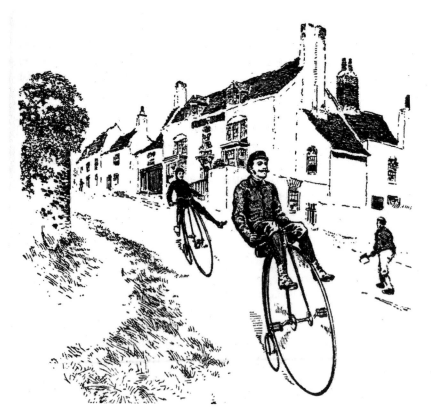

Figure 18.2 The first rider has thrown his legs over the handlebar when coasting downhill.

you time to adjust your toe on the step as it is moving. It requires, I need not say, a certain amount of strength and agility.[9]

The cycling schools and instruction books tried to make the art of bicycling as explicit as possible. For example, what

each learner must remember is simply to turn the handles in the direction in which he is falling. Having drummed this into his head, the rest is easy. He will soon discover that there is a happy medium and that the bars require only to be turned slightly, and instantly brought back to the straight as soon as the machine has resumed the perpendicular.[10]

It is unlikely that a modern bicyclist would be able to describe so adequately what exactly she is doing when keeping her balance. Her craft of riding a bicycle is almost completely "tacit knowledge." However, riding the high-wheeler could be just as pleasant and comfortable as it was dangerous. Having mounted an ordinary bicycle—by this time implicitly meaning a high-wheeler—one would immediately feel its easy-rolling, billowy motion as very different from the bone-shaking effect of the velocipede.[11] Moreover, the pedals almost directly beneath the saddle enabled one to sit comfortably upright, with the bar in one's lap; on the velocipede, there had always been the pushing forward of the legs and the pulling on the handlebar to compensate for that pushing. There was a direct advantage of being so high above the ground: the roads had worsened since the railways eclipsed the horse coach, and the large wheel could keep its rider well above the water-filled holes and mud, while dealing effectively with the bumps.

Few men over middle age, and even fewer women, attempted to ride the high-wheeled bicycle. The typical bicyclist—by this time meaning an Ordinary rider—had to be young, athletic, and well-to-do. Accordingly, bicycling still had, as in the early days of the hobbyhorse, an element of showing off:

Bicycle riding, like skating, combines the pleasure of personal display with the luxury of swift motion through the air. The pursuit admits, too, of ostentation, as the machine can be adorned with almost any degree of visible luxury; and differences of price, and, so to speak, of caste in the vehicle, can be made as apparent as in a carriage. It is not wonderful, therefore, that idle men sprang to the idea.[12]

Generally, bicycling was associated with progress and modern times. This was sometimes voiced in grandiose terms:

The bicycle: the awakening of a new era. The town comes into the village, the village comes into the town, the separation comes to an end, town and village merge more and more. Cyclisation: the era of the bicycle, that is the new time with richer, broader and more mobile civilisation, a back to nature which however keeps all advantages of culture.[13]

But cycling was also linked with new social movements in more concrete ways. The first meeting of the bicycle society of the town of Coburg was observed by a local police

officer, who had to ensure that this society was not an undercover meeting of the forbidden social democratic party. Schröder's wife Anna was pointed out for committing subversive actions that were intuitively understood as revolutionary and the first exemplification of the women's movement in Coburg. "*Petroleuse* on a high-wheeler" read the headline in the local newspaper, thus associating female bicyclists with *petroleuses* of the 1871 *Commune*.[14] And especially in the days of the low-wheeler, after the high-wheeled bicycle had become obsolete, cycling was explicitly linked to feminism. For an instrument of the liberation of the proletariat, the bicycle was too expensive. The laborer who would have liked to use the machine for his transportation to work could not afford one, until a second-hand market had developed.[15] Indeed, many workers were still riding their high-wheeler after 1900; by that time it had been nicknamed "Penny-farthing" because it was not "ordinary" any more. In Ashford, Kent, a gas lamp lighter still used it in 1914, finding it useful in his work (Woodforde, 1970: 49).

The nonusers of the ordinary

With only the group of "young men of means and nerve" riding the Ordinary, there were many more people not using it. Some of them wanted to ride a bicycle but could not afford one, or were not physically able to mount the high-wheeler, while others actively opposed the machine.

There were several reasons for the antagonism against bicyclists. One was irritation caused by the evident satisfaction with which the riders of the high-wheeler elevated themselves above their fellow citizens. This irritation gave rise to derisive cheers such as "Monkey on a gridiron!" (Wells, 1896: 24) or the loudly hailed pronouncement that "your wheel is going round!" (Woodforde, 1970: 50). Jokes like this inflicted no injury, "but when to words are added deeds, and stones are thrown, sticks thrust into the wheels, or caps hurled into the machinery, the picture has a different aspect."[16] The touring clergyman who made this observation added, "All the above in certain districts are of common occurrence, and have all happened to me, especially when passing through a village just after school is closed. The playful children just let loose from school are generally at this time in an excitable state of mind."[17]

Another reason for the antagonism was the threat posed by the bicyclists to those who were walking.

> Pedestrians backed almost into the hedges when they met one of them, for was there not almost every week in the Sunday newspaper the story of some one being knocked down and killed by a bicycle, and letters from readers saying cyclists ought not to be allowed to use the roads, which, as everybody knew, were provided for people to walk on or to drive on behind horses. "Bicyclists ought to have roads to themselves, like railway trains" was the general opinion.
>
> (Thompson, 1941: 18)

Police and magistrates supported this view. Local ordinances posed various restrictions on bicycling, often widely different in different towns. A German cantonal judge observed that these local ordinances stipulated many obligations for the cyclists, but

hardly any rights.[18] Elaborating on these rights, he remarked that the offense bicyclists suffered from most frequently was defamation. Carriage drivers being overtaken by a bicycle, pedestrians having to wait a few seconds before crossing a street—they all would shout insults at the cyclist. The judge described the various forms of defamation recognized in German law and added that the so-called *einfache Beleidigung* (simple slander), which could be exerted by words, gestures, or pawing, was most common. An enthusiastic bicyclist himself, he used to write down all insulting words shouted at him; he was amazed by the public's creativity. Newspaper reports about fights between bicyclists and pedestrians or coach drivers were quite common. A particularly flagrant attack, Woodforde reports, happened on 26 August 1876, when a coach driver lashed an overtaking bicyclist with his whip and the coach guard actually threw an iron ball, which he had secured to a rope, between the spokes of the wheel (Woodforde, 1970: 52). An offense with which bicyclists were frequently charged was "riding furiously," especially on roads with excellent wood paving such as the high road between Kensington and Hammersmith in London. The antagonism of the general public can be sensed through the following excerpt from a court hearing transcript, concerning four men charged with furious riding: "Police constable ZYX 4002 deposed that he was on duty the previous evening, and saw the defendants riding at a rate of forty miles an hour; he walked after them and overtook them . . . taking them to the station handcuffed."[19] If we can assume that this speed of forty miles an hour was a gross overstatement, the acceptance of such a statement suggests a generally negative opinion about bicycling in those days.

There were also people who wanted to ride a bicycle but could not do so. One reason has been mentioned already: the price of the Ordinaries prevented middle-class and working-class people from buying a new machine. The other main reason was the problem of safety. This problem made older men and women reluctant to mount the high-wheeler. For women there was an additional problem, and I will turn to that first.

In 1900 it was still possible to find newspaper articles such as the following, reporting on the observation of a two-seater bicycle with a man and woman on it:

> The numerous public that was walking in the Maximilian-strasse, yesterday at noon, witnessed an irritating spectacle that gave rise to much indignation. . . . Unashamed, proud like an Amazon, the graceful lady displayed herself to men's eyes. We ask: Is this the newest form of bicycle sport? Is it possible that in this manner common decency is being hit in the face without punishment? Finally: is this the newest form of advertising for certain female persons? Where is the police?[20]

This must have been a rather exceptional outcry in 1900, especially as it concerned merely a low-wheeled two-seater. But it makes one think about the sentiments expressed two decades earlier against women wanting or actually trying to ride on high-wheeled bicycles. The whole weight of Victorian prudery set itself against women taking such a masculine and, on the high-wheeler, revealing posture.[21] Some bicycle producers tried to find a solution for what was euphemistically called "the dress problem." In 1874 Starley and Hillman pursued the idea of S. W. Thomas, patented in 1870, of having two pedals on one side of the velocipede, thus enabling it to be "side-ridden."[22] This is what Starley and Hillman did with their successful Ariel high-wheeler. The rider sat in a sidesaddle position, the handlebars being shortened on one side and lengthened on the

other. The rear wheel was mounted on an overhung axle, and the front wheel was offset from the track of the rear wheel to counteract the bias of the sidesaddle posture (see [Figure 18.3]). It all seems rather complicated, and the machine must have been quite difficult to master. This technical solution to the dress problem did not become a success, and few sidesaddle bicycles were sold.

However, solutions other than purely technical innovations were tried—and indeed, were more successful. First, Victorian morals could occasionally be a little more

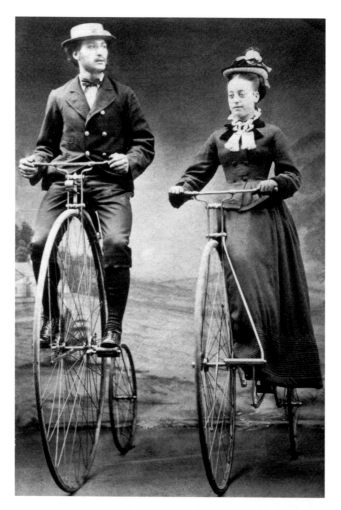

Figure 18.3 The ladies' model "Ariel" (to the right), designed in 1874 by J. Starley and W. Hillman. The pedals do not drive the cranks directly, but are placed at the ends of levers, pivoted some distance in front of and slightly above the front wheel axle on the left side of the bicycle. About halfway along these levers, short connecting-rods communicate the motion of the pedals to the overhung crank-shaft. The axle forming the pivot for the pedal levers is supported on the inside by an arm attached to the front fork and on the outside by a stay that joins the lower crosspiece of the steering head. The lever to rotate the hub with respect to the rim and thereby increasing the tension of the spokes can also be seen in both bicycles. Photograph courtesy of the Trustees of the Science Museum, London.

flexible than one might assume. For example, a young lady who wrote to a magazine in 1885 about having used a bicycle (which at that date must have been a high-wheeled Ordinary) was reassured in the reply: "The mere act of riding a bicycle is not in itself sinful, and if it is the only means of reaching the church on a Sunday, it may be excusable."[23] Another solution to the dress problem posed by the Ordinary was to modify the designs of women's clothing and, accordingly, to set new standards of fashion. A third way for women to ride cycles while avoiding the Ordinary was to use tricycles.

The "safety problem" was pressing for many nonusers of the Ordinary. As mentioned, the Ordinary rider was liable to go head over heels when encountering a small obstacle like a stone, a hole in the road, or an animal wandering about. The trend of enlarging the front wheel of the velocipede had continued once speed had become so important, and this made it necessary to move the saddle forward in order to keep pedals within reach of the feet. This implied a reduction of the rear wheel's diameter— partly because otherwise the machine could not be mounted at all, partly to reduce the bicycle's weight, and partly for aesthetic reasons (it set off the grandeur of the high wheel). But these two developments moved the center of gravity of the bicycle and rider far forward, to a position almost directly above the turning point of the system. Thus only a very small counter force—for example, from the bumpiness of the road, but also from the sudden application of the brake—would topple the whole thing. Another serious and frequent cause of falls was getting a foot caught between the spokes, for example when feeling for the step before dismounting. Different ways of falling forward even got their own labels (as in present-day wind surfing), so that an experienced Ordinary rider remarked, "The manoeuvre is so common, that the peculiar form of tumble that ensues is known by the distinctive name of 'the cropper' or 'Imperial crowner.'"[24] Falls were such an accepted part of bicycling that producers advertised their bicycles' ability to withstand falls, rather than claiming that they did not fall at all. In the *Humber Bicycle Catalogue* of 1873, a letter from a customer is reproduced, saying that although his Humber bicycle "on several occasions [had] been engaged in universal spills and collisions, it is now almost as sound as when first despatched from your works."[25] This, however, was to change within a few years, when manufacturers began to regard women and older men as potential bicycle buyers.

2.4 Relevant social groups

In this section, the flow of the historical case study is halted for the first methodological intermezzo. The concept "relevant social group" will be introduced.

I have described the development of the Ordinary bicycle by tracing what various groups thought of it. I used these perspectives to avoid the pitfall of retrospective distortion. If we are to find out how the so-called detour of the high-wheeled bicycle came about, it seems wise to stick as closely as possible to the relevant actors, rather than bringing our own evaluations to bear on the story. Thus we may be able to show that what in a Whiggish account of bicycle history seemed a strange and ineffective detour was indeed quite straightforward when viewed from the actors' perspective. ("Whiggish" is an account that presents history as uninterrupted progress, implying that the present state of affairs follows necessarily from the previous.)

But there is another reason to focus on social groups than merely the desire to avoid

retrospective distortion. One of the central claims in this book will be that such social groups are relevant for understanding the development of technology. I will first show how empirical research can identify the social groups that are *relevant for the actors*. Then I will argue that these social groups are also theoretically *relevant for the analyst* when he or she sets out to explain the development of technical change.

Empirical research to identify relevant social groups

Relevant social groups may be identified and described by following two rules: "roll a snowball" and "follow the actors." The snowball method is used in contemporaneous sociological research, and I will use a study of a scientific controversy to illustrate this method.[26] Typically one starts by interviewing a limited number of actors (identified by reading the relevant literature) and asks them, at the end of each interview, who else should be interviewed to get a complete picture. In doing this with each interviewee, the number of new actors at first increases rapidly like a snowball, but after some time no new names will be mentioned—you have the complete set of actors involved in the controversy.[27] This is a neat methodological solution to the problem of how to delineate the group involved in a scientific controversy, at least when interviewing is a possible technique.

The same method is applicable in historical research. Just as we can find relevant actor by noting who is mentioned by other actors, we can identify what social groups are relevant with respect to a specific artifact by noting all social groups mentioned in relation to that artifact in historical documents (see [Figure 18.4]). When after some

Figure 18.4 Related to an artifact, the relevant social groups are identified.

time the researcher does not find reference to new groups, it is clear that all relevant social groups have been identified.

By using the snowball technique, a first list of relevant social groups can be made. Using this as a starting point, the researcher can then "follow the actors" to learn about the relevant social groups in more detail.[28] This can be quite a straightforward process: because these social groups are relevant for the actors themselves, they typically have described and delineated the groups adequately. Thus marketing people will identify user groups and describe them as far as is relevant; producers thus had identified rich, young, athletic men as bicyclists; and anticyclists had identified tricyclists and bicyclists. Thus after the first step of identifying the relevant social group, two subsequent steps were taken: a second to describe the relevant social groups in more detail, and a third to further identify the relevant social group by delineating it from other relevant social groups. In practice, these description steps are of course interdependent, and it is not practical to carry them out completely separately.

For example, the relevant social group of Ordinary users was characterized, in the first descriptive step, as being constituted of people who saw the Ordinary as a sporting machine that was rather hazardous to ride. In the second step this relevant social group was further described as consisting of young athletic men, distinctly upper and upper-middle class. A brief reference to road maintenance in the new railway era hinted at the wider socioeconomic context. The description of relevant social groups is as important as the detailed description of artifacts in standard technical histories. [. . .]

Then, for the third step, the relevant social groups' boundaries, intuitively assumed at the outset, are traced more precisely. Again, the actors can be followed. In the turmoil of technical development actors, to make sense of their world, will identify new relevant social groups or forget about others. Thus the boundaries of social groups, although once clear-cut, may become fuzzy; new groups may split off and old groups may merge into new ones. Actors thus "simplify" and reorder their world by forgetting about obsolete distinctions or by drawing new boundaries.[29] As I will show, at some point bicycle producers concluded, for example, that within the relevant social group of nonusers, women should be separated out as an important relevant social group. Similarly, the relevant social group of Ordinary users did not remain unchanged. At first it coincided completely with the group of cyclists. With the coming of the low-wheeled bicycle, some parts of the relevant social group of nonusers became users of the safety bicycle, and the relevant social group of Ordinary users changed accordingly. Its boundaries changed—some categories of cyclists switched from the high-wheeler to the safety. But its key characteristics changed as well: in the beginning its members could be labeled "young men of means and nerve," and Franz Schröder, a typical Ordinary rider, successively passed through the stages of being associated with social democracy and other "revolutionary" movements to being simply the laughingstock of town.

Relevant social groups: also relevant for the analyst

The concept of "relevant social group" is an actor's category. Although actors generally do not use these words, they actively employ the concept to order their world. A crucial claim in the development of a social constructivist model of technology is, however, that "relevant social group" is also an important analyst's category. It will help us to describe

the development of technical artifacts in terms that meet the requirements set out in the first chapter [original context].

Technological development should be viewed as a social process, not an autonomous occurrence. In other words, relevant social groups will be the carriers of that process. Hence the world as it exists for these relevant social groups is a good place for the analyst to begin his or her research. Thus the analyst would be content to use "cyclists" as a relevant social group, but introduce separate "bicyclists" and "tricyclists" only when the actors themselves do so. The basic rationale for this strategy is that only when a social group is explicitly on the map somewhere does it make sense for the analyst to take it into account.

There seems to be one obvious problem with this argument, which has two important aspects, the political and the epistemological. The political aspect arises out of recognition that powerless social groups—those that do not have the ability to speak up and let themselves be found by the analyst—will thus be missing in the account. The epistemological aspect of the problem concerns the suggested identity between actors' and analysts' categories. The first formulation of the problem is relevant for the practical and political relevance of technology studies [. . .]. The second formulation addresses a classic debate in the philosophy of the social sciences. This problem, however, does not need to exist, in either of the two formulations.

The problem of the "missing groups" does not exist if the conceptual framework I am developing is taken in the right spirit—as a collection of sensitizing concepts that aims to provide the researcher with a set of heuristics with which to study technological development. Another slightly rhetorical way of making the same point is to emphasize that the goal is to develop a framework for *scientific research*, not a computer program for an expert system to carry out social studies of technology. [. . .]

Similarly, no simple identity between actors' and researchers' categories is advocated. I am proposing the combined method of "snow-balling" and "following the actors" as heuristics—a negative heuristic to avoid a facile projection of the analyst's own categories, which might lead to retrospective distortion and Whiggish accounts; and a positive heuristic to help identify relevant social groups that do not figure in the standard histories of the specific technology. [. . .]

What I have been arguing here about the identification, delineation, and description of relevant social groups also applies to the characterization of artifacts. If we want to understand the development of technology as a social process, it is crucial to take the artifacts as they are viewed by the relevant social groups. If we do otherwise, the technology again takes on an autonomous life of its own. Thus in this descriptive model the meanings attributed to the artifact by the different relevant social groups constitute the artifact. I described, for example, the artifact Ordinary bicycle "through the eyes" of members of the relevant social groups of women, older men, and Ordinary users. The definition of the Ordinary as a hazardous bicycle (for the relevant social groups of women and elderly men) was supplemented by listing specific ways of using the artifact, such as track and road racing, touring, and showing off in parks (for the Ordinary users). The risky aspects of riding the Ordinary were explicated by describing in some detail the techniques involved in mounting the machine and in coasting downhill.

Notes

* Editors' note: this extract starts at section 2.3 and ends at the end of section 2.4. The following notes therefore have been renumbered (i.e. note 1 was originally note 7).

1 For detailed figures, see Prest (1960), especially pp. 129–130.
2 Hounshell (1984: 188–215) has described a similar development in the United States, where Albert A. Pope contracted with the Weed Sewing Machine Company. The first high-wheeled Ordinary bicycles were produced by the Weed Company by using its sewing machine manufacturing equipment with only special fixtures and cutting tools added.
3 The following report is based on a contemporary account, found in the Starley family papers and quoted by Williamson (1966: 51–53).
4 For a list of early contests, see Rauck et al. (1979: 168–169).
5 For a detailed account, see Rauck et al. (1979: 169).
6 In his novel *Der Mann auf dem Hochrad*, the philosopher and novelist Uwe Timm gives a fascinating account of events in the small German town of Coburg when the local taxidermist, Schröder, started riding a high-wheeled bicycle. This pioneering act upset the sleepy town and made social structures, values, and norms highly visible. The social democratic revolution, feminist actions, and technical progress all became closely linked.
7 "Bang, Bang, Bad, Always on His Head!" (Timm, 1984: 19).
8 If there were no children's bicycles these days, we might need riding schools again. I used to show visiting sociologists and historians of technology around the old town of Delft by taking them on a bicycle tour. Not all of them had had much cycling experience. I am happy to report that no accidents occurred, but in some cases a short refresher course in riding would have been useful.
9 C. Spencer, in *The Modern Bicycle*, quoted by Woodforde (1970: 112).
10 A. C. Pemberton, *The Complete Cyclist*, quoted by Woodforde (1970: 116).
11 That this was indeed an effect of the difference in wheel diameter can be appreciated without much physics, when the reader thinks of the difference in comfort between a baby carriage with large wheels and a stroller with smaller wheels.
12 This quotation is from an article in *The Spectator* of 1869, describing velocipede riding. It could just as well have been used to characterize cycling on Ordinaries. Quoted by Woodforde (1970: 24).
13 Schröder, in notes for a book he planned to write, quoted by Timm (1984: 149).
14 See Timm's (1984: 124–139) description of the antibicycle evening organized by the shoemakers of Coburg.
15 Also see Timm (1984: 83–84, 159, 187) and Wells (1896: 52).
16 Rev. L. Meadows White, *A Photographic Tour on Wheels*, quoted by Woodforde (1970: 49–50).
17 Ibid., p. 50.
18 Schumacher, *Das Recht des Radfahrers*, quoted by Rauck et al. (1979: 79).
19 Quoted from the December 1881 issue of *Wheel World* by Woodforde (1970: 52).
20 This article from the *Münchener Zeitung*, 1900, is quoted by Rauck et al. (1979: 76).
21 This prudence certainly was not restricted to the British isles; see the chapter on "Bicycle Etiquette" in the American book by Cooke (1896: 343–351).
22 Samuel Webb Thomas, British patent specification no. 361, 1870. Most likely, the velocipede was never built for actual use; the original Patent Office model is in the Science Museum, London. For a detailed description, see Caunter (1958: 6).
23 Reply to lady's letter in a magazine of 1885, quoted by Woodforde (1970: 122).
24 The Earl of Albemarle in G. Lacy Hillier, *Cycling*, quoted by Woodforde (1970: 45).

25 Quoted by Woodforde (1970: 47).
26 Here I draw on work by Collins (1981a). He used this sociological technique as an operational definition of the "core set"—the group of scientists centrally involved in a given controversy. Examples of controversy studies in the sociology of scientific knowledge are provided by Collins (1985), Collins and Pinch (1982), Pickering (1984), and Pinch (1986).
27 This limited set of actors was defined by Collins (1981a) as the "core set."
28 See Latour (1987) for more examples of "follow the actors" as an *adagium* for empirical research in science and technology studies.
29 Callon and Law (1989: 64) describe much the same process as "investments of form" in their network vocabulary: "An investment of form is the work undertaken by a translator to convert objects that are numerous, heterogeneous, and manipulable only with difficulty into a smaller number of more easily controlled and more homogeneous entities—entities which are nonetheless sufficiently representative of their heterogeneous and formless cousins that it becomes possible for the translator to manipulate the latter as well." They add that there is no reason that these investments of form would only be carried out to order the world of relevant social groups; the world of nonhuman actors is simplified in similar ways.

References

Caunter, C. F. (1958) *Handbook of the Collection Illustrating Cycles. Part II: Catalogue of Exhibits with Descriptive Notes*, London: Science Museum and Her Majesty's Stationery Office.

Grew, W. F. (1921) *The Cycle Industry: Its Origins, History and Latest Developments,* London: Pitman.

Grout, W. H. J. (1870) 'Improvements in the Construction and Mode of Making Wheels for Velocipedes, Carriages and Other Vehicles', British patent no. 3152 issued on 1 December 1870.

Prest, J. (1960) *The Industrial Revolution in Coventry*, London: Oxford University Press.

Thompson, F. (1941) *Over to Candleford*, London: Oxford University Press.

Timm, U. (1984) *Der Mann auf dem Hochard*, Cologne: Kiepenheuer and Witsch.

Wells, H. G. (1896, 1984) *The Wheels of Chance*, London: Dent & Sons.

Williamson, G. (1966) *Wheels within Wheels: The Story of the Starleys of Coventry*, London: Geoffrey Bles.

Woodforde, J. (1970) *The Story of the Bicycle*, London: Routledge & Kegan Paul.

Vivian Sobchack

A LEG TO STAND ON
Prosthetics, metaphor, and materiality

Matter has been given infinite fertility, inexhaustible vitality, and at the same time, a seductive power of temptation which invites us to create as well.

<div align="right">Bruno Schulz, The Street of Crocodiles</div>

It is this submission which is offered as a sacrifice to the glamorous singularity of an inhuman condition.

<div align="right">Roland Barthes, "The Jet-man," in Mythologies</div>

Let me begin again with the fact that I have a prosthetic left leg—and thus a certain investment in and curiosity about the ways in which "the prosthetic" has been embraced and recreated by contemporary scholars trying to make sense (and theory) out of our increasingly technologized lives. When I put my leg on in the morning, knowing that I am the one who will give it literal—if exhaustible—vitality even as it gives me literal support, I don't find it nearly as seductive a matter—or generalized an idea—as do some of my academic colleagues. And walking around during the day, going to teach a class or shop at the supermarket, neither do I feel like Barthes's "reified hero," the "Jet-man": a mythological "semi-object" whose prosthetically enhanced flesh has sacrificially submitted itself to "the glamorous singularity of an inhuman condition."[1] Not only do I see myself as fully human (if hardly singular or glamorous), but I also know intimately my prosthetic leg's essential inertia and lack of motivating volition. Indeed, for all the weight I place on it, it does not run my life. And thus, as I engage a variety of recent work in the humanities and arts, I am both startled and amused at the extraordinary

moves made of and by "the prosthetic" of late—particularly since my prosthetic leg can barely stand on its own and certainly will never go out dancing without me.

Particularly, shall we say, "well equipped" to do so, I want both to critique and redress this metaphorical (and, dare I say, ethical) displacement of the prosthetic through a return to its premises in lived-body experience. However, this return will not be direct—but rather by way of what might be called a "tropological phenomenology."[2] In *The Rule of Metaphor* Paul Ricoeur writes: "If there is a point in our experience where living expression states living existence, it is where our movement up the entropic slope of language encounters the movement by which we come back this side of the distinctions between actuality, action, production, motion."[3] Thus, in what follows, I will pay as much attention to language as I will to lived bodies. This is because there is not only an *oppositional tension* but also a *dynamic connection* between *the* prosthetic as a tropological figure and *my* prosthetic as a material but also a phenomenologically lived artifact—the *the* and the *my* here indicating differences both of kind and degree between generalization and specificity, figure and ground, aesthetics and pragmatics, alienation and incorporation, subjectivity and objectivity, and between (as Helen Deutsch and Felicity Nussbaum put it) "a cultural trope and a material condition that indelibly affect[s] people's lives."[4] Thus, it is not my aim to privilege here autobiographical experience as somehow "more authentic" than "less authentic" discursive experience. Experience of any kind requires both bodies and language for its expression, and both autobiographical and discursive experience are real in that they each have material causes and consequences. It is also not my aim here to hobble flights of scholarly or artistic imagination and deny them the freedom of mobility that I have come to dearly cherish. In this regard, although I will return to my own prosthetic leg at a later moment—as well as to the prosthetic legs of an extraordinary woman who has made both the metaphorical and the material dance to her own choreography—such an anecdotal move is not meant to overvalue the "secret" knowledge possessed and revealed by the cultural other who has a real prosthetic but, rather, meant to ground and expand the tropological premises of "the prosthetic" as it informs the aesthetic and ethical imagination of the humanities and arts. Perhaps a more embodied "sense-ability" of the prosthetic by cultural critics and artists will lead to a greater apprehension of "response-ability" in its discursive use.

I

Sometime, fairly recently, after the "cyborg" became somewhat tired and tiresome from academic overuse, we started to hear and read about "the prosthetic"—less, in its ordinary usage, as a specific material replacement of a missing limb or body part than as a sexy, new metaphor that, whether noun or (more frequently) adjective, has become tropological currency for describing a vague and shifting constellation of relationships among bodies, technologies, and subjectivities. In an important essay called "The Prosthetic Imagination" that investigates the scholarly uses and abuses of the prosthetic, Sarah Jain writes: "As a trope that has flourished in a recent and varied literature concerned with interrogating human-technology interfaces, 'technology as prosthesis' attempts to describe the joining of materials, naturalizations, excorporations, and semiotic transfer that also go far beyond the medical definition of 'replacement of a missing part.'"[5]

We have, for example, "prosthetic consciousness" ("a reflexive awareness of sup-plementation")[6] and "prosthetic memory" (the public extroversions of photography and cinema that cast doubt on the privilege of interiority that once constructed individual subjectivity and identity).[7] Then there is the "prosthetic aesthetic," which "extends our thinking on the relationship between aesthetics, the body, and technology as an a priori prosthetic one."[8] We have also "prosthetic territories," described as "where technology and humanity fuse"[9]; "prosthetic devices," such as "autobiographical objects," which are "an addition, a trace, and a replacement for the intangible aspects of desire, identification, and social relations"[10]; and "prosthetic processes," such as "contemporary aging," which point to a "postmodern state [that] is clearly a prosthetic creature cobbled together out of various organic and cybernetic sub-units."[11] And, then, there is a recent issue of *Cultural Anthropology* that produces what might be called the "prosthetic subaltern" in two essays, respectively entitled "Stumped Identities: Body Image, Bodies Politic, and the *Mujer Maya* as Prosthetic" and "Desire and the Prosthetics of Supervision: A Case of Maquiladora Flexibility."[12] Indeed, as Diane Nelson (author of one of the essays) points out in her introduction to the issue's focus on prosthesis and cultural analysis: "The prosthetic metaphor is drawn from recent work in cyborg anthropology, feminist studies of science, philosophy, political economy, disability studies, and neurophysiology. . . . [P]rosthetics mediate a whole series of those binaries we know we need to think beyond, but which still tend to ground our politics and our theory (self/other, body/technology, actor/ground, first world/third world, normal/disabled, global/local, male/female, West/East, public/private)."[13]

This is a tall order for a metaphor to fill. Furthermore, somehow, somewhere, in all this far-reaching and interdisciplinary cultural work (and with the exception of disability studies), the literal and material ground of the metaphor has been largely forgotten, if not disavowed. That is, the primary context in which "the prosthetic" functions literally rather than figuratively has been left behind—as has the experience and agency of those who, like myself, actually use prostheses without feeling "posthuman" and who, moreover, are often startled to read of all the hidden powers their prostheses apparently exercise both in the world and in the imaginations of cultural theorists. Indeed, most of the scholars who embrace the prosthetic metaphor far too quickly mobilize their fascination with artificial and "posthuman" extensions of "the body" in the service of a rhetoric (and, in some cases, a poetics) that is always located *elsewhere*—displacing and generalizing the prosthetic before exploring it first on its own quite extraordinarily complex, literal (and logical) ground. As Jain points out in her critique, "So many authors use it as an introductory point—a general premise underpinning their work about the ways in which technoscience and bodies interact," and thus the "metaphors of prosthetic extension are presented as if they were equivalent in some way, from typewriters to automobiles, hearing aids to silicone implants. . . . Both the prosthesis and the body are generalized in a form that denies how bodies can and do 'take up' technologies of all kinds."[14]

There is, then, a certain scandal to this metaphorical displacement and generalization—not because my (or anyone else's) literal and specific experience of prosthesis is sacrosanct or because the metaphor obliterates the political atrocities of mass amputations by landmines in Cambodia or by civil war in Sierra Leone.[15] Rather, the scandal of the metaphor is that it has become a fetishized and "unfleshed-out" catchword that functions vaguely as the ungrounded and "floating signifier" for a broad and variegated

critical discourse on technoculture that includes little of these prosthetic realities. That is, the metaphor (and imagination) is too often less expansive than it is reductive, and its figuration is less complex and dynamic in aspect and function than the object and relations from whence it was—dare I say—amputated. As Steven Kurzman (himself an amputee) summarizes in the aforementioned special issue of *Cultural Anthropology*:

> Rather than develop a metaphor based on ethnographic material about artificial limbs or other prosthetic devices (e.g., breast implants, dental implants, joint implants, and so on), [scholars] develop a theoretical model to explain a problem arising out of a completely different topic and then *retroactively* define it in the world of amputation and artificial limbs. . . . Prosthesis simultaneously occupies the space of artificial limbs, metaphor, and discursive framework. The metaphor becomes unsituated and an instance of totalizing theory, managing to be both everywhere and nowhere simultaneously.[16]

In this regard it is useful to think more specifically, if briefly, about the *function* of metaphor. To be fair to all of us who use metaphor (and who doesn't?), we must acknowledge that metaphor is, by tropological nature, a *displacement*: a nominative term is displaced from its mundane (hence literal, nonfigural) context and placed, precisely, elsewhere so as to illuminate some other context through its *refiguration*—that is, by highlighting certain relations of structural or functional resemblance that might not be noticed without the transportation of a foreign object into an otherwise naturalized scene, an analogy is constituted. However, as Paul Ricoeur notes (quoting Pierre Fontanier), it is important to emphasize that metaphor "does not . . . refer to objects"; rather, "it consists 'in presenting one idea under the sign of another that is more striking or better known'" (57).[17] Thus, primarily based on the relation of *ideas* rather than *objects*, and on structural and functional resemblances rather than physical similarities, metaphorical usage does not owe any necessary allegiance to the literal object—such as a prosthesis—that generated it. Nonetheless, it does owe necessary allegiance to a "common opinion" about the object and context that needs to sufficiently acknowledge the resemblance in order to "get" the analogy. As Ricoeur sums up: "[R]esemblance is principally a relationship between ideas, between generally held beliefs"—and thus, not only does analogy operate between ideas of structure and function rather than between objects as such, but the "idea itself is to be understood not 'from the point of view of the object seen by the spirit' but 'from the point of view of the spirit that sees'" (57–58).[18]

It is not surprising, then, that from the point of view of the "spirited" individuals who use prostheses in the most literal (rather than literary) sense, there are some major problems with the prosthetic metaphor as it is seen (and used) by those whose point of view is positioned elsewhere, in some theoretical rather than practiced—and practical—space. In this regard (and following on the work done by Jain) Kurzman emphasizes not only the short shrift given to actually substantiating the theoretical use of the metaphor (that is, justifying the analogy through careful comparison and contrast of specific structures and functions), but he also emphasizes two major and consequential reversals and reductions that have attended its current theoretical usage that do not correspond to the common opinion of most of us who actually use prostheses.

First, despite the fact that the metaphor emerges from an apparent—and critical—interrogation that is meant to disrupt the traditional notion of the body as whole, unlike

Donna Haraway's nonhierarchical and hybrid cyborg, the metaphor of the prosthetic and its technological interface with the body is predicated on a naturalized sense of the body's previous and privileged "wholeness."[19] Furthermore, this corporeal wholeness tends to be constituted in purely *objective* and *visible* terms; body "parts" are seen (from an "observer's" point of view) as missing or limited and some "thing" other (or some "other" thing) is substituted or added on to take their place. What is elided by this predication (and point of view) are the phenomenological—and quite different—structural, functional, and aesthetic terms of those who successfully *incorporate* and *subjectively live* the prosthetic and sense themselves neither as lacking something nor as walking around with some "thing" that is added on to their bodies. Rather, in most situations, the prosthetic as lived in use is usually *transparent*; that is, it is as "absent" (to use Drew Leder's term) as is the rest of our body when we're focused outward to the world and successfully engaged in the various projects of our daily life.[20] Ideally incorporated not "into" or "on" but "as" the subject, the prosthetic becomes an object only when there's a mechanical or social problem that pushes it obtrusively into the foreground of one's consciousness—much in the manner in which a blister on our heel takes on an objective presence that is something other even though it is our own bodily fluid and stretched skin that constitute it. It is, thus, not the existence or use of a prosthetic that determines whether one feels one's body disrupted. Indeed, in common use, as Kurzman writes, "[a]rtificial limbs do not *disrupt* amputees' bodies, but rather reinforce our publicly perceived normalcy and humanity. . . . [A]rtificial limbs and prostheses only disrupt . . . what is commonly considered to be the naturally whole and abled Body" (380–81).

Second, Kurzman points to the way in which the theoretical use of the prosthetic metaphor tends to transfer *agency* (albeit not subjectivity, as with the cyborg) from human actors to human artifacts. Paradoxically, this transfer of agency indicates a certain technofetishism on the part of the theorist—however closeted and often antithetical to the overt critique of certain aspects of technoculture for which the metaphor was mobilized. As an effect of the prosthetic's amputation and displacement from its mundane context, the animate and volitional human beings who use prosthetic technology disappear into the background—passive, if not completely invisible—and the prosthetic is seen to have a will and life of its own. Thus we move from technofetishism to *technoanimism*. For example, Alison Landsberg, in "Prosthetic Memory," cites an Edison film, made as early as 1908, called *The Thieving Hand*, in which an armless beggar is provided with a prosthetic arm that once belonged to a thief and, against his will—but not the arm's—starts stealing.[21] A similar agency is cinematically granted to the prosthetic arm belonging to *Dr. Strangelove* (Stanley Kubrick, 1964)—and here we might note that, in terms of body parts, more arms and hands (which in fantasy often slip and slide between the severed limb and the prosthetic) have been granted agency by the cinema than legs. (Perhaps, and I speculate, this is because, having an opposable thumb, a hand has essentially a broader and more dramatic range of acting skills.)[22]

According to this seductive (and culturally recurrent) fantasy of the uncanny and willful life of limbs and objects, not only can my prosthetic leg go dancing without me, but it also can "will" me to join it in what, in effect, is a nightmarish *danse macabre*. And, here, in the context of both technofetishism and technoanimism, I cannot help but recall my beloved *The Red Shoes* (Michael Powell and Emeric Pressburger, 1948). Antedating both my own encounter with a prosthetic leg and our current culture of "high-technophilia" (which might regard shoes as a fetish but certainly not a technology),

the film, based on a Hans Christian Andersen story, concerns a young ballerina, torn between love and art, who gets her big break in a ballet in which she plays a woman who longs for a pair of red slippers that, when she finally gets to put them on, force her to dance until she dies from exhaustion. Such transfer of human agency to our technologies allows our artifacts to come back with a vengeance. Thus, in amused response to reading a theoretical essay on the prosthetic rife with technoanimism, Kurzman imagines his "modest collection of below-knee prosthetic legs" (kept in a box in his basement) developing "a collective consciousness of oppression," when they realize that he had "been using them to complete [his] identity," and "march[ing] upstairs to have a word with [him] about it" (380).

In effect, the current metaphorical displacement of the prosthetic into other contexts because of its analogical usefulness in pointing out certain (if vaguely specified) structural and functional resemblances between ideas also—and mistakenly—displaces agency from human to artifact and operates, as Kurzman puts it, as a "silencing dynamic of *disavowal*." Contemporary scholars (and many artists as well) are unwitting technophiles who, despite their critiques of global technoculture, too often "represent prosthesis and phantom limbs as agents, and amputees are present only as stumps and phantoms, which metonymically embody our lack of presence and subjectivity. Amputees . . . become 'the ground': the invisible, silent basis of the metaphor" (383).[23]

Kurzman's use of the term *metonymy* here seems to me critical to our understanding not only of the negative reaction that many prosthetic users have to the current "prosthetic imagination" but also of the specific figural differences and consequent relational meanings and functions that "the prosthetic" discursively serves. Metonymy is a figural operation quite different in function, effect, and meaning from metaphor (even as it is often imprecisely subsumed by it). It is even more significantly quite different from *synecdoche*, with which it appears almost—and problematically—symmetrical. These differences not only often discursively slip and slide into each other in ways that are confusing, but they also form the expressive and dynamic ground of the varying, confused, and ambivalent ways in which prostheses are seen in their relation to the human beings who use them.

In this regard Ricoeur (again glossing Fontanier) is particularly helpful. He not only differentiates the figural operations of the three species of tropes—metaphor, metonymy, and synecdoche—by their respective relations of *resemblance*, relations of *correspondence* (or *correlation*), and relations of *connection* but goes on to explore these relations and their consequences in more detail. Earlier I pointed out that predicated on relations of resemblance, metaphor operates to construct an analogy, presenting "one idea under the sign of another," primarily through highlighting similarities between the structural or functional aspects of objects rather than between the literal objects as such. Hence the prosthetic as a metaphor easily—and often—takes on adjectival form, characterizing and qualifying other nouns rather than serving a noun function itself: "prosthetic memory," "prosthetic territories," and so forth. Unlike metaphor, however, metonymy and synecdoche *do* primarily refer to objects—albeit quite differently. Constructing relations of correspondence or correlation, metonymy "brings together two objects each of which constitutes '*an absolutely separate whole*.' This is why metonymy divides up in turn according to the variety of relationships that satisfy the general condition of correspondence: relationship of cause to effect, instrument to purpose, container to content, thing to its location, sign to signification, physical to moral, model to thing."[24]

(Here, in relation to the prosthetic, we can see this variety of relationships played out across the relevant literature as well as in the culture at large. For example, as Kurzman notes, the way in which agency is transferred from the amputee to the prosthetic is clearly metonymic in character; the cause-effect relation between two "absolutely separate wholes"—a human and an artifact—is exaggerated and becomes not an ensemble but the seemingly complete transference of force or influence from one species of object or event to another.)

Synecdoche, unlike metonymy, constructs relations of connection through which "two objects 'form an ensemble, a physical or metaphysical whole, the existence or idea of one being included in the existence or idea of another'"; this relationship of connection, Ricoeur writes, like metonymy, also divides up into a variety of subordinate but constitutive relations: "relations of part to whole, material to thing, of one to many, of species to genus, of abstract to concrete, of species to individual."[25] What is particularly important not only to an understanding of tropes but also to the troubled—and troubling—figural usage of the prosthetic is that, however symmetrical the functions of metonymy and synecdoche may appear, metonymic correspondence and synecdochic connection are radically different and "designate two relationships as distinct as exclusion ('absolutely separate whole') and inclusion ('included in . . .')."[26] In relation to Jain and Kurzman's critiques—and to the perceptual and discursive conflict between "the point of view of the object seen by the spirit" and "the point of view of the spirit that sees"—the metonymic discourse of scholars describing the prosthetic objectively as an absolutely different species from the body is exclusionary and is at odds with the synecdochic discourse of amputees who describe their prosthetic subjectively as of the same "species" as the body that has incorporated, and therefore included, it. Thus, there is significant figural movement from metonymy to synecdoche, from the prosthetic viewed abstractly to my prosthetic leaning up against the wall near my bed in the morning to my leg, which works with the other one and enables me to walk. And here, I would suggest, it is worth pausing to note how the notion of my "other" leg functions in the previous sentence: that is, my "real" leg is suddenly become the "other." But this is a false—and hence justly confusing—opposition, as well as a telling reversal of figure and ground. My "real" leg and my "prosthetic" leg are not usually lived as two absolutely different and separate things since they function as an ensemble and are each a part of my body participating in the whole movement that gets me from here to there; thus, they are organically related in practice (if not in material) and are, to a great degree, reversible each with the other (my leg can stand in a part-to-whole synecdochic relationship with my body and vice-versa). This is to say (to refer back to Ricoeur and Fontanier) that, as I live them subjectively (and ambiguously), my two objective legs "form an ensemble, a physical [and] metaphysical whole, the existence [and] idea of one being included in the existence [and] idea of another."

Nonetheless, to be fair in regard to the tropological tendency to see the prosthetic (and sometimes to live it) in metonymic relation to the body, it is important to note here that the inclusiveness of synecdochic connection is not always as complete in existence as it is utopian in desire. Robert Rawdon Wilson writes: "Any consideration of prostheses has to take into account their potential failure and, even, the conditions under which they might go wrong or turn against their users. The consciousness of machines always includes . . . a dimension of fear. There is also fear's most intimate radical, an element of potential disappointment: the prosthesis may not work, or may work inadequately, or

may entail unwanted consequences."[27] Although I really never feel like my prosthetic leg (or, for that matter, my eyeglasses when they're dirty) possesses the agency or subjectivity to "turn against" me, I will admit that it does have the capacity to become opaque, to turn into a hermeneutic object that I have to pay attention to and interpret and do something about (other than transparently walk with it). That is, my leg is transformed metonymically at times to another (inhuman) species of thing—the prosthetic resisting its formerly organic function in an ensemble of action directed elsewhere. In these moments it becomes an absolute other. This can happen suddenly—as when, losing a certain amount of suction in the socket that holds my leg in place, I feel (quite literally) a bit detached from the leg and have to press the valve on its side to recreate a vacuum. Or, as is more often the case, it can happen gradually—as when, over a long and hot day of walking, a combination of sweat and the pressure of the edge of the socket against my flesh begins to chafe and, if I don't "do" something about it, causes an abrasion.

The point is that, like the turns and effects of language in use, my experience—and view—of my leg (indeed, of the rest of my body) is not only *dynamic* and *situated* but also *ambiguous* and *graded*. That is, whether and to what degree I live (and describe) my prosthetic metaphorically, metonymically, or synecdochically is dependent on the nature of my engagements with others (how they see or avoid it or talk about it abstractly, or if I worry whether I can keep pace with them), with my environment (when I'm in unfamiliar territory the question is always "How far can I walk on it?"), with my mood (how physically attractive or frumpy do I feel overall and what part of myself will I single out for praise or blame?), and my project (how do I write about "my leg" or "it" within the context of cultural studies?). In sum, what Jain and Kurzman and I find problematic about the tropology of the prosthetic is, first, its vagueness, if not inaccuracy, as a metaphor meant to foreground the similarity of its structures and functions with various other ideas and institutional practices—and, second, its objectifying and often stultifying tendency to privilege and essentialize metonymic and oppositional relations that separate body and prosthetic, thus neglecting or disavowing not only the synecdochic relations that posit the cooperation and connective union of body and prosthetic in world-directed tasks but also the complex and dynamic ambiguity of all these possible existential and tropological relations as they are situated and lived.

II

Let me now turn, as earlier promised, to focus on a few specific prosthetic legs—first my own rather mundane one and then the much more flamboyant ones of double below-the-knee ("BK") amputee Aimee Mullins, a successful model and record-breaking paralympian sprinter, who has subsequently gone on to celebrity as a motivational speaker, a writer, one of *People* magazine's "50 Most Beautiful People" in 1999, and, most recently, the leading lady of *Cremaster 3* (2002), the latest in artist Matthew Barney's series of art-house films filled with "impressive prosthetics and special effects."[28] As you will see, this move to the specific and material does not leave the realm of tropology but, rather, animates it—and the "human-technology interface"—with the complexity, ambiguity, and desire revealed not only in "discourse" but also by "real bodies" living both real and imaginative lives.

Here, then, I want to stay grounded in (rather than displaced from) the materially,

historically, and culturally situated premises of "the prosthetic"—even as "the pros-
thetic" also engages an experiential and discursive realm larger than that of its merely
literal materiality, situation, and logic. As will become particularly evident—and dra-
matic—in the case of Aimee Mullins's legs, such grounding of (and taking the scare
quotes off) the prosthetic does not disavow figuration (which, in any case, cannot be
avoided); rather, metaphor, metonymy, and synecdoche are put in the service of illu-
minating the nature and experience of our prostheses instead of the prosthetic serving
to illuminate something else (and elsewhere). Furthermore, even in my own mundane
instance, focusing on the specificity of the prosthetic in its primary context functions
also to highlight the contingent and uncanny play of its (and my) tropological and exis-
tential possibilities. That is, the prosthetic's many inconsistencies in use and its combi-
nation of elements that are theoretically paradoxical yet creatively functional not only
account for the fascination it holds for others but also open up imagination and analysis
to an expanded range of both action and description.

Thus, beginning with my own situation, I want to take the general and vague trope
of "technology as prosthesis" that Jain and Kurzman criticize and *reverse* it—turning
it back and regrounding it in its mundane context, where, like my prosthetic leg, it
stands objectively in common opinion as the general and vague trope of "prosthesis as
technology." This reversal, however, neither rejects the supposed purpose of the ini-
tial metaphor, which, according to Jain's description, "attempts to describe the join-
ing of materials, naturalizations, excorporations, and semiotic transfer that also go[es]
far beyond the medical definition of 'replacement of a missing part'"—nor does it do
away with figuration. Rather, viewing the prosthesis as technology allows me to stake
out (and stand) my ground in the *materiality* of the prosthetic and its incorporation—
and, in the process, to playfully reconnect such figurative descriptions as "standing one's
ground" with their quite literal "underpinnings."

In the summer of 1993, as the result of a recurrent soft-tissue cancer in my thigh,
my left leg—after three operations, literally as well as metaphorically, "a drag"—was
amputated high above the knee. For six months or so, while my flesh was still healing
and I was engaged in strenuous preliminary rehabilitation, I got about using crutches
(and here we might wonder not only how—but also if—crutches "hold up" in today's
high-tech prosthetic imagination). Finally, however, my body was ready to go through
the arduous plaster casting, fiberglass molding, and microfitting of a prosthetic leg so
that I could begin to learn to walk again—a fairly lengthy and complex process that
imbricated both intensive mechanical adjustment and physical practice. There were all
sorts of physical things I had to learn to do consciously in quick sequence or, worse,
simultaneously: kick the prosthetic leg forward to ground the heel, tighten my butt, pull
my residual limb back in the socket and weight the prosthetic leg to lock the knee, take
a step with my "own" leg and unweight the prosthetic leg as I did so, tighten my stom-
ach and pull up tall to kick the prosthetic forward, and begin again. This, nonetheless,
took a great deal less time than I feared it would, given my middle-age, general physical
clumsiness, and my almost willful lack of intimacy with my own body. Although it took
much longer for me to develop a smoothly cadenced gait, I was functionally walking in
a little over a month.

A prosthetic leg has many components and involves dynamic mechanical and physi-
cal processes, as well as a descriptive vocabulary all its own. To date and beginning with
my very first prosthetic, as an above-the-knee ("AK") amputee I have had four different

sockets—these molded of fiberglass and "thermo-flex" plastic to conform, over time, to the changing shape of my stump. The first socket was secured to my body tenuously through a combination of suspension belt and multilayered cotton "socks" of different thickness, which were added or subtracted depending on my fluid retention, the weather, and my slowly changing shape. The sockets that followed about a year later, however, were secured snugly through the suction I referred to earlier. Now I put the leg on by pulling my flesh into the socket with a "pulling sock" and then screw a valve into a threaded plastic hole embedded in the fiberglass, depressing it so that all the air escapes and my stump and the socket mold themselves each to the other. I have also had three different metal knees made out of aluminum and titanium, all of which were attached to a small wooden block, itself bonded to the socket. The first was a mechanical knee with an interior safety "brake" that could be set to freeze at a certain angle so as to stabilize me in "midfall" inflexion, the second a double-axis hydraulic knee that I didn't like because its reaction time seemed to lag behind my increasingly accomplished and fluid movements, and the third my current single-axis hydraulic knee whose extension and inflexion move transparently (at least most of the time) in isomorphic concert with my own bodily rhythms.

Over time there have also been two different lightweight metal leg rods that, replacing my tibia and fibula, run from the knee down into the foot—the first a dull silvery aluminum rather like the stuff of my crutches, and the second a glowing chartreuse green titanium that I sometimes think a shame to hide. (Before the cosmetic cover was added, I remember an eleven-year-old boy coming over to me in admiration and envy, crowing "Cool . . . Terminator!") Ultimately, these metal rods, like the rest of the leg and thigh, were covered with sculpted foam that my prosthetist lovingly shaped to complement, albeit not exactly match, my fleshy leg. (The prosthetic thigh is a bit thinner than my real thigh since it's not as malleable as flesh is in relation to clothing.) And then I've also had two feet although I've only needed one at a time—both of hard rubber composition with an interior spring that allows me to "roll over" and shift my weight from heel to ball even without an ankle joint, both the same model "Seattle Foot." (Prosthetics often have place names like the "Oklahoma Socket," the "Boston Elbow," the "Utah Arm.") Given my replacement and accumulation over time of all these prosthetic parts, I now have a complete spare leg in the depths of my closet behind some winter coats I have no need for in California and, somewhere in the trunk of my car, there's an extra socket (put there and never taken out after I got a new lighter-weight one). Finally, along with the crutches that I use in the early morning before I shower or late at night when I wake up to get a drink of water or go to the bathroom, I have about six or seven metal, plastic, and wooden canes. Because my remaining femur is extremely short—little more than two inches in length—I need the cane for stability; it basically counters the slight torquing and consequent "wobble" of the pliable mass of flesh within my socket and thus helps ground my walk (but, again, we might ask if canes count in today's prosthetic imagination).

I've paid as much as US$79.95 for the best of my canes (they can run into hundreds of dollars when they have silver handles shaped as the heads of hunting dogs so as to disguise physical need as aristocratic attitude), but I really do not know precisely how many thousands of dollars my prosthetic legs cost. Since I am one of a fortunate few who belong to a health maintenance organization (HMO) that covers such expenses and sends me no bills, I have been spared contemplation of the enormous and quality-

of-life-threatening sums of money spent on producing, purchasing, and maintaining my prostheses.[29] Nonetheless, my research tells me that it is likely that my full (and rather ordinary) "AK" leg cost no less than US$10,000–$15,000, since a top-of-the-line carbon fiber "BK" prosthesis used for sports competition (with a special Flex-Foot its inventor also calls the "Cheetah Foot") costs at least US$20,000 per leg. Should I wish it (which I don't), I could request that my HMO approve the purchase and fitting of the latest Bock "C-leg"— one in which microprocessors, strain gauges, angle detectors, hydraulics, and electronic valves "recreate the stability and step of a normal leg" and, as the *New York Times* reports, was a "lifesaver" for Curtis Grimsley, who used the leg "to walk down from the 70th floor of the World Trade Center on September 11th."[30] On the other hand (or leg?), the HMO might refuse me—not only because the "C-leg" costs US$40,000–$50,000 but also because I'm a woman of a certain age who is generally perceived as not needing to be so "well equipped" as someone who is younger (and male).

Indeed, like the movement it enables, prosthetic technology is highly dynamic and always literally incorporating (in both the bodily and business sense) the newest materials and technology available. Nonetheless, it is worth noting (as does Dr. Richard A. Sherman in a booklet written for amputees): "Just like any other machine, [prostheses] get out of whack and break with time and use. They need to be kept up properly and tuned up. The newer devices have computers, muscle tension and motion sensors, computer-controlled joints, tiny motors, etc. You can expect them to give you and your prosthetist more problems and have more 'down time' than relatively simple mechanical prostheses."[31] As it is, I have to see my prosthetist at least once a year: the mechanisms need checking and cleaning and my cosmetic foam cover always needs some repair or "fluffing up."

I hope, by now, that you—the reader—have been technologized and quantified into a stupor by what is a very narrow and "objective" register of meaning, the bland (or at least straight-faced) enumeration, detailing, and pricing of my prosthetic parts (whether on my body or in the closet) intended to ground and lend some "unsexy" material weight to a contemporary prosthetic imagination that privileges—and, like the eleven-year-old boy quoted above, is too often thrilled by—the exotic (indeed, perhaps erotic) *idea* rather than the mundane *reality* of my intimate relations with "high" technology. (Hence my wonderment about the prosthetic status of my "low-tech" crutches or canes.) Missing here (albeit suggested) is a description of the variety of phenomenological, social, and institutional relations I engage that have been partially transformed by my prosthetic: my consciousness, for example, altered at times by a heightened awareness not only of such things as the availability of "handicapped" access and parking but also of the way in which city streets, although still the same objective size, have subjectively expanded in space and contracted in time so that responding to traffic lights now as I cross the street creates a heightened sense of peril and anxiety I never felt before my amputation.

Missing, too, is the way in which learning to walk and incorporate a prosthetic leg has made me more—not less—intimate with the operation and power of my body: I now know where my muscles are and am physically more present to myself. I also enjoy what for me (previously a really bookish person) always seems my newfound physical strength, and I have discovered my center of gravity (which, in turn, has transformed my entire comportment in ways that include but also exceed my objective physical

bearing). And, then, too, there are the encounters I've had with others that my pros-
thetic leg enabled—for example, a support group I attended at the request of my pros-
thetist (who had just started it and wanted to show me off in my short skirt and one-inch
heels as a success story). There I met the most extraordinary individuals who might
not otherwise have crossed my path: an older quadriplegic man who, for years, had
been locked away by his parents and now, with some assistance, was living on his own
for the first time; a whining, self-pitying woman who had lost one of her legs "BK" to
diabetic gangrene and obviously "got off" on being in a position to tearfully order her
husband to respond to her beck and call; a furious young woman, just graduated from
college, whose legs were crushed in a car accident and whose boyfriend had just broken
up with her but who went on (still furious), with two "AK" prosthetics, to become a
Special Olympics athlete. And, of course, there was my prosthetist—who knows my
aging body and my ageless will perhaps more intimately and approvingly than has any
other man in my life.

My objective description of the prosthetic as technology also doesn't begin to touch
on the great pride I've felt in my physical accomplishments or the great delight I take
both in the way my prosthetic leg can pass as real and the desire I have to show it off.
This paradoxical delight and desire have led to a strangely unselfconscious and exuber-
ant exhibitionism that always catches me by surprise. As Kurzman points out: "In a
social context, artificial limbs are ideally invisible in order to facilitate mimicry of non-
amputees and passing as able-bodied," yet many "amputees are proud of their ability
to walk well and pass, and often disclose because one's ability to pass is most remark-
able when people are aware of it. . . . Prostheses do become visible, but often under
amputees' terms of pass and trespass" (379). Indeed, I often find myself revealing as a
marvel what the prosthetic leg is cosmetically supposed to hide (that I have a prosthetic
leg), and, even more often, I tend to talk about—and demonstrate—the coordinated
and amazing process of walking that we all don't normally think about but that the pros-
thetic leg is able to foreground and dramatize both to myself and for others.

These paradoxical desires and delights become particularly dramatic in relation to
Aimee Mullins—both her legs and their "figuration" (discursive and literal). Consider,
for example, the following passages from an article on Mullins by Amy Goldwasser that
appeared in 1998 in an issue of *I.D.: The International Design Magazine*:

> Men devote themselves to Aimee Mullins' legs. Two men, in particular,
> have made it their business to know every millimeter of the expanse that
> runs from Mullins' knees down to her heels. One of these men can tell you
> precisely how many foot-pounds of torque she stores and releases with every
> running stride. The other can speak authoritatively about the spacing of hair
> follicles on her shins and the width of her Achilles tendons. Then there is a
> third man, who is a glass-blower. "He wants to make glass legs for me. Isn't
> that amazing?" Mullins says, genuinely awed by the poetic offer. "He said,
> 'Cinderella had a glass slipper, I could give you glass legs.'"
>
> In a modern literal twist to the old tale, it's not the beautiful heroine's
> hand but her legs that have inspired such courtly attention. And the king-
> dom at stake spans fewer than four feet, the lower-leg prosthetics, left and
> right, that Aimee Mullins wears. Mullins, 22, was born without fibula bones
> in her shins. Both of her legs were amputated below the knee at age one, a

decision her parents made when doctors told them that otherwise she'd be confined to a wheel-chair. On what Mullins refers to as her "sprinting legs," she is an elite athlete who holds world class records in her class in the 100- and 200-meter dash and long jump. On her "pretty legs," she is the only amputee in the country who looks magazine-model ideal in miniskirt and strappy sandals. If design can be seen as the quest for human solutions, then the challenge of creating legs to meet Mullins' biomechanical and beauty needs is an irresistible one to engineer and artist alike.[32]

What we have here is certainly the "high technology" of practical prosthetics. However, even more apparent—and to jaw-dropping degree—is the particular and contemporary "technological high" that comes not only from imagining but also, in Aimee's case, from realizing prosthetics tropologically. For example, Van Phillips, who designed Mullins's "sprinting legs," says of the Sprint-Flex III foot that is the legs' most prominent component: "I like to call it the Cheetah Foot because if you look at the hindquarters of the cheetah, the fastest animal there is, it's basically a C-shape" (Goldwasser, 48). And then there is Mullins's own description of her "pretty legs": "They're absolutely gorgeous. Very long, delicate, slim legs. Like a Barbie's. Literally, that's exactly how it is." Even though Barbie dolls are anatomically impossible (the breasts too big and the legs too slim to support the torso), Mullins finds "the doll ideal is liberating rather than limiting"; her "cosmetic prostheses make her a leggy 5'8"," and she has an "arch that demands two-inch heels" (Goldwasser, 49). And this "liberation" is experienced not only by Mullins alone but also by Bob Watts, the prosthetist who materialized her desire for "Barbie legs." He tells us, "These are sort of my fantasy legs. With a single amputee, it's easier to get an artificial leg to look like the sound leg. But when you're making two legs, it's twice as much work. But there's twice as much freedom, because there's also no reason why you can't make them absolutely identical and ideal. Aimee offered me an opportunity to produce the perfect female leg" (Goldwasser, 49).

The mind boggles—not only at the complicit male and female gender fantasies literally materialized here but also at the complex and paradoxical desires uncannily articulated through and by the prosthetic. Cheetah legs? On the one hand (or is it leg?), this materialization is all about the desire for the superhuman power and prowess afforded by highly specialized technology; on the other, its highly specialized technological enhancement of human motion and speed in sprinting paradoxically foregrounds the human costs of such technologically achieved and focused animal power. Thus, what is gained on one side is lost on the other. Mullins finds sprinting easy, and she finds "it's standing still that's hard." As the article points out, "One limitation of legs that move like the fastest animal on earth: the fastest animal on earth is more stable than Mullins when not in motion." Thus, in photo shoots featuring her as an athlete, Mullins tells Goldwasser: "The photographer has to hold me and kind of prop me in position before I fall over" (49).

And then there are those fabulous glass legs. Unrealized in 1998 (but not, as we will see, in 2002), they form the basis for a grandiose Cinderella story in which a romantic prince looks for an ideal woman with just the right legs (or lack of them) so he can outdo previous narrative heroes and their glass slippers with something more and bigger. But the prince here is also a prosthetist—revealing both his and the imagined prosthetic's confused substrate of desire and fear. That is, the very physical and social transparency

that prosthetists wish to achieve and amputees to experience with their artificial legs entails in such an extreme figuration slippage not only in the aesthetics of transparency, delicacy, and thus "femininity" but also in the awful fragility of glass.

Except for the glass legs, the tropes articulated here discursively ("Cheetah foot" and "Barbie legs") are also materialized *literally*—but, materially realized, as legs, they maintain their figurative status as tropes nonetheless. That is, like language used figuratively, they are literally "bent out of shape" both in context and material form. Furthermore, as realized figures, they not only literalize both male and female gender fantasies but also confuse such categories as human and animal or animate and inanimate in precisely the ironic way that Donna Haraway's cyborg was originally meant to do. This confusion is embraced quite matter-of-factly by Mullins, who, recalling a technology and design conference she attended, tells us:

> The offers I got after speaking . . . were from animatronics designers and aerospace engineers who are building lightweight but strong materials, and artisans—like the guy who works for Disney and creates the skin for the dinosaurs so that it doesn't rip when their necks move. . . . These ideas need to be applied to prosthetics. . . . With all this new technology, why can't you design a leg that looks—and acts—like a leg? I want to be at the forefront of these possibilities. The guy designing the next generation of theme parks. The engineers. The glass-blower. I want everyone to come to me with their ideas.
>
> (Goldwasser, 51)

Aimee Mullins—at least in this article in 1998—is entirely sincere but hardly naïve. That is, however ironically paradoxical and politically incorrect, for Mullins's practical purposes, the prosthetic fantasies articulated here are all potentially liberating: indeed, Aimee Mullins's "Cheetah legs" have allowed her to set world sprinting records, and her "Barbie legs" have allowed her a successful career as a fashion model.[33]

III

There is something truly uncanny about the literalization of desire—whether prosthetic or discursive. We find it utterly strange when figures of speech and writing suddenly take material form, yet, at the same time, we find this strangeness utterly familiar because we wished such existential substantiations through the transubstantiations of thought and language. Thus, it was both uncannily strange and familiarly "right on" when, quite by accident and within two weeks' time, I suddenly encountered both "Barbie" and Aimee Mullins in two extraordinarily suggestive prosthetic scenarios—both discursive and both very real. Here we find not only prosthetic figuration literally and materially realized but also the literal and material prosthetic reversed on itself reflexively to become figurally the trope of a trope. First, listening to the radio, I learned that Ruth Handler, Barbie's creator, had died—the news obituary flatly recounting how, after achieving corporate success at Mattel Toys, she was ousted from its leadership for "covering over" the company's "losses" but then, a survivor of breast cancer, had gone on to establish a successful company that manufactured "prosthetic

breasts." Impossibly breasted Barbie on those unsupportable legs, cosmetically "covering over losses," a hidden mastectomy, prosthetic breasts—this admixture and further reversal of the literal and figurative, the projective and the introjective, reflexively refers back to earlier figurations and makes metaphor, metonymy, and synecdoche seem, by comparison, figurally straightforward.

And, then, a week later, I read that Aimee Mullins had finally gotten her glass legs—and more. Browsing through a current issue of the *New Yorker*, I came across a short piece on the New York "art-house" opening of artist Matthew Barney's latest addition to his epic *Cremaster* cycle. Suddenly, there was Aimee:

> Hardly less daring was the gown worn to the première by the movie's leading lady, Aimee Mullins: a beige, floor-length number with a deeply plunging backline skimming buttocks that could star in "StairMaster 3." Mullins, who is a double amputee, plays a number of roles in the film, including one in which she wears a backless dress over a pair of translucent high-heeled legs, and another in which she is changed into a cheetah woman, stalking her prey—Barney, in a pink tartan kilt and pink feathered busby—on hind legs that end not in human feet but in feline paws.[34]

This literalized figuration goes far beyond the narrower compass and function of the usual prosthetic imagination—whether that of the cultural theorist or that of a prosthetic user like me. Indeed, I can barely keep pace with Aimee Mullins's legs here. Figuratively, they won't stand still. Not only are there the "glass legs" (made, however, of clear polyethylene), now literalized to function figurally in a movie. But there are also the "Cheetah legs," the literal prosthetic Cheetah foot now figurally extended to incorporate and transform the whole woman. And, further, there is leading lady Mullins offscreen at the première "teetering slightly" in strappy sandals, because, she explains to the reporter, "these legs have, like, Barbie feet, and the heels of the shoes are an inch too short."[35] Indeed, in Barney's film she also has legs fitted with shoes that slice potatoes and, as a giant's wife, "legs cast out of dirt and a big brass toe," and another set of transparent legs "ending in man-of-war tentacles."[36] Again, we are far beyond simple irony here, far beyond metaphor, metonymy, and synecdoche. Indeed, we are both discursively and "really" in the tropological realm of *metalepsis:* the "trope of a trope." This is not simply repetition at a metalevel. Rather, as Harold Bloom (glossing tropes and the "psychic defenses" that inform them in his *A Map of Misreading*) writes: "We can define metalepsis as . . . the metonymic substitution of a word for a word *already* figurative. More broadly, a metalepsis or transumption is a scheme, frequently allusive, that refers . . . back to any previous figurative scheme. The related defenses are clearly introjection, the incorporation of an object or instinct so as to overcome it, *and* projection, the outward attribution of prohibited instincts or objects onto an other."[37] Here, with Aimee Mullins's legs (both onscreen and off) we have both—and simultaneously—incorporation and projection, an overcoming and a resistance, an unstoppable "difference" that is not about negation but about the alterity of "becoming." Aimee Mullins's legs in all their variety challenge simple figuration and fixity. Here the literal and the figural do not stand on oppositional ground, and the real and the discursive together dance to Aimee Mullins's tune—and choreography.

As for me, despite my awe and admiration for Mullins and the complexity of her

life and projects, I have no desire to keep pace with her. I tend to locate my differ-
ence and variety elsewhere than my legs and just want to get on with things both mun-
dane and extraordinary. Indeed, I remember long ago attending that first meeting of
the support group at which my prosthetist proudly showed a video of amputees (with-
out Cheetah legs) racing in the Special Olympics. As I sat there, I watched the people
around me—and knew that all they wanted, as I did, was to be able to walk at work, to
the store, and maybe on a treadmill at the gym. In sum, I've no desire for the "latest"
in either literal or figural body parts. All I want is a leg to stand on, a limb I can go out
on—so I can get about my world with a minimum of prosthetic thought.

Notes

Although part of vernacular expression, "A Leg to Stand On" is also the title of a book
by phenomenological neurologist Oliver Sacks that deals with a topic somewhat related
to the present one: Sacks's experience with a neurologically damaged leg. See Oliver
Sacks, *A Leg to Stand On* (New York: Simon and Schuster, 1984).

1 Roland Barthes, "The Jet-man," in *Mythologies*, trans. Annette Lavers (New York: Hill and
 Wang, 1957), 72–73. The Bruno Schulz epigraph that begins this essay can be found in
 Bruno Schulz, *The Street of Crocodiles*, trans. Celina Wieniewska (London: Penguin, 1963),
 59.
2 It is worth noting here that *trope* has a philosophical definition as well as a rhetorical one: a
 "trope" is a figural use of language, but it is also an argument advanced by a skeptic. In this
 regard a "tropological phenomenology" would take into account both senses of the word
 and would proceed in its "thick description" both fully aware and productively suspicious
 that lived-body experience is always also being imaginatively "figured" as it is literally being
 "figured out."
3 Paul Ricoeur, *The Rule of Metaphor: Multi-disciplinary Studies of the Creation of Meaning in Lan-
 guage*, trans. Robert Czerny, Kathleen McLaughlin, and John Costello (Toronto: Univer-
 sity of Toronto Press, 1977), 309. Subsequent references will be cited in the text.
4 Helen Deutsch and Felicity Nussbaum, introduction to *Defects: Engineering the Modern Body*,
 ed. Helen Deutsch and Felicity Nussbaum (Ann Arbor: University of Michigan Press,
 2000), 1–2.
5 Sarah S. Jain, "The Prosthetic Imagination: Enabling and Disabling the Prosthetic Trope,"
 Science, Technology, & Human Values 24, no. 1 (winter 1999): 32.
6 Robert Rawdon Wilson, "Cyber(body)parts: Prosthetic Consciousness," *Body & Society* 1,
 nos. 3–4 (1995): 242.
7 Alison Landsberg, "Prosthetic Memory: *Total Recall* and *Blade Runner*," *Body & Society* 1, nos.
 3–4 (1995): 175–89.
8 Joanne Morra and Marquard Smith, eds, "The Prosthetic Aesthetic," introduction to "The
 Prosthetic Aesthetic," special issue, *New Formations* 46 (spring 2002): 5.
9 See the blurb on the back cover of Gabriel Brahm Jr. and Mark Driscoll, eds., *Prosthetic Ter-
 ritories: Politics and Hypertechnologies* (Boulder, CO: Westview Press, 1995).
10 Jennifer A. Gonzalez, "Autotopographies," in *Prosthetic Territories: Politics and Hypertechnolo-
 gies*, ed. Gabriel Brahm Jr. and Mark Driscoll (Boulder, CO: Westview Press, 1995), 134.
11 Chris Hablas and Steven Mentor, "The Cyborg Body Politic and the New World Order," in
 Prosthetic Territories: Politics and Hypertechnologies, ed. Gabriel Brahm Jr. and Mark Driscoll
 (Boulder, CO: Westview Press, 1995), 244–45.

12 Diane M. Nelson, "Stumped Identities: Body Image, Bodies Politic, and the *Mujer Maya* as Prosthetic," *Cultural Anthropology* 16, no. 3 (Aug. 2001): 314–53; and Melissa W. Wright, "Desire and the Prosthetics of Supervision: A Case of Maquiladora Flexibility," *Cultural Anthropology* 16, no. 3 (Aug. 2001): 354–73.

13 Diane M. Nelson, "Phantom Limbs and Invisible Hands: Bodies, Prosthetics, and Late Capitalist Identifications," *Cultural Anthropology* 16, no. 3 (Aug. 2001): 303–13.

14 Jain, "Prosthetic Imagination," 33, 39.

15 For a moving and specific discussion of mass amputation in Sierra Leone as a political counter to the slogan "The future is in your hands!" see George Packer, "The Children of Freetown," *New Yorker*, Jan. 13, 2003, 50–61.

16 Steven L. Kurzman, "Presence and Prosthesis: A Response to Nelson and Wright," *Cultural Anthropology* 16, no. 3 (Aug. 2001): 374–87. Subsequent references will be cited in the text.

17 Ricoeur is quoting from Pierre Fontanier, *Les Figures du discours* (1830; reprint, Paris: Flammarion, 1968), 99.

18 Interior quotation is from Fontanier, *Les Figures du discours*, 41.

19 Donna Haraway, "Manifesto for Cyborgs: Science, Technology, and Socialist Feminism in the 1980s," *Socialist Review* 80 (1985): 65–107.

20 Drew Leder, *The Absent Body* (Chicago: University of Chicago Press, 1990).

21 Landsberg, "Prosthetic Memory," 175.

22 Freud, himself possessed of an oral prosthetic, writes in "The Uncanny" of phantasies of "dismembered limbs, a severed head, a hand cut off at the wrist . . . feet which dance by themselves," these chilling and "unheimlich" because "they prove capable of independent activity." See Sigmund Freud, "The Uncanny," in *The Pelican Freud Library, Volume 14: Art and Literature*, trans. James Strachey (Harmondsworth: Penguin, 1985), 366.

23 In this regard I would note that I have a small etching on my wall at home called "Break a Leg," which was given to me by a close friend. Referring to a theatrical phrase perversely meaning "Good luck," the etching shows an onstage chorus line of disembodied legs and is, for me, a delightful figuration of my own early preoccupation with my prosthetic and the general fantasy of the transference of agency—through metonymy—from subjects to objects.

24 Ricoeur, *Rule of Metaphor*, 56 (interior quotation is from Fontanier, *Les Figures du discours*, 79; emphasis added).

25 Ibid. (interior quotation is from Fontanier, *Les Figures du discours*, 87).

26 Ibid.

27 Wilson, "Cyber(body)parts," 242.

28 Rebecca Mead, "Opening Night: An Art-House Epic," *New Yorker*, May 13, 2002, 35.

29 Kurzman, in "Presence and Prosthesis," also discusses these issues—considering, in particular, how the materials and design of his leg are "based on the same military technology which has blown the limbs off so many other young men"; how he has benefited from "the post-Cold War explosion of increasingly engineered sports equipment and prostheses"; and how the man who built his leg "struggles to hold onto his small business in a field rapidly becoming vertically integrated and corporatized" (382).

30 Ian Austen, "A Leg with a Mind of Its Own," *New York Times*, Jan. 3, 2002, D1.

31 Richard A. Sherman, appendix to *Phantom Pain* (New York: Plenum, 1996), 231.

32 Amy Goldwasser, "Wonder Woman," *I.D.: International Design Magazine*, May 1998, 48.

33 It is worth noting that, as a model, Mullins does not always use her "Barbie legs" or opt for "passing." See, e.g., a fashion advertisement for *haute couture* clothing, photographed by Nick Knight, that appeared in *The Guardian*, Aug. 29, 1998; Mullins, purposefully doll-like in her seated pose, is revealed with two distinctly "mannequin-like" lower legs, the knee joints apparent, their condition rather worn, adding to Mullins's abandoned doll-like appearance.

34　Mead, "Opening Night," 35.

35　Ibid.

36　Nancy Spector, "Aimee Mullins," in *Matthew Barney: The Cremaster Cycle* (New York: Guggenheim Museum, 2003), n.p.

37　Harold Bloom, *A Map of Misreading* (Oxford: Oxford University Press, 1975), 74. Unfortunately, although I think it well worth doing, there is not room enough here to take "the prosthetic" as figure through all the tropes and attendant psychic defenses that Bloom lays out in a resonant—and relevant—argument and diagram (69–74, 84).

Sherry Turkle

OBJECTS INSPIRE

\mathbf{A}N EIGHT-YEAR-OLD SITS BRAIDING the hair on the tail of her My Little Pony doll, completely absorbed in the job. The shining plasticized hair is long and resilient; she plays with it for hours.[1]

She starts by taking the tail and dividing it into three pieces that she braids together. Then, she undoes that braid and begins to nest layers of braids. She divides the tail into nine pieces and braids each group of three until she has three braids, and then takes these three braids and braids them together. After a while, the girl is starting with twenty-seven pieces, braiding them first into nine, then into three, then into one. The girl is playing with My Little Pony but she is thinking about recursion.

The eight-year-old is one of my MIT students, telling a story of her childhood. What they have had to say testifies to the importance of objects in the development of a love for science—a truth that is simple, intuitive, and easily overlooked.

There are many paths into science. In one, imagination is fired by an object. Young people discover objects that can "make a mind": a puzzle, a toy pony, a broken radio, a set of gears, origami. And since the many aspects of the self are deeply enmeshed, relationships with objects have much to do with family, friendship, home, love, and loss.

In *Mindstorms: Children, Computers, and Powerful Ideas*, Seymour Papert writes of falling in love with the gears of a toy car that his father gave him when he was two.[2] Fascination with those gears led to fascination with others. He played with gears in his mind and mathematics began to come alive for him. He fell in love with the gears and he fell in love with science. The gears inspired, but Papert makes the point that if anyone had tried to measure what was happening to him as this inner explosion of creative energy was occuring, they would have found nothing to measure.

Looking at how objects inspire a young scientific mind reminds us that just because we can't take a measurement doesn't mean that something important is not occuring. The limit of testing can mark the moment when we turn directly to the child, when we

put our deeper intelligence to work. It can be a moment when we learn what motivates and what inspires.

We cannot know in advance whether we stand before a child who will use objects as a path to science. But a one-kind-fits-all curriculum that takes children away from the idiosyncratic objects they are drawn to might set us up to miss a child who makes Cs and Ds in math and science but goes on to develop an abiding love for designing complex systems because of his connection with LEGOs and a personal computer. We might not count as learning the lessons that come with braiding a pony's tail, stoking a wood stove, or baking a meringue.

Certain things draw students to objects, among these, their transparency, the richness of their materials, that they offer worlds in which one can tinker. Children use objects to build a personal scientific style. Object relationships puts creativity at the start and heart of relationships with science. Respect for the power of objects encourages us to make children comfortable with the idea that falling in love with things is part of what we expect of them. It moves us to introduce the periodic table as poetry and radios as a form of art.

Knots

In 1975, the French psychoanalyst Jacques Lacan visited MIT to discuss his ideas about objects and scientific inspiration. To think through the matter, Lacan had taken to playing with knots. He asked to be brought to the room where he would give his seminar several hours before his talk was scheduled to begin. There, he painstakingly drew knots in four colors on all of the available green chalkboards.[3] Most of Lacan's scientific audience assumed that the interlocking knots described a model of mind, but Lacan was saying something different. Lacan was trying to demonstrate how playing with knots, manipulating and perforating their circles, actually contributed to the birth of new scientific ideas. For Lacan, work on knots was a critical element in the emergence of insight about the self and about science, in the same sense that psychoanalytic insight grows out of a lived relationship between patient and analyst.

During his MIT seminar, Lacan described how he became preoccupied with spheres, circles, and "little loops of string" in an attempt to think about body, psyche, and mathematics at the same time. Lacan argued that topology had grown into a mathematical field apparently detached from the body, but that this detachment is defensive. For Lacan, knot play enables us to circle back to topology's roots as a way of experiencing the body. Knot play changes our vision of mathematics in its relation to the body and to the unconscious. Intimacy with knots gets us closer to science.

Thinking about objects in the development of a young scientist, brings us to details about what inspires a young scientific mind. How are inspiring objects chosen? How are they mastered? What states of mind do they encourage?

Object choice

Walt Whitman captured something about how objects inspire when he said: "A child went forth every day/ and the first object he look'd upon/that object he became."[4] But

Whitman speaks about that first object as though it could be any object. In this collection, we hear about very particular, highly specific connections.

In *Uncle Tungsten: Memories of a Chemical Boyhood*, Oliver Sacks describes the specificity of the object choices that led him to science. During World War II, Sacks, a Jewish child and a native of London, had been sent away with his brother Michael to boarding school in the country. His brother would leave the school broken, both physically and mentally; Oliver fared better, but only by degrees. When at twelve, he returned to London, Sacks found objects that put him in contact with his worst fears and reassured him that they would not come to pass. A fearful object would be aluminum smeared with mercury, which removed the aluminum's protective oxide coat. The surface of the aluminum erupted in "a white substance like a fungus,"

> and it kept growing and growing until the aluminum was completely eaten
> up . . . It made me think of a curse or a spell, the sort of disintegration I
> sometimes saw in my dreams . . .[5]

For Sacks, the breakdown of the surface, the rotting away of the aluminum, evokes the death and carnage of the war, the cancer of fascism, antisemitism, the destruction of his brother's mind by encroaching madness.

While mercury was the metal of destruction, another metal represented safety and stability, promising that life, no matter what its limitations and restrictions, would from that point forward, always stay the same. This was tungsten. Sacks has a beloved uncle, a chemist, who reassures him that tungsten can never be ravaged; mercury and its demons have no power over it. Sacks says: "If I put this little bar of tungsten in the mercury, it would not be affected at all. If I put it away for a million years, it would be just as bright and shiny as it is now."[6] Tungsten, at least, was stable in a precarious world.

The periodic table of the elements provides Sacks with another object of stability. He first sees the periodic table at the Museum of Science in South Kensington on a visit after the war. Its order and symmetry are a balm to his spirit. The table gives him "for the first time, a sense of the transcendent power of the human mind, and the fact that it might be equipped to discover or decipher the deepest secrets of nature, to read the mind of God."[7]

> [S]eeing the table, "getting it," altered my life . . . I copied it into my exercise book and carried it everywhere; I got to know it so well—visually and conceptually—that I could mentally trace its paths in every direction, going up a group, then turning right on a period, stopping, going down one, yet always knowing where I was.[8]

In the periodic table, Sacks finds access to a world frozen in time, a world of eternal truths. "And the perception of this produced in my twelve-year-old self a sort of ecstasy."[9] And then, of course, he has tungsten, the safe haven, that becomes an intimate object to think with, to identify with, and to love.

Sacks's story is unique, but the overdetermination of his object choices is not. Everyone with an object passion has his or her own, overdetermined story. One adolescent, performing with the circus after his parents' divorce, wants to put a wall between himself and the audience. A laser show provides a way to perform of which he says: "I

did not have to directly bare my soul." A kindergarten age child, develops a fear that she will have to leave her house as she grows up. Specifically, she has an anxiety of scale: she fears she will become too big for her house. She tries to master her fear by moving *closer* to her house as an object. She makes detailed maps of the house, a child's version of architectural drawings. They lead her to see her house and its scale in a new way.

As a child, another scientist-to-be, suffered from the conventionality of the suburb in which he was born. He sees himself as a rebel, someone destined for other things. Venus Paradise coloring pencils become his first tools for expressing his sense of difference. The pencils are designed to constrain the user both in what color to apply and where to apply it. His rebellion is to use them in ways that break the rules. He determines that he will deliberately use the wrong colors and paint outside the lines. And yet, he also wants to contribute as a working scientist. He knows he will have to learn to paint both within and outside the lines. To work through these issues, The Venus Paradise Pencil By Number Coloring Set is an inspired object choice.

The psychoanalyst Erik Erikson said that play is children's work.[10] Children use play to separate from adults and develop their own identities. Separation and individuation is the work of childhood and children choose play objects that help them do this work. From this perspective, play, object work, is deeply motivated; the emotion that fuels the investigations of young scientists taps into this intensity.

This perspective on the playing child brings us to a very different place than we would get to with a question such as: "What objects should children play with to learn science?" The object that brings you to science has to be an object that speaks to a particular child. Not every object would have served Sacks as well as tungsten. Others could have been called into service, but tungsten had properties that made it unique—for Sacks.

Object mastery

In object play and mastery, we have a chance both to discover and defy reality as it is presented to us. We have an opportunity to shape things into what they might be. When this sense of discovery is turned toward the self, it is a stepping stone to increased maturity.[11] When it is turned toward the world, it sets up conditions for a scientific sensibility.

Children use object mastery to handle their earliest emotional challenges. Freud describes a game his grandson invented at one and a half as he played with spool and string. The child begins by making the spool disappear (calling it "*Fort*," gone) and then bringing it back (now it is "*Da*," there).[12] Freud theorized that this game of disappearance and return allowed the boy to manage his anxiety about the absences of his mother. By controlling the *actual* presence and absence of an object, he was able to represent his mother as a symbolic object, that is, represent his relationship with her. The young boy came to terms with a concept—that his mother can be gone and yet still be present—both in memory and symbolized in the objects of play. In the play worlds closest to them and in the expanded worlds they share with others, children seek mastery of things outside of themselves in order to put things right within. The role of objects is thus central. To quote Erikson: "As William Blake puts it: 'The child's toys and the old man's reasons are the fruits of the two seasons.'"[13]

The child, Erikson continues, is trying to "deal with experience by creating model

situations and to master reality by experiment and planning."[14] Such experiments can be done in the stillness of the laboratory or they can happen with the laughter and the physical exuberance of a backyard rumble. After one of my student's and her father picked up piles of cardboard refrigerator boxes from the back lot of a Sears Roebuck store, she and her friends began a series of physics experiments. Essentially, the experiments began with the children throwing their bodies around on the boxes. The group of friends realize that things go better if they take the flaps off the boxes and turn them into tubes. Then, the children try to get the boxes to move by standing inside them in little groups. Soon, the experimenters realize that things work even better if only one person stands inside a box. One person can build up speed by throwing his or her body against each side of the box in turn. Gradually, they discover that things go best of all if the person inside the box crawls at a steady pace, because they can work up a more continuous rolling motion. My student commented:

> As all this unfolded, we did not know that we were solving a problem through trial and error. All we were doing was having fun. But looking back, I see that we were applying a scientific method. We tried different ways of moving the box, we made mistakes, and we looked at the results, which we measured in a kind of "box travel distance." This is my first memory of a method I have used all my life, a method of learning through physical action. Everything I know and understand I have learned this way.

Object space

The boxes became an extension of the racers' bodies; otherwise put, they learned to think of object (box) space as body space. Like the objects in Freud's story of his nephew's spool and string, the boxes came to have a place in the children's inner and outer world. The psychoanalyst D. W. Winnicott called such objects transitional.[15]

Developmentally, Winnicott believes that the objects of the nursery (the stuffed animal, the favorite pillow) mediate between the child's sense of being part of the mother and of being an independent self. These objects leave traces that will mark the rest of an individual's life. The joint allegiance of transitional objects to self and external world demonstrates to the child that objects in the external world can be loved. Winnicott believes that during all stages of life, we continue to search for objects we can love, objects that we experience as both within and outside ourselves. As adults, we divide our experience into an inner and outer realm, and an "intermediate area of experiencing, to which inner reality and external life both contribute."[16] That intermediate area is creative, joyful, and expressive.

Some scientists describe science itself as characterized by moments of feeling both at one with and lost in nature, an experience of this intermediate space. Objects help young scientists reach that privileged space. One MIT student, reflecting on soap bubbles and volcanoes, describes that space as his place "within the without." Another, reflecting on the many variants of soil and water she can discern, writes of "being able to think like the mud." A third uses herself "as a geometer's instrument," her body and breath becoming ways to measure physical distances.

Gerald Sussman, a computer scientist at MIT, once described feeling so close to

a pair of binoculars given to him when he was five that when he thought of an idea, he thought that the binoculars shared in it. For example, the fact that he was able to look through his binoculars in both directions brought him to a theory of reversibility, the idea that there were some processes that could work backwards as well as forwards.[17] If you use gasoline to drive a car forwards, it must be possible to get a car to generate gasoline if you run it backwards, or put more formally, if you consume gasoline to generate motion, you should be able to consume motion to generate gasoline. Sussman became confident that a partnership with objects would lead him to discoveries that if not necessarily correct, were thrilling.

Sussman's sense of partnership was not only with a specific gadget but with nature as a whole. The story of the binocular-inspired theory of the motor that would run in reverse, is a story from Winnicott's intermediate zone of relating, where the individual feels at one with larger forces. Sussman's accomplishment did not lead to external reward or even external effect (no reverse motor ever produced any gasoline). Rather, it provides a window onto how the minds of children develop into the minds of scientists. It provides a window onto how object space becomes "transitional" space, a creative space where no idea is too "far out" and every idea can be made to feel part of the big picture.

Christopher Bollas, a psychoanalyst who works in Winnicott's tradition, analogizes these transitional moments to aesthetic moments, breaks in experience during which "the subject feels held in symmetry and solitude by the spirit of the object."[18]

And like Winnicott, Bollas makes it clear that once people have such object experiences, they search for them again and again. "The Christian may go to church and there hope to find traces of his experiences, the naturalist may look for another sighting of that rarest of birds that creates for him a moment of sudden awe, and the romantic poet walk his landscape hoping for a spot in time, a suspended moment when self and object feel reciprocally enhancing and mutually informative."[19] Young scientists become inspired by the feeling of objects in which they become lost on the way to finding themselves.

Objects do not determine the particular ideas they inspire. Sometimes the most important thing they inspire is that they provide children with the feeling of having a "charge," a "thrill" or a "secret theory" that leads them to want to have more. Five-year-olds with grand theories are never to be discouraged. They can be told there is more to learn, but they should be allowed to enjoy their "charges."

It is common for teachers to speak of emotions as though they were contents that might fill a vessel. In this view, children should feel more happinesss if they are enjoying science. But when Richard Feynman played with radios as a chid, his joy had little to do with enjoying "science." He begins his autobiography with a loving description of the "lamp bank" that he built when he was ten, a collection of sockets, bell wire, and serial and parallel switches, screwed down to a wooden base. Feynman plays with the lamp bank to get different voltages by setting switches up in different combinations, serial or parallel. He recounts his electronic universe: the radios he bought at rummage sales, his homemade burglar alarms and fuses. The fuses, made from tin foil, offer spectacle as well as intellectual excitement. Feynman sets them up with light bulbs across them so that he can see when a fuse has been blown. And he puts brown candy wrappers in front of the light bulbs so that a blown fuse translates into a beautiful red spot on his switchboard. "[T]hey would glooooooooooow, very pretty—it was great!"[20]

In such acccounts of children discovering science through objects, emotion does not seem a quantity, but a hue that infuses the space of discovery. In Feynman's pride in

his radios and Sacks's thrill when he meets tungsten and the periodic table, emotion is in the transitional space of the learning. One might even say it *is* the transitional space of the learning.

Object speed

Until the advent of digital culture, working with objects had a tendency to slow things down: with an object passion, you had to make the time to take your time. Scientific thinking that needed uninterrupted reflection flourished in the worlds around objects. School projects are rarely given the time that a young scientist spends building sand castles: the uninterrupted time of whole days and "a resource as boundless as a good stretch of beach and ocean." As a child, a geologist watches her rocks "that have become my friends, almost my children. I watch them even when I don't have to." She takes the time to "note when they behave strangely, observe how their characters alter when baked in groups."

The sand and minerals are natural objects; made artifacts are handled in the same spirit. Scientists describe youths in which they took telephones apart and put them back together again. Blocks worlds are built, taken apart, and re-built. Broken objects are not dismissed but have secrets to tell. In the chemistry laboratory, time seems to stop, as though the point of the experiment is to make more thinking time.

When you use a microscope you can let its world grow around you or place yourself above a magnified world and take a "bird's eye view." Either way, taking the time to play with scale takes time. These pleasures of the young scientist as scale traveler are not so different from young historians who throw themselves into literature that immerses them in other times and ways. What the scientist and the historian have in common is a learning experience that respects immersion rather than curricular pace. Neither has much in common with lesson plans that have teachers rushing through subjects with little time to explore in depth. Neither has much in common with what computers usually offer in educational settings—accelerated drill and practice, the possibility of multiple simulations, glamorized by graphics and exotic links.

One young computer scientist describes how analog objects corrected his digital sensibility. Digital photography gives him the fantasy that he can capture and manage nature. In contrast, the Holga camera, a primitive plastic camera that he describes as having "all the mechanical accuracy and precision of a jar of peanut butter" is humbling. The modest Holga inspires resourcefulness. In a digital photography studio, the student complains about all the materials he doesn't have; the Holga slows him down. He has to work with what is at hand.

Digital media never seems to "want" to be used slowly. The virtue of digital media is that it can present students with an endless stream of "what ifs" —thought experiments that try out possible branching structures of an argument or possible substitutions in an experimental procedure. "What if" possibilities are emblematic of digital life. At its heart, digital culture is about an infinity of possibility. One hacker called it a world where you build "straight from the mind."

Object passions bring us to the same enthusiasm for "what-is" that computation inspires for the "what-ifs." In the shadow of the virtual, some speak about the "what-is" of our planet as a limitation and constraint from which the fantasies of the virtual

might free us. This is telling. When we "fall for" someone, what we once saw as their limitations become simply who they are, their qualities. If we have to make accommodations, we see them as the consequences of relationship; we care for something precious. When we "fall for science" through objects, they ground us. We focus on what kind of sand is best for building castles, on the stubborn complexity of soap bubbles, on the details of light bent by a prism. I believe these moments open us, heart and mind, to "fall for" the what-is of Earth. In doing so, we may come to wonder at it, not only as a frontier of science, but as where we live.

Notes

1 This essay is an adaptation of Sherry Turkle, "Epilogue," in *Falling for Science: Objects in Mind* (MIT Press, 2008). All students cited have short essays in that collection.

2 Seymour Papert, *Mindstorms: Children, Computers, and Powerful Ideas* (New York: Basic Books, 1981).

3 Lacan drew the circles in four colors, designating what he called the imaginary, the symbolic, and the real, and a fourth circle that he referred to as the *symptôme*. The circles were interlocking so that when one is cut, the whole chain of circles becomes undone.
 For a fuller description of the Lacan visit, see Sherry Turkle, *Psychoanalytic Politics: Jacques Lacan and Freud's French Revolution* (Guilford, Conn.: Guilford Press, 1991 [1978]).

4 Walt Whitman, *Leaves of Grass* (New York: Random House, 1993 [1855]), 454.

5 Oliver Sacks. *Uncle Tungsten: Memories of a Chemical Boyhood* (New York: Alfred A. Knopf, 2001), 38–39.

6 Ibid, 187.

7 Ibid., 191.

8 Ibid., 194.

9 Ibid., 211.

10 Erik Erikson, *Childhood and Society* (New York: Norton, 1964), 222.

11 "The playing adult steps sideward into another reality; the playing child advances forward to new stages of mastery." Ibid., 222.

12 Sigmund Freud, "Beyond the Pleasure Principle (1920)," in *The Standard Edition of the Complete Psychological Works of Sigmund Freud*. Edited and Translated by James Strachey (London: The Hogarth Press, 1919–1954).

13 Erikson, *Childhood and Society*, 222.

14 Ibid.

15 D. W. Winnicott, "Transitional Objects and Transitional Phenomena: A Study of the First Not-Me Possession." *International Journal of Psychoanalysis*, vol. 34, no. 2: 89–97.

16 D. W. Winnicott, *Playing and Reality* (New York, Basic Books, 1971), 2.

17 Sussman continues: "I was really shaken by that—that you could turn them around and it worked both way. Somehow that clicked with other things—like if you look in a mirror and see someone, they can see you. I remember all of these things happened very fast. And all of a sudden I had this large collection of things and I suddenly realized that they were all the same thing. Turkle, *The Second Self: Computers and the Human Spirit* (Cambridge, MA: MIT Press, 2005 [1984]), 231.

18 Christopher Bollas, *The Shadow of the Object: Psychoanalysis of the Unthought Known* (New York: Columbia University Press, 1987).

19 Ibid.

20 Richard Feynman, *Surely You're Joking Mr. Feynman!* [as told to Ralph Leighton; Edward Hutchins, ed.] (New York: W. W. Norton, 1985), 15.

PART V

The Objecthood of Images

Michael Fried

ART AND OBJECTHOOD[*]

Edwards's journals frequently explored and tested a meditation he seldom allowed to reach print; if all the world were annihilated, he wrote . . . and a new world were freshly created, though it were to exist in every particular in the same manner as this world, it would not be the same. Therefore, because there is continuity, which is time, "it is certain with me that the world exists anew every moment; that the existence of things every moment ceases and is every moment renewed." The abiding assurance is that "we every moment see the same proof of a God as we should have seen if we had seen Him create the world at first."

<div align="right">Perry Miller, Jonathan Edwards[1]</div>

1

The enterprise known variously as Minimal Art, ABC Art, Primary Structures, and Specific Objects is largely ideological. [. . .] It seeks to declare and occupy a position— one that can be formulated in words and in fact has been so formulated by some of its leading practitioners. If this distinguishes it from modernist painting and sculpture on the one hand, it also marks an important difference between Minimal Art—or, as I prefer to call it, *literalist* art—and Pop or Op Art on the other. From its inception, literalist art has amounted to something more than an episode in the history of taste. It belongs rather to the history—almost the natural history—of sensibility, and it is not an isolated episode but the expression of a general and pervasive condition. Its seriousness is vouched for by the fact that it is in relation both to modernist painting and modernist sculpture that literalist art defines or locates the position it aspires to occupy. (This, I suggest, is what makes what it declares something that deserves to be called a position.) Specifically, literalist art conceives of itself as neither one nor the other; on the contrary, it is motivated by specific reservations or worse about both, and it aspires,

perhaps not exactly, or not immediately, to displace them, but in any case to establish itself as an independent art on a footing with either.

The literalist case against painting rests mainly on two counts: the relational character of almost all painting and the ubiquitousness, indeed the virtual inescapability, of pictorial illusion. In Donald Judd's view,

> When you start relating parts, in the first place, you're assuming you have a vague whole—the rectangle of the canvas—and definite parts, which is all screwed up, because you should have a definite *whole* and maybe no parts, or very few.[2]

The more the shape of the support is emphasized, as in recent modernist painting, the tighter the situation becomes:

> The elements inside the rectangle are broad and simple and correspond closely to the rectangle. The shapes and surface are only those that can occur plausibly within and on a rectangular plane. The parts are few and so subordinate to unity as not to be parts in an ordinary sense. A painting is nearly an entity, one thing, and not the indefinable sum of a group of entities and references. The one thing overpowers the earlier painting. It also establishes the rectangle as a definite form; it is no longer a fairly neutral limit. A form can be used only in so many ways. The rectangular plane is given a life span. The simplicity required to emphasize the rectangle limits the arrangements possible within it.

Painting is here seen as an art on the verge of exhaustion, one in which the range of acceptable solutions to a basic problem—how to organize the surface of the picture—is severely restricted. The use of shaped rather than rectangular supports can, from the literalist point of view, merely prolong the agony. The obvious response is to give up working on a single plane in favor of three dimensions. That, moreover, automatically

> gets rid of the problem of illusionism and of literal space, space in and around marks and colors—which is riddance of one of the salient and most objectionable relics of European art. The several limits of painting are no longer present. A work can be as powerful as it can be thought to be. Actual space is intrinsically more powerful and specific than paint on a flat surface.

The literalist attitude toward sculpture is more ambiguous. Judd, for example, seems to think of what he calls Specific Objects as something other than sculpture, while Robert Morris conceives of his own unmistakably literalist work as resuming the lapsed tradition of Constructivist sculpture established by Vladimir Tatlin, Aleksandr Rodchenko, Naum Gabo, Antoine Pevsner, and Georges Vantongerloo. But this and other disagreements are less important than the views Judd and Morris hold in common. Above all they are opposed to sculpture that, like most painting, is "made part by part, by addition, composed" and in which "specific elements . . . separate from the whole, thus setting up relationships within the work." (They would include the work of David Smith and Anthony Caro under this description.) It is worth remarking that the "part-by-part"

and "relational" character of most sculpture is associated by Judd with what he calls *anthropomorphism:* "A beam thrusts; a piece of iron follows a gesture; together they form a naturalistic and anthropomorphic image. The space corresponds." Against such "multipart, inflected" sculpture Judd and Morris assert the values of wholeness, singleness, and indivisibility—of a work's being, as nearly as possible, "one thing," a single "Specific Object." Morris devotes considerable attention to "the use of strong gestalt or of unitary-type forms to avoid divisiveness"; while Judd is chiefly interested in the kind of wholeness that can be achieved through the repetition of identical units. The order at work in his pieces, as he once remarked of that in Frank Stella's stripe paintings, "is simply order, like that of continuity, one thing after another." For both Judd and Morris, however, the critical factor is *shape*. Morris's "unitary forms" are polyhedrons that resist being grasped other than as a single shape: the gestalt simply *is* the "constant, known shape." And shape itself is, in his system, "the most important sculptural value." Similarly, speaking of his own work, Judd has remarked that

> the big problem is that anything that is not absolutely plain begins to have parts in some way. The thing is to be able to work and do different things and yet not break up the wholeness that a piece has. To me the piece with the brass and the five verticals is above all *that shape*.

The shape *is* the object: at any rate, what secures the wholeness of the object is the singleness of the shape. It is, I believe, that emphasis on shape that accounts for the impression, which numerous critics have mentioned, that Judd's and Morris's pieces are *hollow*.

2

Shape has also been central to the most important painting of the past several years. In several recent essays I have tried to show how, in the work of Kenneth Noland, Jules Olitski, and Stella, a conflict has gradually emerged between shape as a fundamental property of objects and shape as a medium of painting.[3] Roughly, the success or failure of a given painting has come to depend on its ability to hold or stamp itself out or compel conviction as shape—that, or somehow to stave off or elude the question of whether or not it does so. Olitski's early spray paintings are the purest example of paintings that either hold or fail to hold as shapes, while in his more recent pictures, as well as in the best of Noland's and Stella's recent work, the demand that a given picture hold as shape is staved off or eluded in various ways. What is at stake in this conflict is whether the paintings or objects in question are experienced as paintings or as objects, and what decides their identity as *painting* is their confronting of the demand that they hold as shapes. Otherwise they are experienced as nothing more than objects. This can be summed up by saying that modernist painting has come to find it imperative that it defeat or suspend its own objecthood, and that the crucial factor in this undertaking is shape, but shape that must belong to *painting*—it must be pictorial, not, or not merely, literal. Whereas literalist art stakes everything on shape as a given property of objects, if not indeed as a kind of object in its own right. It aspires not to defeat or suspend its own objecthood, but on the contrary to discover and project objecthood as such.

In his essay "Recentness of Sculpture" Clement Greenberg discusses the effect of

presence, which, from the start, has been associated with literalist work.[4] This comes up in connection with the work of Anne Truitt, an artist Greenberg believes anticipated the literalists (he calls them Minimalists):

> Truitt's art did flirt with the look of non-art, and her 1963 show was the first in which I noticed how this look could confer an effect of *presence*. That presence as achieved through size was aesthetically extraneous, I already knew. That presence as achieved through the look of non-art was likewise aesthetically extraneous I did not yet know. Truitt's sculpture had this kind of presence but did not *hide* behind it. That sculpture could hide behind it—just as painting did—I found out only after repeated acquaintance with Minimal works of art: Judd's, Morris's, Andre's, Steiner's, some but not all of Smithson's, some but not all of LeWitt's. Minimal art can also hide behind presence as size: I think of Bladen (though I am not sure whether he is a certified Minimalist) as well as of some of the artists just mentioned.[5]

Presence can be conferred by size or by the look of nonart. Furthermore, what nonart means today, and has meant for several years, is fairly specific. In "After Abstract Expressionism" Greenberg wrote that "a stretched or tacked-up canvas already exists as a picture—though not necessarily as a *successful* one."[6] For that reason, as he remarks in "Recentness of Sculpture," the "look of non-art was no longer available to painting." Instead, "the borderline between art and non-art had to be sought in the three-dimensional, where sculpture was, and where everything material that was not art also was."[7] Greenberg goes on to say:

> The look of machinery is shunned now because it does not go far enough towards the look of non-art, which is presumably an "inert" look that offers the eye a minimum of "interesting" incident—unlike the machine look, which is arty by comparison (and when I think of Tinguely I would agree with this). Still, no matter how simple the object may be, there remain the relations and interrelations of surface, contour, and spatial interval. Minimal works are readable as art, as almost anything is today—including a door, a table, or a blank sheet of paper. . . . Yet it would seem that a kind of art nearer the condition of non-art could not be envisaged or ideated at this moment.[8]

The meaning in this context of "the condition of non-art" is what I have been calling objecthood. It is as though objecthood alone can, in the present circumstances, secure something's identity, if not as nonart, at least as neither painting nor sculpture; or as though a work of art—more accurately, a work of modernist painting or sculpture—were in some essential respect *not an object*.

There is, in any case, a sharp contrast between the literalist espousal of objecthood—almost, it seems, as an art in its own right— and modernist painting's self-imposed imperative that it defeat or suspend its own objecthood through the medium of shape. In fact, from the perspective of recent modernist painting, the literalist position evinces a sensibility not simply alien but antithetical to its own: as though, from that perspective, the demands of art and the conditions of objecthood were in direct conflict.

Here the question arises: What is it about objecthood as projected and hypostatized by the literalists that makes it, if only from the perspective of recent modernist painting, antithetical to art?

<div align="center">3</div>

The answer I want to propose is this: the literalist espousal of objecthood amounts to nothing other than a plea for a new genre of theater, and theater is now the negation of art.

Literalist sensibility is theatrical because, to begin with, it is concerned with the actual circumstances in which the beholder encounters literalist work. Morris makes this explicit. Whereas in previous art "what is to be had from the work is located strictly within [it]," the experience of literalist art is of an object in a *situation*—one that, virtually by definition, *includes the beholder*:

> The better new work takes relationships out of the work and makes them a function of space, light, and the viewer's field of vision. The object is but one of the terms in the newer aesthetic. It is in some way more reflexive because one's awareness of oneself existing in the same space as the work is stronger than in previous work, with its many internal relationships. One is more aware than before that he himself is establishing relationships as he apprehends the object from various positions and under varying conditions of light and spatial context.

Morris believes that this awareness is heightened by "the strength of the constant, known shape, the gestalt," against which the appearance of the piece from different points of view is constantly being compared. It is intensified also by the large scale of much literalist work:

> The awareness of scale is a function of the comparison made between that constant, one's body size, and the object. Space between the subject and the object is implied in such a comparison.

The larger the object, the more we are forced to keep our distance from it:

> It is this necessary, greater distance of the object in space from our bodies, in order that it be seen at all, that structures the nonpersonal or public mode [which Morris advocates]. However, it is just this distance between object and subject that creates a more extended situation, because physical participation becomes necessary.

The theatricality of Morris's notion of the "nonpersonal or public mode" seems obvious: the largeness of the piece, in conjunction with its nonrelational, unitary character, *distances* the beholder—not just physically but psychically. It is, one might say, precisely this distancing that *makes* the beholder a subject and the piece in question . . . an object. But it does not follow that the larger the piece, the more securely its "public" character

is established; on the contrary, "beyond a certain size the object can overwhelm and the gigantic scale becomes the loaded term." Morris wants to achieve presence through objecthood, which requires a certain largeness of scale, rather than through size alone. But he is also aware that the distinction is anything but hard and fast:

> For the space of the room itself is a structuring factor both in its cubic shape and in terms of the kind of compression different sized and proportioned rooms can effect upon the object-subject terms. That the space of the room becomes of such importance does not mean that an environmental situation is being established. The total space is hopefully altered in certain desired ways by the presence of the object. It is not controlled in the sense of being ordered by an aggregate of objects or by some shaping of the space surrounding the viewer.

The object, not the beholder, must remain the center or focus of the situation, but the situation itself *belongs to* the beholder—it is *his* situation. Or as Morris has remarked, "I wish to emphasize that things are in a space with oneself, rather than . . . [that] one is in a space surrounded by things." Again, there is no clear or hard distinction between the two states of affairs: one is, after all, *always* surrounded by things. But the things that are literalist works of art must somehow *confront* the beholder—they must, one might almost say, be placed not just in his space but in his *way*. None of this, Morris maintains,

> indicates a lack of interest in the object itself. But the concerns now are for more control of . . . the entire situation. Control is necessary if the variables of object, light, space, body, are to function. The object has not become less important. It has merely become less self-important.

It is, I think, worth remarking that "the entire situation" means exactly that: *all* of it—including, it seems, the beholder's *body*. There is nothing within his field of vision—nothing that he takes note of in any way—that declares its irrelevance to the situation, and therefore to the experience, in question. On the contrary, for something to be perceived at all is for it to be perceived as part of that situation. Everything counts—not as part of the object, but as part of the situation in which its objecthood is established and on which that objecthood at least partly depends.

4

Furthermore, the presence of literalist art, which Greenberg was the first to analyze, is basically a theatrical effect or quality—a kind of *stage* presence. It is a function not just of the obtrusiveness and, often, even aggressiveness of literalist work, but of the special complicity that that work extorts from the beholder. Something is said to have presence when it demands that the beholder take it into account, that he take it seriously—and when the fulfillment of that demand consists simply in being aware of the work and, so to speak, in acting accordingly. (Certain modes of seriousness are closed to the beholder by the work itself, i.e., those established by the finest painting and sculpture of the recent past. But, of course, those are hardly modes of seriousness in which most

people feel at home, or that they even find tolerable.) Here again the experience of being distanced by the work in question seems crucial: the beholder knows himself to stand in an indeterminate, open-ended—and unexacting—relation *as subject* to the impassive object on the wall or floor. In fact, being distanced by such objects is not, I suggest, entirely unlike being distanced, or crowded, by the silent presence of another *person;* the experience of coming upon literalist objects unexpectedly—for example, in somewhat darkened rooms—can be strongly, if momentarily, disquieting in just this way.

There are three main reasons why this is so. First, the size of much literalist work, as Morris's remarks imply, compares fairly closely with that of the human body. In this context Tony Smith's replies to questions about his six-foot cube, *Die* (1962), are highly suggestive:

> Q: Why didn't you make it larger so that it would loom over the
> observer?
> A: I was not making a monument.
> Q: Then why didn't you make it smaller so that the observer could see
> over the top?
> A: I was not making an object.[9]

One way of describing what Smith *was* making might be something like a surrogate person—that is, a kind of statue. (This reading finds support in the caption to a photograph of another of Smith's pieces, *The Black Box* (1963–65), published in the December 1967 issue of *Artforum,* in which Samuel Wagstaff, Jr., presumably with the artist's sanction, observed, "One can see the two-by-fours under the piece, which keep it from appearing like architecture or a monument, and set it off as sculpture." The two-by-fours are, in effect, a rudimentary pedestal, and thereby reinforce the statuelike quality of the piece.) Second, the entities or beings encountered in everyday experience in terms that most closely approach the literalist ideals of the nonrelational, the unitary, and the holistic are *other persons.* Similarly, the literalist predilection for symmetry, and in general for a kind of order that "is simply order . . . one thing after another," is rooted not, as Judd seems to believe, in new philosophical and scientific principles, whatever he takes these to be, but in *nature.* And third, the apparent hollowness of most literalist work—the quality of having an *inside*—is almost blatantly anthropomorphic. It is, as numerous commentators have remarked approvingly, as though the work in question has an inner, even secret, life—an effect that is perhaps made most explicit in Morris's *Untitled* (1965) a large ringlike form in two halves, with fluorescent light glowing from within at the narrow gap between the two. In the same spirit Tony Smith has said, "I'm interested in the inscrutability and mysteriousness of the thing."[10] He has also been quoted as saying:

> More and more I've become interested in pneumatic structures. In these, all
> of the material is in tension. But it is the character of the form that appeals to
> me. The biomorphic forms that result from the construction have a dream-
> like quality for me, at least like what is said to be a fairly common type of
> American dream.[11]

Smith's interest in pneumatic structures may seem surprising, but it is consistent both with his own work and with literalist sensibility generally. Pneumatic structures can

be described as hollow with a vengeance—the fact that they are not "obdurate, solid masses" (Morris) being insisted on instead of taken for granted. And it reveals something, I think, about what hollowness means in literalist art that the forms that result are "biomorphic."

<div align="center">5</div>

I am suggesting, then, that a kind of latent or hidden naturalism, indeed anthropomorphism, lies at the core of literalist theory and practice. The concept of presence all but says as much, though rarely so nakedly as in Tony Smith's statement, "I didn't think of them [i.e., the sculptures he 'always' made] as sculptures but as presences of a sort." The latency or hiddenness of the anthropomorphism has been such that the literalists themselves, as we have seen, have felt free to characterize the modernist art they *oppose*, for example, the sculpture of David Smith and Anthony Caro, as anthropomorphic— a characterization whose teeth, imaginary to begin with, have just been pulled. By the same token, however, what is wrong with literalist work is not that it is anthropomorphic but that the meaning and, equally, the hiddenness of its anthropomorphism are incurably theatrical. (Not all literalist art hides or masks its anthropomorphism; the work of lesser figures like Michael Steiner wears anthropomorphism on its sleeve.) *The crucial distinction that I am proposing is between work that is fundamentally theatrical and work that is not.* It is theatricality that, whatever the differences between them, links artists like Ronald Bladen and Robert Grosvenor,[12] both of whom have allowed "gigantic scale [to become] the loaded term" (Morris), with other, more restrained figures like Judd, Morris, Carl Andre, John McCracken, Sol LeWitt and—despite the size of some of his pieces—Tony Smith.[13] And it is in the interest, though not explicitly in the name, of theater that literalist ideology rejects both modernist painting and, at least in the hands of its most distinguished recent practitioners, modernist sculpture.

In this connection Tony Smith's description of a car ride taken at night on the New Jersey Turnpike before it was finished makes compelling reading:

> When I was teaching at Cooper Union in the first year or two of the fifties, someone told me how I could get onto the unfinished New Jersey Turnpike. I took three students and drove from somewhere in the Meadows to New Brunswick. It was a dark night and there were no lights or shoulder markers, lines, railings, or anything at all except the dark pavement moving through the landscape of the flats, rimmed by hills in the distance, but punctuated by stacks, towers, fumes, and colored lights. This drive was a revealing experience. The road and much of the landscape was artificial, and yet it couldn't be called a work of art. On the other hand, it did something for me that art had never done. At first I didn't know what it was, but its effect was to liberate me from many of the views I had had about art. It seemed that there had been a reality there that had not had any expression in art.
>
> The experience on the road was something mapped out but not socially recognized. I thought to myself, it ought to be clear that's the end of art. Most painting looks pretty pictorial after that. There is no way you can frame it, you just have to experience it. Later I discovered some abandoned

airstrips in Europe—abandoned works, Surrealist landscapes, something that had nothing to do with any function, created worlds without tradition. Artificial landscape without cultural precedent began to dawn on me. There is a drill ground in Nuremberg large enough to accommodate two million men. The entire field is enclosed with high embankments and towers. The concrete approach is three sixteen-inch steps, one above the other, stretching for a mile or so.

What seems to have been revealed to Smith that night was the pictorial nature of painting—even, one might say, the conventional nature of art. And *that* Smith seems to have understood not as laying bare the essence of art, but as announcing its end. In comparison with the unmarked, unlit, all but unstructured turnpike—more precisely, with the turnpike as experienced from within the car, traveling on it—art appears to have struck Smith as almost absurdly small ("All art today is an art of postage stamps," he has said), circumscribed, conventional. There was, he seems to have felt, no way to "frame" his experience on the road, no way to make sense of it in terms of art, to make art of it, at least as art then was. Rather, "you just have to experience it"—as it happens, as it merely is. (The experience alone is what matters.) There is no suggestion that this is problematic in any way. The experience is clearly regarded by Smith as wholly accessible to everyone, not just in principle but in fact, and the question of whether or not one has really had it does not arise. That this appeals to Smith can be seen from his praise of Le Corbusier as "more available" than Michelangelo: "The direct and primitive experience of the High Court Building at Chandigarh is like the Pueblos of the Southwest under a fantastic overhanging cliff. It's something everyone can understand." It is, I think, hardly necessary to add that the availability of modernist art is not of that kind, and that the rightness or relevance of one's conviction about specific modernist works, a conviction that begins and ends in one's experience of the work itself, is always open to question.

But what was Smith's experience on the turnpike? Or to put the same question another way, if the turnpike, airstrips, and drill ground are not works of art, what are they?—What, indeed, if not empty, or "abandoned," *situations?* And what was Smith's experience if not the experience of what I have been calling *theater?* It is as though the turnpike, airstrips, and drill ground reveal the theatrical character of literalist art, only without the object, that is, without the art itself—as though the object is needed only within a *room*[14] (or, perhaps, in any circumstances less extreme than these). In each of the above cases the object is, so to speak, *replaced* by something: for example, on the turnpike by the constant onrush of the road, the simultaneous recession of new reaches of dark pavement illumined by the onrushing headlights, the sense of the turnpike itself as something enormous, abandoned, derelict, existing for Smith alone and for those in the car with him. . . . This last point is important. On the one hand, the turnpike, airstrips, and drill ground belong to no one; on the other, the situation established by Smith's presence is in each case felt by him to be *his*. Moreover, in each case being able to go on and on indefinitely is of the essence. What replaces the object—what does the same job of distancing or isolating the beholder, of making him a subject, that the object did in the closed room—is above all the endlessness, or objectlessness, of the approach or onrush or perspective. It is the explicitness, that is to say, the sheer persistence with which the experience presents itself as directed at him from outside (on the turnpike

from outside the car) that simultaneously makes him a subject—makes him subject—and establishes the experience itself as something like that of an object, or rather, of objecthood. No wonder Morris's speculations about how to put literalist work outdoors remain strangely inconclusive:

> Why not put the work outdoors and further change the terms? A real need exists to allow this next step to become practical. Architecturally designed sculpture courts are not the answer nor is the placement of work outside cubic architectural forms. Ideally, it is a space, without architecture as background and reference, that would give different terms to work with.

Unless the pieces are set down in a wholly natural context, and Morris does not seem to be advocating this, some sort of artificial but not quite architectural setting must be constructed. What Smith's remarks seem to suggest is that the more effective—meaning effective *as theater*—a setting is made, the more superfluous the works themselves become.

<p style="text-align:center">6</p>

Smith's account of his experience on the turnpike bears witness to theater's profound hostility to the arts and discloses, precisely in the absence of the object and in what takes its place, what might be called the theatricality of objecthood. By the same token, however, the imperative that modernist painting defeat or suspend its objecthood is at bottom the imperative that it *defeat or suspend theater*. And *that* means that there is a war going on between theater and modernist painting, between the theatrical and the pictorial—a war that, despite the literalists' explicit rejection of modernist painting and sculpture, is not basically a matter of program and ideology but of experience, conviction, sensibility. (For example, it was a particular experience that engendered Smith's conviction that painting—that the arts as such—were finished.)

The starkness and apparent irreconcilability of this conflict are something new. I remarked earlier that objecthood has become an issue for modernist painting only within the past several years. This, however, is not to say that before the present situation came into being, paintings, or sculptures for that matter, simply *were objects*. It would, I think, be closer to the truth to say that they *simply* were not.[15] The risk, even the possibility, of seeing works of art as nothing more than objects did not exist. That such a possibility began to present itself around 1960 was largely the result of developments within modernist painting. Roughly, the more nearly assimilable to objects certain advanced painting had come to seem, the more the entire history of painting since Manet could be understood—delusively, I believe—as consisting in the progressive (though ultimately inadequate) revelation of its essential objecthood,[16] and the more urgent became the need for modernist painting to make explicit its conventional—specifically, its *pictorial*—essence by defeating or suspending its own objecthood through the medium of shape. The view of modernist painting as tending toward objecthood is implicit in Judd's remark, "The new [i.e., literalist] work obviously resembles sculpture more than it does painting, but is nearer to painting"; and it is in this view that literalist sensibility in general is grounded. Literalist sensibility is, therefore, a response to the *same* developments

that have largely compelled modernist painting to undo its objecthood—more precisely, the same developments *seen differently*, that is, in theatrical terms, by a sensibility *already* theatrical, already (to say the worst) corrupted or perverted by theater. Similarly, what has compelled modernist painting to defeat or suspend its own objecthood is not just developments internal to itself, but the same general, enveloping, infectious theatricality that corrupted literalist sensibility in the first place and in the grip of which the developments in question—and modernist painting in general—are seen as nothing more than an uncompelling and presenceless kind of theater. It was the need to break the fingers of that grip that made objecthood an issue for modernist painting.

Objecthood has also become an issue for modernist sculpture. This is true despite the fact that sculpture, being three-dimensional, resembles both ordinary objects and literalist work in a way that painting does not. Almost ten years ago Clement Greenberg summed up what he saw as the emergence of a new sculptural "style," whose master is undoubtedly David Smith, in the following terms:

> To render substance entirely optical, and form, whether pictorial, sculptural, or architectural, as an integral part of ambient space—this brings anti-illusionism full circle. Instead of the illusion of things, we are now offered the illusionism of modalities: namely, that matter is incorporeal, weightless, and exists only optically like a mirage.[17]

Since 1960 this development has been carried to a succession of climaxes by the English sculptor Anthony Caro, whose work is far more specifically resistant to being seen in terms of objecthood than that of David Smith. [. . .] A characteristic sculpture by Caro consists, I want to say, in the mutual and naked *juxtaposition* of the I-beams, girders, cylinders, lengths of piping, sheet metal, and grill that it comprises rather than in the compound *object* that they compose. The mutual inflection of one element by another, rather than the identity of each, is what is crucial—though of course altering the identity of any element would be at least as drastic as altering its placement. (The identity of each element matters in somewhat the same way as the fact that it is an arm, or this arm, that makes a particular gesture, or as the fact that it is this word or this note and not another that occurs in a particular place in a sentence or melody.) The individual elements bestow significance on one another precisely by virtue of their juxtaposition: it is in this sense, a sense inextricably involved with the concept of meaning, that everything in Caro's art that is worth looking at is in its syntax. Caro's concentration upon syntax amounts, in Greenberg's view, to "an emphasis on abstractness, on radical unlikeness to nature." And Greenberg goes on to remark, "No other sculptor has gone as far from the structural logic of ordinary ponderable things."[18] It is worth emphasizing, however, that this is a function of more than the lowness, openness, part-by-partness, absence of enclosing profiles and centers of interest, unperspicuousness, and so on, of Caro's sculptures. Rather, they defeat, or allay, objecthood by imitating, not gestures exactly, but the *efficacy* of gesture; like certain music and poetry, they are possessed by the knowledge of the human body and how, in innumerable ways and moods, it makes meaning. It is as though Caro's sculptures essentialize meaningfulness *as such*—as though the possibility of meaning what we say and do *alone* makes his sculpture possible. All this, it is hardly necessary to add, makes Caro's art a fountainhead of antiliteralist and antitheatrical sensibility.

There is another, more general respect in which objecthood has become an issue

for the most ambitious recent modernist sculpture, and that is in regard to color. This is a large and difficult subject, which I cannot hope to do more than touch on here. Briefly, however, color has become problematic for modernist sculpture, not because one senses that it has been applied, but because the color of a given sculpture, whether applied or in the natural state of the material, is identical with its surface; and inasmuch as all objects have surface, awareness of the sculpture's surface implies its objecthood—thereby threatening to qualify or mitigate the undermining of objecthood achieved by opticality and, in Caro's pieces, by their syntax as well. It is in this connection, I believe, that a recent sculpture by Jules Olitski, *Bunga 45* (1967), ought to be seen. *Bunga 45* consists of between fifteen and twenty metal tubes, ten feet long and of various diameters, placed upright, riveted together, and then sprayed with paint of different colors; the dominant hue is yellow to yellow orange, but the top and "rear" of the piece are suffused with a deep rose, and close looking reveals flecks and even thin trickles of green and red as well. A rather wide red band has been painted around the top of the piece, while a much thinner band in two different blues (one at the "front" and another at the "rear") circumscribes the very bottom. Obviously, *Bunga 45* relates intimately to Olitski's spray paintings, especially those of the past year or so, in which he has worked with paint and brush at or near the limits of the support. At the same time, it amounts to something far more than an attempt simply to make or "translate" his paintings into sculptures, namely, an attempt to establish surface—the surface, so to speak, of *painting*—as a medium of sculpture. The use of tubes, each of which one sees, incredibly, as *flat*—that is, flat but *rolled*—makes *Bunga 45*'s surface more like that of a painting than like that of an object: like painting, and unlike both ordinary objects and other sculpture, *Bunga 45* is *all* surface. And of course what declares or establishes that surface is color, Olitski's sprayed color.

7

At this point I want to make a claim that I cannot hope to prove or substantiate but that I believe nevertheless to be true: theater and theatricality are at war today, not simply with modernist painting (or modernist painting and sculpture), but with art as such—and to the extent that the different arts can be described as modernist, with modernist sensibility as such. This claim can be broken down into three propositions or theses:

1. *The success, even the survival, of the arts has come increasingly to depend on their ability to defeat theater.* This is perhaps nowhere more evident than within theater itself, where the need to defeat what I have been calling theater has chiefly made itself felt as the need to establish a drastically different relation to its audience. (The relevant texts are, of course, Brecht and Artaud.)[19] For theater has an audience—it exists for one—in a way the other arts do not; in fact, this more than anything else is what modernist sensibility finds intolerable in theater generally. Here it should be remarked that literalist art too possesses an audience, though a somewhat special one: that the beholder is confronted by literalist work within a situation that he experiences as his means that there is an important sense in which the work in question exists for him alone, even if he is not actually alone with the work at the time. It may seem paradoxical to claim both that literalist sensibility aspires to an ideal of "something everyone can understand" (Smith) and that literalist art addresses itself to the beholder alone, but the paradox is only apparent.

Someone has merely to enter the room in which a literalist work has been placed to become that beholder, that audience of one—almost as though the work in question has been waiting for him. And inasmuch as literalist work depends on the beholder, is incomplete without him, it *has* been waiting for him. And once he is in the room the work refuses, obstinately, to let him alone—which is to say, it refuses to stop confronting him, distancing him, isolating him. (Such isolation is not solitude any more than such confrontation is communion.)

It is the overcoming of theater that modernist sensibility finds most exalting and that it experiences as the hallmark of high art in our time. There is, however, one art that, by its very nature, escapes theater entirely—the movies.[20] This helps explain why movies in general, including frankly appalling ones, are acceptable to modernist sensibility whereas all but the most successful painting, sculpture, music, and poetry is not. Because cinema escapes theater—automatically, as it were—it provides a welcome and absorbing refuge to sensibilities at war with theater and theatricality. At the same time, the automatic, guaranteed character of the refuge—more accurately, the fact that what is provided is a refuge from theater and not a triumph over it, absorption not conviction—means that the cinema, even at its most experimental, is not a modernist art.

2. *Art degenerates as it approaches the condition of theater.* Theater is the common denominator that binds together a large and seemingly disparate variety of activities, and that distinguishes those activities from the radically different enterprises of the modernist arts. Here as elsewhere the question of value or level is central. For example, a failure to register the enormous difference in quality between, say, the music of Elliott Carter and that of John Cage or between the paintings of Louis and those of Robert Rauschenberg means that the real distinctions—between music and theater in the first instance and between painting and theater in the second—are displaced by the illusion that the barriers between the arts are in the process of crumbling (Cage and Rauschenberg being seen, correctly, as similar) and that the arts themselves are at last sliding towards some kind of final, implosive, highly desirable synthesis. Whereas in fact the individual arts have never been more explicitly concerned with the conventions that constitute their respective essences.

3. *The concepts of quality and value*—and to the extent that these are central to art, the concept of art itself—are meaningful, or wholly meaningful, only within *the individual arts. What lies* between *the arts is theater.* It is, I think, significant that in their various statements the literalists have largely avoided the issue of value or quality at the same time as they have shown considerable uncertainty as to whether or not what they are making is art. To describe their enterprise as an attempt to establish a *new* art does not remove the uncertainty; at most it points to its source. Judd himself has as much as acknowledged the problematic character of the literalist enterprise by his claim, "A work needs only to be interesting." For Judd, as for literalist sensibility generally, all that matters is whether or not a given work is able to elicit and sustain (his) *interest.* Whereas within the modernist arts nothing short of *conviction*—specifically, the conviction that a particular painting or sculpture or poem or piece of music can or cannot support comparison with past work within that art whose quality is not in doubt—matters at all. (Literalist work is often condemned—when it is condemned—for being boring. A tougher charge would be that it is merely interesting.)

The interest of a given work resides, in Judd's view, both in its character as a whole and in the sheer *specificity* of the materials of which it is made:

> Most of the work involves new materials, either recent inventions or things not used before in art. . . . Materials vary greatly and are simply materials— formica, aluminum, cold-rolled steel, plexiglass, red and common brass, and so forth. They are specific. If they are used directly, they are more specific. Also, they are usually aggressive. There is an objectivity to the obdurate identity of a material.

Like the shape of the object, the materials do not represent, signify, or allude to anything; they are what they are and nothing more. And what they are is not, strictly speaking, something that is grasped or intuited or recognized or even seen once and for all. Rather, the "obdurate identity" of a specific material, like the wholeness of the shape, is simply stated or given or established at the very outset, if not before the outset; accordingly, the experience of both is one of endlessness, or inexhaustibility, of being able to go on and on letting, for example, the material itself confront one in all its literalness, its "objectivity," its absence of anything beyond itself. In a similar vein Morris has written:

> Characteristic of a gestalt is that once it is established all the information about it, *qua* gestalt, is exhausted. (One does not, for example, seek the gestalt of a gestalt.) . . . One is then both free of the shape and bound to it. Free or released because of the exhaustion of information about it, as shape, and bound to it because it remains constant and indivisible.

The same note is struck by Tony Smith in a statement the first sentence of which I quoted earlier:

> I'm interested in the inscrutability and mysteriousness of the thing. Something obvious on the fact of it (like a washing machine or a pump) is of no further interest. A Bennington earthenware jar, for instance, has subtlety of color, largeness of form, a general suggestion of substance, generosity, is calm and reassuring—qualities that take it beyond pure utility. It continues to nourish us time and time again. We can't see it in a second, we continue to read it. There is something absurd in the fact that you can go back to a cube in the same way.

Like Judd's Specific Objects and Morris's gestalts or unitary forms, Smith's cube is always of further interest; one never feels that one has come to the end of it; it is inexhaustible. It is inexhaustible, however, not because of any fullness—*that* is the inexhaustibility of art—but because there is nothing there to exhaust. It is endless the way a road might be, if it were circular, for example.

Endlessness, being able to go on and on, even having to go on and on, is central both to the concept of interest and to that of objecthood. In fact, it seems to be the experience that most deeply excites literalist sensibility, and that literalist artists seek to objectify in their work—for example, by the repetition of identical units (Judd's "one thing after another"), which carries the implication that the units in question could be multiplied ad infinitum.[21] Smith's account of his experience on the unfinished turnpike records that excitement all but explicitly. Similarly, Morris's claim that in the best new work the beholder is made aware that "he himself is establishing relationships as he

apprehends the object from various positions and under varying conditions of light and spatial context" amounts to the claim that the beholder is made aware of the endlessness and inexhaustibility if not of the object itself at any rate of his experience of it. This awareness is further exacerbated by what might be called the inclusiveness of his situation, that is, by the fact, remarked earlier, that everything he observes counts as part of that situation and hence is felt to bear in some way that remains undefined on his experience of the object.

Here finally I want to emphasize something that may already have become clear: the experience in question *persists in time*, and the presentment of endlessness that, I have been claiming, is central to literalist art and theory is essentially a presentment of endless or indefinite *duration*. Once again Smith's account of his night drive is relevant, as well as his remark, "We can't see it [the jar and, by implication, the cube] in a second, we continue to read it." Morris too has stated explicitly, "The experience of the work necessarily exists in time"—though it would make no difference if he had not. The literalist preoccupation with time—more precisely, with the *duration of the experience*—is, I suggest, paradigmatically theatrical, as though theater confronts the beholder, and thereby isolates him, with the endlessness not just of objecthood but of *time;* or as though the sense which, at bottom, theater addresses is a sense of temporality, of time both passing and to come, *simultaneously approaching and receding*, as if apprehended in an infinite perspective. . . .[22] That preoccupation marks a profound difference between literalist work and modernist painting and sculpture. It is as though one's experience of the latter *has no* duration—not because one in fact experiences a picture by Noland or Olitski or a sculpture by David Smith or Caro in no time at all, but because *at every moment the work itself is wholly manifest*. (This is true of sculpture despite the obvious fact that, being three-dimensional, it can be seen from an infinite number of points of view. One's experience of a Caro is not incomplete, and one's conviction as to its quality is not suspended, simply because one has seen it only from where one is standing. Moreover, in the grip of his best work one's view of the sculpture is, so to speak, eclipsed by the sculpture itself—which it is plainly meaningless to speak of as only partly present.) It is this continuous and entire *presentness*, amounting, as it were, to the perpetual creation of itself, that one experiences as a kind of *instantaneousness*, as though if only one were infinitely more acute, a single infinitely brief instant would be long enough to see everything, to experience the work in all its depth and fullness, to be forever convinced by it. (Here it is worth noting that the concept of interest implies temporality in the form of continuing attention directed at the object whereas the concept of conviction does not.) I want to claim that it is by virtue of their presentness and instantaneousness that modernist painting and sculpture defeat theater. In fact, I am tempted far beyond my knowledge to suggest that, faced with the need to defeat theater, it is above all to the condition of painting and sculpture—the condition, that is, of existing in, indeed of evoking or constituting, a continuous and perpetual *present*—that the other contemporary modernist arts, most notably poetry and music, aspire.[23]

<div style="text-align:center">

8

</div>

This essay will be read as an attack on certain artists (and critics) and as a defense of others. And of course it is true that the desire to distinguish between what is to me the

authentic art of our time and other work which, whatever the dedication, passion, and intelligence of its creators, seems to me to share certain characteristics associated here with the concepts of literalism and theater has largely motivated what I have written. In these last sentences, however, I want to call attention to the utter pervasiveness— the virtual universality—of the sensibility or mode of being that I have characterized as corrupted or perverted by theater. We are all literalists most or all of our lives. Present-ness is grace.

Notes

* Originally published in *Artforum* 5 (June 1967): 12–23. Republished on several occasions, most importantly in *Minimal Art: A Critical Anthology*, ed. Gregory Battcock (New York, 1968), pp. 116–47.

1 Perry Miller, *Jonathan Edwards* (1949; rpt., New York, 1959), pp. 329–30.

2 This was said by Judd in an interview with Bruce Glaser, edited by Lucy R. Lippard and published as "Questions to Stella and Judd" in *Art News* in 1966 and reprinted in *Minimal Art*, ed. Gregory Battcock (New York, 1968), pp. 148–64. The remarks attributed in the present essay to Judd and Morris have been taken from that interview; from Donald Judd's essay "Specific Objects," *Arts Yearbook*, no. 8 (1965), pp. 74–82; and from Robert Morris's essays, "Notes on Sculpture" and "Notes on Sculpture, Part 2," published in *Artforum* in Feb. and Oct. 1966, respectively, and reprinted in Battcock, ed., *Minimal Art*, pp. 222–35. I have also taken one remark by Morris from the catalog to the exhibition *Eight Sculptors: The Ambiguous Image* at the Walker Art Center, Minneapolis, Oct.–Dec. 1966. I should add that in laying out what seems to me the position Judd and Morris hold in common I have ignored various differences between them and have used certain remarks in contexts for which they may not have been intended. Moreover, I haven't always indicated which of them actually said or wrote a particular phrase; the alternative would have been to litter the text with footnotes.

3 See Michael Fried, "Shape as Form: Frank Stella's Irregular Polygons"; idem, "Jules Olitski"; and idem, "Ronald Davis: Surface and Illusion." [. . .]

4 Clement Greenberg, "Recentness of Sculpture," in the catalog to the Los Angeles County Museum of Art's 1967 exhibition *American Sculpture of the Sixties* (see Greenberg, *Modernism with a Vengeance 1957–1969*, vol. 4 of *The Collected Essays and Criticism*, ed. John O'Brian [Chicago, 1993], pp. 250–56). The verb "project" as I have just used it is taken from Greenberg's statement, "The ostensible aim of the Minimalists is to 'project' objects and ensembles of objects that are just nudgeable into art" (*Modernism with a Vengeance*, p. 253).

5 Greenberg, *Modernism with a Vengeance*, pp. 255–56.

6 Greenberg, "After Abstract Expressionism," *Art International* 6 (October 25, 1962): 30. The passage from which this has been taken reads as follows: "Under the testing of modernism more and more of the conventions of the art of painting have shown themselves to be dispensable, unessential. By now it has been established, it would seem, that the irreducible essence of pictorial art consists in but two constitutive conventions or norms: flatness and the delimitation of flatness; and that the observance of merely these two norms is enough to create an object which can be experienced as a picture: thus a stretched or tacked-up canvas already exists as a picture—though not necessarily as a *successful* one".
 In its broad outline this is undoubtedly correct. There are, however, certain qualifications that can be made. To begin with, it is not quite enough to say that a bare canvas tacked to a wall is not "necessarily" a successful picture; it would, I think, be more accurate [what I originally wrote was "less of an exaggeration"—*M.F., 1996*] to say that it is not

conceivably one. It may be countered that future circumstances might be such as to *make* it a successful painting, but I would argue that, for that to happen, the enterprise of paint-ing would have to change so drastically that nothing more than the name would remain. (It would require a far greater change than that which painting has undergone from Manet to Noland, Olitski, and Stella!) Moreover, seeing something as a painting in the sense that one sees the tacked-up canvas as a painting, and being convinced that a particular work can stand comparison with the painting of the past whose quality is not in doubt, are altogether different experiences: it is, I want to say, as though unless something compels conviction as to its quality it is no more than trivially or nominally a painting. This suggests that flatness and the delimitation of flatness ought not to be thought of as the "irreducible essence of pic-torial art," but rather as something like the *minimal conditions for something's being seen as a painting;* and that the crucial question is not what those minimal and, so to speak, timeless conditions are, but rather what, at a given moment, is capable of compelling conviction, of succeeding as painting. This is not to say that painting *has no* essence; it *is* to claim that that essence—i.e., that which compels conviction—is largely determined by, and therefore changes continually in response to, the vital work of the recent past. The essence of paint-ing is not something irreducible. Rather, the task of the modernist painter is to discover those conventions that, at a given moment, *alone* are capable of establishing his work's iden-tity as painting.

Greenberg approaches this position when he adds, "As it seems to me, Newman, Rothko, and Still have swung the self-criticism of modernist painting in a new direction simply by continuing it in its old one. The question now asked through their art is no longer what constitutes art, or the art of painting, as such, but what irreducibly constitutes *good* art as such. Or rather, what is the ultimate source of value or quality in art?" But I would argue that what modernism has meant is that the two questions—What constitutes the art of painting? And what constitutes *good* painting?—are no longer separable; the first dis-appears, or increasingly tends to disappear, into the second. (I am, of course, taking issue here with the version of modernism put forward in the introduction to *Three American Paint-ers* [. . .].)

For more on the nature of essence and convention in the modernist arts see my essays on Stella and Olitski cited in n. 3 above, as well as Stanley Cavell, "Music Discomposed," and "Rejoinders" to critics of that essay, to be published as part of a symposium by the Uni-versity of Pittsburgh Press in a volume entitled *Art, Mind and Religion.* [For those essays see Cavell, "Music Discomposed" and "A Matter of Meaning It," in *Must We Mean What We Say? A Book of Essays* (New York, 1969), pp. 180–237.—*M. F., 1996*]

7 Greenberg, *Modernism with a Vengeance*, p. 252.
8 Ibid., pp. 253–54.
9 Quoted by Morris as the epigraph to his "Notes on Sculpture, Part 2."
10 Except for the question-and-answer exchange quoted by Morris, all statements by Tony Smith have been taken from Samuel Wagstaff, Jr., "Talking to Tony Smith," *Artforum* 5 (December 1966): 14–19, and reprinted (with certain omissions) in Battcock, ed., *Mini-mal Art*, pp. 381–86.
11 This appears in the Wagstaff interview in *Artforum* (p. 17) but not in the republication of that interview in *Minimal Art.*—*M.F., 1966*
12 In the catalog to last spring's *Primary Structures* exhibition at the Jewish Museum, Bladen wrote, "How do you make the inside the outside?" and Grosvenor, "I don't want my work to be thought of as 'large sculpture,' they are ideas that operate in the space between floor and ceiling." The relevance of these statements to what I have adduced as evidence for the theatricality of literalist theory and practice seems obvious (catalog for the exhibition *Pri-mary Structures: Younger American and British Sculptors*, shown at the Jewish Museum, New York, April 27–June 12, 1966, no page numbers).

13 It is theatricality, too, that links all these artists to other figures as disparate as Kaprow, Cornell, Rauschenberg, Oldenburg, Flavin, Smithson, Kienholz, Segal, Samaras, Christo, Kusama . . . the list could go on indefinitely.

14 The concept of a room is, mostly clandestinely, important to literalist art and theory. In fact, it can often be substituted for the word "space" in the latter: something is said to be in my space if it is in the same room with me (and if it is placed so that I can hardly fail to notice it).

15 In a discussion of this claim with Stanley Cavell it emerged that he once remarked in a seminar that for Kant in the *Critique of Judgment* a work of art is not an object.—*M. F., 1966*

16 One way of describing this view might be to say that it draws something like a false inference from the fact that the increasingly explicit acknowledgement of the literal character of the support has been central to the development of modernist painting: namely, that literalness as such is an artistic value of supreme importance. In "Shape as Form" I argued that this inference is blind to certain vital considerations, and that literalness—more precisely, the literalness of the support—is a value only within modernist painting, and then only because it has been made one by the history of that enterprise.

17 Clement Greenberg, "The New Sculpture," in *Art and Culture: Critical Essays* (Boston, 1961), p. 144.

18 The statement that "everything in Caro's art that is work looking at—except the color—is in its syntax" appears in my introduction to Caro's 1963 exhibition at the Whitechapel Art Gallery [. . .] It is quoted with approval by Greenberg, who then goes on to make the statements quoted above, in "Anthony Caro," *Arts Yearbook*, no. 8 (1965), reprinted as "Contemporary Sculpture: Anthony Caro," in *Modernism with a Vengeance*, pp. 205–08.) Caro's first step in that direction, the elimination of the pedestal, seems in retrospect to have been motivated not by the desire to present his work without artificial aids so much as by the need to undermine its objecthood. His work has revealed the extent to which merely putting something on a pedestal confirms it in its objecthood, though merely removing the pedestal does not in itself undermine objecthood, as literalist work demonstrates.

19 The need to achieve a new relation to the spectator, which Brecht felt and which he discussed time and again in his writings on theater, was not simply the result of his Marxism. On the contrary, his discovery of Marx seems to have been in part the discovery of what that relation might be like, what it might mean: "When I read Marx's *Capital* I understood my plays. Naturally I want to see this book widely circulated. It wasn't of course that I found I had unconsciously written a whole pile of Marxist plays; but this man Marx was the only spectator for my plays I'd ever come across" (Bertolt Brecht, *Brecht on Theater*, ed. and trans. John Willett [New York, 1964], pp. 23–24).

20 Exactly how the movies escape theater is a difficult question, and there is no doubt but that a phenomenology of the cinema that concentrated on the similarities and differences between it and stage drama—e.g., that in the movies the actors are not physically present, the film itself is projected *away* from us, and the screen is not experienced as a kind of object existing in a specific physical relation to us—would be rewarding.

21 That is, the actual number of such units in a given piece is felt to be arbitrary, and the piece itself—despite the literalist preoccupation with holistic forms—is seen as a fragment of, or cut into, something infinitely larger. This is one of the most important differences between literalist work and modernist painting, which has made itself responsible for its physical limits as never before. Noland's and Olitski's paintings are two obvious, and different, cases in point. It is in this connection, too, that the importance of the painted bands around the bottom and the top of Olitski's sculpture *Bunga* becomes clear.

22 The connection between spatial recession and some such experience of temporality—almost as if the first were a kind of natural metaphor for the second—is present in much Surrealist painting (e.g., De Chirico, Dali, Tanguy, Magritte). Moreover,

temporality—manifested, for example, as expectation, dread, anxiety, presentiment, memory, nostalgia, stasis—is often the explicit subject of their paintings. There is, in fact, a deep affinity between literalist and Surrealist sensibility (at any rate, as the latter makes itself felt in the work of the above painters) that ought to be noted. Both employ imagery that is at once holistic and, in a sense, fragmentary, incomplete; both resort to a similar anthropomorphizing of objects or conglomerations of objects (in Surrealism the use of dolls and manikins makes that explicit); both are capable of achieving remarkable effects of "presence"; and both tend to deploy and isolate objects and persons in "situations"—the closed room and the abandoned artificial landscape are as important to Surrealism as to literalism. (Tony Smith, it will be recalled, described the airstrips, etc., as "Surrealist landscapes.") This affinity can be summed up by saying that Surrealist sensibility, as manifested in the work of certain artists, and literalist sensibility are both theatrical. I do not wish, however, to be understood as saying that because they are theatrical, all Surrealist works that share the above characteristics fail as art; a conspicuous example of major work that can be described as theatrical is Giacometti's Surrealist sculpture. On the other hand, it is perhaps not without significance that Smith's supreme example of a Surrealist landscape was the parade ground at Nuremberg.

23 What this means in each art will naturally be different. For example, music's situation is especially difficult in that music shares with theater the convention, if I may call it that, of duration—a convention that, I am suggesting, has itself become increasingly theatrical. Besides, the physical circumstances of a concert closely resemble those of a theatrical performance. It may have been the desire for something like presentness that, at least to some extent, led Brecht to advocate a nonillusionistic theater, in which for example the stage lighting would be visible to the audience, in which the actors would not identify with the characters they play but rather would show them forth, and in which temporality itself would be presented in a new way:

> Just as the actor no longer has to persuade the audience that it is the author's character and not himself that is standing on the stage, so also he need not pretend that the events taking place on the stage have never been rehearsed, and are now happening for the first and only time. Schiller's distinction is no longer valid: that the rhapsodist has to treat his material as wholly in the past: the mime his, as wholly here and now. It should be apparent all through his performance that "even at the start and in the middle he knows how it ends" and he must "thus maintain a calm independence throughout." He narrates the story of his character by vivid portrayal, always knowing more than it does and treating "now" and "here" not as a pretence made possible by the rules of the game but as something to be distinguished from yesterday and some other place, so as to make visible the knotting together of the events. (*Brecht on Theater*, p. 194)

But just as the exposed lighting Brecht advocates has become merely another kind of theatrical convention (one, moreover, that often plays an important role in the presentation of literalist work, as the installation view of Judd's six-cube piece in the Dwan Gallery shows), it is not clear whether the handling of time Brecht calls for is tantamount to authentic presentness, or merely to another kind of "presence"—to the presentment of time itself as though it were some sort of literalist object. In poetry the need for presentness manifests itself in the lyric poem; this is a subject that requires its own treatment.

For discussions of theater relevant to this essay see Stanley Cavell's essays "Ending the Waiting Game" (on Beckett's *End-Game*) and "The Avoidance of Love: A Reading of *King Lear*," in *Must We Mean What We Say?* pp. 115–62 and 267–353.

Siegfried Kracauer

CALICO-WORLD
The UFA City in Neubabelsberg

In the middle of the Grunewald[1] is a fenced-in area that one can enter only after going through various checkpoints. It is a desert within an oasis. The natural things outside—trees made out of wood, lakes with water, villas that are inhabitable—have no place within its confines. But the world does reappear there—indeed, the entire macrocosm seems to be gathered in this new version of Noah's ark. But the things that rendezvous here do not belong to reality. They are copies and distortions that have been ripped out of time and jumbled together. They stand motionless, full of meaning from the front, while from the rear they are just empty nothingness. A bad dream about objects that has been forced into the corporeal realm.

We find ourselves in the film city of the UFA studios in Neubabelsberg,[2] whose 350,000 square meters house a world made of papier-mâché. Everything guaranteed unnatural and everything exactly like nature.

In order for the world to flicker by on film, it is first cut to pieces in the film city. Its interconnections are suspended, its dimensions change at will, and its mythological powers are turned into amusement. This world is like a child's toy that is put into a cardboard box. The dismantling of the world's contents is radical; and even if it is undertaken only for the sake of illusion, the illusion is by no means insignificant. The heroes of antiquity have already made their way into the schoolbooks.

The ruins of the universe are stored in warehouses for sets, representative samples of all periods, peoples, and styles. Near Japanese cherry trees, which shine through the corridors of dark scenery, arches the monstrous dragon from the *Nibelungen*, devoid of the diluvial terror it exudes on the screen.[3] Next to the mockup of a commercial building, which needs only to be cranked by the camera in order to outdo any skyscraper, are layers of coffins which themselves have died because they do not contain any dead. When, in the midst of all this, one stumbles upon Empire furniture in its natural size, one is hard pressed to believe it is authentic. The old and the new, copies and

originals, are piled up in a disorganized heap like bones in catacombs. Only the prop-
erty man knows where everything is.

On the meadows and hills the inventory organizes itself into patterns. Architectural
constructions jut upward as if meant to be inhabited. But they represent only the exter-
nal aspects of the prototypes, much the way language maintains façades of words whose
original meaning has vanished. A Frisian village church, which beckons to simple piety
from afar, turns out upon closer inspection to be a hut on a painted slope. And the cath-
edral a few hundred meters further contains no church choirs, since its roof adorned
with gargoyles sits separately off to the side, for filming purposes. Together with the
façades of a pleasure resort and a billionaire's club, it is part of the film *Metropolis* (1925–
1926), which Fritz Lang is making. On some nights elegant extras live it up between
the spiritual *[geistlich]* and worldly imitations. The underground city with its grottoes
and tunnels—in which the film's narrative houses the thousands of workers—is already
gone, blown up, flooded. The water was not really as high as it appeared in the film, but
the burning elevators actually did come crashing down in their full, original size. Metic-
ulously filed cracks in the furnaces still testify to those elemental events. Near the center
of the catastrophe are stretches of decaying wall—a fortress with bowers, ramparts,
and moats. It stymies the archaeologists in the well-known film *Die Chronik von Grieshus*.[4]
When mounted soldiers occupied it recently, in the Middle Ages, the director brought
in croaking frogs, from ponds, to keep the troops in the right mood. When it comes to
deception, the heart and soul appreciate authenticity. In the meantime the fortress has
fallen apart; the materials of its construction are peeking through. It cannot deteriorate
into a ruin, because ruins have to be made to order. Here all objects are only what they
are supposed to represent at the moment: they know no development over time.

The masters of this world display a gratifying lack of any sense of history; their want
of piety knows no restraint—they intervene everywhere. They build cultures and then
destroy them as they see fit. They sit in judgment over entire cities and let fire and brim-
stone rain down upon them if the film calls for it. For them, nothing is meant to last;
the most grandiose creation is built with an eye to its demolition.

Destruction catches up with some things when they've scarcely had a chance to
enjoy their place in the sun. The racetrack tribune in front of which sensational sports
events took place has been toppled, and the Vienna woods that rustled in *Ein Walz-
ertraum*[5] have been cut down. Other things change unpredictably. The remains of
modern houses have been integrated into an old-fashioned alley, an anachronism that
does not seem to disturb anyone. Political interests play no role in such reorganizations,
no matter how violent the latter may be. A Bolshevist guardroom turns into a peaceful
Swedish train station, which is subsequently transformed into a riding school and today
is used to store lamps. It is impossible to tell what it will become next. The laws of these
metamorphoses are unfathomable. No matter what may happen to the objects, however,
in the end their plaster of paris shines through and they are junked.

The regime of arbitrariness does not limit itself to the world as it is. The real world
is only one of the many possibilities that can be moved back and forth; the game would
remain incomplete if one were to accept reality as a finished product. That is why its
objects are stretched and shortened, make-believe objects are sprinkled among the
existing ones, and miraculous apparitions are created without hesitation. The magic
acts of yesteryear were a faint prelude to *cinematic special effects*, which give short shrift
to nature. For them, the cosmos is a little ball to be batted around at will.

At times, the things projected onto the screen take on such a quotidian appearance that they seem as if one could encounter them on the street. Their creation, however, was marked by abnormal circumstances. Lampposts whose steel and cement existence seems tangible are made of wood and are broken off halfway up; the fragment suffices for the section framed by the image. An impressive skyscraper does not tower nearly as dizzyingly as it does in its screen appearance: only the bottom half is actually constructed, while the upper section is generated from a small model using a mirror technique. In this way, such structures refute the colossi: while their feet are made of clay, their upper parts are an insubstantial illusion of an illusion, which is tacked on.

The evocative powers of special effects lend themselves particularly well to the domain of the supernatural. The upcoming blockbuster film version of *Faust* being directed by W. Murnau uses them extensively. In a hall previously employed by pirates for their life of thievery, the planet Earth now expands *en miniature*. Faust will fly through the air from one backdrop to another. A wooden roller coaster that curves down to the valley describes his aerial itinerary. The camera glides down the chute and, thanks to expert guidance, spews forth images of the journey. Fog made of water vapor produced by a steam engine envelops the range of appropriately sculpted mountain peaks from which Faust emerges. For the horrible crash of the foaming deluge, some water is sprayed through a side canyon. The wild urges subside when the wheat covering the fields and meadows beneath the jagged, pine-covered summits rustles in the wind of the propeller. Cloud upon cloud wafts eastward, masses of spun glass in dense succession. Upon Faust's landing, huts surrounded by greenery will most likely shimmer in the blazing, high-wattage glow of the evening sun. Things are also rather Faustian in the Tempelhof UFA studios,[6] where Karl Grune is directing *Die Brüder Schellenberg*. Here apocalyptic riders sweep across the glass studio on horses suspended in midair from the ceiling by wires. Among them is a menacingly huge set of black wings with which Jannings,[7] as the head devil, casts shadows over cities, while the archangel Michael soars on a pair of white wings.

Nature, in body and soul, has been put out to pasture. Its landscapes are surpassed by those that are freely conceived and whose painterly appeal is no longer subject to chance. Nature's suns likewise leave much to be desired. Since they do not function nearly as reliably as floodlights, they are simply locked out of the newest American film studios. Let them go on strike if they want to.

Still, some remnants of the natural are put into storage on the side. Exotic fauna, the by-product of a few film expeditions, thrive along with representatives of the local animal world on the margins of the studio grounds. Some of the creatures captured in Brazil were transferred to the zoological gardens, where they can be a purpose unto themselves and enrich science. Those that have been kept function like a specialty act that travels with its own impresario. Each type of animal has its act in the program. In a sculptured garden, gold and silver pheasants can illustrate the luxury of American billionaires; the rare black hawk evokes the thrill of the exotic; cats in close-up shots lounge in salons. The doves from Berger's beautiful Cinderella film[8] are still flying around. The wild boar that appears in hunting films and a swarm of live crocodiles number among the prominent beasts. They play a major role in the film *Die drei Kuck-ucksuhren*, directed by Lothar Mendes. The baby crocodile is a prop that one can hold in one's hands, but even the fully grown monstrosities are not as dangerous as their lifeless counterparts, which the monkeys fear. Greenhouses complete the collection: their vegetation forms the appropriate background for scenes of jealousy in the tropics.

The occupants of the wildlife preserve are lovingly cared for by the zoologist of the expedition. He calls them by name, grooms them, and gives them acting lessons. Despite their inherent imperfections as creations of nature, they are the most spoiled objects of the enterprise. The fact that they leap or fly without being moved by a mechanism elicits delight, and their ability to propagate without the help of obvious special effects seems miraculous. One would never have thought these primitive creatures capable of this, so much do they seem almost like cinematic illusions.

The world's elements are produced on the spot in immense laboratories. The process is rapid: the pieces are prepared individually and delivered to their locations, where they remain patiently until they are torn down. They are not organisms that can develop on their own. Woodworking shops, glassmaking shops, and sculpture studios provide what is necessary. There is nothing false about the materials: wood, metal, glass, clay. One could also make real things out of them, but as objects in front of the lens [Objektiv] the deceptive ones work just as well. After all, the lens is objective [objectiv].[9]

Certain preparatory measures are necessary in order to integrate things and people. If both remained in their traditional state, they would stand apart like rare museum pieces and their spectators. Light—whose source is the huge electric power plant providing the energy for the entire undertaking—melts them together. The actors are groomed in the makeup room. This is not a workroom like any other but a studio full of skilled artistry. The physiognomies formed here from the raw materials of the human face reveal their secrets only under the beams of the spotlights. The masters of their discipline preside over makeup tables filled with cosmetics of every shade. A chart shows the degree of luminosity that the colors attain when photographed; but when subsequently forced into the black-and-white scale, their color values vanish. This makes the preparatory stage all the more seductive—the degenerate garishness of the wigs in glass cases. Portrait-like masks hang on the walls, fireproof creations that are custom-made for the main actors of whatever film is currently being produced. In certain scenes, these make it unnecessary for the actor to appear in person: other actors transform themselves into the stars by wearing their masks. These disguised figures are stiff and move about like the dead. In the adjoining screening room, one can test the effect of a make-up job on film.

Both films and people are enveloped by this self-sufficiency; every available resource is used to ensure that they flourish. The means of technical reproduction—such as color film stock—are checked and improved in an experimental laboratory. Comparable energies are expended to train a new generation, which will know how to use the various techniques. A real fire department is standing by to put out real fires, and doctors and medics are on call at all times. Luckily accidents, as popular as they are, seldom occur. During the shooting of *Metropolis*, hundreds of children had to rescue themselves from the flood—a horrible sight in the film. The actual event was so harmless that the offstage nurses were left with nothing to do. One of the primary hubs is the canteen, where people in full costume sit among white-collar workers, technicians, and chauffeurs, looking like leftovers from a carnival. They wait.

They wait endlessly for their scene. There are many such scenes, pieced together like the little stones of a mosaic. Instead of leaving the world in its fragmented state, one reconstitutes a world out of these pieces. The objects that have been liberated from the larger context are now reinserted into it, their isolation effaced and their grimace smoothed over. Out of graves not meant to be taken seriously, these objects wake to an illusion of life.

Life is constructed in a pointillist manner. It is a speckling of images that stem from numerous locations and initially remain unconnected. Their sequence does not follow the order of the represented events. A person's fate may already have been filmed even before the events leading up to it are determined; a reconciliation may be filmed earlier than the conflict it resolves. The meaning of the plot emerges only in the finished film; during the gestation, it remains unfathomable.

The cells must be formed one after the other. Here and there, pieces of inventory come together to shape a light-drenched environment where things human unfold. The movements suffused in light are pursued by the cranking boxes. These perch in every spot where people can possibly be ensconced: on the floor, on scaffolding—no point of view is safe from them. Sometimes they pursue their victims. The smallest fragment is born only following terrible labor pains; assistants and assistant assistants are involved, and, amid much gesticulation, it slips out.

The director is the foreman. It is also his difficult task to organize the visual material—which is as beautifully unorganized as life itself—into the unity that life owes to art. He locks himself and the strips of film into his private screening room and has them projected over and over. They are sifted, spliced, cut up, and labeled until finally from the huge chaos emerges a little whole: a social drama, a historical event, a woman's fate. Most of the time the result is good: glass clouds brew and then scatter. One believes in the fourth wall. Everything guaranteed nature.

Elizabeth Edwards

PHOTOGRAPHS AS OBJECTS OF MEMORY

WHEN ROLAND BARTHES, EATEN BY ONTOLOGICAL DESIRE, eventually found the photograph of his mother which transmitted, for him, the essence of that unique being, what he first describes is an object:

> The photograph was very old, the corners were blunted from having been pasted into an album, the sepia print had faded, and the picture just managed to show two children standing together at the end of a little wooden bridge in a glassed-in conservatory, what was called a Winter Garden in those days.[1]

Photographs are perhaps the most ubiquitous and insistent focus of nineteenth- and twentieth-century memory. The photograph infuses almost all levels of memory, even those of which it is not directly part. It constitutes a meta-value of memory construction, its tentacles spread out, blurring and constructing memory in its own insistent image. My focus here is very precisely on the photograph and its presentational forms as material culture, drawing on writing from photography on one hand and the anthropology of material culture on the other. None of the elements I discuss is of itself very original, nor can one, in an essay of this length, discuss any one of them in detail, however I hope through a massing effect to suggest that the relationship between photograph and memory and the way in which it obtains its privileged position as a conduit of memory is refracted through the photograph's materiality.

My argument is not intended to attempt the impossible – to divorce the materiality of the photographic image from the image itself. Just as Barthes argues that the image and its referent are laminated together, two leaves that cannot be separated, so are the photograph and its materiality, the image and object brought into a single coherent form.[2] However, as a heuristic device I shall shift the methodological focus away

from content alone, arguing that it is not merely the image *qua* image that is the focus of contemplation, evocation and memory, but that its material forms, enhanced by its presentational forms, are central to its function as a socially salient object. These material forms exist in dialogue with the image itself to make meaning and to create the focus for memory and evocation. For photographs belong to that class of objects formed specifically to remember,[3] rather than being objects around which remembrance accrues through contextual association (although they become this as well).[4] For photographs express a desire for memory and the act of keeping a photograph is, like other souvenirs, an act of faith in the future. They are made to hold the fleeting, to still time, to create memory. Indeed popular clichés on photography (frozen moments in time etc.) actually encapsulate a cultural expectation of the medium. In their relationship with their referent, their reality effect and their irreducible pastness, photographs impose themselves on memory. They become surrogate memory and their silences structure forgetting. Certainly some have greater 'specific gravity' than others through the intensity of represented expression, or they accrue value, the photograph of the recently dead more precious than that of the living perhaps. Yet their very being or inscription is dependent on the desire for memory expressed through the intervention in time which characterize it as photography. Thus in photographs we see fragments of space and time reproduced to infinity. The analogical insistence that so anguished Barthes projects the past into the present, the dead among the living through the inscribed image, the forms of its materiality, and the modes of its uses.

The transparent object

Photographs have inextricably linked meanings as images and as objects: an indissoluble, yet ambiguous, melding of image and form, both of which are direct products of intention. The transparency of the photograph to its referent has been one of its most cherished features. Culturally, despite rational realizations that photography can 'lie', the photograph has been viewed, especially in its vernacular forms, as a window on the past.

However, 'in order to see what the photograph is *of* we must first suppress our consciousness of what the photograph *is* in material terms.'[5] What things are made of – how they are materially presented – relates directly to their social, economic and political discourses. The appropriateness of their material form is central to their meaning. As Miller has argued, 'Through dwelling upon the more mundane sensual and material qualities of the *object*, we are able to unpick the more subtle connections with cultural lives and values that are objectified through these forms, in part because of the qualities they possess.'[6] In this, photographs do not differ from other classes of 'things' enmeshed in everyday practice.

The materiality of the photograph is integral to its affective tone as an *image*. The subjective and sensuous experiences of photographs as linking objects within memory are equally integral to the cultural expectancies of the medium, the certainty of the vision it evokes, and cultural notions of appropriate photographic styles and object-forms for the expected performance of photography in a given context. The forms in which images are displayed and used follows their function, a cultural expectancy bringing together physical form and cultural *function*. Which photographs are enlarged,

displayed as public faces, and which remain in small private worlds? What choices, affecting visual meaning, have been made concerning processes, printing papers or finishes?

Then one has to consider how photographs are actually used as objects in social space? What is displayed? Where? What is precisely and intentionally hidden (in lockets, wallets, diaries, family bibles), where and why? How do these elements link with the performative material culture with which photographs merge, such as frames and albums? Choices matter: they are decisions with consequences for the objects or humans associated with them. For materiality constitutes the presentational forms which themselves structure visual knowledge as well as those related human actions in modes of viewing which form both private and collective commemorative acts.[7]

In much of the writing on photography, on the history of photography, on memory and on the past, very little attention has been given to the actual plasticity of the photograph as object. Pierre Bourdieu pointed the way many years ago with his examination of the social uses of photography and the social meanings enacted within the act of photographing, of access to and control of photographic technology to perform memorializing acts. This was analyzed in terms of class, gender and access to production.[8] In his later work he also considers the photograph in terms of taste and the accumulation of cultural capital.[9] While he hints at materiality in his discussion of display and taste and genre he does not engage with it in analytical terms. In photo-therapy[10] and in work on family photographs and albums as a collected form and as narrative,[11] other authors have also hinted at the signifying possibilities of materiality, but photographs are largely treated as pure content, triggers for other forms of narrative.[12]

Likewise, much of the theorizing of the image of the last two or three decades, including work by influential writers such as Victor Burgin, Jean Baudrillard and John Tagg, has come out of semiotic, psychoanalytical or phenomenological concerns which have failed to take account of materiality. Linked to much of the Marxist-derived critique of both material objects and photographs, which has concentrated on modes of production or the ideological control of photographs, images have been treated as relatively arbitrary signs, which can be configured into a semiotic web resembling a context which could in turn be deconstructed.[13] Tagg's detailed and convincing essay on photography and slum clearance in Leeds makes mention of the form in which the photographs were presented and viewed within the discourse, but this is given no analytical weight in his argument.[14] In the concentration on the politics of the image, materiality is too often perceived as a neutral support for images rather than integral to the construction of meaning. Photographs are, in such analyses, detached from physical nature and consequently from the functional context of that materiality. The way in which people construct themselves and are constructed by others through the cultural forms of their consumption has been underestimated in relation to photographs,[15] with little attention given to how they matter to people in terms of evocation, of making pasts, and without engaging with their intrinsic and affective qualities, which matter. It would seem that the material forms of memory are central to any engagement with such issues.

Given that photographs as evokers of memory are often related to people, the invisibility of the photograph as object may in part be related to the dualism between person and non-person which has dictated the relationship between people and things. But as Daniel Miller has argued,[16] given that things are a product of human desire, the

dichotomy becomes less certain, ambiguous. This is especially so in the case of the photograph, where it is possible for Barthes to say 'Here is my mother' – that lamination of image and referent perhaps lies at the basis of the ambiguous responses to the material being of photographs.

One of the formal characteristics of photography, which distinguishes it from other mimetic inscriptional devices, such as film and video (and to an extent transparencies, still photographs performed in the mode of cinema), is that photographs make the image visible through the nature of its materiality, without intermediate technical translation to realize the image beyond initial processing. Its objects can be handled, framed, cut, crumpled, caressed, pinned on a wall, put under a pillow, or wept over. Furthermore, the evocative fascination of photographs as they operate in their stillness and materiality is very different from the evocative qualities of film or video. Stillness invites evocation, contemplation and a certain formation of affective memory in a way that film and video, with their temporal naturalism and realistic narrative sequence, cannot. As both Christian Metz and Barthes argue in their different ways, film suggests 'being there' in its temporal immersion, whereas photographs speak to 'having been there': they are fragmentary and irreducibly of the past or of death itself.[17]

In daily interaction, photographs come to stand partially as foci of memory themselves and partially, but never wholly, for moments in which those people existed – mythically presented as 'evermore'. The power of the nexus of image and material is made clearest in the destruction of the material object. As Barthes argued, to reject a photograph and thus the memory-value it holds out demands its physical removal: destruction engages with materiality.[18] To cut, tear or, worse, burn a photograph is, as Mavor describes it, 'a violent, frightening hysterical action, which leaves behind indexical wounds and irreparable scars'.[19]

Materiality and extending the sense of vision

The treatment of photographs is in many ways analogous to that of relics. Deemed significant as a bearer of memory or access to a past either real or imagined, the photograph is treated in a special way, for instance in an album or display. It is authentic in that it is traced off the living; that which was there, like the 'pignora' of the saints. Like relics, photographs are validated through their social biography: ordinary remains (family snapshots) become treasured, linking objects to traces of the past, the dead, a fetishized focus of devotion. Finally they return to the ordinary, indeed disposable object, the detritus of material culture, as they cease to have meaning for the living beyond a generalized 'pastness'.[20] In this they follow Victor Turner's path of ritual experience moving from the ordinary space of secular symbols to the spatially separated non-ordinary for a finite period, perhaps as sacred symbols more overtly linked to death, to return to the ordinary.[21] This relic quality is perhaps most marked in photographic jewellery, where the physical trace – the photograph – is encapsulated with the bodily relic such as a lock of hair. To be fully appreciated the object had to be turned, caressed with the fingers, from trace to relic and back again, with that tactile experience of the relic so strongly linked to emotion.[22] The image as an encoded interface of public and private could be worn about the person within the conventional public genres of personal decoration. Alternatively it could be worn under clothing, next to the skin,

bringing the living and the remembered into bodily relation with one another. Pointon's analysis of hair-jewellery has great relevance here, but how much more so when the image is a photograph, traced off the living by the action of light on chemical.[23] It gives an additive quality of intensity.

For in considering the photograph in this way we have to consider not just sight but touch and even smell. From its earliest days the relationship with photographs has demanded a physical engagement – photo-objects exist in relationship to the human body, making photographs as objects intrinsically active in that they are handled, touched, caressed. This may not necessarily reflect the original intention (which was to create an image) but is none the less intrinsic to the object.[24] The daguerreotype is only visible as an image if manipulated in the hand, moved to reveal the image, not the mirror quality of the polished plate. Similarly the ambrotype, a negative projected positive by means of a dark backing layer, demanded physical engagement, a manipulation of the material object to reveal the creamy tones of the image as a lifelike positive rather than a negative. Both daguerreotype and ambrotype had weight, a concrete quality. They were matted in a gilt mount, packaged in a silk or velvet-lined leather case; or later 'Union' cases, often heavily decorated.[25] Even the humble loose print demands tactile engagement. In the many hours I have spent watching people look at photographs, the describing of content is accompanied by what would appear to be an almost insuperable desire to touch, even stroke, the image. Again the viewer is brought into bodily contact with the trace of the remembered. Thus we can say that the photograph has always existed, not merely as an image but in relation to the human body, tactile in experienced time, objects functioning within everyday practice.

It would appear significant that many of the evocational material forms of photographs have absorbed or adopted the forms of other objects culturally associated with commemoration and remembrance, such as memorial lockets, miniatures, painting and even plates or mugs. They have a skeuomorphic quality and in their mimetic forms resonate with the values of their objects of association. For instance many Victorian family albums assumed the physical form of 'sentimental albums' in which women, in particular, kept locks of hair, pressed flowers, keepsakes, poems, watercolours and drawings.[26] The continuing but suppressed practice of post-mortem photographs, which though no longer displayed as in nineteenth-century practice, are, as Jay Ruby has explored, transformed into private relics, interleaved in family bibles.[27] Again following Turner's model of ritual process, absorption into this material form related them to genealogy and sacred text, sacralizing the image in a specific form, removed here from the daily practice of memory, into the realm of a specific, focused form of contemplation.

Materiality is also integrally linked to social ways of viewing and thus accessing the past, personally or collectively. Are albums, for instance, read as a group or individually? Or on a table or resting on people's knees? Small albums to be held in the hand require close physical proximity for joint viewing, while large albums are unwieldy, and need to be spread out or displayed, on knees or tables for instance, but do not necessarily require such close physical proximity [Figure 23.1]. Albums have weight and tactility, they often smell, sometimes of damp, rotting card, the scent of 'pastness'. In relation to memory, and the resurrectional qualities of photography, it is significant that many early album bindings, with their relief leatherwork and metal clasps, look like family bibles or medieval devotional books; often they suggest, like the special dynamic

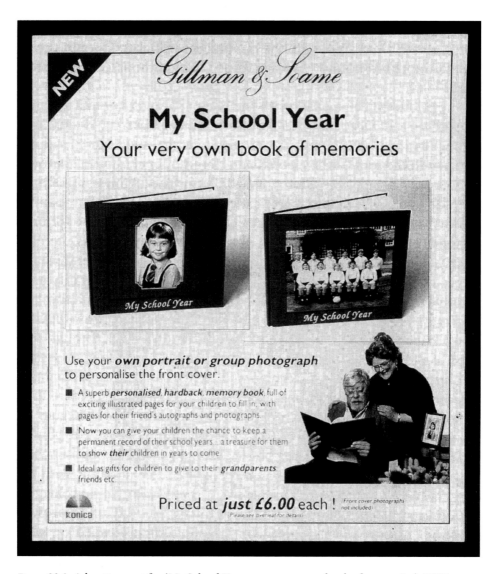

Figure 23.1 Advertisement for 'My School Year: your very own book of memories', 1997
(Gillman and Soame, Oxford)

of the image itself, a miniaturized form, a containment and an intensification.[28] The
heavy tactile surface and material form is suggestive of the weight of visual meaning
contained within it. What are the cultural meanings residing in those albums, morocco-
bound, blind-stamped, gold-embossed and gold-edged?

 If the photo-object engages with the body, it also retemporalizes and respatializes
the photograph. In Barthes' famous phrase, the 'there-then becomes the here-now'.[29]
Again, one can argue that the material culture approach fleshes out the bare bones
and the emotional forces of Barthes' contention. Consider the photographic album.
The album is more than a sum of its parts in that its significance lies multiplied in the
massing of individual images: narrative structure and related texts formed through its

materiality. Crucially, the album retemporalizes, it constructs a narrative of history, not merely in the juxtaposition of separate images but in the way that the viewer activates the temporality and narrative through the physical action of holding the object and turning the pages. The viewer is in control of the temporal relationship with those images. Each viewer will have his or her own track through the physical album, those pages lingered over, those skipped over, investing the object with narrative and memory, interwoven with private fantasy, fragmented readings and public history.[30] One might argue here that there is a temporal aspect to touch where, as Susan Stewart argues, sensing touch relates directly to visualising.[30a] The album also respatializes: disconnected points offer glimpses of possible pasts. They are transformed not into an experienced spatiality but with an imaginative and ambiguous space which the past inhabits, collected and co-located, they transform history into space.[31] Blank spaces in an album suggest memory lost—photographs that escaped or were destroyed, leaving material traces of their absence (glue and torn paper) and opening the object further to the imaginative projection of making histories.

At another level one finds the material forms of albums reflecting precisely the experience contained or constructed within them. For instance Japanese tourist albums of the late nineteenth and early twentieth centuries were often presented in a material form which enhanced the exotic experience. Containing stereotypical genre pieces of Japanese life by commercial photographers, the lacquer-covered albums were kept in padded silk boxes closed with traditional silk and bone toggles. Unpacking the box suggests resonances of exotic experience through the physical action of unpacking the precious and the different.[32] At another level one finds the humble albums sold in their thousands in the early decades of this century, with covers inscribed 'Sunny Memories' or 'Shining Hours' setting a textual tone; albums where the rhythm of differently shaped vignettes offered presentational choice within the album. Linda Berman reports an album whose owner had titled it 'The Family Jewels', linking memory value with the materially precious.[33] I cite only a few examples of the many variations in presenting images, but they are linked in that they are all specific material manifestations of social desire. These relate to the function and appropriateness of form, which makes possible authorial ordering, and text, which is central to evocation and the construction of memory.[34]

Thus we must consider the implications of the materiality of object-forms for the cultural processes in which they are enmeshed. Form and image merge to create function, a satisfaction with the object in terms of its cultural role. This is forcefully exemplified by an embroidered photographic shrine of a young man killed during the First World War in the collections of Wisbech Museum, Cambridgeshire [Figure 23.2]. Without the imagery and text, the patriotic coloration and the act of stitchery as an act of therapy[35] or remembrance, or as tender communion, the photograph would have had less power to evoke human experience and emotion which the image and every stitch project in their merging. It is a memorial which represents an originating act of remembrance but also constitutes an object of redemption through sacrifice. The photograph peoples the cenotaph, providing a body for the empty tomb. While the photograph marks the inevitable absence of the body it also points to the presence (life) of the spirit. As such, one could argue that the photograph also assumes a crucial role in the Christian narrative of resurrection and healing. The act of making inscribes the memory, the photograph gives reality to the mourned, the object acts as cenotaph and

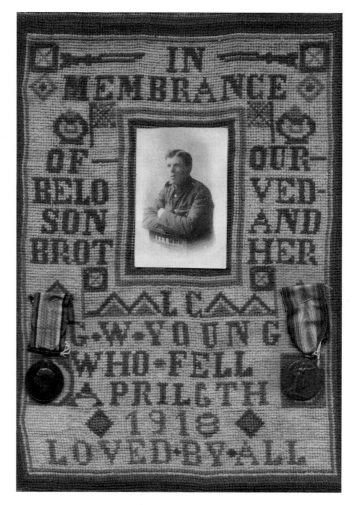

Figure 23.2 Embroidered photographic 'shrine' to George Young, killed during World War I (Trustees of the Wisbech and Fenland Museum)

the icon and the index collapse into one another not simply through the process of signification, but through a dialectical and signifying relationship of image and material form.

Exchange objects

One of the most widespread functions of photographs as material objects is as objects of exchange. While the image itself is, of course, central to the act, giving, receiving and utilizing the material object is integral to the social meaning of those images. Photographs operate as exchange objects and circulate as 'memory texts'.[36] As physical distances in social relations increase, so the tension between knowledge (memory) and ignorance (forgetting) becomes a critical determinant in the flow of 'memory texts'.[37] Exchanges allow, for instance, distant kin to participate in the experience and intimacy

of rites of passage and other important occasions. The exchange of the photograph as image itself expresses the social value of the relationship that is maintained and sustained between groups and individuals, which demands reciprocity to consolidate the socially desired memory of images.

Thus the implications of the gifting relationship are integral to the meaning of the photo-object in gestures which recapitulate or re-enact social articulations.[38] They reinforce networks and identity built on the memory to which they relate, positioning individuals *vis à vis* the group, linking past, present and perhaps implying a future. The specific social dimension is significant in relation to the material form of a specific artefact. Is the gift exchange a whole album? A mounted print? Or a casual group of prints? The inscriptions on the back, the mounting, the size of the print, the intimacy of the image-content in relation to material forms are integral to social meanings and social relationships expressed through the act of exchange. Such exchanges have been found to be deeply implicated in the negotiation of social identities within diaspora communities. Gail Baker's work with Bene Israel communities in UK suggests complex motivations for the exchange, public display or private retention of different image-contents treated in different material ways.[39] Materiality and physical form again set the affective tone, the emotional relationship and the consequence of things dialogically associated with those photo-objects through the associations of personal and collective memory.[40]

The exhibitions of framed collections, on top of televisions, side-boards, pianos or mantlepieces, similarly have shrine-like qualities. They are spatially differentiated in their positioning and in their formats. The focus on the image is created through framing or matting, concentrating the eye on that image, lending it gravitas. The selection and care of these living-room shrines are gendered. The 'family archivist', controlling the overlap of history and fantasy, and the domestic spaces dedicated to the articulation of this function, is usually female.[41] Such spaces, as shrines, become public statements of group achievement and assurance; private statements of devotion, past and present,[42] spaces where public and private memory and evocation overlap. They are as much an instance of the presence of the living as a memory of the dead. The longevity of exchange-objects assimilates them to the person in the sense that parting with them is unthinkable.[43] Such collections of images, as Baker suggests, reach out through their exchange-relations to establish a group cohesion through the act of exchange and display.

Yet the affective tones of the photo-object are difficult to grasp. Artefacts are often at their most powerful and effective as social forces when they appear to be most trivial. The physicality of the photograph is not articulated by those consuming it. It constitutes part of the unarticulated 'habitus', that daily praxis within the material world, a 'household ecology of signs' in which social actions take place.[44] Thus it is possible to state of photographs, 'This is my cat.' Even the embroidered shrine was, one can conjecture, seen in terms of 'This was my brother/husband/son.' But, as I have suggested, material forms of the photographic artefact and their cultural appropriateness to the function sought is not unconsidered. Clearly the photographic artefact matters, although it is not necessarily articulated as such. One merely has to think of the culturally appropriate forms for wedding photographs, in a white album embossed with silver bells, arranged in a narrative expressive of social relationships underwritten by the family, themselves expressed (both denoted and connoted) within the image content. The dialogic relationship between content, form and materiality create the socially

meaningful object and the 'correct' expression of *rite de passage*. Further access to the album and the circulation of images as material objects is an act of cohesion. The material object constitutes an intersection between social context and codified, connotative ideologies of social practice (the form of the content) on the one hand, and material production of the artefact within object-worlds on the other.[45]

While the operation of the 'objectness' of photographs is perhaps most apparent in the consideration of historical images, their salient social uses and biographies as 'things' are every bit as significant in contemporary uses of the photograph. The late twentieth century may indeed be saturated with visual images and their specific social meaning as material culture may be less apparent. However, I would argue that many of the material and presentational forms preserve the traces of earlier forms, yet reflect the modern ubiquity of the image. For instance, images are massed in flip-over albums, which are made to look like books, with fake leather covers and with gold decoration. Indeed there is a recent vogue for family photographs presented as antiques, with a massive range of 'Victorian-style' frames available, often marketed with old photographs in place. Or there are those which extend the sensual experiences of viewing, such as furry frames which can be stroked like pets, or frames which record sound to go with an image: a baby's laugh, for instance. Here the presentational forms are simultaneously reinforcing the reality-effect of the photograph and intensifying the sensual range of associated memory. Thus the presentational forms enhance, as memory, the significance of specifically chosen photographs in a world saturated by images. With the video perhaps becoming the main quotidian memorializer, one might argue that the choice of still photography and its presentation become ever more significant and perhaps more fetishized as a focus of longing and remembrance.

I have touched on only a few of the many material forms of the photograph in which visual meanings and thus memory are inseparably enmeshed. I have intentionally taken a more methodological position so as to shift thinking beyond content towards the cultural object existing in social relations within an experienced world, thus perhaps extending phenomenological approaches to photographs. There are many different forms which deserve detailed analysis in their own right, from photographic gravestones and votive offerings to the spatial configuration of images within the domestic space or the culture-specific practices of photography.[46] One can think of innumerable historically and culturally specific material cultures of photographs, whose meaning is too often subsumed in the contemplation of content, which would benefit from a more rigorous form of material analysis.[47]

Finally, a topical thought. It is the appeal of the material forms of the image which is likely to outlive conventional chemical photography. Future photographs may be digitally produced, but the economy of photographic desires and concepts will surely persist.[48] Human values and human desire for linking objects of memory will, I believe, still demand the material possibilities of photography, where the affective tones of physical tactile quality, as I have argued, integrally construct the photograph and its status as an object of memory. Objects are links between past and present, and photographs have a double link as image and as material, two ontological layers in one object. One wonders if Barthes' ontological desire would have been so stirred if it had not been for the very materiality of his mother's photograph. For he yearned to go into the depths of the paper itself, to reach its other side.

Notes

1 Roland Barthes, *Camera Lucida*, trans. Richard Howard (London, 1984 [1980]), 67.

2 Ibid., 6.

3 David R. Unruh, 'Death and Personal History: Strategies of Identity Preservation', *Social Problems*, xxii (1983), no. 1, 347–6.

4 Alan Radley, 'Artifacts: Memory and a Sense of the Past', in D. Middleton and D. Edwards (eds), *Collective Remembering* (London, 1990), 48.

5 Geoffrey Batchen, *Photography's Objects* (Albuquerque, 1997), 2.

6 Daniel Miller (ed.), *Material Cultures: Why Some Things Matter* (London, 1998), 8–9.

7 *Ibid.*, 11.

8 Pierre Bourdieu, *Photography: A Middle-Brow Art*, trans. S. Whiteside (Cambridge 1990 [1965]).

9 Pierre Bourdieu, *Distinction: A Social Critique of the Judgement of Taste* (London, 1986 [1979]), 44–7.

10 See, for instance, Linda Berman, *Behind the Smile: The Therapeutic Use of Photography* (London, 1993).

11 See, for instance, Glenn Willumson, 'The Getty Research Institute: Materials for a New Photo-History', *History of Photography*, xxii (1998), no. 1, 40–51.

12 See, for example, Julia Hirsch, *Family Photographs: Content, Meaning and Effect* (New York, 1981); Jo Spence and Patricia Holland (eds), *Family Snaps: The Meaning of Domestic Photography* (London, 1991) and Annette Kuhn, *Family Secrets: Acts of Memory and Imagination* (London, 1995).

13 Miller, 'Artifacts and the Meaning of Things', in Tim Ingold (ed.), *The Companion Encyclopedia of Anthropology* (London, 1994), 406.

14 John Tagg, 'God's Sanitary Law: Slum Clearance and Photography in Late Nineteenth Century Leeds', in his *The Burden of Representation: Essays on Photographies and Histories* (London, 1988). His analysis hovers tantalizing on the edge of materiality, alluding to 'folios' (121; 144) and albums passing from hand to hand (145) but never engages precisely with presentational form as integral to discourse.

15 Miller, *Material Cultures*; M. Csikszentihalyi and E. Rochberg-Halton, *The Meaning of Things: Domestic Symbols and the Self* (Cambridge, 1981), 16–17.

16 Miller, *Material Cultures*, 396.

17 Barthes, 'The Rhetoric of the Image', in his *Image, Music, Text*, ed. and trans. Stephen Heath (London, 1984 [1977]), Christian Metz 'Photography and Fetish', *October*, xxxiv (1985).

18 Barthes, *Camera Lucida*, 93.

19 Carol Mavor, 'Collecting Loss', *Cultural Studies*, xi (1997), no. 1, 119.

20 Patrick Geary, 'Sacred Commodities: The Circulation of Medieval Relics', in Arjun Appadurai (ed.), *The Social Life of Things* (Cambridge, 1986).

21 Victor Turner, *Dramas, Fields and Metaphors: Symbolic Action in Human Society* (Ithaca, 1974), 166–9.

22 Batchen, *Photography's Objects*, 7.

23 See Pointon's essay in Marius Kwint, Christopher Breward and Jeremy Aynsley (eds), *Material Memories: Design and Evocation*, Oxford, 1999).

24 Stephen Riggins, 'Fieldwork in the Living Room: An Autoethnographic Essay', in S. Riggins (ed.), *The Socialness of Things: Essays on the Socio-Semiotics of Objects* (Berlin, 1994), 111.

25 Batchen, *Photography's Objects*, 2.

26 Isabel Crombie, 'The Work and Life of Viscountess Frances Jocelyn: Private Lives', *History of Photography*, xxii (1998), no. 1, 41.

27 Jay Ruby, *Secure the Shadow: Death and Photography in America* (Cambridge, Mass., 1995), 187.

28 Susan Stewart, *On Longing: Narratives of the Miniature, the Gigantic, the Souvenir, the Collection* (Durham, NC, 1993), 136–7.

29 Barthes, *Image Music Text*, 44.

30 Spence and Holland, *Family Snaps*, 1.

30a Stewart, 'From the Museum of Touch' in Marius Kwint, Christopher Breward and Jeremy Aynsley (eds), *Material Memories: Design and Evocation*, Oxford, 1999).

31 Stewart, *On Longing*, xii.

32 David Odo, *Japan: An Imagined Geography. Constructing Place Through a Nineteenth-century Tourist Album* (Univ. of Oxford, 1988 dissertation, ISCA/Pitt Rivers Museum, unpublished.

33 Berman, *Behind the Smile*, 105.

34 Willumson, 'The Getty'.

35 See Nigel Llewellyn's essay in Marius Kwint, Christopher Breward and Jeremy Aynsley (eds), *Material Memories: Design and Evocation*, Oxford, 1999), see also Rozsika Parker, *The Subversive Stitch: Embroidery and the Making of the Feminine* (London, 1984), 137–8.

36 See, for example, Brian Lewis and Colin Harding (eds), *Kept in a Shoe Box: The Popular Experience of Photography* (Bradford, 1992); Kuhn, *Family Secrets*.

37 The shape of this idea is from Appudurai, 'Introduction: Commodities and the Politics of Value', *Social Life of Things*, 41.

38 Stewart, *On Longing*, 138.

39 I am most grateful to Gail Baker for allowing me to use her unpublished doctoral research-in-progress.

40 Spence and Holland, *Family Snaps*, 10.

41 *Ibid.*, 9; Jeremy Seabrook, 'My Life in that Box', ibid., 173.

42 Berman, *Behind the Smile*, 9.

43 Csikszentmihalyi's and Rochberg-Halton's Chicago-based study revealed photographs to be amongst the most cherished classes of objects overall and the most cherished in relation to other mementos, *Meaning of Things*, 66–9. See also I. Kopytoff, 'The Cultural Biography of Things', in Appudurai (ed.), *Social Life of Things*, 80.

44 Pierre Bourdieu, *Outline of a Theory of Practice* (Cambridge, 1977); Csikszentihalyi and Rochberg-Halton, *Meaning of Things*, 16–17.

45 M. Gottdeiner, *Postmodern Semiotics: Material Culture and Forms of Postmodern Life* (Oxford, 1995), 56.

46 For an example of the possibilities see Christopher Pinney, *Camera Indica: The Social Life of Indian Photographs* (London, 1997).

47 I believe it is significant that it is precisely this element of photographic identity which has been the focus of a number of artists concerned with the relationship between photography and memory. For instance, Christian Boltanski's work concerns transforming photographs into objects through their massing and presentational forms to explore the themes of memory, photography, object and loss, from the consuming issues of Holocaust to imagined micro-histories of the unknown.

48 Geoffrey Batchen, *Burning with Desire: The Conception of Photography* (Cambridge, Mass., 1997), 213–14.

Maurice M. Manring

AUNT JEMIMA EXPLAINED
The Old South, the absent mistress, and the slave in a box

Before . . . our joy at the demise of Aunt Jemima and Uncle Tom approaches
the indecent, we had better ask whence they sprang, how they lived? Into
what limbo have they vanished?

James Baldwin[1]

Peering out from every supermarket's shelves, between the Pop-Tarts and maple syrup,
is a smiling riddle. Aunt Jemima brand pancake mix has been a part of American life
for more than a century now, an overwhelmingly popular choice of consumers. The
woman on the box has undergone numerous makeovers, but she remains the same in
important ways, a symbol of some unspoken relationship among black servant women,
the kitchen, and good food. This symbol remains too strong a merchandising tool for its
owners, the Quaker Oats Company, to give up.

Aunt Jemima's story should interest us for a number of reasons. She might have
been the first walking, talking trademark, and the product she pitches was among the
first of a wave of supposedly labor-saving products at the turn of the century. But the
reasons that a nineteenth-century mammy still decorates the front of a box of ready-mix
batter in the 1990s seem elusive. While the product's ingredients are listed on the side
of the box,[2] the qualities that make up this person, or idea, called Aunt Jemima are less
apparent. Why was she ever a national spokeswoman for pancake batter? Why did this
advertising campaign work so well, and what is she still doing on that pancake box in a
time that supposedly has relieved itself of so many racist and sexist stereotypes in adver-
tising—from Nigger Head golf tees to the Gold Dust Twins? What explains the pres-
ence of a black mammy on a grocery shelf in the first place?

To answer these questions, we must first assemble a list of "ingredients" for the idea
of Aunt Jemima. To make the pancake batter work, one adds water to phosphates that
make the flour quickly rise on the griddle. The components that made Aunt Jemima rise

in the marketing world aren't as easily identified or explained, but they are evident when we examine the years from the turn of the century to the Great Depression, when Aunt Jemima was created and her personality indelibly established in national print advertising. The ingredients are the idealized slave known as mammy, the creation of the American mass market, the rise of supposedly labor-saving household technology, and the "servant crisis." Blended together, these ingredients made Aunt Jemima. Simply identifying them, however, doesn't explain how or why they worked. Like the product itself, the idea of Aunt Jemima was modified by its owners over the years; different custodians of her image added to the mix at different times. And again, like the product itself, the idea of Aunt Jemima created by advertisers requires the customer to complete the last step of the process. So the second question is, who "added water" to the story of Aunt Jemima, and why would they have wanted to do so? The answers have much more to do with the world outside the box than anything inside it.

The people responsible for creating and recreating Aunt Jemima, in chronological order, were Chris L. Rutt and Charles G. Underwood, who put the mammy's face on a product; R. T. Davis, whose marketing expertise made Aunt Jemima a truly national item; and James Webb Young and N. C. Wyeth, the advertising tandem that added the final ingredients to the mix and created the pancake mammy's definitive image.

Ingredient #1: the mammy

Strangely enough, the idea of Aunt Jemima as a salesmammy indirectly resulted from two bachelors looking for a new use for cooking flour and a chance visit to a St. Joseph, Missouri, minstrel show. St. Joseph, known mostly for its brief reign as the starting point for the Pony Express, was also an important milling center on the frontier in the late 1800s. By 1888, however, the amount of flour St. Joseph's mills produced far exceeded demand. When a mill fell into bankruptcy that year, Chris L. Rutt, an editorial writer for the *St. Joseph Gazette*, and Charles G. Underwood, a mill worker, decided to try their hands at the business. They bought the property and set up shop as the Pear Milling Company.[3]

The mill's former operators had failed by marketing conventional products, and Rutt and Underwood faced the same problem. They decided to create an entirely new product that would, in turn, create a new demand for flour. Because pancake batter was difficult to make with any consistency and because it used a relatively large amount of flour, Rutt and Underwood began experimenting with a self-rising flour that, when mixed with milk and cooked on a griddle, would produce pancakes. After numerous tests on the kerosene oven in Rutt's home during the summer of 1889, they hit upon a mixture of wheat flour, corn flour, lime phosphate, and salt. They tested the new product on the town librarian, who assured them it made good flapjacks.[4]

The self-rising pancake mix had no name, and Rutt and Underwood searched for a trademark. Rutt stumbled upon the name Aunt Jemima after attending a local minstrel performance in the autumn of 1889. On the bill were a pair of blackface performers known as Baker and Farrell, who performed a New Orleans-style cakewalk to a tune called "Old Aunt Jemima." The performers wore aprons and red bandannas, imitating the southern mammy in the kitchen. There was nothing unusual about this performance, because the character of Aunt Jemima—sometimes "Jemimy," sometimes

"Mandy"—was a regular in minstrel shows of the late nineteenth century. She was headstrong, fat, and simpleminded, a companion of the country dullard Jim Crow and his foppish city cousin, Zip Coon. A superstitious character, she was especially alarmed and confused by any advance in technology such as the telephone (and later the automobile), and her inability to cope made her the butt of the joke for white audiences. But in the kitchen, she was an unchallenged expert, the cook for an idealized version of the Old South, a land of good food, beautiful but fragile white women, warm weather, gentility, and leisure.[5] The number was a hit, and Rutt realized he had found his trademark. The words "Aunt Jemima Pancake Mix" were stamped on the first bags of the ready mix, along with a grinning, wide-eyed caricature of a black woman wearing a bandanna.[6]

That would be a satisfyingly brief summary of Aunt Jemima's origins if it were not for one question: if Aunt Jemima of pancake fame came from the Aunt Jemima of the minstrel stage, what was the origin of the minstrel show's version of Aunt Jemima? This image of the female slave has its roots in both the Old and the New South. In his accidental choice of a trademark, Rutt selected a figure that already resonated with northerners and southerners, whether they knew mammy from personal experience or literature. Historians of slavery disagree widely on what mammy did—specifically, the extent to which she might have nursed white children and the amount of power she really might have exercised within a plantation home. They often cast doubts as to whether there was anyone in the home like the mammy. But it is beyond dispute that the slave woman performed one of the more important and difficult tasks on a southern plantation, working long hours in a hot, often detached kitchen, where a wood fire needed to be kept burning throughout the day.[7] This was a job that required skill and endurance, and it is no wonder that postbellum southern whites might have looked back fondly on the mammy in the kitchen.

And when they did look back, they saw in mammy a person who was important for more than her cooking. Rather than rejecting the idealized mammy, the New South kept a special place for her in its heart, on its own terms, as many postwar redeemers built their arguments for change on approving looks to the mythic southern past. The Old South was a nearly perfect land, "studded with magnolias," filled with sprawling plantations, and populated by beautiful women and courtly gentlemen, whites who lived lives of leisure. The work that had to be done was performed by black slaves, who typically were "lovable, amusing and devoted." Spokesmen for the New South in the 1880s, regardless of the particular program they advocated, rarely failed to praise the golden era that had passed.[8] The protests of loyalty to the old regime went beyond politics and were evident in literature, music, and journalism, and in organizations such as the Kappa Alpha Order and various associations of the Sons and Daughters of the Confederacy. Aunt Jemima Pancake Flour was likewise soaked in what C. Vann Woodward has referred to as the sweet "syrup of romanticism."[9] During the Confederate memorial movement, "the mythology of the mammy actually emerged and expanded . . . to serve the needs of a generation of nostalgic southern whites searching for their past and perhaps seeking to justify existing race relations."[10] Thus the image of the happy, loyal mammy—as distinguished from what the slave woman actually did—did not merely linger during the latter years of the nineteenth century but thrived and expanded even as memories of the antebellum South faded (or arguably *because* memories faded). Ironically, during the era that has been described as the "peak time for the glorification of the mammy" in southern diaries and literature, about 1906 to 1912, the real black women who inspired the image were headed in a different direction, increasingly

toward domestic service in the North. This was not lost on some white southerners; for example, in Georgia, a group called the Black Mammy Memorial Association in 1910 sought to establish a vocational school to train more black women not only in domestic service but in the "spirit of service" of mammydom. By 1923 the United Daughters of the Confederacy sought not a vocational school but a national memorial to the mammy in the nation's capital, reflecting a desire to commemorate "a long-lost southern icon instead of an attempt to recreate it."[11]

That mammy—the slave woman romanticized in the postwar era and mocked on the minstrel stage—was the person Chris Rutt put on his bags of pancake flour. She soothed guilt over slavery, kept white women out of the kitchen, and put hot food on the table. Like the real slave woman, she saved whites from work; but the mammy remembered in the New South saved whites from worry, too. However haphazardly Rutt came to call his concoction "Aunt Jemima Pancake Mix," he selected an icon that was meaningful to whites in 1889 and would continue to be for decades to come.

Ingredient #2: the promotional revolution

The trademark selection was Rutt's only stroke of marketing genius, however. The pancake batter did not sell locally, mostly because neither Rutt nor Underwood understood how to advertise their innovation. By the winter of 1889, they were out of money. Rutt returned to writing editorials, and Underwood took a job with the R. T. Davis Milling Company, the largest flour miller in Buchanan County. Underwood's brother, Bert, registered the Aunt Jemima trademark and briefly attempted to market the mix himself. But in January 1890, the partners sold the company and recipe to Charles Underwood's new boss, R. T. Davis.[12]

By 1890, Davis had been in the flour business for about fifty years. His products were on grocery shelves throughout the Missouri Valley, and he had the necessary capital to launch a new product. Davis also was experienced in the area in which Rutt and Underwood were especially naive: the revolution in the production and promotion of consumer goods that occurred during his years in the business, creating a mass market for consumer goods as the nation moved from rural to urban, production to consumption, and agricultural to industrial. Changes in law and technology in the 1880s and 1890s facilitated this process. From 1870, when the first act protecting trademarks was passed by Congress, to 1905, when trademark rights were affirmed to the point that they had no legal expiration date (unlike copyrights, for instance), the number of protected corporate names and emblems grew at a prodigious rate. Only about one hundred trademarks were registered with the federal government in 1870. By 1875, 1,138 were registered, 10,500 in 1906, and more than 50,000 by 1920.[13] While the law protected the language that major firms used to communicate directly to consumers, advances in printing processes provided the means. Changes in printing costs and processes meant that publishers could depend on advertising instead of literary content to make money and that a number of prominent magazines established in the 1880s—*Ladies' Home Journal, Cosmopolitan, McClure's*—set out to do so, directing content "toward the increasingly numerous and prosperous urban middle classes," who had previously shown little interest in literary monthlies.[14] Changes in magazine content during the last decades of the nineteenth century created a demand for a type of producer—the advertising

agency. Before the 1890s advertising agents mostly brokered space, purchasing it from newspapers and magazines and selling it to manufacturers, who planned their own campaigns and wrote their own copy. In 1880 the Wanamaker clothing retail firm hired an agent to write its copy, and large department stores began to adopt that approach. Likewise, producers of household products increasingly employed agents to write their copy, although in 1900 more than 2,500 manufacturers still crafted their own ads. From the turn of the century to World War I, ad agencies were increasingly hired to promote new products (Crisco, household appliances) and old (textiles, oranges, and caskets).[15]

What companies could propose to consumers through advertising changed during the last two decades of the nineteenth century, when an old hand like Davis took over Aunt Jemima from the entrepreneurs Rutt and Underwood. After 1880 the extension of railroads helped to create regional markets for products that could be produced uniformly and in greater quantities through centralized manufacturing. Still, most products were unbranded, and wholesale distributors, not the more distant producer, dominated the sales process and controlled the way products were marketed. Manufacturers like Davis, however, sought greater control over the pricing and distribution of their products to ensure maximum profit and predictability; "massive outputs demanded dependable markets." Firms such as Procter & Gamble worked to centralize the distribution process as well as manufacturing and thus took a greater stake in the promotion of their products, courting local merchants, creating in-store displays, and providing instructions on how the products should be used. New promotional strategies meant a new relationship had to be forged between the maker of a product and the person who eventually purchased it. Because the manufacturer's interest was not only in selling the product but supporting a predictable and profitable price, the buyer needed to be persuaded to accept no substitute for the manufacturer's product and to distinguish among brand names.[16]

Davis put more than capital behind the Aunt Jemima brand; he brought a promotional strategy. He also possessed the insight to make three changes with Aunt Jemima. First, he added powdered milk to the mix, which meant that housewives needed only Aunt Jemima and water to make pancakes. Second, he added rice and corn sugar to improve the product's texture and flavor. The third change, however, was by far the most important: R.T. Davis decided to promote "Aunt Jemima Pancake Mix" by creating Aunt Jemima—in person. He mixed the mammy and the mass market. The two have been inseparable since.

The image of Aunt Jemima as a legendary cook was the one upon which Davis attempted to capitalize after buying the Pearl Milling Company, which he rechristened the R. T. Davis Milling Company in 1890. He sent out requests to his large network of food brokers, asking them to keep an eye out for the personification of Aunt Jemima: a black woman with an outgoing personality, cooking skills, and the poise to demonstrate the pancake mix at fairs and festivals. In a time long before television and its myriad animated trademarks, Davis had decided to take product promotion a step further. His trademark not only would breathe and speak but its personality would sell the product, charming audiences into giving the mix a try. The simple-minded Aunt Jemima, who had so much trouble with modern times, was destined to sell the scientific magic of the self-rising pancake.

Charles Jackson, a food wholesaler, found the first Aunt Jemima. Her name was Nancy Green, a 59-year-old servant for a Chicago judge. She had been born into slavery

on a Montgomery County, Kentucky, plantation, and she enjoyed sharing stories of her childhood in slavery. Davis, certain he had found the living Aunt Jemima, signed Nancy Green to an exclusive contract to play the role of her life. Her debut came at the 1893 Columbian Exposition in Chicago, in a booth designed to look like a giant flour barrel. She greeted guests and cooked pancakes, all the while singing and telling stories of life on the plantation, some real, some apocryphal. Purd Wright, the librarian who had taste-tested the first batch of pancakes and now served as Davis's advertising manager, distributed a souvenir button he had designed. On it was the likeness of Aunt Jemima; below her smiling face was the caption "I'se in town, honey." Aunt Jemima's debut was a smashing success. Crowds jammed the exhibit, waiting for a glimpse of her, and "I'se in town, honey" became a catchphrase. Fair officials awarded the "pancake queen" a medal, and Davis claimed that merchants who had attended the fair placed more than 50,000 orders for his pancake mix. But more important, the persona of Aunt Jemima had proved to sell a lot of pancakes. Green, whose more pleasant face had replaced the hideous mammy on the original logo, began participating in sales promotions across the country. Aunt Jemima herself couldn't be everywhere; the legend, however, could.

Purd Wright wrote the earliest version of Aunt Jemima's life story. Titled "The Life of Aunt Jemima, the Most Famous Colored Woman in the World," the pamphlet blended fact and fiction, Nancy Green's slave stories with Wright's imagination. Aunt Jemima was the loyal cook for Louisiana's Colonel Higbee, a prosperous planter on the Mississippi. Her pancakes were the envy of the region, but she would not share the secret recipe. During the Civil War, Union soldiers threatened to rip Higbee's moustache off his face when Aunt Jemima interceded, offering the northerners pancakes, and the Colonel was able to escape. According to the legend, the northerners never forgot the taste of the most delicious pancakes in the world. After Higbee's death some of them persuaded Aunt Jemima to come upriver and share her secret with the world.[17]

This is the essence of the myth that Davis used to promote the pancake mix until his death in 1900, a story maintained by the executives who followed his company through one bankruptcy and a reorganization in 1903. Robert Clark, Davis's former general manager, assumed control of the company that year and renamed it Aunt Jemima Mills. He extended Aunt Jemima's visibility by beginning a rag doll coupon promotion in 1906. Eventually, Aunt Jemima gained a husband, Uncle Mose, and "two cunning pickaninnies," Diana and Wade—all available to those who sent in three boxtops and small change.[18] The rag doll campaign, even in bad times, was a consistent success for the milling company, as Clark recalled in a 1925 company memo; the first year Clark found to his surprise that the company needed to hire extra help to process all the "bushel baskets" of requests "for this delightful southern mammy that could be cuddled, dropped, thrown and sat upon, and would still turn up, good as new. But it was impossible to deliver the dolls quickly enough."[19]

In late 1923 the company sought to measure interest in the rag doll promotion and began offering consumers a choice: either six cents for a sample package of buckwheat flour, a sample package of regular flour, and a recipe folder or, for thirty cents, all of the above, plus the "jolly Aunt Jemima family" of rag dolls. When the responses to the ads in *Good Housekeeping*, *Ladies' Home Journal*, and the *Chicago Tribune* were tallied, 3,309 had opted for the six-cent offer, and 4,853 for the thirty-cent offer. In December 1923 the company placed a series of ads across the country, offering the samples for free and the rag doll family for an additional dime. The ten-cent offer received 6,692 responses,

outdrawing the free offer's 3,716 replies. The advertising memo only noted that it was "interesting" that the free offer was less attractive than the rag doll offer, and also commented: "The amount of money enclosed with the coupons has exceeded the cost of the space used to advertise the offer. It seems quite probable that this could continue to pull for some time."[20]

The myth of Aunt Jemima and its trappings—rag dolls, salt and pepper shakers, and cookie jars—continued as the company again prospered under Clark and struggled during World War I. The story of the black mammy's pancakes was adopted by the Quaker Oats Company, which bought Aunt Jemima Mills in 1925 and applied its considerable marketing resources. The legend even survived the death of the original Aunt Jemima, Nancy Green, who was struck by a car in 1923. Three more women eventually became the national Aunt Jemima, in different media (although dozens of women played Aunt Jemima in smaller promotions). The 350-pound Anna Robinson beat out hundreds of other hopeful mammies in 1933 and created the darker and heavier Aunt Jemima depicted on boxes during her reign, which ended with her death in 1951. Edith Wilson first depicted Aunt Jemima on radio advertisements in 1948 and eventually replaced Robinson as the mammy. Wilson continued the tradition of personal appearances and slave stories, and she became the fourth face on the Aunt Jemima box, the one that lost the bandanna and gained a handkerchief in 1968 and then was further modified in 1989 in an attempt to "update" her image. Finally, from 1957 to 1964, Aylene Lewis played Aunt Jemima at the Aunt Jemima Pancake House, in Disneyland's Frontierland, where Colonel Higbee lived too in a "gracious Old South setting."[21] Throughout their careers the differences among the women who played Aunt Jemima, as well as Aunt Jemima herself and her origins, tended to blur. For example, the 15 November 1923 issue of *Missouri Farmer*, under the headline "Aunt Jemima Is Gone," mentioned that Green had been struck by a car and then blended the facts of Green's life with the fiction of Aunt Jemima's. It said that the "boys" in the home of the Chicago judge where Nancy Green worked loved the pancakes made by the ex-slave from Kentucky, and her pancakes became famous throughout the neighborhood. "In due time, a big St. Joseph mill heard about her, obtained her recipe and induced her to make pancakes at the Chicago World's Fair. . . . After the fair, the mill itself adopted her name and she was employed to go from one exposition to another to demonstrate her skill."[22] Nancy Green, of course, adopted Aunt Jemima's name, not the other way around. The idea that Aunt Jemima was a real person can be seen in more contemporary accounts; for example, a Gannett News Service report in 1989 said:

> Aunt Jemima was a bubbly person and fun to talk to. Born in Montgomery County, Kentucky, she moved to Chicago shortly after the turn of the century and cooked for a judge's family, where her specialty was—get ready—pancakes. Aunt Jemima became famous at the World's Fair in Chicago in 1893 where, legend has it, she flipped more than a million pancakes by the time the fair was over. In 1923, Aunt Jemima, 89, and jolly as ever, died in a car accident.[23]

Nearly one hundred years after the Columbian Exposition, reporters still occasionally refer to Aunt Jemima as someone who actually lived, if not "the most famous colored woman in the world." R. T. Davis and Purd Wright built their legend to last.

Ingredients #3 and #4: servants and technology

While some things stayed the same—like the basic story of Aunt Jemima's life—other things changed during her career. One was her owner's fortunes in the years after World War I. Aunt Jemima Mills, reorganized under Robert Clark, was usually cash poor, and after prewar sales hit an all-time high, the substitute flours used during the war eroded the ready-mix's popularity. At this difficult time in the milling company's history, the J. Walter Thompson Company rethought the Aunt Jemima account that it had held since 1909. By late 1917 two more white men had come aboard to reshape the image of Aunt Jemima yet again, and their version of the mammy became the best remembered. The advertising firm assigned James Webb Young, a Chicago ad writer, to develop a new campaign and hired N. C. Wyeth to illustrate it. Young, a native Kentuckian, was the son of a Mississippi riverboat captain. His mother was "a fiery partisan of the Confederacy." Wyeth, a widely known illustrator and painter and the father of Andrew Wyeth, was a New Englander. He also was a disciple of Howard Pyle, an illustrator and art teacher who emphasized accuracy and authenticity in recording historical fact. Young and Wyeth took the legend of Aunt Jemima and fleshed it out in vivid color.[24] In doing so, they made the perfect servant more real to more people than she had been before.

Making the mammy more real than ever was a brilliant move on Young and Wyeth's part, given the times. The perfect servant the mammy represented, or for that matter, any kind of servant, was becoming scarce in the early-twentieth-century United States, mostly in the North. By the end of the nineteenth century and through the 1920s, prospective white female servants in northern cities were increasingly attracted to other employment, particularly factory work. To a small degree the drop in the household labor force was offset by the entry of increasing numbers of part-time (married) black women into household service. Even with the influx of black women from the South, however, the North's continuing "servant problem" persisted; the seemingly perpetual turnover and shortage of household servants took on a black face.[25] While the South lost its legendary mammy during the migration to the North, the North did not import its own version of her. Instead, the major trend in household work after World War I was the introduction of "labor-saving" devices, from electric irons to washing machines to indoor plumbing, and the overall decline of the servant population. Labor-saving devices, however, tended to "save" only the labor of the servants households formerly employed by compelling housewives to spend more time cleaning, cooking, and sewing themselves. Advances in household technology perhaps made life without a servant more bearable; they were not preferable to the service of a woman too loyal to leave for factory work across town. Electric irons were not a suitable replacement for the class identity that comes with employing servants, either.[26]

For the first quarter century that American households had electricity, the people who could afford it were the same people who could afford servants, and ads emphasized electricity as a means by which white women could better deal with their servants. They could summon them with an electric bell or temporarily deal with a laundrywoman's sudden departure by using an electric washing machine. By 1918, however, as servants became harder to find in middle-class homes and electricity became more commonplace, advertisements appealed to the specific needs of the white housewives in a servantless household. Household technology not only spared women—servants or

mistresses—from having to haul water, tend fires, and clean lamps by hand, it also "liberated" housewives from the burden of servants themselves. "Don't go to the Employment Bureau. Go to your Lighting Company or leading Electric Shop to solve your servant problem," a General Electric ad read in 1917.[27] Other ads emphasized that the time saved by electric appliances could enable mothers and wives to fill more important roles. They might no longer command a servant, but household technology allowed them to "put first things first," expanding the attention they gave to their husbands' happiness and giving them more time to serve as a civilizing influence on their children.[28] In this way postwar advertising echoed themes already explored among women of the nineteenth-century domestic science movement; the Christian civilizing function of the home was enhanced by twentieth-century advances in production.[29] Despite the ironic nature of "labor-saving" devices—the fact that they redistributed rather than "saved" labor—it would be a mistake to conclude that housewives did not see advantages in them and that appeals to purchase and use them did not address real questions.

The Aunt Jemima print campaigns of the 1920s addressed the problem of class identity caused by the twin ingredients of fewer servants and more "laborsaving" products, and in doing so, it fit within the larger context of post-World War I advertising, which reflected its own concern with moral uplift. During this period, advertising leaders— like James Webb Young, who came to Aunt Jemima after pioneering ads for women's deodorant—saw themselves as making more than money; they were "claiming recognition as a preeminent civilizing and modernizing force," educating consumers on standards of health, beauty, and class.[30] Accepting this role meant also accepting at least two inherent contradictions. Advertising, as a spokesman for "modernity," also had to transcend its very nature, using mass communications to achieve a personal tone and strike a chord with the individual consumer. But the very assumption that the economic citizenry needed moral uplift also meant that advertisers perceived that their audience was culturally and intellectually distant and that appeals to popular taste, particularly to women, were by necessity shaped not to appeal to reason but to "rather raw and crude emotions." The mostly male and all-white advertising elite considered the cultural gap to be pronounced not simply among different classes but between men and women, the latter of whom were considered inert emotionally and mentally. "It was both a comfort and a challenge," in Roland Marchand's words from *Advertising the American Dream*, "to conclude that even 'The Colonel's Lady' must be addressed in a language different from that normally spoken among advertising men."[31]

The effort to reach—or in this case create—"The Colonel's Lady" is where the four ingredients of Aunt Jemima's appeal come together. The mammy of the Old South, the mass market, the servant problem, and changes in household technology were mixed in a unique appeal that sold a modern product by drawing on older ideas about race and women. The trademark took the concept of the mammy out of the realm of ideas about racial and gender hierarchies and employed it to distinguish a particular product. Transporting the slave mammy to the twentieth century meant putting her back in her Old South place—a land of white leisure and apparently only upper-class white women. The image of the slave as well as the product itself addressed the present-day problem of putting food on the table in an age when live-in household servants were in short supply. And the advance in advertising techniques made possible the mammy's resurrection from Old South slave, New South icon to a living woman who addressed the consumer directly, either in colorful print ads or in flesh-and-blood promotional tours. Young and

Wyeth made her real. They made her plantation real. They put everyone in his or her proper place—masters, servants, and most important, the mistress of the house.

How the ads worked: adding water to Aunt Jemima

Those are the ingredients. Here is how they worked together, and why they worked at all. First, while Aunt Jemima was created amid a wave of seemingly similar trademarks for household products, she was different in important ways. She was, from the moment Nancy Green took up the role, always more real than any other trademark. She was always the focus of the advertisement, even in a time in which images of servants were actually disappearing from ads that emphasized the things a housewife could do without help.[32] And in the hands of Young and Wyeth, the fantasy black mammy addressed the real concerns of the modern-day, middle-class, white housewife.

The trademarks employed by the makers of products such as Cream of Wheat, Gold Dust Washing Powder, Old Dutch Cleanser, Diamond Crystal Shaker Salt, and Quaker Oats appear, at first glance, to be similar to Aunt Jemima in their depiction of racial or religious figures. It is important, however, to discuss how these trademarks were used or, rather, how they were not used. There was no attempt by the makers of Cream of Wheat to create a biography for Rastus, the chef depicted on the cereal's box, and Rastus himself never spoke nor, in fact, did anything in Cream of Wheat ads. There was nothing magical about his cooking ability, and his personality was unknown to buyers.[33] Similarly, the Quaker on the Quaker Oats box acted only as a logo and did not even appear in many of the company's ads.[34] The Gold Dust twins, a pair of black children, were never depicted as doing anything in their advertisements, and it appears unlikely that the advertiser meant to connect black children with cleaning powder in any meaningful way.[35] Likewise, despite whatever reputation the Dutch might have for cleanliness, the presumably Dutch woman on Old Dutch cleanser lacked not only a face but also a name, and the advertiser made no further attempt to link her ethnic identity with her ability to "chase away dirt."[36] The Quaker woman depicted on Diamond Crystal Shaker Salt appeared to be as much a play on words as anything; the word "Shaker" related as much to the salt's intended use as it did to the woman depicted on the container.[37]

The Aunt Jemima campaign was different. From the more crude ads just after World War I, which featured a more grotesque version of the mammy, to the ads painted by N. C. Wyeth in the 1920s, Aunt Jemima was always the focus of the ads' message. If she did not speak to the reader directly, the text was about her. Her image was displayed prominently, almost always with the tag line, "I'se in Town, Honey," in small type.[38]

The second and most important way in which the promotion of pancake flour differed from that of other products was its reliance on the story of Aunt Jemima and not simply her image. In 1918 and 1919 the advertisements emphasized a number of points. They depicted the pancakes as especially loved by children, convenient for busy mothers, and served at "sixty million breakfast tables" annually. The ads, like those for many other products, mentioned at least in passing that the special formula had been scientifically tested for reliability. Regardless of science, however, the ads asked white housewives to put their faith in Aunt Jemima herself—it was her mixture in the box, the same one that so pleased visitors to the old plantation. In the ads of 1917 to 1919 the

legend of Aunt Jemima is ubiquitous: "When they taste the famous Aunt Jemima flavor they will wonder how you learned the secret of the old-time cooks of the South, for only the Southern pancakes we have all heard praised can compare in flavor with the cakes you can make with Aunt Jemima Pancake Flour."[39]

One of the earliest examples of Young and Wyeth's collaborations appeared in the October 1919 issue of *Ladies' Home Journal*. Titled "The Cook Whose Cabin Became More Famous Than Uncle Tom's," it reintroduced Aunt Jemima and Colonel Higbee through a variety of colorful illustrations from the Old South, in the days "befo' de war." Aunt Jemima's plantation home became alive in a print ad: "Passengers on the old Mississippi river-boats never failed to point out the stately white-pillared mansion, and their mouths watered as they told of the wonderful breakfasts he [Higbee] was famous for giving. Oh, the meals that 'Colonel Higbee's Jemima' used to cook! Chicken dinners that left the Colonel and his guests with their faces wreathed in smiles—and gravy. Corn fritters, waffles and beaten biscuits that seemed to melt in your mouth. But most of all—pancakes!"

The ad depicted a grinning, friendly Aunt Jemima standing along the river's edge and then serving pancakes to the Colonel's guests. It showed Colonel Higbee, with his white moustache and goatee, standing before the pillars of his mansion, with a caption saying that the master, "Knew a good horse, suh, and a good dinner." The message is not merely about economy or ease, it is about a time and a place supposedly in America's past, a time when a grinning servant happily served hot food to her generous master's guests. And the reader was reminded that although that time is past, the secret of those tempting pancakes is available on your grocer's shelf.

Other ads in the series followed the same approach: they told a story and featured a variety of Wyeth illustrations of the Old South. "When Guests Dropped in to Stay a Week or Two" emphasized southern hospitality, which of course included generous helpings of Aunt Jemima's pancakes: "There were plenty of extra rooms in the big pillared mansion—plenty of chickens and butter and eggs and rice and other good things to serve any number at any time! And always, at a moment's notice, Aunt Jemima could whisk up a batch of her famous pancakes—the like of which, you'd never taste elsewhere in all the Old South!"

The ad was a sketch of sorts involving Aunt Jemima and Uncle Mose. It showed guests arriving in a carriage, with Uncle Mose unloading the luggage and exclaiming, "Yas Suh! Yas suh—de cun'l sho' do like lots of company." Uncle Mose also was depicted as a pancake thief, as Aunt Jemima shooed him away, saying, "Scat! Yo' black rascal. Don't come hamperin' me when they's company waitin fo' breakfast!" Another part of the ad showed white guests scampering down steps with the caption, "Polkas till midnight—but the Colonel's guests were always prompt to breakfast!" The pancake mix was advertised as a link to a life of leisure, with friendly but foolish black servants handling the cooking and the luggage. In other ads Young and Wyeth contributed specific episodes to the story of Aunt Jemima. "The Last Christmas on the Old Plantation" tells the story of Christmas 1860, before the attack on Fort Sumter. Once again, Uncle Mose toted the luggage as guests arrived in anticipation of Aunt Jemima's cooking: "The rafters of the old mansion fairly rang, from the moment the avalanche of guests and luggage arrived, till the last carriage rattled down the driveway the day after New Year's. Never a shadow of the fast-approaching struggle between North and South that was to make this their last Christmas together."

In the warmth and security of the Old South, the "children, stuffed like little geese, delight in teasing Aunt Jemima." She and Mose, who proclaimed, "Lawzee, but dey sho' do keep me humpin' fo' mo' pancakes," are the perfect servants: friendly, docile, and in Jemima's case, possessing that magical touch in the kitchen. In a second ad, "When the Robert E. Lee Stopped at Aunt Jemima's Kitchen," Young and Wyeth attempted a second explanation of Aunt Jemima's discovery by a northern mill operator. "Twenty years or so after the Civil War," the ad explained, the sidewheeler "Robert E. Lee" neared the confluence of the Red and Mississippi rivers. Then "an old Confederate General in the upper deck called the attention of the other passengers to a little old cabin on the bank." The general told the other passengers that he and his orderly had become separated from troops and stopped at the cabin for a snack, where Aunt Jemima served them the most delicious pancakes he had ever tasted. When the passengers came ashore, the landing party rushed to the cabin to "see if by any chance the old cook were still there":

> Sure enough, she was still living in the same cabin and gladly mixed up a batch of her cakes for them. Several of the gentlemen immediately made her tempting offers for the recipe, but all were refused.
>
> Later, however, one of the party returned. He was the representative of a large flour mill and had not been able to forget those pancakes. This time he was more successful—he persuaded the mammy to sell him the recipe, and that is the way Aunt Jemima's pancakes became known to the world.

If, after the 1893 World's Fair, Nancy Green's tours, and R. T. Davis's promotion efforts, there had been any line remaining between reality and fiction concerning Aunt Jemima, these ads removed it. The link between specific times, places, and things made the Aunt Jemima legend even more real. She was not merely from a Louisiana plantation but from a plantation near the confluence of the Red and Mississippi rivers (that means Colonel Higbee's mansion was in the vicinity of Simmesport, Louisiana). She lived there during the secession crisis that followed Lincoln's election. After the war, still in her plantation cabin, she was visited by passengers of the "Robert E. Lee," a famous Mississippi riverboat. Many other ads addressed similar aspects of the mammy's life on the plantation.

One ad especially stands out, however, as an example of the blurring line between Aunt Jemima's reality and fiction. In March 1921 Young and Wyeth's "At the World's Fair in '93, Aunt Jemima was a sensation," melded a real event, a real person, a fictional person, and the fictional person's background. Although Nancy Green had "been" Aunt Jemima personified to thousands, Aunt Jemima became, in the ad, the real person who appeared at a famous exhibit at the 1893 world's fair. The ad tells the story of what happened after the milling company representative brought Aunt Jemima north: "There she was—at the World's Columbian Exposition, Chicago. And, up on a platform where all could see, she was making pancakes a new way—from ready prepared flour! You remember reading of how, some twenty years after the Civil War, a representative of a milling company in Missouri bought from Aunt Jemima her pancake recipe and persuaded her to direct its preparation in the great mills. Well, this pancake flour was the result. It had been made from Aunt Jemima's own recipe—the recipe that had made her famous through all the South even before the war, when she was cook in Col. Higbee's mansion down in Louisiana."

The ad is an oddity in many ways. It picks up the Aunt Jemima legend but relates it to real events, moving her somewhere beyond mere puffery but nowhere near reality. Nancy Green was not Aunt Jemima at the 1893 fair; the real Aunt Jemima was fresh off the fictional plantation created for her by Purd Wright after the exposition. The ad reminds readers that Aunt Jemima was mobbed by the masses and won a medal, events that actually happened, but the explanation for her popularity is rooted in fiction: "Those who knew her best, who knew her even from the time when she first came up from her little cabin home, they found her still the simple, earnest smiling mammy—it was all the same to her."

Nancy Green was not found in a little cabin on the Mississippi, of course, but in the kitchen of a Chicago judge's home. The ad also offers the first reference to the recipe's purchase by a "milling company in Missouri," meaning, of course, the real Pearl Milling Company, owned by a pair of bachelors (one of them, the ad also neglects to mention, happened upon a minstrel show one night). It doesn't matter, of course, that the ad wasn't factual (no Aunt Jemima ad had ever been factual), but it is striking how much of the story of Aunt Jemima was intentionally rooted in reality. Aunt Jemima, who never existed, had become a real person through the imagination of the men who manipulated her image in personal appearances and in print. Curiously, given the ad writer's desire to make Aunt Jemima real, he also made her deceased—two years before Nancy Green died in a car accident. "At that great World's Fair in '93, they saw Aunt Jemima in person; today we cannot," the ad said. "But what she did, lives on—that and her smile." (Future ads placed Aunt Jemima back among the living, with no explanation.)

To the advertising copywriter, Aunt Jemima became a real enough person to be included "among the famous cooks of history." She was real enough, according to a "distinguished writer on foods," to have left Mark Twain "hankering" for some famous Mississippi buckwheat pancakes during a trip to Europe. The ad writers eventually cited a source for all they knew about Aunt Jemima's life on the Mississippi and her discovery. The small print note appeared on numerous ads throughout the 1920s: "We are often asked, 'Are these stories of Aunt Jemima and her recipe really true?' They are based on documents found in the files of the earliest owners of the recipe. To what extent they are a mixture of truth, fiction and tradition, we do not know."[40]

Other food processors attempted to capitalize on extended myths about origins of their products in the fine cooking of the Old South. Maxwell House Coffee was served to famous southerners and "families who appreciated the best" in its eponymous Nashville hotel, according to a series of ads in the mid-1920s. The ads, like Aunt Jemima's, emphasized southern traditions and the excellence of southern cooking in general, but they were fuzzy and contradictory as to how its current manufacturers were linked to the past.[41] Likewise, Brer Rabbit Molasses was supposedly made by a pair of southerners who longed for the special taste of the molasses of their youth.[42] The Aunt Jemima campaign devised by Young and Wyeth had its imitators not only in myth but in the use of a black mammy. It is a mistake, however, to say that early twentieth-century print ads using black mammies or porters were imitating Aunt Jemima, since black faces fill the frames of ads too numerous to mention here. Most were like "Mandy," an otherwise anonymous black woman who was amazed at how easily her mistress unclogged the sink with Drano, or the black chef who advertised Armour's Star Ham as "The Ham What *AM*."[43]

Those ads, however, generally can be said to be focused on the product (as opposed to the legendary life and exploits of the product's inventor), and none of the campaigns

was particularly long-lived. None possessed as imposingly "real" a figure as Aunt Jemima. The Aunt Jemima ads created by Young and Wyeth rooted the tale in reality—real times, real dates, real places. They also can be said to have manufactured their own contribution to the story of the Old South, forging a place and time in which guests were always welcome, the pace was slow, and Aunt Jemima was present to whip up a set of pancakes at any moment. Presumably, the other slaves were off performing still drearier household tasks, not only toting luggage but cleaning windows, washing clothing, and emptying chamberpots. Scientific testing and nutrition took a back seat as housewives were invited to share in a southern delicacy once made by a slave. Hardly any personal labor was required; all one needed to do was add water.

But who, exactly, added the water? In the ads discussed, the southern mistress herself was missing, with the exception of the "bride of 1860," who, try as she might, couldn't duplicate the taste of Aunt Jemima's pancakes. Colonel Higbee was there, as were the other slaves, relatives, and guests who flocked to the plantation. Only the lady of the house was missing, and the absent mistress was a key component of the ads' appeal. The southern mistress didn't appear in the ad because the appeal required white housewives to finish the thought themselves and place themselves in that role. They were the mistresses of their respective homes. Aunt Jemima, a real person, a real slave, an actual Old South recipe, was working for them. In reality, they couldn't have Aunt Jemima, let alone a hired servant. But, the ads seemed to say to white women, you can approximate the lifestyle once created for plantation mistresses by the efforts of female slaves by purchasing a creation of a former female slave. White housewives did not aspire to be Aunt Jemima; they aspired to have her. They were buying the idea of a slave, in a box.

The advertisements created during the 1920s were reprinted for years after Young retired in 1929, and Wyeth's drawings were on the menus and place settings in Aunt Jemima's Pancake House in Disneyland until it closed in 1970. The print ads continued to feature the Aunt Jemima legend prominently at least until 1955, when one campaign in *Life* and *Better Homes and Gardens* reminded readers of "What Aunt Jemima would *never* tell them . . . she got her matchless flavor with a blend of *four* flours." It featured a painting of a white antebellum woman who apparently was trying to talk the recipe out of the mammy, but the caption read, "Coax as long as they might, guests at Colonel Higbee's plantation never could get from Aunt Jemima the flavor secret of those wonderful pancakes." The legend eventually took a backseat to other types of appeals by the late 1950s, when Quaker Oats began promoting "Aunt Jemima Party Pancakes," a recipe involving flavored milks apparently developed at Disneyland; peanut butter and jelly waffles; and a twenty-five-cent plastic shaker for the mix that the ad said, "revolutionizes pancake mixing."[44] The shift in the advertising campaign appears to have been a complete break from the past, with Quaker Oats offering shakers and recipes instead of rag dolls; still, as late as 1986, the company returned to the old strategy, as an ad featuring Aunt Jemima rising like the sun over urban townhomes told readers that "she spent a whole lot of time beating and blending and baking so you don't have to."[45] Aunt Jemima and her legend, relics of the 1920s, lived to see the Space Shuttle, the Reagan presidency, Madonna, and a time when historians were writing books questioning whether mammies ever really existed in the first place. The legend outlived Jim Crow (both the minstrel character and the laws), Sambo, and Amos 'N' Andy.

The pancake queen in contemporary America

The ad campaign lasted a long time, but most important, it worked, as Aunt Jemima Pancake Flour gained millions of new customers in the years before the Great Depression and held them afterwards. The product still has millions of customers today, and it still has a smiling mammy on the box.[46] Protests and boycotts from black Americans led Quaker Oats to drop the bandanna in 1968 and give Aunt Jemima a headband, in addition to slimming her down and making her look somewhat young; Disneyland closed its pancake house two years later. Marilyn Kern-Foxworth, a journalism professor who has studied the image, believes the change in appearance was crucial to the continued success of the trademark; she wrote in 1990 that "the physical attributes . . . became more positive and less stereotypical than the caricatures of the past."[47] Likewise, noting changes in soft drink brand names such as Chinese Cherry and Injun Orange in the 1960s, Steven Dubin argued that the rise of black consciousness and attention to black images in popular culture made some racial stereotypes in advertising less "grease" and more "grit" in the "smooth functioning of U.S. society" and that advertising agencies, interested in keeping the wheels turning, adjusted accordingly.[48] In 1977 *Washington Post* columnist William Raspberry similarly argued, when asked why he objected to the Sambo's restaurant chain but not Aunt Jemima, that the changes in Aunt Jemima's appearance, in addition to the fact that most people no longer connect titles like "aunt" and "uncle" to slavery, had made her an innocuous image.[49] This is a conclusion, however, that many contemporary critics of racial stereotypes in advertising would challenge—after all, the image is still Aunt Jemima on the box, adjustments to her wardrobe and weight not withstanding. The novelist Alice Walker, in a 1994 essay, argued that Aunt Jemima and the mammy she exemplifies, regardless of all attempts to refine her image, are too firmly rooted in the subconscious of white American culture to erase. Walker sees and hears Aunt Jemima everywhere, from the Dallas airport gift shops to the rantings of syndicated radio host Howard Stern.[50] Perhaps no matter how her owners dress her, Aunt Jemima is still a slave, something too difficult to explain, but too valuable ($300 million in sales annually by 1989) to give up—a dilemma not unlike that faced by antebellum slave owners who struggled to spin apologies for the peculiar institution itself.[51]

In 1989 Quaker Oats made its latest alterations to Aunt Jemima, removing her headgear, graying her hair, and giving her a pair of earrings. The attempt was, as a company spokeswoman said recently, "to make her look like a working mother." The spokeswoman also said that, bandanna or not, Aunt Jemima remains on the box because she is a southern character and the South is known for good food and home cooking.[52] The more interesting questions are left unanswered. What makes a black woman a particularly "southern character"? Might it have something to do with slavery? (Otherwise why not try "Scarlett O'Hara" Pancake Flour?) What was a mammy in the first place, if not the ultimate "working mother"? And how many working mothers, white or black, identify with the name "Aunt Jemima"? (Try to imagine a contemporary product aimed at men—cologne, for instance—using Uncle Mose as an emblem of masculinity or success.) Clearly, though, the Quaker Oats Company believes, perhaps based on their own market studies, that transforming Aunt Jemima into a "working mother" makes her even less "grit" and more "grease" in society.

Whether Aunt Jemima the working mother will have any special appeal to white

or black consumers is not only beyond the scope of this essay but possibly beyond the grasp of marketing experts themselves, who in the 1990s still struggle with problems of ethnicity and language. For example, Gallo Wine has attempted unsuccessfully to position Thunderbird wine in the marketing niche occupied by middle-class blacks, while Kentucky Fried Chicken, now known as KFC, test markets the black consumers who make up 25 percent of their market, wanting to know if Colonel Sanders might somehow be offensive. They decided he was not, as long as he kept off the front porch of the plantation. The R. J. Reynolds Tobacco Company spent $10 million to target Uptown cigarettes to blacks, but the target audience instead protested, and the product was dropped. More amusingly, the Perdue chicken company's ad agency once accidentally translated its slogan "It Takes A Tough Man to Make a Tender Chicken" into Spanish as "It takes a sexually stimulated man to make a chicken affectionate" in an attempt to reach a Latino audience. That appeal didn't work, either.[53] In September 1994 Aunt Jemima's advertisers trotted out the working grandmother image in their first national television campaign since 1990, but instead of having Aunt Jemima speak for the Aunt Jemima brand, they hired singer Gladys Knight and two of her grandchildren, which means that a real black woman is now speaking for an imaginary black woman. Knight reminded reporters that she was not playing any role but herself—a working black grandmother (like Aunt Jemima)—and said, "I'm not Aunt Jemima, I'm only a spokesperson." She noted that the transformed image, sans bandanna, "helped in my decision" to endorse the brand. *Newsweek* magazine added, "Perhaps it's time to call her [the image] Ms. Jemima."[54] Perhaps it is, but she remains "Aunt" Jemima, and Cap'n Crunch doesn't require, for some reason, a real, apologetic white male sea captain to speak for him or the cereal that bears his name. Maybe her owners could have argued instead that the one-hundred-year-old Aunt Jemima, by the late 1980s, was superannuated, released from servitude, and allowed to wear her gray hair any way she pleased. Obviously they didn't, because that would have meant acknowledging what an Aunt Jemima or a mammy was and always has been from her origins—a slave. Maybe that is why she cannot speak for herself today; she might say something embarrassing.

Eldridge Cleaver remains a better source on Aunt Jemima than anybody at Quaker Oats. "The white man turned the white woman into a weak-minded, weak-bodied, delicate freak, a sex pot, and placed her on a pedestal," he wrote in 1968. "He turned the black woman into a strong self-reliant Amazon and deposited her in his kitchen—that's the secret of Aunt Jemima's bandanna."[55] While it might be enough to argue that the "secret of the bandanna" was simply taking a symbol of personal pride and making it a mark of servility, and leaving it at that, that doesn't explain how the symbol of servility worked. It doesn't explain the message Aunt Jemima carried from white men or how it was interpreted by white women. Servility to whom? For what purpose?

The analysis might be overly harsh, but the author of *Soul on Ice* was onto something. It is true that the white woman who mixed Aunt Jemima pancakes was in no danger of becoming weak-bodied or more delicate, and the rise of processed foods did not enhance her sexuality. But the mammy was a tool for white men to use in creating a fantasy in which white women could aspire to live, an alternative household in which they were the ultrafeminine, fragile mistresses who sat alongside Colonel Higbee as guests at his plantation. Race and gender, as Cleaver suggests, are both forces in explaining how the advertising campaign worked. But class was a factor as well, for whatever vacuum cleaners might have done to enhance a housewife's notion of her place in society, they

couldn't put her back on the idealized plantation. Aunt Jemima could. They couldn't have made the housewife an employer of labor, instead of the laborer herself. Aunt Jemima did. It was an advertising fable tailored to address the realities of dreary, work-filled days of white housewives, facilitating the transition from household manager to household laborer, just as the Old South myth also served as a balm for defeated white southerners.

Aunt Jemima's race remains inseparable from the message white females completed when they read her ads. She could not have been white. A white Aunt Jemima (provided she didn't quit domestic service for other work) could have liberated white housewives from the kitchen, but she could not have accentuated their whiteness and femininity as did the plantation mammy. Aunt Jemima was persuasive because she was a black serv-ant, in an age when perpetual human bondage existed, in a place legendary for its good food and white leisure.

In the final analysis, no one person really "invented" Aunt Jemima or her leg-end—not even the women who portrayed her. The idea of Aunt Jemima worked because of its appeal to existing white female needs in a time of revolutionary changes in the household and, indeed, because of general white perceptions of self relative to blacks—perceptions formed by events and forces much greater than any of the shap-ers of Aunt Jemima's image could have realized. As in Cleaver's explanation, white men are the manipulators, but white women, not blacks, are the real object of manip-ulation, which depends upon their willful participation, their understanding of the message, and their desire to receive it. And as James Baldwin wrote, in response to the question cited at the beginning of this essay, "this was the piquant flavoring to the national joke. . . . Aunt Jemima and Uncle Tom, our creations, at the last evaded us; they had a life—their own, perhaps a better life than ours—and they would never tell us what it was."[56] That is because the punchline to the "national joke" was never aimed at someone like Baldwin; Aunt Jemima was a pawn in a game played white on white, male on female.

Notes

1 James Baldwin, *The Price of the Ticket: Selected Nonfiction, 1948–1985* (St. Martin's Mark, 1985), 67. This quote is originally from Baldwin's *Notes of a Native Son.*

2 Enriched unbleached flour (flour, niacin, reduced iron, thiamine mononitrate, riboflavin), sugar, rice flour, leavening (sodium bicarbonate, sodium aluminum phosphate), salt. For thicker pancakes, add milk instead of water.

3 Arthur F. Marquette, *Brands, Trademarks, and Good Will: The Story of the Quaker Oats Com-pany* (McGraw-Hill, 1967), 139–140; Hannah Campbell, *Why Did They Name It . . .?* (Fleet Press Corp., 1964), 40–41; Chris L. Rutt, *History of Buchanan County and the City of St. Joseph and Representative Citizens* (Biographical Publishing Co., 1904), 240–241; Harvey A. Levenstein, *Revolution at the Table: The Transformation of the American Diet* (Oxford Uni-versity Press, 1988), 32; *Buchanan County History: The Heritage of Buchanan County, Missouri* (Missouri River Heritage Association, 1981), 374.

4 Marquette, *Brands, Trademarks, and Good Will,* 140–141.

5 Marilyn Kern-Foxworth, "Aunt Jemima: Plantation Kitchen to American Icon," *Public Relations Review* 16, no. 3 (fall 1990): 56–57; J. Stanley Lemons, "Black Stereotypes as Reflected in Popular Culture, 1880–1920," *American Quarterly* 29, no. 1 (spring 1977):

104–105, 110; Joseph Boskin, "Sambo and Other Male Images in American Culture," in *Images of Blacks in American Culture; A Reference Guide to Information Sources*, ed. Jesse Carney Smith (Greenwood Press, 1988), 264; Sam Dennison, *Scandalize My Name: Black Imagery in American Popular Music* (Garland Publishing, 1982), 47–50, 58–59; Preston Powell, *Gentlemen, Be Seated: A Complete Minstrel, with Notes on Production* (S. French, circa 1934), 114–126; Walter Ben Hare, *The Minstrel Encyclopedia* (W. H. Baker and Co., 1926), 82–93. The mammy stereotype persisted well into the twentieth century and was seen in print media and movies. Some examples: "Mirandy on Automobiles," a short story in the August 1918 issue of *Good Housekeeping* ("De only objection I's got to ortymobiles is dat I can't set on de fence an' see myself ride by in mine!"); and the servants played by Butterfly McQueen ("I don't knows nothin' 'bout birthin' babies!") and Hattie McDaniel (who won an Academy Award for Best Supporting Actress) in the 1939 movie *Gone with the Wind*. Aunt Jemima's closest parallel in the movies was "Aunt Delilah," a mammy whose old family pancake recipe was marketed by a white woman in the 1934 film *Imitation of Life*. See Donald Bogle, *Toms, Coons, Mulattoes, Mammies, and Bucks: An Interpretive History of Blacks in American Films* (Viking Press, 1973), 9–10, 56–59, 66, 82–90, 120. Also, the "Aunt Jemima Revue," a minstrel group, toured as late as 1927, possibly relying on the popularity of a pancake trademark that, ironically, was largely the creation of minstrel performers in the first place. See Henry T. Sampson, *Blacks in Blackface* (Scarecrow Press, 1980), 493. The visual image of Aunt Jemima and the mammy in general is traced by Karen Sue Warren Jewell in "An Analysis of the Visual Development of a Stereotype: The Media's Portrayal of Mammy and Aunt Jemima as Symbols of Black Womanhood" (Ph.D. dissertation, Ohio State University, 1976). The first appearance of Aunt Jemima that I have found dates to 1855, in a song titled "Aunt Jemima's Plaster" by "M.A.I." and published by Lee and Walker of Philadelphia. This Aunt Jemima is white. In the song, she mixes up a batch of plaster so strong that her neighbor's cat gets stuck to the floor (Newberry Library, Chicago).

6 Marquette, *Brands, Trademarks, and Good Will*, 143; Campbell, 40; Stanley Sacharow, *The Package as a Marketing Tool* (Chilton Book Company, 1982), 122–124. A good example of the "cakewalk" style is offered by Frank Dumont, *The Witmark Amateur Minstrel Guide and Burnt Cork Encyclopedia* (M. Witmark and Sons, circa 1899), 97–108. The tune "Aunt Jemima" is credited to Billy Kersands (1840? to 1915?), a noted composer and member of the Georgia Minstrels. Kersands's "massive mouth was as famous then as Jimmy Durante's prodigious proboscis is today," according to Jack Burton in *The Blue Book of Tin Pan Alley* (Century House, 1950), 22–23. See also Charles Eugene Claghorn, *Biographical Dictionary of American Music* (Parker Publishing Co., 1973), 252. For more on Kersands's importance in the development of postwar minstrel culture, see Mel Watkins's recent *On the Real Side: Laughing, Lying, and Signifying—the Underground Tradition of African-American Humor That Transformed American Culture, from Slavery to Richard Pryor* (Simon and Schuster, 1994), 104, 111–113, 188–120, 125–127, 150, 168, 394.

7 Some prominent histories of slavery that embrace the mammy as a real person are Eugene Genovese, *Roll, Jordan, Roll: The World the Slaves Made* (Pantheon, 1974; First Vintage Books Edition, 1976), 355, 361, 363; John Blassingame, *The Slave Community* (Oxford University Press, 1979), 266; and Elizabeth Fox-Genovese, *Within the Plantation Household: Black and White Women of the Old South* (University of North Carolina Press, 1988), 291–292. Doubts about the antebellum mammy's role are expressed in Deborah Gray White, *Ar'n't I A Woman? Female Slaves in the Plantation South* (W. W. Norton, 1985), 44–47, 49, 55–58, 60–61; Catherine Clinton, *The Plantation Mistress: Woman's World in the Old South* (Pantheon, 1982), 202; Patricia Morton, *Disfigured Images—The Historical Assault on Afro-American Women* (Greenwood Press, 1980), 102–105; Herbert Gutman, *The Black Family in Slavery and Freedom, 1750–1925* (Random House, 1977), 443–444; Jacqueline Jones, *Labor of Love,*

Labor of Sorrow (Basic Books, 1985; Vintage Books, 1986), 24–25; and Sally G. McMillen, *Motherhood in the Old South: Pregnancy, Childbirth, and Infant Rearing* (Louisiana State University Press, 1990), 128.

8 Paul M. Gaston, *The New South Creed* (Alfred A. Knopf, 1970), 151–186; C. Vann Woodward, *Origins of the New South 1877–1913* (Louisiana State University Press, 1951), 142–155; Hugh C. Bailey, *Liberalism in the New South: Southern Social Reformers and the Progressive Movement* (University of Miami Press, 1969), 120–121; Jonathan M. Wiener, *Social Origins of the New South: Alabama, 1860–1885* (Louisiana State University Press, 1978), 215–221; Dana F. White, ". . . The Old South under New Conditions," in *Olmsted South: Old South Critic/New South Planner*, ed. Dana F. White and Victor A. Kramer (Greenwood Press, 1979), 161–162. Historians, including those cited here, disagree on the question of continuity among the planter elite from Old South to New South. What distinguishes the works cited is their agreement that an allegiance to a largely mythical Old South was in some way tied to arguments for progress. For some differing views on the emergence of the Old South myth, see Dan T. Carter, "From the Old South to the New: Another Look at the Theme of Change and Continuity," in *From the Old South to the New: Essays on the Transitional South*, ed. Walter J. Fraser Jr. and Winfred B. Moore Jr. (Greenwood Press, 1981), 23–30; and Gaines M. Foster, *Ghosts of the Confederacy: Defeat, the Lost Cause and the Emergence of the New South* (Oxford University Press, 1987), 80–85. Carter discusses some progressives who were disenchanted with the Old South, myth and all.

9 Woodward, *Origins*, 155, 158. Both Gaston and Woodward describe how the idea of an Old South moved beyond discussions of politics and economy to literature, journalism, music, and other aspects of society toward the end of the nineteenth century. Some of the new organizations that sprang up to glorify the Old South are discussed in Joel Williamson, *A Rage for Order: Black/White Relations in the South since Emancipation* (Oxford University Press, 1986), 247–254. The northern origins of the Old South are discussed by Patrick Gerster and Nicholas Cords, "The Northern Origins of Southern Mythology," in *Myth and Southern History, Volume 2: The New South*, ed. Gerster and Cords (University of Illinois Press, 1989), 43–58.

10 Cheryl Thurber, "The Development of the Mammy Image and Mythology," in *Southern Women: Histories and Identities* (University of Missouri Press, 1992), ed. Virginia Bernhard et al., 94–95.

11 Thurber, "Development," 96, 99. On the national mammy memorial, see Jessie Parkhurst, "The Role of the Black Mammy in the Plantation Household," *Journal of Negro History* 28, no. 3 (July 1938).

12 Marquette, *Brands, Trademarks, and Good Will*, 143–145.

13 James D. Norris, *Advertising and the Transformation of American Society, 1865–1920* (Greenwood Press, 1990), 19, 97; Susan Strasser, *Satisfaction Guaranteed: The Making of the American Mass Market* (Pantheon, 1989), 43–46.

14 Norris, *Advertising*, 33–35.

15 Strasser, *Satisfaction Guaranteed*, 93–94; Norris, *Advertising*, 43–45. The turning point for the advertising agency was World War I, when agency leaders mounted campaigns to sell war bonds, encourage enlistment, and promote patriotism and conservation of resources. The year after the war ended, larger agencies—most notably the J. Walter Thompson Company in New York—consolidated their hold on national campaigns for a variety of products. One historian of American advertising has estimated that the total U.S. advertising volume increased from $682 million in 1914 to $1.4 billion in 1919. See Daniel Pope, *The Making of Modern Advertising* (Basic Books, 1983), 22–29.

16 Strasser, *Satisfaction Guaranteed*, 18–26, 42–43, 51–57; Norris, *Advertising*, 13–20; Richard S. Tedlow, *New and Improved: The Story of Mass Marketing in America* (Basic Books, 1990), 11–15.

17 Marquette, *Brands, Trademarks, and Good Will*, 144–147; Campbell, 35; Kern-Foxworth, *Aunt Jemima*, 58–60.

18 Marquette, *Brands, Trademarks, and Good Will*, 148–149. The rag doll offer was usually featured at the bottom of Aunt Jemima ads, and by the 1920s four boxtops and a quarter could purchase the entire family. By the fall of 1921 the ads dropped the reference to "cunning pickaninnies" and just referred to them as the "jolly" rag doll family. See *Good Housekeeping*, December 1921, 165. This is not to say that Aunt Jemima's makers were the first to make "mammy" dolls; similar figures such as the Old Nurse appeared as early as 1875 (see Boskin, "Sambo," 282–283). Aunt Jemima rag dolls and salt shakers fit within a larger tradition of black images on kitchenware, postcards, and other products, as described by Boskin, "Sambo," and in *Ethnic Notions, Black Images in the White Mind*, a book based on Janette Faulkner's exhibition of "Afro-American stereotype and caricature" at the Berkeley Art Center (Berkeley Art Center, 1982). Uncle Mose, incidentally, has his own origins on the minstrel stage. See David R. Roediger, *The Wages of Whiteness: Race and the Making of the American Working Class* (Verso, 1990), 99–100.

19 Robert Clark, *J. Walter Thompson Company Newsletter* no. 61, 8 January 1925, 6, Special Collections Library, Duke University.

20 *J. Walter Thompson Company Newsletter* no. 9, 10 January 1924, 6, Special Collections Library, Duke University; *J. Walter Thompson Company Newsletter* no. 10, 17 January 1920, 2, Special Collections Library, Duke University.

21 Despite Aunt Jemima's success, the usually cash-poor owners of the milling company sold out to Quaker Oats in 1925, mainly because a collapse in commodity prices in 1920 had wiped out what remained of its reserves. Marquette, *Brands, Trademarks, and Good Will*, 149, 153–154, 156–157; Kern-Foxworth, *Aunt Jemima*, 60–61; Lucy A. McCauley, "The Face of Advertising," *Harvard Business Review* 67 (Nov.–Dec. 1989): 156; "A New Look for Aunt Jemima," *New York Times*, 1 May 1989, p. D10; "Quaker Oats Is Shedding New Light on Aunt Jemima," *Wall Street Journal*, 28 April 1989, p. B3; "Mammy's Makeover," *Economist*, 6 May 1989, 60; Aunt Jemima Pancake House place settings and menu, Walt Disney Archives, Burbank, Calif.

22 The *Missouri Farmer* account is reprinted in *J. Walter Thompson Company Newsletter* no. 8, 3 January 1924, 4, Special Collections Library, Duke University.

23 Gannett News Service, 24 April 1994 (Lexis database service, Mead Data Central).

24 Marquette, *Brands, Trademarks, and Good Will*, 149–151; Douglas Allen and Douglas Allen Jr., *N.C. Wyeth, The Collected Paintings, Illustrations and Murals* (Crown Publishers Inc., 1972), 11–35, 143–145. It should be emphasized that the Aunt Jemima ads represented only a fraction of Wyeth's work in commercial art, but as his biographers concede, the pancake advertisements "had a long-lasting influence on the development of creative techniques in American advertising." (Allen and Allen, 145.)

25 David Katzman, *Seven Days A Week* (Oxford University Press, 1978), 241–249; Susan Strasser, *Never Done* (Pantheon, 1982), 167–168, 172–176, 243, 268; Daniel E. Sutherland, *Americans and Their Servants: Domestic Services in the United States from 1800 to 1920* (Louisiana State University Press, 1981), 183, 188–199.

26 Ruth Schwartz Cowan, *More Work for Mother: The Ironies of Household Technology, from the Open Hearth to the Microwave* (Basic Books, 1983), 44, 101, 120–122, 124, 175, 178; Cowan, "The Industrial Revolution in the Home: Household Technology and Social Change in the Twentieth Century," in *Women's American: Refocusing the Past*, ed. Linda K. Kerber and Jane Sherron De Hart (Oxford University Press, 1991), 380–382, 378. Cowan argues that the Industrial Revolution freed males from their "sphere" of household work—splitting logs, sewing leather, grinding wheat—while it actually expanded the amount of time women were required to spend on more "feminine" tasks (see Cowan, *More Work for Mother*, 51–53, 61, 101).

27 Strasser, *Never Done*, 76–77.

28 Ibid., 78; Phyllis Palmer, *Domesticity and Dirt: Housewives and Domestic Servants in the United States, 1920–45* (Temple University Press, 1989), 33.

29 On the domestic science movement, see Laura Shapiro, *Perfection Salad: Women and Cooking at the Turn of the Century* (Farrar, Straus, and Giroux, 1986), 18–20.

30 Roland Marchand, *Advertising the American Dream: Making Way for Modernity, 1920–1940*, 8–9. Young wrote a famous ad for Odorono titled "Within the Curve of a Woman's Arm," that apparently for the first time discussed female body odor. While two hundred readers of the *Ladies' Home Journal* canceled their subscriptions in protest, Odorono sales increased 112 percent in one year after the ad.

31 Ibid., 12–13, 66–69, 72. "The Colonel's Lady" refers to a character created by Rudyard Kipling and, according to Marchand, was an example of an upper-class woman who, despite her status, was expected to be the "same under the skin" as a lower-class woman. See Marchand, *Advertising the American Dream*, 65–66.

32 Strasser, *Never Done*, 77.

33 Cream of Wheat ads usually were placed conspicuously on the inside cover of both *Ladies' Home Journal* and *Good Housekeeping*, in full color. For examples, see *Ladies' Home Journal*, January 1919; October 1919; January 1920; April 1920; March 1921; May 1921; July 1922; March 1923. The same ads ran in *Good Housekeeping* but not as prominently and often in black and white. See January 1924, 117; February 1924, 83; June 1927, 145; August 1929, 141; July 1930, 130. In many of the ads, Rastus's image is minor.

34 A pattern seems to emerge in the use of the Quaker Oats man in the 1920s. When the purpose of the ad is to discuss the nutritional value or method of producing the food, the Quaker usually is replaced by a picture of Alexander P. Anderson, the man who invented the cereal "shot from guns," and who actually existed. The ads described Anderson as "an expert in child feeding." The fictional Quaker returns in ads stressing the economy of Quaker products. In ads toward the end of the 1920s, Quaker often used photographs of children and parents rather than the image of either Anderson or the Quaker. Regarding Anderson, see Marquette, *Brands, Trademarks, and Good Will*, 105–110. For examples of Quaker ads, see *Ladies' Home Journal*, August 1919, 84; October 1919, 102; November 1919, 96; December 1919, 120; January 1920, 112; February 1920, 100; March 1920, 172; April 1920, 111, 120; May 1920, 70, 89, 109; June 1920, 83, 117, 128; September 1920, 142; October 1920, 106, 136; November 1920, 84; December 1920, 81; February 1921, 50; October 1921, 37; December 1921, 44; November 1922, 48, 84; January 1923, 70; February 1923, 61; March 1923, 71, 100; November 1923, 51; December 1923, 44; January 1924, 44; February 1926, 94; November 1926, 103; January 1927, 105; February 1927, 44, 117, 135; March 1927, 53; November 1927, 93, 95; January 1928, 98; February 1928, 90, 93; October 1928, 78; November 1928, 103; March 1930, 113, 216.

35 *Ladies' Home Journal*, February 1922, 86; October 1922, 94; December 1922, 93; January 1922, 89; February 1924, 74. See also "Gold Dust Twins Still Golden," *Black Ethnic Collectibles* (spring 1991): 30–33. Although the Gold Dust Twins, like Aunt Jemima, appeared in person at the St. Louis World's Fair in 1904, that was the extent of live performances for the product. The Gold Dust Twins did appear on a radio program of the same name in the late 1920s, but the program and the product itself disappeared in the early 1930s. Black images were familiar figures in advertising for washing powder. In *White on Black: Images of Africa and Blacks in Western Popular Culture* (Yale University Press, 1992), Jan Nederveen Pieterse argues that soap and blackness in advertising are connected by white desires to "wash blacks" into civilized life and the assumption that blacks want to be white. In one ad from the Netherlands, a happy white child tells a sad black child, "If only you too had washed with Dobbelmann's Buttermilk Soap," (see 196–197).

36 *Ladies' Home Journal*, February 1921, 233; October 1921, 102; December 1921, 119; February 1922, 142; October 1924, 49; November 1924, 49; October 1925, 50; November 1925, 55; December 1925, 45; February 1926, 42; October 1926, 48; July 1928, 39; April 1929, 48; February 1930, 47. The same ads ran in *Good Housekeeping* throughout the decade.

37 *Ladies' Home Journal*, September 1920, 203; October 1922, 124; February 1923, 90; *Good Housekeeping*, December 1927, 143.

38 The more grotesque mammy is depicted in advertisements in *Good Housekeeping*, December 1916, 165; and February 1917, 132. By 1918 the ads are more streamlined, and the Aunt Jemima pictured is the familiar Nancy Green image (see *Good Housekeeping*, January 1918, 110).

39 *Good Housekeeping*, February 1918, 110.

40 *Ladies' Home Journal*, October 1919, 153; November 1919, 116; December 1919, 141; January 1920, 129; March 1921, 86; October 1925, 138; December 1925, 111; November 1928, 80.

41 *Good Housekeeping*, May 1927, 127. *Ladies' Home Journal*, March 1925, 123; and December 1925, 66. At one time the inventor of the coffee blend is named Joel Cheek; another time, he is Mr. Black. Finally, he is the Old Colonel.

42 *Ladies' Home Journal*, January 1921, 82; February 1921, 69; January 1923, 117; October 1923, 144; December 1923, 122; February 1924, 108; October 1924, 141. Brer Rabbit Molasses, according to its makers, was "an old time southern delicacy restored." A similar campaign was used by Baker's Coconut, that "gave the South its most favorite delicacy." See *Ladies' Home Journal*, March 1923, 49.

43 *Good Housekeeping*, November 1926, 140; *Ladies' Home Journal*, November 1921, 37. The "Ham What *AM*" advertisement is echoed in the 1948 movie "Mr. Blandings Builds His Dream House," in which the family mammy helps advertising agent Cary Grant with a ham slogan: "If you ain't eatin' WHAM, you ain't eatin' HAM!" See Bogle, *Toms, Coons, Mulattoes, Mammies, and Bucks*, 66. An ad for a cooking fat called Snowdrift might rightfully be identified as an imitation of Aunt Jemima. It introduced consumers to Sarah, a maid who had a "repitashun" for making fried chicken. But the (literally) pale imitation didn't trade on the mystique of the Old South or the cooking genius of the mammy, and the campaign was short-lived. See *Good Housekeeping*, March 1924, 233; and *Ladies' Home Journal*, January 1925, 76–77.

44 J. Walter Thompson Company Papers, Special Collections Library, Duke University. The ad cited appeared in the magazines' April issues.

45 J. Walter Thompson Company Papers, Special Collections Library, Duke University.

46 Marquette, *Brands, Trademarks, and Good Will*, 151–153; Walt Disney Archives, Burbank, Calif.

47 Kern-Foxworth, *Aunt Jemima*, 63.

48 Steven C. Dubin, "Symbolic Slavery: Black Representations in Popular Culture," *Social Problems* vol. 34, no. 2 (April 1987): 132.

49 Elizabeth Haynes, *Sambo Sahib, The Story of Little Black Sambo and Helen Bannerman* (Barnes and Noble, 1981), 163–164.

50 Alice Walker, "Giving the Party: Aunt Jemima, Mammy, and the Goddess Within," *Ms.* (May–June 1994): 22–25.

51 No one knows how "valuable" Aunt Jemima might be today, but consider the fact that the Aunt Jemima brand is annually near or at the top of a category of breakfast food lines whose U.S. sales doubled 1983–87. See Daniel Elman, "New 'Budget' Breakfast Sales Strong," *Supermarket News*, 9 January 1989, 23. For information on Aunt Jemima sales, see "Mammy's Makeover," *Economist*, 6 May 1989, 60.

52 "Product Figureheads Often Are Fanciful," *Kansas City Star*, 16 December 1993, p. F1.

53 "Ads on Minorities Fall Short," *St. Louis Post–Dispatch*, 24 March 1994, p. 1B. For information on Colonel Sanders's return, see "Col. Sanders Cooks up Comeback," *USA Today*, 15 May 1994, p. 4B. On "Uptown" cigarettes, see "Tobacco/Alcohol's New Foe: Black Ministers Target Ads," *Adweek*, 12 March 1990, 1, 60.

54 "Aunt Jemima Brand Hires Gladys Knight," *Wall Street Journal*, 16 September 1994, p. B5; "Pancakes and Politics," *Newsweek*, 17 October 1994, 85.

55 Eldridge Cleaver, *Soul on Ice* (McGraw-Hill, 1968), 162.

56 Baldwin, *Price of the Ticket*, 69.

PART VI

Leftovers

Barbara Penner

A WORLD OF UNMENTIONABLE SUFFERING
Women's public conveniences in Victorian London

Introduction

England, and by extension its civilisation, has shown only too well that the master of waste and the warden of souls are one and the same.

Dominique Laporte[1]

On 5 September 1900, a curious affair unfolded in the London Vestry[2] of St. Pancras. The Vestry received an influential deputation made up of omnibus proprietors and local residents, objecting to a proposal to construct a female convenience on Park Street, at its busy junction with Camden High Street [Figure 25.1].[3]

While the Park Street residents maintained that the lavatory would lower their property values, the omnibus proprietors argued more convincingly that it had already proved to be an impediment to traffic. The representative for the bus companies, Mr French, noted that a wooden model of the lavatory erected on site by the Vestry had been hit an incredible forty-five times, causing several accidents and very nearly a serious casualty.[4]

The *Vestry Minutes* recount one history. Its authority, however, is challenged by another version of events, given voice by a Vestryman who served St. Pancras between 1897 and 1903: the playwright George Bernard Shaw.[5] In an essay written in 1909 called *The Unmentionable Case for Women's Suffrage*, Shaw recalls the alleged traffic difficulties this way:

[The wooden obstruction] brought about all the power of the vestryman over the petty commerce and petty traffic of his district. In one day, every omnibus on the Camden Town route, every tradesman's cart owned within

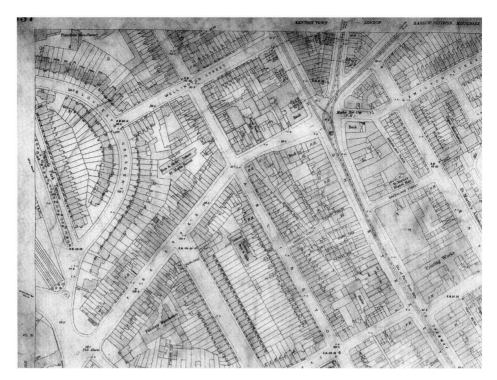

Figure 25.1 Ordnance Survey map of Camden Town, 1894–6. The disputed site is to the north on Park Street where it meets Camden High Street (between the Bank and Public House). Note the existing convenience for gentlemen in the middle of Camden High Street (opposite the Mother Red Cap Public House)

a radius of two miles, and most of the rest of the passing vehicles, including private carriages driven to the spot on purpose, crashed into that obstruction with just violence enough to produce an accident without damage. The drivers who began the game were either tipped or under direct orders; but the joke soon caught on, and was kept up for fun by all and sundry.[6]

The absurdity of the scene Shaw describes is striking. The men Shaw accuses were not mere pranksters involved in a spontaneous joke but, in many cases, respectable members of the community, whose indirect yet determined opposition on this and other occasions ensured that the struggle over the Park Street convenience would drag on in the Vestry for another five years.

This paper proposes to investigate the various manifestations of the Park Street lavatory debate, drawing on the sometimes conflicting evidence of the *St. Pancras Vestry Minutes*, the accounts of Vestry meetings in the *St. Pancras Gazette* and the writings of George Bernard Shaw. Its aim is not to reconstruct one true version of the controversy; rather, it is to provide a detailed account of how the decision to build an everyday object such as a public lavatory for women was implicated in producing, maintaining and contesting the patriarchal power structure.

Underlying this project are two central propositions. The first is that a lavatory is

not simply a technological response to a physical need but a cultural product shaped by complex and often competing discourses on the body, sexuality, morality and hygiene. In other words, far from being neutral or self-evident, the planning of conveniences is informed by a set of historically and culturally specific notions that are loaded in gender and class terms. To cite an obvious example: prior to the modern industrial period, toilets were frequently communal and mixed. It was only in the nineteenth century, with increasingly strict prohibitions on bodily display and the emergence of a rigid ideology of gender, that visual privacy and the spatial segregation of the sexes were introduced into lavatory design, and they continue to be its dominant features today.[7]

The second proposition follows on from the first and takes its cue from the work of feminist geographers such as Gillian Rose and Doreen Massey, and architectural historians like Beatriz Colomina: everyday spaces such as public lavatories do not merely passively reflect existing social relations and identities but are involved in actively producing and re-producing them.[8] According to this view, users do not have a universal response to spaces but experience them differently according to factors such as their sexuality, gender, race, class and age. Daily encounters with the built environment continually position people in relation to the dominant power structure, enforcing and reinforcing their differences. (Rose likens everyday space to 'an arena' where power relations are '(re)created and contested'.)[9] While power relations most obviously operate in everyday space through physical barriers and various forms of exclusion, as we will see, they can also work more subtly, creating invisible boundaries that shape experience in equally powerful ways.

If we accept the role of everyday space in shaping personal and collective experience, then the fight over the construction, location and visibility of the Park Street lavatory does not appear marginal or unimportant. Instead, we see such a debate as being necessarily political, invoking issues such as access and mobility, as well as a more complex set of social relations. On a basic level, as the Vestrymen well knew, the presence or absence of a female lavatory on Park Street sent local women a powerful message about their right to occupy and move through the streets of Camden Town. Moreover, by its very nature, the debate over the lavatory's construction contested prevailing cultural notions of privacy, decency and femininity, concepts which are not stable but are open to redefinition within certain, historically specific limits.

Although it did not represent a dramatic break with convention, this paper will argue that small struggles like the Park Street debate pushed against the boundaries of existing social concepts, allowing for a subtle, sometimes subversive, renegotiation of their terms. As such, what seems at first to be little more than a local political clash over an everyday space deserves to be recognized as, in the words of Lisa Tickner, 'an integral part of the fabric of social conflict with its own contradictions and ironies and its own power to shape thought, focus debates and stimulate action.'[10]

Of the necessity of latrine accommodation for women

By 1900, the time of the Park Street controversy, there was a veritable boom in convenience construction, with facilities being built throughout St. Pancras: on High Street, Tottenham Court, Prince of Wales, Fortress, Mansfield, Pancras and Kentish Town Roads. In fact, reading the *St. Pancras Vestry Minutes* between January 1890 and

December 1900, one is struck by how often public conveniences come up in Vestry business. The Vestry, whose jurisdiction contained 200,000 inhabitants, regularly dealt with a long list of convenience matters, from providing temporary urinals, to hearing complaints about existing ones or the lack thereof, and overseeing the construction of new permanent facilities.[11] Public conveniences were not insignificant investments for the council—the Fortress Road facility, for example, cost nearly £2,000[12]—and were frequently designed to be handsome public landmarks, equipped with ornamental wrought-iron railings and expensive marble and teak fittings.

This boom in construction was the result of several factors: first, by that period, local authorities had been authorized both to spend ratepayers' money on public amenities and to build underground; and second, because of the health reform movement from the 1850s onwards, there was a greater recognition of the necessity of providing conveniences, particularly to improve the cleanliness of London's streets. It was not only medical experts and sanitary engineers who appreciated their importance. Conveniences were welcomed by enlightened members of the public as symbols of progress, particularly on occasions where large crowds gathered: in 1852, describing the Duke of Wellington's funeral, Lady Stanley of Alderly was moved to exclaim, '200 conveniences are provided—how the world improves!'[13]

The most significant precedent was set when conveniences, designed and operated by George Jennings, were installed at the Great Exhibition in 1851. Mention of the lavatories was predictably discrete: the exhibition's official guide noted simply that 'Commodious refreshment rooms, with the accompaniments usually connected with them at large railway stations, have been provided.'[14] The conveniences were a great success; they were reportedly used 827,820 times, raising £2,441 over the course of the 141 days of the Exhibition.

Jennings was a fervent early supporter of public lavatories, believing the day would come when they would be a permanent feature of both large and small towns. Furthermore, he noted, 'the engineer who has the courage to carry into effect a scheme of this kind, in the interest of public health, will have established a lasting record of the wisdom of his age.'[15] However, even though such facilities were both popular and financially rewarding, their provision at public events was not guaranteed: during the Henley Regatta of 1886, for example, the *Lancet* medical journal revealed that thousands of watchers on the banks and boaters on the Thames had resorted to using the river as a latrine.[16]

Ameliorating the city's sanitary conditions was not the only benefit the publicly minded found in conveniences. Many also recognized the importance of ensuring that the populace could meet in and move through the city in comfort. The success of the Great Exhibition conveniences, for instance, prompted a declaration of the 'necessity of making similar provisions for the public wherever large numbers are congregated [to alleviate] the sufferings which must be endured by all, but more especially by females on account of the want of them.'[17]

The lack of facilities was a very real impediment to female mobility in the urban realm. Mary Vivien Thomas, in her autobiography *A London Family*, described how in the 1870s she and her mother would come by bus to shop at Peter Robinson's but could only stay for half-a-day: 'a morning's shopping was all we could manage for one day, for, strange as it seems now, the big shops had no restaurants, no rest-rooms, no conveniences for toilet, however dire one's need.'[18] This situation was made worse by the

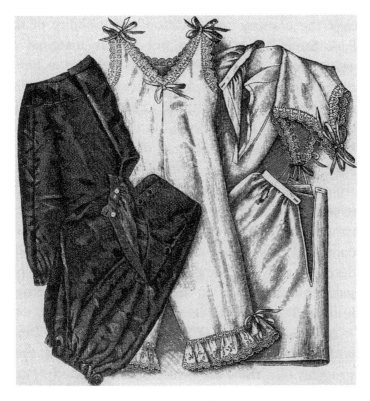

Figure 25.2 Ladies' bloomers and 'combination' outfits, 1897

prevailing dress styles of the day. Despite the fact that dresses were considerably less bulky than in previous decades—the crinoline had died out in 1860s, and the bustle was by then out of fashion—both working- and middle-class women's dress in the 1890s still included corsets and full-length skirts.[19] In addition to their corsets, women habitually wore several other pieces of underclothing: often a chemise and drawers, or a 'combination' outfit, with a petticoat over top [Figure 25.2].

In the absence of public conveniences, women who got caught short in public had few hopes of 'civilized' relief. While stowing a chamber-pot under the seat was practical for those women who owned private carriages, this was not a possibility for the majority who relied on public transport.[20] Many had little choice but to resort to relieving themselves in city back-alleys, a custom testified to by the presence of *Commit No Nuisance* or *Decency Forbids* signs in many London streets and yards.[21] Shaw also corroborates this practice, darkly referring to 'the world of unmentionable suffering and subterfuge' which existed for women in the 'little byways and nooks in the borough which [afforded] any sort of momentary privacy.'[22] In these cases, women were most likely grateful for the protection offered by their long skirts and for the fact (subtly obscured in most nineteenth-century fashion catalogues and magazines) that underclothing, drawers and combinations were left open at the crotch.[23] Indeed, buttons or fastenings on underclothes would have made going to the lavatory a practical impossibility for women.

From the 1860s on, however, women did begin to have other options. Some department stores, such as Seaman, Little & Co. on Kensington High Street, and restaurants

such as Crosby Hall in Bishopsgate, introduced facilities for females relatively early on in an effort to win their custom.[24] Private companies also stepped into the void: in 1884, for example, the Ladies' Lavatory Company opened its first establishment on Oxford Circus (near Peter Robinson's).[25] Some women's organizations, such as the Ladies' Institute at 19 Langham Place (where the *English Woman's Journal* was published), also attempted to remedy the problem by providing a place where women could eat, relax and find lavatories while in central London.[26]

These facilities, however, were still inadequate in proportion to the demand for them. Moreover, they were mostly reserved for the use of paying customers, not for the ever-increasing mass of female passers-by who were either heading to or returning from work or a day of shopping. For them, the need for public conveniences had never been more urgent, a problem that did not go unnoticed by sanitation officials. James Stevenson, the Medical Officer of Health for Paddington, in his 1879 report *Necessity of Latrine Accommodation for Women in the Metropolis*, drew attention to the increasing numbers of women travelling into the city or to work. He observed, 'From recent returns it appears that there are 143,321 women enrolled in the trade societies of the metropolis alone, many of whom . . . have daily to walk long distances to and from their workshops.' Stevenson pointed out that these women were often forced to seek out a millinery, a confectionery or a restaurant 'and order refreshments which they do not require' to make use of the establishment's facilities: he shuddered at the thought that they might obey the calls of nature *sub frigido Jove*.

Joining a number of health experts who believed resisting the calls of nature could be fatal, Stevenson warned that abstinence posed a great health risk, causing or aggravating conditions such as apoplexy, and cerebral and cardiac disturbance. In addition, Stevenson hinted at the increased need women had for conveniences while pregnant or menstruating. 'There are,' he stated delicately, 'periods and conditions peculiar to the sex, when latrine accommodation would be specially convenient; and as at such times the requirements of nature are apt to be more urgent and more frequent, women would be spared much unnecessary mental and physical distress, were the accommodation provided.' Concluding that the demand for ladies' conveniences would 'at length be impossible to resist', Stevenson also outlined exactly how to ameliorate the situation, including aspects of lavatory design, location, maintenance and finance.[27]

Stevenson's extensive report was written as a response to the Ladies' Sanitary Association (LSA) which, since the 1870s, had been actively campaigning local vestries such as Paddington and St. Pancras for the provision of women's conveniences.[28] Founded in 1857, with a membership that ranged from the Princess of Wales to Janey Morris, the LSA was a high-profile and vigorous group whose mandate was to enlighten the public on issues related to the general welfare and health of women and children. To this end, the LSA organized lectures and published tracts on sanitation, domestic economy and dress reform, and mounted campaigns to raise awareness about existing conditions which endangered public health.[29] Like its campaign to improve poor working conditions for female dressmakers and shopgirls, the LSA's 'lavatories for women' campaign was long-running and remarkably persistent though, as the LSA Report noted with frustration in 1881, the local vestries' response was often 'weak' and 'halting'.[30]

The LSA was not the only organization lobbying for change by the 1890s. On 21 December 1898, the Union of Women's Liberal and Radical Associations of the Metropolitan Counties, which claimed to represent four thousand mostly working-class

women in and around London, wrote a letter asking that each Vestry be obliged to provide one free water closet in each of their public conveniences for women.[31] And on two separate occasions, men addressed the Vestry as well, urging that the inadequate provision for women be remedied.[32]

While Stevenson noted in 1879 that women's conveniences were already established in Glasgow, Nottingham, Paris and other continental cities, the first permanent women's conveniences in London were reportedly built only in 1893 in the Strand opposite the Royal Courts of Justice.[33] By 1900, the year of the Camden High Street controversy, however, there were already at least two conveniences in St. Pancras, on Kentish Town Road and Pancras Road, which did provide accommodation for women.[34] Overall, one might conclude from these facts that there existed a fair degree of public awareness of, even sympathy for, the need for female conveniences by 1900. However, as Shaw's anecdote revealed earlier, not everyone was so eager for women's lavatories to adorn London's streets and the expression of their disapproval took many forms.

An abomination

Owing to the fact that they were built by local councils, women's public lavatories in London are surprisingly well documented in official records. These documents provide us with a path into the Park Street lavatory debate and a glimpse of the women it was meant to serve. However, the *Minutes* shed little light on to the Vestry's attitude towards these women or their actual experiences. Women's views were in fact rarely aired through official institutions: few women served on the London vestries and they were banned entirely by the 1899 London Government Act.[35] Furthermore, the woman who was best situated to discuss female needs, St. Pancras' female sanitation inspector, was unable to report to the Vestry, for as Shaw explained, 'the subject of sanitary accommodation [was] one to which no lady should allude in the presence of a gentleman.'[36]

The fact that local papers such as the *St. Pancras Gazette* reported the proceedings of the councils in great detail, adding the Vestry's reactions in brackets (i.e. laughter, applause, 'no, no', 'hear, hear'), furnishes us with a means of reading the official accounts against the grain for clues as to contemporary attitudes towards both lavatories and women. Through the *Gazette* a more complete picture of the debate begins to emerge, providing hints of the highly sexist sub-text and innuendo that swirled about the women's convenience debates but was never articulated within the *Vestry Minutes*. What follows is a detailed account from the *St. Pancras Gazette* of the debate that took place at the St. Pancras Vestry meeting on 5 September 1900.

Before the Omnibus Proprietors and Park Street Residents were allowed to proceed with their deputation, George Bernard Shaw moved that the Vestry not receive them on the grounds that, although the lavatory was a women's question, there was no woman on the deputation. Shaw was immediately overruled by the Chairman of the Vestry, Mr McGregor. His complaint was also responded to by Mr White of the National Bank who later observed to the Vestry that 'no man came on a deputation of this sort without his wife knowing it' (laughter).

Mr French, the representative of the omnibus companies, then stated that their objection to the proposed lavatory was that it would greatly increase the congestion in an already crowded thoroughfare and would endanger traffic [Figure 25.3]. He

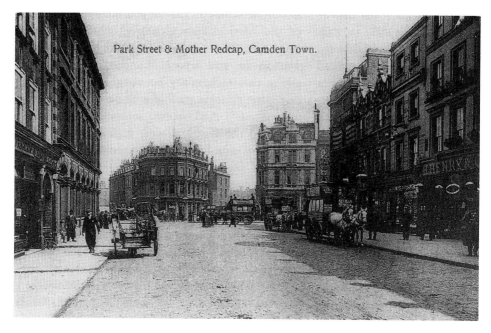
Park Street & Mother Redcap, Camden Town.

Figure 25.3 The busy intersection of Park Street and Camden High Street, *c.* 1900. The wooden obstruction would have been situated near the bollards (opposite the Britannia Public House)

painstakingly explained how only 16ft. separated the wooden model of the lavatory from the kerb and that, as an omnibus was 7ft. 9in. wide, this left just 9ft. or 9ft. 2in. for other vehicles to pass, despite the fact that many brewers' drays were 9ft. wide. Not only was this site a danger, Mr French concluded, it would 'certainly not be acceptable to ladies who constantly used the omnibuses on their way to shop in the West-End.'

Then the Vestry heard from Mr Tibbs, also representing the omnibus trade, who argued that Camden Town was 'not a place like Piccadilly and he was prepared to guarantee that 90 per cent of the women passing to and fro lived in the neighbourhood of Camden Town', implying that they could avail themselves of facilities at home. Mr White, representing the local inhabitants, confirmed the legitimacy of the omnibus proprietors' points and added, on a personal note, that he, like (he supposed) every member of the Vestry, 'did not want such a place under his own windows.' Finally, Mr H. Wakeley noted that the lavatory would 'spoil a most important thoroughfare and seriously depreciate the character and value of property in the immediate vicinity.'

After the presentation of the deputation, Mr Barnes, a Vestryman, moved that the Works Committee be instructed to find another site for the women's convenience. In response to Dr Smith's suggestion that a house in the vicinity might suit the purpose, Mr McGregor stated that he would investigate whether 'a suitable house for the use of ladies' could be found (laughter).

There was some dissent. The sole Vestrywoman present, Mrs Miall Smith, urged the Vestry to investigate the matter properly, asserting that a women's convenience near Park Street was desperately needed for the 'thousands of women and girls on their way to and from the factories of the district'. George Bernard Shaw expressed his fear that

the matter was being abandoned altogether and chastised another Vestryman for calling the proposed structure 'an abomination'. Mr Barnes' motion, however, was carried by an overwhelming majority: the matter was referred to the Works Committee and the Park Street site was abandoned.[37]

In considering the intricacies of the St. Pancras' Gazette's account, two points stand out. The first is that the members of the deputation clearly felt the proposed convenience's capacity to shock and offend was caused less by its function than by the sex of its future users. While Mr French believed that the view of the Park Street lavatory would not 'be acceptable to ladies . . . on their way to shop in the West-End', he seemed to find it unremarkable that for years they had endured the sight of a gentleman's convenience at the very same intersection, without suffering any obvious ill effects.

The second point is that not one of the Vestry members attempt to deny the sheer volume of women in the streets. The women mentioned in the Vestry meeting, whether shopping or heading to work, were highly visible participants in the public sphere, going past the proposed site in 'the thousands' according to Mrs Miall Smith. The principal argument against the proposed lavatory was not that ladies had no need of it, but that Park Street was already too congested, a point which later prompted Shaw to ask: 'Does not so much traffic make lavatory accommodation all the more urgent?'[38]

What, then, underlies the deputation's objections? Reading through their testimony, one gets a distinct sense of their uneasiness not only about the sex but the class of the lavatory's potential users: the factory girls identified by Mrs Miall Smith. Mr Tibbs' statement, for instance, is a good example of how local residents attempted to deny the existence of a mobile, working-class female populace in Camden Town. Not only was Mr Tibbs' assertion—that 90 per cent of the women on Park Street were living locally, rather than travelling in from other districts—highly implausible,[39] but the implication that most women would have access to facilities at home was disingenuous at best. Only middle- and upper-class residences of this period were regularly equipped with water-closets and baths: despite the recommendations of prominent health reformers such as Edwin Chadwick, working-class housing would not regularly enjoy such facilities until the 1920s, relying instead on chamber pots, outdoor privies and common urinals.[40]

Taken as a whole, the deputation's comments reveal how the issue of class, along with its attendant connotations of decency and morality, was embedded in the Park Street debate. It also reveals how misleading it is to speak of 'women's needs' as a unified entity, as it is evident that the needs of working-class women and 'ladies who shop' were not considered to be the same. Indeed, far from being universal, women's needs during this period appear highly contingent, fissured by social distinctions and fractured by class, a point which another, parallel debate over lavatory charges makes even more strikingly.

A prohibitive charge

Three years before the Camden High Street debate, another major controversy erupted around women's lavatories, this time over the subject of free accommodation. Public lavatories, like public baths and washhouses, were built mainly for the use of the working-classes.[41] While men were able to use urinals at no cost and paid a penny only if they needed to use a water closet, women were charged one penny every time, which, as Shaw correctly observed, was an 'absolutely prohibitive charge for a poor woman'.[42]

The penny charge was the legacy of Jennings, who had charged this amount for use of his water-closets at the Great Exhibition (this is reputedly also the origin of the expression to 'spend a penny'). The controversy over free accommodation for women points to a tension between the competing imperatives of public service and profit that underlay the vestries' management of public lavatories. While the vestries did not look at the conveniences necessarily as a money-making venture, they were clearly not meant to 'become an infliction in any degree on the ratepayer'.[43] Sometimes conveniences did report profits—those at Waterloo, Cannon Street and Charing Cross stations were particularly lucrative—but rarely in poor neighbourhoods. In addition, contractors occasionally ran facilities, paying all water charges, attendants, lighting and so on, in exchange for users' fees. The financial necessity that these facilities made money, or at least broke even, meant that these conveniences were never truly public. Instead, they adopted practices which, as the Union of Women's Liberal and Radical Associations recognized in their 1898 petition for free provision, inherently discriminated against women, particularly poor ones. These policies ranged from charging for the use of a water-closet to providing fewer facilities for women.

James Stevenson anticipated this problem in his unbuilt design for a female lavatory in 1879. As a preventive measure, he recommended creating two classes of female lavatory accommodation—first and second. These two classes would be physically separated from each other, demarcated by their own sign and entrance. The second-class closets were to be free, while the first-class closets, which would be considerably more elaborate, would be paying. Stevenson initially justified the spatial segregation of the facilities by stating that it was only reasonable to offer finer accommodation to those who intended to pay directly for it. His subsequent comments, however, reveal a powerful social motive as well. He stated: 'women of the middle class will not be willing to company, for however short a time, with a promiscuous crowd, even of their own sex.'[44] Underpinning his proposed segregation of the lavatories by class as well as sex was a strong desire to prevent the mixing of the classes and to reinforce existing social relations.

A more radical proposal to get around the penny charge was for the installation of 'urinettes' [Figure 25.4]. Smaller than conventional water-closets, with curtains instead of doors (hence less acoustical privacy), they were automatically flushed like men's urinals. Although a halfpenny was to be charged for their use, the unnamed Vestry which installed urinettes as an experiment gave the attendant permission to allow some people to use conveniences for free, generously recognizing that poor people have, 'the same calls of nature as those of us who can afford to pay for the convenience provided'—an enlightened stance for the day.[45]

Looking at the ground plan for the convenience with urinettes, one is struck by a strangely familiar sight: while the women's side is equipped with four water-closets, three urinettes and one lavatory, the men's side has seven water-closets, fifteen urinals and two lavatories [Figure 25.5]. This asymmetry was no accident but was standard in conveniences at this time [Figure 25.6]. The successors to George Jennings' firm, George B. Davis and Frederick Dye, explained in their 1898 work *A Complete and Practical Treatise upon Plumbing* that the problem was that women often did not make use of their side, with the consequence that conveniences for 'the weaker sex' were 'more often failures, financially and practically, than a success'. Men made frequent use of their side, making them ultimately more profitable. Consequently, Davis and Dye praised

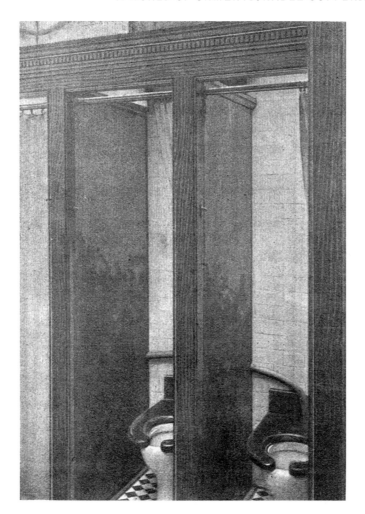

Figure 25.4 Photograph of urinettes installed in an unnamed London Vestry, *c.* 1898. Note the use of curtains instead of doors

plans which give less space to women's facilities than to men's, observing that 'with the scanty appreciation such places receive' more were not necessary. They went so far as to recommend that a building be arranged so that if women did not use their side, the whole could be easily converted into a men's-only facility (and gave precise directions as to how this could be done with minimum expense and trouble).[46]

Clearly, private contractors, vestries and ratepayers regarded the issue of providing free accommodation or an equal number of places for women as a potential drain on their revenue. However, the St. Pancras Vestry did agree in July 1897 to provide one free water-closet in all existing women's lavatories for a trial period of six months, despite the fear of Mr Fitzroy Dell that the water supply would be used by flower and watercress girls to freshen up their violets and watercress.[47] At the end of the six months, however, the free place was abolished. Shaw's letters at the time reflected his anger and disgust. On 27 April 1898, he wrote:

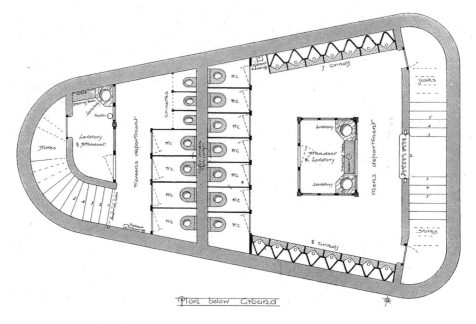

Figure 25.5 Plan of gentlemen's and ladies' convenience. The ladies' side (on the left) includes urinettes

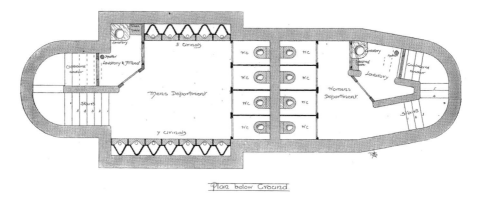

Figure 25.6 Plan of gentlemen's and ladies' convenience

Fearful trials at Vestry . . . One particularly fearful business over a resolution to stop free accommodation for women in sanitary conveniences. I move amendment [to continue free closet]. [J. W.] Dixon, a pillar of the Church, rises in saintly majesty, and says my remarks are disgusting. Then says Mrs. Phillimore has behaved indecently in seconding me. Chairman [W. H. Matthews], much ashamed, rebukes him & he collapses . . . I sit amiably & feel that I must soon unmask my guns & begin to fight the vestry.[48]

On 7 May 1898, Shaw reports to Sidney Webb:

> [I have] at last thrown off the mask and attacked it [the Vestry] in print . . .
> The thing goes like this. Cunningham Graham writes a letter to the [*Daily*]
> *Chronicle* raising the question whether, as a dramatist, I am a pupil of Ibsen
> or De Maupassant. I reply with a long letter, shewing that the real force
> which influences me is the attitude of the St. Pancras Vestry on the question
> of providing free sanitary accommodation for women. This gives consider-
> able piquancy to the correspondence, and had a most subduing effect on the
> Vestry.[49]

Shaw, like Stevenson before him, clearly relished his role as champion for the female cause. In fact, Shaw's representation of the situation—and his role in it—merits ana-lysis because, in its own way, it is as revealing as the reactions of the more conservative Vestry members.

By the 1890s, as we have seen, there was actually a limited acceptance of the need for women's facilities and women (such as Mrs Miall Smith and Mrs Phillimore) and women's organizations (such as the LSA) played a key role in campaigning for them. Shaw, however, represents himself as a lone champion, speaking of his desire to 'unmask his guns' and 'fight' and 'attack' his opponents in the Vestry on the behalf of suffering masses of women.[50] This portrayal in turn is picked up later by others who, ignoring the role played by other Vestrymen and women's groups, praise Shaw as 'a pioneer in pro-viding lavatories for women'.[51]

The use of the word 'pioneer' immediately signals the larger game afoot. As Judith Walkowitz has noted, the metaphor of discovery often characterized the narratives of Victorian urban explorers such as Charles Dickens or Henry Mayhew, who used it to transform 'the territory of the London poor into an alien place, both exciting and dan-gerous'.[52] After reading Shaw's descriptions, it becomes evident that the unknown, alien territory he considers himself to be charting is the female body—particularly the poor, lower-class body—with its unmentionable functions and needs which he claimed 'no man ever thought of'.[53]

Shaw's description, as much as those of the more conservative Vestrymen or the men of the deputation, effectively secured women in their place as Other, by defin-ing them rigidly in relation to the dominant male identity. All the while he offers proof of female suffering at the hands of a paternalistic political system, he naturalizes their status by emphasizing the distinction between his (privileged) position as a male Vestry-man and that of the largely disenfranchised women for whom he speaks. The women, whose letters he describes as 'piteous, anonymous', are seen as a silent mass with no names and no voices, powerless at the political level and undifferentiated as a social group.[54]

This is not to say that we should completely reject Shaw's account, nor to deny its usefulness to this history. However, it is to recognize that Shaw's testimony, far from being objective and removed from the dominant discourse, uncritically reproduced its terms, participating, however subtly, in the assignment of women to their subordinate position. It also indicates the pervasiveness of the Victorian ideal of womanhood, which not only infused the debates for and against the construction of lavatories, but often overrode the experiences and needs of its users themselves.

The barrier of publicity

As Davis and Dye's comments indicate, the reason why ladies' conveniences were notorious financial duds, was not simply because poorer women could not afford to use them. The reality was that, far from being universally put to use by women, public lavatories were often shunned by them, whether out of fear, distaste or, as Davis and Dye put it, with no small degree of impatience, a 'peculiar excess of modesty' which often forced their closure.[55] The degree to which women had internalized the patriarchal system of representation, particularly the discourse of decency and femininity, can be roughly gauged by the sheer number of times this observation recurs. Their widely acknowledged embarrassment was why the St. Pancras Vestrymen could argue with some confidence that, if built, the Park Street lavatory would occupy 'too public a position and ladies would not care to use it for this reason'.[56]

There is something profoundly ironic about a public amenity being condemned for being 'too public'. However, the sense of transgression roused by this excess of publicity must be understood in light of the lavatory's intimate association with the female body, as the container of its natural functions: urinating, defecating and menstruating. Owing to its provocative corporeal associations, a female lavatory evoked the spectre of sexuality which, as Walkowitz has observed, encompassed a nebulous constellation of issues above and beyond sexual conduct itself: 'dangerous sexualities [for the Victorians] had as much to do with work, life-style, reproductive strategies, fashion and self-display . . . as with nonprocreative sexual activity.'[57]

Sexuality was explicitly invoked when, after the Park Street site was abandoned, Mr McGregor promised to find a 'suitable house for use of ladies' as an alternative; the laughter which accompanied his remark makes clear what type of house the Vestrymen had in mind (a joke given extra *frisson* owing to the proximity of several 'houses of ill-fame').[58] The easy slip from lavatory to brothel betrays the most extreme prejudice of the concerned citizens, the Vestry and of women themselves: that, in using a public convenience, women would be little better than 'public' women, prostitutes, who exposed their bodies in the streets.

Certainly, as the condemnation of the convenience as an 'indecent' object or an 'abomination' signals, the objections to its construction had an unmistakable moral dimension. They implied that providing a lavatory would encourage a gradual loosening of the tightly maintained mechanisms of control which circumscribed women's movements and behaviour—with potentially disastrous consequences for standards of decency and the ideal of femininity. It was not only sexuality and gender but class which underlay such fears. The complaints about the 'promiscuous' mixing of working- and middle-class female bodies which occurred in such facilities indicates that decency and femininity were defined primarily as middle-class attributes: mixing in the lavatories threatened the moral contagion of the 'ladies' by the factory and flower girls, auguring the former's descent into vulgarity and corruption.

When lavatories were provided, the desire to reduce an overt connection with women's bodies and prevent mixing affected discussions not only about the conveniences' location but their design as well. Often located underground without windows, protected from the 'public' gaze and, by means of internal partitions, from the eyes and ears of other women, the conveniences were meant to seal off and contain the 'unmentionable' secrets of the female body [Figure 25.7]. Other strategies of concealment

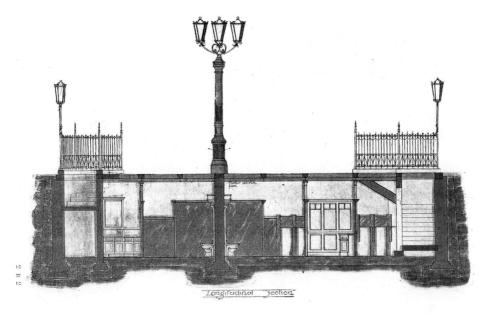

Figure 25.7 Longitudinal section of an underground gentlemen's and ladies' convenience. Note the ventilating fan lamp-post

focused on reducing the prominence of the lavatory's entrance, as it was in negotiating its threshold that women were most compromised.

Davis and Dye, for instance, enthusiastically approved of one design which obscured the entrance to the ladies' facilities, praising it as an ideal scheme for avoiding 'the publicity which is such a barrier to the use of those places by the opposite sex' [8] [Figure 25.8].[59] This proposed building, while providing a street entrance to the men's facilities, eliminated the street entrance for the women's. Instead, the women's conveniences could only be reached through the ladies' waiting room, located at the end of a sequence of spaces which moved from the most visible and public (the general waiting room, lobby and parcels office), to the semi-private (the ladies' waiting room), to the most invisible and private (the ladies' lavatories). This hierarchical distribution of rooms according to degrees of privacy, gender and class was not uncommon but was a well-established convention of late Victorian planning. Deployed in domestic, public and commercial interiors from country houses to schools to hotels, it perhaps reached its apotheosis in the elaborate sequence of ladies-only Club and Retiring Rooms which developed in department stores like Harrods and Debenhams a decade later.

In considering tactics aimed at containing the female presence, we are now treading on familiar academic ground. As feminist historians such as Elizabeth Wilson and Judith Walkowitz have convincingly demonstrated, by the mid-to-late Victorian era, increasing female (working-class) mobility was widely regarded as a potential threat to patriarchal order and a wide variety of strategies were deployed to check it: from the production of an ideology of separate spheres which aimed to confine 'respectable' women to the home, to the creation of laws aimed at regulating prostitutes (i.e. the 1864 Contagious Diseases Act), which made all women in the city streets an object of speculation.[60]

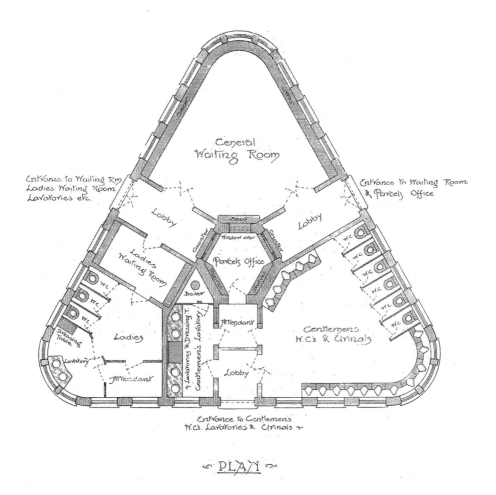

Figure 25.8 Proposed waiting rooms and convenience at Bristol by R. Stephen Ayling, Architect, *c.* 1898

Yet like most of these strategies and in spite of their careful design, lavatories were only ever partially successful at containing the secrets of the female body. At the edges, a reminder of things buried or concealed continually threatened to break through. For a women's convenience exposed female bodies at the same time as it hid them, amplifying their presence in the public mind. In addition to the conveniences' physical presence in the street, medical reports about their necessity, campaigns and political struggles for their provision and the press coverage of those struggles had the effect of making the female body the legitimate subject of popular scrutiny. Far from suppressing the female body, debates such as that in St. Pancras gave it greater symbolic force, pushing it from the sidelines to an increasingly public and central position.

As this movement was not one that sat easily with the Vestrymen, local tradesmen and property-owners, or even with a large proportion of women, it did not go unchallenged. Indeed, this sense of discomfort and anxiety lay behind the passionate objections to the lavatory's construction and ultimately mobilized the attack on the wooden

obstruction in Park Street—a symbol of the future lavatory and of women's presence in the metropolis—an aggressive reminder, to the disorderly women who forgot their place, of who ultimately controlled the streets.

Happy ending

On 20 December 1905, following an inquiry by Mrs Miall Smith and a report from the Highways, Sewers and Public Works Committee, the Borough quietly and swiftly agreed to construct a female lavatory on the Park Street site, bringing five years of stalling to an end.[61] The lavatory still stands in Camden Town to this day and, though shut for many years in the 1980s, has now reopened for the use of women, free of charge, a deceptively banal feature of everyday life [Figure 25.9].

While it is tempting to read the lavatory as a sort of early 'triumph' for feminism

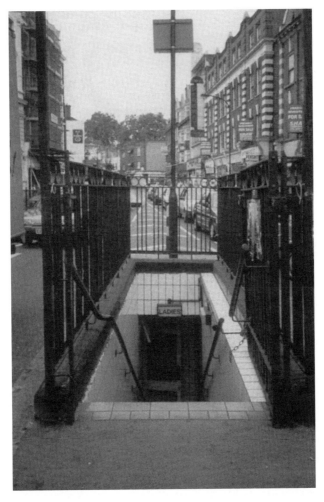

Figure 25.9 Camden Town public convenience today, reopened for the use of women and free of charge

en route to suffrage, to do so, as Joan Scott has warned, is to dull the critical impact of its history, setting up a causal link between women's experience and emancipation and neglecting the significance of other forms of difference (e.g. class) in organizing social identity.[62] In fact, perhaps the most useful aspect of this history is how it resists simple conclusions and categorizations. Far from being unified or universal, women's experience during this period appears highly contested, split by class distinctions and intertwined with the ideological construction of Victorian womanhood. As we have seen, the latter not only permeated (and was perpetuated by) legal, political and social institutions, but was so deeply embedded in female identity that it often assumed a far greater authority—both on an individual and a social level—than the physical needs of women themselves.

In this history, then, women's 'experience' cannot be tied directly to their senses, a transparent 'reflection of the real' from which knowledge springs; rather, the link between female experience and knowledge is shown to be constantly mediated by the dominant (patriarchal) system of representation. By rejecting the notion that female identity is the sum total of individual, visceral experiences, the way is opened for a more sophisticated understanding of how it is constructed by collective social practices and positioned by difference. In other words, an understanding of how the distinctions not only between men and women but between 'ladies' and 'watercress girls' were constructed, maintained and reinforced in late Victorian London, through individual acts, group protest, media coverage, local and national government action, and everyday spaces.

In the same way that 'woman' is not a monolithic, unchanging category, the significant concepts that play a key role in this story—the 'private', the 'public', 'femininity', 'decency'—are revealed to be equally elastic. In *Keywords*, Raymond Williams drew attention to the way that 'nominal continuity' of words often masked or obscured quite radical changes in their meaning, giving them a fictive stability. When we go beyond dictionaries, he wrote, 'we find a history and complexity of meanings; conscious changes, or consciously different uses; innovation, obsolescence, specialization, extension, overlap, transfer.'[63]

Although the history of the Camden Town lavatory does not illuminate radical changes, it does demonstrate how meanings are flexible and contingent. To begin with, in the Park Street debate, the meaning of particular concepts was clearly influenced by their speaker's position within the power structure and their interests: 'decency', for instance, did not encompass the same standards of behaviour for Mr Tibbs as for Mrs Miall Smith. The clash of these differing interpretations effectively amounted to an ongoing process of negotiation, in which the boundary separating seemingly opposed concepts (private/public, indecent/decent) was challenged and occasionally stretched to include new objects, spaces or conventions of behaviour. So, with the decision to construct a ladies' public convenience, the 'public' in Camden Town was suddenly expanded to include women, though in other matters (e.g. serving in local government) the 'public' continued to be defined as exclusively male. While not a major triumph for women, this shift in the definition of 'public' was a positive one, not only because it helped legitimate the female presence in Camden's streets but because it pointed to the fact that such changes could occur: small shifts in existing boundaries that could be embraced—or contested—in their turn.

Notes

I would like to thank Suzannah Biernoff, Adrian Forty, Amelia Gibson, Michael Hatt, Katharina Ledersteger-Goodfriend, Jane Rendell, Charles Rice and Lynne Walker for their helpful and generous feedback, along with Margot and Werner Fieguth for keeping me in a steady supply of loo-related books. A special thanks to Iain Borden for his long-term support in developing this piece. Finally, I would like to thank Lucy Pratt and Rachael Church at the V & A Costume Department, and Lesley Marshall and Richard Knight at the Camden Local Studies and Archives Centre, for their enthusiastic help.

Some of the historical material discussed here was first broadcast in *The Ladies' Room*, a documentary produced for BBC Radio 4 by Just Radio in 1998. (For a short summary of the broadcast, see the review by Lucinda Lambton, 'At whose convenience?', *New Statesman*, 5 June 1998, pp. 42–3.)

1 Dominique Laporte, *History of Shit*, trans. Nadia Benabid and Rodolphe el-Khoury (1978), MIT Press, 2000, p. 63.
2 At this time, London was made up of a 'patchwork' of forty-two vestries which were in charge of local governance. Vestrymen were elected by the ratepayers of each parish and were largely responsible for making decisions regarding local drainage, paving, lighting, repairing, the maintaining of streets and the removal of 'nuisances'. (Larger decisions concerning city drainage or Building Acts were the domain of the London County Council.) The St. Pancras Vestry's jurisdiction extended from Islington to Marylebone, Holborn to Hampstead.
3 *St. Pancras Vestry Minutes*, vol. 22, July–December 1900, p. 282.
4 *St. Pancras Gazette*, 8 September 1900.
5 For a detailed account of Shaw's six years in local politics, see Michael Holroyd, 'The political philosophy of Bernard Shaw and the St. Pancras Vestry', *Camden History Review*, vol. 21, 1997, pp. 2–6; and Michael Holroyd, *Bernard Shaw: Volume 1, 1856–1898*, Penguin Books, 1990, pp. 409–25.
6 Bernard Shaw, 'The unmentionable case for women's suffrage', in Lloyd J. Hubenka (ed.), *Practical Politics*, University of Nebraska Press, 1976, p. 104.
7 For an account of the increasingly strict rules guiding conduct and displays of the body, see Norbert Elias, *The Civilising Process*, trans. E. Jephcott (1934), Blackwell, 1994; and Richard Sennett, *Flesh and Stone: The Body and the City in Western Civilization*, Faber and Faber, 1994.
8 The relationship between space, identity and gender is elaborated in Doreen Massey, *Space, Place and Gender*, Polity Press, 1994; Gillian Rose, *Feminism and Geography: The Limits of Geographical Knowledge*, Polity Press, 1993; and Beatriz Colomina, 'The split wall: domestic voyeurism', in Beatriz Colomina (ed.), *Sexuality and Space*, Princeton Architectural Press, 1992, pp. 73–130.
9 Rose, op. cit., p. 17.
10 Lisa Tickner, *The Spectacle of Women: Imagery of the Suffrage Campaign, 1907–14*, Chatto & Windus, 1987, p. ix.
11 Urinals were frequently the cause of ratepayers' complaints. For example, it is recorded in the *St. Pancras Vestry Minutes* of 1 July 1891 that a deputation was heard from Reverend Woffendale, the Minister of Somer Town Presbyterian Church. Revd Woffendale complained that the urinal of the Shepherd and Shepherdess Public House adjoined the entrance to his church and caused much offence to the women and children in his parish. *St. Pancras Vestry Minutes*, vol. 4, July–December 1891, pp. 43–4.

12 A £2,000 investment would represent approximately £132,000 today. Robert Twigger, 'Inflation: the value of the pound, 1750–1998', *House of Commons Research Paper*, 23 February 1999.

13 Quoted in M. D. R. Leys and R. J. Mitchell, *A History of London Life*, Longman, Green & Co., 1958, p. 155.

14 *Great Exhibition of the Works of Industry of all Nations, 1851, Official Descriptive and Illustrated Catalogue*, W. Clowes & Sons, 1851, vol. I, p. 67.

15 Quoted in George B. Davis and Frederick Dye, *A Complete and Practical Treatise upon Plumbing and Sanitation Embracing Drainage and Plumbing Practice etc.*, E. & F. N. Spon, 1898, p. 172. Jennings, in fact, did attempt to be this mythical engineer: he proposed to build a network of conveniences all over London which he would maintain in exchange for charging a small fee. Although he did manage to install several urinals around London, his scheme was never adopted on a larger scale.

16 Quoted in Sir John Simon, *English Sanitary Institutions: Reviewed in their Course of Development, and in Some of Their Political and Social Relations*, John Murray, 1897, p. 467. After observing that the refuse from house-boats was deliberately dumped into the Thames, the reformer John Simon asked despairingly: 'What sentiment of cleanliness prevailed among the thousands who could thus deal with their neighbours' drinking-water, and among the millions who were placidly bearing the outrage, is a question which may be left for such future historians as will discuss the curiosities of English civilization at the close of the nineteenth century.'

17 Quoted in Duncan Crow, *The Victorian Woman*, George Allen & Unwin, 1971, p. 118.

18 Quoted in Alison Adburgham, *Shopping in Style: from the Restoration to Edwardian Elegance*, Thames & Hudson, 1979, p. 141.

19 Christopher Breward, *The Culture of Fashion*, Manchester University Press, 1995, p. 156.

20 For some examples of eighteenth- and nineteenth-century chamber pots, see Lucinda Lambton, *Chambers of Delight*, Gordon Fraser, 1983. Perhaps the most spectacular example is Marie Antoinette's gilt-enriched Sèvres porcelain travelling chamber pot of 1758, p. 28.

21 Thomas Burke, *The Streets of London Through the Centuries*, B. T. Batsford Ltd., 1940, p. 133.

22 Shaw, op. cit., p. 104.

23 Thanks to Lucy Pratt and Rachael Church for assisting me in establishing this fact with reference to the V & A's collection of late nineteenth-century women's undergarments.

24 Elizabeth Wilson, 'The invisible flâneur', *New Left Review*, vol. 191, 1992, p. 67.

25 Adburgham, op. cit., p. 141.

26 Lynne Walker, 'Well-placed women: spaces of the women's movement in Victorian London', in Iain Borden, Joe Kerr, Alicia Pivaro and Jane Rendell (eds.), *Strangely Familiar*, Routledge, 1996, p. 25.

27 James Stevenson, M.D., *Report on the Necessity of Latrine Accommodation for Women in the Metropolis*, Paddington, 1879, pp. 7, 11, 13–14, 21–2.

28 As John Richardson has established, wrangling over female conveniences in St. Pancras had also occurred throughout the 1870s and 1880s. In the 1870s, for instance, despite the urging of several doctors and the application of a company to build and run them, the Vestry refused to approve a plan for female lavatories, prompting a letter of complaint from the LSA in 1878. Richardson, *Camden Town and Primrose Hill Past*, Historical Publications, 1991, p. 61.

29 By 1891 the LSA claimed to have published over one hundred tracts on a variety of subjects and distributed nearly two million copies of them. *The Report of the Ladies' Sanitary Association to the Seventh International Congress of Hygiene and Demography*, Ladies' Sanitary Association, 1891.

30 *Twenty-Third Annual Report of the Ladies' Sanitary Association*, Ladies' Sanitary Association, 1881, p. 5.

31 *St. Pancras Vestry Minutes*, vol. 18, July–December 1898, p. 777. A water-closet is an individual cubicle containing a lavatory.

32 *St. Pancras Vestry Minutes*, vol. 15, January–June 1897, p. 309; vol. 17, January–June 1898, p. 230.

33 Sue Cavanagh and Vron Ware, *At Women's Convenience*, Women's Design Service, 1990, p. 15. Thanks to Lynne Walker for originally directing me to this source.

34 Each convenience has an interesting anecdote attached to it. In the case of the Pancras Road convenience, the building of female lavatories necessitated the hiring of female attendants—not surprisingly, when two were hired in 1897, they were paid 18s. a week, versus the male attendants who were paid 25s. a week. *St. Pancras Vestry Minutes*, vol. 15, p. 965. In the case of the Kentish Town Road proposal, the deputation of Kentish Town ratepayers who protested against its construction argued that there was no need for it as there were already several urinals in the vicinity. How they imagined this would help local women was far from evident—thankfully, the Vestry moved to go ahead with construction. *St. Pancras Vestry Minutes*, vol. 15, pp. 350–1.

35 The London Government Act removed the forty-two vestries and replaced them with twenty-eight metropolitan boroughs. While women were granted the right to vote (without a property requirement), they were disqualified from serving on the vestries (as they had been doing since 1894), according to Shaw on the basis that the House of Lords facetiously decided that a woman could not be an alder*man*. The borough elections first took place on 1 November 1900, which explains the presence of Mrs Miall Smith and Mrs Phillimore in the debates that follow. Christine Bolt, *The Women's Movements in the United States and Britain from the 1970s to the 1920s*, University of Massachusetts Press, p. 185; Holroyd, op. cit., pp. 416–17.

36 The St. Pancras Vestry did have a female sanitation inspector on staff who was hired to look into the conditions of factories and workshops which employed women. One of her specific duties was to ensure that women had adequate and clean lavatory provision (often they had none). Miss O'Kell, the female inspector in St. Marylebone, made 2,122 inspections in 1900, for instance, and checked the female public conveniences two to three times a week to ensure their cleanliness. While few people were better situated to discuss female needs, however, the female sanitation inspector was nearly invisible at Vestry meetings: Shaw felt that had it not been for her name on the salary-list, he never would have known of her existence at all. He commented: 'The exclusion of women from the Borough Council left the inspectress in a difficult position. The barrier of the unmentionable arose between her and members of the Health Committee. It was all the higher because the inspectress was generally an educated woman of university rank, not at all conversant with the sort of local tradesman who regards the subject of sanitary accommodation as one to which no lady should allude in the presence of a gentleman.' Shaw, op. cit., p. 105.

37 *St. Pancras Gazette*, 8 September 1900.

38 *St. Pancras Gazette*, 21 December 1901.

39 Camden Town at this time was an active and busy thoroughfare, a shopping, business and trade district well serviced by trams and the North London Line train. For a detailed description of Camden Town businesses, shops and transport links, see Richardson, op. cit., pp. 53, 99–116, 121.

40 The author of the first Public Health Act (1848), Edwin Chadwick recommended that all outdoor privies and cesspools be replaced by water-closets. Under his influence, Henry Roberts' 'Model Houses for Four Families' on display at the 1851 Great Exhibition provided each flat with its own water-closet. His precedent, however, took many years to catch on. Adrian Forty notes that, while bathrooms began to be appear in all new homes subsidized by the state in 1919, bathrooms were not widely standard in working-class homes home until about 1930. Adrian Forty, *Objects of Desire*, Thames & Hudson, 1986, p. 167.

41 That these public facilities were part of a general effort to enlighten the masses about personal hygiene is made clear by the title of Jasper Roger's 1857 book, *Facts and Fallacies of the Sewerage System of London . . . Pointing out the Necessity for Public Lavatories, Closets etc. etc. as the First Step Towards the Moral Advancement of the Lower Classes*. The first step towards their 'moral advancement', however, had already been taken with the 1846 Baths and Washhouses Act, which was intended to provide bathing and laundry facilities for London's urban poor. The campaign seemed only partially successful so that in 1899 A. Tiltman was still able to complain that there were still many members of the lower class who seemed unconvinced of 'the necessity and benefits of the bathing habit'. A. Hessell Tiltman, 'Public baths and washhouses', *Royal Institute of British Architects Journal*, vol. 6, 1899, p. 170.

42 Shaw, op. cit., p. 103.

43 Davis and Dye, op. cit., p. 172.

44 Stevenson, op. cit., p. 19.

45 Davis and Dye, op. cit., p. 185.

46 Ibid., pp. 171–2, 182.

47 Supposedly his assertion was met with laughter and shouts of 'Nonsense!' and Shaw went on suggest (to much laughter) that this was one of the best reasons why the lavatories should be free. Quoted in David Thomson, *In Camden Town*, Hutchinson, 1983, p. 214.

48 Quoted in Dan H. Laurence (ed.), *Bernard Shaw: Collected Letters, 1898–1910*, Max Reinhardt, 1972, pp. 37–8.

49 Ibid., p. 40.

50 Ibid., pp. 37–8.

51 R. F. Rattray quoted in John Ervine, *Bernard Shaw: His Life, Works and Friends*, Constable & Company Ltd., 1956, p. 352.

52 Judith Walkowitz, *City of Dreadful Delight: Narratives of Sexual Danger in Late Victorian London*, Virago Press, 1992, pp. 18–19.

53 Shaw, op. cit., p. 104.

54 Katherine Kelly has drawn attention to the fact that, despite the popular perception that Shaw shared the political stance of progressive feminists, Shaw's relationship to feminism, like that of many avant-garde intellectuals of his day, was actually quite ambivalent. While he did write plays, essays and letters and gave speeches in support of feminist issues, his statements often revealed profound scepticism about the aims of the suffrage movement and the political necessity of the female vote. Katherine E. Kelly, 'Shaw on woman suffrage: a minor player on the petticoat platform', in Bernard F. Dukore (ed.), *1992: Shaw and the Last Hundred Years*, Pennsylvania State University Press, 1994, p. 71.

55 Davis and Dye, op. cit., pp. 171, 185. Their statements are borne out by the fact that the Ladies' Lavatory Company at Oxford Circus failed because 'ladies feared to be seen entering' it. Adburgham, op. cit., p. 141.

56 *St. Pancras Vestry Minutes*, vol. 22, p. 282.

57 Walkowitz, op. cit., p. 6.

58 These houses of ill-fame were located just a mile away, clustered in streets like Warren Street off Tottenham Court Road. Holroyd, op. cit., p. 413.

59 Davis and Dye, op. cit., p. 182.

60 Elizabeth Wilson, *The Sphinx in the City*, University of California Press, 1991.

61 *St. Pancras Vestry Minutes*, vol. 10, July–December 1905, pp. 656, 660, 840, 895.

62 Joan W. Scott, 'The evidence of experience', in James Chandler *et al.* (eds.), *Questions of Evidence: Proof, Practice, and Persuasion across the Disciplines*, University of Chicago Press, 1994, pp. 368, 382.

63 Raymond Williams, *Keywords: A Vocabulary of Culture and Society*, Fontana Press (1976), 1988, p. 17.

Celeste Olalquiaga

HOLY KITSCHEN
Collecting religious junk from the street

Kitsch causes two tears to flow in quick succession. The first tear says: How nice to see children running on the grass! The second tear says: How nice to be moved, together with all mankind, by children running on the grass! It is the second tear that makes kitsch kitsch.

<div align="right">Milan Kundera, 1984</div>

Catholic imagery, once confined to sacred places such as church souvenir stands, cemeteries, and botanicas, has recently invaded the market as a fad. In the last few years, the realm of religious iconography in Manhattan has extended beyond its traditional Latino outlets on the Lower East Side, the Upper West Side, and Fourteenth Street. The 1980s appropriation of an imagery that evokes transcendence illustrates the cannibalistic and vicarious characteristics of postmodern culture. This melancholic arrogation also diffuses the boundaries of cultural identity and difference, producing a new and unsettling cultural persona.

A walk along Fourteenth Street used to be enough to travel in the hyperreality of kitsch iconography.[1] Cutting across the map of Manhattan, Fourteenth Street sets the boundary for downtown, exploding into a frontierlike bazaar, a frantic place of trade and exchange, a truly inner-city port where among cascades of plastic flowers, pelicans made with shells, rubber shoes, Rita Hayworth towels, two-dollar digital watches, and pink electric guitars with miniature microphones, an array of shrine furnishings is offered. Velvet hangings picturing the Last Supper are flanked on one side by bucolic landscapes where young couples kiss as the sun fizzles away in the ocean and on the other by 1987's "retro" idol, Elvis Presley, while the Virgin Mary's golden aura is framed by the sexy legs of a pin-up, and the Sacred Heart of Jesus desperately competes in glitter with barrages of brightly colored glass-bead curtains.[2]

Nowadays, the Catholic iconography brought to the United States by immigrants from Puerto Rico, the Dominican Republic, Mexico, and Cuba is displayed in places where the predominant attitude toward Latino culture is one of amused fascination. Religious images serve not only as memorabilia in fancy souvenir shops[3] but also as decoration for night clubs. The now-exorcised Voodoo, on Eighteenth Street, used to have a disco on its first floor and a bright green and pink tropical bar on the second. The bar's ceiling was garnished with plastic fruits hanging from one end to the other, and in the center of the room stood an altar complete with Virgin Mary, flowers, and votive candles. Fourteenth Street's Palladium, famous for a postmodern scenario in which golden Renaissance paintings emerge from behind a bare high-tech structure, celebrated All Saints' Day in 1987 with an invitation that unfolded in images of and prayers to Saint Patrick, Saint Francis of Assisi, and Saint Michael the Archangel.

Suddenly, holiness is all over the place. For $3.25 one can buy a Holiest Water Fountain in the shape of the Virgin, while plastic fans engraved with the images of your favorite holy people go for $1.95, as do Catholic identification tags: "I'm a Catholic. In case of accident or illness please call a priest." Glowing rosary beads can be found for $1.25 and, for those in search of verbal illustration, a series of "Miniature Stories of the Saints" is available for only $1.45. In the wake of punk crucifix earrings comes designer Henry Auvil's Sacred Heart of Jesus sweatshirt, yours for a modest eighty dollars,[4] while scapularies, sometimes brought all the way from South America, adorn black leather jackets. Even John Paul II has something to contribute. In his travels, the Holy Father leaves behind a trail of images, and one can buy his smiling face in a variety of pope gadgets including alarm clocks, pins, picture frames, T-shirts, and snowstorm globes.[5]

This holy invasion has gone so far as to intrude in the sacred space of galleries and museums, as a growing number of artists incorporate Catholic religious imagery in their work. Some recent examples are Amalia Mesa-Bains's recasting of personal *altares*, Dana Salvo's photographs of Mexican home altars, and Audrey Flack's baroque re-representations of Spanish virgins.[6] Can the objects found in botanicas and on Fourteenth Street, the ones sold in souvenir shops and those exhibited in galleries be considered one and the same? I will argue for their synchronized difference, that is, for contemporary urban culture's ability to circulate and support distinct, and often contradictory, discourses.

Religious iconography as kitsch: developing a vicarious sensibility

I will begin by describing the peculiar aesthetics and philosophy underlying the circulation of the iconography of home altars. A popular Latin American tradition, home altars or *altares* are domestic spaces dedicated to deities and holy figures. In them, statuettes or images of virgins and saints are allocated space together with candles and other votive objects. Triangular in analogy to the Holy Trinity, *altares* are characterized by a cluttered juxtaposition of all types of paraphernalia; they are a personal pastiche. Illustrating a history of wishes, laments, and prayers, they are built over time, each personal incident leaving its own mark. *Altares* embody familiar or individual histories in the way photo albums do for some people. Consequently, a home altar is not only unique and unrepeatable, it is coded by the personal experience that composed it, and the code is

unreadable to foreign eyes. This mode of elaboration explains the variety of artifacts to be found in home altars and why there are no set rules as to what they might be made up of, except that everything must have a particular value. In *altares*, value is measured both sentimentally and as an offering. Since most of the people who make them have low incomes, their economic worth is symbolic and is conveyed by glitter and shine, mirrors and glass, a profusion of golden and silvery objects, and sheer abundance. This symbolic richness accounts for the artificial look of *altares*, as well as for the "magical kingdom" feeling they evoke.

Fundamentally syncretic, *altares* are raised or dedicated to figures who are public in some way, usually taken from the Catholic tradition, a local miraculous event, or national politics. Instead of following a formal chronology, home altars rearticulate history in relation to events relevant to the believer. To symbolize personal history, they transgress boundaries of time, space, class, and race. This is well illustrated in the Venezuelan cult of María Lionza, a deity who is revered along with heroes of the Independence and contemporary presidents—such as Carlos Andrés Pérez—in the gigantic altar of Sorte, a ritual hill dedicated to her worship. In both their elaboration and their meaning, *altares* are emblematic of the mechanics of popular culture: they familiarize transcendental experience by creating a personal universe from mainly domestic resources. In so doing, they stand directly opposite the impersonal politics of high and mass culture, although they steal motifs and objects from both.

That the *altares* tradition is being appropriated by artists both in the United States and abroad (Cuban artist Leandro Soto's home altars to revolutionary heroes, for example) at the same time that their constitutive elements are heavily circulated in the marketplace is no coincidence. This phenomenon is based on the stealing of elements that are foreign or removed from the absorbing culture's direct sensory realm, shaping itself into a vicarious experience particularly attracted to the intensity of feeling provided by iconographic universes like that of Latin American Catholicism. Vicariousness—to live through another's experience—is a fundamental trait of postmodern culture. Ethnicity and cultural difference have exchanged their intrinsic values for the more extrinsic ones of market interchangeability: gone are the times when people could make a persuasive claim to a culture of their own, a set of meaningful practices that might be considered the product of unique thought or lifestyle. The new sense of time and space generated by telecommunications—in the substitution of continuity and distance with instantaneousness and ubiquity—has transformed the perception of things so that they are no longer lived directly but through their representations. Experience is mainly available through signs: things are not lived directly but rather through the agency of a medium, in the consumption of images and objects that replace what they stand for. Such rootlessness accounts for the high volatility and ultimate transferability of culture in postmodern times.

The imaginary participation that occurs in vicarious experience is often despised for its lack of pertinence to what is tacitly agreed upon as reality, for example in the generalized notion that mass entertainment is dumbfounding. Ironically enough, vicariousness is similar to the classic understanding of aesthetic enjoyment, which is founded on a symbolically distanced relationship to phenomena. This symbolic connection, which used to protect the exclusivity of aesthetic experience by basing it on the prerequisites of trained sensibility and knowledge, has given way to the more ordinary and accessible passageway provided by popular culture. Therefore, it is not against living others'

experiences—or living like another—that high-culture criticisms are directed, but rather against the popular level where this vicariousness is acted out and the repercussions it has on other cultural projects. Vicariousness is acceptable so long as it involves a high-level project (stimulating the intellect) but unacceptable when limited to the sensory (stimulating the senses).

The acceptance of vicariousness enables an understanding of how, as the result of a long cultural process, simulation has come to occupy the place of a traditional, indexical referentiality. For this process is not, as many would have it, the sole responsibility of progressively sophisticated media and market devices, but is rather the radicalization of the ways in which culture has always mediated our experience. The difference in postmodernity is both quantitative and qualitative, since it lies in the extent to which experience is lived vicariously as well as in the centrality of emotion to contemporary vicariousness. The "waning of affect" in contemporary culture is intrinsically related to a distance from immediate experience caused in part by the current emphasis on signs.[7] Attempting to compensate for emotional detachment, this sensibility continually searches for intense thrills and for the acute emotionality attributed to other times and peoples. The homogenization of signs and the wide circulation of marketable goods make all cultures susceptible to this appropriation, and the more imbued with emotional intensity they are perceived to be, the better. It is in this appeal to emotion that religious imagery and kitsch converge. The connection proves particularly relevant because kitsch permits the articulation of the polemics of high and low culture in a context broader than that of religious imagery, smoothing the way for a better understanding of its attraction and importance for vicarious experience.

Known as the domain of "bad taste," kitsch stands for artistic endeavor gone sour as well as for anything that is considered too obvious, dramatic, repetitive, artificial, or exaggerated. The link between religious imagery and kitsch is based on the dramatic character of their styles, whose function is to evoke unambiguously, dispelling ambivalence and abstraction. After all, besides providing a meaningful frame for existence and allocating emotions and feelings, Catholicism facilitates through its imagery the materialization of one of the most ungraspable of all experiences, that of the transcendence of spiritual attributes. Because of the spiritual nature of religious faith, however, iconolatry (the worship of images or icons) is often seen as sacrilegious, as the vulgarization of an experience that should remain fundamentally immaterial and ascetic. In this sense, not only Catholic iconography but the whole of Christian theology has been accused of lacking in substance, and therefore of being irredeemably kitsch.[8] Like kitsch, religious imagery is a mise-en-scène, a visual glossolalia that embodies otherwise impalpable qualities: mystic fervor is translated into upturned eyes, a gaping mouth, and levitation; goodness always feeds white sheep; virginity is surrounded by auras, clouds, and smiling cherubim; passion is a bleeding heart; and evil is snakes, horns, and flames. In kitsch, this dramatic quality is intensified by an overtly sentimental, melodramatic tone and by primary colors and bright, glossy surfaces.

The crossing over between the spheres of the celestial and kitsch is truly concordant. Religious imagery is considered kitsch because of its desacralization, while kitsch is called evil and the "anti-Christ in art"[9] because of its artistic profanities. Kitsch steals motifs and materials at random, regardless of the original ascription of the sources. It takes from classic, modernist, and popular art and mixes all together, becoming in this way the first and foremost recycler. This irreverent eclecticism has brought both glory

and doom upon kitsch, for its unbridled voraciousness transgresses boundaries and undermines hierarchies. Religious kitsch is then doubly irreverent, displaying an impious over-determination that accounts, perhaps, for its secular seduction.

Kitsch is one of the constitutive phenomena of postmodernism. The qualities attributed so far to kitsch—eclectic cannibalism, recycling, rejoicing in surface or allegorical values—are those that distinguish contemporary sensibility from the previous belief in authenticity, originality, and symbolic depth.[10] Furthermore, the postmodern broadening of the notion of reality, whereby vicariousness is no longer felt as false or secondhand but rather as an autonomous, however incredible, dimension of the real, facilitates the current circulation and revalorization of this aesthetics. Likewise, in its chaotic juxtaposition of images and times, contemporary urban culture is comparable to an altarlike reality, where the logic of organization is anything but homogeneous, visual saturation is obligatory, and the personal is lived as a pastiche of fragmented images from popular culture.

Fourteenth Street and first-degree kitsch

One of the most conspicuous features of postmodernity is its ability to entertain conflicting discourses simultaneously. Rather than erasing previous practices, it enables and even seeks their subsistence. This peculiar coexistence of divergent visions is made possible by the space left in the vertical displacement of depth by surface, which implies a gathering on the horizontal level. Fragmentary but ubiquitous, discontinuous and instantaneous, this new altarlike reality is the arena for a Byzantine struggle in which different iconographies fight for hegemony. In this manner, cultural specificity has given way to the internationalization of its signs, losing uniqueness and gaining exposure and circulation. Within this context, it is possible to distinguish, according to their means of production and cultural function, three degrees of kitsch that have recently come to overlap in time and space.

In what I will call first-degree kitsch, representation is based on an indexical referent. Here, the difference between reality and represention is explicit and hierarchical, since only what is perceived as reality matters. Acting as a mere substitute, the kitsch object has no validity in and of itself.[11] This is the case of the imagery available at church entrances and botanicas, sold for its straightforward iconic value. Statuettes, images, and scapularies embody the spirits they represent, making them palpable. Consequently, this imagery belongs in sacred places, such as home altars, and must be treated with utmost respect. In first-degree kitsch, the relationship between object and user is immediate, one of genuine belief. Technically, its production is simple and cheap, a serial artisanship devoid of that perfectly finished look attained with a more sophisticated technology.[12] In fact, these objects exhibit a certain rawness that is, or appears to be, handmade. This quality reflects their "honesty," as lack of sophistication is usually taken for authenticity. On the other hand, this rawness adds to first-degree kitsch's status as "low" art, when it is considered art at all: usually, if not marginalized as folklore, it is condemned as gaudy.[13]

Almost a century old, first-degree kitsch is what is usually referred to in discussions of kitsch. It is not, however, inherently kitsch. It is understood as such from a more distanced look, one that does not enjoy the same emotional attachment that believers

have to these objects. For them, kitsch objects are meaningful, even when they are used ornamentally. Yet for those who have the distanced look, whom I will call kitsch aficionados,[14] it is precisely this unintentionality that is attractive, since it speaks of a naive immediacy of feeling that they have lost. Aficionados' nostalgia leads them to a vicarious pleasure that gratifies their desire for immediacy. They achieve this pleasure by collecting kitsch objects and even admiring their inherent qualities: bright colors, glossy surfaces, and figuration. By elaborating a scenario for their vicarious pleasure, kitsch aficionados paradoxically reproduce the practice of believers, since this scenario is meant to provide an otherwise unattainable experience, that of immediate feeling for the aficionados and of reverence for the believers. Aficionados' sensibility cannot be dismissed as secondary or intellectual because their attachment to these objects is as strong and vital as that of first-degree believers. Yet what is relevant here is that first-degree believers' attachment is directly related to the devotional meaning of the iconography, while for aficionados, this meaning is secondary: what matters is not what the images represent, but the intense feelings—hope, fear, awe—that they inspire. Aficionados' connection is to these emotions, their appreciation one step removed from first-degree kitsch.

The different relationships to first-degree kitsch may be illustrated by a Fourteenth Street fad of the past few years, the Christ clocks. Rectangular or circular, these clocks narrate various moments of Christ's life in three dimensions. We see Christ gently blessing a blond girl while a few small, fluffy white sheep watch reverently, Christ bleeding on the cross or delivering the Sermon on the Mount, or all of these scenes together in the special "quarter-hour" versions, where, in the narrative logic of the Stations of the Cross, each quarter hour has its own episode. True to Fourteenth Street and home-altar aesthetics, Christ clocks eschew the boredom of bareness, naturalness, and discretion and exploit the prurience of loudness, dramatics, and sentimentality. The profusion of these clocks bears witness to their popularity. Selling for about twelve to fourteen dollars, they have become a dominant part of the Fourteenth Street scene.

For most Christ-clock shoppers there is no contradiction in using Christ's life as a backdrop for time. In kitchens or living rooms, these clocks are used as extensions of the home altar, conveying a comfortable familiarity with a figure that represents cherished values. This relationship to Christ is loving and quotidian, totally ordinary. For kitsch aficionados, however, these clocks are a source of endless amazement and wonder. Lacking a religious attachment to them, aficionados are fascinated by the directness of the feelings these clocks represent and evoke: there is something definitely moving about Christ's sorrow as—on his knees on Mount Olive, hands dramatically clasped—he implores his Father's compassion for the sinful human race. For an aficionado it is the intensity of this drama—heightened by an artificial aura created by the picture's lack of depth and bright colors—that is attractive. This aesthetic experience is radically different from the highly conceptualized one of modern art.

Little Rickie and second-degree kitsch

First-degree kitsch familiarizes the ungraspable—eternity, goodness, evil—while tacitly maintaining a hierarchical distinction between reality and representation. The opposite is true of second-degree kitsch, or neo-kitsch,[15] which collapses this difference by making representation into the only possible referent. In so doing, it defamiliarizes

our notion of reality because representation itself becomes the real. Neo-kitsch is inspired by first-degree kitsch and is therefore second-generation. Sold as kitsch, it lacks the devotional relation present in first-degree kitsch. Its absence of feeling leaves us with an empty icon, or rather an icon whose value lies precisely in its iconicity, its quality as a sign rather than as an object. This kitsch is self-referential—a sort of kitsch-kitsch—and has lost all the innocence and charm of the first-degree experience.

Whereas first-degree kitsch is sold in variety stores, among articles of domestic use, second-degree kitsch is found in more specialized shops, like those that sell souvenirs. Among the most interesting is New York's Little Rickie, where in the midst of all types of memorabilia, religious imagery reigns. In its dizzying clutteredness, Little Rickie is a sophisticated microcosm of Fourteenth Street and home-altar aesthetics. As such, it succeeds in creating a total disorientation that engulfs the viewer inside the store. But although it offers all the religious kitsch one could ever hope to find, the catch for aficionados lies in the given or prefabricated quality of the objects. Take for instance the holy water bottles, transparent plastic bottles in the shape of the Virgin Mary. These bottles stand obliquely to the original iconography—which does not include them—and rely exclusively on concept for their existence. Lacking in visual and signifying exuberance, they profit from the religious imagery fad and from the idea of a bottle for holy water being funny. Never having established a first degree of affection, these bottles are devoid of the intensity aficionados seek. They are simply toys, curiosities bought to show or give to somebody else. Second-degree kitsch exists only for transaction, to pass from hand to hand, and in this lack of possessing subject lies its ultimate alienation and perishability.

Neo-kitsch is intentional, and it capitalizes on an acquired taste for tackiness. It is a popularization of the camp sensibility, a perspective wherein appreciation of the "ugly" conveys to the spectator an aura of refined decadence, an ironic enjoyment from a position of enlightened superiority.[16] This attitude allows a safe release into sentimentality. Neo-kitsch's exchange value is intensified by the interchangeability of religious imagery with the rest of the memorabilia in the store. For consumers of second-degree kitsch, the choice between, say, a sample of holy soil and a plastic eye with two feet that winks as it walks around is totally arbitrary, decided only by last-minute caprice or a vague idea of which would be more hilarious. For "authentic" aficionados half the pleasure of acquisition is lost when kitsch is a given and not a discovery. As for first-degree believers, they are not among the store's buyers, although the store is located in the East Village, which is home to a substantial Latino community.

Mass marketed, these products involve a more elaborate technology and often come from mass-culture production centers like Hong Kong. First-degree homeyness is replaced by the mechanical look of serial reproduction. Designed as a commodity for exchange and commerce, second-degree kitsch has no trace of use value, no longer being "the real thing" for connoisseurs. The passing over of kitsch to mass culture is similar to the desacralization of high art occasioned by mechanical reproduction.[17] In both cases the loss of authenticity is based on the shift from manufactured or low-technology production to a more sophisticated industrial one, with its consequent displacement of a referent for a copy. To consider second-degree kitsch less authentic than first-degree kitsch because of its predigested character would be contradictory, since kitsch is by definition predigested. The difference lies in how intentional, or self-conscious, this predigestion is.

The mass marketing of religious imagery as kitsch is only possible once the icon has been stripped of its signifying value. The religious kitsch that was available before the 1980s was first-degree kitsch, albeit mechanically reproduced. The change to a fad, something fun to play with, is a recent phenomenon. What matters now is iconicity itself; worth is measured by the icon's traits—the formal, technical aspects like narrative, color, and texture. Void, except in a nostalgic way, of the systemic meaning granted by religious belief, these traits are easily isolated and fragmented, becoming totally interchangeable and metonymical. As floating signs, they can adhere to any object and convey onto it their full value, "kitschifying" it. This lack of specificity accounts for neo-kitsch objects' suitability for random consumption.

Third-degree kitsch and the advantages of recycling

Religious imagery reached its highest level of commodification when it lost specificity to market interchangeability. It has gained a new social place, however, thanks to a simultaneous and related process: the legitimization of its signifying and visual attributes by the institutionally authorized agency of artists. This revaluation takes place through the multifarious recycling of Catholic religious iconography, constituting what I will distinguish as third-degree kitsch. Here, the iconography is invested with either a new or a foreign set of meanings, generating a hybrid product. This phenomenon is the outcome of the blending between Latin and North American cultures and includes both Chicano and Nuyorican artists' recovery of their heritage as well as white American artists working with the elements of this tradition.

Since individual *altares* represent personal histories of memories and wishes, the tradition of home altars as a whole can be taken to represent collective remembrance and desire. In varying degrees of nostalgia and transformation, several Chicano and Nuyorican artists are using the *altares* format to reaffirm a precarious sense of belonging. Second-generation altar making is complicated by the currency of its iconography: in more ways than one, the fashionable home altars' aesthetic benefits from such timely recirculation. Yet any consideration of these artists as the authentic bearers of the *altares* tradition assures Chicano and Nuyorican artists' marginality by stating that they are the most suited to carry on with their forebears' work, since cultural continuity conveniently eliminates them from participating in other creative endeavors. Chicano and Nuyorican home altar recycling, therefore, is treading a very fine line between reelaborating a tradition whose exclusive rights are questionable and being artistically identified solely with that task.

Some of the edge can be taken off this discussion by acknowledging the differences between this kind of artistic recovery and first-degree home-altar elaboration. As a recent exhibition title suggests, the recasting of *altares* is often meant as a "ceremony of memory" that invests them with a new political signification and awareness. This artistic legitimization implies formalizing home altars to fit into a system of meaning where they represent the culture that once was; they are changed, once again, from referents to signs. This loss of innocence, however, allows *altares* to be reelaborated into new sets of meanings, many of which were inconceivable to the original bearers of this tradition but are certainly fundamental to more recent Chicano and Nuyorican generations.[18]

One such example of home-altar recycling may be found in Amalia Mesa-Bains's

work, which is both a recovery of and a challenge to her family tradition and cultural identity. Mesa-Bains is a Chicana who began making *altares* after earning several college degrees. Her revival of this tradition is therefore not spontaneous but calculated, impelled by a conscious gesture of political reaffirmation of Chicano cultural values. One of her recent shows, Grotto of the Virgin, consisted of *altares* raised to such unhallowed figures as Mexican painter Frida Kahlo, Mexican superstar Dolores del Rio, and her own grandmother. What is specific to Mesa-Bains's altars is that the personal is not subordinated to a particular holy person. Rather, a secular person is made sacred by the altar format, the offerings consisting mainly of a reconstruction of that person's imagined life by means of images and gadgets. The Dolores del Rio altar, for example, is raised on several steps made with mirrors, bringing to mind the image cults that grow up around Hollywood actors and actresses. This altar is stacked with feminine paraphernalia such as perfume bottles, lipstick, and jewelry, as well as letters, pictures, and other souvenirs of her life. In this way, the image of Dolores del Rio as a "cinema goddess" becomes literal.

This secularization of the *altares* is probably due to the importance Mesa-Bains assigns to personal experience. In traditional altar raising, the personal was always secondary to the deity, and religious sensibility articulated in the last instance the whole altar. By privileging what were only coding elements so that they become the main objective of her *altares*, Mesa-Bains has inverted the traditional formula. As a result, women and mass culture are invested with a new power that emanates from the sacredness of *altares:* in postmodern culture, Mesa-Bains's work would seem to contend, old patriarchal deities are no longer satisfactory. What she has done is to profit from an established tradition to convey new values. Beyond mere formal changes, her *altares* replace the transcendental with the political. In them, the affirmation of feminist and Chicano experiences is more relevant than a pious communication with the celestial sphere. Such a secularization of home altars is evidence of their adaptability as well as their visual versatility.[19]

Chicano and Nuyorican artists are not alone in exploring home-altar aesthetics. Boston photographer Dana Salvo has exalted the tradition of Mexican home altars by uprooting them from their private context and presenting them as sites both of unorthodox beauty and of first-hand religious experience. Salvo transforms *altares* into objects of aesthetic contemplation: in elegant cibachrome prints, the colors, textures, and arrangements of *altares* stand out in all their splendor. For Salvo, an artist who has also focused on the recovery of lost or ruined textures (some of his other work consists of uncovering the debris and capturing the layers of time and decay in ruined mansions), the seduction of home altars is primarily visual. The absence of some contextualization to help decode home altars underlines their value as objects as well as their ultimate otherness: they represent a reality that speaks a different language. Still, even if the appreciation of *altares* is limited to an aesthetic discovery of their iconic attributes, this remains a relevant connection to a hitherto ignored cultural manifestation. Furthermore, the participatory process in which Salvo and the creators of the altars engaged when they rearranged the *altares* for the photos speaks for the reciprocal benefits of active cultural exchange.[20]

Finally, religious iconography is used as a format for modern experience in the work of Audrey Flack, who explores her own feelings through images of the Virgin Mary. For more than a decade, Flack has drawn from the Spanish Marian cult as a source of

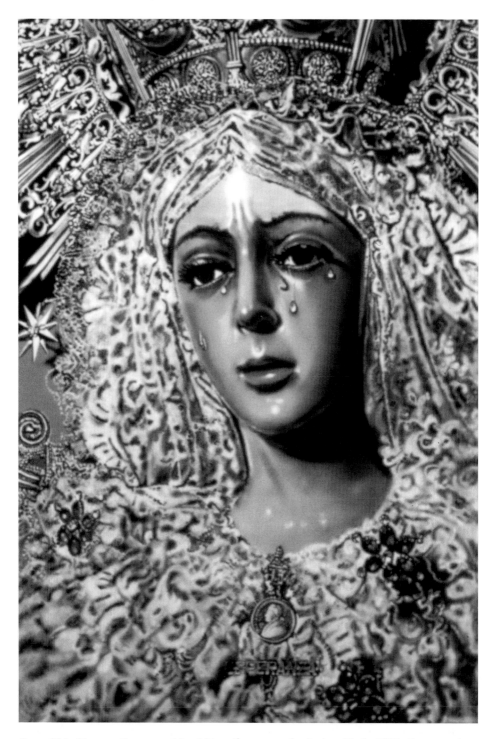

Figure 26.1 Macarena Esperanza, 46 × 66 in. oil on canvas by Audrey Flack, 1971. Courtesy the Louis K. Meisel Gallery.

inspiration. Her choice of imagery is based on an identification with what she feels are analogous experiences of motherhood. Flack overdramatizes her Virgins, making them hyperreal by accentuating color, giving the paintings a glossy quality, and even adding glittery tears. It is this overdramatization that, together with the baroqueness of the imagery, makes her work "popular kitsch," a kitsch that takes itself seriously and is sentimental and Romantic. Flack distinguishes this kitsch from "art world kitsch," which in her opinion covers sentiment with humor. Emotional identification is the basis for her claim to a more valid relationship to religious imagery than that of other artists.[21] Flack's emotional affinity with the Virgins notwithstanding, her use of them is mainly functional and isolated from the Marian tradition as a whole. A syncretist, she takes elements from any religion that suits her needs, in an interchangeability that renders the specificity of religious traditions secondary.

Third-degree religious kitsch consists in a revalorization of Catholic iconography and the accentuation of those traits that make its aesthetics unique: figurativeness, dramatization, eclecticism, visual saturation—all those attributes for which kitsch was banned from the realm of art. In providing an aesthetic experience that transcends the object, kitsch is finally legitimized as art, an issue that has been of more concern to art critics than to kitsch artists. Consequently, it has been argued that the recirculation of kitsch is but a co-optation by the late avant-garde, a formal gesture of usurpation coming from its desperate attempt to remain alive.[22] There is little difference between the use of kitsch as a motif by the market and by avant-garde art, since the value of the icon lies for both in its exotic otherness, its ornamental ability to cover the empty landscape of postindustrial reality with a universe of images. Such pilfering of religious imagery is limited to reproduction, displacing and subordinating its social function but not altering the material in any significant way.

But what is happening in the third-degree revaluation of kitsch is more than the avant-garde's swan song. It is the collapse of the hierarchical distinction between the avant-garde and kitsch—and, by extension, between high and popular art—a collapsing of what modernity considered a polar opposition. According to this view, sustained principally by Clement Greenberg, the avant-garde revolution transferred the value of art from its sacred function (providing access to religious transcendence) to its innovative capabilities (leading to a newly discovered future via experimentation and disruption). Since kitsch is based on imitation and copy, countering novelty with fakeness and artificiality, it was consequently understood as the opposite of the avant-garde and considered reactionary and unartistic.[23]

The current crisis of representation, however, implies not only disillusionment with progress, originality, and formal experimentation but also a reconsideration of all they excluded. It follows that copy, simulation, and quotation are raised to a new level of interest, representing a different experience of art and creativity. In postmodern culture, artifice, rather than commenting on reality, has become the most immediately accessible reality. Fakery and simulation were present in modernism as aesthetic means. They had a function, as in the reproduction of consumer society's alienation in Andy Warhol's work. In postmodernity, there is no space for such distances: fake and simulation are no longer distinguishable from quotidian life. The boundaries between reality and representation, themselves artificial, have been temporarily and perhaps permanently suspended.

Moreover, these boundaries are questioned not only by third-degree kitsch, but

also by the current recirculation of kitsch. Anticipating this postmodern taste, Walter Benjamin wrote in a brief essay that kitsch is what remains after the world of things is extinct. Comparing it to a layer of dust that covers things and allows for a nostalgic recreation of reality, Benjamin believes kitsch—the banal—to be more accurate than immediate perception (thus favoring intertextuality over indexicality). For him, immediacy is just a notion of reality, and only the distance left by the loss of this immediacy permits a true apprehension of things. Therefore, he trusts dreams, rhythm, poetry, and distraction. Because of its repetitiveness—worn by habit and decorated by cheap sensory statements—kitsch is most suitable for this nostalgic resurrection, making for an easier and more pleasurable perception.[24] In discussing the Iconoclastes and their fury against the power of religious images, Baudrillard ascribes to simulacra a similar nostalgic function. Yet in his characteristic neutralization of signs, Baudrillard fails to assign them any discursive power.[25] Such empowerment is precisely the issue at stake in third-degree kitsch.

Besides imploding the boundaries of art and reality, the third degree carries out an active transformation of kitsch. Taking religious imagery both for its kitsch value and its signifying and iconic strength, it absorbs the icon in full and recycles it into new meanings. These meanings are related to personal spiritual experiences, recalling users' relationships to first-degree imagery, except that the first-degree images are part of a given cultural heritage and as such they are readily available and their usage is automatic. Third-degree kitsch, on the other hand, appropriates this tradition from "outside," searching for an imagery that will be adequate to its expressive needs. Its cannibalization of imagery, however, stands in sharp contrast to previous appropriations. In the early avant-garde, for instance in Picasso's use of African masks, the break with Western imagery had a symbolic function. Similarly, in surrealism and the release of the unconscious, exploring difference meant disrupting a cultural heritage perceived as limited and oppressive. Venerated for its ability to offer an experience in otherness, difference stood as the necessary counterpart of Western culture. Its function was to illuminate. Yet this assigned purposefulness tamed the perception of those cultures, ultimately erasing difference from the Western imaginary landscape.

In the work of the artists mentioned earlier, Catholic religious imagery provides access to a variety of intense emotions that seem otherwise culturally unattainable. In Salvo's photography the pleasure seems to come from the intimacy of the home altars, where family history is revered in a colorful clutter of figures and personal objects. This affectionate and ingenuous assortment stands in contrast to the photographic gaze through which it is perceived. For their viewers, the beauty of *altares* lies in their direct connection to reality, a connection that succeeds in stirring the capacity for amazement. A similar pleasure is found in Flack's virgins, whose melodramatic intensity becomes almost sublime, following the tradition of Catholic hagiography. Meanwhile, Mesa-Bains and other Chicano and Nuyorican artists are moving toward a radical transformation of tradition by imposing their own will on the material they work with, as in Mesa-Bains's use of *altares* to sanctify contemporary femininity.

This colonization of religious imagery, in which it is occupied by alien feelings and intentions, can be said to work in both directions. After all, the exotic, colonized imagery has now become part and parcel of the appropriator's imagination—it is part of the cannibal's system. Instead of appropriation annihilating what it absorbs, the absorbed invades the appropriating system and begins to constitute and transform it.

The unsettling qualities of such cross-cultural integration are underscored by kitsch's syncretic tradition of mixture and pastiche. Since kitsch can readily exist in a state of upheaval and transformation, there is no eventual settlement of the absorbed. In the past, this reverse colonization has been minimized by adverse historical conditions. Yet the vast Latin American immigration to cosmopolitan urban centers in the past few decades is forcing a redefinition of traditional cultural boundaries, one that both shapes and is shaped by the circulation of images. If at one time exotic images were domesticated, they now seem to have lost their tameness to a newly found space: the one left by the exit of traditional referentiality. It isn't surprising then that third-degree kitsch in the United States is coming mainly from the East and West Coasts, since it is in these places that a new culture, deeply affected by Latinos, is being formed.

Religious imagery in third-degree kitsch surpasses the distance implied in second-degree kitsch. Instead of consuming arbitrarily, it constitutes a new sensibility whose main characteristic is the displacement of exchange by use. The consumption of images has been qualitatively altered: images are not chosen at random; they must convey a particular feeling, they must simulate emotion. Third-degree kitsch is the result of that search. Whether its potential destabilization will have a concrete social result before it is annihilated by a systematic assimilation that hurries to institutionalize it—making it into second-degree kitsch, for example—is debatable. Still, it is not a question of this assimilation seeping down into the depths of culture and carrying out some radical change there. After all, American culture is basically one of images, so that changes effected at the level of imagery cannot be underestimated. Since commodification is one of the main modes of integration in the United States, it can certainly be used as a vehicle of symbolic intervention. Third-degree kitsch therefore may be considered a meeting point between different cultures. It is where the iconography of a culture, instead of ceasing to exist, is transformed by absorbing new elements. Rather than of active or passive cultures, one can now speak of mutual appropriation. Even if an iconography is stolen it remains active, and the artists' work discussed here illustrates how this iconography can occupy the appropriator's imagination by providing a simulation of experiences the native culture has become unable to produce.

It can be said that each degree of religious imagery satisfies the desire for intensity in a different way: in the first degree through an osmotic process resulting from the collection and possession of objects still infused with use value; in the second degree by the consumption of commodified nostalgia; and in the third degree by cannibalizing both the first and second degrees and recycling them into a hybrid product that allows for a simulation of the lost experience. Even though they're produced at different moments, these three degrees cohabit the same contemporary space. Their synchronicity accentuates the erasure of cultural boundaries already present in third-degree kitsch, throwing together and mixing different types of production and perception. This reflects the situation of the urban cosmopolis, where myriad cultures live side by side, producing the postmodern pastiche. Such an anarchic condition destabilizes traditional hegemony, forcing it to negotiate with those cultural discourses it once could oppress. The ability of cultural imagery to travel and adapt itself to new requirements and desires can no longer be mourned as a loss of cultural specificity in the name of exhausted notions of personal or collective identities. Instead, it must be welcomed as a sign of opening to and enjoyment of all that traditional culture worked so hard at leaving out.

Notes

1 For a description of contemporary hyperreality see Umberto Eco, *Travels in Hyperreality: Essays*, trans. William Weaver (San Diego: Harcourt Brace Jovanovich, 1986) and Jean Baudrillard, *Simulations*, trans. Paul Foss, Paul Patton, and John Johnston (New York: Semiotext[e], 1983).

2 I would like to thank the following people for allowing me to repeatedly photograph in their stores: Sam and Silvia at Sasson Bazaar, 108 W. Fourteenth Street; Maurice and David at Esco Discount Store, 138 W. Fourteenth Street; and Jamal at Sharon Bazaar, 112 W. Fourteenth Street. Fourteenth Street's internationality can be fully appreciated in these people's polyglotism: most of them speak four or five languages, including English, Spanish, Hebrew, Arabic, and French.

3 Little Rickie is located at 49 ½ First Avenue (at the corner of Third Street). Thanks to Phillip Retzky for letting me photograph in the store. The prices quoted are from 1987, when this chapter was written.

4 Available at Hero, 143 Eighth Avenue, and Amalgamated, 19 Christopher Street.

5 Much has been written about the video pope. For his 1984 visit to Puerto Rico see Edgardo Rodríguez Julia, "Llegó el Obispo de Roma," in *Una noche con Iris Chacón* (n.p.: Editorial Antillana, 1986): 7–52. For his 1986 visit to France see the wonderfully illustrated "Pape Show" issue of the French daily *Liberation*, October 4 and 5, 1986: 1–7.

6 Amalia Mesa-Bains, Grotto of the Virgins, Intar Latin American Gallery, New York City, 1987; Dana Salvo, Mary (group show), Althea Viafora Gallery, New York City, 1987; Audrey Flack, Saints and Other Angels: The Religious Paintings of Audrey Flack, Cooper Union, New York City, 1986.

7 Fredric Jameson, "Postmodernism; or, the Cultural Logic of Late Capitalism," in *New Left Review* 146 (July-August 1984): 53–92.

8 "In a vase of Kitsch flowers there is a formal defect, but in a Kitsch Sacred Heart the defect is theological," says Karl Pawek in "Il Kitsch Cristiano," in Gillo Dorfles, *Il Kitsch* (Milan: Gabriele Mazzotta Editore, 1969): 143–50. For another view of religious kitsch see Richard Egenter, *The Desecration of Christ* (Chicago: Franciscan Herald Press, 1967). For kitsch in general see Hermann Broch, "Kitsch e arte di tendenza" and "Note sul problema del Kitsch," trans. Saverio Vertone, in Dorfles, *Il Kitsch*, 49–76, and "Art and Its Non-Style at the End of the Nineteenth Century" and "The Tower of Babel," in *Hugo Von Hoffmannsthal and His Time: The European Imagination 1860–1920*, trans. and ed. Michael P. Steinberg (Chicago: University of Chicago Press, 1984): 33–81 and 143–83. Gillo Dorfles's book is a compilation of essays on kitsch, several of which will be mentioned throughout this chapter. See also Matei Calinescu, "Kitsch," in *Five Faces of Modernity* (Durham, N.C.: Duke University Press, 1987): 223–62; Haroldo de Campos, "Vanguarda e Kitsch," in *A Arte no horizonte do provavel* (São Paulo: Editorial Perspectiva, 1969): 193–201; Umberto Eco, "Estilística del Kitsch" and "Kitsch y cultura de masas," in *Apocalípticos e integrados ante la cultura de masas* (Barcelona: Lumen, 1968): 81–92; Clement Greenberg, "Avant-Garde and Kitsch," in *Art and Culture* (Boston: Beacon Press, 1961): 3–21; Abraham Moles, *Le Kitsch, L'Art de Bonheur* (Paris: Maison Mame, 1971). Aimée Rankin's "The Parameters of Precious," *Art in America* (September 1985): 110–17, was brought to my attention after the completion of this chapter; some of her arguments about the recycling of kitsch coincide with my understanding of it as pertaining to a vicarious sensibility.

9 Hermann Broch, *Hugo Von Hoffmannsthal*, 170.

10 The concept of cultural cannibalism was advanced in a different context by Oswald de Andrade, *Do Pau-Brasil a Antropofagia e as Utopias*, Obras Completas, vol. 6 (Rio de Janeiro: Civilizaçao Brasileira-Mec, 1970).

11 For some art theoreticians, this is a "primitive" confusion between referent and representa-
 tion. See Aleksa Celebonovic, "Nota sul Kitsch tradizionale," in Dorfles, *Il Kitsch*, 280–89.

12 Décio Pignatari, "Kitsch e repertório," in *Informaçao. Linguagem. Comunicaçao* (São Paulo:
 Perspectiva, 1968): 113–17.

13 Gillo Dorfles, *Il Kitsch*, and Clement Greenberg, "Avant-Garde and Kitsch."

14 Hermann Broch spoke of the "kitsch-man" in Gillo Dorfles, *Il Kitsch*, 49.

15 This term was first used by Abraham Moles, *Le Kitsch*, 161–86.

16 For camp sensibility see Susan Sontag, "Notes on Camp," in *Against Interpretation and Other
 Essays* (New York: Octagon, 1982): 275–92.

17 See Walter Benjamin, "The Work of Art in the Age of Mechanical Reproduction," in *Illu-
 minations*, trans. Harry Zohn (London: Jonathan Cape, 1970): 219–53.

18 Ceremony of Memory, Museum of Contemporary Hispanic Art (MOCHA), New York
 City, 1989. Ironically, this is happening at a time when Hispanics are said to be turning
 away from Catholicism. See "Switch by Hispanic Catholics Changes Face of U.S. Religion,"
 New York Times, May 14, 1989.

19 For a more extensive account of Mesa-Bains's work and of *altares* in general see Tomás
 Ybarra Frausto's essay "Sanctums of the Spirit—The Altares of Amalia Mesa-Bains," pub-
 lished in the catalog for this show.

20 In his artist's statement for the Pastorale de Navidad show (Nielsen Gallery, Boston, 1987),
 Salvo describes this exchange: "The Polaroid process quickly dispelled any apprehension or
 supersition that arose, and the instant image generated an enormous amount of enthusi-
 asm. Soon a crowd of villagers would be about the camera and house. They were moved
 that their creations were being photographed, and they treasured the Polaroids, displaying
 the image as part of the altarpiece. . . . Once everyone was accustomed to the photograph
 they would oftentimes arrange the interiors to better fit the frame. Or, this would encour-
 age others to add small treasures to an altar as it would be seen minutes later in a Polaroid
 image."

21 Personal interview with Lowery S. Sims, published in the catalog for Flack's Cooper Union
 show.

22 Gerardo Mosquera, "Bad Taste in Good Form," *Social Text* 15 (Fall 1986): 54–64. For
 another view on Cuban artistic kitsch see Lucy R. Lippard, "Made in the U.S.A.: Art from
 Cuba," *Art in America* (April 1986): 27–35. For kitsch in the United States see J. Hober-
 man, "What's Stranger Than Paradise?" in "Americanarama," *Village Voice Film Special*, June
 30, 1987: 3–8.

23 This is Greenberg's main proposal. See also Miriam Gusevich, "Purity and Transgression:
 Reflections on the Architectural Avantgarde's Rejection of Kitsch," Working Paper no. 4,
 published by the Center for Twentieth Century Studies of the University of Wisconsin-
 Milwaukee, Fall 1986.

24 Walter Benjamin, "Traumkitsch," in *Angelus Novus, Ausgewählte Schriften*, vol. 2 (Frankfurt
 am Main: Suhrkamp. 1966): 158–60.

25 Jean Baudrillard, *Simulations*, 7–9.

Chapter 27

Julian Stallabrass

TRASH

THIS IS WILLIAM GIBSON'S DESCRIPTION of the reactions of a visitor to a virtual world:

> She took her place beside him and peered down at the dirty pavement between the scuffed toes of her black Paris boots. She saw a chip of pale gravel, a rusted paperclip, the small dusty corpse of a bee or hornet. 'It's amazingly detailed . . .'[1]

Cyberspace, as we have seen, may come to concern itself largely with the strict control of the contingent, binding every aspect of the real to concepts. In trying to indicate the extent of the resources brought to bear to produce one rich man's consensual hallucination, it is natural, then, that Gibson should point to the inclusion of the useless and the neglected – to trash. Here the attention paid to rubbish, for so many people a matter of absolute necessity, becomes the expensive whim of the fantastically wealthy. In a world where concept and object are brought into perfect unison, the meaningless is the only area left for the exercise of conspicuous consumption.

While technotopia remains forever just over the horizon, it is as well to look at trash as it actually appears in our environment. Perhaps because it is so omnipresent, in greater or lesser concentrations, trash as such tends to be left unregarded, edited out of vision (and generally of photographs), ignored except as a practical problem, and deplored from an 'aesthetic' point of view, which repudiates it so as not to see it.

Trash is of course the direct product of the 'consumption' (in the sense of the early history of the word which Raymond Williams traced) of commodities. For Marx:

> a product becomes a real product only by being consumed. For example, a garment becomes a real garment only in the act of being worn; a house where no one lives is in fact not a real house; thus the product, unlike a mere natural object, proves itself to be, *becomes*, a product only through consumption. Only by decomposing the product does consumption give the product the finishing touch [. . .].[2]

It is a truism that as commodities acquired more of a character, as marketing decked them out as lavishly as models, then more and more packaging – immediate trash – surrounded them, while their passage from commodity to rubbish was ever shortened by the pace of fashion.[3] So the commodity and trash are as closely linked as production and consumption. It may even be that we can think of commodities as deferred trash.

I want to look at the afterlife of commodities closely for a while, to examine it as advertisements would have us look at new products, to see if it might yield narratives or express identities; to see, in short, if it is possible to salvage from it, unlike commodity culture, some 'true stories'. One of the constant claims of this book has been that grounds for critique may be found in mistakes and contingencies, whether in the bugs of computer coding, the inane techniques of the amateur photographer or the accidental effects of overwriting in graffiti. It might be strange to call it culture, but a great and subversive work of art, an immensely complex collage, is made and remade every day on the street and everyone participates in its fabrication. Trash, like graffiti, is something which people make collectively, and not quite inadvertently. Its form and the manner of its making are closely tied to the materials of our commercial culture and our attitudes to its products and the environment. Such a treatment of this subject can be relevant only in rich capitalist societies where the material from which broken commodities is made is not endlessly reused, bricolaged into intricate and ingenious devices, but is simply thrown away. There are certain precedents for such an analysis: Adorno wrote of Siegfried Kracauer, for instance, who concentrated on objects as a compensation for the lack of meaningful relationships with people and attempted to turn reification against itself, by taking its claims seriously:

> To a consciousness that suspects it has been abandoned by human beings, objects are superior. In them thought makes reparations for what human beings have done to the living. The state of innocence would be the condition of needy objects, shabby, despised objects alienated from their purposes. For Kracauer they alone embody something that would be other than the universal functional complex, and his idea of philosophy would be to lure their indiscernible life from them.[4]

It was also, of course, a part of Benjamin's project to make history from its refuse, and Adorno wrote of him in similar terms: 'Philosophy appropriates the fetishization of commodities for itself: everything must metamorphose into a thing in order to break the catastrophic spell of things'.[5] An apparently redundant beauty, particular only to trash, is certainly a frequent feature of its appearance in the street and by the roadside – anywhere, in fact, where it is not meant to be. Sometimes in the country a storm will catch the top layers of some landfill site, and suddenly, when calm has returned, the bare trees will be full of strange new flowers in bright primary colours, twisting and rustling in the breeze. These plastic bags hang on the branches for months, slowly becoming more soiled, faded and ripped until they take on the appearance of glossy rags. The meaning of trash would seem to lie in a surreal absurdity, but by taking it seriously, this very quality may come to illuminate the real absurdity of the situation in which it is produced.

There are a shrinking number of everyday spaces which do not construct eternal presents, where memory is not discarded from moment to moment – we have looked at

the computer screen and driving, and will look at television. The street is one of the few environments which do not at least aspire to phantasmagoria; here incident is constantly thrown into competition with commercial propaganda. The Walkman is of course an attempt to seal off the street from the pedestrian, but its effect is very incomplete and may end up organizing the incident of sights, other sounds, jostling and the feel of the pavement into a narrative by providing it with a sound track. It can load trivia with significance, thus ironically increasing its sense of particularity. As far as rubbish goes, strenuous attempts are of course made, particularly in the wealthier areas, to keep this displaced matter hidden from sight. These municipal measures are pitted against the constant torrent of packaged goods which pours out on to the streets in the hands of millions every hour of the day, and they constantly fail.

To inquire about rubbish is to ask what happens to commodities when they cease to be commodities, but which for a time retain their form as objects. For Marx, as we have seen, only when the object is consumed does it shed its material nature and become a product; when its use value, or at least the appearance of its use value, is exhausted, the product should become once more a merely material husk. Yet there hangs about it a certain air of embarrassment, a reminder of some vague promise unredeemed. Such objects, when abandoned in the streets, first allow their material natures to step out from behind the form of use value. They seem lost, like children who have strayed. Thrown into combination with other objects or with dirt, they comment ironically on themselves. Unmade, their polished unitary surfaces fall away, reinscribing in them for a time the labour that went into their making. As they begin to disintegrate, their mixing and eventual merging with other diverse products reveals for a time their differentiated identity as matter, and when they are finally ground into the unity of filth, their graded identities as commodities, unified only by the universal typology of money, become apparent. Somehow, during this process, their allure is not lost but, loosed from exchange and use value, it takes on an apparently more genuine aesthetic air.

While the puns and subversive gestures of Cubist and Dada collage have long since lost their power for radicalism, hanging on the walls of public museums and exclusive galleries, the collage of filth in the street retains its effect precisely because it really is impermanent (rather than merely looking it) and because it really does register something of the constantly changing forces which surround us. Indeed this collective, unconscious action on cultural products (writing, pictures, packaging, commodities all) amounts to an act of criticism of the culture as a whole, a tearing of it into equal fragments and their random disposal, followed by a promiscuous mixing and blending. Habermas's comments about the role of criticism in relation to allegorical works of art are relevant here: 'the critique practices this mortification of the work of art only to transpose what is worth knowing from the medium of the beautiful into that of the true and thereby to rescue it'.[6] Disposal then may be seen as a form of criticism; the way in which objects are thrown down in the street reveals a certain contempt, and it may be witnessed often enough in that singular, abrupt gesture in which people toss something down on the pavement, or let it fly in a little arc from a car window. Truth does not lie in the disciplined gardens and the scrubbed streets of the rich, where anything disposed of is kept in containers sealed away from sight and then quickly whisked away: the poor have a near monopoly on this non-commodity. The allegorical nature of criticism itself is here entirely appropriate for we are already dealing with the fragmentary remains of dead objects.

Objects gain and lose something when they are abandoned as rubbish. What they lose is related to their presentation by advertising as desirable commodities: newness, utility, wholeness, a distinction from other objects, or at least a resistance to arbitrary merging. The presentation of the commodity in advertising photography has been, almost from its origin, to stress these qualities, to mark the object as highly distinct from its surroundings – however appropriate they might be – to stress its cleanliness, to light it in order to emphasize the clarity of its borders. If it is brought into contact with other objects, or even transformed into them, this only happens after the most meticulous research into their symbolic suitability. In becoming rubbish the object, stripped of this mystification, gains a doleful truthfulness, as though confessing: it becomes a reminder that commodities, despite all their tricks, are just stuff; little combinations of plastics or metal or paper. The stripping away of branding and its attendant emotive attachments reveals the matter of the object behind the veneer imposed by a manufactured desire.

Abandoned objects have crossed a great divide from which they can never return. Commodities are of course signs in a system of value, both monetary and social, which is lost when they are abandoned. When objects are seen together as trash, relationships of a more poetic and intrinsic interest emerge. The qualities of the thing itself begin to appear in sharp relief like pictures in a developing tray. We see them for the first time with clarity, which is the same as that clearsighted ridicule with which we greet old adverts and the particularities and idiosyncrasies of design in old commodities: their arbitrariness and alien nature are suddenly revealed. With the ever more rapid cycling of products into obsolescence, the whole process of manufacture and discarding becomes an accelerated archaeology.

The uniqueness and materiality of commodities are false projections or fetishes which are nonetheless realized when the individual commodity begins to acquire a history in its consumption: when objects finally cease to be of commercial use, these qualities are realized and released. Aside from its dishonourable history in the service of advertising, photography has long had a role in making this latent content manifest: we might think, for instance, of the work of Bernd and Hilla Becher, who photograph derelict industrial architecture. The sharpness of their photographs and the weight of presence of each peculiarity in the buildings they represent suggest that we can only see these structures as themselves, or rather that they only become suitable for aesthetic appropriation, when they have ceased to function. Just as the product only becomes real in being consumed, so Hilla Becher has claimed that their work is only complete when its subject has been destroyed.[7]

Trash is often present as writing or images as well as mere matter. When packaging is discarded the bright, slick company logos, deformed by buckled paper or plastic, finally find their proper place. Because the brand name is an attempt to forge form and signification into an inseparable unit, when the material of the brand name falls as trash, its content must follow. Commodities – and let us think of those which most often end up underfoot, soft drinks, confectionery, fast food – are literally mired with filth. This trash writing may be seen as another form of graffiti, omnipresent like its wall-bound counterpart, critical, and, unlike brand-name graffiti, full of content. Pictures and words disintegrate as water dissolves the fabric of the paper, or under the wear of feet and tyres, producing an image of the decline of reading and expression. Accidental meanings in collages of trash sometimes emerge, often as inadvertent puns and jokes.

When language is so governed by commerce and a specious equivalence of signifier and signified has been established, the dissolution of words, of language itself, can seem positive. The simultaneous destruction of fabric and the content it supports may serve as a comment on the deleterious effects of the false unity of form and content on meaning. In commodified language, when taken as a whole as an elaborate collage of text and advertising, the significance of content falls away and a uniformity of form holds sway: we can generally spot a hobbyist's magazine or a newspaper supplement well before being able to read the title, or identify any of the predictable content. In the street, where this discarded material loses its content and is transformed into matter, its form at last takes on something of the truth of its content, being turned slowly into pulp. Of course in the original photographs and often in texts there is some residue of the particular, something which in its fragmented state exceeds commodification, and this suffers from material degradation as much as everything else. To look to destruction for the positive, and for critique in garbage, is one way of saying how bad things are.

It is important to realize that what we are examining here is filth, not stuff disposed of in rubbish dumps where it can be safely ignored, but rather trash on the streets or by roadsides: it is not merely redundant, but out of place, reacting against the unitary phantasmagoria of capital. As Mary Douglas famously put it in 'Purity and Danger', 'Where there is dirt there is system.'[8] Dirt is an omnibus category for matter out of place. Each displaced object is collaged with others and with a mismatched environment, whether rural, industrial or urban. In all cases an allegorical aesthetic of the fragment is opened up which may be read as revelatory of the operation of capitalism. The advert attempts to present its product as an autonomous and vaguely significant symbol, while in trash, commodities, having passed out of the hierarchies and false associations of exchange, are revealed as specific allegories.

Photography may bring out the allegorical potential of lost objects by framing, dematerializing and arranging them within the frame of the picture, thus presenting them as something to be read. Advertisements and the more generalized use of photography to make narratives prepare us for such a reading. In taking rubbish as an allegory of contemporary capital we are simply using the devices of commerce and turning them on other objects which lie all about us. This is certainly not to claim, as the propagandists of commercial culture constantly do, that there are symbolic or organic connections between these things. Trash, breaking with the false unity of the consumer object, reveals its allegorical potential by unmasking the symbolic pose of the commodity as a sham. Torn, dirtied or broken, thrown into combination with other fragmentary objects, while it remains itself, it becomes a broken shell, its meaning reaching out to its partners in a forlorn but telling narrative.

In making an image of the dissolution of our dominant systems, trash finds forms which reflect various aspects of high art – or they, drawn by certain affinities, sometimes come to reflect its appearance. The straightforward presentation of such objects in photographs may be open to Adorno's critique of Benjamin's methods in 'The Paris of the Second Empire in Baudelaire'. Adorno argued that motifs can be explained only by the overall social and economic tendency of the age, by an analysis of the commodity form, and that, for instance, 'The direct inference from the duty on wine to L'Ame du vin imputes to phenomena precisely that kind of spontaneity, palpability and density which they have lost in capitalism.' He continues that a lack of mediation, a wide-eyed presentation of the facts (and this is photography exactly) lends to empirical evidence

a 'deceptively epic character', placing it solely in the realm of the subjective so ignoring its 'historico-philosophical weight'.[9] The rejoinder here, of course, is that in looking at ex-commodities, there may be some occasional return of a palpability and density which are still present as an ideal in our minds, that they may cling to certain residues of object and thought alike. The predilection of photography, though, to construct a false epic, one much used by advertisers, must be admitted. The question is whether this tendency can be turned.

Benjamin's reply to Adorno was that his practice of philology was a prelude to critique and was itself an implicit critique of philology.[10] While Douglas warns us that 'We should not force ourselves to focus on dirt',[11] to look seriously at trash is a similar activity: a means to critique, and an implicit condemnation of the readings of those who peddle commercial culture. In literary allegory there is an apparent excess of detail which alerts the reader to the operation of a structure beyond the norms of realism; this cannot be expected to operate in the real, where there are no expectations of reading, however literal the combinations of trash sometimes appear to be. The presentation of this subject in photographs, however, creates expectations, especially in its parasitic operation against customary commercial readings.

We should also recall, from the first chapter, Benjamin's criticism of a photography which makes enjoyment out of abject poverty and transfigures even a 'refuse heap'.[12] Yet there is also a positive side to this recognition of beauty in the world, one closely related to the practice of amateur photography, of working against the evidence in the hope of transforming the world. Arcadian images spoilt by the presence of trash show how beauty survives the transformation, if only by contrast, and how ruination provides an indication of the possibility of something better.

The image of trash is perfectly suited to allegory for 'it is as something incomplete and imperfect that the objects stare out from the allegorical structure'. By separating image and meaning, allegory rejects the false appearance of artistic unity and presents itself as a ruin.[13] In this it has an honesty which utopian symbolism can no longer claim. As a form, allegory contains a critique within itself, since in its presentation of itself in ruins and decay it becomes an expression of the experience of 'the passionate, the oppressed, the unreconciled and the failed'.[14] The fragment, torn from a false totality, becomes the ground for a totalizing critique, if only because its symbolic connection to the whole has not been completely shed in its transformation into allegory. The links are still felt, but are now manifestly arbitrary and so the natural appearance of the system of commercial symbols is broken. Allegory, in showing us images of death and of a mortified nature, also reveals the fixed and arbitrary systems which are responsible.

While allegory has often been associated with decaying objects and petrified nature, advertisements, though they inadvertently take allegory as their form, shy away from such subjects, very nearly without exception. In such marketing all is the exact opposite in a display of pristine objects and an absolute, mandatory liveliness. More than anything else, trash reveals the broken utopian promise of the commodity. The lesson of the obsolete gives the lie to the promise of ultimate satisfaction. It is all the more powerful at a time when there is rising disaffection with materialism and the price that must be paid for mass-produced idiocy, when green issues are rightly seen to be ever more urgent. The capitalist 'answer' to this is a move to encouraging the increased consumption of software. There is no trash in cyberspace because there is nothing material to be disposed of and indeed because everything may be kept. This technological

fix is of course insufficient, for many reasons which we have already considered, but also because, until the rich are transfigured as digital angels, they will retain their current material and bodily needs and whims.

Maybe there are other things that trash can say. It is of course a powerful reminder of the West's profligacy in consumption, of the extraordinary engines of waste that are our economies, sacrificing vast quantities of matter and human labour on rubbish dumps. In this way trash rightly becomes a matter of guilt because of the despoliation of the environment, because of conspicuous wastage flaunted in the face of those who do not have enough, and because of our own indulgence, carefully fostered by corporations.

In commodities, as we have seen, branding is the identification of the object as quasi-human, the embodiment of a principle, a demon which is fixed and faithful, inexorable in its cheerfulness, reliability, protectiveness, or whatever quality is at that moment being marketed. When they are thrown out as rubbish, commodities lose this character but gain a semblance of a 'real' personality, that is, something fluid which alters and is altered by the things around it, and which, as groups, forever create and destroy each other. Where commodities have taken on the guise of persons in branding, and when they are thrown away, then this action and their fall into the gutter are the equivalent of discarding persons, and indeed there they accompany the real outcasts. As if seeing their companionship, some of the homeless collect trash, using it to help clothe and shelter them. Some carry their own fantastical trash collages in old supermarket trolleys. Occasionally one sees, as in a vision, scraps of plastic, paper and cloth, bound together with string, rising again from the street in human form, shuffling down the street, an animated stumpy tower of trash, a hybrid human-object. Only when the commodity is done with can it assume human form. Both brands and workers are imperfect persons, being carefully graded types matched to markets and tasks respectively. As with Lukács's self-recognition of reification, there is some poignant self-recognition to be found in trash, when it is torn from its usual context and presented in the light of the social totality. When the commodity form is stripped away, something may be revealed of the social relations which are immanent in the objects and which bind people and their fates.

Benjamin wrote of children:

> They are irresistibly drawn by the detritus generated by building, gardening, housework, tailoring, or carpentry. In waste products they recognize that the world of things turns directly and solely to them. In using these things they do not so much imitate the work of adults as bring together, in the artifact produced in play, materials of widely differing kinds in a new, intuitive relationship.[15]

So there is a certain freedom revealed in children's relation to objects, which is not governed by instrumentality, in which all qualities of their playthings are treated equally. This is surely an aesthetic attitude; in their innocence, children may still have unmediated access to the playful, light-hearted aspect of art, which is essential to it, but which adults of the twentieth century may have to repudiate.[16] It is doubly true of an art which is non-commercial, by accident or design, which may serve as a refuge, however fragile, against the unremitting instrumentality of the market.[17] When something has been required to throw into opposition to the commodity, the work of art has often been cast

in the role. Lukács, for instance, argued that art provides features that the commodity cannot: a form irreducible from content, an enriching objectification of the subjective, and a deconstruction of the opposition between freedom and necessity, since each element of the work of art seems both autonomous and subordinated to the whole.[18] Now many of these factors have changed as a result of modernism, which has affected the work of art and the commodity alike, especially as commodities and the marketing which surrounds them have aspired to the condition of art. However, some of these qualities can be looked for in trash. For Adorno the modernist work of art produced a dialectic of particularity and aesthetic integration, the latter formed by a progressive emptying of content from the elements of a work. So, 'The particular, the very life element of the work, flees the viewing subject, its concreteness evaporates under the micrological gaze'. Amorphous elements, when combined in a composition, find in this organization a 'natural moment' in which the 'not yet formed' and 'unarticulated' return in strength. Taken separately, they evaporate.[19] While subsuming each element to its overall scheme, the work of art must recognize and exploit some intrinsic quality of that element with which to order it in relation to the others, so in the composition each element finds its particularity understood.

Now, ironically, this is something like the operation of the metonymic field of differentiated commodities which as a whole forms that structure which presents itself as an aesthetic unit, the consumer market. Each element is empty except in relation to each other and the appearance of the whole is as of nature, an inevitable form. As in the modernist work of art, the same dialectic of integration and particularity is established. The grounds of this operation are the single, apparently universal typology of monetary value, just as in art it is the aesthetic.

It may be, then, that a certain liberation can be found in aspects of trash which is no longer present in the thoroughly colonized ground of high art. Commodification and much contemporary art seek to subjectify the objective, while trash activates the opposite process, muddying the subjective with the objective and revealing something of the former's vanity. The elements of commodities are subject to false instrumental unities, while the random collage of trash allows each element its own voice for as long as it survives, yet seems governed by the necessity of a higher power. The constant flux of objects on to and through the streets, and their removal or disintegration, has a rhythm which is usually too slow and disjointed to grasp, although we might get an impression of it when papers are blown about in high winds, or carrier bags lifted into the air like balloons. When snorkelling once I caught sight of something which seemed to summarize this process: swimming between two narrowing rock faces, I saw that the sea-bed at their foot was carpeted with garbage and unidentifiable detritus forming a thick mass which shifted in and out with each tug and push of the waves, changing its form subtly as it did so. In such scenes there appears a vision of an emergent order, gathering rubbish, and governing its disposition and the rate of its disintegration. Such an order, better than that of immaterial cyberspace, may serve as an image of an otherwise unrepresentable capital.

While in modernist high art, elements may lose all qualities other than those which sustain them within an order, photography starts from the opposite position. In 'straight' photographs, where the photographer finds rather than creates subject matter, each element of the picture retains a large portion of its autonomy and particularity, for they are integrated mostly through the selection of a viewpoint. It is a form of composition in which elements are arranged rather than altered. It is when integration is at the

point of disappearing (for the more subtle it is, the more retiring) that the meaning of the particular steps out from behind it. Photography's loose compositional structure and respect for contingency may then be allied with the allegorical form of trash.

Adorno, writing of a desperate historical situation, but one no worse than our own, stated grimly, 'there is no longer beauty or consolation except in the gaze falling on horror, withstanding it, and in unalleviated consciousness of negativity holding fast to the possibility of what is better'.[20] Unmanipulated photography may for the moment allow an unalleviated gaze of this kind. There might be a sense in which commodities, represented in photographs and stripped of specious attractions, acquire something of a true aesthetic charge as trash. They become a complex of contradictory, oppositional and negative forces. If a 'true' aesthetic is to be found in trash then the art-historical references which it unwittingly produces (and which a viewer may construct) assume a particular importance as an 'unconscious' construction of a tradition, and as a mark of trash's artistry. Of these art-historical 'references' in trash, the connection between still life and allegory, particularly the memento mori, is the most striking.

There is no sense in which this merely aesthetic recuperation is more than the start-ing point for a critique which must be material and social as well as affective. It is no more than an illustration. In itself such aestheticism is a highly marginalized, elite and powerless kind of radicalism. Yet even this carries its own dangers. The most immedi-ately obvious is that this concentration on the fragment and on allegory is seen as a mere gesture against the total system of capital rather than a specific critique of a set of partic-ular circumstances, however persistent. Nevertheless, Adorno is surely right that such a totalizing critique, while being a form of untruth, is a necessary consequence of and response to a totalizing system.[21]

There is also a danger that in too specifically spelling out the other side of homog-enization and domination, and particularly in bringing it to representation, we might make it fixed enough to be reified as an object for consumption in its turn. This brings us to the matter of whether there are things which capital cannot assimilate. [. . .] Terry Eagleton has argued that it can only fail to assimilate its own defeat,[22] but is this strictly the case? While high art is in part defined by the freedom which it is permit-ted, its sphere of operation is strictly proscribed. Is it really true that everything has been levelled, everything commercialized, that there is nothing that cannot be assim-ilated into the chat and the image of the advertisement? As Bataille understood, there are certain aspects of uncleanliness and filth that do seem resistant to this treatment. Advertisements may deal sometimes with disturbing or even horrific imagery, but it is more difficult to imagine them dealing with something which is their precise obverse: with fragmented, aged, dirty and chaotically combined objects – with the discarded. The filth in the street is radical because it informs us of the fate of commodities, a des-tination which is carefully repressed in all adverts: it is impossible to imagine adver-tisements for chocolate bars turning from their predictable references to fellatio to reminding the customer of the final destination of their product. Commodity culture is certainly bound by rigid exclusions and the regular censorship of the mainstream media for political and commercial purposes points to matters which go beyond assim-ilation. So there is plenty that capitalism must suppress, at least for the consumption of those outside the elite. At the same time commercial culture is voracious in its appro-priation of the new, the radical and the potentially dangerous: the Benetton advertise-ments are only the most notorious recent example of this, illustrating precisely the need

of a certain kind of advertising to push back the boundaries of assimilation. Any marked tendency that tries to put itself beyond the pale, especially if it labels itself as marginal, is inviting this treatment.

In looking at the negative, the problem is of course how to avoid turning shock into schlock, for any form of represented or mediated horror is immediately absorbed as part of the culture industry. Fallen objects resist such assimilation in the brief time of their existence, but works of art in their travel through time cannot: the photographs in this book, then, must serve as mere illustrations, as evidence for an argument. As we have seen, photography tends to say the same thing over and over again: this is the way things are. Here photographs serve a more explicit purpose, being governed by their relationship to the text.[23] It is worth asking, though, what photography itself contributes.

In their presentation of sheer surface, trash and photography have a certain affinity for one another. Roland Barthes has written of the way Dutch still life concentrates on surface, on 'the secondary vibrations of appearance', particularly on sheen. Is this, asks Barthes, so as 'to lubricate man's gaze amid his domain, to facilitate his daily business among objects whose riddle is dissolved and which are no longer anything but easy surfaces?'[24] Here, at the origins of the capitalist world, is a type of painting which tries to make objects easier to handle and trade by glossing over them with the unitary brush of the aesthetic. In photography, as we have seen, surface is all, yet, in some occult fashion, it is supposed to give us access to some universal essence. With the representation of trash, however, things are a little different; here any sheen is not the product of some advertiser's skill, but is the gloss formed by a layer of liquid over the object, or of some corruption breaking its surface. In wet climes, at any rate, trash carries its own aura of dampness about it, as though it had bled evenly on to the pavement. It is in the process of breaking down surface and progressively revealing its insides until there is no longer a rigorous distinction between them. So where the surface of trash is expressive of the nature of the object and the processes which it undergoes, then photography can assume its superficial role without dissimulation or guilt.

Context is everything in the construction of critical meanings. Irving Penn made refined black and white platinum prints of pieces of trash which he had picked up and then shot in the studio against pristine white backgrounds. Torn from the company of the environment and their fellow objects, they lost the largest part of their significance. These isolated fragments were treated just like new commodities by this successful commercial photographer, becoming renewed as abstractions, and most of all revealed themselves as discrete objects and as prints for purchase. No photography, however, can avoid beginning to embark along this road of abstraction, if only through the selection, framing and disposing of objects within a pictorial configuration. Such a practice is bound up with modern and postmodern scrutiny of the street, with sniffing about in the place where some vestigial community might be found, in the hope of picking up some scent of significance, which may then be marketed to distinguish some product. This is especially true also of a photography which searches, isolates and to an extent fabricates meaning in the street. If context disappears, and all that is left is a typically masculine view of the urban environment, where a flaneur wanders, selecting fragments for aesthetic delectation, and understanding nothing of people's interactions or the fitting together of elements, then this is not accidental. The aesthetic appears only as functions shrivel, and the operation of commodity culture and all its products acts to sever people from one another, leaving the poorest to dwell among its discarded goods.

All this is not of course been to claim that there is some radical, popular power to littering. It is merely a symptom which may be activated by criticism. Photography acts as another layer of subject matter, a comment fixing and laid over what is temporarily there and what will continue to be transformed after the shutter blades have closed. It freezes the temporal unfolding of allegorical decay producing dialectics at a standstill, a snapshot of a conflicting process under way, revealing past, present and future. In its rarest and very best moments, photography may also indicate a point in the historical process where the tensions are greatest, the point of phase change.

As we have seen, Benjamin's angel flies backwards into the future, looking to the past as an ever greater pile of catastrophes mounts at its feet. Our life in the developed world, too, is a constant process of discarding, of consigning ever greater piles of material to waste, and with it, often all values which are not based on continuing this renewal and disposal, all sense of continuity. The grounds for criticism are literally in front of our eyes.I

Notes

1 William Gibson, *Count Zero*, London 1986, p. 26.
2 Karl Marx, *Grundrisse. Foundations of the Critique of Political Economy (Rough Draft)*, trans. Martin Nicolaus, Harmondsworth 1973, p. 91.
3 For a curious account of this process, and the way in which rubbish can eventually acquire a new kind of value as a non-disposable artefact, see Michael Thompson, *Rubbish Theory. The Creation and Destruction of Value*, Oxford 1979.
4 Theodor W. Adorno, 'The Curious Realist: On Siegfried Kracauer', *Notes to Literature*, ed. Rolf Tiedemann, trans. Shierry Weber Nicholsen, New York 1992, vol. II, p. 75.
5 Adorno, *Prisms*, trans. Samuel and Shierry Weber, Cambridge, Mass. 1981, p. 233.
6 Jürgen Habermas, 'Walter Benjmain: Consciousness-Raising or Rescuing Critique', in Gary Smith, ed., *On Walter Benjamin. Critical Essays and Recollections*, Cambridge, Mass. 1988, p. 99.
7 Paris, Centre National des Arts Plastiques/Prato, Museo d'Arte Contemporanea Luigi Pecci, *Un'altra obiettività/Another Objectivity*, curated by Jean François Chevrier and James Lingwood, Milan 1989, p. 57.
8 Mary Douglas, 'Purity and Danger', in Robert Bocock and Kenneth Thompson, *Religion and Ideology*, Manchester 1985, p. 111.
9 Theodor Adorno, Walter Benjamin, Ernst Bloch, Bertolt Brecht and Georg Lukács, *Aesthetics and Politics*, London 1980, p. 129.
10 Ibid., p. 136.
11 Douglas, 'Purity and Danger', p. 111.
12 Benjamin, 'The Author as Producer', in Andrew Arato and Eike Gebhardt, eds., *The Essential Frankfurt School Reader*, New York 1982, p. 262.
13 Benjamin, *Trauerspiel*, p. 186; cited and analysed by Charles Rosen, 'The Ruins of Walter Benjamin', in Gary Smith, ed., *On Walter Benjamin*, pp. 150–51.
14 Habermas, 'Walter Benjamin', p. 96.
15 Benjamin, *One Way Street and Other Writings*, trans. Edmund Jephcott and Kingsley Shorter, London 1979, pp. 52–3.
16 See Adorno, 'Is Art Lighthearted?', in *Notes to Literature*.
17 See Adorno, *Minima Moralia. Reflections from Damaged Life*, trans. E.F.N. Jephcott, London 1974, p. 68.

18 As discussed by Eagleton in *The Ideology of the Aesthetic*, Oxford 1990, p. 324.

19 Adorno, *Aesthetic Theory*, trans. C. Lenhardt, London 1984, pp. 148–9.

20 Adorno, *Minima Moralia*, p. 25.

21 See Adorno, *Negative Dialectics*, trans. E.B. Ashton, London 1973, pp. 5–6.

22 Eagleton, *The Ideology of the Aesthetic*, p. 372.

23 Benjamin's answer to the uncontrolled aestheticization of subject matter by photography was of course to unify it with writing, so controlling the context of each. Benjamin, 'The Author as Producer', in Arato and Gebhardt, eds., *The Essential Frankfurt School Reader*, p. 263.

24 Barthes, 'The World as Object', in Susan Sontag, ed., *A Barthes Reader*, London 1982, p. 64.

Christina Lindsay

FROM THE SHADOWS
Users as designers, producers, marketers, distributors and technical support

THE TRS-80 WAS INTRODUCED to the market by Radio Shack in August 1977. Although its name probably does not immediately, if at all, spring to mind today when thinking about personal computers, for 7 years the TRS-80 was at the forefront of home computing power. However, in 1984 Radio Shack ceased to upgrade the TRS-80 and changed it into a clone of the IBM personal computer, which had reached the market 3 years earlier. The TRS-80 vanished from the personal computer scene and, for some, became just one of the fond memories of the early days of home computing. The original intention of my research was to focus on the entire life history, albeit a short one, of this personal computer. The aim of the project was to examine how different ideas about the users were constructed by the developers and producers of this computer, and how these ideas both shaped and were shaped by the technology.

The twist in this tale came when I found that some people are still using this supposedly obsolete technology. Contrary to its perceived disappearance from mainstream personal computing, the TRS-80 has moved beyond obsolescence, emerging alive and well with a new lease on life. The designers, engineers, producers, marketers, advertisers, support staff, and software developers have long since moved on, leaving just some users and the TRS-80 itself. Almost 25 years after its first introduction, the TRS-80 is being kept alive and fully functional by some remaining users, who not only are further developing the technology, but are also defining their identities and constructing new ideas of what it means to be a user of the TRS-80.

Bringing this story full circle is the complex relationship of the current TRS-80 and its users to earlier TRS-80 users. Contemporary TRS-80 users define themselves as being in resonance with the computer hobbyists who first used the TRS-80 in the 1970s and in contrast to users of current personal computers. Ironically, this contemporary community is being kept alive primarily through e-mail communication and the Internet, neither of which can be accessed fully through the TRS-80.

This then is an account of the changing roles of users during the life history of one particular technology. The users in this particular story begin as somewhat stereotypically gendered representations constructed by the designers of the computer and end by becoming designers, producers, and retailers providing technical support for the technology and taking responsibility for its further development. In the process they also rework their own identities as computer users in relation to this technology. Throughout the life of the TRS-80, different representations of users have been constructed and negotiated, and have influenced its design and its use. The co-construction of users, user representations, and technology is not a static, one-time exercise by the designers of the TRS-80, but is a part of a dynamic ongoing process in which many different groups, including the users themselves, participate.

This chapter is thus a story in two parts. In the first part, I examine the "what, by whom, and how" of the co-construction of user representations and technology in the design, development, and marketing of the TRS-80 in the late 1970s. I have relied mainly on secondary data for this part of the case study, using resources both written and online about the history of the TRS-80 and early personal computers. The second part jumps ahead to the late 1990s and asks the same questions. Here, I used information from web sites run by current TRS-80 users. I also conducted extensive online interviews with 40 such users, some of whom have been using this computer since its introduction. The enthusiasm of these people for my interest in the TRS-80 was a rich source of stories and experiences.

User representations

The biography of the TRS-80 shows that it is not just the actual, real-life users who matter, but that ideas about the user—user representations—are just as important in the relationships between users and technology. The argument that the users are designed along with the technology is crucial to this discussion. Three frameworks have informed my research.

In their work looking at the creators of the personal computer, Thierry Bardini and August Horvath introduced the idea of the reflexive user (Bardini and Horvath 1995). By looking at the linkage between technical development and cultural representations, particularly those of the user, Bardini and Horvath asked how the creators of the personal computer at the Stanford Research Institute and at Xerox PARC in the 1970s envisioned the user, and how this influenced subsequent decisions made about technical options. They suggested that the innovators were the first users of the PC technology, and consequently defined the future users in their own image. The reflexive user is therefore the future "real" user in the minds of the developers, and this enables them to anticipate potential uses of the technology. This reflexive user, while influential in the early development of the technology, is shown to be a static, one-time view that is bound to disappear and to be replaced by the real user.

Steve Woolgar's work also looks at the development of a particular computer. He shows how the design and production of a new technological entity amounts to a process of configuring its user. This act of configuration involves defining the identity of putative users and the setting of constraints upon their likely future actions through the functional design of the physical artifact with a focus on how it can be used (Woolgar

1991). In effect, the new machine becomes its relationship with its configured users. Woolgar claims that, whereas insiders know the machine, users have a configured relationship with it, such that only certain forms of access and use are encouraged. For example, insiders or experts, unlike regular users, are able to take the back off the computer box and play around with the electronics inside. Woolgar's configured user is inextricably intertwined with the development, especially the testing phase, of the technology.

Madeleine Akrich (1992) introduced the idea of the projected user, created by the designers of technology. The projected users are defined with specific tastes, competencies, motives, aspirations, and political prejudices. The innovators then inscribe this vision or script about the world and about the users into the technical content of the object, and thus attempt to predetermine, or prescribe, the settings the users are asked to imagine for a particular piece of technology. The prediction about the user is thus built into, or scripted into, the technology. Akrich recognizes that the projected user is an imaginary user, and asks what happens when the projected user does not correspond to the actual user.

Each of these three frameworks presents the representation of the user as a one-time static view constructed by the developers of a technology in the design phase of its life cycle. Bardini and Horvath's framework of the reflexive user fails to recognize that the technology, its uses, and its users may change after introduction to the marketplace. Their ideas present a stationary picture in which the reflexive user is constructed by the developers and is then replaced by "real" users, who act as mere consumers of the technology with no role in shaping either the technology or their role as users. While his model is equally static, Woolgar, in saying that the new machine becomes its relationship with the configured users, draws attention to the importance of interactions between the users (in the testing phase) and the technology. However, he stops much too soon. While he argues that the design and production of a new entity amounts to a process of configuring the user, he does not study the actual use of the technology by these people, to understand whether the configuration process still continues. Like Bardini, Woolgar does not seem to consider that the user may play a role in shaping the uses of the technology. In both of these models, limited groups of people create these reflexive or configured users, and neither Bardini nor Woolgar consider that the reflexive or configured users may be created throughout the life history of a technology. Akrich's projected user is also constructed only by the designers of the technology.

I argue that there is much more to these imagined users than a static image constructed by one group sometime during the development phase of the technology's life history. I propose that "user representations" encompass many other imagined users, and that these user constructions are not built, and do not exist, in isolation. Each of the social groups involved with a technology throughout its life history, even those that are not directly involved, will have its own ideas about who and what the user is. My approach is to study the interplay of these various user representations, the ways in which the social groups use these constructions to reinforce or challenge their own ideas of the user, and how individuals' relationships to the technology are mediated by these ideas about the user.

The introduction of the TRS-80

In the 1970s, though the main sites of computer power were still in the mainframes and minicomputers found in corporations, in government, in universities, and in the military, computer power had begun to enter the home. Computers came into the household through the basements and the garages of computer hobbyists, usually young men, who frequently had knowledge of and experience with computers through their work sites. The early personal computers, such as the Altair 8800, were sold as kits and marketed as minicomputers for people who wanted their own computing power. It was possible for individuals to have their own personal computers if they were able to assemble the many pieces of electronics that came in the computer kits and make them all work. Doing this required some specific hobbyist skills, and much persistence and perseverance. It was into this "hacker" culture (in the original sense of the word as "hobbyist" or "enthusiast") that Radio Shack introduced the TRS-80.

Under the umbrella of the Tandy Corporation, Radio Shack, with its origins in "ham" radio, was a major retailer of consumer electronics. Between June 1975 and June 1976, Radio Shack opened 1,200 outlets in the United States and Canada, bringing the number of North American outlets to 4,599, and the number worldwide to 5,154. Radio Shack did not sell off-the-shelf consumer electronics such as televisions and radios, but instead served as a hobbyist store.

In this period, one of Radio Shack's biggest markets was for Citizens' Band (CB) radio (Farman 1992). Although Radio Shack brought the very first 40-channel CB radio to the marketplace in January 1977, the company feared that the CB radio boom might be coming to an end. Many other companies were flooding the market with similar gear. To stay competitive, Radio Shack decided to develop new products. To this end, the company concentrated on developing a new line of calculators, because "they were kind of the latest thing" (ibid.: 400). Some of the people on the development teams enjoyed the hobbyist activity of putting together "computer parts jigsaw puzzles." At the instigation of these people, Radio Shack initiated a half-hearted project to look at developing its own computer kit. Steve Leininger, recruited from National Semiconductor to lead the project, decided to take a risk and worked to develop a ready-wired complete system, a computer that would not need much putting together by the user. This was a new idea. At the time, home computers were available only in kit form. The computer that was developed was called the TRS-80—T for Tandy, R for Radio Shack, and 80 for the Zilog Z-80 microprocessor.

The TRS-80 was developed without a long-range plan. Charles Tandy, the CEO of the company, was somewhat reluctant to support the project. "A computer!" Tandy blared. "Who needs a computer?" (Farman 1992: 404) One of the reasons for Tandy's skepticism was that the development group envisioned the new computer selling for $500–$600, and Radio Shack had never sold anything that expensive. Indeed, Radio Shack's median sales ticket at this time was just $29.95. The members of the development group admitted that there were no existing customers for the new device and that it was virtually impossible to identify buyers. They had designed the computer for hobbyists like themselves.

Engineers' designing for themselves, in effect considering themselves to be representatives of the future users, is not uncommon. Such engineers are reflexive users (Bardini and Horvath 1995). In this method of constructing user representations,

which Akrich named the "I-methodology," the personal experiences of the designers (in this case, the engineers) are used to make statements on behalf of the future users. Already, however, these ideas about the users do not directly correspond to the developers' ideas. The TRS-80 was designed so that its few components would require less skill to put together than the computers in kit form already available and used by the design engineers.

The TRS-80 was formally introduced at a press conference in August 1977 in New York. For $599.95 the buyer got a 1.77-megahertz processor with 4 kilobytes of storage, a black-and-white visual display unit, a keyboard, and a cassette tape player, which was used to store the programs and the data.[1] There was also an operating system and a very limited selection of software, including games, educational programs for teaching multiplication and subtraction, and conversion tables. Basic was the programming language used; it had been licensed from Bill Gates for a one-time fee. For people who could not afford the complete computer, the processor alone was available for $399.

After developing the TRS-80 for users who were conceived of as being similar to the developers, Radio Shack sought to explain its computer to two existing groups they felt might be interested. The first group, targeted through post and computer mailings, consisted of existing Radio Shack customers, described as "the guy that's gonna put up his own antenna, the guy that's gonna repair his own telephone, the guy that's gonna fix his own hi-fi" (Farman 1992: 143). A spokesperson at the time stated: "We thought we had a good product that was of interest to the traditional Radio Shack customer, and at $600 we hoped we could sell it" (ibid.: 410). Even though one of the main features of the TRS-80 was that it was not in kit form, the user representation was linked to the consumer electronics do-it-yourselfers who were already Radio Shack customers. The second group consisted of current computer enthusiasts and hobbyists. These were reached through advertisements in *Byte* magazine, with its focus on the hobbyist computer market in which the users built personal computers from kits. *Byte*'s articles were "written by individuals who are applying personal systems or who have knowledge which will prove useful to our readers" (*Byte* 2, 1977, October). It was anticipated that members of this second group would transfer their interest in computers, along with their skills in building them, to the TRS-80.

This process of recruiting new user groups can be likened to Woolgar's concept of replacing the configured user with the actual user. The original representation of the users had been expanded. In this way, knowledge of users of existing consumer electronics technologies were added to ideas about who the users of the TRS-80 would be. However, the skills and interests of the people in the two new groups still closely matched those of the engineers.

The envisioned users of the TRS-80 would then be members of the early hacker culture—people who had not only an existing interest in electronics, but also the skills and knowledge to put together their own machines. These computer hobbyists were usually young and male, with an extensive knowledge of electronics or computers obtained from work experience or from previous hobbies. Such users wanted their own computing power. They were in general not the businessmen anticipated by Charles Tandy as the initial users of the TRS-80. In its 1977 annual report, the Tandy Corporation had stated: "The market we foresee is businesses, schools, services and hobbyists. The market others foresee is 'in-home'—computers used for recipes, income tax, games, etc. We think home use is a later generation happening." The original aim had

been to make computers available to a lot of people, "especially businessmen who have never had a chance, that could not afford a computer" (Farman 1992: 419).

The contradictions in the user representations are more obvious in the initial print advertisement for the TRS-80, which appeared in October 1977. This advertisement makes the representation and the role of the users more apparent by depicting the TRS-80 in its intended environment of use. The computer had been moved both literally and figuratively out of the basement or garage of the computer hobbyists and into the home, specifically the kitchen.

The advertisement shows a man seated at a kitchen table using the computer while a woman looks on, smiling. These are the projected users (Akrich 1992) made visible, with their tastes, competencies, and motives described through pictures and text. While the user is still conceived to be a man, he is neither a young hobbyist nor working in a business environment. The gendered messages of this ad are complex. Bringing the computer into the household suggests that it is now a domestic technology. However, placing it in the kitchen, traditionally the woman's domain raises the question of whether it was to be seen as a "white goods," like the stove and the refrigerator, or as a leisure appliance such as the television and stereo (Cockburn and Ormrod 1993). Was the personal computer to be just another home appliance, such as the toaster or the stove, to be used by women? Apparently not. The ad shows a man, presumably the man of the house, happily using the computer while the woman stands at the counter, smiling at him. Bringing the computer into the kitchen does not necessarily position it as a technology that would, or should, be used by women. The users of such computers would still be men, but now the computer's use would fit comfortably into the household chores.

In the move from the basement and the garage into the living space of the home, the personal computer began to be marketed as a tool for household management tasks, as well as a hobbyist machine for the writing of programs. However, the constructed user of the new technology was always male, and implicitly knowledgeable concerning the technology's construction and use. Although most subsequent TRS-80 advertisements were not explicitly gendered (in fact, there were no people in the adverts at all), the extensive computer skills and knowledge required to be a TRS-80 user were still possessed mainly by men. The TRS-80 was advertised as "a system ready for you to plug in and use." "Program it to handle . . ." was the opening phrase of the next sentence. In fact, the TRS-80 was not as easy to put together and keep running as the advertisement suggested, and some hands-on craft skills, other than programming, were needed. The machine was introduced into a climate of hobbyist enthusiasms and skills. Although it did not come in kit form, the various components had to be linked together, presuming at least a familiarity with consumer electronics and the requisite assembly skills.

The user representations displayed in the ad were textually supported by a list of possible uses for the TRS-80. Most of the uses concerned control of the household, but some related directly to tasks associated with the kitchen and food preparation. The uses suggested in the original press release concerned household tasks, including personal financial management, learning, games, and (with the addition of an external device controller) future control of the operation of appliances, security systems, and the monitoring of a home weather station.[2] There were quite a few suggested uses given for the kitchen, including storing recipes, keeping a running inventory of groceries, menu planning, and adapting recipes for larger or smaller servings.[3]

The design and development of the TRS-80 is thus a story of "technology push" in which engineers and businesspeople searched for a new market for a new technology. In developing the TRS-80 explicitly for people like themselves, the engineers provide a wonderful illustration of Bardini and Horvath's "reflexive users" and of Akrich's "I-methodology" of product development. But soon other user representations were developed. Charles Tandy envisioned a business user. Other ideas about who the user might be came from Radio Shack's experience and knowledge with other technologies. Current Radio Shack consumer electronics customers would have the knowledge and skills needed to assemble the computer, and readers of *Byte* would have an interest in home computing and also an interest in, if not the skill to build, home computers. The different uses listed for the computer, such as business software and household applications, also contributed to the different representations of the user.

Mediators

After the introduction of the TRS-80, other groups became involved in constructing who the user was or could be. Of particular interest are the groups that served as mediators between the technological and the social realms—those who, in effect, explained the technology to the user.

One such group consisted of computer magazine writers who reviewed and evaluated the TRS-80 for readers. User representations were developed in two ways, the first of which was again a reflection of their knowledge about users of related technologies, such as kit computers. In this case, users would apply their considerable interests and skills acquired from kit computers to the more ready-to-use TRS-80. User representations were further developed by a comparison of TRS-80 users to those of a similar personal computer, the Apple II. By focusing on the differences between the two computers, writers were able to reflect on the interests and the skills of the relevant users. Many of these product reviews compared the TRS-80 with the Apple II. Although both computers were considered "high-end," the reviewers established a distinction between the users of the two computers built around the skills needed to use each machine. The Apple II was an all-in-one machine that did not have to be assembled, and it was marketed as a home computer for which the user did not need prior specialized knowledge. The relatively high price of the Apple II served to further distinguish the two kinds of users. One of the current TRS-80 users interviewed (Bathory-Kitsz) expressed the view that the "TRS-80 was always kind of the people's computer and the Apple was the elite's computer."

Ideas about who the users could be, or would be, began to change with the success of the TRS-80. Another important group of mediators were the writers of technology columns and articles in computer magazines. While not directly evaluating the TRS-80, they often provided help and offered information about how to deal with problems with the computer. They published the source code of programs for various kinds of new applications, and they effectively served as co-producers of the technology.

These writers not only began to develop a new role for themselves as TRS-80 users in providing help as part of their job, but also were instrumental in changing ideas about who the users could be. Their work provided a new avenue of assistance for TRS-80 users, who now did not have to be individually knowledgeable about all aspects of the

computer and did not have to be limited to the few programs that were available. Of course, a user still had to be able to program the computer! The representation was of a user who could draw on other resources. This was very important to the success a person might have in using the TRS-80. The Tandy Corporation did not provide much service support for its computer, and the knowledge of the salespeople in the Radio Shack stores was very limited. The user as originally envisioned by Radio Shack was someone who had all the knowledge necessary to build and use the computer, and also to trouble-shoot any problems that might arise. Technical articles in computer magazines were the first step to reducing the amount of knowledge an individual user needed.

The TRS-80 users themselves were instrumental in continuing to change the idea of who could be a successful user, and the formation of support groups turned out to be an important influence. Special-interest groups formed to provide support and advice for TRS-80 users formed all over the United States. Most of these groups held monthly meetings and produced newsletters.

To talk about users as co-producers of the TRS-80 may seem an over-statement. But to become a successful user of this early personal computer, one had to actively put together the machine and to type already-written programs into it—no easy task when just one incorrect letter or number could cause havoc. Thus a dichotomy between developers and users is not useful here, as there is a third group, the expert users. To use the TRS-80 successfully, the user had to open it up and then wire in the selected peripherals.

If co-production is considered as not just using the technology, but as taking the development of the technology further, then the TRS-80 users became very active co-producers. They did this by developing software programs that they then exchanged among the support groups. In addition, some attempts were made, primarily through advertisements in computer magazines, to set up software exchanges of user-written programs. This fits in with the prevailing "homebrew" ideology of the hacker culture into which the TRS-80 was introduced.

By November 1978, a further new user representation had developed. Some of the early users, in addition to becoming co-producers of the TRS-80 technology through their hobbyist activities, had begun to make a commercial business of it. Both individuals and businesses began to advertise software for sale. For example, a software company called Micro Systems Service advertised "dial-a-program." Using a toll-free number, the caller could have programs for the TRS-80 transmitted over the phone line. The data was received using a standard home phone pickup onto audiocassette tape. While inventive, this method was not successful because the programs could not be transmitted reliably (*Byte* 2, 1977, September). Another software development company advertised a TRS-80 programming contest. Thus a picture of a different user emerged: one who used the TRS-80 for the commercial business of producing and selling TRS-80 materials.

More details can be added to the changing picture of the user by studying the classified ads in *Byte*. In the June 1978 issue, the first advertisement appeared for the sale of a TRS-80. The computer was still in its wrapping, and its owner was moving up to a more powerful system. Numerous such advertisements appeared over the next few years in *Byte* and other computing magazines. The TRS-80 user was now perceived as no longer being satisfied with the performance of the original Model I.

Different types of users were identified, differentiated by what they would want to use the TRS-80 for and by the power it would have. The TRS-80 would now have a role in the business world as well as at home. The Radio Shack developers came back into the picture, introducing different levels of Tandy machines for different types of user needs. These included the Model II, a "small-business computer for people who like to pay less than the 'going price'" (*Byte* 4, 1979, October), and also a new level of Basic with advanced features, including full editing and integer arithmetic. The developers were now explicitly distinguishing between home users and businesspeople.

In tracing the path of the TRS-80 from the developers to the user, I have illustrated different representations of who the users were or could be. The initial representations of the user were changed by the different groups who became involved with the TRS-80 and with changes to the technology itself—whether those changes were made by Radio Shack in producing new models or by the users who wrote software for the computer. Representations of the users were developed in various ways, including the initial I-methodology of the developers, the anticipated transference of interests and skills from users of similar or related technologies, and the intervention of the users who developed new roles for and expectations of future users. One of the most significant changes in the user representation was from the TRS-80 user as an individual knowledgeable about, and skilled in, the DIY aspects of consumer electronics to a user who could be less knowledgeable and could obtain support and knowledge from a TRS-80 community, either through reading computer magazines or through joining a computer club. The mediating groups and the users became co-producers both of the technology of the TRS-80 and of the user representations that were constructed.

The TRS-80 had a shorter commercial life span than the Apple II or the IBM personal computer (introduced in 1981). For a few years, the TRS-80 was at the forefront of the home computing market and was considered to be a sales leader (Levering, Katz, and Moskowitz 1984). The TRS-80 Color Computer, one of the first computers capable of displaying color, was introduced in 1980. It had nothing in common with the original TRS-80. It provided color capability at a low price, and there was nothing else like it on the market at the time. The Welsh Dragon computer, introduced in 1982, was the first clone of the TRS-80. In 1983, Radio Shack introduced a portable version of the TRS-80.

By 1984, Radio Shack had stopped introducing new models and had turned the TRS-80 into a clone of the IBM PC. The TRS-80, in its original form, subsequently vanished from mainstream personal computing, and the Apple, the IBM PC, and the Macintosh became the personal computers of choice.

Obsolescence

The story now turns to the late 1990s (23 years after the TRS-80 was introduced to the public) and moves beyond the standard technological life trajectory of "design to use" to consider obsolescence. It is in this period of perceived obsolescence that the biography of the TRS-80 takes an interesting turn.

Some people today are still using their old TRS-80 computers. The producers, advertisers, support staff, commercial TRS-80 software developers and salespeople have long since vanished, leaving behind the users and the artifacts of the TRS-80 itself. The focus of this part of the research is thus only on the current users of the TRS-80. As

there are only a small number of such users, it is possible to focus not only on user representations but also on the actual users themselves. As the only group left in the story, the users are active in constructing their own identities and in maintaining and further developing the technology. For this part of the research, I interviewed 40 of these current users, all men. In what turned out to be a paradoxical element to the story, and one that I'll address in detail later, I found these people by searching for "TRS-80" on the World Wide Web.

I was unable to find a female user of the TRS-80. This is more disappointing than surprising, as technology, in general, has been shown by researchers to be a masculine culture.[4] Men's "love affair with technology" (Oldenziel 1997), both in childhood and in adulthood, reflects an experience of technology as fun. Computer culture continues this masculine association (Haddon 1992; Turkle 1984). The cultural context of computers has been gendered masculine with respect to intellectual strength and abstract thinking, two skills associated with men rather than with women (Lie 1996). There may also be an element of fear: women may be reluctant to become involved with a tool they see as threatening (Turkle 1988). This is amplified within the computer hacker culture, with its image of hackers as young technology-focused men without social skills (Haddon 1988; Hafner and Markoff 1991; Turkle 1984). While there are women hackers on the World Wide Web (Gilboa 1996), the hacking skills needed for the TRS-80 are not only the skills to write programs but also the hands-on ability to manipulate the hardware components of the computer.

The co-construction of users and technology in current TRS-80 culture is very clear, the difference being that now it is only the users who are involved. This raises the question of whether it is felicitous to continue to talk about user representations when it is now possible to talk to the users themselves and to obtain their self-descriptions. Can these self-descriptions or subjective identities (Cockburn and Ormrod 1993) be considered user representations? I would argue that, insofar as these ideas about the current users still continue to influence who can or should be using the TRS-80 and how it is to be used, they have a useful purpose in a public forum as user representations. In addition, the relationship of current user representations to those of the past became an important element in the contemporary relationships of users with the TRS-80.

The TRS-80 users today

The first step in examining the current co-construction of users and the TRS-80 is to introduce the users and to examine why and for what they are continuing to use the TRS-80. These people's constructions of their own identities as computer users are tied inextricably to the TRS-80 and to current personal computers and also to past ideas about computer users as hackers. By examining these identities, or representations, we can understand how the users construct their own identities with respect to the technology and how they are changing the technology in relationship to those identities.

Many of the TRS-80 users I interviewed were either engineers or had obtained technological skills and knowledge from childhood, whether at home or at school. Several of the interviewees cited working with other members of their family as their introduction to the world of building things. The gendered relationships of children with technology have been well researched. From model cars (Oldenziel 1997) to robots

(Faulkner 2001), building things as a hobby has been shown to be primarily a mascu-line pursuit. In general, parents tend to encourage boys more than girls to play with technology, and so to acquire manual and problem-solving skills (Millard 1997). This early exposure to technology often leads to a familiarity with technology that many boys carry forward to later life, whether in the careers they choose or in their leisure pursuits (Berner and Mellström 1997).

The initial involvement of the interviewees with the TRS-80 was often through exposure to computers at high school, university or graduate school. In addition, many of the users worked in computers already, or were professionals in the computing indus-try. Two of the respondents specifically worked on and used arcade game machines and were able to transfer their skills and interests to the TRS-80. Several of the users worked for Radio Shack or Tandy, and learned of the TRS-80 when it came into the Radio Shack retail stores. Several people mentioned linking childhood pursuits to adult experiences. "Toys for boys" was a theme throughout some of these early exposures to the TRS-80, with one interviewee stating that his father gave him the choice of getting a speedboat or a computer.

Many users continue to use their TRS-80s because they meet their current needs. One user stated that his TRS-80 boots up faster than his three well-equipped PCs with Windows. TRS-80s are still sometimes used for word processing and text manipula-tion. For one user, these computers are the only ones he uses. He has one at home and another in his office and uses them for all his home and business word processing needs. Another user wrote his doctoral dissertation (on technology ethics and public policy) using his TRS-80. Some other users are still writing game programs for the TRS-80 and distributing them as freeware. One enthusiastic radio amateur uses his computer to send and receive Morse code on the amateur bands.

Time and the new users

Central to the relationships of the current users and the TRS-80 of today is the concept of time—more accurately, the two periods of time detailed in this case study. The iden-tities of the current TRS-80 users were constructed in relation to the identities of com-puter users not only in the past but also in the present. Likewise, the relationships of these people with the TRS-80 were linked both to the TRS-80 of the past and to cur-rent personal computer technologies. Thus, this is not a straightforward story of the co-construction of users and technology; it is made complex by linkages across time.

The current identities of the TRS-80 users were constructed through processes of aligning or identifying themselves with certain groups and differentiating themselves from others. Both of these processes were to be found within the explicit links made to past TRS-80 user representations.

The current TRS-80 users who responded to my questions identified and labeled themselves in various ways. The term "tinkerer" was used by several people, referring to either or both of hardware or software tinkering. This label resonates with the hacker culture into which the TRS-80 was first introduced. One user alluded to the specialist knowledge of the TRS-80 users when he stated that "the TRS-80s are perhaps remem-bered in a kinder light because the community that used these machines were not your typical home user awash in myths."

A process of differentiation concerning skills and knowledge was used by these current users to distinguish themselves from the developers of the TRS-80. Many of the users identified themselves as critics of Radio Shack's technical, marketing, and service support. They claimed to have more knowledge and skills than that available from the company. Even people who had worked in the technology support area of Radio Shack acknowledged the lack of adequate technical help.

The self-identities of the current TRS-80 users in relation to computer users of today were established primarily through a process of differentiation from other computer groups. TRS-80 users did not consider themselves to be the same as the run-of-the-mill computer users of today. Echoing Woolgar's idea that configuring the user is an act of drawing boundaries between the inside and the outside of the machine, one user labeled himself a programmer and not an end user, thereby aligning himself with those who knew the workings of the computer and were active in using and expanding it rather than with the users who "just" used the machine. Along these lines, another user stated that he was a marketer of software previously written by himself, and two others were publishers of TRS-80 magazines.

These people also differentiated themselves from the programmers of today's personal computers. Some of the TRS-80 users were there when you had to do "more with less" of the technology, and learned to use these same skills on today's computers. One interviewee stated:

> Today's programmers are not the same caliber of people we had in my day. Today's software is large and fat and wastes huge amounts of memory, CPU and disks for very little benefit. . . . You sit there saying "I've got a machine 100 times faster [than the TRS-80], with 100 times more memory, and 10,000 times more disk and IT'S SLOWER." It makes you wonder what today's programmers know.

This interviewee was using his knowledge of the TRS-80 to construct an identity of a "real programmer" that set him apart from today's programmers, and even further from today's end users. He was not alone in this. Many of the respondents stated that using the TRS-80 allows them to get at the "guts" of the machine and the code, reinforcing their self-identity as tinkerers, hardware hackers, and hobbyists.

In all of the boundary drawing being performed here by the TRS-80 users—between themselves, end users, Tandy, and today's programmers—their construction of their own identities as computer users was invariably attached to the artifact of the TRS-80, and they were also aligning themselves with and declaring their affinity for past periods of computing. They were qualifying their labels as "users" and "programmers" by attaching the label "TRS-80," and bringing along all that is associated with that computer. They were resisting being associated with the users and programmers of current PC technologies, and in doing so were trying to keep alive their virtuosity as technically oriented people. This user identity implies that greater skills and knowledge are needed to use the TRS-80 computer than are needed for today's machines. In effect, it implies that programmers and users from the past can easily use the current technology, but that the programmers and users of today would not have survived in the personal computing world of the late 1970s.

The user identities constructed by the current TRS-80 users strongly echo the user

representations that developed along with the technology. Even the terms "tinkerer" and "hacker" link them directly back to the "homebrew" computer culture of the late 1970s. Indeed, many of the contemporary TRS-80 enthusiasts I interviewed were there at the beginning. However, their identities as computer users were linked more closely with the past than just possessing a sense of history.

Simplicity and reliability of use

Why are the identities articulated by users important to the present TRS-80 community? I posed this question explicitly to my respondents. Many of the answers I received concerned the effectiveness of the TRS-80 as a piece of technology, especially when compared with present-day personal computers, particularly with respect to simplicity, reliability, and cost.

One TRS-80 user identified himself as a "neo-Luddite" and stated that he used his old computer as it was simpler than those of today. Many other users echoed this sentiment. However, this is not the limited simplicity of ease of use; rather, it is a simplicity that can only be appreciated by people who have the skills and knowledge to work within the computer's limitations and the rudimentary programming that it allowed. Some comments emphasized this point:

> No finicky complex OS, no bloated applications, no oddball device drivers, NO SEGMENTED MEMORY ARCHITECTURE, no pointy-clicky, no icons, no GUI—just get up and go computing. Anywhere. The OS [operating system] was simple. . . . It didn't have all that security crap. The lack of CPU power is actually a blessing since there is no time for kludges.

In the language used here ("pointy-clicky," "GUI" (graphical user interface), "security crap"), the desire for simplicity served as a rejection of the user-friendly additions to personal computer systems associated in the main with Macintosh computers and with making the computer accessible to all levels of users. Simplicity can also mean speed. One user remarked that he uses his TRS-80 "to run very simple programs that aren't worth firing up the PC for."

Along with this simplicity comes reliability:

> [The TRS-80 is] simple, extremely reliable, runs on regular AA batteries and is quite quiet in the library.

One user wanted a TRS-80 Model I to do his business mailing labels:

> . . . as long as you feed the labels to the old dot matrix printer, the old computer and the old printer will "chug along" all day and all night with little or no assistance from individuals who can as well be doing something better.

In addition to simplicity and reliability, several users cited cost as a factor. One said:

This is important because I am a neo-Luddite and do not wish to contribute to the useless and wasteful faddishness that has been going on for some time now.

Another expressed a view held by several other users:

All of the ports . . . come with the motherboard—[you] don't have to spend thousands of dollars buying boards and some Mickey Mouse software to run it.

Nostalgia

The most-cited reason for continuing to use the TRS-80 once again linked the past and the present; it also served to underscore the relationships between users, user representations, and the technology. Practicalities of use, reliability, and cost aside, one of the primary reasons that people were still using their TRS-80 machines was nostalgia. This was more than just wishing for a time of (depending upon one's viewpoint) less or more complex computing. However, there was an element of fond remembering of people's introduction to the computing world. "These were our first computers," said one user. "We loved them." Another user was rebuilding his system "just for old times' sake." But this nostalgia also included an element of exploration. Many of the users I interviewed portrayed the TRS-80 user as a hacker who had been at the frontier of personal computing in the 1970s and who was now at the frontier of the physical boundary of the artifact of the personal computer. Unlike users of current PC technologies, these current TRS-80 users were able to cross this physical boundary and to manipulate their machines:

These days computers have been reduced to pre-packaged consumer tools, and that aspect of exploration is out of reach of many potential hobbyists.
Some of us stick with it (in addition to the modern powerful machines) because it is fun to experiment with, or just out of nostalgia, like pipe organs or pinball machines.

The nostalgia also included a sense of fun:

It's fun to see if I can still remember how to program the old dinosaurs. . . . I am reminded that, once upon a time, 64K of memory was a lot of space, and you could have an entire operating system on one 360K floppy disk.

A major part of the fun was in being able to cross successfully the physical boundary between the user and the computer:

They're fun. Today's machines have taken all the fun out of hardware and software hacking; like "tinkering"; taking it apart and putting new pieces in to see if I can get it to run better.
You can get inside and tinker.

The pleasure that men take in technology, from the hands-on tinkering with the hardware or the cognitive analytical problem solving of programming has been noted for other technologies, such as software engineering and robot building (Faulkner 2001).

One particular result of this nostalgia was to explicitly and purposefully link the past with the present. There was also a historical and educational aspect to this nostalgia—a desire to show people who were not involved in early personal computing what it was all about. Some of the current users took their TRS-80s to computer shows, especially vintage computer shows. This was not done to show people how small and slow the machines were; some users treated these forums as opportunities to instruct the public on how programmers were able to "do more with less"—less computer memory, less speed, less "user-friendly" computing languages, less help from computer companies and less experience. This served to reinforce the identity of such TRS-80 users as tinkerers, both in the heyday of the TRS-80 and now in their continued ability to use the machine:

> A very very high percentage of all owners learned to program to at least a small degree. Practically no one who buys a PC ever learns to write programs on it.

Resistance

For some users, nostalgia for the good old days in which TRS-80 users did "more with less" went beyond identity construction and beyond merely differentiating themselves as TRS-80 programmers as distinct from "end users" and from the programmers of today's computers. Instructing people in how the TRS-80 was used signified a form of explicit resistance. One user, who was engaged in a personal project of documenting the development of the operating systems of the TRS-80, stated:

> What I want to record for future generations is what REAL programming looks like. . . . I want to tell people that just because Microsoft does things one way, that doesn't mean that it's the ONLY way to do things. Here's another way. Here's why this way is *better*. Perhaps you should question why you do things their way.

Thus, the TRS-80 users constructed their identities through relationships with the users representations and technologies of both the past and the present, forging links between the two times and the different computer cultures. These users' representations of their own identities as computer users were similar to the original conception of the users when the TRS-80 was introduced. The past and present ideas about the users are centered around the TRS-80 and are linked by an emphasis on skills, knowledge, and technical competence. However, as the only group left in relationship to the TRS-80, the current users not only constructed their own identities as computer users, but also moved from co-producers of the technology to assuming fully the responsibility of maintaining and developing the TRS-80. The role of the user has become one of designer, developer, marketer, and technical support.

One link between the time periods is the desire of the present users to improve the

artifacts of the past. The users have improved on the original technology by actively changing the TRS-80. In light of the poor technical support from Tandy, TRS-80 users have always had a history of "tweaking" their computers and solving their own problems. However, in later years, after Tandy dropped all support, the users gradually took over that role, fixing the last few operating system bugs and writing new programs: "The machine is very close to twice as fast as when Tandy sold it . . ." Left to their own devices, the users have continued to shape and improve the physical artifact and also to develop new technologies which continue to enable the current use of the TRS-80.

In an interesting twist, and bringing the past directly into the present, some users have developed emulators. These are software programs that run on computers, other than the TRS-80, and which make that computer behave as the TRS-80 did. The emulators form yet another link between the old computers and current hardware. One user even runs a TRS-80 emulator on his Pentium computer! The original push behind the development of such emulators was to access data produced when using the TRS-80 that could not be loaded onto today's PCs. Some of today's emulators are very accurate and, according to one interviewee, "replicate the look and feel of those wonderful old machines." In keeping with the hacker culture's emphasis on mutual support and free software, the TRS-80 users worked together to adopt a standard format for the emulated floppy disks—"and that," said one user, "means that anyone can trade all their old floppies with everyone else."

Emulators are not the only link between the 20-year-old TRS-80 technology and modern personal computing. In a direct relationship between the early days and now, one of the popular current uses of the TRS-80 computer is for e-mail and to access the Internet, though only textual and graphical information can be obtained.

However, the linking of the TRS-80 to the Internet and to state-of-the-art PCs raises interesting questions about the relationships between the old and the new technologies here, and about any dependencies between them. One enthusiastic user of the TRS-80 stated:

> The TRS-80 community is experiencing a rebirth and emulators are a large part of the reason why. The Internet being the other. . . . The Internet is almost single-handedly responsible for the rebirth of the TRS-80 community. It is how we found each other again, and how we trade information amongst ourselves. The real glue is e-mail. That's actually where most things are actually going on. We're pretty much in constant contact with each other, exchanging news, making more contacts, and working out plans for the future.

The TRS-80 has taken on a new lease of life on Internet and the World Wide Web. There are newsgroups in which information is exchanged and problems posted and solved; there are personal web pages, which include offers of software and operating system "patches" and fixes; there are web advertising emulators and software for sale, and advertisements about buying and selling these computers; as well as e-mail and mailing lists, information is disseminated through at least one online publication; there are computer history web pages and virtual museums online, in which people display pictures of their home computer collections.

The Internet plays a large, if not an essential, role in keeping the TRS-80 alive and

well. This is paradoxical in that current computer technologies—the very technologies from which the TRS-80 users are careful to dissociate themselves—are an essential means for their continuation.

A few TRS-80 support groups still meet "in real life." The Nybblers meet monthly in Hayward, California. And there is an annual Vintage Computer Festival, also in California; its mission is "to promote the preservation of 'obsolete' computers by offering attendees a chance to experience the technologies, people and stories that embody the remarkable tale of the computer revolution" (Ismail 1998).

Time is therefore an important element in the complexity of the co-construction of users and technology. The subjective identities of the TRS-80 users are linked to both technologies and user representations simultaneously in the past and in the present, and the TRS-80 world continues to be a masculine culture. This story is somewhat paradoxical in that the users have constructed their identities as TRS-80 users in a large part by aligning themselves with the past and by differentiating themselves from current personal computer users. However, these TRS-80 users need these very same technologies for the communication and community that support the continued maintenance and future development of the TRS-80.

Conclusion

I learned three valuable lessons from my case study. The first is that user representations are dynamically constructed by different groups, including the users themselves, and by using different methods throughout the whole life history of the technology. The users I interviewed were, and still are, very active in the co-construction of their own identities and the TRS-80, and have taken on the many roles of developers, producers, retailers, advertisers, publishers, and technical support staff.

The second lesson is that there is a complex relationship between user representations and technologies of the past and those of the present. The relationship between the two time periods examined here is not linear and unidirectional, but exists in both directions and continues to be both interdependent and iterative. Studying the entire life history (or at least all of it so far), rather than just the design or use of a technology, enabled me to see these linkages across time.

The third and final lesson is that the disappearance of a technology from mainstream public view is not necessarily the end of that technology's life. Just because a technology is no longer being produced or sold does not mean that it is no longer being used or even, as in the case of the TRS-80, developed further. The disappearance of everyone except the users may, in fact, mean that the technology has been given a new lease of life through the skills, knowledge, interest, and expertise of those people previously considered and constructed to be just the recipients of the technology.

Notes

1 A home television set could be used in place of the visual display unit. The programs and the data were both stored on audio cassette tapes.

2 The movement of the home computer from the garage to the kitchen, implied by its

suggested use in food preparation, is similar to the initial advertisement for the Apple II, introduced at the same time as the TRS-80. The text of the Apple advertisement reads: "Clear the kitchen table. Bring in the color television. Plug in your new Apple II and connect to any standard cassette recorder/player. . . . Only Apple II makes it this easy." (*Byte*, August 1977) However, the Apple II was much more expensive than the TRS-80, and was claimed to be the first "all in one" computer that did not require any special skills to put together.

3 All this with 4 kilobytes of storage, Basic as the programming language, and hardly any available computer programs.

4 For a good introduction to studies on the masculine culture of technology, see Wajcman 1991.

PART VII

Object Lessons

AIBO

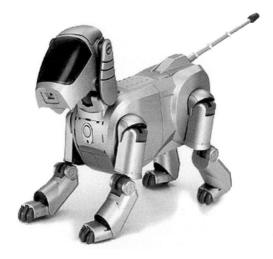

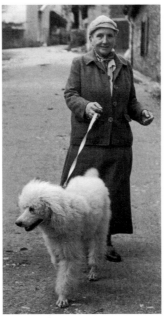

I am I because my little dog knows me.
Gertrude Stein, 'Identity' in *The Geographical History of America,
or the Relation of Human Nature to the Human Mind* (1936)

Gertrude Stein's dynasty of standard poodles were identity carriers; conferring identity with wagging acknowledgement and recognition: *caninus ergo sum*. Stein was a serial poodle-ist: she replaced her first white standard poodle, Basket, with a second white

standard, Basket II. After the second dog's demise, she acquired a third, Basket III. Stein, whose prose style famously relied on repetition, repeated the selection of her canine others on the basis of their similarity in breed and conformation. Dog breeders rely on the technologies of genetic-engineering in order to repeat certain features, eliminate others, and to insure the predictability and uniformity of a breed. If her "little dog" was always a poodle, Gertrude Stein knew who she was.

The *canine familiaris* has long served as an identificatory vessel, a four-legged companion embodying our projections of who we think we are. Dogs, too, may constitute their identities in a canine model of the mirror phase. The canine "grin," in which a dog's lips are pulled back, exposing its teeth, has only been found in dogs that have been raised with humans. As we gaze into those dog eyes looking back at us, we are drawn into the full-tangle of counter-transference: What are they thinking? Who do they think we are? But if my little dog is a robot, who am I?

For centuries, humans have been compelled to build simulacra that emulate human and animal behavior. The list is long: from the Greek myth of Pygmalion and Galatea to the ancient automata in China and Greece, to Descartes's mid-17th-century companion female automaton; Jacques de Vaucanson's duck (1740) that would eat, quack, flap its wings, and defecate; Swiss clockmaker Pierre Jaquet-Droz's writing automaton (1772) who could write: 'cogito ergo sum' and 'we are androids'; Thomas Edison's robotic female talking doll (1890); Philip K. Dick's *Do Androids Dream of Electric Sheep?* written in 1968, set in 1992. Automata have thus teetered on the brink of anthropomorphism or zoomorphism, testing the definition of sentience, posing the question: "can machines think?"

In 1999 the Sony Corporation launched AIBO, a four-legged, head-moving, tail-wagging, mass-produced "robot designed for home entertainment purposes." An "entertainment robot," AIBO is not a domestic helper robot: he was not designed to perform utility tasks like vacuuming the floor, mowing the lawn, or cleaning the pool. (AIBO stands for an **A**rtificial **I**ntelligence Ro**BO**t, a name that also sounds much like the Japanese word for companion.[1]) AIBO is an object—3 lb of silicon and plastic—that becomes 'animate' as it barks and wags in an audio-animatronic simulation of caninity. AIBO conveys a sense of dogness reduced to its component characteristics of *head*, *snout*, *tail*, and *four legs*. With these reductive signifying elements, even a line drawing or a cartoon can be convincingly canine. AIBO can walk (in a clunky quadrupedic gait), can "see" (with the video cameras behind its eyes), can "hear" commands (with audio sensors), and can "learn" from external stimuli from their owner, their environment, or from other AIBOs. The first AIBOs came equipped with 16 Mb of main memory, a 64-bit processor, a thermometric touch sensor, a CCD color video camera equipped with a pattern recognition technology that allowed it to recognize shapes and colors,[2] LED lights in its eyes and tail for expressing emotion, a 90-minute lithium ion battery and a charging station, and an 8 Mb memory stick, with changeable behavioral modules to teach dancing tricks by inserting changeable 'modules' into the dog's belly.[3] In a particularly human fantasy akin to sex-prediction or gender selection in adoption, AIBOs were manufactured as gender-neutral, its gender to be determined by its owner.

An object is sentient if it appears to have intent or agency. AIBO doesn't decide his gender but he appears to make decisions. Perhaps the attraction of AIBO is that he puts us humans in a liminal state where the simulacra seem real, as if the pleasure that AIBO confers is the acknowledgement of his dogness flickering alongside a disavowal of his robotic-ness. To encounter him (let's assign a gender) with his eyes flashing, his tail

wagging, as he sits in response to voice command, AIBO seems like a sentient object. He asks us: how do we draw the line between an object-thing and a thinking-thing, between the rock and the hard place of sentience, where all objects could indeed be thinking?

I don't own an AIBO, or, to be more in keeping with the terminology used by those of us who consider animals as full partners in a dyadic relationship, I have not had the pleasure of living with an AIBO as a robotic companion. The difference between *owning* and *having as a companion* is foregrounded with AIBO, a companionate cyborg. (The rhetorical campaign to shift the linguistic terminology away from pet ownership to animal companionship has been eloquently championed by Donna Haraway in her recent work, *The Companion Species Manifesto: Dogs, People, and Significant Otherness* and *When Species Meet*.) As a mass-marketed mass-manufactured object, AIBO takes his place in the circuit of fetish objects in commodity culture, exemplary of the *pet*ishism that the billion dollar pet industry relies upon—where even the sentient pet, the companionate other, is a commodity-thing, owned and collected. And yet, however alive AIBO was, in 2006, after more than 150,000 of the mass-marketed AIBOs had been released to join households and research labs, SONY 'discontinued' AIBO: they put the dog to sleep.

Here my meditation on the relation between the robotic and the real is poised from my own vantage of mourning the recent death of my beloved carbon-based canine companion. As much as I would like to have, to know, to live with a robotic companion canine, I couldn't manage to spend $3,000 on AIBO when he was on the market and—as my recent eBay searches have indicated—AIBO has only become more expensive since SONY took him off the production line. In the wake, I've been reduced to watching videos of AIBOs as they walk, wag their tails, and cock their heads in response to human command. In one particularly poignant eBay video, an owner who is selling his AIBO says: "I love my AIBO but I don't play with him very much." In the video, the black plastic-bodied cyborg-canine is addressed by an off-screen human voice as he stands in front of his pink ball, turning his head around. The human voice commands: "sit," "good boy," "stand up," "good boy," and "turn around." AIBO cocks his head, flashes his eyes, looks at the camera as if he understands. The human voice repeats: "turn around." AIBO pauses. The human voice repeats: "turn around." AIBO sits. The human concludes: "I think he thinks I said sit down" . . . *I think he thinks . . .*

What is he thinking? Perhaps like AIBO, I dream of the real dog.

Notes

1 In Japanese *aibou* means pal or buddy. Designed by Hajime Sorayama, a Japanese artist, known for his suggestive robotic forms taken from "pin-up" art, the first generation of AIBOs were released in two litters (ERS-110/111): in June 1999, 5,000 AIBOs (3,000 for Japan and 2,000 for the US market); in November 1999, 60,000 grey and black pups were released.

2 AIBO's vision system was an experimental system relying on a SIFT (scale invariant feature transform) algorithm. The invariant features system pulls out the most distinctive features of an image and encodes information about their location, orientation, brightness and size in a small file. A database holds descriptions of several hundred features for each image, which a computer can search when it encounters an unfamiliar image. The software can accurately select a matching image even if only 10 percent or so of the features match. AIBO could recognize his charging station.

3 AIBO evolved with some intelligent design. The second generation of AIBOs in 2001–
2002 upped its core memory to 32 Mb and introduced new colors: gold, red, blue, green,
white (3 hues), champagne, latte, and pug brown. A third generation (2003–2005) of
white, black, and brown AIBOs had evolutionary software upgrades that enabled AIBO to
talk back and express verbal communication with its owner using more than 1,000 words
in English and to recognize approximately 30 Spanish words and phrases, including *sientate*
(sit down), *ven aqui* (come here), and *buen perro* (good dog). The AIBO MIND 3 Upgrade
Kit—the last iteration of Sony's robot companion—introduced two new capabilities: the
AIBO Net News Reader enabled AIBO to read news or weather from the owner's selection
of RSS feeds and the AIBO Diary, which enabled AIBO to take pictures, add notes on its
daily activities, and upload its diary entries directly to a blog site.

Anne Friedberg

Critical Studies, University of Southern California

BOUNCING IN THE STREETS:
A PERFORMANCE REMIX

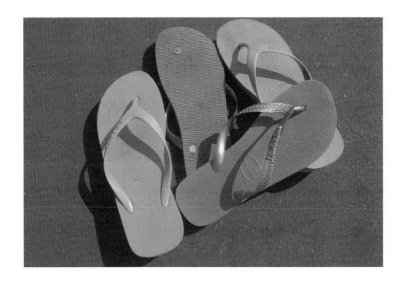

O Objeto

Story, stone, click, bounce, thwack . . . FLIP-FLOP!

SC [sound cue]: *Flip-flop overture*

RubberDance Trance

Chinela, Chinelo ou Sandália?

The Coffee Dance *(done while talking)*

Slide projection of slippers

SC: acid chillilique redux

In 1962 the Havaianas division of Alpargatas S.A. was born to create an economic yet more durable and comfortable alternative work shoe for the coffee plantations of Brazil. Inspired by the zori (thonged, inflexible Japanese Samurai clog), rubber flip-flops replaced the first caffeinated shoe, the espadrille, which had reigned under the red berried bushes since the early 1900s, arriving with either Spanish or Chinese workers. Known as *alpargatas*, the espadrille was considered a work shoe for the disenfranchised or barely nationalized. Its mid-century replacement, the flip-flop,

SC: Flip-flop walk

is intimately connected to low wage labor and poor working conditions, even worn on leisurely feet.

Havaianas are the original, indigenous flip-flop of Brazil. The key to their ubiquity is the natural rubber sole *and* thong. These flip-flops do not wear out, do not pick

up odor, but they do bounce. The 'shoe' of the poor out of the home and at work, the 'sandal' of the middle class at the beach, and the 'slipper' in the homes of the middle to upper class, Havaianas slipped into disuse in the 1980s when the market was flooded with cheap, rubberless Chinese knockoffs.

Baiano slang, *Chinela* comes from the Spanish word *chinelo* which means slipper, in its female form to indicate any backless shoe, but particularly flip-flops. Frequently Spanish words become slang in Portuguese due to Spanish immigration to Bahia; but they are also remnants of various border wars fought by African-descended people on behalf of the planters' class. These wars were leveraged to eradicate both native and African populations; the former at the border, the latter in the city. 'Vagrants' were abducted right off the street and sent to fight. How was it determined if they were vagabundos? By their shoes, or rather, lack thereof. Vagrant just meant ex-slave with nowhere to go and no means of getting there anyway.

SC: acid chillilique 60 sec

Tire Treading *(gestured in shoes)*

movie 1

Hanging out
Drinking Dining Talking Reading Waiting
high green

Traveling
Driving Riding Crawling Walking
purple

Shopping
Getting paid Paying up
high pink

Conversing
Calling Phoning Texting
high white

Working
Pulling Pushing Toting Mixing
black

Scrubbing Vending Cooking Cleaning
striped green

Habitual movement shapes space into consciousness, objects into totems, people into mechanisms. A tracking, call it a neighborhood . . .

or a grand choreography of fluids, social constructs, civic duties, building ordinances and historical erasures.

Arrasta o pé

SC: Rubberband Afoxe

Schla, schla, schla. Too many revelers, too much drink, too late an hour, no marshals adds up to a lot of dancing in place. In situ. Cobblestone holding memories of bare feet and struggle. Piedade. Rubber-soled feet slap the same stone where drawn and quartered slaves were dragged to church to leave their heads for others to ponder. Pietar. 500 years of breaking in. Still not broke. Pity. Resilient, boppy even in the refrain. Borracha bouncing along to the samba reggae beat, ignoring the headless rebel ghosts.

This, The City of Seven Doors. Seven, seven, all go to heaven. All god's children got shoes.

Slaves couldn't wear shoes.

SC: Flip-flop walk

Flipped

'Oh migawd! Those are sooo cool!'

SC: Samba boing

The flip-flop is a class marker in Bahia. One wears it only to the beach, assuming one has the cash to request a beach hawker to watch one's personal belongings.

Should the flip-flops, or *chinelas*, be the primary or sole pair of shoes, then one would go to the beach barefoot, rather than risk having them stolen.

One will see workers, from maids to gas vendors, wearing chinelas. Sometimes they are actually provided in company colors. Shorts and flip-flops.

Pulling a load of bricks, carrying a mound of laundry on the head, hoisting a beam in a high rise. Toes out, gripping, groping for the sanity in the gesture while the back teeters on collapse.

SC: sproing

A laboring foot in flip-flops echos, retraces the historical fact of slaves, even wealthy ones, being forced to go barefoot.

Every so often, a vessel ruptures

SC: sproing

from the sheer effort of keeping the foot flipped to flop. Under the extreme weight of avoiding hunger and homelessness, a well-muscled arch struggles to find the backbone to keep dancing.

SC: Cuica

SC: Voodoo Bach

<div align="center">

Theraband Dance

Tire Treading Return

</div>

SC: Even More Bounce with Street

<div align="center">

RubberPop Dance

</div>

More Bounce to the Ounce

The secret to Havaianas' success is in the vulcanization.

SC: HiHopesHell

Were it not for 70,000 hijacked seeds, the rubber of these famous flip-flops would most likely all come from Brazil. It might. Vertically integrated parent company São Paulo Alpargatas S.A. did not disclose this in public non-investor materials.

Collected from *hevea brasiliensis* one excruciating hack at a time, latex (the white sticky fluid that oozes from these trees between the bark and wood) was one of the primary nineteenth-century Brazilian exports. In fact, the country dominated the global market until the mid-1880s.

Brazil's reign came to an end in 1876 when one Henry Wickham returned to England to sprout and study *hevea brasiliensis* in the Royal Botanical Garden. His success was shipped to Ceylon (now Sri Lanka) and Thailand.

Brazilian tappers *foraged* for latex, rushing against rainy seasons and tree-killing fungus: hack tree, collect latex in cup, add ammonia to 'cup lump', smoke it right there, make balls, hike to river, send balls down the Amazon to be vulcanized again into sheets. Meanwhile Britain *harvested* their latex, sending it all at once to a central smoke-house on the plantation. Great Britain soon wrested the rubber market from the Brazilian government, ironically at about the same time that Brazil finally abolished slavery, in 1888. To add insult to injury, after its eight-year maturation, the British discovered a rubber tree excretes more latex if superficially Y-slashed rather than gouged.

Currently, only 96,000 tons of Brazil's 239,000 tons of consumed rubber is actually grown, extracted, and processed in Brazil, according to Natural Soluções Setorías.

Collecting latex from *hevea brasiliensis* in the Amazon was the work of indentured laborers. Tied to the groves by rigged contracts and company store 'credit', they were hindered by greed-bred inefficiency, but the global market had an insatiable urge itself. Speed. Here, Goodyear enters the picture, developing a vulcanizing process which made rubber withstand higher temperatures.

Anyone wanna go for a ride? Bouncy tires, smoother rides, softer treading, sheathed penises, sterile hands . . . rubber rubber rubber everywhere.

Globe trottin': the rubber flip-flop was created in Brazil by a company founded by a Scotsman and two Englishmen; the raw materials were extracted by African- and Aboriginal-descended indentured laborers, later, Southeast Asian colonial subjects of Britannia.

The flop of the sole is an object of colonialist desire, an echo of the machete slamming into the soul of a just-freed corpo-real.

SC: birds of Brazil

SC: Havaianas webtrack

Runaway Rubber Cat Walk Dance

Havaianas, heaven and the public parts of the private.

Flip-flops are now ubiquitous, not only among the lower classes, but in the higher echelons of global consumer society. Getting a grip has become fashionable.

Havaianas beat back imposter no-name imports in the 1990s by co-opting a surfer adaptation: inverted flip-flops so that the thong and the bottom colors are on the same side, making the shoe stay on during a ride.

'Tops' launched a series of cool styles and limited editions—everything from Brazilian Flags to technicolored high heels—but flip-flops are flip-flops . . .

Moving it from its humble beginnings to runway fashion is an enviable transformation. Delete sweaty brown bodies, but bring up their beach and house parties soundtrack. Put shoes on harried, sexy consumer. Connect the simplicity of human interaction, nationalism, and creativity through transposition to product.

Havaianas = beach vagabundo = marginal = edgy = unique = evocative = artist.

By hiding the labor in the shoe itself and the laboring for which it was originally created through slick packaging—now colored and/or stenciled, the rubber of the shoe is the package and the product—wearing a flip-flop is a modernizing turn, a privatization of pedestrian as flâneur, dabbler, collector.

SC: Rubber balls

My Souls

I have very flat feet. Flip-flops are a guilty pleasure to me, or a torture. Whenever I wear them, you'll rarely hear that rushed thwacking or sexy dragging. Sucking. Duck feet, I've been told, but my feet are very long and slender.

SC: Long walking flip-flops

These feet make me stand out in Bahia where I watch the flip-flops go by. I wear a 41. Yup. 41. Average size there is about a 32, 34. There are rarely cute shoes left on the rack that fit me. Sensible and plain, larger sizes are normally wider. In this global Havaiana craze driven by seasonal, beaded, bejeweled, colored small flip-flops, ranging from $10 to well-over a hundred dollars, I embody 'unstylish'. I fear not: Earth Shoes recently launched a foam pair for the podiatrically challenged. Fashionably expensive, rubber-free.

But then there's the cost of slipped discs, crushed toes, elephantine ankles, and varicosities that plague the working poor of Bahia because the upper class thinks that slaves should not wear shoes . . .

So should I get this in the berry or topaz?

Anna Beatrice Scott

Department of Dance, University of California, Riverside

THE BROKEN MUG

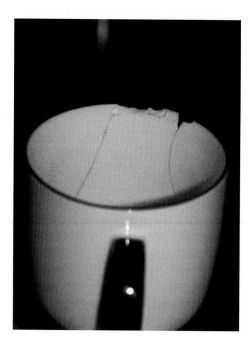

He was late as usual. As he went into the kitchen he ran through the motions of every morning: making a quick breakfast before rushing to work, and at the same time skimming through the headlines of the newspaper. He heard the water running through the coffee machine and made some toast while waiting. His shoelaces were still loose. He thought of tying them. The toast was ready and, still reading, he spread it with butter and took a bite. He looked at the coffee, irritated that it wasn't ready. He had to go but needed the coffee. The paper distracted him although he was also thinking about his first meeting. He heard that the coffee was ready and took a mug from the cupboard. He poured coffee in it and walked back to the table with the spread newspaper. Maybe he tripped over his shoelaces, maybe not. He suddenly cried out. Scorching hot liquid soaked through his clothes, burning him. In his hand he held the handle and almost half of the mug. The other half lay at his feet and rocked slowly before coming to a halt. He pulled his shirt and tried to clear the fabric of his trousers from his skin. His astonishment prevented him from feeling much pain, and the coffee cooled fast. He stood there too baffled to think or to do anything. The broken mug was still in his hand. The first thing he thought was that he was now certainly too late and it made him angry. He blamed the mug. Why did it break at this precise moment? Exactly when he most needed to be at work on time. It was as if the mug had decided to annoy him. Well, he was late anyhow so he sat down and looked at the thing. He still wanted coffee so he poured another mug and watched very carefully whilst carrying it to the table. It held. He sat down, took a sip and looked at the broken mug again. Neatly broken. He lifted the other half and it fitted precisely. If he applied some pressure on, he could not see the crack. The blue flower looked faded as always but complete. He had to look very carefully to see it was broken. He didn't understand how it could have broken. He didn't

trip; the thing just broke. It fell apart and the contents spilled over him. The wet fabric was cold now, he had to change clothes but he kept looking at the mug and wondering. He looked at the small dents in the rim. He didn't know there were so many. It was an old mug and he had never noticed they had been made. It must have been hit several times over the years. He didn't remember how long he had had it. He didn't even remember how it came into his possession. One never bought a coffee mug. They slowly appeared in the household. Now he thought about it, he had no idea how all his mugs had appeared. None matched, that was for sure, probably because they had all appeared one by one, and never as a set. They all were ugly. They invariably had pretentious prints or supposedly funny texts on them. Given the choice he would never have bought a single one of these mugs. Still they were in his house and he used them. Now he thought of it he could not remember seeing them in the shops. He probably would have no idea where to buy a new one nor could he imagine receiving one as a present. This broken one, for instance, all blue flowers, as if it came from a 19th-century farm, but the print so obviously made by a machine that it only showed how pathetic the thing was; a silly attempt to bring nature into the household and a travesty of the Arts and Crafts movement. Still he liked drinking from it. Somewhere it fit into his lips and it held exactly the right amount of coffee. And something about the handle: it felt good to put one's fingers in it and hold it. Even the thickness of the material was right. It let some warmth through so your hands felt good when holding it. The mug was, in a strange way, part of his life. It belonged to his mornings. Although not much of a morning with the rushing and so on, he still liked to think of reading the paper with his mug in his hand enjoying the slow awakening. The more he looked at the broken pieces the more he liked his mug. Or the more he mourned for his mug. Strange, he thought, because he had never paid any attention to the thing. As stated, it was there, it belonged to the household and he drank from it. That was it. It was just a thing, taken for granted, not worth any attention. But now his clothes were ruined and sticking to his skin. Even worse, because of all this he was late. He blamed the mug for it as if it had decided to fall apart, to stop being a useful mug. Decided to get even, cry for attention. As if the mug had suddenly after years of service taken a dislike to him and hit back. As if it had broken of its own will.

This was ridiculous. He was mad about his clothes and the whole mess he was in. He had better start changing and hurry up. He considered mending the thing. He could glue it together. It didn't make sense. He stood up and tossed the pieces in the bin and went upstairs to change.

Ruud Kaulingfreks

University of Humanistics, Utrecht

THE COSMIC SYMBOL

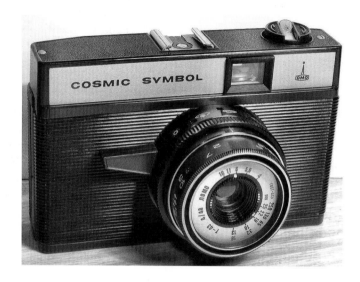

I was given my first camera on my tenth birthday, my initiation into double figures. It was a Cosmic Symbol, and I loved it. I loved the tiny white symbols on the lens, the little figures, the tower block and trees representing infinity, and the weather symbols, similar to the ones used on film instruction leaflets. And I loved the name: Cosmic, like cosmonauts, signified to me the Soviet world of space exploration. I knew little else of the Soviet Union, except that it produced the gymnast Olga Korbut. The camera was, of course, also an instrument for me. It came after the cameras made from the malt tins of home-made beer kits, which we used to enter a newspaper pinhole camera contest, and after I had learned to develop prints in the cupboard under the stairs. It was my first real 35 mm film camera. With it I could do manual photography without having to understand the numerical system for shutter-speeds or fully grasp the workings of the aperture.

This was made possible by the pictograms on the lens. They were descendants of Isotype, the system of pictorial statistics invented by the logical positivist and social-ist Otto Neurath. Isotype was intended as a transparent universal and neutral language, able to overcome barriers of literacy and mathematical competency. It was officially adopted by the USSR in the early 1930s and gave a neutral, modern and pedagogic air to state propaganda. By the 1960s, pictograms were being used to give a design iden-tity to successive Olympics, and as part of the styling of commodities, alongside brand logos. On Soviet cameras, such as the 1964 Voskhod camera then the Smena Symbol (exported as the Cosmic Symbol) these symbols are highly stylized, but they serve the old purpose of enabling the camera to be operated by the photographically semi-literate. It was a cheap, easy-to-use introduction to controlling the technology of photography. It was a teaching tool as well as a means of making pictures.

The Cosmic Symbol was imported to Britain by a company called Technical and Optical Equipment, which promoted Russian photographic equipment on the basis of its functional and durable character, and by association with the Soviet space programme. As an export name, 'Cosmic Symbol' attempts to conjure up these same associations.

But to me the name also signified something mystical, universal, something occult. Small wonder that the photographs I took with it showed ghostly apparitions which could not be seen with eyes alone. My camera was an instrument for penetrating beyond the world of strictly visible phenomena, a magical means of exposing a world of spirits, and its images corresponded to my 10-year-old self's intensified, hallucinatory perception. In this I was only unwittingly following in a long tradition: for a decade or two after its invention the camera had been used as a means to establish spiritualism in rational and scientific terms.

Science had established the existence of forces and rays invisible to the human eye and, with instruments like the x-ray, had penetrated beyond the seen world into the unseen. That photography might similarly reveal imperceptible presences had seemed highly plausible as spiritualism took off in both Eastern and Western Europe in the 1870s and again after 1918, promising the bereaved some last contact with relatives and loved ones killed in war and revolution. Even a series of highly publicized frauds and the appearance of numerous clearly faked ghost photographs intended to ridicule spiritualism did not entirely shake the spiritualists' faith, nor the faith in the camera as a scientific and objective instrument. The camera as instrument simultaneously lent support to Neurath's 'physicalist' and anti-metaphysical view of an empirically knowable universe and the aim of the spiritualist movement to establish the truth of a non-sensuous reality, a world of spirits beyond the visible. There is no paradox in this. More interesting is the way in which the potential for the production of spectres is literally built into the Soviet camera.

My ghostly apparitions were mostly light leaks (though some were the result of shooting directly into the sun – a surefire way of conjuring angels). The first photographed ghosts in the mid-19th century were also accidents, in which poorly cleaned plates revealed older images beneath the new exposure. The otherworldly also manifested itself as indistinct blobs and blurs. By the 1970s, few consumer model cameras in the West leaked light, while Soviet cameras had a reputation of being shoddily built. But these were not produced simply as cheap exports: since the 1930s, 35 mm cameras had been significant domestic commodities, the fact that anyone could own one standing as evidence of Soviet social and technological achievement. They originated as home-grown copies of the Leica rangefinder cameras constructed by *besprizorniki*, children orphaned and abandoned as a result of war and famine. In the Dzerzhinsky commune in the Ukraine, set up by and named after the founder of the secret police and led by the educationalist Makarenko, whose militaristic pedagogy emphasized productive work, these children manufactured the first few Soviet Leicas (FEDs) in 1932.

The Dzerzhinsky commune's success led to the mass production of cameras by military optics factories, then (from 1962) by a joint-stock company formed by their merger with the Kinap Motion Pictures Equipment plant: the Leningradskoye Optiko Mechanichescoye Obyedinenie (Lenigrad Optical and Mechanical Enterprise). Dzerzhinsky's was one of the first statues to topple following the collapse of the Soviet Union. The photography industry he indirectly instigated has been a little more fortunate. LOMO cameras now fetch relatively high prices and are admired for their 'lo-fi' aesthetic, in particular their tendency to leak light: the technical result of a manufacturing system that required 'tolerant' exchangeable parts that were easy to assemble and a planned economy that emphasized quantity. This manufacturing system was itself the product of the need to produce goods outside (and alongside) a capitalist market system, and of the specifically Soviet commodity production system.

One of the difficulties with Marx's theory of the commodity is that it is specifically concerned with the commodity under capitalism, and offered no prognosis for the fortunes of the commodity in a communist society. Under capitalism, Marx suggested, the simple useful object becomes a performer. His example is, not incidentally, a wooden table, which gets up and begins to dance, just as the tables in 19th-century spiritualist photographs of séances rise from the ground and leap about. And, as in the séance, it conjures up spirits, for out of its 'wooden brain' arise fraudulent apparitions, 'grotesque ideas'. As Derrida observed, commodity fetishism is a spectral thing, haunting and animating the object. Revolutionary uprising, Marx implies, can also animate the thing-world, turning the tables, and raising the spectre of communism. But the ghosts produced by fetishism are mystifications resulting from the capitalist economic system; in a socialist society, presumably, they would be exorcised. In fact, the Soviet Union initially attempted no such thing, developing its own quasi-capitalist consumer culture under the New Economic Policy of the 1920s. But avant-garde artists and writers of the period did try to envisage the socialist consumer object; and they envisaged it primarily as functional and utilitarian. Commodity fetishism animates the object only once it has been rendered mute, like the medium's trance state which allows the spirits to speak through her. But the socialist thing, freed of fashion and status-signifying, would be a socially active, transformative technology, dynamic, flexible, and geared to the demands of a collective society.

We know now that technologies don't eliminate ghosts but generate them. The gaps and flaws, the white noise, the blurs, the incomprehensible interruptions and accidental marks that haunt modern media are such ghosts. And they have now become the trappings of style, of a marketable aesthetic, the useless marks of distinction, fetishistic hauntings which functionalism failed to eliminate. The aesthetic and marketing possibilities of Soviet 35 mm cameras were recognized in the early 1990s by two Austrians who signed a deal with LOMO to become worldwide distributors of the LC-A camera. Now they also export the Cosmic Symbol, this time as the Smena Symbol, and its technical failings have become selling-points. Nevertheless the spectres generated by this technology, by its inbuilt technical flaws, as well as by the incompetency of its user, are also the spaces of imagination, intimations of possibility which suggest that the world might be more, or other, than it appears. More than a commodity, or technical instrument, the Cosmic Symbol remains, for me, a Utopian thing.

References

Fricke, Oscar (1979) 'The Dzerzhinsky Commune: Birth of the Soviet 35 mm Camera Industry', in *History of Photography*, vol. 3, no. 2, April 1979, pp. 135–55.
Klomp, Alfred (2007) 'Why I Don't Like LOMOgraphy', 'The Voskhod', 'Introduction to the Soviet System', 'The Smena SL', 'Technical and Optical Equipment (London) Ltd', Available: <http://cameras.alfredklomp.com/> (accessed 24 September 2007).

Michelle Henning

Department of Culture, Media and Drama, University of the West of England, Bristol

THE EAMES CHAIR (DAX)

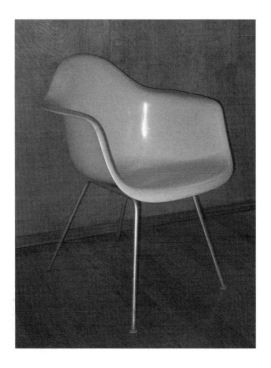

In the 1980s in the throes of graduate school-induced "underemployment," I came upon a lovely $2 chair in a dusty thrift store. Its sculpted fibreglass curves called out to me, evoking some vague sense of recognition and comfort. I took it home. It was years before I learned that my basic yet elegant chair was an "Eames," a DAX to be more precise, and that Charles Eames had also made the lively science film of my junior high years, the one about the "powers of 10," but that was about all I knew. As we moved toward the 21st century, my 1980s ignorance was impossible to sustain. The mid-century furniture of Charles and Ray Eames became hot commodities, and my simple plastic chair was soon worth hundreds of dollars.

If these chairs have enjoyed a renewed interest, they were also quite popular in postwar America. Produced in large quantity by Herman Miller, the chairs gained a ubiquitous presence in schools, workplaces, and modern homes. They were available in a rich array of colors and styles, allowing consumers to participate in the design process by customizing the choice of legs, upholstery, and finish. The chairs were celebrated at MoMA (Museum of Modern Art), featured across popular culture, and quickly integrated into post-World War II American life.

The Eames Office is best known for its iconic furniture designs and for the famous Case Study House 8 (1949), an early experiment in prefab architecture set in southern California. But the Eameses were much more than the creators of furniture; in many ways, they were designers *of* and *for* the future, leaving behind a body of work which encompassed furniture and architecture, as well as a vast image culture of photographs, films, and exhibitions. While their work has recently been fêted—in both an international retrospective and an endless stream of products—I am interested in what

we might learn from their design practice about the role of objects (or what Charles referred to as 'covetables') in mid-century American culture. From their modular furniture to their vast 'databank' of hundreds of thousands of slides, the work of the Eameses provides a valuable case study of a culture in transition from a Fordist to a post-industrial economy. The central work of the Eames office shifted in the 1960s to what might best be understood as information design.

From their innovative 1959 exhibition "Glimpses of the USA" (which premiered in Moscow and was seen by millions) to their museum displays for corporate clients like IBM, the Eameses developed complex methods for visualizing abstract information and for relating image, text, sound, and even smell. They were also deeply engaged with computer culture from an early date, producing books and exhibits designed to illustrate the importance of the computer. Further, their interest in computer culture extends far beyond works that directly address the machine as subject matter. Rather, the very *form* of their investigations into media design predict the intermedial constructs which so characterize contemporary digital technologies. The Eameses were deeply interested in how the presentation of visual material impacted its ability to impart meaning, and their work engages with issues of speed, scale, relation, juxtaposition, and variation in compelling ways. Finally, their designs also attempted to deploy media in the service of an enhanced public sphere by illustrating new civic uses of information and imagination. Still, their steadfast faith in design limited their ability to critique the world they helped to build and provides valuable "object lessons" for today's theories of media and of objects.

While a look at their experiments in early multimedia might seem far removed from my plastic armshell, it would be a mistake to see their furniture designs as somehow standing apart from this legacy of information management. The chairs are part and parcel of their broad take on the designed environment. At the most literal level, the furniture created for Herman Miller was featured prominently in the popular public exhibitions they created for clients like IBM. It was also among the first lines of furniture designed for both the home and the workplace. Advertisements and product brochures from the period extol the furniture as ideal for both the living room and the board room, while also stressing its modular design. As one 1968 Herman Miller advertisement proclaimed, the designs were an essential part of "environments for living, learning, working and healing." Other advertisements situated Eames chairs and desks as part of new-fangled, adaptable "Action Offices," where workers could unwind and relax without having to go home. These traits—the blurring of work and leisure, the rise of mass customization—are often seen as symptoms of our contemporary moment, but a close engagement with the Eames legacy helps us to locate these tendencies more accurately at their mid-century origin. Eric Alliez and Michel Feher characterize the post-industrial economy that begins to take hold at this time as a shift away from the massive scale of factory production in the Fordist era toward a regime marked by flexible specialization, niche marketing, service industries, and an increasing valorization of information (1987: 316). The separation of the spaces and times of production from those of reproduction which was central to an earlier mode of capitalism is replaced by a new spatio-temporal configuration in which the differences between work and leisure blur. This leads to heightened flows of information, and the Eames chairs circulate information just as much as their films or exhibitions did. Comfortable and beautiful, the chairs also model new ways of being and laboring in service of a global information economy.

The future the Eameses envisioned was a bright and shiny one, sprinkled with fun furniture, a vision expressed in Charles's motto 'the most of the best to the greatest number of people for the least'. While their design practices reinforced an optimistic take on our electronic, modular future, the work of the Eames Office frequently and paradoxically focused on craft. For instance, the lyrical film *Kaleidoscopic Jazz Chair* reveals the labor embedded in the commodity and shows many hands working on the chairs at the very moment furniture is increasingly *not* made by hand. A film produced for Polaroid strives to locate technology very much within the everyday by situating its celebration of SX-70 camera's "high techness" among photographs of the domestic and mundane. Such films lovingly detail the wonders of technology and the emergence of information systems but also shift the focus from technology to images of family ritual, craft and nature.

Yet, in the 1960s, the US economy is shifting away from domestic production of goods to information management. In its pioneering in multimedia, the Eames Office participates in this shift even as its focus on craft and domesticity helps to naturalize the process. In a lecture called "Goods," Charles talks about the "new covetables" and waxes on about the beauty of material objects (like balls of twine and kegs of nails). This fetishization of material objects – how they look, "feel and think"—celebrates a new materialism at precisely the moment the economy begins to go virtual.

The Eames image banks archive these goods and extol earlier modes of craft even as the technologies they are helping to pioneer are destabilizing the dominance of older modes of production. This is not simply a variant of imperialist nostalgia but *a snapshot of an important moment of transition between modes of production and epistemological registers*. These strategies also naturalize a movement toward corporate globalization and a particular version of internationalism. The Eames-designed IBM exhibits traveled to Europe, Asia, and Latin America, and Herman Miller began a rapid expansion of its product line into global markets. In 1958, the Eameses, in partnership with the Ford Foundation, authored "The India Report," a curious document that partially fixates on traditional craft in asserting the role design might play in India's modernization. From Day of the Dead celebrations to Indian lotas to origami, the Eameses consistently turn to indigenous "local color" in order to fuel their designs for colorful, postwar living. Their visual language of multi-culti craft helps set the stage for emergent corporate globalization and for shifting representations of difference.

Of course, most of this escapes me when I sit in one of the many Eames chairs I've now collected, answering work emails from the comforts of home. But as I continue to study the expansive careers of Charles and Ray, I wonder about my own investment in these objects now, and, indeed, about scholarship's increasing turn to material objects at this time. We inhabit an era of heightened virtuality and displaced production that makes the earlier, mid-century moment of dematerialization seem quaint and optimistic, even as it remains an origin story for our present. Yet, like Charles Eames, we still grasp out for goods, determined to ground our dissolution through touch and the mark of the hand. The risk for object studies is that, in our return to materiality, the tactile and the sensuous might underwrite an elaborate sleight of hand, allowing us to forget that our material objects are always (at least since the era of the Eames Office) laced through and through with powerful, if largely invisible, systems of dematerialized labor and information.

Reference

Alliez, Eric and Michel Feher (1987) 'The Luster of Capital', trans. Alyson Waters, *Zone 1–2*, pp. 315–59.

Tara McPherson

Critical Studies, University of Southern California

A FLAKE OF PAINT

In 2004, Patricia Cornwell published her thirteenth detective story featuring Kay Scarpetta, entitled *Trace*. The object of this brief essay is to consider the implications of Cornwell's trace fragments of the material world. These fragments give her book its title, for as Walter Benjamin said, traces of the occupant are left on every interior, and so the detective story that follows these traces comes into being.

The 'trace', more properly 'traces', of Cornwell's story is tiny flakes of red, white and blue paint, together with minute particles of human bone, which Scarpetta sees in soil samples when she examines them under a compound microscope; the flakes 'look big and bright, like a child's building blocks' (2004: 348). The samples come from two sites, the basement area of the institution which she once headed as Chief Medical Examiner, and the mouth of a girl named Gilly found elsewhere in the city, 'who was asphyxiated and had chips of paint and metal in her mouth' (p. 318). The murderer, a serial killer, is threatening Scarpetta's beloved niece, Lucy, but the trace flakes enable him to be identified, and his lethal desire for revenge to be thwarted.

Although this is a fictional narrative, each flake of paint is treated entirely realistically, that is, exactly as it would be in a real analytical or forensic investigation. It is subjected to a technical analysis, which determines its precise colour, judged against the colour charts for paint, and the chemical composition which gives rise to this shade, and to its other physical characteristics, like original liquidity, degree of hardening, and so forth. Its exact occurrence in time and place is established, that is, they are recorded photographically and in the investigator's documentation.

Of course, the trace flakes of paint have their own biography, as all objects do. They have an exact presence in the space–time continuum, which comes to them because they possess physical bodies, which must occupy one specific time and place at any moment, and no other, as do humans and all living things. This means that the paint flakes have life events, which can be reconstructed through the study of physical analysis and records, written and unwritten. In many ways, this material life history operates as a parallel life to that which the flakes lead in their 'real' life; it is a constructed

narrative of events, presented as an explanation of why and how the traces come to be where they actually are at each specific moment. It would, of course, be equally true to say that the paint traces generate their own narratives; it is their physical nature and the events they have been involved in which drive their story. One of the themes throughout Cornwell's book is the forensic process of building up what the history of these particular flakes has been.

This reconstruction, or reflection, of what has happened to the flakes may be regarded as their secondary lives, that is, their lives which exist in the consciousness of a viewer or reporter. Since, however, the only way we can apprehend the flakes at all is through the construction of such secondary biographies, it can be said that, as far as we are concerned, the flakes only exist because we can perceive them. In this sense, the trace flakes are not 'real', they are symbols of themselves. Scarpetta makes her crucial find of the traces in the crematorium area of the old building, where dusty steel trays carrying unclaimed bodies were 'shoved' into a long, dark iron door in the wall, and pulled out, when 'there was nothing much on them but ashes and chunks of chalky bone' (p. 466). Unregarded fragments are given emotional and intellectual significance through the operation of human imagination, in this case Scarpetta's, which transforms their status. She can then add an ethical dimension to her musings. She reflects that the system did not 'allow the dead any dignity at all. [. . .] There were baseball bats propped in a corner because when cremains were removed from the oven, some chunks of bone needed to be pulverized' (p. 455).

In the case of all forensic material, in which category the flakes belong, their symbolic presence is as evidence. The flakes have become the major player in a secondary narrative of 'cause and effect' which is credible to us because we belong to a society which turns material like the trace flakes into fetishes. We do this by isolating them from their surrounding matrix and treating them as entities in their own right, which can have independent characteristics; they no longer simply respond to us, we respond to them.

The operation becomes a very complex process in which the flakes are first turned into the kind of symbol we call 'evidence', and then this material category of 'evidence' is detached from the process to be fetishized as something existing in its own right. In Cornwell's book, we see this process in action:

> In the trace evidence lab, forensic scientist Junius Eise [. . .] could take himself out of service for a moment [. . .] briefly regain a sense of control. He peers into the binocular lenses of his microscope. Chaos and conundrums are right where he left them [. . .].
>
> (p. 200)

But Junius works towards a 'solution' of the conundrums which face him, and eventually succeeds. At the climax of the novel, Scarpetta finds 'a spray can of black paint, and two touch-up paint bottles, one red enamel paint and the other blue enamel paint, both empty, and she places them in a plastic bag' (p. 467). The flakes can be physically linked to the paint bottles, and to the dead girl and the murderer. The chain of evidence is complete. In the case of forensic material, this is no mere academic exercise; such thought processes are enough to send a man to the electric chair.

Trace is, of course, a novel, a 'whodunit', in which a murder takes place within a

domestic setting, a cast of interested persons is assembled, the detective heroine, Scarpetta, examines the event and its surrounding circumstances, and discloses the killer, with his methods and reasons. Like all fiction, it represents a writer's understanding of the world, and particularly perhaps of the ways in which his or her characters make imaginative sense of the circumstances in which they find themselves. This gives an additional dimension to the material traces which are at the core of Cornwell's book; they and all their complexities have been embodied in a fictional narrative, which encloses, but does not displace, all the other mental processes in which the traces have been involved, as I have just described. The thrust of this short essay has been to suggest that the fictional status of the trace flakes of coloured paint is only the final version of what is, in truth, a series of narratives to which all experienced objects belong.

Reference

Cornwell, Patricia (2004) *Trace*. London: Little, Brown.

Susan Pearce

Department of Museum Studies, University of Leicester

GAME COUNTER

One of the least discussed and least understood aspects of conflict simula-
tion design is, ironically, that which is most obvious: the graphics and physi-
cal systems that make a game a reality in the hands and eyes of the gamer. In
fact, the better the graphic design, the more likely it will *not* be noticed.

Redmond A. Simonsen (1977)

The US Department of Defense (Joint Chiefs of Staff, 1987: 393) defines a war game as
"a simulation, by whatever means, of a military operation involving two or more oppos-
ing forces, using rules, data, and procedures designed to depict an actual or assumed
real life situation." During the mid-1970s, commercial game designers (who abhorred
the word 'hobbyist') produced many of the ideas shaping the development of military
simulations. In the United States, military traditions of wargaming, with historical
roots reaching back to the Prussian *Kriegspiel* of the early 19th century, had been driven
down by the perceived failures of political-military gaming since the 1950s, including
the Vietnam War. By contrast, sophisticated war game designs were thriving in the
commercial sector, beginning with the founding of The Avalon Hill Game Company by
Charles S. Roberts in 1958. Roberts's own *Tactics* (1952) and *Tactics II* (1958) and sub-
sequent Avalon Hill titles like *D-Day* (1961) popularized wargame conventions such as
hexagonal grids on maps to regulate movement (borrowed from RAND Corporation,
one of the military think tanks), combat result tables, and the use of printed cardboard
counters to represent military units and display their individual characteristics. These
innovations shifted the mechanics of boardgame design from abstract strategy (as in
chess) or chance (as in *Monopoly*) to representations of historical reality defined by com-
plex systems of rules and data, that is, simulation. Boardgames became the hotspot of
game design in the 1970s, and war games were at their leading edge.

While Avalon Hill introduced the modern conception of historical war games
as simulations, further refinement and popularization of this genre was the work of

Simulations Publications Inc. (SPI), led by James F. Dunnigan and a group of game designers that included Redmond Simonsen, Al Nofi, and others. While a student at Columbia University, Dunnigan designed his first game, *Jutland*, for Avalon Hill in 1966. In 1969, he became the publisher of *Strategy & Tactics* magazine, which had been founded two years earlier. Early issues analyzed data and rules in existing games, but before long *Strategy & Tactics* published game modules, add-ons, and eventually complete, original games in every issue. Just before taking over the magazine, Dunnigan had founded SPI, which took over publication of *Strategy & Tactics* as well as publishing boxed war games. His company also became the leading publisher of boxed commercial war games, for which Dunnigan coined the term "conflict simulations," and disseminated information on military systems and history in the magazine. By the late 1970s, Dunnigan and his collaborators were working closely with the US Army and other service arms to re-invigorate military wargaming, planting the seeds of a deeper collaboration among military and commercial designers that would eventually lead to the development of high-end computer simulations for military training.

What distinguished issues of *Strategy & Tactics* physically from other magazines was not simply that there was a new game in every issue, but the inclusion of a printed map and cardboard counters that spilled out of the magazine. Removing the map and counters naturally took precedence over the articles. Deconstruction for once preceded reading, as these objects were first eagerly removed from each new issue, followed by unfolding the map and – for those who chose to play the game – carefully 'punching' (cutting away) counters from their cardboard sheets. Whether from a magazine issue or a boxed game, playing a conflict simulation began with physical construction of the game. The essential building blocks were the counters, typically half-inch square playing pieces of cardboard-and-ink. They were called 'unit counters', because they represented historical or hypothetical military units or perhaps individual leaders or politicians. (A few others were merely 'markers' that helped players to keep track of the game state.) For example, the rules for Avalon Hill's *Bitter Woods* (1998) tell players that 'the cardboard pieces or unit counters represent individual combat units that fought during the battle' (in this case, the Battle of the Bulge).

But how do players know which units are represented or what the counter is telling them? A typical unit counter features a symbol taken from standard military schemes such as NATO's 'Military Symbols for Land Based Systems'; if the counter depicts an individual person or vehicle, it usually shows an image or silhouette instead. This symbol identifies the unit type (say, cavalry or infantry or king). From that point, the information becomes more abstract. Larger numbers usually placed below the symbol quantify unit capabilities, such as fighting strength and movement rate; smaller numbers, usually to the side of the symbol, stand for any number of additional characteristics, from morale to weapon range. Additional numbers and letters, usually at the top of the counter, reveal the historical identity of a unit, and colors or color bands indicate at a glance nationality or affiliation with other units on the board. Reading information on a typical counter depends heavily on conventions of representation that are virtually undecipherable to anyone but a wargamer. As complicated as the grid of information on this tiny cardboard square might appear to be, by the mid-1970s it had become so conventional that players immediately scanned and interpreted counters upon opening a new game, then launched into heated discussions of the game system's accuracy as a detailed simulation. It is through the understanding of these conventions that game counters link simulation and subculture.

The consumption of media by readers, viewers, and players typically leads to the evaluation of books, movies, or games in terms of content rather than packaging, to experience of using rather than system of constructing. And so it has been with boardgames. Redmond Simonsen, who led SPI's efforts to systematize development and production of historical simulations in the late 1960s and early 1970s, nevertheless sought frequently to unveil the production process for players. In one essay (1977) written for a book on wargame design, Simonsen described the role of graphic design in "simulation games" and "how a game is produced" as *terra incognita*. He meant that effective production and graphic design should in fact be invisible. What better way to illustrate a wargame design maxim than with a military metaphor, which Simonsen called "the signal-to-noise ratio in graphics." As Simonsen put it, "the player is an unspecialized demolitions man defusing a complex bomb and receiving instructions on how to do so via a radio. The game is the bomb, the game designer is on the other end of the radio and the artwork *is* the radio." His explication of artwork and physical system design in wargames owed as much to Claude Shannon as it did to industrial product design, for Simonsen viewed good design of counters, maps, and rules as a communicative act.

Thinking of counters and other boardgame artifacts as codewords and radios of course makes it much easier to ruminate about games as a medium, but it also raises the question of how the materiality of these games works for them. If the game design is easily "read" in terms of the rules system and components, and the act of moving a piece or reading a results table is entirely contingent upon the strategies and tactics of play, the physical components of boardgames such as historical simulations become purely informational; their physicality becomes in some sense "immaterial." We can easily appreciate the rush to "computerize" simulation that began in the late 1970s. As this rush was about to begin (but without reference to it), Simonsen used the term "physical system" in his essay to explain how graphics design functions in conflict simulation boardgames; his idea of a system portrayed physical components as aids to the player's "work" of digesting and using information needed to play a game and encompassed rules, tables regulating movement on the map, and data presented on unit counters.

Dunnigan, the rockstar designer of SPI's boardgames, realized that many wargamers ignored the possibilities offered by agonistic play; they were only interested in the system itself, not the interactivity of gameplay. He pointed out often that studying the components of historical simulations was a way of quite literally reading game systems as authored accounts of historical events. Gamers who did this collected boardgames without ever punching the counters, let alone playing them. Dunnigan (1980) recognized, however, that "this does not mean they are not used." Such a "player" engaged the simulation in a different way, "unfolded maps, looked at counters, read rules, or maybe set up an opening move for solitaire play to discern orders of battle, the lay of the land, and the historical commander's options." These moments of single-player simulation always occurred in a player's "head with the aid of game components."

Today computer simulations and video games have usurped the terms simulation and game. The dominant game cultures form around digital games. Therefore it makes sense to contrast the material boardgame to its computer-based counterpart. Consider "real-time strategy" games such as the *Warcraft* series. In these games, information is interface; players master interface as the syntax of tactics. This interface mastery calls upon a physicality (reflexes, fast hand movements) absent in "physical," paper-based boardgames. By contrast, how one moves the playing piece of a boardgame is indeed

immaterial; whether a player can move his cardboard counter quickly is of no consequence. But perhaps it is even more important to credit the ways in which the physical components of a boardgame convey modes of simulation disentangled from the expectations of experience, interactivity, and performance of digital simulations and games. Rulebooks and graphics systems can be read in order to understand a complex model of historical reality as a system rather than an interface, counters scanned on the sheet or sorted as a kind of historical manifest, counter values translated into abstract representations of historical or predicted performance, or maps carefully laid out on the table as windows through which a flow of events can be perceived and understood. Surprisingly perhaps, the material objects of paper-and-cardboard conflict simulations open up an abstract information space that calls upon the (often solitary) player to contemplate them by understanding deep issues of scale, quantification, and modeling in simulation that are often hidden from view in digital games. The boardgame counter teaches us that we can hold a simulated world in our hands.

References

Dunnigan, J. (1980) *The Complete Wargames Handbook*. New York: Morrow.
Joint Chiefs of Staff (1987) *Publication 1, Department of Defense Dictionary of Military and Associated Terms*. Washington, DC: GPO.
Simonsen, R. (1977) 'Image and System: Graphics and Physical Systems Design', in Staff of *Strategy & Tactics* magazine, *Wargame Design: The History, Production and Use of Conflict Simulation Games*. New York: Hippocrene.

Henry Lowood

History of Science and Technology Collections and Film and Media Collections, Stanford University, California

THE GRAY'S INN LANE HANDAXE

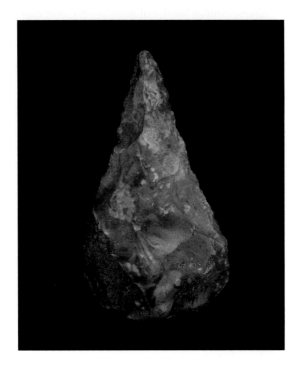

British Museum Press publishes a series of short books each of which deals with an important object in the museum's collection. The Rosetta Stone, the Lewis Chessmen, the Sutton Hoo Helmet and the Anderson-Gayer Cat are among the titles, but, when offered the topic of the Gray's Inn Lane handaxe, the Press declined a contribution about this 350,000-year-old flint implement. What makes one object more significant than another? The Gray's Inn Lane handaxe is not a unique, priceless piece of artistry produced for the elite echelons of a hierarchical society. It is an example of a common type of handheld tool made in northern Europe between about 600,000 and 40,000 years ago but stretching back to about 1.7 million years ago in Africa and just over a million years in Asia. Prior to the 20th century, no object was so widely made and used, but this remarkable geographical and chronological spread also makes a handaxe mundane. What would justify a short book about a particular Coca-Cola can or a cell phone? Association with a celebrity name would do for the modern analogy but not for a handaxe: in the archaeology of human evolution the artisans, like many of their more recent counterparts, are forever anonymous. So what led to the collection of the Gray's Inn Lane handaxe and how is it still on exhibition today?

The Gray's Inn Lane handaxe has sometimes been cited as the first stone tool to be published as an ancient tool or weapon in times when such shaped stones were generally regarded as being of supernatural origin: made by elves or fairies or having fallen from the sky. Unfortunately, the resulting implication that the Gray's Inn Lane handaxe represents the triumph of rational empiricism over superstition is not true. While the Gray's Inn piece is certainly the first handaxe to be published as an ancient artefact, other types of stone tool had been described and illustrated as such in both British and

continental works of the late 17th century. By the time John Conyers found the Gray's Inn Lane handaxe in 1673 no literate person would question that such an object was anything but another new type of humanly manufactured implement. What really caused a stir was its discovery next to an elephant tusk.

At the end of the 17th century nothing was known about ice ages, climate change, evolution or extinctions, so the implications of this juxtaposition were profoundly challenging. There were two possible explanations for it: the elephant could have been drowned by the biblical flood but, given the handaxe, this would mean there were people in Britain before Noah's sons had been sent out to repopulate the earth after that catastrophe. The alternative possibility was that this was one of the elephants brought to Britain by Emperor Claudius during the Roman invasion of AD 43 and killed by handaxe-wielding Britons defending their territory. This was the safe, preferred opinion offered by John Bagford, a dealer and antiquary who published an account of Conyers' find in 1715. It was in line with the views of the great naturalist Niels Stensen known as Steno, who explained the occurrence of elephant remains in gravels of the River Arno near Arezzo in Italy as evidence of Hannibal's invasion. Steno's work had been translated into English and published by the Royal Society in 1679 and was well known to the antiquaries in Conyers' circle. However, looking at Conyers' manuscript notes, it is possible that he did not publish his own finds because he was finding it difficult to justify how the elephant remains could have ended up dispersed in the gravels by the force of the river current in Roman times. This required that the elephants were brought by boat along a navigable river and slaughtered on landing. Conyers wrestled unsuccessfully with this problem whereas Bagford ignored it, preferring to celebrate the work of an Ancient Briton rather than grapple with a controversy about its potential age.

At the time of its discovery, the Gray's Inn Lane handaxe was clearly valued. From Conyers' own museum in Shoe Lane it passed to the collection of the controversial Master of Merton College Oxford, Dr Charlett, and then to the London antiquary John Kemp, better known for his interest in coins and classical material. When Kemp's collection of fine Greek and Roman items was sold, the handaxe was eventually acquired by Hans Sloane and finally, through his auspices, The British Museum where it remained the only object of its kind for the next 150 years. Its survival confirms that it was considered an interesting, if contentious, piece. Having acquired the handaxe, Sloane did some remarkable research on elephants, drawing together the published records of finds from all over Europe and following up accounts by travellers in Russia, and collected for Tsar Peter the Great, of frozen mammoths found in Siberia. He concluded that the European elephants and mammoths must have lived at a time when the climate was different before Noah's flood. Perhaps to avoid controversy, Sloane did not mention the handaxe, but as the 18th century progressed and the concept that there had been a period of human activity prior to written history developed, antiquaries frequently referred back to it.

By the 1790s the geological work of William 'Strata' Smith and James Hutton had led to the widespread acceptance of the much greater age of the earth, and antiquaries were also referring to an unspecified but longer timescale for prehistory. When handaxes were found at Hoxne in Suffolk in 1800, John Frere told the Society of Antiquaries that they were made at 'a very remote period indeed, even beyond that of the present world', echoing in its latter part Hutton's view that the earth was so old and had so repeatedly changed that 'there was no vestige of a beginning'. However, it was not

the Hoxne discovery which was invoked when, in the 1860s, the question of human antiquity was reinvigorated by Darwin's theory of evolution and a group of eminent geologists, palaeontologists and antiquaries visited the Somme Valley in France to examine the discovery of handaxes with the remains of extinct animals. Finding them to be contemporary remnants of a newly recognized Ice Age period, the savants recalled the Gray's Inn Lane handaxe and recognized its significance. The object has opened most histories of archaeology ever since.

Exhibited in Room 1 of The British Museum, the Gray's Inn Lane handaxe is now shown amongst other natural and artificial things which altered our understanding of history and nature in the 18th century and provided the intellectual impetus, as well as the practical knowledge base, for the economic and social changes of the industrial revolution and the artistic aspirations of the Romantic Movement. As well as being a stone tool deftly made for some everyday task some 350,000 years ago, it is an object which stands for the history of ideas which could only be explored and developed in the milieu of a stable, tolerant society. This history justifies its presence, but what of other everyday items, ancient and modern, which lack such association?

We tend to forget that history is often a means of justifying the present. In the context of museums and galleries it is also the narrative which enables us to build up a reassuring accumulation of treasured objects which not only project the acquisitive compulsion of consumerism, but also provide a reflection of what culture we value and how we wish to project ourselves through it. In many of the world's major museums and galleries the collections are confined to works of art from the great civilizations. The objects revered are priceless items which played no part in the daily lives of the majority of people in the hierarchical societies in which they were made. This is not the case at the British Museum, the Smithsonian, the Hermitage or Peter the Great's *Kunstkammer* in St Petersburg. In these institutions, all founded during the Enlightenment, the ordinary paraphernalia of prehistoric and recent life are collected though archaeological excavation and anthropological fieldwork with as much enthusiasm as the instantly recognizable masterpieces of world culture. Elsewhere they are excluded and passed to specialist natural history or anthropological collections. The consequent repetition of what culture and types of society we should respect has conditioned our expectation that the products of elites are what we should see, whereas the genius of everyman may be relegated and pejoratively judged as 'other' because it does not leave us in awe of the power, wealth or faith of the society which produced it. Of course, we should gaze in wonder at great works, but a reminder of our common origins, basic needs and everyday ingenuity tempers such icons with less chauvinistic themes which we could equally explore and respect for their relevance to modern life in the way of the Enlightenment. It is perhaps this rather than history which should justify a place for an object on display.

Jill Cook

Department of Prehistory and Europe, The British Museum

THE HOMIES, OR THE LAST ANGEL OF HISTORY IN SILICON VALLEY[1]

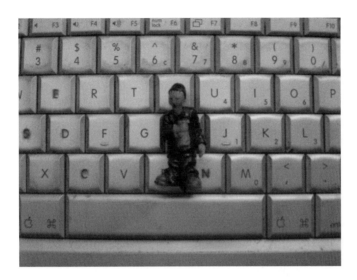

The last decade or so has witnessed an explosion of collectable plastic figurines for sale on the world market. Leading the way have been the Homies, a popular line of very small, plastic figurines representing the largely Chicana/o inhabitants of an imaginary barrio. These finely detailed and painted figures of various barrio 'types', with names like "Smiley," "Shy Girl," and "Spooky," are widely sold in gumball machines, at swap-meets, and on eBay. Each of the almost 200 Homies has a name and a brief biographical sketch, and together over 100 million have been sold. They have been so successful that their creator, David Gonzales, is developing a Homies TV series, video game, and movie. Gonzales works on the expanding Homies merchandising empire from his office in Oakland, and he has based many of the figures on people from his hometown of San José, the Chicano metropolis directly adjacent to northern California's Silicon Valley. In this context the Homies have emerged as revealing iconic responses to the history of information technology in Silicon Valley and the euphoric fantasies of technological progress that accompanied it. In contrast with studies of IT and cyberspace that focus on their transcendence of time, space, and materiality, the Homies invite us to reconsider the ways in which ideas and fantasies about new media emerge in relationship to material conditions of production that depend upon the exploitation of racialized and gendered migrant labor.

By the mid 1990s, a new, high-tech economy had emerged in Silicon Valley, and, for those who profited, such growth sustained an optimistic ideology of progress through information technology. Its promoters projected that the IT economy would transcend many of the limitations of the old, industrial age of capitalism that it promised to super-sede. At the same time, however, the new industry reproduced forms of labor exploitation that recalled earlier forms of production. The dot.com boom depended upon an expansion of low-wage jobs and the employment in particular of migrant women in

Silicon Valley, the US/Mexico border region, and other parts of the world. Many low-wage jobs in IT production are dangerous, exposing workers to highly toxic chemicals. Moreover, during the boom, Silicon Valley was highly segregated, and Mexican and Asian workers lived in poor neighborhoods vulnerable to the dumping of toxic waste generated by IT industries. In response, workers have organized unions and environmental organizations, including the successful unionization of janitorial workers at Apple and other companies in Silicon Valley, and environmental justice organizations such as the Santa Clara Center for Occupational Safety and Health (SCCOSH) and the Silicon Valley Toxics Coalition (SVTC) that fight the disproportionate vulnerability of workers to disease and death from exposure to industrial toxins on the job and in their neighborhoods.

The Homies express these conflicts between capital and labor by alternatively undermining and reproducing industry fantasies of technological progress. In recent history, the increasing speed and shrinking size of new communications technologies have been represented as signs of technological progress, the commodity fetishes of the information age. This emphasis on speed and size tended to symbolically dematerialize communications commodities and the labor that produced them. In the first instance, the speed of information flows promised to melt formerly solid geographical distances into thin air, enabling consumers to communicate in real time with people in vastly distant places. Moreover, this manner of fetishizing the new technology tended to displace alternative representations of space such as the segregated work sites and neighborhoods in and around Silicon Valley. In the case of size, the style and form of shrinking computers and cell phones suggested commodities that were so high tech that their thin margin of materiality seemed on the verge of vanishing without leaving a trace of the labor that made them. In these ways, narratives of technological progress contributed to forms of reification that seemingly "disappeared" the labor of the women of color who built Silicon Valley and other nodes in the high-tech economy.

Collectively, the Homies gave three-dimensional shape to these contradictions. From one perspective, they effectively leveraged counter images of the micro that, instead of obscuring labor, actually foregrounded the Chicana/o working class. From this vantage point, they represent the return of the oppressed workers disappeared in dominant depictions. From another perspective, however, as commodities themselves, the Homies replicated the reifications of shrinking cell phones and computers. Individual Homies recalled the icons and avatars of cyberspace, whereas prepackaged Homies, geometrically arranged and covered in modular clear plastic, resembled computer disks and microchips. All of which reminds us that Gonzales is himself a sort of information capitalist who markets the Homie brand to manufacturers and other licensees. Recalling the horizontal disintegration of production characteristic of post-Fordism, Gonzales in effect subcontracts with other companies in order to produce the Homies. But if the Homies represent the occluded Chicana/o working class, who makes the Homies? All of the figures in my collection have "Made in China" stamped on their backs, suggesting that the Homies have followed the strategy of the many IT companies that have turned to manufacturing zones on the coast of China in search of cheap female labor.

Similarly, the Homies also represent contradictory responses to influential discourses about speed and new media technology. Whereas discourses of speed promise to enable the users of new technologies to compress time and space and transcend temporal and geographic boundaries, the Homies are imaginatively rooted in a barrio with well-defined borders. By focusing on the distinctiveness of the barrio, the Homies'

neighborhood marks the forms of segregation and uneven development that have characterized information capitalism. In contrast to a progressive narrative of technological speed triumphing over space, the Homies' barrio reminds us that the information age has also reproduced local geographic differences. Rather than simply compressing time and space, information capital reproduces differences between, on the one hand, the exclusive neighborhoods of Silicon Valley millionaires and, on the other hand, the working-class barrios near one of the many regional Superfund sites produced by the high-tech industry's dumping of toxic waste. The Homies also indirectly reference the race and gender segregation within the industry. Whereas Silicon Valley companies expressly target immigrant women for low-wage jobs, the Homies' neighborhood includes more men, many of whom are involved in activities in the informal sector of the economy, including petty crime. With what one newspaper account called their "shady history," many Homies represent the reserve army of male lumpenproletarians who are excluded from low-wage work in the formal sector.

A good example is the Homie called "Wino." According to his on-line biography, "Wino" used to own a "Dot-Com website company" but he returned to the barrio and became an alcoholic when his company failed: "He used to drink Crystal and Dom now it's Ripple and T-Bird." In contrast with the upward arc of conventional narratives of technological progress and boom time upward mobility, Wino's story is circular, returning to the same limited barrio conditions and prospects with which it began. By representing a perspective from below on the dot.com boom, figures like Wino undermine fantasies of technological progress by suggesting that new developments in IT industries coincided with older forms of barrio segregation and poverty.

While the Homies seem to represent the intractability of spatial segregation and inequality in the face of IT's compression of time and space, however, their own mode of production presupposes just such time/space compression. Gonzales developed his products on the margins of the new economy and ultimately mimicked some of its central practices. He markets the Homies on the web and presumably takes advantage of the novel forms of "just-in-time" production that the Internet and subcontracting with Chinese manufacturers enable. As these examples all suggest, at one and the same time the Homies undermine and reinforce the ideas and practices associated with IT industries in Silicon Valley, combining the perspective of the worker with that of the capitalist.

In contrast with other approaches to reading cultural objects, in which they are effectively praised or blamed for the subversive or dominant ideas they supposedly encode, I have instead attempted to construct a dialectical materialist interpretation of the Homies which focuses on how they represent the labor relations that have characterized the recent history of the information age and new media, contexts which are often discussed as if they had little to do with labor. On the one hand, the Homies bring into critical relief the phantasmagoria of information technology, defetishizing the dream worlds it conjures up by representing people and places exploited or rendered disposable within IT economies. On the other hand, however, the Homies also reproduce ideologies of technological progress that obscure the labor that produces the plastic figures themselves. Icons with two hands, the Homies are what Walter Benjamin called "dialectical images" that express the raced and gendered contradictions between capital and labor that have informed the IT economy. Which is finally to say that the Homies are contradictory because the contradictions between capital and labor that they express continue to dog us, even in a world of virtual realities.

Note

1 "The Last Angel of History" is a reference from Walter Benjamin's essay, "Thesis on the Philosophy of History." My account of Silicon Valley is drawn from Lisa Sun Hee Park and David Nabuib Pellow (2002) *The Silicon Valley of Dreams: Environmental Injustice, Immigrant Workers, and the High-Tech Global Economy*, New York: New York University Press, and Stephen J. Pitti (2003) *The Devil in Silicon Valley: Northern California, Race, and Mexican Americans*, Princeton, NJ: Princeton University Press.

Curtis Marez

Critical Studies, University of Southern California

INSIDE AND OUTSIDE THE iPOD

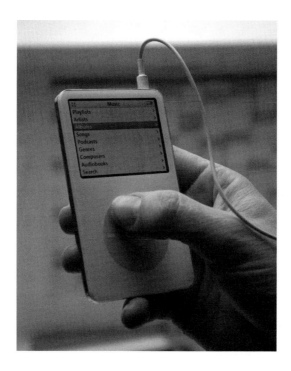

Few instruments of personal and collective pleasure have gained so much design discussion as the iPod. *Almost* every aspect of it has been familiarized into everyday parlance, creating new words (e.g. 'podcast') and expressions ('iPodding'). Its features have generated verbal shortcuts to imagining the whole object: 'clickwheel' and more recently 'touchscreen'. Even its chief designer, Jonathan Ive, has become better known simply as 'Jony'.

The ubiquity of iPod-derived language may be explained by the sheer volume of sales of this most social of personal music players. From its launch in October 2001 to early 2006, 50 million iPods had been sold. It was estimated that sales would outstrip the Sony Walkman and Discman's cumulative units of 309 million over 27 years by 2012, despite being in a more competitive marketplace than its predecessor. By this year, new market penetration was tailing off – consolidation was to be through repeat sales with a replacement cycle of 18 months (Credit Suisse 2006).

The iPod might have moved through the classic product lifecycle curve of introduction, growth, maturation and decline like its evolutionary predecessor, the Sony Walkman. The difference that challenges such business school orthodoxies is that the iPod has gone a lot further. Upgrades have moved beyond incremental changes of style to step changes in capacity and performance. More importantly, it is hard-wired into a set of commercial and social networks. Usage is contingent on its supporting iTunes software which takes one directly into the entire Apple download retail system. By 2006 over a billion tunes and 15 million movies had been downloaded from the iStore (Ferguson 2006) – profit from downloads is the staple bread-and-butter that the iPod instigates.

Use takes you from the object to a more extensive system of technologies and commercial actions. It also moves from intimate, personal use to social worlds. Thus the object has to be analysed in its own terms as well as within a constellation of aesthetic gestures.

Formally, the iPod is highly ordered. Its uniformly white or black front, sans serif typeface and uncompromisingly minimalistic rectilinear interface provide a visual clarity. The conjunction of circle and rectangle, sharing the same proportions, anchors it into a modernist canon of geometrical platonic perfection. This is completed by your own content. It is the perfect, metaphorical 'white cube' within which you can curate your personal sound collection. Meanwhile, where the fascia offers an environment to 'step into', its reflective back acts as a protective mirror. It invites engagement and repels detachment.

Its curved edges encourage holding and this is where the intimate interaction begins. Using your iPod is more than just listening. It entails an entire bodily immersion. Once in use, the iPod delivers correspondence between tactile, visual and aural experience. Its clickwheel provides a raised textured surface. This acts as a visual signature for the object but also as its touchpoint. Circular stroking and scrolling through the menu on its screen brings together touch and sight. This action is completed as sound is selected and delivered through its distinctive white earphones. The iPod invites touch, holding, manipulating, caressing. Its surface is an exoskeleton to an intimate technology. The addition of an iSkin – an optional thin covering – adds to this notion. And so it turns the user into part cyborg, extending the body into an electronic gadget and that digital technology back into the body.

Once this embodied experience is instigated through the object, then it connects the body to space and action. The iPod's capacity to archive sound and for this to be arranged in personalized formats, for example through the creation of specific playlists, means that, in turn, it becomes instrumentalized in the creation of soundtracks to everyday activity. Listening to certain tunes to accompany particular activities – commuting, jogging, ironing – turns these ordinary actions into filmic experiences. A verve for photographing one's iPod at distinctive global tourist destinations and uploading this image onto the iLounge.com website reinforces this equation between specified sound and place. The exoticism of such destinations is made familiar by the proven presence of an iPod and the memory of what was being listened to at the time. Individual engagement with the object is constantly linked, then, to an outer world. Sometimes the connection via the iPod is to mundane activity, sometimes to extraordinary moments.

Having collected and archived tunes, layers of other activities are engaged through and beyond the object. Swapping music files with friends, making the iTunes library available to inspection and use by others as both a self-identifying act and a socially bonding process, following up news on the plethora of websites and blogs devoted to the iPod: these few examples belong to a set of 'second-order' activities that expand the range that constitutes the iPod project and shift its use from the individual to the social. This is where iPod content is discussed, compared, analysed or shown-off – where its existence and meanings, and the consumption thereof, are articulated and made familiar. Swapping tunes, iPod DJing, surveying each others' iTunes library connect the object and the individual to something bigger. The legibility of the object and its interfaces facilitates these connections. The iPod becomes a node in a series of social vectors.

However, there is one crucial vector – between production and consumption – that

is interrupted. In his book *Empire of Signs* (1982), Roland Barthes describes Japanese packaging. The more elaborate the product 'clothing', so the more trivial is the final object of desire. Barthes goes on to equate this verve for packaging with a profusion of 'instruments of transport' in Japan, noting how every citizen in the street carries some sort of bundle. Putting these thoughts together, he concludes that fabricated objects must be 'precise, mobile, and empty'. There is precision in the iPod's minimalistic design and mobility in its connecting to infinite locations and constellations of use.

Meanwhile, inside, deep inside, much of the iPod remains enigmatically empty. Its shiny, resistant exterior does not afford entry points to its inner workings – there are no screws, hinges or clips to give access. Equally, product development at the Apple design headquarters in Cupertino, California, is undertaken in strict secrecy. 'Jony' gives few interviews and glosses over details of the working processes of his design team. He and Apple chief executive Steve Jobs live 'typical', very ordinary home lives that give no possible clues to their inner motivations as creative people.

Enthusiasts are left to ruminate on the form and functionality of the next iPod or iPhone to be released via discussion websites. Cultural historians contemplate its phenomenological meanings. The object gets filled out through loading files and connecting it into networks of discourse and use. Consumers produce meaning for themselves. But as ever in advanced capitalism, these actions divert attention away from the real connections with productive base, whether that be its design in Cupertino, California, or final assembly in Longhua, China. The iPod remains the ultimate personalizable alienating object.

References

Barthes, Roland (1983) *Empire of Signs*, London: Jonathan Cape.
Credit Suisse (2006) 'iPod: How Big Can It Get?' (report).
Ferguson, K. (2006) 'The Anti-Pod: After Michael Bull's "Iconic Designs: the Apple iPod"', *Senses & Society*, vol. 1, no. 3, pp. 359–66.

Guy Julier

The Leeds School of Architecture, Landscape and Design, Leeds Metropolitan University

THE LC4 CHAISE LONGUE BY LE CORBUSIER, PIERRE JEANNERET AND CHARLOTTE PERRIAND, 1928

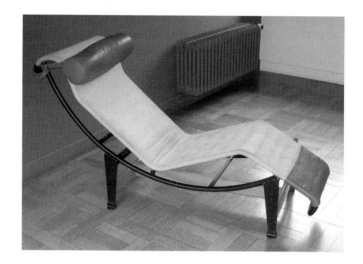

The strikingly modern-looking LC4 chaise longue was designed by the French modernist architect, Le Corbusier, aided by his cousin, Pierre Jeanneret, with whom he frequently collaborated, and his assistant, Charlotte Perriand, who worked with him on the development of most of his furniture designs (although that fact was not fully acknowledged until late in her life). The chaise was originally conceived as a piece of seating 'equipment' for Corb's Villa La Roche, a house built in Paris, in 1925, for the Swiss banker and art collector, Raoul La Roche. A later version of it appeared in the architect's *Villa Church* of 1928/9, while at the 1929 Salon d'Automne in Paris it was presented in an even more developed form. Designed, as were all Le Corbusier's furniture designs, for mass production, it went through several evolutionary stages until it reached its final form.

On one level, however, the chaise has never been a single, fixed object. The Thonet company acquired rights to the design and produced it, albeit in limited numbers, in the early 1930s. A Zurich firm, Embru-Werke, took over production in 1932. In 1940–1, during a visit to Japan, Charlotte Perriand created a handmade version of it in bamboo. When the production rights were later transferred, firstly, to Heidi Weber in the late 1950s, and thence to the Milanese furniture manufacturer, Cassina, in 1964, it acquired yet another life. Subsequently numerous cheap copies have appeared in the marketplace, and the Vitra Museum has even produced a miniature version of it for collectors.

Given its ever changing nature and its rich 'life story' it is difficult to locate the definitive chaise longue. That is compounded by the fact that it has become an 'iconic' object, one, that is, that, through its widespread dissemination through the mass media, has entered the public's consciousness as an embodiment of the values of inter-war architectural and design modernism – those, in particular, of a utopian model of social democracy

and of the elimination of the distinction between the public and private spheres. Indeed its high level of symbolism distinguishes it from other, more quotidian, objects transforming it into what Roland Barthes has called a 'second level signifier' or 'myth'.

As a visual, material and spatial object the chaise has a number of defining characteristics. Formally, its curved silhouette represents the reclining human body. Perriand undertook studies of figures in different positions when she entered Le Corbusier's studio in 1927, and 60 years later she explained the origins of the chaise by drawing a soldier resting on the ground with his feet raised against the trunk of tree. Le Corbusier defined his furniture items as pieces of equipment, rather than furnishings. The various chairs he created represented the activities of working, conversing and resting, the chaise facilitating the last and performing the role of a 'machine for resting in'. Drawing on a furniture typology which had Greek, Etruscan and Roman origins, which reached new heights of elegance in the 18th century, and which subsequently moved into the 19th century in the form of Thonet's rocking chairs and the deckchair, Le Corbusier's immediate sources included the 'Morris' chair (in 1922 a reclining chair of that type had appeared in a sketch of a living–dining area) and reclining chairs used for health-giving purposes, including those used in tuberculosis sanitoria. Historians of the chaise have pointed out that the architect was particularly inspired by a contemporary chair, the 'Sur-repos', which was invented for therapeutic purposes by a Dr Pascaud. Le Corbusier's dependence upon non-domestic models reinforced his deeply felt anxieties about nineteenth-century bourgeois domesticity and underpinned his commitment to bring a sense of modernity into his environments.

Materially the message was much the same. In 1929 Perriand – believed by many historians to have provided much of the chaise's conceptual underpinning and detailing – explained that 'Metal is playing the same role in furniture as concrete has for architecture. It is a revolution'. Black-painted steel was used for the base, and chromed tubular steel for the support frame. Rubber, springs and screws, purchased in a bazaar, were used to link the canvas of the first model to the frame, while the foot-rest and head-rest were made of leather. In later versions the canvas was replaced by a black leather upholstered seat, and pony-skin versions were also produced. For a special, one-off *Chaise*, designed for the Maharajah of Indore, tiger skin was employed. The predominance of industrial materials contributed to the 'rational' machine aesthetic to which Le Corbusier and his collaborators aspired. Also, most importantly, the metal's inherent strength permitted the chair's designers to create a skeletal structure which would not disrupt the space it occupied. Although Le Corbusier used mechanical and functional metaphors and analogies to define his furniture designs, the movement of the frame of the chaise, which enabled sitters to lie back with their feet in a raised position, was not achieved by cogs or levers but merely by the recliner's movements.

While the materials used to construct the chaise played a key part in its functional and symbolic role, its spatial aspirations worked in tension with them to a certain extent. Inasmuch as its skeletal structure sought a high level of immateriality, there was an attempt to reduce the chair to an abstraction, to, that is, an activity rather than a material possession or commodity. That ambition accorded with the designers' abhorrence of what they saw as the excessive materialism of Victorian domesticity and their desire to sever what had been perceived in the 19th century as the inevitable links between comfort and visual display. Above all, the modernists sought openness and transparency in their objects and their interiors. That was not to deny their occupants a level of

comfort but it had to be compatible with their immaterial ambitions and their desire to create spatial continuity between the inside and the outside of their environments. Such was the portability and flexibility of the chaise longue that it could be easily moved, as in a sanatorium, from inside living spaces to open air balconies and verandas.

Ultimately the visual, material and spatial characteristics of the chaise combine to communicate the core messages of modernism. As suggested above, however, the object was never fixed but it evolved, rather, over time. Its meanings were necessarily transformed, therefore, as it was modified and the context around it changed. It also sat at the centre of a fundamental paradox. While it was overtly linked with modernist ambitions it remained, until recently, an élite object. Always produced in relatively small numbers, its manufacture was complex and costly and it fulfilled the taste requirements of an intellectual minority. Only recently, now that it has been recognized that the social agenda of modernism was unrealizable, and that the movement's main contribution was a stylish, minimal aesthetic which sits alongside others in the mass consumer marketplace, has Corbusier/Jeanneret/Perriand's chaise longue become, ironically, a popular appendage of modern environments on a significant scale. As the author of an article in a 2002 *Good Housekeeping* magazine explained, 'Hard to believe that such a contemporary-looking piece is 75 years old'.

Penny Sparke

Faculty of Art, Design, and Architecture, Kingston University, London

MATERNAL OBJECT: MATRIXIAL SUBJECT

It is Mother's Day 2008 in the United States. I am in New York when I finally sit down to write my 'object lesson' which will be about an 'artwork' reviewed under the title 'Mother's Day' by film critic Amy Taubin in *Art Forum* in October 2005. In it, the mother in the film says 'My dear girl, I am so happy to have lived to see this day'. So is Amy Taubin. Tenuous as the connection seems, it allows me to talk about a film that concerns a maternal object, an object belonging to and connected to someone's mother, and how it functions as the site of and for matrixial trans-subjective connection in the face of the loss it bears and displaces.[1]

The object I want to discuss is, therefore, embedded in this artwork that, however, refuses to be an object itself, and also cannot be reclaimed as an *art object*. This is not just because the medium is video and the work is made by a renowned filmmaker. It is because something critical happened to art and its objecthood at a certain moment in history, in art history, sometime during the 1960s, which took a while to filter into art critical language and into art history, still thinking its job was to deal with, focus on, and protect the imaginary thing: the art object that is meant to be at the heart of art history.

When Western art became a critical space, a theoretical space and propositional space following the major reorientation of conceptual art and became an invocation to subjective encounter through its use of new media, its objecthood was displaced and the potential for art to divest itself of objecthood without losing its specificity as a creative, semiotic and affective economy was radically enlarged. The extent to which the 'end of the object' was necessary for the beginning of an expanded potential for art to be a space of enunciation and inscription of other affects, traces and subjectivities, including those of varied minorities and differences, is still to be fully, or even crudely, asserted. I suspect it to be the case. So for me, as a writer on art, this challenge to think about the object has been not at all simple. Either I no longer deal with (art) objects at all, since, as a good poststructuralist feminist, I now write about *texts*. Or the object, in so far as it comes into view, is already framed by a meta-textuality of the new kind of work art — artworking — now does. Art may work with objects: found, used, freighted, reframed, made to bring in history, or to mark loss. Objects become the site of affects and relays of time.

But there is another sense of object at play. From a classically Freudian psycho-analytical perspective, the object is theorized as the means by which a drive achieves the satisfaction which is its aim. Drives have aims and objects by which the aim is met. The objects in question here might be the breast, the gaze, the voice, the mother's body. Such objects are clearly not thing-objects; they are already a psychic object: that is, a representative of the unthinkable shapeless thing (lack) to which the object gives a kind of thinkability and shape through which temporary substitutive relief from absolute lack can be achieved. That would be the Lacanian model. Psychic objects are furthermore illusory veils for what Lacan called the *objet a*, which are the unthinkable traces carved into the scarred psyche of *missing* objects: psychic objects known only in their missing-ness – the breast as lost, the voice as lost, and so forth; hence these become the 'objects' of desire, that for which we long, hopelessly, repetitiously, in vain.

This model has been modified by feminist Lacanian revisions in which the Lacanian absolute lostness of the *objet a* is revised as never completely lost for it is not fantasized as having been once completely possessed. Thus, outside an either/or logic, Bracha L. Ettinger poses a 'matrixial *objet a*' that registers the undulating sense of a solace in which having versus not having is replaced by longing for a moment of transsubjective connectivity and sharing that is never resolved into the phallic opposition of presence/absence, but manages a yearning for connectivity that can also tolerate at the same time a sense of separateness and difference. This is vital as we think about rupture, about death or trauma and living with either.

Thinking the object psychoanalytically at another level is more tricky but relates to this insistence on the intersubjective. In 'Object Relations', developed by Melanie Klein and her British followers, the object in object relations is in fact another subject, and the point is that from earliest infancy the emerging human subject is involved in a form of intersubjective play initially with part-objects – breast, voice, gaze, and then with whole objects: discrete others, such as the Mother. These objects are not used, but are neces-sary means to realization of needs, posed as demands and thus caught up in the intersub-jective interplays by which fundamental necessities of living organisms become subject to psychological freighting and weighting and imaginative investment.

Thus, even if a certain theoretical turn in critical thinking about art rejects the idea of art as objects of dispassionate contemplation and judgement and asserts instead that they operate as critical spaces of proposition and inscription, we can still track in them the working of psychological, affective investment through 'objects' that function as psychic representatives through which the plays of connectivity and separation are traced into cultural practice.

Let me shift from this abstruse beginning back to my focused case study: the object in question.

In 2004, Chantal Akerman created an installation at the Pompidou Centre titled *To Walk Next to One's Shoelaces inside an Empty Fridge*. Widely regarded as one of the lead-ing experimental filmmakers of her generation, the Belgian Akerman now has a gallery, Marion Goodman, and her work is often presented in exhibitions where film and video work can be presented under the expanded art rubric of installation. She has moved from the Warhol- and Godard-inspired independent film circuit to the artworld, where alone it now seems that such formal explorations using time-based media can be housed.

Akerman's 2004 piece operates across two spaces. In the first a double spiral made out of transparent tulle draws the viewer into and moves them out of a disorienting

labyrinth of delicate material across which streams, too fast to read and keep in focus, filmed words. Once through this double spiral, the viewer encounters another hanging scrim of tulle on which is a projection of a page of a notebook and a small watercolour portrait of a large-eyed young woman. So far no objects, only illusions. Beyond this veil is a double-projection on the wall of a 22-minute film featuring Chantal Akerman herself and her own mother. The topic of their filmed exchange in a Brussels apartment is the notebook itself, held in their hands, read and debated in a real space. The book, it transpires, was made by and is about the large-eyed woman of the portrait. It is the only object connected to her that remains to those who handle it. The object becomes, therefore, a subjective trace, a bearer of memory, a monument, tiny as it is, a memorial, a relic, an inheritance, a thread linking an absent person to those present to each other and to us on the screen, a transport across time and space. As the film unfolds, the filmmaker is asking her mother to read out loud for posterity the faint pencil marks of the handwritten notebook. It is written in Polish, and dates from 1920–2. It is revealed to be the private diary, written in her teens, of the reader's mother, Sidonie Ehrenberg, the filmmaker's grandmother, who was killed in Auschwitz in 1942 when she was in her mid-30s.

For me, as for Amy Taubin, and I am sure for all of us who have followed, enthralled, the long career of Chantal Akerman as a filmmaker working through in often shocking and violent as well as tender ways the idea of the mother and mother–daughter filiation, this installation work represents a culmination and a retrospective key to a whole body of work, now hinging that maternal theme directly to a horrifying and traumatic history of the Shoah.

> This diary, with entries written by three generations of women, is the Rosetta Stone not just for this piece but for Akerman's entire body of work in film, installation, and performance. As the filmmaker explains in her conversation with her mother, she is compelled to speak because her grandmother and mother were silenced, first by the traditional Jewish culture in which they were raised, then by the Holocaust, which left one dead and the other 'broken'. It is this maternal bond – the primal connection – that gives her formally austere work its emotional power.[2]

Taubin is suggesting that the entire film oeuvre of Akerman might be read as a long journey back to this object, that could not, however, become itself without the journey because of the pain, the trauma and the horror, that hovered around it, haunted it, infused lives lived in the shadow of the Shoah, that vast and terrifying multitude of deaths, that moment of the single, life-defining death for Nelly Akerman of her own mother, she who would then mother two daughters, one of whom would glean the traces of these lives and confront them by making a film about this object, at last.

The object, the diary, was somehow preserved, passed on from the murdered mother to her 18-year-old daughter on her own liberation in 1945. She cannot remember how she, a traumatized adolescent, acquired this personal relic of her mother's anxious, lonely adolescence. In it, however, in 1945 she immediately inscribed a message to her dead mother, a message of her own sense of love, loss and commitment to the memory of her mother. Given to, or found by Chantal Akerman as a child, the diary became a space for her own third-generation feminine addition. She read her mother's

inscription to her lost mother, Akerman's never-known grandmother, the haunting figure of loss present, however, in the diary through her self-portrait, and added her own love letter to her bereaved mother in an act of childish compassion that surpasses what we might ever expect from a child. Yet it registers the way in which the matrix of transmitted trauma and ruptured connectivity fragilizes subjectivities across time and generation, revealing reversals of the expected orders, hierarchies and sequences of responsibility that usually run from adult to child. Chantal Akerman's sister also found the now tri-generational object and added her letter to her mother, doubling this generational reversal of care.

In the actual 'object', the double-screened projection, the writing and what is written are not shown. Instead, there is a period of silence, during which the mother is filmed reading these three supplements. As she takes in what she is reading, tears flow and she spontaneously turns and brushes with her hand the face of her middle-aged daughter, kissing her on the cheek. The meaning of the gesture – a Warburgian *pathosformel*– can only be 'explained' by the accompanying catalogue, by reviewers telling us what is written there. The viewer, however, without knowing the content, is witness to a sudden *punctum*: the gestural register by a touch and a kiss of the written gesture of compassion the object-diary literally bears into time, and history.

I met Chantal Akerman in New York in the late 1990s. I had just seen her film and installation *D'Eest* at the Jewish Museum, New York, and was interested in the acknowledgement offered there of the haunting trauma of the Shoah in her work, something invisible in the 1970s when she was hailed first as a feminist filmmaker. She told me then she was thinking about doing a piece about her grandmother who was an artist and who had been killed in Auschwitz. From the haunted landscape of Eastern Europe with its missing millions, she was moving in close to something intensely familial in this larger history. This is the work she produced. As intimate and pathos-ladened as most of her work is formally structured and dispassionate, it hangs on the great rupture in history that her own family lived out for which this one remaining object is the fragile link. The object, however, functions, as the installation insists with all its screens, veils and projections, as the surface for the textual inscription of transgenerational transsubjective matrixial affectivities: compassion from the daughters to their mothers in the face of loss. The event of making the film about the object in its intense fragility, its faintly traced words fading before their eyes, was an occasion not for handling a closed, fixed, defined object. The object they held in their hands and discussed, only because it was a link-trace, facilitated a moment of encounter with loss that in its intense affectivity allowed for the remaking of a connection whose visible sign was the pathos-gesture of the stroked cheek and the kiss that passed between the present and absent, the past and present. This is what Bracha L. Ettinger means when she tries to describe in both aesthetic and psychoanalytical terms a supplementary subjective dimension she calls the matrixial, when she thinks about art as a transport-station of trauma.[3] The matrixial object is, therefore, not an object in any sense I otherwise know. It is as deeply subjective as the Kleinians imagine. It is as deeply engaged with the dialectics of loss and absence as the Lacanians insist. But it also suggests that the boundaries between subject/object (subjects and their objects), or presence/absence, are not absolute. They are borderlines that become borderspaces which we begin to sense when aesthetically confronted with their workings. That is why certain modes of contemporary art daring to approach these borderspaces, opened and tinged by trauma, opened by means of post-

object based processes that make art the occasion for encounters, change the terms of our understanding of objects from their material to the psychic functions.

In this case, the object for such transport of trauma for Chantal Akerman was the diary of her grandmother. In my own case, writing about it, Akerman's installation becomes an object-transport station of trauma when I encounter it as an event. In writing about this, my object lesson is perhaps that I am always more involved with matrixial subjects than with objects, even maternal objects.

Notes

1 Matrixial is a theoretical term elaborated over the last 20 years by artist-theorist Bracha L. Ettinger. I will not explain the term, hoping instead that the usage within the following reading of an aesthetic process will instantiate its contribution to thinking about objects and subjects, aesthetically and psychoanalytically. For further reading see Bracha L. Ettinger (2006) *Matrixial Borderspace*, edited by Brian Massumi, with preface by Judith Butler and introduction by Griselda Pollock, Minneapolis: University of Minnesota Press.
2 Amy Taubin (2005) 'Mother's Day', *Art Forum* October 2005.
3 Bracha Ettinger (2000) 'Art as the Transport-station of Trauma', in *Artworking 1985–1999*, Ghent: Ludion.

Griselda Pollock

Centre for Cultural Analysis, Theory and History (CentreCATH) at the School of Fine Art, History of Art, and Cultural Studies, University of Leeds

MERMAID'S TEARS

On January 10, 1992, dishwasher-safe cargo spilled into the mid-Pacific. The accident occurred over 1,000 miles east of Japan and more than 2,000 miles west of Alaska. Encountering waves up to 40 feet, an as yet anonymous ship traveling from Hong Kong to Tacoma, Washington, had twelve 40 × 8 ft steel cargo containers wash overboard. At some point during the ferocious winter storm, or soon after, the cargo burst free from its container-cum-murky-crypt and bobbed to the surface. With the assistance of the abrasive salinity and cold water density of the mid-Pacific, the cargo's cardboard packaging soon came unglued to release its contents: around 29,000 "floatees"—plastic novelties for bathtub fun such as red beavers, green frogs, blue turtles, and the most iconic of the toys, the bright-yellow rubber duck made famous by no less than *Sesame Street*'s Ernie. Destined for the bathtubs of the US, these toys mass produced for the Massachusetts based company Kiddie Products (now The First Years Inc.) were lost at sea and never made it to their intended market.

This "life aquatic" does not end on these stormy waters: floatees float. Plastic, the "stuff of alchemy" for Roland Barthes, neither absorbs water, nor biodegrades. Estimated to have traveled seven miles a day on ocean currents, the weathered cargo began washing up on the shores of islands that form Alaska's panhandle. Since 1992, beachcombers have coveted the wayward floatees that landed at the Aleutian Islands, Puget Sound, Gooch Beach in Maine, Indonesia, Australia, and which were predicted to arrive on British shores in the summer of 2007 (one was reported to have already landed in Scotland in 2003). Had we an aerial view of the tens of thousands of floatees riding high on the currents of the mid-Pacific, the sublime scene may have prompted a comparison to American artist Robert Smithson's earthwork in the Great Salt Lake, *Spiral Jetty* (1970). Unlike the rock, mud, salt, algae, and rising water levels that comprise Smithson's 1,500-foot sculpture, the floatees' constant drift precludes a static pattern. Imagined as a "seawork" their appearance would be more akin to kinetic art, with the erratic movement of each individual object dependent upon ocean currents.

The visualization of floatees takes far more numerous forms than my analogy to art. One is the popular image of nostalgia. The world press ran many features on the great migration. Donovan Hohn's enthralling *Harper's* article on the floatees highlights a synecdochic relation between how the floatees are visually imagined and the actual material floatees adrift. He notes that the figure of the rubber duck has become the epitome of the spillage, the lone survivor. Eric Carle's children's book, *10 Little Rubber Ducks*, was inspired by the accident and champions this duck's tale. A paddling of lost rubber ducks "braving" treacherous waves to desperately find land is, after all, a happy narrative ripe with Disney/Pixar animistic overtones (all that's missing is Hollywood actor voice-overs and showboating critters wearing sunglasses). The rubber duck's iconic status serves as a nostalgic image, a harkening back to an idyllic and hygienic childhood. This image fossilizes connotations of childhood; to depict a decrepit and sun-bleached duck is to sour this sentimentality and undermine the frozen image of childhood bliss for the adult world.

While the constant image of the survivor duck works to preserve an imagined collective memory, another form of visualization through which the floatee is known is of an altogether different value system: as a plotting instrument for computer-simulated surface currents. Oceanographers Curtis Ebbesmeyer and James Ingraham began tracking sightings to simulate the path of ocean currents as well as raise awareness of the vast toxins of commercial debris that pollute the Earth's oceans. Floatee sightings, reported by beachcombers, help plot their drift routes. Their exact physical location—calculated, mapped, charted—enables the simulation of patterns of movement. The floatee is represented as a coordinate for information visualization. Ingraham of the National Oceanographic and Atmospheric Administration, in collaboration with Ebbesmeyer's network of beachcombers, recorded coordinates of documented sightings into a computer modeling system known as the ocean surface current simulator (OSCURs).

Beachcombing father and son duo, Dean and Tyler Orbison, shared the floatees that they've gathered between 1992 and 2004 at the 2004 Beachcomber Fair in Sitka.[1] Based upon the Orbison recoveries, Ebbesmeyer and Ingraham's drift simulator program concludes that the

> data indicate that flocks of toys completed four orbits of the [North Pacific Subtropical] Gyre. The first (two years) may be faster than the latter three, because the toys developed holes but continued floating full of water buoyed by the low specific gravity of their plastic.[2]

Its image, while simultaneously preserving affective value for popular imagination, is also statistical, an analytic, a survey instrument for cybercartography. Like buoys outfitted with transponders for oceanographic research, or sealife tagged and satellite-tracked for migration patterns, the floatee, too, functions as an informational image and valuable instrument for scientific research.

The smiling duck's bill of (failed) commodity-form cuteness and oceanographic instrumentation offers yet another image and tiny object-type for further consideration. Floatees are a fossil fuel-based synthetic polymer that degrades poorly and is incredibly difficult to recycle. The familiar smile becomes a cruel smirk as the hygienic object of bathtub play and affection reveals its ugly chemical constitution. The tons of plastic stuff that dots our everyday world promises disposability in its cheap guises while the

recycling of plastics proves laborious and expensive, degradation time is slow, landfills are severely impacted by the growing mass, and incineration may release harmful toxins into the atmosphere. Quack, quack: plastics are viciously durable. Hohn reaches a conclusion not too dissimilar from Barthes. Where Barthes scorns plastic for its imitative banality, ubiquity, transformative and leveling qualities, Hohn points to its uncanny fantasy capabilities as a broken promise of disposability that has helped "to create a culture of wasteful make-believe, an economy of forgetting."[3] A sun-bleached toxic duck may serve as a reminder; one not bound to nostalgic tones of childhood and make-believe alone, but to the responsibilities of sustainability and our continued cut-throat over-dependence on fossil fuels.

The floatee's object lesson resides in its mermaid's tears. The North Pacific Subtropical Gyre, 800 miles off the coast of California, goes by another name, the Eastern Garbage Patch or Great Garbage Patch. The weak wind patterns and sluggish rotating currents create a vacuum sucking in floating debris. Estimated to be the size of the state of Texas and invisible on the surface, this oceanic landfill spat out the following waste for Charles Moore of the Algalita Marine Research Foundation: "polypropylene fishing nets, a drum of hazardous chemicals, a volleyball 'half-covered in barnacles,' a cathode-ray television tube, and a gallon of bleach 'that was so brittle it crumbled in our hands.'"[4] Plastic rubbish, on account of being so light, rides the surface of the circular currents for years as it slowly disintegrates into increasingly smaller pieces. The term "mermaid's tears" describes the results of the photodegradation process that affects petroleum based products: sunlight assists in breaking plastic into tiny shards to litter the Earth's oceans.

The plastic tear is also reminiscent of another: the famous "Keep America Beautiful" Ad Council pollution-prevention advertising campaign of the early 1970s wherein a lone Native American sheds a mournful tear at the sight of vast pollution and the irresponsibility of industrial "progress." The US television campaign debuted on the first Earth Day on March 21, 1971 and included Hollywood actor "Iron Eyes Cody" (actually Italian-American, Espera De Corti, 1904–1999) as the unnamed Native American who paddles his canoe across a contaminated riverbank and comes ashore. There he is greeted by "litter-bugs" mindlessly tossing trash out of their speeding cars that lands at his moccasin-clad feet. The "Crying Indian" ad, as it is known, bore the anti-litter slogan of the era: "People start pollution, people can stop it". Iron Eyes Cody's orientalist and exoticist appearance—depicted as tribal, indigenous, noble, more spiritual and "in touch with nature" than "modern man," positioned as both out-of-synch with and victim of first-world industrial modernization—served as an historical (one might add, genocidal) and sentimental reminder for the ecology movement of that era.

In the television campaign from 1971 the litter-bug who flings trash out of their car and the ominous factory belching fumes into the air are portrayed as identifiable. The 'people who start pollution' within the free-market tides of global capital aren't as easily pinned down. The tear of the 21st century is petroleum based. It neither falls from human eyes, nor conjures the same sense of preventionist ideals. It is a minuscule object drifting across oceans, far away from land-locked eyes. Regardless of its size, mermaid's tears are chemical pollutant pellets—acting like a sponge for non-water-soluble chemicals such as polychlorinated biphenyls, known to contain high levels of toxicity, as well as dichloro diphenyl trichloroethane aka DDT—that interrupt the feeding-chains of the Laysan albatross (whose chicks starve to death from their steady diet of plastic) and are

commonly found lodged in the tissue of jellyfish, a filter-feeder who subsists by straining particles from the sea and common food source for North Pacific cod, herring, and flounder. The floatee's state of slow photodecomposition may well be an indigestible reminder to us as its chemical basis is absorbed in other sealife resting batter-fried on our plates next to chips.

Notes

1 The image that I've used for my object lesson is of the Orbisons' floatee collection. Are the beachcombers who gather the debris of free-market tides 21st-century historiographers? Do they challenge Walter Benjamin's 19th-century flâneur and rag-picker as isolated beachfronts signify the expansive cultures of global capitalism far better than modernity's urban spaces? Behind the angel of history's wings does a decomposing duck drift?

2 Curtis C. Ebbesmeyer (2004) 'Beachcombing Science from Bath Toys', www.beachcomb ersalert.org/RubberDuckies.html (March 1, 2008).

3 Donovan Hohn (2007) 'Moby-Duck: Or, The Synthetic Wilderness of Childhood', *Harper's Magazine*, January 2007, pp. 39–62, p. 61.

4 Cited in Hohn, p. 46.

Raiford Guins

Department of Comparative Literary and Cultural Studies & Consortium for Digital Arts, Culture and Technology (cDACT), State University of New York, Stony Brook

THE MUSEUM OF CORNTEMPORARY ART

I have been an avid collector since I was young. In grammar school, I amassed a large collection of comic books. By the time I finished high school, I had left them behind—except for my almost complete run of *MAD* comics—and added insects, which I mounted on pins in a Cuban cigar box (this was before 1959), LP jazz records, books, including some relatively rare volumes whose value I was unaware of at the time, and stamps, which I systematically mounted in my huge Master Global album.

During my college years and for a long time after that I was preoccupied with other activities—studies, travel, and finding myself. I continued to buy books, but mainly to read and not to possess as special objects. While a senior at Columbia, I discovered the New York galleries and spent much of my time looking at art. My parents were modest art collectors and landed a few prizes, including a watercolour by the former Russian Futurist, David Burliuk, and a plaster bust of a newsboy by the African American sculptress Augusta Savage. While growing up, I absorbed the visual influence of those and other works in my parents' house, only learning years later that a few of them were of significant cultural worth.

During the late 1960s, I started to purchase art myself, particularly from a local dealer in Washington, DC, whose shows were extremely eclectic. I enjoyed the exercise of aesthetic judgment that is at the core of art collecting and recall the moment when I first wished that I could be a major collector like Joseph Hirshhorn and buy enough art to fill my own museum. This goal seemed out of reach until the epiphany around 1990 that led to my founding the Museum of Corntemporary Art in my office at the University of Illinois, Chicago. I was inspired by the chance discovery in a gutter of a small ouzo bottle that was housed in a frame of plastic caryatids and capped with a top in the shape of an Ionic column.[1] What struck me about the bottle was the delicious impropriety of transposing the grandeur of Greece's architectural heritage to a small object that would have ended up as a pile of glass shards and broken plastic had I not seen some hidden value in it.

The acquisition of the ouzo bottle and a prolonged exposure to its aura led to my conception of a new *corntemporary* aesthetic that gave visual meaning to myriad objects that would otherwise be rudely treated as kitsch. Having embraced this aesthetic, I found myself in a territory that belonged to no one else and realized that with modest resources I could begin collecting corntemporary objects for a new museum that celebrated them and proclaimed their worthiness to the entire world.

Over the years I have had innumerable adventures in disparate places as I set out to build a collection of corntemporary art. I have traipsed through flea markets, souvenir stores, and junk shops in Mexico City, Singapore, New York, Miami Beach, Hong Kong, Helsinki, Rio de Janeiro, Havana, Sydney, and numerous other cities. From these and other places I have retrieved miniature chairs made from pop cans, Eiffel Tower perfume bottles, stereotypical Chinese couples that were made in Japan, a wooden truck with a doll-like Commandante Marcos, and Red Guard figurines that were purported to have been created during China's Cultural Revolution but were most likely contemporary fakes made in Shenzen. In the course of discovering these things, I have traversed the vast underbelly of global material culture and learned more than any university could teach me about the things that people around the world live with. Scholars are only now beginning to discover these objects as they publish books and articles on souvenirs and popular culture but for the most part they have gone undocumented and untheorized.[2]

My remedy for this situation was elevating my collection to the status of a museum. I assumed the role of director and have invited collaborators to write about the objects and curate exhibitions with them. As part of a university course on high and low art, I included a field trip to the museum in the syllabus. Students made the trek across the

hall from the art history department's seminar room to my office, where they spent time viewing the collection. Subsequently they wrote papers about it. Several students asked to curate exhibitions and did so with the concomitant fanfare of official openings and in one case a catalog.

I was also invited to exhibit objects from the collection at Sarah Lawrence College, where I presented a small group of artifacts on a shelf in an otherwise empty room. On one of the pristine white walls were huge black sans serif letters that spelled out "Museum of Corntemporary Art," making ironic reference to the graphic style of the Museum of Modern Art. Accompanying the exhibition was a lengthy mix of corntemporary music by Paul Lloyd Sargent, a sound and video artist.

The museum status has been meaningful in a number of ways. First, it has facilitated my ongoing performance as director and enabled me to walk the fine line between presenting the collection as a witty commentary on museum practice, while also actively calling attention to the objects as icons of social significance. Second, the objects, when placed in an institutional setting, have mediated a set of social relations with students, colleagues, and the public that would not otherwise have taken place. For the several students who curated exhibits from the collection, the museum provided a valuable learning experience as it did for others who wrote short class papers in which they selected particular objects for discussion. Third, the collection has stimulated others to look for related objects that they could contribute to the museum, thus causing them to reflect on what might be worth including and what might not. Fourth, the collection-cum-museum resulted in a book, *Culture is Everywhere*, that consisted of several scholarly essays and a collection of beautifully photographed dioramas by Patty Carroll. As one of the essayists, I introduced my alter ego, the critic Hermione Hartnagel, organizer of numerous exhibitions including *The Transgressive Tattoo* and the *Third World Bottle Cap*. Hartnagel also wrote the lead essay for a student-curated exhibition *Island Hopping* and curated her own show, "Operation French Freedom," as a response to the American invasion of Iraq. Hartnagel has become part of the museum's history as I have presented it at several conferences and is now inscribed in a narrative that is simultaneously serious and tongue-in-cheek.

The corntemporary aesthetic is based on a dialectical premise that the objects to which it applies are simultaneously socially meaningful and visually pleasurable. To treat such objects simply as icons of social value would be ponderous, while considering them solely as inconsequential but pleasurable examples of material culture would be frivolous. When recognized as both, they embody both resonance and wonder, to use Stephen Greenblatt's phrase. The Museum of Corntemporary Art can also take its place among other museums such as Claes Oldenburg's Mouse Museum and Marcel Broodthaers's Museum of Eagles. It is part of a discourse that raises questions about how museums endow their collections with meaning and as such it plays a vital role in current aesthetic debates.

Notes

1 I describe the incident and its implications in more detail in my essay "Culture is Everywhere: An Introduction to the Museum of Corn-temporary Art," in Victor Margolin

and Patty Carroll, *Culture is Everywhere: The Museum of Corntemporary Art* (Munich, Berlin, London, New York: Prestel Verlag, 2002).

2 Two pioneering works are Ruth B. Phillips, *Trading Identities: The Souvenir in Native North American Art from the Northeast, 1700–1900* (Seattle: University of Washington Press and Montreal: McGill-Queen's University Press, 1998) and Ruth B. Phillips and Christopher B. Steiner (eds.), *Unpacking Culture: Art and Commodity in Colonial and Postcolonial Worlds* (Berkeley, CA: University of California Press, 1999).

Victor Margolin

Professor Emeritus of Design History, University of Illinois, Chicago

NO THING TO REGRET . . .

For a young left-wing academic in the late 1960s and early 1970s, as for almost anyone else for that matter (but that both is and is not the heart of the question: the part that is hardest to acknowledge – that one is, in all too many respects, like almost anyone else), it was desirable to have an object in a world filled with lost objects; or, even better for those who had already lost some, an object of loss. That, I suppose, is part of what it was to grow up in the society of the spectacle just at the moment it was first named as such, already an intellectual *and* a fashion victim, both of which I hope I have remained.

Once I began to size up the political terrain I began to envy a whole number of different individuals for the way in which their loss or their attachment to lost objects located them so fluidly, so tragically or even comically, in the greater flow of historical events to which we were inclined to believe that we belonged. 'Men (sic) make their own history . . . *hic Rhodus, hic salta*' and so forth; so if the Stalin–Hitler pact or the suppression of the Hungarian uprising and Khrushchev's not very secret speech or the deposition of Dubček was your object of loss, Communism your lost object and 'actually existing socialism' your melancholic introjection of any one or any combination of these, you were indeed in clover.

You had something to talk about, to lament, a source of guilt as of ostentatious self-negation and, moreover, new ways of thinking about history and the history of objects in the commodity system that was and is our natural habitat.

That's why Maoism was such a stroke of luck for me: it was the best possible far-away thing, the phantasm-object-critique of the whole baggage of the West from its old to its new decrepitudes, from its capitalist excesses to its ageing Communists in constant sorrow. For a number of years after the defacing of the Ming tombs in China, some time in 1966, that grandly traditional, revolutionary vandalism sufficiently represented my own feelings towards the hallowed and stifling mellowness of the university, its intellectual vacuity, and it also stood for something outside the frame, my own frame and the framing metaphors of the worn-out narcissism of unending historical

respect – an attitude that my approximate generation is credited with having affronted and undermined – I hope. Yet even as I became involved I could envision the end of the affair, that I would sort out my life according to desires that had yet to name themselves, and that this singular event would turn out to be transient and an ego-ideal, if one for which attachment could never quite fade away.

For it was not the case that I would ever dare to step too far out of the frame, actually to go to China; importantly, as this timidity was also a talisman against the dreadful literalism that had led to the hung-over melancholy of the moment; '. . . *hic salta*' was never an injunction on which I was prepared to stake too much. Rather I was happy to play it all for the nth time, too, as farce. Provided, that was, I could learn to read the Marxist canon, at least try to stand up for social justice and against imperialism and still go clubbing, as well as attending plenty of *vernissages* on the London scene, sensuous, aesthetically radical soirées at the Arts Lab in Drury Lane, eat rice and peas in the West Indian dives of Westbourne Grove and still languish in fascination and velvet loons before the Piero di Cosimo in the National Gallery.

It was hardly necessary to make a strong argument for living out these social and ethical catachreses if the work of the avant-garde in art as in sex, for example, could as such conjugate with the work of politics as well as the supervening conception of the historic social class, the working class, as both at once central, foundational and marginal to the *socius* as a whole. This argument allowed for a flexible and tactical positioning, a speaking for and a speaking from, of what we were soon to come to call the speaking subject or, later on, the performance of the subject. To be on one's own side and another, and for this to be as if a viable universal or a proper judgement was, in academic terms for example, to have both a discipline and its critique; or in politics to be inside and outside the revolutionary class at the same time or by turns. This was neither a matter of sincerity nor its opposite, but of a form of general desire to be elsewhere and of a specific desire to be just one – in the Cartesian mode.

Or you can begin to see that this question of being both in the frame and out of the frame, both at the heart of the matter and at the same time the matter's supplement, was indeed altogether the heart of the matter; not an either/or, but a suspense story, a story in suspense. As if, again, one was already, always a ghost of Marx or Freud, ghosting the future's script for one's self out of the theoretical deferrals yet to come. And, in a way, this was just as well, as it turned out to make for something different from the old decrepitudes and opened the space for a lot of intellectual adventures that might be able to unfold without a proper starting point or having too often to stop and throw down an anchor: even if all too many of them were to freeze in the institutional ice of a discipline.

When I daydream about what the object-like texture of all this might be, how I might make a symbol for all or some of this, out of something illusory, impossible, deluded and desiring, sometimes I think that I would like it to be a painting. At first this seems right because it is possible the idea that 'painting is dead', which has risen and fallen in dramatic turns over the last 30 years of art theory and criticism, in part owes its currency to these unfolding processes themselves, to the putting of substance, in all its immateriality, beyond the frame. But clearly painting is far from dead and, indeed, is alive from its very first recorded appearances, in a still triumphant objecthood. The mistake in thinking painting was dead is that the theoretical discovery of outside-the-frame was confused with the notion that what is inside is therefore limited when, of course, it was the inside's own, elliptical illimitability that made such a knowledge possible in the

first place. So a painting, an easel painting, should do for the object that I want — but that is far too easy.

It's far too easy to get away with a category and a near infinity of single parts, so I must look for something more limited, a reminder like Milton's olive leaves that I might feel and hold and sense, a sharp reminder of the kitsch of wanting as well as its oceanic potential.

Hand in pocket, I try to rediscover myself fingering some smooth, shiny little object, with all the kitschy feel of mass culture, imitation craft, like the material of so many of my studies and reflections yet to come. I can follow the forms, ripples like the rays of a sun, the outline of a shape which must be that of a face, a profile, and on the other side some coarser metal, cheap and rough with a badly attached pin which is crumbling loose. The pin pricks my finger and I have to lick the bloody trickle. But that's why it's in my pocket, it might have fallen off in the hurly burly of a demonstration, and I loved it very much, my Mao badge, my first one, far too much to lose. Though where it is today, I have no idea.

Adrian Rifkin

Department Art, Goldsmiths College, University of London

PIXEL

Perhaps not surprisingly the word "pixel" is as devoid of historical reference as the informatic systems supporting it; the word dates in English to the early to mid 1960s. "Pixel" is a contraction of the term "picture element" via the word "pix," slang for "pictures." A picture element, or pixel, is the smallest atomic unit of an image that has been quantitatively sampled. It is essentially a visual atom, from the Greek *atomos* meaning "not cuttable" or "indivisible." Atoms are uncuttable, but they are also, from Epicurus, invisible, as they must exist below the threshold for humans to discern one atom from another.

Invisible and uncuttable, these are the two modes in which the pixel has been understood. From the first derives the dominant notion: a pixel is akin to something like a small swatch of color, barely visible to the naked eye, if at all. This is the definition of the pixel as a *little square*. From the second derives the less dominant but still crucial notion: a pixel is not simply a little square, it is at the same time a numerical value, a *sample point*.

In Aristotle's *Physics* the difference is between *monas*, a unit or unity, and *stigme*, a point. Both *monas* and *stigme* were uncuttable for Aristotle, but *monas* was fundamentally a question of arithmetic, while *stigme* was a question of geometry. Thus while it is essentially a singular mathematical value, in its representational modality the pixel is never merely a point. The pixel is a little dot (or square), because it has both a width dimension and a height dimension.

The pixel is to the digital image as the frame is to the cinematic image: both are 'atomic' media, that is, media entities that are uncuttable in themselves, but exist solely for the purpose of constructing larger entities. Both are subperceptual (invisible), only becoming visible through a fusion of many similar subelements into a larger 'image'. With cinema this is called flicker fusion. With digital images it is something more like "pixel fusion" whereby discrete dots or squares dissolve together to create lines, curves and solids. Technologies like anti-aliasing help in this process.

The tendency to conceive of pixels as little squares—or alternately little dots—runs

right through 19th- and 20th-century technological and aesthetic practice. The little square appears prominently in the work of Gerrit Rietveld, Bart van der Leck, Vilmos Huszár, and Piet Mondrian, but also in minimalism and color field painting by Ellsworth Kelly, Sol Lewitt, and Agnes Martin. In the early 1970s grids suddenly re-enter the art historical discourse with articles by Rosalind Krauss and John Elderfield, having previously been seen in discussions around Renaissance perspective and linearity. But this is not the beginning of the story; no, that must gesture even further back to the dotted color mixtures of pointillism, to the more primitive form-making of mosaics, and indeed to tapestries and the grids of little squares produced by all manners of pictorial weaving. Running in parallel to this are dot-based image technologies such as the half-tone dot of William Fox Talbot or the fluorescent dots of the cathode ray tube.

Yet to understand the complementary tendency, the pixel as an uncuttable, genetic sample point, it will help to return to the 18th century. Blind from a young age, the celebrated Cambridge mathematician Nicholas Saunderson excelled at intense thought, particularly in the field of algebra. He developed a keen interest in the work of Newton, who was at Cambridge with him and preceded him in the Lucasian professorship (other luminaries like Charles Babbage and Stephen Hawking would hold the same position). Saunderson was as well versed in Newton's recent optics research as he was in his work on physics and material science. "It will be matter of surprise to many," his Cambridge colleagues acknowledged, referencing Saunderson's blindness,

> that our Author should read Lectures in Optics, discourse on the Nature of Light and Colours, explain the Theory of Vision, the Effect of Glasses, the *Phaenomena* of the Rainbow, and other Objects of Sight: but if we consider that this Science is altogether to be explained by Lines, and subject to the Rules of Geometry, it will be easy to conceive that he might be a Master of these Subjects.
>
> (Anon. 1740: vi)

Saunderson held forth fluidly on such topics, although he did not have perceptual knowledge of optical sight.

The mystery of Saunderson's abilities lay in a special device. I defer to John Colson, Saunderson's immediate successor, who in the essay 'Dr. *Saunderson*'s Palpable Arithmetic Decypher'd' describes a small handheld tool designed and built by the blind professor.

> His Calculating Table was a smooth thin Board, something more than a Foot square, raised upon a small Frame so as to lie hollow; which Board was divided by a great number of Equidistant parallel Lines, and by others as many, at right Angles to the former. The Edges of the Table were distinguished by Notches, at about half an Inch distance from one another, and to each Notch belonged five of the aforesaid Parallels; so that every square Inch was divided into an Hundred little Squares. At every Point of Intersection the Board was perforated by small Holes, capable of receiving a Pin; for it was by the help of Pins, stuck up to the Head through these Holes, that he expressed his Numbers. [. . .] A great Pin in the Center of the Square (which, and no other, was always its Place) was a Cypher, or 0, and therefore I shall call it by that Name.

Its chief Office was, to preserve Order and Distance among his Figures and Lines. This Cypher was always present, except only in the Case of an Unit; to express which the great Pin in the Center was changed into a little one. When 2 was to be expressed, the Cypher was restored to its Place, and the little pin was put just over it. To express 3, the Cypher remained as before, and the little Pin was advanced into the upper Angle on the right Hand. [Numbers four through nine are achieved in a similar fashion]. And thus all the Digits were provided for, by an easy and uniform Notation, which might readily enough be apprehended and distinguished by the Feeling.

<div style="text-align: right">(Colson 1740: xxi–xxii)</div>

This small abacus, dubbed Saunderson's "palpable arithmetic," is a magical device. Touch, not vision, was the operative modality, with mathematics as the intervening vehicle. Colson called it "a new Species of Mathematical Symbols." It is a feeling machine, a digital machine, a cipher machine. Predating other touch technologies such as Napoleon's 'night writing' or Louis Braille's raised-point inscriptions, Saunderson used his palpable abacus to calculate numbers purely manually, as well as to represent shapes and symbols which he achieved by spanning silk thread in and around multiple pegs. Like a small hand loom or needlepoint hoop, Saunderson's handheld table used encoding of numerical values (in Colson's description, "a commodious Notation for any large Numbers") at the micro level as well as combinatorial and synthetic cohesion at the macro level. "It was by the Sense of Feeling our Author acquired most of his Ideas at first," wrote his Cambridge colleagues. "By the help of these [haptic tools] he could calculate, and set down the Sums, Products, or Quotients in Numbers, as exactly as others could by Writing" (Anon. 1740: xi–xii).

Today it would have a different name: a pixel raster. Saunderson's hand loom was arranged in a grid with fixed-size measurements and spaces between pegs; each peg point was able to 'store' a numeric value; the aggregate effect of the device, however, was not in the solo functioning of a point or set of points, but in the entire 'image' achieved by the interaction of each constituent point.

The two modalities (little squares and point cyphers) are thus evident in Saunderson: on the one hand there is the material or perceptual modality of the pixel as a little square (dots in scanning television screens, the jagged edges seen in anti-aliasing, and so on), but, on the other hand, there is the informatic or mathematical modality of the pixel as a sample point (mathematical variables measuring color, intensity, etc. for a given position).

While more interesting historical precedents exist, such as Peter Mitterhofer's typewriter of 1864, which featured a typeface built up from pixels rather than continuously curved lines, and the aforementioned cathode ray tube, which uses raster scanning of fluorescent materials, the true modern birth of the pixel happened at some point in the first six months of 1948. A team working at the Institute for Advanced Study (IAS) in Princeton, led by John von Neumann, used simple quadratic equations plotted on an oscilloscope to draw letters to the screen (which was then photographed). The pixel was a byproduct; the dots used in the plotted graphs were manipulated in such a way as to create letters using a monospaced grid of five dots by eight dots. Like Mitterhofer before it, who famously used the device to print his own name, the IAS team used their new pixel lettering to spell out the acronyms for their institutional home, and that of the electronic computer project (ECP) they were working on. Hence the modern

pixel appears first not as an utterance but as a code: "ECPIAS." The whole affair was "a whim," the scientists wrote in the summer of 1948, to demonstrate "the use of this equipment to plot not graphs but letters" (Bigelow et al. 1948).

As with Saunderson before, the founding inscription of the modern pixel is not simply via that of a little dot, but a mathematical sample point. Names are syntactically reduced to letter abbreviations, just as each letter is displayed using a fixed grid of sample points turned on or off. Further, the pixels were created, not using a raster-based display system, but using its opposite, the oscilloscope which draws its image analogically using continuously variable x and y coordinates. How unlikely it is that the modern pixel appears first on the oscilloscope, not on its grid-bound cousin, the television. The least hospitable piece of hardware ends up leading to the development of a new representational mode. The reason for this is that the 1948 pixel is an informatic construct, not a fact of hardware (as it was with Saunderson). It is a remnant not of the raster grid, but of pattern manipulation simulated by discrete signal voltages, not from a little square, but from a sample point. In other words, the first modern pixel is a simulated pixel.

References

Anon. (1740) 'Memoirs of the Life and Character of Dr Nicholas Saunderson, Late Lucasian Professor of the Mathematics in the University of Cambridge', in N. Saunderson, *The Elements of Algebra, in Ten Books*, Cambridge: Cambridge University Press.

Bigelow, J. H. et al. (1948) 'Fourth Interim Progress Report on the Physical Realization of an Electronic Computing Instrument', records of the ECP, archives of the Institute for Advanced Study, Princeton, NJ.

Colson, J. (1740) 'Dr. Saunderson's Palpable Arithmetic Decypher'd', in N. Saunderson, *The Elements of Algebra, in Ten Books*, Cambridge: Cambridge University Press.

Alexander R. Galloway

Department of Media, Culture, and Communication, New York University

MY ROCK

I can't help thinking of the rock as *my rock*. The rock is a shapely squared-off oval, about six inches long, which fits heavily in the hand; it weighs about a pound. It is creamy-colored and porous, composed of grains as large as a millimeter in diameter, veined with rust-colored cracks. Its color, weight, texture, and rough symmetry make it pleasing.

I found this rock on a beach in Cambria, California, in June 1996. I was driving up Route One USA, nursing a heartache, and I had stopped for the night. Walking Brontëesque on the dark shore as the wind whipped my heavy skirt about me, I glimpsed the rock, glowing among darker rain-wet stones. "Of all the gin joints in the world" – it just happened that I came by *that* stormy evening, just when the rock happened to be riding on the shore's edge.

I love the rock not only because it is beautiful and it lifted my heart when I needed it, but also because it is the living embodiment of time, philosophy in stone. Oscillating in my perception between metaphor and thing in itself, the rock deeply confirms what is dear to me, then radically negates it. I will show you that the rock is not an inanimate object—just very slow.

Even putting away anthropomorphism, the rock feels familiar. Of course we can identify with rocks, in the sense that we project a meaning onto them. Smooth stones like mine call up comparisons to organic and human-made things: eggs, fish, bowls, children, wise old heads. But the rock has aspects, in its independent entity as rock, that also call up a sense of shared being. It is smooth because it has been tumbled together with other rocks for eons. Its fissures show that eventually it will break up into smaller rocks, and finally to dust. As we humans undergo a polishing in the course of life, so the rock has suffered and endured. The rock is what we call an object, and so, in many ways, am I. The rock corresponds to me not because of my projections onto it but in our inter-objectivity (to use Vivian Sobchack's term).

Yet the insurmountable difference between the rock and me makes it terrible to know: sublime. Sublimity occurs when something that inhabits the space–time of my

experience makes reference to a space–time I cannot comprehend. This smooth rock that corresponds so comfortingly to the shape of my palm comes from a time so ancient I cannot imagine it. The rock turns out to be between 5,000,000 and 23,000,000 years old. Attributing maximum youthfulness to the rock, it has lived 114,000 of my life-times. The rock has been in my company for one-quarter of my life; I have been with it for less than one-five-hundred-thousandth of its life. So far.

I confess that I have brought the rock to class for several years now, to illustrate to students the concepts of virtuality, monad, and plane of immanence. The rock, I suggest, is a node on the plane of immanence. Not the best node, not the one that yields the most actualizing activity, but a node nonetheless. It teems with virtuality, with places it might have been and events it might have witnessed, but we cannot know what they are. Monads are individuals that reflect the entire universe from their particular vantage point. The rock and I are both monads, with quite different capacities. The rock has witnessed a lot but can express little; I have witnessed a little but can express a lot. If the rock were a movie, it would have a shooting ratio of 5,000,000 to 1.

I began to feel that I was prostituting my rock to philosophy. Contemplating it abstractly began to seem misguided; I needed to understand it physically. Research led me to hypothesize that the rock might be limestone—an extremely common carbonate rock. But when I gingerly rubbed it with a cheese grater and poured some wine on the resulting particles, it did not fizz, as limestone would.

So, nervous as a matchmaker, I took the rock to my colleagues in the geology department. Three geologists hovered over my rock and praised its unusualness and beauty; I was quite chuffed. Each saw it from his or her point of view. James MacEachern, a specialist in sedimentary rocks, analyzed my rock. First he peered at it with a loupe. He rubbed it with a porcelain plate and dropped weak hydrochloric acid on the resulting powder; there was no reaction. His first guess was that it was quartz sandstone. He examined it through a reflecting binocular microscope, which showed it to contain many crystals that are idiomorphic, i.e. sharp-edged. This suggests it was not transported very far. It is so crystalline that it appears to have been partly cooked, as though it had been near a volcanic tunnel. It contains no fossils.

Robbie Dunlop, a specialist in volcanic rock, scraped the rock and smelled it, revealing the earthy smell of volcanic ash. She suggested it is *lapilli* tuff, a transitional form between sedimentary and volcanic rock. The third geologist, Kevin Cameron, determined the rock to be pyroclastic crystal tuff. This means it was formed of volcanic ash that settled while annealing, then sedimented. The rock would then have broken off from the sedimentary layer as a cobble or boulder, and been carried out to sea by a river. The geologists suggested it was from a former volcanic mountain of inland California.

A little more research leads me to the following hypothesis: My rock was created in a violent eruption from an island volcano off the coast of California sometime in the early Miocene, which began 23 million years ago. Rock and ash spewed out of the volcano, crystallized, then lay there sedimenting for several million years. It is a young rock in the scheme of things: it was not around for the dinosaurs, who became extinct 65.5 million years ago. Mastodons and horses might have galloped through the grass along its surface.

During the late Pliocene, just 2–3 million years ago, as portions of the Earth's crust shifted, the volcanic islands were lifted up and became the Gabilan coastal mountain range. As my rock tilted in its bed and joined a continent, over on another continent

Homo erectus was beginning to stand up. Erosion flattened these mountains, and streams washed their sediments toward the Pacific and the interior. I am guessing the chunk containing my rock washed inland at around the time of the Pleistocene Great Ice Age, which began 1.8 million years ago.[1] There it probably reformed in alluvial sediment, perhaps got buried under glacial debris, and when the Gabilan mountain range tilted westward and eroded, my rock washed into the Salinas valley. When the Mongols invaded Baghdad in 1258, my rock was riding toward the sea, perhaps on the Little Sur River, which empties north of Cambria. There it rolled along the coast for some hundreds of years, refining its smooth egglike shape, until I found it and took it away.

All of this is hypothesis, and invites a philosopher's respect for scientific caution: for the more carefully I try to ascertain the rock's trajectory, the more apparent it becomes that it is impossible really to know. My rock seems to represent virtuality, but to understand what it *actually* is, is tentative work indeed! Generalizing reduces my rock from a singular monad to a mere example, which I am loath to do. To misidentify it would be, in a certain way, to annihilate its actuality (from the human point of view), like putting the wrong name on someone's grave.

Rocks are extreme relativizers. How foolish we are to think a domesticated rock is holding down the papers on our desk! For in the big scheme, our desk and papers—and the invention of paper, and the origin of language—are but a whisker in the long and slow life of geology.

People like to wear gemstones, which are treasured for their literal crystallization of historical forces. A diamond ring is a tiny piece of absolute alterity on your finger. And people like fossils, which communicate specific, legible information about time past. The rock is halfway between fossil and diamond, and not valued as either of them is—the diamond for its abstractness, the fossil for its particularity.

But my rock is precious, too. Slowly, slowly, it took shape through cataclysmic events: volcanic eruption, tectonic shift, and erosion. It carries the distant echoes of all that occurred on the Earth in the last five million years. They are etched in its geologic memory. Wise and silent, it lies quietly on my windowsill.[2]

Notes

1 This information is gleaned from Arthur D. Howard, *Geologic History of Middle California*, Berkeley: University of California Press, 1979.
2 I thank Sharon Kahanoff, Richard Coccia, and my colleagues in the geology department at Simon Fraser University for their insightful comments.

Laura U. Marks

School for the Contemporary Arts, Simon Fraser University, British Columbia

SACCHARIN SPARROW (*CIRCA* 1955)

When an object is designed to interact with the body, how do we study its material culture? The question is particularly relevant when considering wearable objects (clothing, accessories, iPods), objects designed to shape the body (weight machines, diet/bulking pills and potions), and objects that enhance physical pleasure (massage chairs, sex toys). These items, while possessing a solid materiality, take on cultural meanings only through their encounter with human users. Because they require an intense physical connection in order to "work," and because the connection can effectively merge material and self for the user, these objects must be considered equal parts 'stuff' and sensation. The historian who would work with historical body objects thus has a particular challenge. When the original users are no longer available for questioning or if too much time has passed to recapture their initial experiences, how might we conceptualize the dynamic meanings created through such physical-material engagements? Here a saccharin container is offered as a case study of one possible approach. Through a combination of close material observation and a careful re-imagining of body encounters, it is possible to suggest a means of decoding that I term 'experiential' material culture.

The Sparrow

In the early 1950s, Larry Kasoff, a Brooklyn-based jewelry maker, saw an opportunity in the makeshift decorative containers women were using to dispense saccharin rather than the medicinal bottles in which the tablets were sold. His sparrow appears to be the first container expressly for this purpose. Its decorative exterior echoed the costume jewelry and pincushion design he had previously perfected; a special interior metal coating prevented taste distortion through oxidation.

Why the sparrow? Indeed why any of the 'animal' containers Kasoff designed and successfully sold between 1950 and 1970? They were not easy to operate. They were

not particularly convenient. They clashed with table décor. The sparrow's top was easily dislodged from the base; any attempt to put it in a bag or purse (or even quickly pass it between users) scattered pellets everywhere. It required close attention to manipulate. It certainly didn't match the tableware: the bird was as ill at ease among the clean lines of 1950s *moderne* as it was among the fussy florals of antique Victoriana.

The sparrow was a high-maintenance object designed to stand out in design and use. Reconstructing the entanglements it invited with its primarily female users suggests that the bird's cultural value was in just this *required* attention.

Encounters

The sparrow was frequently first encountered by its users as a gifted object. According to its manufacturer, department stores began to carry the object prewrapped in the 1950s after managers determined it was a popular hostess gift. Receiving a sparrow in this form required one to carefully unwrap the small package and likely heightened the expectation that something special lay inside. As gifts were, and are, typically a means to demonstrate the status and good taste of the giver, encountering the sparrow in this manner encouraged recipients to regard the saccharin container right from the start as a desirable object.

This is significant. Saccharin had been roundly rejected in the early 20th century. Because it originally appeared unannounced as a cheap replacement for sugar in packaged foods and beverages, saccharin had become the poster-child for unscrupulous business practices and inadequate regulatory oversight. Saccharin remained available in the US but was packaged expressly for diabetics and others who had medical conditions that necessitated abstention from sugar. Evidence suggests that few, if any, consumers willingly substituted saccharin for sugar prior to 1950 unless they had to. Even during World War II, when sugar rationing drove housewives to drastic experiments with alternative sweeteners, saccharin remained an 'inferior' product.

It would be a mistake to suggest that these sparrows single-handedly transformed saccharin from an undesirable to a desirable commodity. After all, only about 50,000 of them appear to have been purchased in the US over a period of 20 years.[1] Yet for those who did use a container, especially for those who received them as gifts, the sparrow may have been an influential item. Receiving a gift of a saccharin container required the receiver go to the store or pharmacy and purchase a bottle of saccharin to fill it. Had consumers' only encounters with saccharin been the medicinal bottle at the pharmacy, the experience would have reinforced previous notions of the substance as an undesirable chemical. In this context, the unwrapped festive sparrow dramatically reframed the encounter for its users. Quite the opposite of an unwanted invisible commodity, saccharin now arrived as a sign of affection, a material marker of hospitality between friends.

Engagements

Today's sparrows are no longer wrapped. We can imagine, however, that after removing the bird from its casing one had to discern how it worked. The object had three parts: the bird opened easily; removing the 'top' separated the bird horizontally along

the middle revealing a hollow interior body cavity. Hidden on the underside of the top, secured by a magnet, were the tongs; these were easily detached with a slight pull and could be used to manipulate the pellets. Inserting these saccharin pellets required a complex series of motions. One had to carefully remove them from the miniature medicine bottle and shake them directly into the bird's interior cavity. My own experiments with bottles from this era suggest the pellets flow quite freely, requiring practice to get the right number in the body without having them bounce out or overflow.

Saccharin tablets typically came in three sizes, ¼ grain, ½ grain, and 1 grain. The decision on grain size depended on the desired sweetness: ¼ grain was equal to about 1 teaspoon of sugar. Assuming that typical saccharin users preferred smaller grain sizes, getting saccharin out of the container and into one's coffee or tea required finesse. To use the enclosed tongs successfully, one had to hold the bird body with one hand, grasp the tongs between the thumb and index finger, reach just at the side of the pellet, and carefully lift it out of the container and into a neighboring cup of coffee or tea. This was not easy to do on the first try, or the second. Whereas sugar required familiar motions and equipment, saccharin dispensing required a new process, one more closely associated with beauty procedures than food preparation. The tongs look like tweezers and grabbing the pellet evokes sensations similar to sewing or laboratory work. Using the tweezers put the user's body on display: because this delicate reach, grab, and lift were commonly in the service of sweetening coffee and tea, the display was frequently a public one. During my own experiments removing pellets from the sparrow I was keenly aware of others' watching me repeatedly attempt to pick up (and drop) a pellet before achieving success. I was acutely aware of fingers, hands, and face being observed by others.

The sparrow's design may have heightened this sense of physical display. According to historian Deanna Cera, animal designs were among the most popular in costume jewelry in the 1950s, particularly renderings of birds and domestic pets.[2] Many who encountered the sparrow would have been familiar with Kasoff's better-known jewelry line, Florenza. The gemstone eyes were identical to those used in his costume settings; the patina echoed that of bestselling pins and earrings. Such similarities enabled the sparrow to bridge body and table. It is quite possible to imagine women encountering the sparrow wearing similar pins and earrings. The attention required by the process of releasing saccharin into one's tea did not stop at the cup. Lines between functionality and beauty were easily blurred. Users may have engaged the sparrow primarily to make it work. Design similarities, however, invited a simultaneous hyper-awareness of the 'working' body.

The sparrow enabled women to maximize attention for themselves through the act of minimizing caloric intake. Few women confronted saccharin unaware that it had far fewer calories than sugar; as early as 1953 saccharin was promoted as a primary way to lose weight or maintain thinness. Carefully opening the bird, dislodging a single pellet, and placing it gently in the glass enacted a drama in which 'diet' sweet was an opportunity for complete self-absorption.

Conclusion

The sparrow exists apart from the body. We could describe its size (about 3 inches long and 1½ inches tall), we could detail its composition (cast metal in yellow gold, non-

oxidizing interior coating), and we could describe its design. All of this is necessary to contextualize the sparrow. The purpose of this exercise, however, is to demonstrate that when engaging body objects one also needs to undertake a bodily engaged analysis. Because using the sparrow required an intimate entanglement between body and object, we as historians must recast the object within an embodied context. This necessarily requires imaginative leaps: the author must herself enter the object, bringing her own impressions to the process. As scholars have argued, there is no way to recreate the sensory past: our own subjective impressions, combined with the sheer multiplicity of human reactions, prevent us from 'feeling' the factual past. Yet those feelings ought not be dismissed; they offer a point of entry into the possible. More research is necessary before we can conclude that saccharin sparrows enabled women to fuse self-indulgence with self-denial. Only by embodying our own inquiry, however, can we illuminate that possibility.

Notes

1 It is difficult to determine precisely how many of Florenza's containers were sold, as company records were destroyed in the 1980s. Kasoff recalls "everyone" having a sparrow in his Brooklyn social circle and estimates the number of sparrows alone sold in the US through the 1960s as 50,000. Certainly the price of the Florenza containers, $2 in the 1950s, put them within reach of working- and middle-class consumers. (Email correspondence with author and Larry Kasoff, July 1, 2004.)

2 According to Cera, the costume jewelry industry by 1949 had reached sales of millions of dollars a year and was widely regarded as a means by which women of the middle and working class expressed creativity and inner beauty. See Deanna Farnei Cera, "The Luxury of Freedom, the Freedom of Luxury in the United States, 1935–1968," in *Jewels of Fantasy: Costume Jewelry of the 20th Century* (New York: Harry N. Abrams, 1991): 179, 149.

Carolyn Thomas de la Peña

American Studies Program, University of California, Davis

MY SECRET WEAPON

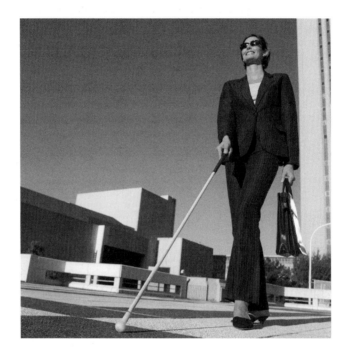

Sometimes when I walk down the street with my white cane, I know what it must feel like to carry a gun. People freeze, lurch forward then jump back in confusion. They whisk toddlers and dogs out of my path, ready to shield their loved ones with their own bodies. Sighted companions tell me that their faces show the kind of shock and panic associated with confronting life-threatening danger. I know this even when I'm on my own from the telltale sounds that accompany these responses: the squeaks and yelps as small bodies—human and canine—are yanked out of my way.

What is the fear about? On one level, it is the fear of collision, the fear that I may bump into them, their children, their little dogs, that I may hurt them, or myself, or both. There seems to be an assumption that I have no awareness that I am sharing the public spaces I travel through, that I am oblivious to whatever and whomever may be in my path, that I, as an other-worldly, alien creature, have a brutal disregard for the sanctity of human life. Or is it a fear of the cane itself? Do they think it is a magic wand that will transform whatever it touches, into what, I wonder. Do they think that my blindness is catching, and when my cane touches them they'll go blind too? Or do they think I'm out there waving an electronic cattle prod around, determined to zap as many unsuspecting pedestrians as I can.

The fear is at odds with the usual responses to blindness: pity and awe—pity at the unfortunate tragedy of lost sight, and awe at the seemingly remarkable fact that I am out and about in the world and not home grieving. The whiteness of the cane is meant to make it more visible, especially in low light, but it is also associated with surrender. The white flag is a signal that the combatant has abandoned the fight and is willing to be taken prisoner rather than to face certain death. In picking up the white

cane what have I surrendered? Does the whiteness of the cane denote that I am a prisoner of blindness?

Although I have been legally blind since I was 11, I have only carried a cane for the last 15 years or so. Like many people who are blind in the eyes of the law, and therefore eligible for government services, I am not completely sightless. I actually have enough peripheral vision to move through space with some degree of ease. But my central vision is so impaired that objects and people directly in front of me are invisible. I cannot perceive street signs or traffic signals. Despite these dangers, I was never encouraged to use a white cane when I was a child or young adult. It was better to "pass" as sighted than to announce my visual impairment with a visible signifier. If this meant that I sometimes bumped into people or stood uncertainly at street corners until I could cross in a sighted pedestrian's wake, this was preferable to letting the world know that I was flawed and therefore vulnerable. Fortunately, logic eventually took over and I realized that I was more of a hazard to myself and others without a cane than with one.

My cane is elegant in its simplicity: a sleek and slender tube of lightweight carbon fiber—a material developed for the space program for its resilience and durability. My technique is simple too. While some people like to tap, I prefer to slide the cane in a smooth arc ahead of my feet. The cane's length is relative to my height so that when the cane's tip encounters a curb or an obstacle, I will still have two strides before my feet reach it. While the cane's tip sweeps back and forth I can feel the texture of the pavement transmitted up its length and into my hand. On familiar routes, different textures let me know where I am. When I am in a less populated area and I can really hit my stride, it feels as if the cane is there to pull the ground along, scrolling it under my moving feet.

As the cane communicates relevant details about the path before me, it also sends messages to others around me. It is particularly useful when I find myself at a street corner where there is only a stop sign and no traffic signal. The motorist pausing there, who would normally signal the pedestrian to cross, is supposed to notice the cane and realize that I cannot see the gesture. In reality this often takes longer than one might think; motorists do not always notice the cane, or else do not readily recognize what it signifies, and then must debate with themselves or their passengers how best to communicate with me. Sooner or later they will hit on the happy solution to roll down the window and call out. But I know better than to heed their instructions to cross since, in their confusion, they may not notice other vehicles in the vicinity and may direct me out into oncoming traffic. It is safer for me to wave them through the intersection so I can hear for myself when it is time to cross.

In many situations—shops, train stations, airports—the cane is a sign that I may ask a question, and that I may need more information than the usual, "It's right over there." Often, sighted people need some gentle prodding about how to give nonvisual directions. "Are you pointing with your right hand?" I ask. When I sit in a lecture hall or other place where I may want to ask a question, I keep my cane visible, leaning companionably against my shoulder, as a signal to the person fielding the questions that I will need some audible indication that I am being invited to speak: "The blind lady in the front row has a question."

Of course, this statement is never actually pronounced. Although the cane makes my blindness the most obvious of all my characteristics, people are reluctant to mention it—at least to my face. Airline employees calling for someone to escort me to my

gate or the baggage claim area are at a loss to communicate that I need an escort but not a wheelchair. "Tell them I'm blind," I say, but they seem under some sort of international stricture against uttering the word. Behind my back—though not always out of my hearing—the word "blind" is suddenly on everyone's lips. "Look, that lady is blind!" small children exclaim. No wonder their parents fear that I'm out there to mow them down.

My cane does in fact have magical power. It has the power to transform me and anyone in my company. In addition to clearing any pavement I walk down, it makes me invisible to panhandlers and street pollsters. No one ever asks me for spare change or to sign a petition. Then there's the halo effect: a phenomenon first identified by a friend, who noticed that she felt herself to be inordinately conspicuous whenever we walked around together. She started to pay attention and observed that people would look at me, following the length of my cane with their eyes. Then they would look at her and smile. The smile was like being crowned with a halo, a reward for being nice to the blind lady. The effect is magnified if we happen to be with another blind person. But goodwill vanishes when there are more then two blind people in the group. Then the sighted companion is perceived to be an irresponsible custodian who has unleashed her unruly charges into the world.

It is the fear of all this conspicuousness that makes many newly blind people reluctant to start using a white cane. Adolescents fear they will be ostracized by their peer group. Elderly adults resent the way the cane will mark them as past their prime. But for me, and many like me, the cane is an emblem of independence and autonomy. It gives me the freedom to move through the world in safety and with grace. It gives me license to ask for information when I need it and to decline condescending solicitude. If it makes me a startling presence on public thoroughfares it may be because I deviate from stereotypical images of the blind as dependent and frail. This may change in the future as the population ages and more and more people with age-related vision impairments abandon their fears and take up the cane. In the meantime, if my white cane makes me look dangerous, I accept the label; shattering stereotypes is a dangerous business. For now, striking fear in the hearts of my fellow pedestrians seems preferable to the alternative view that would keep me sequestered at home, out of sight and out of mind.

Georgina Kleege

Department of English, University of California, Berkeley

SHIN'S TRICYCLE

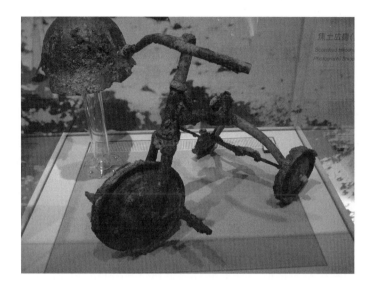

At the Hiroshima Peace Memorial Museum, I saw a tricycle. It's not really a tricycle anymore. It is what was left of a tricycle after it was subjected to the atomic blast at Hiroshima on August 6, 1945. But it is easy to identify as a tricycle. The characteristic form is still evident—the armature and the hubs of the wheels and the handle bars are all more or less intact—and that ready identification is integral to its presence in the museum, but so is its degree of damage. It is not, for example, a pile of melted scrap metal, as it might have been had it been closer to the hypocenter. Nor is it undamaged, as it would have been farther away. The tricycle is a survivor, although its rider is not. Like the human witnesses who provide testimony about atrocities, the tricycle was close enough to be damaged by the trauma but "survived" to tell the story.

It is very important to the role the tricycle plays in the museum that we can identify it and also that we can identify with it and with its former owners. The tricycle's role is to help us to imagine both the physical and emotional impact of the bomb. So it must be familiar and "work" on us in a register of already known objects. Standing in front of it, we (should) imagine the tricycles of the children we were or have, or have known, and the extent of the loss were we or they to be victims of a comparable trauma. In this sense, it is an object intended to provoke a kind of productive nostalgia. This effect is enhanced by the placement of the tricycle at child's eye level, and, at the moment when I photographed the tricycle during my visit to the museum, a child of almost the ideal age and size was standing in front of the display case.

The room in the museum where the tricycle is housed also contains educational panels that focus on the damage of atomic weapons to human bodies, with graphic illustrations of sores and burns and actual samples of "lost hair" and preserved keloids. That the damaged body of the tricycle resembles and is meant to stand in for the damaged bodies of the human beings, is obvious. Both are forms of collateral damage, because clearly neither this 4-year-old child nor his tricycle were the overt targets of the US military. The tricycle has retained its structural elements but all the soft parts are gone.

There is no seat. There are no pedals and no handles on the handle bars. There are no tires, just wheel hubs. The pattern of the rust echoes the patterns of scarring in the photographs, and the incomplete "limbs" of the cycle foreshadow the malformations of the next generation of victims shown in another room of the museum. Rust is not direct damage from an atomic blast, but the blast may have removed the protective coating from the metal surfaces or the rust could be the result of subsequent "black rain." The rust brings to my mind other concentrations of post-industrial rust, in regions where factories have been abandoned rather than blown up.

The tricycle shares its vitrine with a helmet. Although the form of the helmet is military or industrial rather than recreational and although I know that toddlers in 1945 did not wear sports helmets, the proximity nonetheless makes me think of a contemporary bicycle crash helmet and so the pairing adds another layer of vulnerability to the imaginary child victim. It's a somewhat random pairing—objects thrown together by the blast or, more likely, by curatorial expediency. What the helmet and the tricycle have in common is the extent and type of their damage. They are in a sequence of rooms called "Damaged by Radiation," which also include "shirt stained by black rain" (1,800 m), "lunch box" (600 m), "water bottle" (600 m), "glasses" (1,000 m), "razor" (500 m), "sake decanter" (600 m), "golf set" (1,800 m), etc. The most famous object in this display is the paradigmatic watch stopped at the time of the blast—8:15 (1,600 m). The numbers in parentheses, taken directly from the displays, are distances from the hypocenter, and are offered in the display as part of the careful scientific study of the impact of the bomb. "Our" tricycle was 1,500 meters from the blast.

All of these objects are being called into play as evidence, proof, documentation, so that the tricycle loses its status as a "real" object and is instead a symbolic object and a discursive object, deployed in the effort to "strive for a lasting peace so that the events of that terrible day are never repeated." In this way, the tricycle and its companions in the museums at Hiroshima and Nagasaki have counterparts at other trauma memorials. Of these, objects preserved at Holocaust memorials are most comparable in volume but often quite different rhetorically. By way of contrast, we might consider the mounds of shoes or the collections of silverware in several of the Holocaust museums. These sorted compilations of objects were assembled, not by curators but by the Nazis, who in orchestrating an industrial genocide left behind "industrialized" evidence. While the *targets* at Hiroshima and Nagasaki were industrial, the deaths were individual and the strategy of the museums there is to emphasize the specificity of the suffering through the individuality of the objects on display.

And "my" tricycle is an extremely specific object. It was, I learned, owned by Shin-ichi Tetsutani, who was two weeks short of his fourth birthday at the time of the explosion. Japanese school children, and some children from other parts of the world, may be at the museum specifically to see "Shin's Tricycle," which was the name of the children's book that told its story. They will know the specific story of this tricycle and its rider: that Shin was riding his tricycle at the time of the blast, that he died later that same day, and that he and his tricycle were buried together in their backyard.[1] So for this particular group of spectators, the tricycle is an object of "pilgrimage," it is a destination object.

The tricycle can no longer transport a young rider, yet it continues to *work*. Representation, surrogate, destination, evidence: the tricycle works as a palimpsest of memory culture. As a traumatized object, it is uniquely suited for this role. Taken out

of quotidian practice, it invokes and evokes ordinary events and their extraordinary disruption.

Reference

Kodama, Tatsuhara (1992) *Shin's Tricycle*, New York: Walker and Company.

Note

1 Shin's father exhumed the bicycle and donated it to the museum many years after it was buried, when he and his wife decided to give their son "a proper burial in a cemetery."

Laurie Beth Clark

Art Department and Visual Culture Center, University of Wisconsin-Madison

SNOW SHAKER

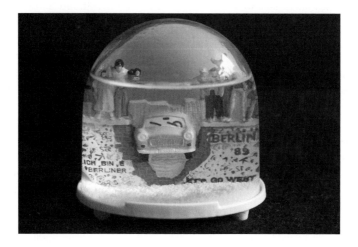

A man who stands submerged in water holds an umbrella over his head. He is sheltering from the gently falling snow. This was the scene depicted in one of the first snow globes, which was displayed at the Exposition Universelle in Paris in 1878. Crystallized here is an absurd contradiction: what good is the umbrella when surrounded by water? Over a hundred years later another snow globe scene renders a different anomaly: a souvenir of the ending of the Cold War, this snow globe features the graffitied Berlin Wall just breached by a Trabant. Atop the wall stand a couple of clumps of people, facing west, towards their new life. However, the snow falls endlessly on this vision of the defrosting of political relations. If these objects fascinate, it may be because of the conundrums they pose, the contradictions they open and do not resolve.

Some time in 1931 or 1932 Walter Benjamin jotted down a little note on ships, mine shafts and crucifixions inside bottles. He cited a comment by Franz Glück on Adolf Loos. On reading Goethe's complaint against philistines and those art connoisseurs who grab hold of the engravings or reliefs that they are examining, Loos concluded that anything that can be touched cannot be an artwork and, conversely, that whatever is an artwork must be withdrawn from access. Benjamin's typically contrarian extension of the thought asks then whether these objects under glass are therefore artworks, 'because they have been placed out of reach' (Benjamin, 1999: 554). This sliver of insight leads to the heart of Benjamin's ideas as laid out most famously in his essay from the 1930s 'The Work of Art in the Age of its Technological Reproducibility' (Benjamin, 2003). In the epoch of mass production, cultural artefacts meet the viewer halfway, metaphorically and actually. They exit from darkened niches of cathedrals, leave the gallery, are released from the captivity of singular time and space to enter into the orbit of the viewer. In reproduced form artworks can be grasped in the viewer's hand. As film, the pacey and choppy rhythms and milieu they depict are familiar to viewers from their everyday technologized and city lives and so can be easily grasped – or understood. These objects, appropriable by the masses, are not artworks, but democratically manipulatable forms of culture, after art, prefigurations of a new political age. What then of the object in a bottle, unable to be fingered, available only to contemplation?

Are these ornaments, against all conventional systems of value, now artworks? Benjamin's thoughts on objects under glass were stimulated by his investigations of the late 19th-century bourgeois parlour that had been his own childhood home. These rooms were cluttered with glass domes over hair sculptures or wax-flower arrangements, stuffed animals or fake religious relics, and these new objects, a development out of the decorative glass paperweight: snow globes. Would those particular glassy objects that Benjamin collected and which, as Adorno recounts, numbered among his favourite belongings (Adorno, 1963: 237) also count as works of art? Or is in fact, in this case, the contemplative glassed-over scene there to be grabbed? Is the snow globe so charged an object for Benjamin because it is and is not, at one and the same time, distanced and close, an object that marks the cusp between art and non-art?

That snow globes, commonly characterized as the epitome of kitsch, should feature in a controversy about aesthetic definition and value is not a surprise, for everything about the snow globe elicits contradiction. The snow globe contains a world under glass, or, later, clear plastic. As such the scene contained is untouchable, but the globe itself exists precisely to be grasped in the hand. The hand neatly fits around its rounded or oval contours, in order to shake the miniature scene, so that the artificial snow flakes, or flitter, be they of bone, rice, corn, polystyrene or glitter, slowly sink through water, enhanced with glycol and perhaps antifreeze and anti-algae agents. The snow globe comes properly to life only when it is fully filled with a liquid that becomes invisible, functioning solely as a medium for impeding and transporting snowflakes until they settle. After shaking, it is as if life has suddenly entered and then crept away again.

For Adorno, the glass globes contained *Nature morte*, still live, dead life: their appeal, like that of other 'petrified, frozen or obsolete components of culture' (Adorno, 1963: 237), such as fossils or plants in herbariums, signals Benjamin's attraction to everything that has alienated from itself any 'homely aliveness'. For the literary theorist Paul Szondi, the emphasis, on the contrary, was on their freeze-framing of a scene of life, not death. He called the snow globes 'reliquaries', which provide a form of shelter, an idea of preserving something, a scene, an event, for the future. For this reason, he associated them with Benjamin's miniature memoir scenes that snapshot moments of 'hope in the past' and transport them into the future (Szondi, 1978: 500–1). Szondi's sentiment can be phrased in a more sentimental version: the snow globe circulates commercially as a souvenir or memento. It is supposed to capture an instant to be relived forever in memory, a moment that compels the viewer to express, like Goethe's Faust, 'verweile doch, du bist so schön', 'stay a while, you are so beautiful'.

This souvenir designed to mark an individual's unique experience is, needless to say, generic. Indeed, the resurgence of commercial production of snow globes in the 1950s was attributed to a generically German Romantic experience in the Odenwald. Bernhard Koziol, who was to become one of two main postwar German snow globe manufacturers, glimpsed a snowy landscape with deer and fir trees through the dome-shaped rear windows of his Volkswagen Beetle car, and the vision inspired him to reanimate the snow globe production that his firm had abandoned in the 1930s – and using the VW windows' shape. He, by the way, lost the rights to the now-dominant dome shape in 1954, for the other main German company, Walter and Prediger, filed its registration papers first. Both firms needed another outlet for the excess plastic brooches that they produced as souvenirs. These flat outlines of buildings or scenes found new shelters under plastic, but their lack of three-dimensions meant that a blue backing was

added to the rear of the container. The scene that was once observed from all sides was narrowed in the postwar to a front-on view.

The snow globe's dimensions narrowed. And yet it still aspires to encapsulate a moment out of time, a fantastic scene or idealized memory. Such aspiration is evident in the name still given the snow globes by Koziol – *Traumkugel*, dream bullets. To trace that imaginative power, an excursion beckons into the weekly escapades of a bourgeois boy of about 6, whose fantasies of travel across regions and into the hidden spaces of cities come just after those of another young bourgeois boy, Walter Benjamin, whose fantasies of travel and cities are recorded retrospectively in his Berlin memoirs.

In 1906 one episode of *Little Nemo in Slumberland*, the comic strip by Winsor McCay, begins with a polar bear in arctic wastes (McCay, 1997: 71). Nemo is, as usual, in his bed – though he is not usually shown there; more often he is darting through dream-jungles, miniaturized or oversized cityscapes or floating over continents in airships. Nemo lies in his bed and he feels cold. It is snowing in his bedroom. The snow falls quickly and forms a thick blanket on the floor, which rises and rises until it covers the bed and covers Nemo. The snow becomes the bed's blanket. A snowstorm is raging right in his very room. Once he is fully covered by the thick snow Nemo begins to burrow through the drift in search of his father's room. But he loses his bearings and finds himself in the realm of Jack Frost. Here Snowball awaits him in the valley of silence and Nemo agrees to go with him, but the beauty of the landscape distracts him. 'Nemo was all eyes and all ears and the result was a delightful excursion into the grandest region ever dreamed of', until, because Nemo is unable to repress the sound of his breathing and so breaks the silence, the polar bears come onto his trail. One chases Nemo through the snowy landscape back to his bed, where Nemo wakes, as he does every week, and this time is 'panting'. In predictable fashion his guardian calls out, as every week, 'get back to sleep'. The snow fell in a dream and seemed to fill the room itself. In his dream Nemo's room becomes a snow globe, and like a snow globe the room seems to be a microcosm of the wider world inside just one part of it, a world within a world, reflex of the way in which the dream might be seen as a repetition of the world within the smaller globe of the head.

References

Adorno, T. W. (1963) 'Charakteristik Walter Benjamins', *Prismen: Kulturkritik und Gesellschaft*, Munich: Deutscher Taschenbuch Verlag.

Benjamin, Walter (1999) *Selected Writings: Volume 2:2, 1931–1934*, trans. Rodney Livingstone and others, Cambridge, MA: The Belknap Press of Harvard University Press.

—— (2003) 'The Work of Art in the Age of its Technological Reproducibility' in *Selected Writings: Volume 3, 1935–1938*, trans. Edmund Jephcott, Cambridge, MA: The Belknap Press of Harvard University Press.

McCay, Winsor (1997) *Best of Little Nemo in Slumberland*, New York: Stewart, Tabori, & Chang.

Szondi, Peter (1978) 'Hope in the Past: On Walter Benjamin' [1961], *Critical Inquiry*, Spring.

Esther Leslie

School of English and Humanities, Birkbeck, University of London

TEN FOOT, FOUR

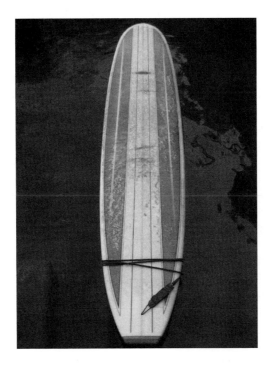

My surfboard is 10' 4" from nose to tail, 2' 5" wide from rail to rail, and just over 3.5" thick.[1] It is, as one of my grad students taunted, "big enough to get the whole family on." The top deck's color scheme features a red fade from nose to tail and black pinlines. The overall effect is understated, and in moments of buyer's remorse, less visually seductive than I wish it were. The bottom is white with black pinlines, and has a balsa stringer running down the center. The nose has a teardrop done in black pinlines that encircles the shaper's logo. This perfectly formed and sited detail is my favorite part of the graphic design. The whole board is glossed and has a polished finish, though with use it has developed character. Dings and water seepage show that it's no collector's board, and to be frank, thick layers of surf wax usually obscure the deck's color and design. On the other hand, the board has been maintained well enough that even after five years it hasn't been reduced to a beater, good only for lending to friends and their kids.

However it looks, a surfboard is defined by how it handles and rides in the water. The board was built for a stable ride and long turns, and, if you are nimble enough, the chance to noseride. It's from this particular fixation that we get the term "hang ten," for those gifted souls who plant their board so well in the wave that they can dance out to the front of the board and grip it with all 10 toes. The most I've ever managed is five, followed by an almost immediate fall from grace. Leaving aside my limitations, let's return to the board's shape: it has a concave nose, and a moderate rocker, which is to say that it cuts into the water fairly easily. The thick rails, or sides, and squared off tail also contribute to a stable glide through the surf. The three fins are in the thruster formation—two smaller fins forward on the sides, the larger one in a center fin box—which

helps with both control and drive in the water: All these factors together combine to create what is considered a "modern longboard."

I try to tell myself that I own a longboard because I value grace and fluidity, but the real reason that I have one is that I'm too big and too old to have a short board. Long versus short means picking sides in a fight that flares up every few years. Until 1968, all surfboards were longboards. John Van Hamersveld's pop-art silk-screened movie poster for Bruce Brown's *Endless Summer* (1966) is surfing's single most iconic image.[2] But the three surfers posed in front of the setting sun, all carrying boards taller than they are, is not a picture that would have been taken, much less taken seriously, by 1973. The introduction of shortboards between 1966 and 1968 transformed the sport. Now surfers could "tuberide," getting inside the very curl of the wave itself. Shortboards expanded exponentially what surfers could do while at the same time upping the power and agility demanded of their riders. Shortboarders are stereotypically young and aggro (short for aggressive). They go for air, quick cutbacks, and other tricky maneuvers that move them up and down the wave.

Although longboards almost died out in the 1970s and 1980s, they made a comeback in the 1990s. There were now a fair number of surfers in their 40s and 50s, who even with experience couldn't use their short boards as effectively as they once had. Also, the truth is that you can get more pleasure more quickly out of surfing on a longboard with less of a learning curve than you can on a short board. So it is that longboarders are typically older, soul surfing with, rather than against, the wave. Or so goes the propaganda. The longboard renaissance is now officially a Risorgimento, with more than 60 percent of new board sales. With my purchase of a longboard, I joined a market segment, a demographic, whether I was conscious of it or not.

I was 40 years old, and had been living in Southern California for 15 years when I finally decided that I wanted to surf. I had been one of those people who would stand on piers and watch surfers, who would admire them as I drove down Pacific Coast Highway (referred to as PCH by SoCal locals), who would swim near them and even boogie board on the same waves with them, all the while knowing that until I stood up on a board, I would never understand something fundamental about living on the West Coast of the Pacific. So, I learned to surf. I rented a few soft boards and flailed about in the water. Then I heard about a guy named Malibu Mike, a sun-grizzled survivor of the stratospheric escalation of coastal real estate.[3] A few sessions with him and I was off to buy the object itself, the board.

If you choose, you can buy a board from the person who manufactures it by hand for the same price as buying one from a retailer. This makes a surfboard one of the last artisanally produced goods in contemporary sports. Although I can afford a surfboard, I cannot afford a bespoke suit, and living in LA, where every day is casual Friday, why would I even wear one? But the notion of something being made for you, by someone standing in front of you is seductive, and as with many a successful seduction, can result in a relationship. My relationship is with a laconic shaper named Bruce Jones. He is tall, in his late 50s or early 60s, and has been shaping boards by hand since the early 1960s.[4] Jones is known for his expertise in longboards, and I was obviously buying into the "credibility" of the man and his shop, located in the small town of Sunset Beach, CA.[5] Jones's matter-of-fact quality, and the stripped-down functionalism of the shop's interior helped me overcome the associations of going long that I'm not crazy about. These include nostalgia for the 1960s, a kitsch factor involving roomy Hawaiian print shirts,

and a strong sense of upper-middle-aged, upper-middle-class entitlement. But a long-board is what I surf, a longboard is what I own, and I suppose those two come together to define me as a longboarder, dodgy stereotypes and all.

When you acquire an object, it brings with it a community that you may or may not wish to join. The French sociologist of science Bruno Latour has recently suggested that we need to talk about a *Dingpolitik*. This is his German neologism to speak of a *Realpolitik* of things. For Latour, the ultimate goal is to create the foundation for an "*object*-oriented democracy." Latour acknowledges that each and every object we encounter can trigger "new occasions to passionately differ and dispute."[6] If *Dingpolitiks* are to be of more than theoretical interest, though, we'll have to admit that our things induct us into *Dingpolitik*-al parties, whether we want to join them or not.

On days when I surf poorly I think about my board. I curse it for not being agile enough, as though it were the ride and not the rider's fault. Sometimes I covet a super fish—shorter, with a wider nose, swallow-type tail, and two fins—like some kid who thinks new Nikes will make him jump higher. But on good days, when the waves roll in at just the right height, and my approach is solid, and my stance is good, and I'm actually carving turns, when I'm really, honest-to-god surfing, my ten foot, four longboard is my most beloved possession.

Notes

1 For those lucky enough to have escaped the tyranny of English customary units, the board is 3.15 m × 74 cm × 8.9 cm.
2 The poster and a short paragraph explaining its origin can be found at http://www.van hamersveldmuseumofart.com/museum/03_1960/pages/03_endlesssummer.htm
3 His full name is Malibu Mike Avatar. There are certain things about California that you do not have to make up.
4 This would be the place, if I were the nostalgic type, to recount that Jones worked at the legendary Hobie Surfboard Shop, with the greatest collection of shapers in the world at that time, people like Ralph Parker, Phil Edwards, and the legendary Dale Velzy. But I'm not the nostalgic type, so I have relegated this information to a footnote. http://bruce jones.com/
5 Bruce Jones is just one town north of Huntington Beach (HB) on PCH. HB is also known as "Surf City" and is the absolute epicenter of large-scale sports retail marketing, with Huntington Surf and Sport (HSS) facing off against Jack's Surfboards. These two super-stores, both on PCH opposite the HB pier, anchor what is essentially an open mall of surf shops on Main Street. HB is all about aggro.
6 Bruno Latour, 'From Realpolitik to Dingpolitik, or How to Make Things Public', in Bruno Latour and Peter Weibel (eds), *Making Things Public: Atmospheres of Democracy*, Karlsruhe: ZMK and Cambridge, MA: MIT Press, 2005, pp. 14–41, republished in this volume, pp. 153–164.

Peter Lunenfeld

Design/Media Arts Department, University of California, Los Angeles

THUMBNAILS

160 × 120

At 160 × 120 pixels, the images my SLVR camera phone generates are small and read-ily moveable, ideally suited for viewing on mobile micro screens and for posting to blogs, moblogs and other web-based platforms of display. These images, or thumbnails, are curious bits of "visible evidence," their content often oddly framed, frequently in extreme close-up and sometimes blurred. Not unlike their photographic forebears, they are the remains of a seeing already past: so many glimpses recorded in the time of their happening; remnants of momentarily piqued attention when the spontaneous glancing of a thumb or finger against a shutter button snapped sight into an experience of encoun-ter. And yet, thumbnails as objects are quite distinct from photographs. They neither pose in frames nor inhabit photo albums. In fact, they are very rarely printed to paper. In part, this is a consequence of size. For being not much larger than the size of an ana-tomical thumbnail (160 × 120 pixels measuring approximately 1½ inches × 1 inch), thumbnails are not aptly suited for conventional modes of pictorial display. And so, they live another sort of existence, one that is governed by immediacy, plurality, and mobil-ity. Even as they are technically "still" images, thumbnails accumulate (at a rate more instant than the snapshot) and then disperse. They proliferate in streams.

In their streaming, thumbnails abide by the conditions of the template: columns and rows prescribed by a software application regulating their display. At first obser-vation this organization of images is schematic, taxonomical. However, thumbnails are not as stable, i.e., immobile, as their gridding might imply, for they accrue on moblogs and similar image management platforms (e.g., Flickr), the most recent push-ing the previously posted others across the screen along their regimented ranks and files. There is an expressive tempo—a rhythm and pacing—to their appearance and movement in reverse chronology across and down the screen's surface. Viewers of these strings will notice patterns in the punctuated seriality of thumbnails, a steady or staccato pulsing of imaging-posting or its elongated murmurings constituting a photo-stream's visuality.

Thumbnails as discrete objects within a string might provide content to be parsed and rendered legible—a spotlighted pair of failing dice in one, strings of Japanese lan-terns, blurred, in another. But this way of approaching thumbnails locates the expres-sive, the aesthetic, to the isolatable instance of a single image, each image suffered to stand still in its autarky, bound to the constraints of its framing. What goes miss-ing in such viewing: the dynamic nature of the intensity and tempo of attraction and experience as recorded by an ever-shifting string of thumbnails. Rate and frequency of

imaging, typical times and locations for imaging, kinds of objects and people imaged, quantity of images for any one (kind of) object or person, typical quality of imaging (e.g., amount of blurring, suggestive of movement of different sorts), etc.: these are the trappings of the expressive, made visible as series, repetitions, combinations, chunkings and juxtapositions across streams of mobile-imaging thumbnails. Only in their streaming do thumbnails reveal the constellations and trajectories of curiosity and affect materialized during one's engagement with the world.

Metadata

Each and every thumbnail image conveys information—metadata. Encoded at the moment of imaging, metadata index conditions surrounding the particular instant (and instance) of capture. For example, a single thumbnail might bear information regarding camera make and model, date and time of capture, width and height of the image in pixels, whether a flash was used, focal length used, exposure time, aperture value and metering mode, location information (either GPS or GSM cell information from network towers, but also names of country and city) and information regarding Bluetooth environment (other Bluetooth enabled devices "visible" within a 30-foot radius), events from a camera phone's calendar, as well as tags and descriptions added by the camera phone user – not to mention "footprints," i.e., metadata about the visits and comments, or tracks, by others to a thumbnail once it is in-stream. And there are projections regarding the soon-to-be encodability of environmental factors, such as temperature and barometric pressure, and biological data, including body temperature, galvanic skin response, heartbeat, and pulse.

This information that thumbnails bear is neither static nor contained, for streaming opens onto the possibility of further circulation and, consequently, the multiplied dissemination of metadata. The logic of social networking guarantees thumbnails' continued dispersal: they are downloaded to computers and uploaded to personal webpages, MMS-ed and emailed to friends and family, posted to moblogs and blogs as well as to file-sharing sites (e.g., Flickr) and personal presentation pages (e.g., MySpace, Facebook), filtered and linked to a variety of sites via RSS and Atom feeds. In being accessed, commented on and disseminated worldwide, thumbnails enter into diverse contexts where they are given new life. This is their iterability: the possibility of ceaseless extraction and grafting elsewhere.

In their continuous streaming and circulation, thumbnails can be tracked, their various pauses, re-routings and dispersals always subject to monitoring on a systemic and systematic scale (by governments, corporations, news organizations, site managers, etc. —all of which are, in fact, responsible for the infrastructure and technologies that make streaming and circulation possible). Thus, thumbnails do not simply provide information about an individual person, they do so within and in relation to a larger social networking of people. Their registering of tendencies and transactions, their recording of persisting and varying patterns in circulation, provide an account upon which statistical measures and predictive analyses can be based. And so, future inter-relations, transactions, and exchanges can be anticipated; they can be managed. Thumbnails are vehicles by which life is counted, taken into account and accounted for. We, who undertake (intentionally or not) to self-record via thumbnails, make ourselves calculable, our

tendency to self-document contributing to and ensuring a larger project of regulation and control.

Vital signals

In June 2006, the *Oxford English Dictionary* (online) included a "draft addition" to its entry on "thumb-nail, *n.*" It reads: "A miniaturized version of a document or part of a document; (*Computing*) a small version of a digital image, freq. acting as a hyperlink to a larger version."[1] Listed before this newly added definition are two other definitions of note: "1. The nail of the thumb" and "2. *transf.* A drawing or sketch of the size of the thumb-nail; hence *fig.* a brief word-picture." That the thumbnail image always resounds a reference to the somatic thumbnail is significant. In the ambiguity of the homonym, the thumbnail inhabits a circumstance of both-and. In which case, thumbnails always occupy a position of contingency and indeterminacy, their appellation signaling a mutually compensating relation between technological and biological domains. The status of their objectness shifts. They index the *that-has-been* of an instantaneously integral and vital articulation of physiological process and technological mechanism.

As small digital images, thumbnails register the here and now of a different sort of "self," one in which the physiological asserts its primacy over the cognitive. Precisely because of their capacity for spontaneous snapping and dissemination, mobile-imaging thumbnails are best regarded, not as intentioned picturings of things seen, but as materializations of bodily responses to sensory stimulation. They process encounters with objects, people, etc., as so many pulsings of what neurobiologist Antonio Damasio calls "core consciousness." The autobiographical self is not yet instantiated; the "I" of extended consciousness as yet unspoken, as yet unspeakable. Instead, the organism as such predominates. At the level of the organism, there is no thinking, self-aware whole, only the multiple and concurrent (parallel) networkings of diverse impulses mapping a flesh. In their instantaneity, plurality and mobility, thumbnails are grafts of this neurobiological living. Each thumbnail indicates less an act of thought than a particular moment in which a second-order neural pattern dilated into the something felt of awareness and triggered the impulse to image. Such a change in the overall state of the organism provokes a series of motor adjustments; imaging happens. The resulting thumbnail potentially posts to a moblog. It is the remains of that singular instant in which living was simultaneous with imaging, when imaging was one with living.

Thumbnails, then, are proof of life. Signatures of vitality—or rather, so many vital signs, they stream an autography, graftings of core (neurobiological) self elsewhere. And their rhythmic proliferation at 160×120 pixels mobilizes a persistence of a vision that once was lived, at the same time that it signals the movements of a body whose record "lives" on in various streams that document a past and anticipate a future. In this, the body and its thumbnails are a guarantee: the condition of possibility for the continued networking of forces, whose flows of energy both keep and track life as such.

Note

1 *OED* online (1989; Oxford: Clarendon Press/Oxford University Press, March 2000), http://www.oed.com/.

Heidi Rae Cooley

Department of Art/Media Arts and Film and Media Studies Program, University of South Carolina

WHAT LUBE GOES INTO

Juicy fruit

Before turning to the bottle, I found my lube of choice in a poem: Christina Rossetti's 1859 *Goblin Market*. It concerns two sisters, Lizzie and Laura, who find their simple ways threatened by goblin merchant men selling luscious exotic fruits that make the eater desperate for more but deaf to their sellers. Lizzie resists. Laura succumbs, eats voraciously, wants more, is consumed with need that leads "to swift decay." Lizzie goes to buy fruit for her sister. The goblins say: eat it here. She wants it to go. In rage they attack her, smash the food all over her body. She races home: "never mind my bruises / hug me, kiss me, suck my juices." Laura does. It cures her:

> Swift fire spread throughout her veins, . . .
> Met the fire smouldering there
> And overbore its lesser flame . . .

Fast-forward to when they are mothers telling their children the moral of the story:

> [T]here is no friend like a sister
> In calm or stormy weather . . .
> (Rossetti 1862, lines 279, 467–8, 507–9, 562–3)

To summarize a poem's plot seems contrary: the device so dry and linear; a poem poetic in what exceeds even crazy plot points. But in 1980, during my second year in graduate school, that's precisely where I found my lube. The antidote is the poison? Lizzie says "suck my juices," Laura "kissed and kissed her with a hungry mouth" (p. 492) and the point is simple filial loyalty? The juice was in the poem, but the lube was also the poem itself. I used its blatant homoerotics, not that any other student acknowledged it, to troll

for an advisor. While I really liked Laura—just like I preferred Amy in *Little Women*, another girl who loved pleasure, fuck the disapproval, said it, took it, lived to tell—I played it like Lizzie. Here's juice on my outsides: it's all about sex in that poem over there, lesbian content. Could I say that in Beth's class and come calling again? Apparently so.

Later in dissertation years, I dreamed that Beth fed hot dogs to daughters that my dream invented for her. She dreamed I brought a gay chorus into her class. My own desiring students did something with a giant wooden spoon that I kind of wish they hadn't told me about.

Product placement

A 1992 ad in *Parade* magazine for Gynemoistrin extended my scholarly interest to lubes peddled by humans. Gynemoistrin, the ad says, is especially designed for "a woman's delicate vaginal area." It doesn't name the comparative orifice, which might call up anal penetration as sexual, or ask you to think about the extent to which "delicate" accurately distinguishes *this* hole or might instead function as pseudoscientific drivel designed to multiply product need. (Thanks for offering one of your blue disposable razors, but I need to buy the pack of pink ones for the delicate womanly skin on my legs.) But the ad does use the image of a harem denizen, Ingres's *Grand Odalisque* of 1814, to locate the sexual buzz and obfuscation in an exotic mysterious elsewhere. Reclining, seen from the back, she turns her head to face us with a mysterious look. There's a slightly risqué visual joke here: perhaps she's thinking about vaginal dryness. There's a joke for the more perverse in our rear view.

It's a joke, however, with questionable politics. Perversion is great, but rerouted into an enslaved "oriental" woman? "So you like sky scrapers, Osama Bin Laden?" reads contemporary vengeance prose: anti-Arab, anti-queer, feminizing as punishment (see Puar and Rai, 2002).

Greasy no matter the hype

That's the thing about lube. On the one hand, as my friend Debbie succinctly put it, as we commiserated about dykes who disdain lubing their cocks for pussy, lube can get you where you want to go. Far from heralding studly failure—can't you get the girl wet enough? —having a bottle as a nightstand fixture is simultaneously chivalrous and hot. Lube can get you into some places you would be hard pressed to enter without it, and can sometimes get you better to where you could have gone anyway. It can enhance your choices of size, move, hole, position, and partners (ageist and ableist as it is, among other ists, to require girls to manufacture our own vaginal lubrication in response even to your skillful advances).

On the other hand, just when you think that you are using lube to advance or even emblematize your own desires, you may discover how much you are being handled. Consider Astroglide. It used to be the glorious lube of perverts, with gender-ambiguous kissers on the bottle signaling it as the queer and stylish alternative to the dreary medicinal K-Y. Having Astroglide suggested a certain commitment to pleasure, maybe

perverse pleasure, especially, before www, if you lived a distance from queer urbanity. At least that's what I thought until I found an article in *Glamour*, around 2000, that advised women plagued by vaginal dryness to buy Astroglide in the "family planning" section of their local chain pharmacy. Who knew? No queers that I canvassed. But there it was, albeit packaged in de-queering abstraction. (The kissers still serve selected markets, like women-geared sex shops such as Toys in Babeland or Good Vibrations.) Interestingly enough, CVS had super-sized bottles. What does it mean for the dimensions of *family* when lube goes "family-sized?"

Anyway, Astroglide's really not so glorious if you read the fine print. It usually contains glycerin. Probe does, too, glossing it seductively as "a sweet liquid derived from plants." That's understandable: it certainly sounds better, if no more organic, than "risk of yeast infections." Less clear is why Probe distracted attention from the manly connotations of its name for the sake of featuring "Natural Citrus Preservative" in large letters on the front of its bottle. Between "preservative" and the notoriously unregulated supermarket word "natural," it just seems sketchy.

Meanwhile, it's K-Y that now aims for sexy first. Ky.com offers soft-core sex advice for using its premium line, Intrigue™: "Discovery . . . can be as tame as bringing your favorite silk scarf to bed, or as risqué as investing in a new guidebook or a new toy that you both feel comfortable with." Investment, guidebook, comfort, your scarf; the sheltered woman as tourist to her native temptress. But why bother trying to extract connotation? The site also offers its preferred interpretation of the lube's name, which "conjures up images of sexual adventure," its bottle design, "at once sensual and ergonomically satisfying," and its "Feel," which is enhanced by "Blissful LIQUIMER™ Technology." One needs to look elsewhere to find the lesson in knotting silk scarves safely that Intrigue's imagined consumer surely needs or the not-so blissful-sounding ingredients of LIQUIMER™: dimethiconol and dimethicone, used also in sunscreens, hair conditioner, and, when dimethicone meets silicon dioxide, Gas-X. Mmmm. (However, as the Coalition against Toxic Toys (http://badvibes.org/) explains, silicone should absolutely be considered the most appetizing ingredient if you want to avoid sex toys that may leach toxic chemicals.)

Slick moves

Because of both what it allows and where it foils the illusion of free choice, I find in lube a great metaphor and model for activist cultural work. During my early encounters with *Goblin Market*, I understood analyzing the poem to epitomize the purpose of academic criticism, and my use of the poem to troll for an advisor as a perverse activity to the side of, if, for me, necessary to it. Now I think we should scoop into the intellectual project the possibility of using cultural products to initiate work that aims not to explain them—nor to pursue the common two-directional path where objects illuminate contexts which illuminate objects—but to enact, accomplish, or analyze something else. It's a little like buying lube in the "family planning" section when you are not planning to stick it into the "family planning" hole.

I began thinking about lube this way during a project on the Ellis Island Museum (Rand, 2005) as I tried to deal with the weirdness of a detention center turned tourist site. The ride can be rough where entertainment meets incarceration, where the past

meets its marketing, where historical photos of migrant detainees eating mystery meat adorn the Aramark-run snack shop. You could follow the path slicked up for you: take a moment for sober contemplation, then order the vaguely ethnic "nacho grande." Or you could slick up nearby where they don't want to send you. Maybe you'd learn that Aramark's employees likely can ill afford the price of admission, or that prison privatization puts Aramark in the mystery meat business, too, with the same complaints of insufficient, unhealthy, and unsanitary food that its predecessors at Ellis faced (Dannenberg: 2006).

Academic order: dinner before dessert, analysis before action, discipline before interdiscipline, work before pleasure. Change direction. Make better slick moves. Lube is great because it can get you where you want to go, even if, or because, it may gunk up the furniture.

Acknowledgements

For diverse reasons regarding lube and this essay, I thank Debbie Gould, Sawyer Stone, Jackie Parker-Holmes, Gina Rourke of the Nomia "sensuality boutique," and Yee Won Chong. Especially, I thank Elizabeth Helsinger, for being an advisor far beyond what I even dared to want, fantastic then and since. This is for you.

References

Dannenberg, J. (2006) 'Aramark: Prison Food Service with a Bad Aftertaste', *Prison Legal News* 17, no. 12, vol. 10. Available: http://www.prisonlegalnews.org/(S(tm41q145wa4vei2 crrojyiav))/displayArticle.asp?articleid=11002&AspxAutoDetectCookieSupport=1 (accessed 5 September 2007).

Puar, J. K. and Rai, A. S. (2002) 'Monster, Terrorist, Fag: The War of Terrorism and the Production of Docile Patriots', *Social Text*, 72, no. 3, pp. 117–48.

Rand, E. (2005) *The Ellis Island Snow Globe*, Durham, NC, and London: Duke University Press.

Rossetti, C. (1862; manuscript dated 1859), *Goblin Market*, in R. W. Crump (ed.) (1979) *The Complete Poems of Christina Rossetti*, Baton Rouge, LA, and London: Louisiana State University Press, pp. 11–25.

Erica Rand

Art and Visual Culture, Women and Gender Studies, Bates College, Maine

YESTERDAY UPON THE STAIR

In 1994 I started my doctorate and almost immediately ceased to work. I was the first PhD student at Keele University to register on a theory-practice programme and as well as writing a thesis I was supposed to make art, a formulation that produced a great deal of disquiet in the academic establishment and, consequently, in me. To make matters worse I was given an office in Keele Hall, an old stately home which had been incorporated into the university, and, sitting at my desk, I would quite distinctly get the creeps. Not surprisingly my first year was a mess. I didn't know how to work and the few pieces I attempted to make were not remotely successful. And then, someone told me a story.

Barbara Johnson, one of the cleaners at the Hall, related how sometimes in the early morning there was an icy spot at the foot of the grand staircase and that she knew this cold was the presence of the dead Lady Sneyd. According to her, the ghost of Lady Sneyd moved down the staircase, across the central hall and out, past my office, over the formal gardens. She was apparently the ghost of a young woman with long thick hair and with no hands. When she had lived, Lady Sneyd had been very proud of her hair and she had brushed it continually. Her husband had objected to this as she was of high rank and they had servants to perform such tasks. But she persisted and eventually, in order to stop her behaving in this demeaning way, he cut off her hands. Later, the university photographer, Terry Bolam, told me another version of the story: that the 'Grey Lady' had a maidservant who had brushed her hair for her and her husband had given her a choice: she could either keep her hands or her maid and she chose the maid.

That year, the English translation of Jacques Derrida's *Specters of Marx* was published and it provided me with a way to think about the Grey Lady. In traditional stories, ghosts continue to appear as long as an initial injustice remains unresolved. In response Derrida suggests that they act as a demand; that the living confront the legacies of the past and the image of the future (like the ghost of Christmas Future, ghosts can always come *back*). Understood in these terms a spectral appearance always involves a 'politics of memory, of inheritance and of generations' (p. xix).

For me, this ghost was still walking, not just around my office but through all the rooms of academia where female sexuality and autonomy continued to be heavily if not quite so dramatically limited. In Britain in 1994 it wasn't unusual to be the only woman academic in a department and while female students were in a majority, the numbers became increasingly skewed in men's favour thereafter. Less than 4 per cent of British professors were women and they were also severely under-represented in senior administrative and research positions. In consequence women had comparatively little say in university decision-making processes. Perhaps even more fundamentally what the university had historically recognized and validated as knowledge had excluded women on the grounds that they, unlike men, were less capable of rational thought. These and other embedded exclusions had largely stripped academia of female sexuality, physical warmth, storytelling and rich, yet unscholarly experience. Academia was itself ghostly, living a curious half-life.

I started to research the story of the ghost; I made this intermittently immaterial thing into my object of study. There was an extensive archive related to the Sneyd family in the university library where I found an 18th-century collection of their hair, wrapped in tiny annotated packets, but none of the archival material supported the tale. I approached other members of staff who worked in the Hall and asked them about what they had heard or seen, but I got no further in my investigation. I didn't know if I believed in ghosts but I wanted to find out if this particular woman had existed and to see her, to witness the spectre for myself.

For Derrida, ghosts do not belong 'to that which one thinks one knows by the name of knowledge' and, as he continues, it may be impossible 'for a reader, an expert, a professor, an interpreter, in short for . . . a "scholar"', to ever make a spectre speak (pp. 6, 11). While the tale of the Grey Lady spoke to a legacy of repression within the university, rational academia could not acknowledge the possibility of her appearance, and so, wondering if I was being too much of a scholar to speak to spectres, I decided to make her a memorial.

I constructed an artwork in three parts. I took a double-exposure photograph of myself in evening dress standing at the top of the stairs, the site of the haunting, which I hung in the same place alongside other Sneyd family portraits. At the turn of the stairs, I placed a wax sculpture made to resemble a memorial stone, on top of which lay two wax arms missing their hands, and a wreath of synthetic hair. The third artefact was a small guidebook which contained three stories: the two versions of the ghost story and a story of how, working at the site of her mutilation, I had lost the use of my hands and been unable to work.

And still, the ghost did not appear to me. I had thought that working as an artist rather than within a traditional area of doctoral study, together with my gender, placed me on the fringes of mainstream university enquiry, and I had hoped that somehow I would be able to engage with this thing that had escaped the parameters of academic study, that like the cleaning and technical staff I would be able to see her. Finally, I decided I would have her speak to me through other means, and included in the guidebook were three pieces of automatic writing, purportedly Lady Sneyd's words channelled through me. These texts were an attempt to make the invisible visible and to articulate what I did not know or have access to. The problem was that my own voice took the place of the ghost's and I could not make contact with her.

Looking back I realize that I'd behaved like a ghost-hunter armed with tape-recorders

and trip-wires. In waiting to see her, in wanting a sighting, I was looking for empirical evidence of something that is not subject to hard proof. Insofar as they might be there at all, ghosts are indeterminate manifestations; they can exist as a cold patch in the corridor, a breeze when the doors are closed or a smear of light in an old photograph. To try to represent her and to make her material, to attempt to bring her into full presence was a misrecognition which rendered her even more elusive.

Yet, I had encountered the ghost. I didn't know at the time how to recognize what my crawling skin was telling me. I didn't imagine that my hands were cut off, they were; it had taken me nearly two years to make this first piece of artwork. Every time I felt a sense of foreboding as I walked across the campus, into the Hall and my office, I felt the ghost. When I sat on my studio floor and let my hand trail across the paper I wasn't mimicking automatic writing, I was producing it. I wanted to experience something other than rationalism but I was too trained to realize that I could, that I already did. Being a scholar didn't exempt me from that experience; rather I couldn't grasp what my own experience was. Other academics seemed to have done this: once the piece was exhibited they sidled up to me in corridors and told me about the sounds of children playing, of scratching and crying emitting from empty rooms. The divide between academic and non-academic knowledge was not absolute, it was just rare for anyone to acknowledge its fracture.

Examining the university, or any other professional organization, often takes the form of sociological analysis or statistics. In addition to these things that can be grasped we may also need a spectral, sensory, emotional account of the organization. We ought to recognize that our object can be encountered when the hairs rise on the back of our neck in an unaccounted noise or in our sense of unease. These are not just empty responses, they are a form of bodily ethics, of protest, resistance or acceptance, they are ways of knowing an institution, of understanding a political situation. Our expertise does not preclude our ability to feel, indeed, it can be premised upon it. In order to be good academics, intellectuals, we have to learn the patterns of a haunting, to accept that we can speak with the voices of dead women and we need to listen to the stories of cleaners and technicians.

A question remains: does the ghost continue to walk? I could mention the subsequent increase in the number of women staff whilst pointing out that we are disproportionately represented in the lower-status posts and on short-term contracts; that in 2007 only 16 per cent of British professors were women.[1] I could discuss the continuing pay differential, that male academics earn an average of 5.5 per cent more than their female counterparts and, in extreme cases up to 20.4 per cent more, and that in 2008 researchers could not account for this disparity in terms of role, subject or institution.[2] I could note that women are disproportionately overburdened with pastoral care and committees, that we are less likely to be recognized as research active and that levels of childlessness among academic women are almost double those of male colleagues.[3] We could talk about how feminism has become rather passé, now that women are considered, at least cosmetically, to have equal rights. But I could also, simply say that I do see her, in different cities and universities. When the chills run, when the anxiety is high, that's her and she's talking to me. I listen. She says, 'I'm here, you *can* feel me'.

Reference

Derrida, Jacques (1994) *Specters of Marx: The State of the Debt, the Work of Mourning and the New International*, London: Routledge.

Notes

1 Tysome, T. (2007) 'Sex Parity 50 Years Off', *Times Higher Education*, 19 January. Online, available at http://www.timeshighereducation.co.uk/story.asp?sectioncode=26&storycode=207484 (accessed 27 May 2008).

2 Newman, M. (2008) 'Economists Confirm Existence of Glass Ceiling for Women Academics', *Times Higher Education* 27 March. Online. Available at http://www.timeshighereducation.co.uk/story.asp?sectioncode=26&storycode=401219 (accessed 27 May 2008).

3 Baty, P. (2004) 'Sex Bias Limits Women in RAE', *Times Higher Education*, 16 October. Online, available at http://www.timeshighereducation.co.uk/story.asp?sectioncode=26&storycode=190047 (accessed 27 May 2008).

Fiona Candlin

School of Arts, Birkbeck, University of London

An Object Bibliography

An Object Bibliography

An object . . .

Alford, S. E. and Ferriss, S. (2007) *Motorcycle*, London: Reaktion.

Banerjee, M. and Miller, D. (2003) *The Sari*, Oxford: Berg.

duCille, A. (1996) 'Toy Theory: Black Barbie and the Deep Play of Difference', in *Skin Trade*, Cambridge, MA: Harvard University Press.

du Gay, P. et al. (1997) *Doing Cultural Studies: The Story of the Sony Walkman*, London: Sage.

Gabbard, K. (2008) *Hotter than That: The Trumpet, Jazz, and American Culture*, New York: Faber & Faber.

Holiday, L. S. (2001) 'Kitchen Technologies: Promises and Alibis, 1944–1966', *Camera Obscura*, vol. 16, no. 2, pp. 79–131.

Levinson, M. (2008) *The Box: How the Shipping Container Made the World Smaller and the World Economy Bigger*, Princeton, NJ: Princeton University Press.

Levy, S. (2006) *The Perfect Thing: How the iPod Shuffles Commerce, Culture, and Coolness*, New York: Simon & Schuster.

Nickles, S. (2002) '"Preserving Women": Refrigerator Design as Social Practice in the 1930s', *Technology and Culture*, 43, pp. 693–727.

Pascoe, D. (2001) *Aircraft*, London: Reaktion.

Petroski, H. (1989) *The Pencil: A History of Design and Circumstance*, New York: Knopf Inc.

—— (2007) *The Toothpick: Technology and Culture*, New York: Knopf Inc.

Wright, L. (1980) *Clean and Decent: The History of the Bath and Loo and of Sundry Habits, Fashions and Accessories of the Toilet Principally in Great Britain, France and America*, London: Routledge & Kegan Paul.

. . . things . . .

(1994–2008) *Things*.

Appadurai, A. (2006) 'The Thing Itself', *Public Culture*, vol. 18, no. 1, pp. 15–21.

Boradker, P. (2006) 'Theorizing Things: Status, Problems and the Benefits of the Critical Interpretation of Objects', *The Design Journal*, vol. 9, no. 2, pp. 3–15.

Briggs, A. (1988) *Victorian Things*, Chicago: University of Chicago Press.

Brown, B. (1998) 'How to Do Things with Things (A Toy Story)', *Critical Inquiry*, vol. 24, no. 4, pp. 935–64.

—— (2002) 'The Tyranny of Things (Trivia in Karl Marx and Mark Twain)', *Critical Inquiry*, 28, pp. 443–69.

—— (2004) *A Sense of Things: The Object Matter of American Literature,* Chicago: University of Chicago Press.

Davidson, C. C. (ed.) (2001) *Anything,* Cambridge, MA: MIT Press.

Graham, M. 'Sexual Things', *GLQ: A Journal of Lesbian and Gay Studies,* vol. 10, no. 2, pp. 299–303.

Grosz, E. (2002) 'Notes on the Thing', *Perspecta,* 33, pp. 78–9.

Henare, A., Holbraad, M. and Wastell, S. (eds) (2007) *Thinking through Things: Theorising Artefacts Ethnographically,* London: Routledge.

Martin, F. D. (1974) 'Heidegger's Being of Things and Aesthetics Education', *Journal of Aesthetic Education,* vol. 8, no. 3, pp. 87–105.

. . . objects in everyday life . . .

Arvatov, B. (1997) 'Everyday Life and the Culture of the Thing (Towards the Formulation of the Question)', *October,* 81, pp. 119–28.

Attfield, J. (2000) *Wild Things: The Material Culture of Everyday Life,* Oxford: Berg Publishers.

Bachelard, G. (1994) 'Drawers, Chests, and Wardrobes', *The Poetics of Space,* Boston, MA: Beacon Press, pp. 74–89.

Bronner, S. (1986) *Grasping Things: Folk Material Culture and Mass Society in America,* Lexington: University of Kentucky Press.

Busch, A. (2004) *The Uncommon Life of Common Objects*: Essays on Design and Everyday Life, New York: Metropolitan Books.

Csikszentmihalyi, M. and Rochberg-Halton, E. (1981) *The Meaning of Things: Domestic Symbols and the Self,* Cambridge: Cambridge University Press.

Harris, S. and Berke, D. (1997) *Architecture of the Everyday,* New York: Princeton Architectural Press.

Heskett, J. (2002) *Toothpicks and Logos: Design in Everyday Life,* Oxford: Oxford University Press.

Hoskins, J. (1998) *Biographical Objects: How Things Tell the Stories of People's Lives,* London: Routledge.

Weiner, A. B. and Schneider, J. (1989) *Cloth and Human Experience,* Washington, DC, and London: Smithsonian Institution.

. . . designing things . . .

Borgmann, A. (1995) 'The Depth of Design', in R. Buchana and V. Margolin (eds), *Discovering Design: Explorations in Design Studies,* Chicago: University of Chicago Press, pp. 13–22.

Forty, A. (1986) *Objects of Desire: Design and Society, 1750–1980,* London: Thames and Hudson.

Hebdige, D. (1988) *Hiding in the Light: On Images and Things,* London: Routledge.

Julier, G. (2000) *The Culture of Design,* London: Sage Publications.

Margolin, V. (2002) *The Politics of the Artificial: Essays on Design and Design Studies,* Chicago: University of Chicago Press.

Norman, D. A. (2002) *The Design of Everyday Things,* New York: Basic Books.

—— (2004) *Emotional Design: Why We Love (or Hate) Everyday Things,* New York: Basic Books.

—— (2007) *The Design of Future Things,* New York: Basic Books.

Sparke, P. (1986) *An Introduction to Design and Culture (1900 to the Present),* London: Routledge.

van Allen, P. (ed.) (2007) *The New Ecology of Things (NET),* Pasadena: Media Design Program, Art Center College of Design.

...and shopping ...

Douglas, M. and Isherwood, B. (1979) *The World of Goods: Towards an Anthropology of Consumption*, New York: Basic Books.

Hillis, K., Petit, M. and Epley, N. S. (eds) *Everyday eBay: Culture, Collecting, and Desire*, New York: Routledge.

Miller, D. (1998) *A Theory of Shopping*, Ithaca, NY: Cornell University Press.

—— (2001) *The Dialectics of Shopping*, Chicago, London: University of Chicago Press.

Pinch, A. (1998) 'Stealing Happiness: Shoplifting in Early Nineteenth Century England', in P. Spyer (ed.), *Border Fetishisms: Material Objects in Unstable Spaces*, London and New York: Routledge.

...commodities, gifts, exchange ...

Appadurai, A. (1986) *Social Life of Things: Commodities in Cultural Perspective*, Cambridge: Cambridge University Press.

Bataille, G. (1991) 'The Gift of Rivalry: Potlatch', in *The Accursed Share*, vol. 1, New York: Zone Books.

Godelier, M. (1999) *The Enigma of the Gift*, Chicago: University of Chicago Press.

Marx, K. (1990 [1865]) 'The Fetishism of Commodities and the Secret Thereof', in *Capital*, vol. 1, London: Penguin Classics.

Taussig, M. T. (1980) *The Devil and Commodity Fetishism in South America*, Chapel Hill: University of North Carolina Press.

...mass culture and kitsch ...

Adorno, T. W. (1991) *The Culture Industry: Selected Essays on Mass Culture*, trans. J. M. Bernstein, London: Routledge.

Benjamin, W. (1999) *The Arcades Project*, trans. Howard Eiland and Kevin McLaughlin, Cambridge, MA: Harvard University Press.

—— (1999) 'Dream Kitsch', in M. W. Jennings, H. Eiland and G. Smith (eds), *Walter Benjamin: Selected Writings, Volume 2, 1927–1934*, Cambridge, MA: MIT Press.

Buck-Morss, S. (1989) *The Dialectics of Seeing: Walter Benjamin and the Arcades Project*, Cambridge, MA: MIT Press.

Dorfles, D. (1969) *Kitsch: The World of Bad Taste*, New York: Bell Publishing Company.

Horkheimer, M. and Adorno, T. W. (1993) *Dialectic of Enlightenment*, trans. John Cumming, New York: Continuum.

Margolin, V. and Carroll, P. (2002) *Culture is Everywhere*, New York: Prestel.

Olalquiaga, C. (1998) *The Artificial Kingdom: A Treasury of the Kitsch Experience*, New York: Pantheon Books.

...waste...

DeSilvey, C. (2006) 'Observed Decay: Telling Stories with Mutable Things', *Journal of Material Culture*, vol. 11, no. 3, pp. 318–38.

Grossman, E. (2006) *High Tech Trash: Digital Devices, Hidden Toxins, and Human Health*, Washington, DC: Island Press.

Hawkins, G. and Muecke, S. (2003) *Culture and Waste: The Creation and Destruction of Value*, New York: Rowman & Littlefield.

Hawkins, G. (2006) *The Ethics of Waste: How to Relate to Rubbish*, New York: Rowman & Littlefield.

Nevill, B. and Villeneuve, J. (eds) (2002) *Waste-Site Stories: The Recycling of Memory*, Albany: State University of New York Press.

Rathje, W. and Murphy, C. (eds) (2001) *Rubbish!: The Archaeology of Garbage*, Tucson: University of Arizona Press.

Scanlan, J. (2005) *On Garbage*, London: Reaktion.

Slade, G. (2006) *Made to Break: Technology and Obsolescence in America*, Cambridge, MA: Harvard University Press.

Thompson, M. (1979) *Rubbish Theory: The Creation and Destruction of Value*, Oxford: Oxford University Press.

...and art,

Baxandall, M. (1980) *The Limewood Sculptors of Renaissance Germany: Images and Circumstances*, New Haven: Yale University Press.

Benjamin, A. (1994) *Object Painting*, London: Academy Editions.

Clark, L. B., Gough, R. and Watt, D. (eds) (2007) 'On Objects', *Performance Research*, 12, p. 4.

Clifford, J. (1988) *The Predicament of Art*, Cambridge, MA: Harvard University Press.

Edwards, E. and Hart, J. (2004) *Photographs Objects Histories: On the Materiality of Images*, London: Routledge.

Gell, A. (1996) 'Vogel's Net: Traps as artworks and artworks as traps', *Journal of Material Culture*, vol. 1, no. 1, pp. 15–38.

—— (1998) *Art and Agency: An Anthropological Theory*, Oxford: Clarendon Press.

Melville, S. (ed.) (2002) *The Lure of the Object*, Williamstown, MA: Sterling and Francine Clark Art Institute.

Mitchell, W. J. T. (2005) *What do Pictures Want? The Lives and Loves of Images*, Chicago: University of Chicago Press.

Scribner, C. (2003) 'Object, Relic, Fetish, Thing: Joseph Beuys and the Museum', *Critical Inquiry*, vol. 29, pp. 634–49.

...possessing and collecting...

Akin, M. (1996) 'Passionate Possession: The Formation of Private Collections', in W. D. Kingsley (ed.) *Learning from Things: Method and Theory of Material Culture Studies*, Washington, DC: Smithsonian Press.

Belk, R. (2001) *Collecting in a Consumer Society*, London: Routledge.

Blom, P. (2002) *To Have and to Hold*, New York: Overlook.

Dilworth, L. (2003) *Acts of Possession: Collecting in America*, New Brunswick, NJ: Rutgers University Press.

Elsner, J. and Cardinal, R. (eds) (2002) *The Cultures of Collecting*, London: Reaktion Books.

Hastie, A. (2006) *Cupboards of Curiosity: Women, Recollection, and Film History*, Durham, NC: Duke University Press.

Hillis, K., Petit, M. and Scott Epley, N. (eds) (2006) *Everyday eBay: Culture, Collecting, and Desire*, New York: Routledge.

Pearce, S. (1994) *Interpreting Objects and Collections*, London: Routledge.

——— (1999) *On Collecting: An Investigation into Collecting in the European Tradition*, London: Routledge.

Stewart, S. (1993) *On Longing: Narratives of the Miniature, the Gigantic, the Souvenir, the Collection*, Durham, NC: Duke University Press.

...collections, exhibitions and museums ...

Asma, S. T. (2003) *Stuffed Animals and Pickled Heads: The Culture and Evolution of Natural History*, Oxford: Oxford University Press.

Barringer, T. and Flynn, T. (eds) (1998) *Colonialism and the Object: Empire, Material Culture and the Museum*, London and New York: Routledge.

Bennett, T. (1995) *The Birth of the Museum: History, Theory, Politics*, London: Routledge.

Bronner, S. J. (1989) *Consuming Visions: Accumulation and Display of Goods in America 1880–1920*, New York: Norton.

Clifford, J. (1997) *Routes: Travel and Translation in the Late Twentieth Century*, Cambridge, MA: Harvard University Press.

Cook, J. W. (1996) 'Of Men, Missing Links, and Nondescripts: The Strange Career of P. T. Barnum's "What Is It?" Exhibition', in R. G. Thomson (ed.), *Freakery: Cultural Spectacles of the Extraordinary Body*, New York: New York University Press, pp. 139–57.

Findlin, P. (1996) *Possessing Nature: Museums, Collecting, and Scientific Culture in Early Modern Italy*, Berkeley: University of California Press.

Gunning, T. (1994) 'The World as Object Lesson: Cinema Audiences, Visual Culture and the St. Louis World's Fair', *Film History*, 6, pp. 422–44.

Highmore, B. (2003–4) 'Machinic Magic: IBM at the 1964–1965 New York World's Fair', *New Formations*, 51, pp. 128–48.

Hooper-Greenhill, E. (2001) *Museums and the Interpretation of Visual Culture*, London: Routledge.

Karp, I. and Lavine, S. D. (eds) (1990) *Exhibiting Cultures: The Poetics and Politics of Museum Display*. Washington, DC: Smithsonian Institution Press.

Rugoff, R. (1995) 'Beyond Belief: The Museum as Metaphor', in P. Wollen and L. Cooke (eds), *Visual Display: Culture Beyond Appearances*, Seattle: Bay Press, pp. 68–81.

Stocking, G. W. (1985) *Objects and Others: Essays on Museums and Material Culture*, Madison: University of Wisconsin Press.

Weschler, L. (1996) *Mr. Wilson's Cabinet of Wonder: Pronged Ants, Horned Humans, Mice on Toast, and Other Marvels of Jurassic Technology*, New York: Vintage.

Wollen, P. (2004) *Paris Manhattan: Writings on Art*, London: Verso.

Yanni, C. (2005) *Nature's Museums: Victorian Science and the Architecture of Display*, New York: Princeton Architectural Press.

...objects, nation, identity ...

Brown, B. (1993) 'Science Fiction, the World's Fair, and the Prosthetics of Empire, 1910–1915', in A. Kaplan and D. E. Pease (eds) *Cultures of United States Imperialism*, Durham, NC: Duke University Press, pp. 129–63.

Clarke, A. J. (2001) *Tupperware: The Promise of Plastic in 1950s America*, Washington, DC: Smithsonian Press.

Deetz, J. (1996) *In Small Things Forgotten: An Archaeology of Early American Life*, New York: Anchor Books.

Haraway, D. (1993) 'Teddy-Bear Patriarchy: Taxidermy in the Garden of Eden, New York City, 1908–1936', in A. Kaplan and D. E. Pease (eds), *Cultures of United States Imperialism*, Durham, NC: Duke University Press, pp. 237–91.

Phillips, R. B. and Steiner, C. B. (eds) (1999) *Unpacking Culture: Art and Commodity in Colonial and Postcolonial Worlds*, Berkeley: University of California Press.

Prown, J. D. and Haltman, K. (eds) (2000) *American Artifacts: Essays in Material Culture*, East Lansing: Michigan State University Press.

Rand, E. (2005) *The Ellis Island Snow Globe*, Durham, NC: Duke University Press.

Thomas, N. (1991) *Entangled Objects: Exchange, Material Culture, and Colonialism in the Pacific*, Cambridge, MA: Harvard University Press.

Willis, S. (2002) 'Old Glory', *SAQ*, vol. 101, no. 2, pp. 381–2.

. . . materiality and material culture . . .

Graves-Brown, P. (2000) *Matter, Materiality and Modern Culture*, London: Routledge.

Knappett, C. (2005) *Thinking through Material Culture: An Interdisciplinary Perspective*, Philadelphia: University of Pennsylvania Press.

Meskell, L. (ed.) (2005) *Archaeologies of Materiality*, Oxford: Blackwell Publishing.

Miller, D. (ed.) (1998) *Material Cultures: Why Some Things Matter*, Chicago: University of Chicago Press.

—— (2005) *Materiality*, Durham, NC: Duke University Press.

Myers, F. R. (2001) *The Empire of Things: Regimes of Value and Material Culture*, Santa Fe, NM: School of American Research Press.

Schiffer, M. (1999) *The Material Life of Human Beings: Artefacts, Behaviour and Communication*, London: Routledge.

. . . the stuff of science and technology . . .

Bailey, L. W. (2005) *The Enchantments of Technology*, Urbana: University of Illinois Press.

Bijker, W. E. and J. Law (eds) (1992) *Shaping Technology/Building Society*, Cambridge, MA: MIT Press.

Daston, L. (2000) *Biographies of Scientific Objects*, Chicago: University of Chicago Press.

—— (2004) *Things that Talk: Object Lessons from Art and Science*, New York: Zone Books.

Gershenfeld, N. (1999) *When Things Start to Think*, New York: Henry Holt and Company.

Latour, B. (2007) *Reassembling the Social: An Introduction to Actor-Network-Theory*, Oxford: Oxford University Press.

Law, J. (2002) *Aircraft Stories: Decentering the Object in Technoscience*, Durham, NC: Duke University Press.

Lubar, S. (1996) 'Learning from Technological Things', in W. D. Kingery (ed.), *Learning from Things: Method and Theory of Material Culture Studies*, Washington, DC: Smithsonian Institution Press.

Pels, D., Hetherington, K. and Vandenberghe, F. (2002), special issue on objects, *Theory, Culture and Society*, vol. 19 (5/6).

Schaffer, S. (1997) 'Experimenters' Techniques, Dyers' Hands and the Electric Planetarium', *Isis*, vol. 88, no. 3, pp. 456–83.

Shapin, S. and S. Schaffer (1985) *Leviathan and the Air-Pump: Hobbes, Boyle, and the Experimental Life*, Princeton, NJ: Princeton University Press.

Turkle, S. (ed.) (2007) *Evocative Objects: Things We Think With*, Cambridge, MA: MIT Press.

—— (ed.) (2008) *Falling for Science: Objects in Mind*, Cambridge, MA: MIT Press.

—— (ed.) (2008) *The Inner History of Devices*, Cambridge, MA: MIT Press.

Verbeek, P. P. (2005) *What Things Do: Philosophical Reflections on Technology, Agency, and Design*, University Park: Pennsylvania State University Press.

Wajcman, J. and MacKenzie, D. (eds) (1973) *The Social Shaping of Technology: How the Refrigerator Got Its Hum*, Oxford: Oxford University Press.

... media technologies ...

Acland, C. R. (ed.) (2007) *Residual Media*, Minneapolis: University of Minnesota Press.

Clemens, J. and Pettman, D. (2004) *Avoiding the Subject: Media, Culture, and the Object*, Amsterdam: Amsterdam University Press.

Dant, T. (1999) 'Turn It On: Objects that Mediate', *Material Culture in the Social World*, Buckingham: Open University Press.

Fuller, M. (2005) *Media Ecologies: Materialist Energies in Art and Technoculture*, Cambridge, MA: MIT Press.

Hastie, A. (2007) 'Detritus and the Moving Image', themed issue, *Journal of Visual Culture*, vol. 6, no. 2.

Klinger, B. (2006) *The Contemporary Cinephile. Beyond the Multiplex: Cinema, New Technologies and the Home*, Berkeley: University of California Press.

McCarthy, A. (2001) *Ambient Television: Visual Culture and Public Space*, Durham, NC: Duke University Press.

Morley, D. (1994) Television: Not So Much a Visual Medium, More a Visible Object', in C. Jenks (ed.), *Visual Culture*, London: Routledge.

Spigel, L. (1992) *Make Room for TV: Television and the Family Ideal in Postwar America*, Chicago: University of Chicago Press.

... sound reproduction technologies ...

Adorno, T. W. (1990) 'The Curves of the Needle', *October*, 55, pp. 49–55.

—— (1990) 'Opera and the Long-Playing Record', *October*, 55, pp. 62–6.

Gitelman, L. (2006) *Always Already New: Media, History, and the Data of Culture*, Cambridge, MA: MIT Press.

Pinch, T. and Trocco, F. (2002) *Analog Days: The Invention and Impact of the Moog Synthesizer*, Cambridge, MA: Harvard University Press.

Sterne, J. (2003) *The Audible Past: Cultural Origins of Sound Reproduction*, Durham, NC: Duke University Press.

Théberge, P. (1997) *Any Sound You Can Imagine: Making Music/Consuming Technology*, Hanover: Wesleyan University Press.

... with feeling,

Classen, C. (ed.) (2005) *The Book of Touch*, Oxford: Berg.

Edwards, E., Gosden, C. et al. (eds) (2006) *Sensible Objects: Colonialism, Museums and Material Culture*. Oxford: Berg Books.

Kleege, G. (2006) 'Visible Braille/Invisible Blindness', in *Journal of Visual Culture*, vol. 5, no. 2, pp. 209–18.

Lingis, A. (2000) 'The Navel of the World', in *Dangerous Emotions*, Berkeley: University of California Press.

Marks, L. U. (1999) *The Skin of the Film: Intercultural Cinema, Embodiment, and the Senses*, Durham, NC: Duke University Press.

—— (2002) *Touch: Sensuous Theory and Multisensory Media*, Minneapolis: University of Minnesota Press.

Merleau-Ponty, M. (1962) *Phenomenology of Perception*, London: Routledge & Kegan Paul.

Scarry, E. (1985) 'The Interior Structure of the Artefact', in *The Body in Pain: The Making and Unmaking of the World*, New York, Oxford: Oxford University Press.

and desire,

Bataille, G. (1991) 'The Object of Desire', *The Accursed Share*, vols II and III, New York: Zone Books, pp. 137–47.

Freud, S. (1961 [1927]) 'Fetishism', *Standard Edition, The Complete Psychological Works of Sigmund Freud*, vol. XXI, edited by James Strachey, London: The Hogarth Press, pp. 152–7.

—— (1991) 'Unsuitable Substitutes for the Sexual Object – Fetishism', in *On Sexuality: Three Essays on the Theory of Sexuality and Other Works*, London: Penguin Books.

Lacan, J. and J.-A. Miller (1991) 'The Gaze and the Petit Objet A', in *The Four Fundamental Concepts of Psychoanalysis*, Harmondsworth: Penguin.

Rifkin, A. and Camille, M. (2001) *Other Objects of Desire: Collectors and Collecting Queerly*, Oxford: Blackwell Publishing.

final things.

Amato, J. A. (2000) *Dust: A History of the Small and Invisible*, Berkeley: University of California Press.

Baker, N. (1986) *The Mezzanine*, London: Granta.

Caillois, R. (1985) '"Pierres-Aux-Masures" or Ruin and Landscape Marbles', in *Writing of Stones*, Charlottesville: University Press of Virginia.

Cook, J. (2004) 'Rocks, Fossils and the Emergence of Palaeontology', in K. Sloan and A. Burnett (eds), *Enlightenment: Discovering the World in the Eighteenth Century*, London: British Museum Press.

Hustvedt, S. (1992) *The Blindfold*, London: Hodder and Stoughton.

Leslie, E. (2005) *Synthetic Worlds: Nature, Art and the Chemical Industry*, London: Reaktion.

Mitchell, J. (2005) 'Theory as an Object', in *October*, 113, pp. 27–38.

Index